*Masterworks of American Painting
and Sculpture from the*

Smith College Museum of Art

Masterworks of American Painting

Linda Muehlig, *editor*

Betsy B. Jones, Patricia Junker, Elizabeth Mankin Kornhauser,
Deborah Chotner, Elizabeth C. Evans-Iliesiu, and
Cynda L. Benson, with contributions by Kristen Erickson,
Linda Merrill, and Daniel J. Strong;
Conservation notes by David Dempsey

nd Sculpture from the

Smith College Museum of Art

Hudson Hills Press, New York,
In Association with the Smith College Museum of Art,
Northampton, Massachusetts

First Edition

© 1999 by the Smith College Museum of Art.

All rights reserved under International and Pan-American Copyright Conventions.

Published in the United States by Hudson Hills Press, Inc., 122 East 25th Street, 5th Floor, New York, NY 10010–2936.

Distributed in the United States, its territories and possessions, and Canada by National Book Network.
Distributed in the United Kingdom, Eire, and Europe by Art Books International Ltd.

Editor and Publisher: Paul Anbinder

Manuscript Editor: Virginia Wageman

Proofreader: Lydia Edwards

Indexer: Karla J. Knight

Designer: Sisco & Evans

Composition: Angela Taormina

Manufactured in Japan by Dai Nippon Printing Company.

Library of Congress Cataloguing-in-Publication Data

Smith College. Museum of Art.

 Masterworks of American painting and sculpture from the Smith College Museum of Art / Linda Muehlig, editor: Betsy B. Jones . . . [et al.]: with contributions by Kristen Erickson, Linda Merrill, and Daniel J. Strong: conservation notes by David Dempsey.—1st ed.
 p. cm.
 Includes bibliographical references and index.
 ISBN: 1–55595–171–6 (pbk.: alk. paper).
 1. Art, American Catalogues. 2. Art—Massachusetts—Northampton Catalogues. 3. Smith College. Museum of Art Catalogues. I. Muehlig, Linda D. II. Jones, Betsy B. III. Erickson, Kristen. IV. Merrill, Linda, 1959– . V. Strong, Daniel J., 1966– . VI. Title. VII. Title: Smith College Museum of Art.
N6505.S545 1999
709′.73′07474423—dc21 99.35616
 CIP

Cover illustration: Charles Sheeler, *Rolling Power* (detail), 1939

Contents

Acknowledgments 6

Introduction 8

A Note on the Catalogue 14

*Masterworks of American Painting
and Sculpture from the
Smith College Museum of Art 15*

Notes 245

*Checklist of Important American
Paintings and Sculpture
from the Smith College Museum of Art 265*

References 279

Index 301

Photograph Credits 307

Acknowledgments

OF THE MANY PEOPLE who must be acknowledged for making this catalogue a reality, first and foremost are my fellow co-authors and contributors, who took on their writing assignments in addition to their professional and family commitments. In alphabetical order, they are: Cynda L. Benson, Deborah Chotner, Kristen Erickson, Elizabeth C. Evans-Iliesiu, Betsy B. Jones, Patricia Junker, Elizabeth Mankin Kornhauser, Linda Merrill, and Daniel J. Strong. All of them are former staff members, interns, or associates of the Museum, and it seemed only fitting that the work they had done while here—the research they had entered into the Museum's object files—should be credited, along with their new discoveries, by publication in this catalogue. Museum histories are often organized according to a succession of directors, and the sometimes less public contributions of curators can be overlooked in the dynastic accounts of the institutions they serve. I am pleased, therefore, for this opportunity to express my warm thanks to my colleagues, for their scholarship, for their commitment to the object, and for their friendship over the years. Betsy B. Jones, the senior scholar represented in this catalogue and for a dozen years the curator of this Museum, deserves special acknowledgment. She is, for the present writer certainly, the role model of what a museum curator is and does.

Director Suzannah Fabing and my colleagues on the staff of the Museum have all been supportive of the catalogue, but several individuals must be singled out in particular, especially Suzannah Fabing, who made certain that funding was in place for the publication and allowed her curator essentially to disappear into the project in the labor-intensive period prior to completion of the manuscript. Her directorial predecessors Edward Nygren and Charles Parkhurst each encouraged the project during their administrations. David Dempsey, Preparator/Conservator, is the author of the conservation notes in the object entries of the catalogue. Museum Registrar Louise Laplante arranged for photography; Stephen Petegorsky and David Stansbury photographed most of the works featured here. Michael Goodison, Archivist/Program Coordinator, assisted with copyright issues. Doctoral candidate Nancy Noble tracked down bibliographic questions over two successive summers, assembled photographs, and attended to myriad tasks and details quickly, accurately, and with good humor. Newly appointed Luce Curatorial Assistant Maureen McKenna is thanked for her perseverance and grace under fire in pursuing the remaining comparative photographs and copyright issues still outstanding at the time of her arrival, one month before delivery of the manuscript to the publisher, and for continuing the fact-checking process throughout the final editing phase.

As this project developed, a number of Smith College student assistants lent their aid to the catalogue: Megan Hurst (class of 1994), Lucy Maulsby (class of 1995), Anna Yim (class of 1996), and Kathryn Patterson (class of 2000). Other members of the Smith community who must be acknowledged include Professor John Davis, who organized the symposium honoring Oliver Larkin that coincides with the publication of this book. Assistant Professor Dana Leibsohn and Professor Neal Salisbury both provided valuable insights on the sociopolitical and historical issues addressed in Jaune Quick-to-See Smith's *Red Mean: Self-Portrait* (cat. 73). Barbara Polowy, her predecessor Amanda Bowen, and the entire staff of the Hillyer Art Library are warmly thanked for their help with reference questions and for allowing so many books to be absent from the library in service of this project.

A special salute is owed Elizabeth P. Richardson (class of 1943), an author in her own right and a historian of the Bloomsbury group who took on the editing of the catalogue from its beginnings as object worksheets consisting of exhibition and literature histories. Sadly, she was forced to withdraw from the project because of serious illness. Her death on July 5, 1998, has left her friends and colleagues with memories of her quick wit and intellect. In turn, it has been a pleasure to work with Paul Anbinder, President of Hudson Hills Press, and Virginia Wageman, who edited the manuscript. They are acknowledged, with admiration and gratitude, for this very handsome publication.

The authors and contributors join in thanking the following individuals and institutions for their assistance with research and other aspects of the catalogue process: Joan Banach (and the Dedalus Foundation, New York), Diane Waterhouse Barbieri, Vivian Endicott Barnett, Ethel Baziotes, John D. Berry, Michelle Storrs Booz, Katherine Caplan, Terry Carbone, Mikki Carpenter, Bruce W. Chambers, Rolando Corpus, N. C. Christopher Couch, Judith Cousins, Katherine B. Crum, Delphine Danaud, Terry Dintenfass, Richard A. von Doenhoff, Joellyn Duesberry, T. Lux Feininger, Scott R. Ferris, Debra J. Force, Ilene Susan Fort, Noel Frackman, Barbara Dayer Gallati, William H. Gerdts, Susan Glover Godlewski, Sidney Grolnic, Grey Gundaker, Anna M. Halpin, Joseph Helman Gallery (New York), Christine Hennessey, Janet Hicks (Artists Rights Society [ARS]), Jean Hines, Sanford Hirsch (and the Adolph and Esther Gottlieb Foundation, New York), Susan A. Hobbs, Herbert W. Hooper, Martha J. Hoppin, Althea H. Huber, Lance Humphries, Doru Lucian Iliesiu, Philip M. Isaacson, Wendy Jeffers, Jennifer Johnson, Allison Kemmerer, Melinda Kennedy, Betty Krulik, Robert L. Kurtz, the Lachaise Foundation (Boston), Sylvia Lahvis, Rebecca E. Lawton, Cheryl Leibold, Margaret V. Loudon, David Lubin, Barbara Buhler Lynes, John Manship, Joan H. Marter, Melissa De Medeiros, Achim Moeller, Leigh A. Morse (and Salander O'Reilly Galleries, New York), Virginia Norton Naudé, Emily Norris, Tom Ormond, Anna O'Sullivan, Marie Panik, David Platzker, Ann Prival (VAGA), Michael Quick, the George Rickey Workshop, Arthur Risser, Alexander S. C. Rower, Ann Rule, Bart Ryckbosch, Betye Saar, Rita Sanders, Gail R. Scott, J. Bruce Singer (and the *International Herald Tribune*), Lisa M. Skrabek, Joan Snyder, Richard Spellanberg, Debra Stasi, Allan Stone, Dora Straus, Donald Sultan, Robert Farris Thompson, Carol Troyen, Elizabeth G. de Veer, Elizabeth Walker, Richard Wattenmaker, Robyn Waxman, Bruce Weber, Richard V. West, Mary Ann Wilkinson, Cara L. Wood, and Ann S. Woolsey.

In addition, grateful acknowledgment is made of the research assistance of the staffs of the Archives of American Art (New York office), the Frick Art Reference Library (New York), the Library of Congress (Washington, D.C.), the Museum of Modern Art Archives (New York), the Library of the National Gallery of Art (Washington, D.C.), and the New York Public Library, including both the Forty-second Street Library and the Library at the Center for Performing Arts at Lincoln Center.

Finally, the following funding sources are gratefully acknowledged for underwriting, in part, this publication: the Charlotte C. Evans Fund (from the bequest of Charlotte Cushman Evans, class of 1929, whose daughter Elizabeth C. Evans-Iliesiu is a co-author of this catalogue), the Friends of the Museum, the Tryon Associates, and the Enid Silver Winslow (class of 1954) Fund. The catalogue was supported by two grants from the National Endowment for the Arts, which underwrote both the research/writing and publication phases, and by the Henry Luce Foundation's American Collections Enhancement Grant.

LINDA MUEHLIG
Associate Curator of Painting and Sculpture
Smith College Museum of Art

Introduction

Linda Muehlig

THE COLLECTING HISTORY and policies of the Smith College Museum of Art have been documented and recounted in a variety of publications,[1] especially its beginnings as a collection of contemporary American art. Repetition and familiarity, however, do not alter the fact that this Museum is a remarkable institution with an even more remarkable collection, formed by the purchases of a college president, successive Museum directors and their curators, and the constant generosity of Smith alumnae. With the advent of the millennium and a new building campaign on the immediate horizon, the publication of this catalogue offers the opportunity to revisit the past, by celebrating the masterworks of this institution's inaugural collections, and to look forward to the Museum's future.

In spring 1998 the Trustees of Smith College announced an ambitious plan to expand and renovate the present Museum building, the fourth home of the college's art collections. The Museum will be closed for two years, beginning in 2000, while the work is completed. A portion of the Museum's collection, including many of the American masterworks in this catalogue, will go on tour. This recalls a similar evacuation of masterworks from the collection from 1969 to 1972, when the nineteenth- and twentieth-century European and American paintings were sent on national tour while the present Museum was being built.[2] Another, more recent, disruption in 1990 sent the masterworks briefly to New York for exhibition.[3]

In 1999, on the cusp of our closing and the end of the century, a number of anniversaries and signal events will occur that will focus attention on the importance of American art at Smith College. A small exhibition will be mounted in spring 1999 to celebrate the sesquicentennial of the birth of artist Dwight W. Tryon (cat. 31), whose name and works are preserved by the Museum. The publication of this catalogue in the fall will be marked by an expanded reinstallation of the American works from the collection, the last exhibition before the building closes. In conjunction with the catalogue publication and reinstallation, a symposium, organized by the Art Department and the Museum, will be held to commemorate the fiftieth anniversary of *Art and Life*

in America, a seminal publication in American art history by former Smith College faculty member Oliver Larkin. In these several ways, the Museum will re-engage with its American holdings, the works that formed its nascent collections in 1879 when Smith's first President, L. Clark Seelye, began to buy original art for the college. It is a rare moment to reflect on energetic beginnings and to recognize courageous decisions as well as cautionary errors.

An undated article from 1879 in the *Springfield Republican* newspaper gives insight into the flurry of collecting activity that began the collection. Announcing that Smith College had assembled "an unequaled collection by American artists" chosen with the "utmost care" by President Seelye and Professor James Wells Champney, the article enumerated some twenty-seven paintings that were hanging on the second floor of College Hall in a gallery that also included plaster casts of classical sculpture. The names include J. G. Brown, Champney, Samuel Colman, John Enneking, Robert Swain Gifford, James McDougal Hart, Winslow Homer (cat. 23), George Inness (cat. 25), William Sartain, Walter Satterlee, Louis Comfort Tiffany, Alexander H. Wyant, and others,[4] with the addendum that "Church and Hunt have been engaged to contribute a new picture." Most of these works did not remain in the collection; however, among the earliest paintings purchased that still remain part of the Museum's holdings is Thomas Eakins's small genre picture *In Grandmother's Time* (checklist no. 11), the first painting by Eakins to enter a public collection. The earliest check in the College Archives that can be securely associated with an acquisition is dated February 8, 1879, for the purchase of Robert Swain Gifford's *Old Orchard near the Sea* (still in the collection); the Eakins was purchased soon after with a check for one hundred dollars (dated May 3, 1879).[5]

Seelye was active in fulfilling the promise made in his inaugural address of July 14, 1875, to provide the college with a "gallery of art, where the student may be made directly familiar with the famous masterpieces."[6] His strategy in the early stages of building the collection was to acquire reproductive prints and casts of his-

torical works and to buy original contemporary American art. He often visited artists' studios in Boston and New York and received concessions on purchase prices. Of the works represented in this catalogue, the Eakins genre scene and Albert Pinkham Ryder's *Perrette* (cat. 34) were purchased by Seelye directly from the artists, and William Merritt Chase's *Woman in Black* (cat. 32) was possibly acquired from its author as well. President Seelye was also open to the advice of contemporary artists on his purchases. As Betsy B. Jones speculates in her entry for this catalogue on the early Rockwell Kent painting *Dublin Pond* (cat. 40), Seelye may have been advised by Kent's teachers, Chase and Abbott Thayer, in the acquisition of this painting, which was purchased from the 1904 Society of American Artists exhibition. The painter Dwight W. Tryon, who was appointed to teach art at the college in 1886, often advised Seelye as well, and both he and Chase were members of the 1904 exhibition selections committee. In any case, the purchase of this painting by a twenty-one-year-old artist, whose reputation was yet to be established, was noted in the press at the time; as Jones points out, it was the first Rockwell Kent painting ever to enter a museum collection.

In 1905 Alfred Vance Churchill was appointed the first chair of the History and Interpretation of Art at Smith College and was also placed in charge of the Hillyer Art Gallery (figs. 1 and 2), the building that had been completed in 1882 to house the art department and growing collection of art. Under his leadership the gallery began to collect European works of art. Churchill's purchases in this area were strong and also unusual, in that he consciously sought out and acquired unfinished works for their educational value. During the time he administered the gallery and his subsequent directorship (1919–32) of the newly named Smith College Museum of Art, some of the Museum's most noted French works were acquired, including Edgar Degas's early (unfinished) history painting *Jephthah's Daughter*, Gustave Courbet's *Preparation of the Dead Girl* (also unfinished), and the superb Paul Cézanne landscape *La Route tournante à la Roche Guyon*. Late in his tenure Churchill purchased one of the glories of

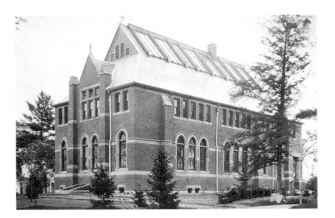

Figure 1. *Hillyer Art Gallery, designed by Peabody and Stearns and completed in 1882; undated photograph.*

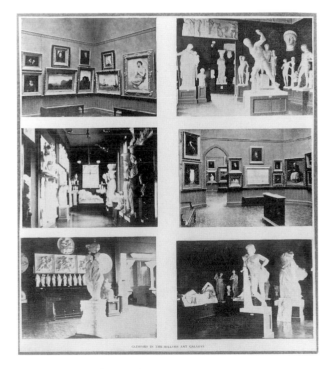

Figure 2. *Views of the Hillyer Art Gallery. Abbott Thayer's* Winged Figure *is visible in the upper left vignette (hanging at the right). From an unidentified file clipping, "Glimpses in the Hillyer Art Gallery," with the date "Jul 21 1919" stamped on the mount.*

Figure 3. Tryon Art Gallery, designed by Frederick L. Ackerman and completed in 1926; photograph made in the fall of 1958.

the American collection, Eakins's late portrait of *Edith Mahon* (cat. 41), acquired more than fifty years after Seelye's purchase of *In Grandmother's Time*. The first three-dimensional American works of record to enter the collection were both acquired in 1915: a demure marble of a little girl garlanded as the May Queen by Daniel Chester French (cat. 24) and a reduced bronze version of an Augustus Saint-Gaudens sculpture described by catalogue author Patricia Junker as "the most conspicuous nude in late-nineteenth-century American art" (cat. 38).

In 1920, at the request of the College Trustees, Churchill also formally developed the Museum's collecting policy, still in force today, the "concentration" and "distribution" plans that together emphasized the active development of the Museum's core collection of modern art (then considered to begin chronologically with the French Revolution), with a representative "distribution" of great works from earlier periods. Midway through his directorship the third building to house the collection (and the first intended exclusively as a museum) was erected in 1926. Called the Tryon Art Gallery (fig. 3), the building was underwritten by a large donation from Dwight Tryon (who had retired from the faculty in 1923) and his wife, Alice Belden Tryon.

Jere Abbott's directorship of the Museum from 1932 to 1946 produced a number of extraordinary acquisitions, perhaps the most important of these the late Cubist painting by Pablo Picasso, *La Table*, then a controversial purchase. The founding associate director of the Museum of Modern Art before he came to Smith, Abbott had a celebrated eye for art. He bought the great Charles Sheeler *Rolling Power* (cat. 55) from the *Fortune* magazine *Power* series in 1940, when it was shown at Edith Halpert's Downtown Gallery with the five other

paintings from the group. This highly significant purchase of a contemporary American painting, now considered an icon of twentieth-century art, was preceded by another prescient acquisition the year before from the same gallery, when Abbott acquired a large still life by a nineteenth-century American painter "rediscovered" in the twentieth century and touted by the press as inherently modern. In the end it did not matter that the still life of worn books, *Discarded Treasures* (cat. 42), was not by its purported author, William Harnett, whose easily forged monogram appeared on this and other paintings. When scholar Alfred Frankenstein solved the mystery years later and the painting was reattributed to its rightful author, John Frederick Peto, its quality remained undisputed. Abbott also purchased the Calder *Mobile* (cat. 52) in 1935, a year after its creation.

Abbott was succeeded by the Renaissance scholar Frederick Hartt, whose directorship was brief, from 1946 through 1947. During this time approximately eighty works were deaccessioned from the collection. This period has not been addressed in any of the historical accounts of the Museum, but it should be examined more fully than is possible in this context, not to assign blame for decisions made over fifty years ago in different times and circumstances, but rather to consider a lesson learned at pain.[7] In order to raise money for the seventy-fifth anniversary of the Museum and to offset other expenses, the decision was taken with the full agreement of the Art Department and with the approval of the Board of Trustees to sell works that, at the time, were not considered of first quality or were deemed to be duplicates. Most of the works were American paintings, including many that had been bought by President Seelye from artists in the nineteenth and early twentieth centuries. These were sold primarily through Gimbel

Brothers of New York in 1946 and 1947, with unsold works remaindered to Kende Galleries and others sold to individual buyers or galleries.

Especially regretted is the loss of Abbott Thayer's *Winged Figure* of 1889 (see fig. 2), now a centerpiece of the American collections at the Art Institute of Chicago. Another signal loss is Thomas Wilmer Dewing's serene *Lady with a Lute* of 1886, purchased by Walter Timme shortly after an intermediate buyer acquired it from the Gimbel's sale. In May 1947 Timme wrote to inform the Museum of his intention to give the canvas to the National Gallery of Art in Washington, D.C., which has owned the painting since 1978.[8] Alumnae also wrote to protest the sale of works they had studied as undergraduates.[9] Winslow Homer's *Song of the Lark* of 1876, an early Seelye purchase, was first offered to Wildenstein's, but sold instead to M. Knoedler and Company in December 1946. It was eventually acquired by Walter P. Chrysler, who gave the painting to the Chrysler Museum in Norfolk, Virginia. Other deaccessioned works include paintings by Ralph Blakelock, George de Forest Brush, William Merritt Chase, John Enneking, Childe Hassam, George Inness, Edmund Tarbell, Dwight W. Tryon, John Twachtman, and J. Alden Weir among other artists. In making the determination of which works were to be deaccessioned, it was stipulated that no works received as gifts were to be sold. Chase's *Woman in Black*, Kent's *Dublin Pond*, Tryon's *First Leaves* (cat. 31), and Whistler's portrait of *Mrs. Lewis Jarvis* (cat. 28), all purchases from the early days of the Museum, survived the deaccessioning process, as did the little Eakins genre picture *In Grandmother's Time*.

After another brief directorship under Edgar Schenck (1947–49), the Museum was headed by the distinguished architectural historian Henry-Russell Hitchcock from 1949 to 1955. Under his leadership and that of curator and American art specialist Mary Bartlett Cowdrey, the American collections began to grow once again. A number of the paintings in this catalogue bear accession numbers dating from this period, attesting to renewed collecting activity. Purchases made during this time include Thomas Cole's study for his *Voyage of Life: Manhood* (cat. 14), Asher Brown Durand's *Woodland Interior* (cat. 17), *Mourning Picture* (cat. 33) by the artist-genius of the Berkshires Edwin Romanzo Elmer, Thomas Charles Farrer's *View of Northampton from the Dome of the Hospital* (cat. 21, unattributed at the time of its acquisition but later convincingly ascribed to Farrer by Betsy Jones), Martin Johnson Heade's *New Jersey*

Meadows (cat. 22), Homer's *Shipyard at Gloucester* (cat. 23), Alfred Henry Maurer's *Bal Bullier* (cat. 39), and Margaretta Angelica Peale's *Still Life with Watermelon and Peaches* (cat. 12). This period was also marked by important gifts of American art: William Stanley Haseltine's *Natural Arch, Capri* (cat. 18), Willard Leroy Metcalf's *Willows in March* (cat. 43), Florine Stettheimer's portrait of *Henry McBride* (cat. 48), and Benjamin West's *Conversion of St. Paul* (cat. 7). The first Peto retrospective was organized by the Museum in 1950, followed by monographic exhibitions of the work of Edwin Romanzo Elmer and Florine Stettheimer in 1952.

Hitchcock was succeeded by Robert Owen Parks (1955–61), whose important acquisitions include the great German Expressionist canvas *Dodo and Her Brother* by Ernst Ludwig Kirchner and a highly important early-sixteenth-century drapery study by Mathis Grünewald. During his directorship two Anglo-American portraits came into the collection: *Henrietta Elizabeth Frederica Vane* by Gilbert Stuart (cat. 6), one of the artist's rare full-length portraits of children, and *A Master in Chancery Entering the House of Lords*, by Ralph Earl (cat. 5). Albert Bierstadt's *Echo Lake, Franconia Mountains, New Hampshire* (cat. 20) and Lee Bontecou's relief (cat. 63) were both purchased in 1960.

Under Charles Chetham's long directorship (1962–88), the Museum expanded in size as well as personnel, and the professional status of its staff and operations was firmly established. The John Singleton Copley portrait of John Erving (cat. 4) and John Smibert's portrait of Erving's wife, Abigail Phillips Erving (cat. 1), were among the American works acquired during this time. The Copley painting was a gift from a Smith alumna descendant of the sitter; the Smibert portrait was a later purchase, which reunited the couple. Two late-eighteenth- or early-nineteenth-century American wood carvings were acquired (cats. 8 and 11), including the large eagle architectural ornament (cat. 8) given by Dorothy C. Miller, class of 1925, a celebrated curator at the Museum of Modern Art and longtime adviser, donor, and friend to her alma mater's museum. Another masterful painting by Edwin Romanzo Elmer, *A Lady of Baptist Corner* (cat. 36), was added, as were portrait pairs by the itinerant artists William Jennys (cat. 10) and Erastus Salisbury Field (cat. 13) and paintings of two members of the Gillam Phillips family by Joseph Blackburn (cat. 2). Author and educator Mina Kirstein Curtiss, class of 1918, underwrote the purchase of John Singer Sargent's *My Dining Room* (cat. 29) and gave the

monumental cast concrete *Garden Figure* (cat. 51) by Gaston Lachaise. She was also the source of Elie Nadelman's *Resting Stag* (cat. 46). Nanette Harrison Meech, class of 1938, gave Lyonel Feininger's *Gables I, Lüneburg* (cat. 50) in honor of her alumna daughter, and actress Helen Hayes, who received an honorary doctorate from Smith College in 1940, gave Edward Hopper's "portrait" of her house, *Pretty Penny* (cat. 54). Other important twentieth-century acquisitions were made as well, including Frank Stella's nearly forty-foot-long *Damascus Gate (Variation III)* from the *Protractor* series (cat. 67), Joan Mitchell's untitled canvas (cat. 64), Claes Oldenburg's *Sketch for a Soft Fan* (cat. 65), and Sol LeWitt's *Cube Structure* (cat. 69), which remains one of the Museum's relatively few examples of Minimalist and Conceptual art.

One of Chetham's most important achievements was the building of the present facility (fig. 4). Although many regretted the loss of Tryon Hall, which was razed in 1970 to make way for the new fine arts complex, the collections had by that time outgrown the building. The masterworks were sent on tour and other works retreated into storage while the new building was completed, which united the Museum and art department across a central sculpture courtyard. The new Smith College Museum of Art opened to the public in 1973, with increased gallery and exhibition space on three floors. Equally important, however, were the lasting contributions Chetham made to scholarship and education. Generations of Smith College students studied at the Museum or participated in his Museum seminar courses over the years. He also invested in training future professionals in the field, women who are now active among the ranks of museum curators and educators, art dealers, authors, and professors of art history.

A number of the co-authors of this catalogue began their careers as graduate interns at the Museum during Chetham's directorship and went on to respected careers and accomplishments in American art. They include Patricia Anderson (now Patricia Junker, Associate Curator of American Art, Fine Arts Museums of San Francisco), Deborah Chotner (Associate Curator, American and British Paintings, National Gallery of Art), and Elizabeth C. Evans-Iliesiu (an independent art historian living in New York). The present writer, also a graduate intern, has remained on staff since her internships in the academic years 1976–77 and 1977–78. Co-authors Betsy Jones (now retired) and Elizabeth Mankin Kornhauser (Chief Curator and Curator of American Art, Wadsworth Atheneum) were both on the staff of the Museum during Chetham's tenure. Betsy Jones (class of 1947) was Curator of Painting and Associate Director of the Museum from 1974 to 1986 and was especially active in research on the collection. Elizabeth Kornhauser served briefly as the Museum's registrar before going on to earn her doctorate.[10] The principal writers for this catalogue have also achieved scholarly recognition for monographs and exhibitions on a number of the artists whose works they discuss here: Deborah Chotner on Samuel S. Carr, Betsy Jones on the work of Edwin Romanzo Elmer, Patricia Junker on Winslow Homer, and Elizabeth Mankin Kornhauser on Ralph Earl.[11] Linda Merrill (Curator of American Art, High Museum of Art, Atlanta), a contributor to this publication, graduated from Smith College in 1981, during the Chetham years; she is an acknowledged expert on the work of Dwight W. Tryon.

After Charles Chetham retired, Edward Nygren assumed the directorship of the Museum in 1988. Although Nygren left in 1991 to become Director of Art Collections at the Huntington Library, Art Collections, and Botanical Gardens, he renewed the Museum's original mandate to collect and show contemporary art. A series of site-specific installations was inaugurated, reflecting the curatorial decision to emphasize the work of women and artists of color through exhibition and acquisition. Smith students who assisted the artists in assembling their installations gained not only the experience of participating in the artistic process but also the chance to learn about the cultural traditions that informed the work. In some cases, works by the visiting artists were later added to the permanent collection;[12] Jaune Quick-to-See Smith's *Red Mean: Self-Portrait* (cat. 73) and Betye Saar's *Ancestral Spirit Chair* (cat. 74) were both acquired after exhibitions at the Museum. John Storrs's witty *Auto Tower* (cat. 49) was purchased during this time, and two alumnae families gave important gifts of American art: George Inness's radiant *Landscape* (cat. 25) and William Glackens's *Bathers, Bellport, No. 1* (cat. 44), which was given by the artist's son Ira Glackens in honor of his first wife, a graduate of Smith College.

After Nygren's resignation, Charles Parkhurst served as interim director for eighteen months, a continuation in "retirement" of his long and eminent career as a museum professional. Suzannah Fabing was named as the first woman director in the Museum's history in 1993. Under her administration, the Museum's educational mission has been expanded, with many more courses across a wide variety of disciplines making use

of the collections. Alumnae support through gifts of works of art and funds, both of which have been critical to the Museum throughout its history, has been strengthened during this time, highlighted by the largest gift of contemporary art to date. Louise Nevelson's late assemblage *Mirror-Shadow XIII* (cat. 71), Joan Snyder's *My Temple, My Totems* (cat. 70), and Donald Sultan's *Ferry, Sept. 17, 1987* (cat. 72) are three of the almost one hundred works given to the Museum in 1994 by Mr. and Mrs. William A. Small, Jr. (Susan Spencer, class of 1948). In spring 1998, a unique cooperative venture was created when the Smith College Museum, the Mount Holyoke College Art Museum, and the Davis Museum and Cultural Center at Wellesley College were designated by Norma Marin (daughter-in-law of artist John Marin) as the future co-owners of her twentieth-century American art collection. The directors of the three institutions were also named trustees of the Norma Marin Foundation to benefit women working in the arts.[13]

At this writing, the director and staff of the Smith College Museum of Art are assembling wish lists for the newly renovated and expanded Museum building. Increased gallery space will allow more of the Museum's holdings to be shown, especially the American works of art, which despite unfortunate culling in the 1940s, remain an area of considerable depth. The strengths of the American painting and sculpture collection are showcased by the works discussed in the essay section of this catalogue, which is followed by an illustrated checklist of other important American works from our holdings.[14] Together they form a foundation for collecting American art in the twenty-first century, including works by artists not already represented in the collection and works-yet-to-be-created by artists of the future. As the definition of American art broadens in scope to embrace the artistic production of an increasingly diverse and multicultural population, Churchill's "concentration" and "distribution" plans may be revisited and reinterpreted by new generations of Museum directors and curators.

Change is inevitable and intrinsic to the growth of the Smith College Museum of Art. As we anticipate another chrysalis stage, the Museum's future conformation and colors remain to be imagined and discovered. Smith College students will be an important part of that future and, we hope, will continue to participate in the life of the Museum, not only through their course work, but by direct involvement as work-study assistants, interns, and docents, and in other ways yet to be envisioned. Their support as alumnae will also be vital to the Museum, as it has always been. In a time of transition and transformation, what cannot change is the importance of the Museum to the college and its educational mission, and that of the college to the Museum. What must not change is the Museum's commitment to the high aesthetic quality of its collections and the excellence of its programs.

A Note on the Catalogue

Shortened references have been used for literature and exhibition histories as well as in the notes to each entry. Typically, a shortened literature reference consists of the surname of the author and the year of publication. In the case of exhibitions and exhibition catalogues, the citation consists of the city location, an identifying name of the first venue (as necessary, to differentiate museums and galleries in, for example, New York and Washington, D.C.), and the year of presentation (first venue only, rather than the inclusive dates of a tour). Exhibitions with multiple venues are identified by a plus sign (+) after the city location and are listed according to the first venue (rather than the organizer). Therefore, the short reference for an exhibition presented first in Los Angeles in 1978 but organized by the Museum of Modern Art and shown in New York in 1979 would be listed as "Los Angeles + 1978." The short references are keyed to the full citations in the backmatter.

Measurements for paintings are given as height by width and do not include the frame dimensions. Sculpture measurements are given as height by width by depth; where applicable, the dimensions include the self-base (as in the case of the French *May Queen* [cat. 24], Saint-Gaudens *Diana* [cat. 38], and Manship *Centaur and Dryad* [cat. 45], for example). The objects were remeasured for the catalogue by Preparator/ Conservator David Dempsey, who wrote the conservation notes for each entry.

The essay section, arranged chronologically by object date, is followed by an illustrated checklist of other important American paintings and sculpture in the collection. Checklist objects are numbered and are referred to in the essays by cross-references to the number.

Abbreviations:

AAA	Archives of American Art, Smithsonian Institution, Washington, D.C.
cat.	catalogue (also catalogue number)
ckl.	checklist
colorpl.	colorplate
dtl.	detail
repro.	reproduced
SCMA	Smith College Museum of Art
unno.	unnumbered
unpag.	not paginated

Authors and contributors:

CLB	Cynda L. Benson
DC	Deborah Chotner
KE	Kristen Erickson
ECE-I	Elizabeth C. Evans-Iliesiu
BBJ	Betsy B. Jones
PJ	Patricia Junker
EMK	Elizabeth Mankin Kornhauser
LM	Linda Muehlig
LMERRILL	Linda Merrill
DS	Daniel J. Strong

Masterworks of American Painting
and Sculpture from the

Smith College Museum of Art

John Smibert

EDINBURGH, SCOTLAND 1688–1751 BOSTON

1. *Mrs. John Erving (Abigail Phillips),* c. 1733

Oil on canvas; 39¾ × 30¾ in. (101 × 78.1 cm); not signed, not dated

Purchased with funds realized from the estate of Maxine Weil Kunstadter, class of 1924 (1981:12)

PROVENANCE: Descendants of the sitter, to John Erving V (1833–1917), New York; to his daughter, Sarah Erving King (Mrs. James Gore King), New York; to her son, James Gore King, Cambridge, Mass. (with his estate until 1981).

EXHIBITIONS: Northampton 1982 Smibert, ckl. 8; New York, IBM 1990.

LITERATURE: Foote 1950, pp. 75, 151, repro. opp. p. 80; Sellers 1957, pp. 426, 434, 463, repro. p. 439; Belknap 1959, p. 298 (no. 22D), pl. XXVI; *Smibert* 1969, pp. 91, 110; Saunders 1979, fig. 191; Gustafson 1982, p. 986, repro.; Deitz 1982, p. 37; *SCAQ* 1982, p. 23, repro.; *Erving* 1984, p. 5, repro. p. 3; Chetham et al. 1986, no. 103, repro.; Saunders 1995, pp. 180–81 (no. 87), repro.

CONSERVATION: The painting is wax lined and mounted on a new turnbuckle stretcher. There is a repaired and inpainted tear beginning in the cheek and continuing downward to the mouth. There are numerous smaller losses, particularly along the right edge and throughout the background.

JOHN SMIBERT, a native of Scotland, had established a studio in London by 1722.[1] There he received instruction under Sir Godfrey Kneller before returning to Edinburgh, where he spent three years painting portraits before traveling to Italy. During his three-year stay there, Smibert recorded the details of the trip in his notebook. He studied works by the old masters and copied them, acquired works of art for himself, and painted portraits from life.

In September 1728 Smibert left for America in company with Dean George Berkeley, who had invited him to serve as a professor of art for the college he intended to found in Bermuda. When plans for the college failed, Smibert established himself in Boston. He became the first professionally trained artist to arrive in America, where he led a highly successful career as a portrait painter. His knowledge of current London fashion and his academic training helped to transform portraiture in the colonies with such works as his noted portrait *The Bermuda Group* (c. 1729–31, Yale University Art Gallery), painted to commemorate those who participated in Dean Berkeley's venture.

Smibert kept a small notebook in which he recorded the 250 portraits he painted during his American career. In March 1733 a commission for a half-length portrait of "Mrs. Irwin" is noted, probably a reference to the Museum's portrait of Mrs. John Erving. (Smibert also recorded a portrait commission from Captain John Erving in March 1738).[2] At the time her portrait was made, probably in 1733, Abigail Phillips Erving (1702–1759), the daughter of John and Mary (Grosse) Phillips of Boston, had been married to the successful Boston merchant John Erving for eight years. Depicted at three-quarter length, she is shown as a woman of wealth and social prominence. Her right hand is placed on the muslin-trimmed bodice of her blue-green dress; her left hand rests on a mauve scarf lying on a table. She wears a scarf that envelops her right shoulder and arm. With her head held upright and gaze directed outward toward the viewer, Abigail Erving appears alert and attractive. She is a large woman, with dark hair and eyes, and is placed against a plain dark background.

Mrs. John Erving (Abigail Phillips) is considered one of the finest depictions of a woman by Smibert and is characterized by finely modeled facial features and a lively pose.[3] When this portrait of the young matron was acquired by the Museum, it joined John Singleton Copley's portrait of her husband as an older man, painted almost forty years later (cat. 4).

EMK

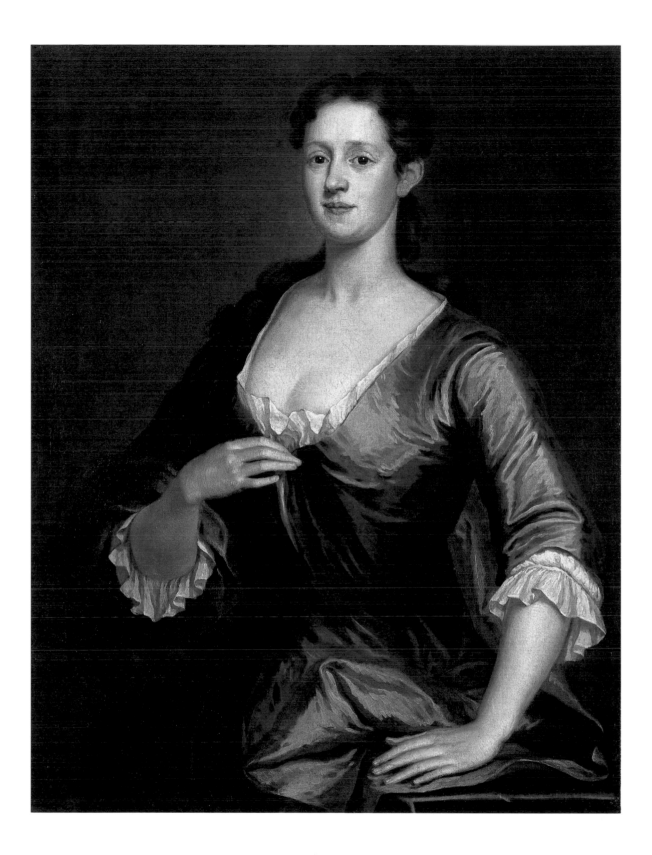

Joseph Blackburn

BORN LONDON; ACTIVE IN NORTH AMERICA 1754–63

2. a) Gillam Phillips, 1755
b) Mrs. Gillam Phillips (Marie Faneuil), 1755
c) Andrew Faneuil Phillips, 1755
d) Ann Phillips, 1755

cat. 2(a)

Oil on canvas; 50¼ × 40 in. (127.6 × 101.7 cm); signed and dated in black paint, left, on base of pilaster: *I. Blackburn Pinxit 1755*

Bequest of Carter F. Jones (1992:44-1)

PROVENANCE: Descended through the family of the sitter to Wallace T. Jones, Brooklyn, N.Y.; to his son, Carter F. Jones, Nassau County, N.Y.

LITERATURE: Morgan 1919, p. 148; Park 1923, p. 310 (no. 53); Bolton and Binsse 1930 "Blackburn," p. 90; Morgan and Foote 1936, p. 18; Baker 1945, p. 41.

CONSERVATION: The painting is on a linen canvas that has been wax lined to a new fabric mounted on a new keyed stretcher. The original tacking edges are still intact. The painting has mechanical and age craquelure overall, with two bull's-eye cracks to the proper left side of the head. There is some frame rub along the top edge, and there is some minor inpainting.

cat. 2(b)

Oil on canvas; 50⅛ × 40⅛ in. (127.3 × 101.9 cm); signed and dated in black paint, left, below midline: *I. Blackburn Pinxit 1755*

Bequest of Carter F. Jones (1992:44-2)

PROVENANCE: Descended through the family of the sitter to Wallace T. Jones, Brooklyn, N.Y.; to his son, Carter F. Jones, Nassau County, N.Y.

LITERATURE: Morgan 1919, p. 148; Park 1923, pp. 310–11 (no. 54); Bolton and Binsse 1930 "Blackburn," p. 90; Morgan and Foote 1936, p. 18; Baker 1945, p. 41.

CONSERVATION: The painting is on a linen canvas that has been wax lined to a new fabric mounted on a new keyed stretcher. The original tacking edges have been removed. The painting has mechanical and age craquelure overall and stretcher-bar cracks. There are some accretions under the varnish layer, particularly in the proper left side of the nose, the left forearm, and the right side in general.

WHILE JOSEPH BLACKBURN is thought to have been trained in England, nothing is known of this artist prior to his arrival in Bermuda in August 1752. He painted approximately twenty-five portraits on the island during an extended stay. His likenesses of leading Bermudian families indicate the artist's familiarity with the work of London portrait painters of the 1740s. He left for America, arriving in Newport, Rhode Island, in 1754. After painting a number of portraits of prominent Newport families, Blackburn moved on to Boston with a letter of introduction that described the artist as "late from the Island of Bermuda a Limner by profession & is allow'd to excell in that science, has spent some months in this place, & behav'd in all respects as becomes a Gentleman, being possess'd with the agreeable qualities of great modesty, good sence & genteel behaviour."[1]

Blackburn was embraced by Boston's leading families who wished to have their portraits painted. Impressed by his graceful poses, his precise treatment of costume detail, and his ability to depict generalized landscape settings, they awarded him numerous commissions. Blackburn influenced the young John Singleton Copley (cat. 4), who rapidly emerged as a major talent in his own right. Blackburn left in 1758 for Portsmouth, New Hampshire, where he remained for about five years actively painting portraits. He also returned to the Boston area, and possibly Rhode Island, to paint portraits. He left for England in 1763, where he painted portraits in the provinces as well as in Dublin, Ireland, until 1777.

Blackburn painted four portraits of members of the Phillips family not long after his arrival in Boston. The head of the family, Gillam Phillips (1695–1770), son of Samuel and Hannah Gillam Phillips, took over his father's bookshop in Boston and later owned part interest in a paper mill. He married Marie Faneuil (1708–1790), sister of the wealthy Boston merchant Peter Faneuil, in 1725. Both Gillam and Marie inherited substantial fortunes, allowing Gillam to retire in order to manage their estates. Blackburn painted the couple and their two children, Andrew Faneuil Phillips (1729–1775) and Ann Phillips (1736–before 1770), thirty years after their marriage. Andrew declared himself a loyalist at the outbreak of the Revolution but remained in Boston, serving as an addresser of the Massachusetts colonial governor, Thomas Hutchinson. Ann, who never married, is thought to have died before 1770 and is not mentioned in her father's will.[2]

Blackburn produced stylish portraits of the Phillips family, with flattering poses and elegant attire. In the most conservative composition of the four, Gillam Phillips is shown seated on a Queen Anne side chair, his left hand placed in his vest and his right hand holding a tricorn hat resting on his lap. The hat covers his awkwardly placed splayed legs. Wearing a formal powdered wig, he is presented with a stern visage; Blackburn does not conceal his subject's wandering left eye. He is placed against a plain dark background with a column at the left.

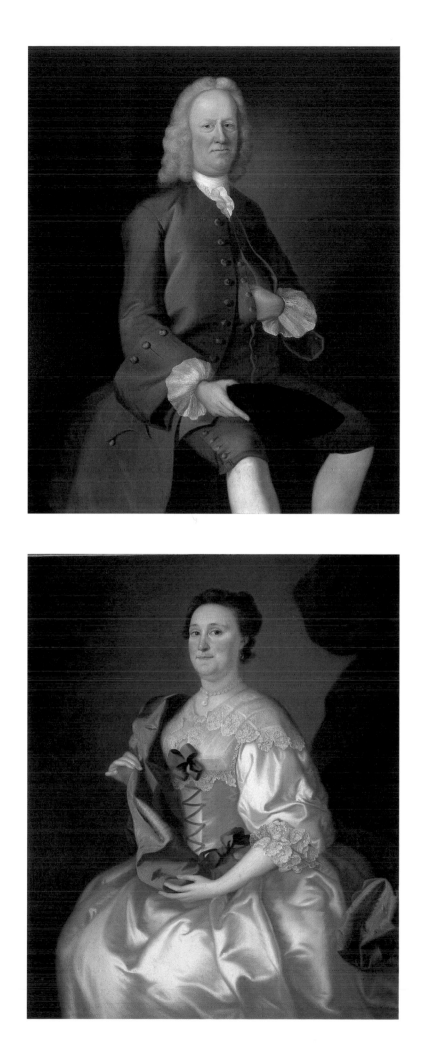

cat. 2(c)

Oil on canvas; 50⅜ × 40⅜ in.
(128 × 102.5 cm); signed and dated
in black paint, left, below midline:
Jos. Blackburn Pinxit 1755

Gift of Mrs. Winthrop Merton Rice
(Helen Swift Jones, class of 1910)
(1973:25)

PROVENANCE: Descended
through the family of the sitter to
Wallace T. Jones, Brooklyn, N.Y.;
to his daughter, Helen Swift Jones
(Mrs. Winthrop Merton Rice),
Hightstown, N.J.

EXHIBITIONS: Northampton 1976
American; Northampton 1979, ckl. p. 26.

LITERATURE: Morgan 1919, p. 148,
repro. p. 149; Park 1923, p. 309
(no. 52); Bayley 1929, pp. 51–52,
repro. p. 113; Bolton and Binsse 1930
"Blackburn," p. 90; Morgan and
Foote 1936, p. 18; Baker 1945, p. 41;
Chetham et al. 1986, no. 101, repro.

CONSERVATION: The original can-
vas has been wax lined to a linen fab-
ric and placed on a modern stretcher.
The original tacking edges have been
removed. There is overall mechani-
cal craquelure, and there are several
small areas of inpainting. There is a
heavy natural resin varnish overall.

cat. 2(d)

Oil on canvas; 50⁷⁄₁₆ × 40⁵⁄₁₆ in.
(128 × 102.3 cm); signed and dated
in black paint, left, below midline:
I. Blackburn Pinxit 1755

Gift of Mrs. Winthrop Merton Rice
(Helen Swift Jones, class of 1910)
(1982:27)

PROVENANCE: Descended
through the family of the sitter to
Wallace T. Jones, Brooklyn, N.Y.;
to his daughter, Helen Swift Jones
(Mrs. Winthrop Merton Rice),
Hightstown, N.J.

LITERATURE: Morgan 1919, p. 148;
Park 1923, pp. 308–9 (no. 51); Bolton
and Binsse 1930 "Blackburn," p. 90;
Morgan and Foote 1936, p. 18; Baker
1945, p. 41.

CONSERVATION: The original can-
vas is glue lined to a thick canvas sup-
port mounted on a new stretcher. The
original tacking edges are missing.
There is mechanical craquelure over-
all. Areas of inpainting are visible
under ultraviolet light. The painting
appears to have a synthetic varnish.

Marie Phillips is presented in a more formal three-quarter-length pose. The artist took great care in the details of her antique costume, which dates to the early to mid–seventeenth century. A large, imposing figure, she wears a white silk gown with blue ribbons at the bust and waistline and meticulously rendered lace at the collar and sleeves. Her dress style is termed Van Dyck after the court portraitist of Charles I. Wearing attire of the previous century allowed women to escape from their everyday world into the past.[3] Her long white arms and hands hold a mauve shawl. She wears a pearl choker with a single drop pearl and one visible earring. Drapery is seen at the right, and in the upper left background is a sketchily painted rococo frame, perhaps a mirror. Like her husband, she meets the viewer's gaze directly, displaying the hint of a smile.

Andrew Phillips is presented by Blackburn at three-quarter length, standing outdoors, posed in a more stylish manner than his father. His slight, elongated figure is set in an S curve, with head turned to the left and hands pointing right; his left hand holds a tricorn hat. He wears a powdered wig tied at the back, a pale gray coat, breeches embellished with silver or pewter buttons, and a pale blue vest with silver gilt. His carefully modeled facial features are highlighted by pinkish flesh tones. He stands against a landscape background with trees and foliage at right and a craggy rock overhang at the left.

Ann Phillips, echoing her brother's pose, is shown standing, at three-quarter length. She has a small, elegant figure and strong features (a strong family resemblance between brother and sister is evident in the large, almost Hapsburgian jaw and firmly set mouth). She wears a pinkish mauve gown with a low-cut bust line outlined in lace and a string of pearls. An elaborate striped shawl encircles her shoulder. Like her mother's, Ann's dress echoes fashionable attire of the 1740s, in the style of fancy dress popular in England in the eighteenth century that was intended to represent the historic past.[4] Her hair is adorned with an ornament of pearls, a tea rose, and a feathered plume. Her right hand rests on a marble-topped gilt pier table, and her left hand holds a Chinese vase of multicolored tulips. The background consists of blue drapery at the right and a lunette at the upper left that appears to open to a view of the sky.

Blackburn succeeds in conveying the upper-class status of the Phillips family through his depiction of elaborate costume detail and elegant poses and accouterments. All four Phillips portraits have retained their original rococo frames.

EMK

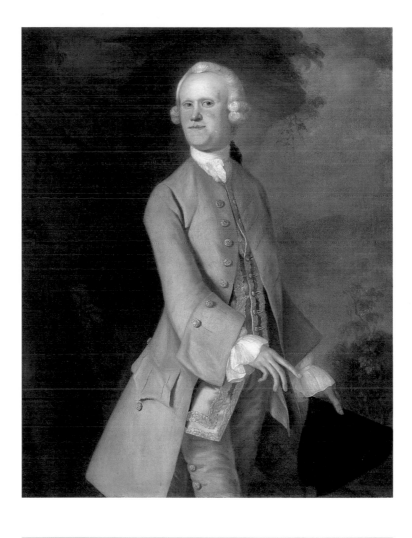

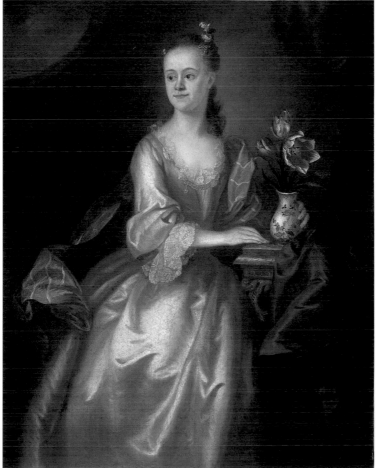

Thomas McIlworth
SCOTLAND (?)–1770 (?) MONTREAL

3. *Dr. William Samuel Johnson, 1761*

Oil on canvas; 30⅛ × 25⅛ in. (76.5 × 63.8 cm); not signed, not dated

Purchased, Eleanor Lamont Cunningham, class of 1932, Fund (1955:4)

PROVENANCE: Samuel William Johnson (1761–1846), son of the sitter; to his son, William Samuel Johnson (1795–1883); to his daughter, Laura Woolsey Johnson (Mrs. William H. Carmalt [1837–1923]); to her daughters, Ethel (c. 1865–?) and Geraldine (c. 1870–?) Carmalt (great-great-granddaughters of the sitter); to Ralph Thomas, New Haven, Conn., 1954; with Hirschl and Adler Galleries, New York, by 1955.

EXHIBITIONS: New York, Columbia 1954; Northampton 1962, no. 8; Chicago 1964; Northampton 1968 *Hitchcock,* no. 14; Northampton 1976 *American;* Northampton 1979, ckl. p. 27; Northampton 1980, no. 1, repro.; Williamstown 1983, p. 19, no. 4, pl. 4.

LITERATURE: Groce 1937, p. 195; Sawitzky 1951, p. 136 (no. 7); Hitchcock 1954–55, pp. 18–19, repro.; Davidson 1955, pp. 278, 280, repro.; *Art Q* 1955, repro. p. 305; *Connoisseur* 1956, p. 310, repro.; Hyde 1961, repro. p. 5; Mongin 1965, repro. p. 518; Kammen 1968, pl. IV; Chetham et al. 1986, no. 104, repro.; Burkett 1987, pp. 216–17 (no. 30, as attributed to Christopher Steele), fig. 223; Knapp 1989, repro. p. 83.

CONSERVATION: The painting is on canvas that has been glue lined to another canvas. The tacking edges have been removed, and the painting has been mounted on a new keyed stretcher. There is mechanical craquelure overall. A scratch on the forehead has been inpainted, and there are a few additional inpainted losses in the forehead area.

LITTLE IS KNOWN about Thomas McIlworth despite the fact that he painted portraits of New York's most distinguished families, including the Stuyvesants, Livingstons, Schuylers, Van Rensselaers, and Van Cortlands.[1] Thought to have been born in Scotland, McIlworth is first documented in New York in 1757, when he joined the St. Andrew's Society, one of the city's first benevolent organizations, made up of prominent members of the Scottish community. He advertised as a portrait painter in the *New York Mercury* of May 8, 1758, and later announced in the *New York Gazette* that "His first sett of pictures are now finished."[2] He served as the manager of St. Andrew's from 1759 to 1760.

Following his marriage in 1760, McIlworth began traveling up the Hudson River Valley seeking commissions for portraits from the region's prominent landholders. In 1763 he executed a portrait of the colonial superintendent of Indian affairs, Sir William Johnson, whom, to judge by the extensive correspondence between them, he apparently enlisted as a patron. Through Johnson's intervention, McIlworth obtained the clerkship of Indian affairs in Schenectady, New York, and later became town clerk. In 1766 he wrote to Sir William of his wife's illness and sought Johnson's support in retaining his clerkship. By the following year the artist had moved to Montreal and in a further letter complained of "ill fortune and the slight demand for portrait painting," suggesting that he might seek commissions in Quebec.[3] He evidently died in Montreal a few years later.

Before leaving New York in search of new commissions, McIlworth painted Dr. William Samuel Johnson (1727–1819), a distinguished politician and educator. Born in Stratford, Connecticut, Johnson received his early education from his father, the Reverend Samuel Johnson (1696–1772), a noted Anglican cleric. Like his father, William was graduated from Yale College; he studied for a master's degree at Harvard College in 1747, eventually receiving an honorary doctorate of law from Oxford University. Although groomed for the Anglican church, Johnson pursued a career in law and became active in Connecticut politics as a member of the colonial House of Representatives in 1761 and 1765.

Johnson served as commercial attaché in London from 1767 to 1771 in order to defend Connecticut's title to the Mohegan lands and other territorial claims. While there he visited the studios of Benjamin West (cat. 7) and Sir Joshua Reynolds (1723–1792). Upon his return to the United States, he served as a judge of the Connecticut Superior Court and was one of the most learned members of the Continental Congress. A member of the Constitutional Convention of 1787, he helped ratify the document. In 1787 Johnson became the first president of the newly named Columbia College in New York (his father had served as president when it was known as King's College), retiring in 1800.[4]

McIlworth painted his distinguished subject as a young man of thirty-four, the year he was elected to the House, and also painted a portrait of Johnson's wife, *Ann Beach Johnson* (fig. 5). The overall flat, linear quality of the Museum's painting and the use of strong local color with little modeling in light and shade point to the artist's provincial

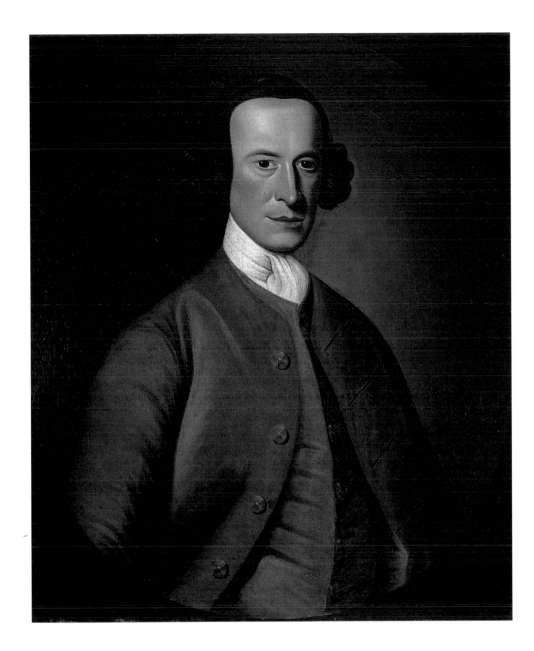

background. The sitter's squared-off face, high forehead, glossy complexion, and unaligned eyes are all characteristic of the painter's work. Despite these shortcomings as a self-taught artist, McIlworth has successfully conveyed the elevated social position and imposing demeanor of his subject. Johnson is placed in an oval spandrel format and shown at bust length.

Johnson's distinguished father, the Reverend Johnson, was also painted by McIlworth at about the same time as this portrait.[5] Upon seeing his son's portrait he declared it "a shocking thing" that ought to be "blotted out," while calling the portrait of Ann Beach Johnson a "good likeness."[6] Gilbert Stuart (cat. 6) would paint William Samuel Johnson's portrait over thirty years later (1793, private collection), and John Wesley Jarvis (1780–1840) painted Johnson as an elderly man, five years before his death (c. 1814, National Portrait Gallery, Washington, D.C.).

EMK

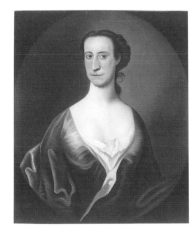

Figure 5. Thomas McIlworth, Portrait of Ann Beach Johnson, c. 1760, oil on canvas, 30 × 25 in. (76.2 × 63.5 cm). Munson-Williams-Proctor Institute Museum of Art, Utica, N.Y. (56.72).

John Singleton Copley
BOSTON 1737–1815 LONDON

4. *The Honorable John Erving,* c. 1772

Oil on canvas; 50½ × 40½ in. (128.3 × 102.9 cm); not signed, not dated

Bequest of Alice Rutherford Erving, class of 1929 (1975:52-1)

PROVENANCE: Descended through the family of the sitter to Alice Rutherford Erving, Santa Barbara, Calif.

EXHIBITIONS: New York, Metropolitan 1909, no. 9; Santa Barbara 1941, no. 32; Northampton 1959, no. 7, repro.; Santa Barbara 1966, no. 4, repro.; Northampton 1976 *American;* Northampton 1979, ckl. p. 27: Northampton 1982, *Smibert,* ckl. no. 3; Williamstown 1983, pp. 18–19, no. 5, pl. 5; New York, IBM 1990.

LITERATURE: Perkins 1873, suppl. p. 3; Bayley 1915, p. 101; Bolton and Binsse 1930 "Copley," p. 116 (ckl.), 118; La Follette 1935, repro. p. 336; Parker and Wheeler 1938, pp. 69–70, pl. 112; Prown 1966, pp. 31, 85, 105, 154–55, 213, fig. 319; Sherrill 1976, repro. p. 396; *Erving* 1984, p. 5, repro. p. 2; Tyler 1986, repro. p. 31; Chetham et al. 1986, no. 102, repro.

CONSERVATION: The painting has been wax lined (the tacking edges have been removed) and is mounted on a keyed wooden stretcher. There is a scratch or tear in the upper right edge, and there is a tear just to the right of the buttons on the vest.

THE SON of humble Irish immigrants, John Singleton Copley possessed an innate artistic genius that allowed him to develop quickly as the leading artist in colonial America before leaving the country for England in 1774.[1] When he was ten, his mother married Peter Pelham (1697–1751), a London-trained mezzotint engraver based in Boston; Copley was thus exposed as a young man to the tools of the artist's trade. In the 1750s he experimented with a number of artistic endeavors, first developing his skills at scraping a mezzotint; following this, he painted mythological works drawn from print sources, made anatomical drawings, and produced a variety of portraits in pastel, watercolor, and oil. His portraits at this time show the influence of such artists of the day as the English-trained painter Joseph Blackburn (cat. 2), but are marked by a strong linearity, contrasts of light and shade, and a directness of approach.

By the early 1760s Copley's position as Boston's leading artist was unchallenged. Having brought portraiture in America to a new level of sophistication, Copley made his first bid for international recognition in 1766, testing his skills by sending the portrait of his half-brother Henry Pelham (1749–1806), known as *Boy with a Squirrel* (1765, Museum of Fine Arts, Boston), to the Society of Artists in London, where it received positive notices.[2] In 1769 he married Susanna Clarke, daughter of a prominent Boston merchant, and began to build a mansion on Beacon Hill. In addition to the liberal patronage he received from Boston-area merchants, Whig and Tory alike, Copley spent a profitable season painting thirty-five portraits in New York in 1771.

The rising political turmoil in Boston precipitated Copley's departure for England in 1774. After being welcomed to London by Benjamin West (cat. 7), he set off on a year of travel in Europe (August 1774–September 1775), returning to the city to settle in a large house in Leicester Square. Copley built a prosperous career abroad, with many commissions to paint portraits, and aspired to succeed as a leading painter of historical and, to a lesser extent, religious subjects. He attained admission to the Royal Academy in 1779 and produced his great historical painting, *The Death of the Earl of Chatham* (1779–81, Tate Gallery, London), exhibited to wide popular acclaim. This was followed by another powerful, heroic modern history piece, *The Death of Major Pierson* (1783, Tate Gallery, London), which marked the height of his career.

One of the high points of Copley's American career was his series of portraits of prominent Boston-area merchants painted in the 1760s and 1770s. Copley often identified the distinguished subjects of his portraits on the business papers that appear in his still-life vignettes. In the Museum's portrait, the elderly figure of John Erving is seated next to a royal-blue-cloth-covered table holding a silver (or pewter) inkstand with feather pen, a letter, and an envelope displaying the inscription: "To / The Hon John Erving— / in / Boston." The son of Scottish fisherfolk, John Erving (1693–1786) emigrated from the Orkney Islands in about 1705 to Boston. He arrived as a common sailor and eventually became one of Boston's most prominent and wealthy merchants. In 1725 he married Abigail Phillips (1702–1759), whose portrait, painted by John Smibert about eight years later, is also in the Museum's collection (cat. 1). The Ervings solidified their social position through the successful marriages of their children: John

to Maria Catherina Shirley, daughter of Governor William Shirley; George to Lucy Winslow, and later to Mary Royall; Elizabeth to James Bowdoin, a governor of Massachusetts; Mary to George Scott, governor of Dominica and Granada; Anne to Duncan Stewart Waldo of Maine; and Sarah to Colonel Samuel Waldo of Maine.[3]

On his death, Erving received the following tribute in the *Independent Chronicle* (August 24, 1786):

> Died . . . at his house in Tremont Street, in the 94th year of his Age, the Honorable John Erving, Esq., who for twenty years was a Member of the Council under the old Constitution, and one of the most eminent Merchants in America—as a man of probity, and strict honesty, he was universally esteemed. Those who were acquainted with his character must regret the loss of so worthy a member of the community.[4]

Copley's dignified portrait of the nearly-eighty-year-old merchant is a meticulously rendered likeness. Emphasis is placed on the subject's inner character—John Erving confronts the viewer directly with his sharp blue eyes. Copley does not conceal signs of aging, evident in the subject's deeply wrinkled face and sagging flesh. Erving sits casually with an arm slung over the ear of a carved Chippendale side chair, with his strong hands firmly clasped in front of him. Bathed in sharp light, his disproportionately large head, with its meticulously rendered wig, and large hands contrast with the comparatively small body, dressed in dark attire. He is placed against a plain brown background; to his right, the blue drapery sets off the tabletop still life composed of business implements.

This portrait remained in the Erving family until its bequest to the Museum; two modern copies of the painting were made.[5]

<div align="right">EMK</div>

Ralph Earl

LEICESTER, MASSACHUSETTS 1751–1801 BOLTON, CONNECTICUT

5. *A Master in Chancery Entering the House of Lords*, 1783

Oil on canvas; 49½ × 39½ in.
(125.7 × 100.3 cm) remaining
original canvas, 50⅛ × 40¼ in.
(127.3 × 102.2 cm) current canvas;
signed and dated in black paint,
lower left: *R. Earl Pinxit / 1783*

Purchased (1956:52)

PROVENANCE: Undisclosed English
dealer; purchased in England by
John Nicholson Gallery, New York;
to Vose Galleries, Boston.

EXHIBITIONS: Boston, Vose 1961,
no. 40; Montreal 1967, no. 141,
repro.; Storrs 1972, no. 3, repro.;
Northampton 1976 *American;*
Baltimore 1976, no. 32, repro.;
New York, IBM 1990; Washington
+, NPG 1991–92, no. 13, pp. 28, 121,
repro. p. 122.

LITERATURE: Graves 1905–6,
vol. 3, p. 2; *Art Q* 1957, p. 94, repro.
p. 99; Parks 1957 *College*, pp. 73–75,
repro.; *Art Newsletter* 1957, repro.;
Comstock 1958, pp. 64–65, repro.;
SCMA Bull 1958, p. 31, fig. 27;
Sawitsky and Sawitsky 1960, p. 29,
fig. 21; Goodrich 1967, pp. 26–27,
repro.; Northampton 1979, ckl. p. 27;
Washington +, NPG 1980–81, p. 62;
Chetham et al. 1986, no. 100, repro.;
Kornhauser 1989, pp. 121–23.

CONSERVATION: The original linen
canvas has had its tacking edges
removed and is glue lined to a sec-
ondary canvas. The current stretcher
appears to be larger than the original
stretcher, causing draws in the top
left and right corners of the canvas.
There is traction crackle in the green
painted areas. An inpainted A-shaped
tear is in the lower center, and there
is frame rub along the edges. The
painting is heavily varnished.

RALPH EARL was raised in Worcester County, Massachusetts, the son of farmers, Ralph and Phebe Wittemore Earll.[1] In 1774 he established himself as a fledgling artist in New Haven, Connecticut, where he painted portraits of a number of leading patriots, including his early masterwork *Roger Sherman* (1775–76, Yale University Art Gallery, New Haven). This and other early works demonstrate Earl's admiration for, and emulation of, the colonial portraits of John Singleton Copley (cat. 4), whose influence is reflected in the full-scale format adopted by Earl and in the characterization of his subjects.

Earl also collaborated with his New Haven colleague, the engraver Amos Doolittle (1754–1832), to produce sketches for four engravings of the 1775 Battle of Lexington and Concord, which were among the first historical prints made in America. Despite his seemingly patriotic endeavors, Earl declared himself a Loyalist, and in 1778 with the assistance of a young British officer, Captain John Money, he fled to England, deserting his first wife, Sarah Gates Earl (1755–1831), and their two children. During his eight-year stay in England, Earl divided his time between Norwich, the site of Captain Money's country estate in the province of East Anglia, and London. His early years were spent painting portraits for the Norwich country gentlefolk. By 1783 Earl was part of the entourage of American artists in the London studio of Benjamin West (cat. 7), where he absorbed the lessons of the British portrait tradition. Earl's highly accomplished London and Windsor portraits, many shown at the Royal Academy exhibitions, represent a variety of subjects, including military portraits and sporting pictures; he also demonstrated a growing interest in landscape art, as evidenced by the scenic backgrounds of his portraits.

Earl's *Master in Chancery Entering the House of Lords* is dated 1783, when he is first known to have had a residence in London. He began exhibiting portraits at the Royal Academy in that year, listing his address at Hatton Garden near Holborn, and would submit *A Master in Chancery* for exhibition the following year.[2] While the portrait represents one of Earl's finest English works, the identity of the subject remains in question. In the eighteenth century, masters in Chancery acted as legal functionaries in the court of Chancery and in the House of Lords. The subject of Earl's portrait wears a legal costume including a black silk gown and white linen bands at the collar, over a formal, official black suit and vest.[3] This three-quarter-length portrait reveals the strides Earl had made under the guidance of West. His improving technical skills are seen in his use of delicate glazes to illuminate the subject's face, his skillful handling of gradations of gray and black in the costume, and his creation of a convincing receding space, which includes a stairway rising behind the figure. Under his arm the subject carries a scroll inscribed with portions of two bills written by Lord North that were passed and repealed in 1775, as follows: "An Act to restrain / Trade of Massach / Rhode island Con / Virginia South Ca / North America." The bills were intended to restrict trade with the northern and southern colonies in America.

It has been suggested that the sitter may be Henry, second earl of Bathurst (1714–1794), who served in Parliament and was later appointed lord chancellor.[4] If so, the

inscription on the scroll may refer to his support for Lord North's ministry. Earl's likeness bears a marked resemblance to a drawing (1779–80, Museum of Fine Arts, Boston) of Bathurst made by Copley in 1779 in preparation for his historical painting *The Death of the Earl of Chatham* (1779, Tate Gallery, London), but since there is no firm evidence that Bathurst served as a master in chancery, the subject's identity remains uncertain. Earl's signature in black is in keeping with the somber palette of the portrait (the artist commonly used vermilion to sign his later New England works).

The first of West's students to return to America after the restoration of peace, Earl established a residence in New York City in 1785. This ambitious start came to a sudden halt when he was confined in New York's debtor's prison. Upon his release he followed his court-appointed guardian, Dr. Mason Fitch Cogswell, to Connecticut, where Cogswell provided him with portrait commissions.

Over the next decade, Earl contributed to the formation of a national imagery by portraying a segment of American society, the rising middle class in rural New England, which had not received the attention of a trained and highly gifted artist before. More than any other artist of his time, Earl was qualified to create an appropriate style to satisfy the aesthetic sensibilities of his Connecticut subjects. Earl achieved the desired effect in his portraits by a deliberate rejection of British aristocratic imagery, cleverly tempering his academic style to suit his subjects' modest pretensions. He abandoned the formal qualities of his English and New York portraits in favor of more direct portrayals of his subjects' likenesses and surroundings, including their attire, locally made furnishings, newly built houses, regional landscape features that celebrated land ownership, and emblems of the new nation.

EMK

Gilbert Stuart
NORTH KINGSTON, RHODE ISLAND 1755–1828 BOSTON

6. *Henrietta Elizabeth Frederica Vane,* 1783

Oil on canvas; 65⅞ × 38⅝ in. (167.3 × 98.1 cm); not signed, not dated

Gift in memory of Jessie Rand Goldthwait, class of 1890, by her husband, Dr. Joel E. Goldthwait, and daughter, Mrs. Charles Lincoln Taylor (Margaret Rand Goldthwait, class of 1921) (1957:39)

PROVENANCE: The Honorable Charles Vane, Norfolk, England, father of the sitter; to the sitter, Lady Langham (1773–1807); to her daughter, Henrietta Langham Sanford; with M. Knoedler and Company, New York, 1947–57; purchased for the Museum by Dr. Joel E. Goldthwait, Medfield, Mass.

EXHIBITIONS: London 1783, no. 266; London 1910, no. 108, repro. (as by an unknown artist); New York, Knoedler 1948, no. 9; Utica 1960, no. 103, repro.; Northampton 1962, no. 10; Chicago 1964; Washington +, National Gallery 1967, no. 10, repro.; Northampton 1975 *Five*, no. 15; Northampton 1976 *American*, no. 10; Boston, MFA 1976, no. 19, repro.; Northampton 1979, ckl. p. 28; Washington +, NPG 1980–81, pp. 54, 58, fig. 37; New York, IBM 1990.

LITERATURE: *St James's Chronicle* 1783; *Connoisseur* 1926, p. 258, color repro. p. 219; Whitley 1932, pp. 37–38; *Amer Coll* 1948, repro. cover; *Pict Exh* 1948, repro. p. 6; Parks 1957 *SCAQ*, repro. p. 12; *SCMA Bull* 1958, p. 61, fig. 28; Guitar 1959, repro. p. 114; McLanathan 1960 "Museum," repro. p. 27; McLanathan 1960 "Art," pp. 456–57, repro.; Mount 1964 *Gilbert*, pp. 76–78, 84, repro. opp. p. 128; Mount 1964 *Country*, p. 380, fig. 5; Chetham 1969, p. 710, repro. frontispiece; Sherrill 1976, repro. p. 396; DeLorme 1979, pp. 344–45, fig. 2; Chetham et al. 1986, no. 98, repro.; McLanathan 1986, pp. 48–49, repro.; Strong 1991, p. 253, pl. 241.

CONSERVATION: The painting is glue lined and mounted on a keyed wooden stretcher. There are in-painted losses on the nose, chin, and cheek.

GILBERT STUART (who was baptized "Stewart") was the son of a Scotsman who operated a snuff mill in North Kingston, Rhode Island.[1] He moved with his family in 1761 to Newport, where he received artistic instruction from the Scottish artist Cosmo Alexander (1724–1772). Stuart followed Alexander to Edinburgh as his apprentice, probably in 1771. Alexander died suddenly in 1772, and Stuart returned the following year to Newport, where he began to paint portraits in the controlled, linear style of his teacher.

In 1775, with war threatening, Stuart, who was then in Boston, left for England in order to pursue his painting career. The artist spent two unsuccessful years in London as a portraitist, failing to gain enough commissions to support himself. His financial failure led him to appeal to Benjamin West (cat. 7) for help; with his characteristic generosity, West allowed Stuart a space to work in his studio for the next few years. Stuart's career gained momentum with the exhibition at the Royal Academy in 1782 of his full-length portrait of his friend William Grant, called *The Skater* (1782, National Gallery of Art, Washington, D.C.) and acknowledged to be the artist's early masterpiece. In the same year he married Charlotte Coates. While Stuart achieved the admiration of his peers for his elegant portraits, his inability to curb his spendthrift ways forced him to flee to Dublin in the fall of 1787 to escape his creditors. He remained there until he was enticed back to his native country in 1793 with the prospect of greater financial gain.

After his return to this country, Stuart spent the first two years in New York, painting portraits of recent heroes of the war and socially prominent families in his fashionable portrait style, founded on the painterliness of late-eighteenth-century British portraiture. One of his goals in returning to the United States was to paint its most famous citizen, George Washington. With that purpose in mind, he moved in 1795 to Philadelphia, then the seat of national government, where he painted Washington and other famous national figures, including Thomas Jefferson. When the seat of government moved to Washington in 1803, Stuart followed and stayed two years. In 1805 he was encouraged to return to Boston, where he spent the remaining two decades of his life.

As the most sophisticated American portrait painter of his generation, Stuart brought his exuberant and refined style to America. His works were celebrated for their painterly traits—facile handling of light, space, and form and a keen appreciation for the optical blending of colors. By the end of his life he was recognized as his country's foremost portrait painter, and he is best known for his portraits of George Washington.

Stuart's full-length portrait of the ten-year-old Henrietta Elizabeth Frederica Vane, painted in England in 1783, is one of his rare depictions of children; only a few are known in his substantial body of work. The most direct parallel is that of the young boy *George Thomas John Nugent*, painted circa 1790–92 in Dublin (fig. 6). The boy, like Henrietta, is shown at full-length standing in a landscape setting (both the full-length format and the landscape settings are also rare compositional elements in

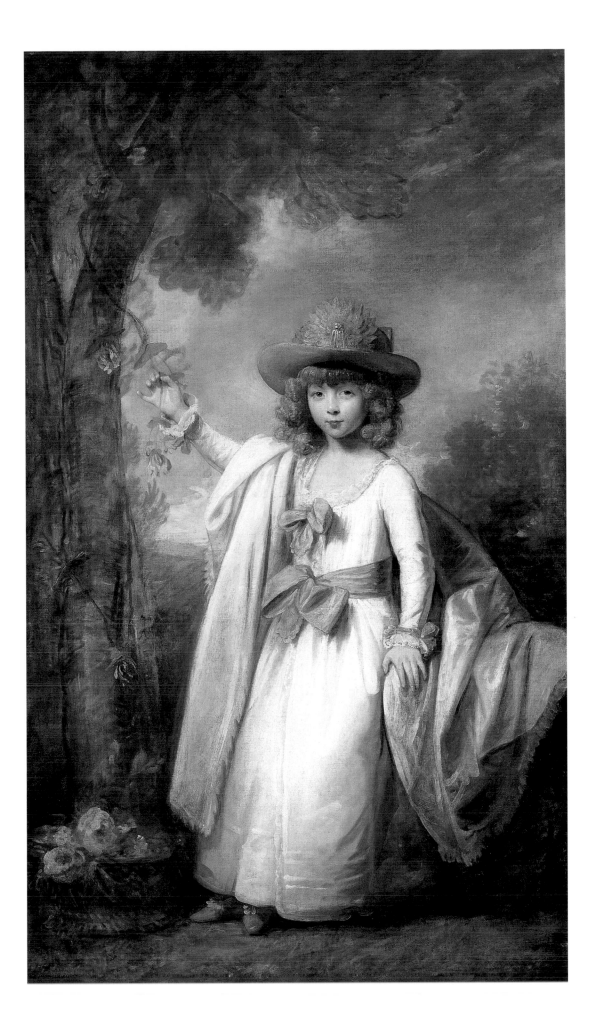

Figure 6. Gilbert Stuart, Portrait of
George Thomas John Nugent,
*c. 1790–92, oil on canvas, 49¾ × 40 in.
(126.5 × 101.5 cm). The Armand
Hammer Collection, UCLA at the
Armand Hammer Museum of Art and
Cultural Center, Los Angeles.*

Stuart's long career). Stuart had painted his first full-length portrait only a year earlier than the portrait of Henrietta, his famous *Skater;* this innovative composition, with its active movement, pushed beyond the traditional crossed-legged standing pose for men common to English portraiture. Its success allowed Stuart to leave West's London studio and establish one of his own nearby on Newman Street, where he painted a series of portraits, beginning in 1783, including that of Henrietta Vane, one of the first portraits painted in his new studio.

Stuart doubtless received this commission from the subject's father, the Honorable Charles Vane of Mount Ida, Norfolk, sixth son of the second Baron Barnard. In 1795 Henrietta (1773–1807) married Sir William Langham, eighth baronet and sheriff of Northampton County, and they raised three children.[2] The portrait descended in the subject's family and remained unknown to scholars until the 1940s, when William Sawitzky, conducting research on Stuart's portraits, identified it as the work Stuart submitted for exhibition at the Gallery of the Incorporated Society of Artists in 1783 and the sitter as Henrietta Elizabeth Frederica Vane. Stuart sent a total of nine portraits for exhibition at the Society of Artists' gallery, considered a lesser venue than the Royal Academy, where Stuart had previously shown his work.[3] The Vane portrait is listed as "no. 266 Portrait of a Young Lady—whole length" and received favorable comment from the press. One writer noted: "a very pleasing composition. This is upon the whole the most elegant picture of this artist. Mr. Stuart is to be praised for facility; let him take care it does not degenerate into slightness. Too much dispatch is dangerous in a rising artist."[4]

Stuart's portrait of the young girl, which clearly demonstrates the influence of Thomas Gainsborough (1727–1788) in its full-length outdoor pose, immediately engages the viewer with the exquisite execution of the face, set off by golden wavy curls and a large hat. Attired in a white dress with a salmon-colored sash, she appears to lean against a ledge hidden by the voluminous cloak draped over her right shoulder, which falls at the lower right. Her left hand leans on the cloak while she reaches up with her right hand to grasp a floral vine that hangs from the tree. This rather tentative stance is the only awkward passage of the painting, particularly noticeable in the unconvincing placement of the tiny feet. She stands in an idyllic landscape, executed in thinly applied, feathery brushwork, with a large tree at left, foliage, misty sky, and a basket of red flowers at her feet. While the setting connotes the innocence of childhood, Stuart captures a lively character in his young subject's face.

Following her marriage, Henrietta was later painted by John Hoppner (1758–1810) (location unknown), and there is an engraving after the Hoppner portrait by C. Wilkin entitled *Lady Langham.*[5]

EMK

Benjamin West

SPRINGFIELD, PENNSYLVANIA 1738–1820 LONDON

7. *Preliminary design for the painted window in St. Paul's Church, Birmingham: The Conversion of St. Paul* (center); *St. Paul Persecuting the Christians* (left); *Ananias Restoring St. Paul's Sight* (right), 1786

Oil on canvas; center 50½ × 23½ in. (128.3 × 59.7 cm); side canvases each 35½ × 9 in. (90.2 × 22.9 cm); center canvas signed and dated in ocher paint, lower left: *B. West 1786*

Gift of Caroline R. Wing, class of 1896, and Adeline F. Wing, class of 1898 (1951:169)

PROVENANCE: Possibly the artist's sons, Raphael West and Benjamin West, Jr., until June 1829; possibly sold through George Robins, London, *Original Pictures . . . of the Late Benjamin West, Esq., P.R.A., and Upwards of One Hundred Unfinished Pictures and Sketches from the Pencil of the . . . Same Celebrated Master . . .*, June 20 and 22, 1829, lot 132* ("Two narrow pictures, the Conversion of St. Paul and Companion"); G. P. A. Lederer, Esq., London; sale, Christie, Manson, and Woods, London, *Modern Pictures, the Property of G. P. A. Lederer, Esq., Deceased . . . also Ancient and Modern Pictures and Drawings from Various Sources*, Dec. 1, 1950, lot 49 (as "The Conversion of Saul," 51 × 23½ in., sold anonymously); sold to Frost and Reed, London, 1950; John Mitchell and Sons, London; sold to Childs Gallery, Boston, by May 1951.

EXHIBITIONS: Possibly London 1791, no. 426 ("*The Conversion of St. Paul:* a finished sketch, a design for the painted window in St. Paul's Church, Birmingham"); Northampton 1968 *Hitchcock*, no. 24, repro. p. 23; Northampton 1979, ckl. p. 28.

LITERATURE: Hitchcock 1951 *SCMA*, pp. 12–17, figs. 6–8; Hitchcock 1951 *Art*, pp. 268–69, repro. p. 266; *Antiques* 1955, p. 240, repro.; Evans 1959, pp. 66–67, 76–77, figs. 48, 49; Dillenberger 1976, pp. 104–5, 155–57, 193, 195, 212, fig. 72; Meyer 1979, p. 65; Meyer 1981, p. 223; Erffa and Staley 1986, pp. 90, 92, 382–83 (nos. 390–92), 401, repro. pp. 93, 382–83; Chetham et al.

THIS TRIPARTITE COMPOSITION — framed with a pair of decorative studies of putti, probably by another hand—was long thought to be Benjamin West's finished design for the painted window at St. Paul's, Birmingham, a study presumably exhibited twice at the Royal Academy, in 1791 and 1801. But the discovery in recent years of a second finished study of *The Conversion of St. Paul*, one more closely conforming to the design of the completed window, reveals that West actually created two versions of the work, making it difficult to establish the exhibition and ownership history of the Museum's painting. The Museum's version, more loosely painted than the second set of panels, now in the collection of the Dallas Museum of Art, and varying significantly in the central motif of Christ, may represent a first, preliminary sketch for the St. Paul's project.[1]

The Conversion of St. Paul was created by West for the glass painter Francis Eginton (1737–1805), who in 1785 was commissioned to design a window for the east wall of the decade-old St. Paul's church in Birmingham. The three-light window for St. Paul's was intended to function as a kind of altarpiece, and West appropriately chose as his subject the transforming moment in the spiritual life of Saul of Tarsus, as told in the New Testament Acts of the Apostles: his blinding by a divine light in punishment for his persecution of Christians, followed by the miraculous restoration of his sight by Ananias, and his subsequent baptism as the Christian Paul. The window would be executed in the then-popular semi-opaque enamel technique, in simulation of oil painting on canvas. Eginton excelled in glass enameling on a monumental scale, a slow, difficult process requiring a painter to work in small areas, laying on color in short, hatching strokes, which were then burned onto the glass over a period of two days. A careful manipulation of materials and firing was necessary to ensure a consistent matching of color and tone throughout a composition.[2]

The late eighteenth century saw an unparalleled collaboration between English painters and glass stainers, who attempted to achieve a painterly illusionism in their glass designs. Eginton understandably turned to West for assistance with this, his first important commission. West was historical painter to George III and the country's foremost painter of historical and religious themes. When Eginton solicited his collaboration for St. Paul's, in late 1785 or early 1786, West was already at work on designs for a great tripartite window for St. George's chapel in Windsor Castle and had begun work on a monumental arched canvas on the subject of St. Paul to hang above the altar in James Stuart's rebuilt chapel in the Royal Naval Hospital at Greenwich.[3]

Eginton did not acquire West's designs outright but merely rented them for a fee of eighty guineas. Thus both models were eventually returned to West, a fact that contributes to the confusion surrounding the disposition of the St. Paul's studies.

West developed his narrative of *The Conversion of St. Paul* through theatrical light effects, clearly envisioning the role that sunlight would play in the reading of the

1986, no. 99, repro.; New York, Kennedy 1987, unpag. (Dallas version); London + 1989, pp. 109–10, fig. 2 (Dallas version); *Paviljoen* 1989, pp. 115–16, repro.

CONSERVATION: All three canvases are glue lined onto secondary support canvases and remounted on keyed wooden stretchers. Each canvas has additional wooden strips tacked onto the outer edges to secure them in the frame. All of the canvases have overall mechanical craquelure and significant areas of loss and inpainting. There are two tears in the right-hand canvas, a smaller tear in the center right of the central painting, and a T-shaped tear in the upper portion of the left-hand canvas.

composition in the painted window. Light is indeed the key element in the story of St. Paul, and West used it with great effectiveness both as symbol and as artistic device, employing it to model his solid, sculptural figures and to highlight dramatic expressions of fear and exultation. He uses it to pick out the essential characters in the biblical drama: the sorrowful young woman in bondage, in the left panel; the stricken Saul at center; and the divinely inspired Ananias, in the right panel. The great burst of blinding heavenly light that West created in the central panel would only appear more intense when the morning sunlight poured through the painted glass.

The central canvas of the Museum's version of *The Conversion of St. Paul* is dated 1786, which may identify it as the earlier of the two models for the Eginton window. Although the salient features of the side panels are the same in both oil studies and in the finished window, the composition of the central panel differs significantly. The Museum's flat-topped panel, with its full frontal figure of Christ surrounded by angels—his eyes uplifted, left arm raised, and right arm outstretched—is a significant departure from the center panel of the other composition and the painted window.[4] The Dallas painting has an arched top, akin to the actual window, and shows Christ in profile, his head bowed, his right arm upraised, and his left arm on his chest, with the angels confined to those few figures directly beneath him—precisely as the figure appears in Eginton's completed design.

Although the central light of the window bears the date 1789, church documents show that as late as December of that year West had not yet supplied Eginton with the third, Ananias panel.[5] Therefore, Eginton would not have finished the window until at least some time in 1790. Its installation was officially celebrated on Easter Wednesday, 1791, after a protracted effort to raise funds for completion of the project. It is possible, therefore, that West's second, working model was still being employed as an aid in Eginton's final labors on the window into the early months of 1791. West's model may also have served the prolonged fundraising effort; funds were so slow in coming, it seems, that even after its installation, Eginton reportedly threatened to take the window away.[6] If, indeed, West's working model remained at St. Paul's until the spring of 1791 or even longer—and such a scenario is plausible—then the painter's entry in the Royal Academy exhibition that spring (a submission clearly planned to call attention to the St. Paul's project) might well have been his earlier, preliminary design, now the Museum's panels. That version of *The Conversion of St. Paul* remained in West's studio until it was sold from the artist's estate in 1829 by his sons, his long-time collaborators, who may have added the additional putti panels that are now part of the Museum's painting.[7]

By 1805 a version of *The Conversion of St. Paul*, this one "in one frame, divided in three parts," was in the collection of the Dutch merchant Henry Hope, who had settled in London in 1794.[8] Hope's picture is likely the study exhibited by West in 1801 and is conceivably West's final, working model for the window. This is possibly the Dallas triptych, still in what appears to be its original three-part, arched-top, Adamesque frame corresponding to the format of the completed window.[9] The Dallas painting may have been West's final, working model.

PJ

Unknown artist
EARLY 19TH CENTURY

8. *Eagle* (architectural ornament), c. 1810[1]

Bronze powder paint and gesso over Eastern white pine; 37 (height without base) × 26½ (width across top of wings) × 60 (depth from beak to wing tips) in. (94 × 67.3 × 152.4 cm); not signed, not dated

Gift of Dorothy C. Miller, class of 1925 (Mrs. Holger Cahill) (1969:83)

PROVENANCE: Found in New England; Old Print Shop, New York, 1957; to Mr. and Mrs. Holger Cahill, New York, 1958.

EXHIBITIONS: Northampton 1976 *American;* Northampton 1980, no. 6, repro.

LITERATURE: *Old Print Portf* 1957, pp. 78–79, repro.; Chetham et al. 1986, no. 108, repro.

CONSERVATION: The current mount appears to have been added after a new mounting hole was drilled in the base of the eagle. The metal brace on the back seems to have been a later addition as well, since the screw holes protrude through the wings. There are checks in the wood in the wings, and there is evidence that the trailing edges of the feathers have been replaced. There is evidence of gilding in some areas. There has been extensive overpainting; the current surface is predominantly bronze powder paint. Before acquisition of the sculpture by the Museum, cracks in the head and neck were repaired with modern infills.

IN AMERICA in early colonial times the eagle was not often used as decoration, but by 1810 it had become the most popular patriotic emblem.[2] Eagles had, of course, been part of national insignia throughout recorded history. The large beak with its dangerous-looking recurved tip, the strong talons, the great wingspread (up to eight feet for bald eagles), and its predatory habits have made it, along with the lion, a favorite symbol of godly and national might. Its ability to soar to great heights, its habit of nesting in tall trees or on cliffs lend it an air of aloof nobility that has recommended it to royalty. It figures prominently in Christian iconography as well.

The Museum's eagle, carved from native Eastern white pine, is presumed to represent the bald (probably from piebald) eagle, a member of the sea eagle family, native to North America. The exaggerated brow of the Museum's eagle (which has a tripartite form suggestive of a crown) may have been meant to represent the crest that appeared on the first renditions of the American eagle (including that on the early version of the Great Seal of the United States), even though the crest was a characteristic of European eagles, not the bald eagle.[3]

Of the carving's origins little is known. The dealer from whom it was purchased described it as "American wood carving, 1790–1820, . . . from New England,"[4] but no record was kept of the date of its discovery, nor did he speculate on the identity of the carver. Sylvia Lahvis, author of a dissertation on the great Boston carvers John Skillin (1746–1800) and Simeon Skillin, Jr. (1756/57–1806), and their workshop,[5] believes that the Museum's eagle was not produced in a major workshop, but by a New England carver who "wanted to identify with the Skillin workshop or with [Samuel] McIntire [1757–1811] . . . an artisan who has not yet graduated from the stylization of the folk artisan."[6] She speculates that he may have been commissioned to make a copy of the great eagle in the Massachusetts State House (1790, attributed to Charles Bulfinch [1763–1844]) for a monument or cupola in his community.[7] Philip Isaacson, author of an extensive study of representations of the American eagle,[8] judged it "convincingly American, but produced by a carver familiar with European precedents."[9]

A comparison with photographs of actual eagles reveals the dramatic, but confident, artistic license taken by the carver of the Museum's bird. The neck is almost swanlike in length, and with the exaggerated brow and elongated beak, the fancifully rendered cere (the fleshy, waxlike protuberance where the beak and brow meet), and the bulging eyes, it presents a fear-inspiring creature rather like a gargoyle or the serpent–dragon heads that decorated the prows of Viking ships. The feathers are rendered in rather high relief, in stylized detail. The wings are made up of one or more separate pieces, now held to the body by two heavy metal straps. A peculiarity is the differing stylization of the feathers on the two wings: those on the bird's right wing have smooth edges, while the feathers of the left wing are notched on the edges. Every carver had his own way of translating these soft, flexible parts into wood, and it may be that the right wing, whose feathers do not conform as well to those on the rest of the body, was a replacement done by another hand, perhaps by an apprentice.

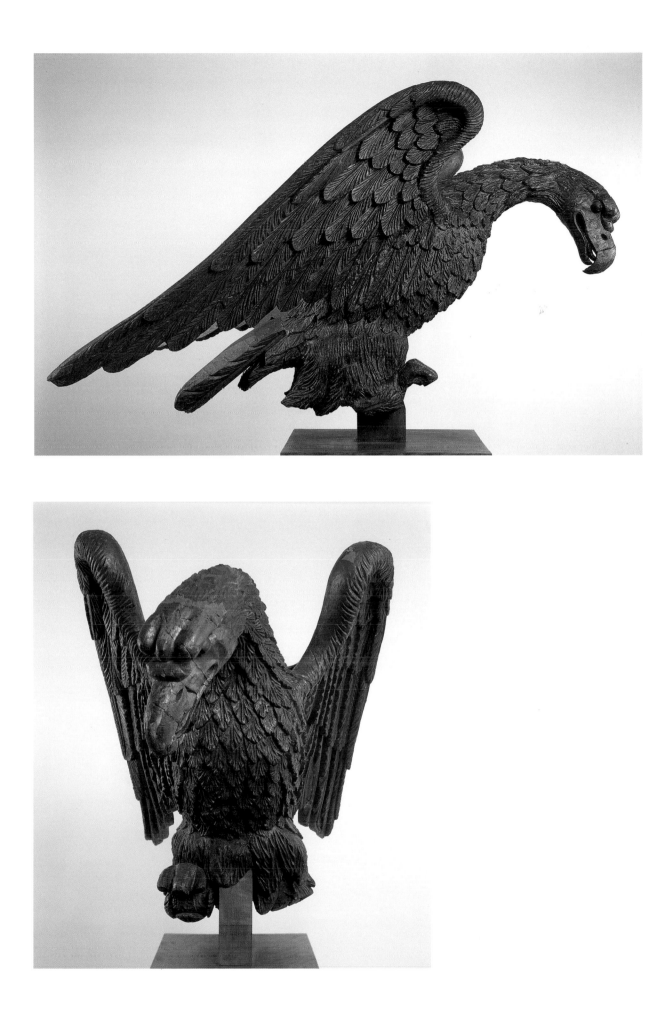

Another unknown is the function the carving was intended to serve. The back of the body and the top sides of the wings and tail are uncarved, suggesting that it was meant to be seen from the front or side, and probably from below—perhaps on a column, cupola, or flagpole, or against a wall in a niche or the pediment of a building. The upraised right claw, of which only part of the talons remains, might have held the escutcheon of the United States, while the completely lost left claw might have clutched arrows or an olive branch, or rested on a ball. The carved parts have the remains of layers of heavy bronze powder paint, under which are traces of gesso and gilt. The thick paint, the missing parts, and the evidence of damage to the beak and the wings all suggest that the carving occupied an outdoor setting for at least part of its life.

There is an argument to be made that the eagle was a ship's figurehead. Most eagles in architectural settings have widespread wings. The Museum's eagle's wings are in a rising position, drawn back, perhaps to fit against the prow of a ship. The piece measures 61 inches from the top of the head to the tip of the tail, but the distance between the wing tips is only 22¾ inches. The head is not turned to one side, as is so often the case with eagles in architectural settings, suggesting that frontality was important, as it would be if the eagle were a figurehead. The back and the top sides of the wings show less weathering and have fewer layers of paint than other parts, suggesting that these areas were not only less exposed to weather, but also, perhaps, less accessible to painters than would be the case if the carving had been on a cupola, for instance. A sketch for an eagle intended for the U.S.S. *Hornet* (fig. 7) bears some resemblance to the Museum's carving.[10]

Women and men known to mythology, history, or the owner's family were the favored figurehead ornaments on American ships in the eighteenth and nineteenth centuries, but the eagle was close behind. In the Port of New York alone, between the years 1793 and 1867, no fewer than eighty-three ships named *Eagle* were recorded.[11] Of course, many ships with other names sported eagle figureheads. No doubt the eagle's vaunted sharp eyesight, which could guide a ship through uncharted waters, recommended it. From the earliest times in the East, among Greeks and Egyptians as well as other seafaring cultures, a painted or carved eye often decorated each side of a ship's prow. Besides its apparent ease and range of flight, the eagle's power symbolized a challenge to unseen demons of the deep as well as more prosaic enemies. Whatever its function, this carving is the bold and vigorous conception of an imaginative craftsman.

BBJ

Figure 7. Proposal for a figurehead for the U.S.S. Hornet, *submitted by Commodore Isaac Chauncy to Robert Smith, Secretary of the Navy, July 18, 1805. Letters Received by the Secretary of the Navy from Masters Commandant, Records of the Naval Records Collection of the Office of Naval Records and Library, Record Group 45, National Archives, Washington, D.C.*

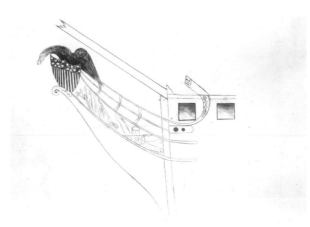

Unknown artist
POSSIBLY WORCESTER COUNTY, MASSACHUSETTS,
LATE 18TH–EARLY 19TH CENTURY

9. *Bridget Duncan*, c. 1795–1807

Oil on canvas; 27¼ × 25¾ in. (69.3 × 65.4 cm); not signed, not dated

Gift of Berenice R. Tuttle, class of 1902, in memory of her sister, Doris Tuttle Braislin, class of 1917 (1962:7)

PROVENANCE: Berenice R. Tuttle, Rutland, Vt.

EXHIBITIONS: Brockton 1969, no. 26, repro.; Northampton 1975 *Five*, no. 16, repro.; Northampton 1976 *American;* Northampton 1979, ckl. p. 35; Northampton 1980, no. 4, repro.; Northampton 1995.

CONSERVATION: The painting is wax lined and mounted on a new turnbuckle stretcher. There are small losses in the face of the sitter and generally over the background. There are three repaired tears: two to the left of the sitter and an L-shaped tear to the right. There is overall mechanical craquelure.

ALTHOUGH GENEALOGICAL RESEARCH supports the traditional claim that this portrait represents Bridget Duncan of Billerica and Worcester, Massachusetts, efforts to identify the artist have yielded little information.[1] To date, only one other canvas that appears to be by this distinctive hand has been located: an unattributed portrait of William Henshaw (1735–1820) of Worcester, Massachusetts, in the collection of the American Antiquarian Society, Worcester (fig. 8). These two portraits share fundamental stylistic qualities, including a similar light brick-red background, a strongly linear treatment of the face and features, pale flesh tones, a loosely painted, generalized representation of costume, and a nearly square format. Moreover, both sitters display equally sober and flinty expressions, their age-creased faces shown with the utmost clarity, adding to an overall sense of severity. Henshaw and Bridget Duncan were exact contemporaries and fellow residents of Worcester County, and it is fair to speculate that both portraits were painted in that region at the turn of the nineteenth century. That Bridget Duncan's portrait was found in central Vermont may be explained by the fact that the sitter's last surviving child resided and died in Dummerston, Vermont, which is north of Brattleboro.

Bridget Duncan and the Henshaw portrait are strongly conceived and reveal the firm, confident hand of an experienced limner. Some of the stylistic qualities of *Bridget Duncan*—notably the flat pattern of the figure with the spare, linear definition of features; the muted tones; the light red ground; and the striking, expressionless face—suggest the work of known limners: Reuben Moulthrop (1763–1814) of Connecticut; John Brewster, Jr. (1766–1854), an itinerant who ranged widely through New England; and the elusive Massachusetts portraitist J. Brown (active 1803–8). Comparisons can even be made with the early Border period work of the western Massachusetts, New York, and Connecticut painter Ammi Phillips (1788–1865). Yet attribution to any of these painters cannot be made with any assurance.

Bridget Richardson Duncan descended from one of the first families of Billerica, Middlesex County, Massachusetts, northwest of Boston. It was in Billerica on August 22, 1743, that she married Simeon Duncan, a Worcester farmer whose ancestors were also among the founders of Billerica. Bridget and Simeon Duncan had nine children. Son Jason, who may have inherited the painting from either his mother or one of the siblings, distinguished himself as a judge of probate, first in Worcester and later in Dummerston. Son Simeon, Jr., a Worcester cooper, fought the British in the Revolutionary War, earning the rank of captain. Simeon Duncan, Sr., died on the family homestead in what is now Auburn, Massachusetts, on June 19, 1781. Bridget Duncan died in Worcester on April 4, 1807.[2]

PJ

Figure 8. Unknown artist, William Henshaw, *c. 1800, oil on canvas, 23 × 20 in. (58.4 × 50.8 cm). American Antiquarian Society, Worcester, Mass.*

William Jennys
ACTIVE IN AMERICA 1793–1807

10. a) *Lieutenant David Billings,* c. 1800
b) *Mabel Little Billings,* c. 1800

cat. 10(a)

Oil on canvas; 30 × 24⅞ in. (76.2 × 63.2 cm); not signed, not dated

Gift of H. Louisa Billings, class of 1905, and Marian C. Billings, class of 1901 (1972:41-1)

cat. 10(b)

Oil on canvas; 30⅛ × 24¹⁵⁄₁₆ in. (76.5 × 63.3 cm); not signed, not dated

Gift of H. Louisa Billings, class of 1905, and Marian C. Billings, class of 1901 (1972:41-2)

PROVENANCE (both paintings): Descended in the Billings family until 1972.[1]

EXHIBITIONS (both paintings): Northampton 1947, nos. 26 *(Mabel),* 27 *(David);* Springfield 1954, nos. 23 *(David),* 24 *(Mabel);* Northampton 1975 *Five,* nos. 21 *(Mabel),* 22 *(David);* Northampton 1976 *American;* Northampton 1979, ckl. p. 27; Northampton 1980, nos. 7 *(Mabel),* 8 *(David),* repro.; New York, IBM 1990; Northampton 1995.

LITERATURE (both paintings): Wells and Wells 1910, pp. 196–98, repro.; Historical 1939, p. 39, (nos. 207 *[David]* and 208 *[Mabel]*); Dods 1945, pp. 4–12, figs. 1 *(Mabel)* and 2 *(David);* Larkin 1949, p. 120, repro. *(Mabel);* Warren 1956, p. 51; Chetham et al. 1986, nos. 105 *(David)* and 106 *(Mabel),* repro.

CONSERVATION *(David Billings):* The painting is on canvas (43 threads per inch vertically, 42 threads per inch horizontally) that has been wax lined, with tacking edges still intact, and mounted on a new turnbuckle stretcher. There is a repaired zigzag tear in the upper central region, and there is minor inpainting to the left of the head.

CONSERVATION *(Mabel Billings):* The painting is on a linen canvas (39 threads per inch vertically, 36 threads per inch horizontally) that has been wax lined, with tacking edges still intact, and mounted on a new turnbuckle stretcher. The painting is in good condition, with a few small inpainted losses in the face and the dress area.

WILLIAM JENNYS painted portraits throughout New England in the late eighteenth and early nineteenth centuries in company with Richard Jennys (active 1766–1801), thought to be his father. The Jennyses found modest success as itinerant portrait painters, working in a severely plain style characterized by somber colors, plain compositions devoid of decorative details, and stern likenesses. Active first in Boston as an engraver, Richard had produced an engraved mezzotint portrait, *The Reverend Jonathan Mayhew* (1766, American Antiquarian Society, Worcester, Mass.). The Jennyses' later oil portraits show the influence of Richard's experience as an engraver, in the bust-length format they favored, the surrounding spandrels, and the sharp contrasts of light and shade. While the most basic details of the artists' lives remain unknown, they were prolific during their careers and collaborated on at least three occasions between 1795 and 1801, co-signing the portraits of *Captain David Judson* and *Grissel Warner Judson* (1799, Chrysler Museum, Norfolk, Va.) and the portrait of *Mrs. David Longenecker (Effie Dock)* (1801, Lancaster Historical Society, Pa.).

The Jennyses pursued several branches of the painter's trade to make a living, advertising that they would perform ornamental painting and miniature portraiture. In addition, they opened schools in New Haven in 1792 and Norwich in 1793 for the purpose of "instructing young Ladies and Gentlemen in the Art of Drawing and Painting Flowers, Birds, Landscapes or Portraits."[2] Because the two artists collaborated on several portraits, it is often difficult to separate their unsigned works, but the documented examples signed singly permit subtle distinctions to be made in the manner of each. William's portraits are characterized by more sharp contrasts of light and shade than Richard's; William also executed boldly modeled features, crisply outlined to create a sculpted effect.

William's earliest documented work was executed in company with Richard in 1794 and 1795 in New Milford, Connecticut, where the two artists painted approximately sixteen portraits. William is then listed in New York City directories for 1797 and 1798. By 1800 he appears to have traveled up the Connecticut River Valley into central Massachusetts and Vermont, as well as eastward to Portsmouth, New Hampshire, and Newburyport, Massachusetts. His last-known documented portrait was that of *James Clarkson* (1807, private collection) of Newburyport.[3]

William and Richard Jennys found their niche in the New England market for portraits by adhering to a plain, highly realistic manner of portrayal, executed quickly on a modest, bust-length scale that frequently precluded the need to depict arms and hands. As a result, the painters charged modest prices, well below those of their competitor Ralph Earl (cat. 5), for example, and thus managed to make a living in an increasingly competitive market.[4]

Lieutenant David Billings (1730–1807) and his wife Mabel Little Billings (1744–1815) lived in the Connecticut River Valley town of Hatfield, Massachusetts, and were painted by William Jennys about 1800. The couple were farmers, and Lieutenant Billings served as the town selectman from 1775 to 1800. The tombstone inscriptions for the Billingses attest to their prominence as respected members of their small town community and to their piety.[5]

In his most severe manner, William Jennys depicted the elderly couple without the benefit of decorative devices. Their likenesses are devoid of flattery; their faces are stern. The artist placed his subjects within ovals (his favorite format) framed with black spandrels and presented them at bust length with their arms stiffly at their sides. They are set against a plain brown background. Lieutenant Billings is conservatively attired, wearing a powdered wig and a black coat and vest. Mrs. Billings wears a simple brown silk dress, a white cap and collar, and gold beads. The artist's characteristic bold outlines and sculpted features with strong contrasts of light and shade are seen in these portraits.

EMK

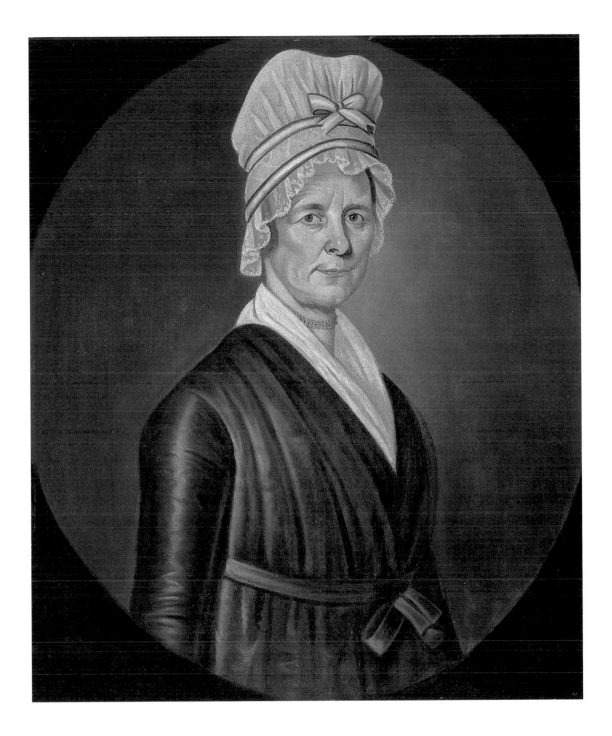

Unknown artist[1]
EARLY 19TH CENTURY

11. *Ceres* (ship's figurehead), c. 1825–30[2]

Pine with traces of gesso and paint; 71¾ × 24½ × 25½ in. (182.3 × 62.2 × 64.8 cm); not signed, not dated

Purchased (1977:45)

PROVENANCE: Discovered in a shipyard near Boston; Sumner Healey (antiques dealer), New York; to Edith Gregor Halpert, American Folk Art Gallery, New York, Apr. 1933; to Terry Dintenfass, Inc., New York, c. 1970; to James Tolkan, New York, c. 1972; to Gerald Kornblau, New York, by 1974.

EXHIBITIONS: New York, Downtown 1933, no. 16; New York, Marine Museum of the City of New York, extended loan, Mar. 1935–Apr. 1939 and later 1939–1950; Brooklyn 1939; Washington, Corcoran 1950;[3] Akron 1951; New York, Dintenfass 1970–71, no. K102, repro.; Amherst 1974, cat. 71, repro.; Huntington 1975, no. 21, repro. cover; Northampton 1980, no. 5, repro.

LITERATURE: Breuning 1933; Keyes 1933, pp. 228–29, repro.; Pinckney 1940, p. 171 (no. 50); Bishop and Coblentz 1974, no. 132, repro. p. 85; Chetham et al. 1986, no. 107, repro.; Clark 1987, p. 85, repro.; Wilkie and Tager 1991, repro. p. 115.

SEAFARING is a superstition-bound profession, exposing its followers as it does to unforeseeable, uncontrollable, and often devastating forces of nature. Among the most persistent superstitions of the sea is the belief that women on board bring bad luck. On the other hand, Pliny the Elder is said to have observed that a storm might be stilled by a woman uncovering her body at sea. And perhaps it is by way of propitiation that sailors habitually characterize ships as female.[5] Whether women were a boon or a curse to sailors, representations of them were common as ships' figureheads.

The use of figureheads dates back at least to the Phoenicians, and almost every succeeding seafaring culture decorated the prows of ships in some way. The earliest images were probably intended to secure the protection of the sea gods, to frighten sea monsters and other enemies, or to guide across uncharted expanses. Later they served to identify the ship's nationality or name or to lend prestige to a ship, since they did not all carry figureheads. Over the centuries animals and birds, religious images, historical personages, gods, and heroes all figured on ships. American owners often favored carved figureheads representing Native Americans and, especially in the early days of the Republic, figures from Roman mythology.

Ceres, Roman goddess of grain—and by extension agriculture and the harvest—was a fairly popular name for a ship. In the registers of a number of New England seaports from 1787 to 1852 some seventeen vessels of that name were recorded,[6] and between 1795 and 1866 thirty ships named *Ceres* made port in New York.[7] Since there was usually a connection between the name of the ship and its figurehead, unless the name did not lend itself to sculptural shape, it seems likely that the Museum's figurehead came from a ship named *Ceres*.

The carver of *Ceres* and its place of origin remain unknown. It is made from pine, a wood preferred by American carvers to the hardwoods used in Europe because it was softer and allowed for a larger, simpler conception of form appropriate to a figurehead, which was normally seen from a distance. *Ceres* is of a type called "walking," that is, a figure stepping forward, breasting the winds, its foot resting on a scroll or other support. Her head is raised, suggesting that in place the figure was tilted forward somewhat. On earlier ships the figureheads were almost upright because the stem rose up nearly perpendicular to the water, but during the era of the sleek clipper ships (c. 1835–60) they became almost horizontal.

The figure carries a sickle and sheaf of wheat, attributes of the goddess of grain. On her head is a rather substantial wreath of plaited grain. Her sleeveless gown, fastened at the shoulders with buttons, is gathered at the waist, the skirt billowing in the wind. Her stoic mien is somewhat disfigured by the awkwardly carved replacement of her original nose.

It is not clear whether the residue of white paint now seen on *Ceres* was its first finish color or a primer. From at least as early as 1933 until around 1974, when a previous owner attempted to remove them, the carving was adorned with dark colors, evident in a photograph of the figurehead (fig. 9), published in 1933. Figureheads were often

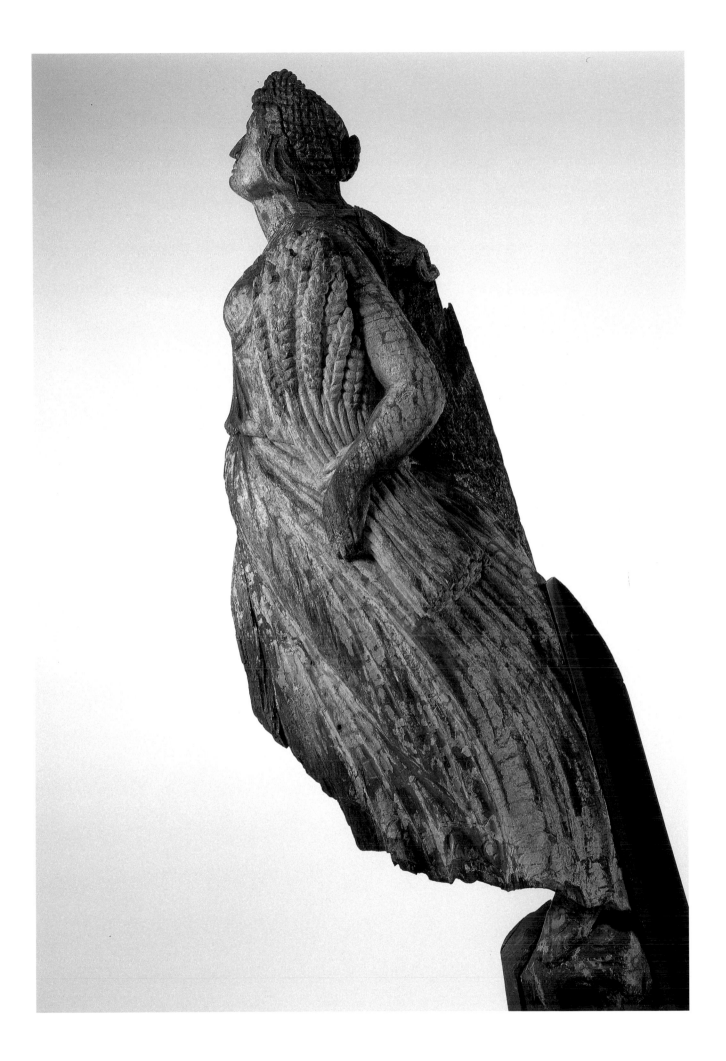

repainted. In their heyday (c. 1789–1825) they were usually, in the words of William Rush (1756–1833), one of the greatest carvers, "painted to the life," that is, painted in bold colors.[8] Some were gilded or painted gold. In the clipper ship era they were most often painted white, to suggest stone, but white was also used whenever the head had to be repainted at sea.

When this carving first appeared on the market in the early thirties, interest in America's folk art was still young. Edith Halpert, proprietor of the newly opened American Folk Art Gallery in New York, had purchased the carving from a New York antiques dealer, who told her it had been found "in an old shipyard near Boston where a specialty was made of dismantling the old East India Men and Clipper Ships."[9] When it was exhibited in 1933, the art critic of the *New York Evening Post* remarked on its "swirl of draperies and a thrust of figure against buffeting winds, which recalls the famed Victory of Samothrace."[10] The editor of *Antiques* observed that it "possesses a kind of Giottoesque massiveness. . . . The combination of crudity and vigorous assurance in its cutting guarantees the Americanism of its source."[11] Though these citations of lofty antecedents may seem odd today, they have a certain aptness: the Nike of Samothrace is probably the earliest surviving representation of a woman's figure on the prow of a ship, and there is a kind of stolid, sober dignity to *Ceres*.

Figureheads would eventually lose their place of prominence on America's seagoing vessels. After the middle of the nineteenth century, as the steamship displaced the sailing ship, the billethead, a downward turning scroll (or fiddlehead, if upturned), began to replace figureheads more frequently until both disappeared.[12]

BBJ

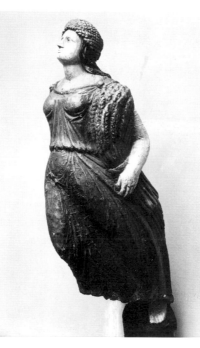

Fig. 9

The polychromed Ceres *figurehead before its paint was removed and it was acquired by the Smith College Museum of Art. Photography courtesy of the Abby Aldrich Rockefeller Folk Art Center, Williamsburg, Va.*

Figure 9. The polychromed Ceres *figurehead before its paint was removed and it was acquired by the Smith College Museum of Art. Photograph courtesy of the Abby Aldrich Rockefeller Folk Art Center, Williamsburg, Va.*

Margaretta Angelica Peale
PHILADELPHIA 1795–1882 PHILADELPHIA

12. *Still Life with Watermelon and Peaches*, 1828

Oil on canvas; 13 × 19⅛ in. (33 × 48.6 cm); signed in black with a stylus, lower right: *M A P;* inscribed and dated on back of original canvas (transcribed onto lining canvas): *Anna C Peale / from Margaretta Peale / Dec 1828*

Purchased with funds given anonymously by a member of the class of 1952 (1952:53)

PROVENANCE:[1] Anna Claypoole Peale Staughton Duncan (1791–1878), Philadelphia, the artist's sister; to her sisters, Margaretta Angelica Peale and Sarah Miriam Peale (1800–1885); to their nephew, James Godman Peale (son of James Peale, Jr. [1789–1876]); to his widow, Ellen Q. M. Peale; to their son Clifton Peale; to Walker Galleries, New York, 1939; M. Knoedler and Company, New York, by 1944; Harry Shaw Newman Gallery, New York, 1949–50; Victor Spark, New York, by 1952.

EXHIBITIONS: New York, Walker 1939, no. 6; Philadelphia 1944, no. 37; New York, Newman 1949–50; Williamstown 1953; New York, Century 1953, no. 34; Cincinnati 1954, no. 108; Newark 1958, no. 30, repro. p. 7; DeKalb + 1974; Pittsburgh 1976, no. 5, pl. 10; Northampton 1979, ckl. p. 44; Amherst 1980, no. 41, repro.; Tulsa + 1981, no. 105, fig. 3.12; Philadelphia + 1996–97, no. 120, pp. 224–25, 227, pl. 110.

LITERATURE: *NY Herald Trib.* 1939; Born 1946, p. 14, fig. 3; *Panorama* 1949–50, pl. 10; Parks 1960, fig. 58; Gerdts and Burke 1971, p. 37, fig. 2-14; Nochlin 1974, p. 73, repro.; Munsterberg 1975, p. 60, repro.; Wilmerding 1976 *American*, p. 59, pl. 62; Chetham et al. 1986, no. 109, repro.; Heller 1987, p. 80, fig. 51; Zoccoli 1987, no. 34, repro. p. 156; Ferris 1990, repro. p. 61.

CONSERVATION: The painting is on a fine linen canvas mounted on a wooden strainer. There is a fine overall craquelure, but no inpainting shows under ultraviolet illumination. There is a heavy varnish coating.

MARGARETTA ANGELICA PEALE was a member of what is arguably America's most illustrious artistic dynasty. She was the fifth child and fourth daughter of James Peale (1749–1831), himself a painter and the younger brother of the renowned artist and naturalist Charles Willson Peale (1741–1827). Margaretta's cousin Raphaelle Peale (1774–1825) is recognized as this country's first professional painter of still lifes.[2]

At the end of the eighteenth century, when Raphaelle Peale exhibited his first works, the common belief among those with some awareness of European aesthetic precedents was that it was less worthy to paint still lifes than landscapes, which in turn were of lower stature than historical, religious, and allegorical subjects. Creating a mere illusion of common objects, with no ostensible higher moral or educational purpose, had been held in low esteem. In the first decades of the nineteenth century, however, Raphaelle and later his uncle James achieved increasing recognition for their simple subjects. Appealing to the worldly values and comforts of their middle-class patrons, they developed a genre that would continue to gain acceptance, particularly in Philadelphia. Later in the century it would find its fullest expression in the work of William Michael Harnett (1848–1892) and John Frederick Peto (cat. 42).

One explanation for the increasing importance of the genre in Philadelphia is that these subjects were related to the popularization of science taking place in that city. Linda Bantel points out that "in that era of professional generalists, Philadelphians excelled in engineering, agriculture, economics, electricity, medicine and most of all, botany."[3] The fruits and flowers in the Peales' still lifes were likely to have been chosen for horticultural interest as well as their decorative qualities.[4] Margaretta Peale's white watermelon may be a rarer species today than it was 150 years ago, when both the variety and the abundance of America's agricultural products were a source of national pride and interest for farmers and horticulturists alike. In 1821 William Cobbett had the following to say about melons:

> There are, all the world knows, two distinct tribes: the *Musk* and the *Water*. Of the former the sorts are endless, and indeed, of the latter also. Some of both tribes are globular and others oblong; and, in both tribes there are different colours, as well with regard to flesh as to rind. In this fine country, where they all come to perfection in the natural ground, . . . the finest Watermelons that I have ever tasted were raised from seed that came out of melons grown in Georgia.[5]

Handbooks from later in the nineteenth century list several varieties of white watermelon.[6]

James Peale appears to have used this kind of melon as the subject of at least one of his still lifes. A copy of just such a painting by him is recorded as the last work of Rubens Peale (1784–1865).[7] Although Margaretta Peale was probably trained and undoubtedly influenced by her father, her identified works have a simplicity that departs from his somewhat more lavish compositions. She follows his formula (and indeed Raphaelle's as well) of a plain background (in this case taupe) fading from darker at upper left to lighter at upper right; like them, she often places the objects on

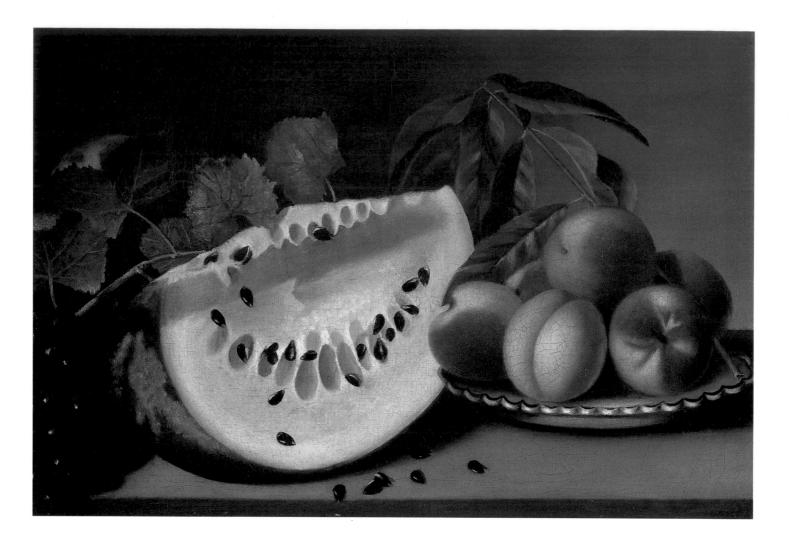

a simple, brown shelf. There is a certain hardness to the edge of forms in her work that is not unpleasant (see, for example, *Still Life: Strawberries & Cherries*, Pennsylvania Academy of the Fine Arts, Philadelphia).[8]

While not many works by Margaretta Peale are known, she was clearly a practicing artist of some ambition. Her older sisters Maria (1787–1866) and Anna, a miniaturist (1791–1878), painted more sporadically. Her younger sister Sarah Miriam (1800–1885), who also began as a still-life painter, was eventually a productive portraitist. Margaretta painted a few portraits as well, but it was her efforts as a still-life painter that were exhibited in Philadelphia at the Artists Fund Society between 1828 and 1837 and at the Pennsylvania Academy of the Fine Arts during those years.

Still Life with Watermelon and Peaches, dated 1828, may be the work that was exhibited in 1829 at the Pennsylvania Academy as *Water Melon, Peaches &c.*[9] It is a skillful painting that demonstrates both the artist's powers of observation, for example, in detailing the drying, brown-edged leaf of the grapevine or the slightly green cast of the unripe peach at the left, and the knowledge of her craft, for example, the red-brown shading transforming black spheres into believable grapes and the flecks of white on the watermelon seeds suggesting reflections on their wet and shiny surfaces. A refined image of quiet beauty, the painting leaves the viewer wishing for more examples from Margaretta Peale's hand.

DC

Erastus Salisbury Field
LEVERETT, MASSACHUSETTS 1805–1900 LEVERETT, MASSACHUSETTS

13.
a) *Nathaniel Bassett*, c. 1836
b) *Bethiah Smith Bassett*, c. 1836

cat. 13(a)

Oil on canvas; 35 × 28⅝ in. (88.9 × 72.7 cm); not signed, not dated[1]

Purchased (1985:29-1)

cat. 13(b)

Oil on canvas; 35 × 28⅞ in. (88.9 × 73.3 cm); not signed, not dated[2]

Purchased (1985:29-2)

PROVENANCE (both paintings): Nathaniel and Bethiah Smith Bassett; to their son, Joseph Bassett (1801–1873), and his wife, Almira Dodge Bassett (1802–1838); to their son, James Watson Bassett (b. 1829); to his daughter (?), N.B.M; to Don Howe, Ware, Mass.; to Mr. and Mrs. Andrew Weil, New York, c. 1960; to Douglas Auction House, South Deerfield, Mass.

EXHIBITIONS (both paintings): Williamsburg 1963, nos. 19 (*Nathaniel*), 20 (*Bethiah*); Northampton 1988; Sturbridge 1992–93, nos. 14 (*Bethiah*), 15 (*Nathaniel*), pp. 41, 75–77, 93, repro. p. 53, colorpls. 6 (*Bethiah*), 7 (*Nathaniel*); Northampton 1996–97.

CONSERVATION (*Nathaniel Bassett*): The painting is on a lightweight textile (approximately 45 threads per inch vertically, 47 threads per inch horizontally), with an unattached Mylar backing mounted on a very lightweight strainer. There are stretcher creases and overall mechanical craquelure, with several inpainted losses, especially on the proper left side of the coat.

CONSERVATION (*Bethiah Smith Bassett*): The painting is on a lightweight textile (approximately 45 threads per inch vertically, 47 threads per inch horizontally), with an unattached Mylar backing partially strip lined and remounted on a very lightweight strainer. There are stretcher creases on all four sides. There is a small inpainted loss on the tip of the nose and a patched and inpainted tear in the background above the proper left shoulder, and there is inpainting on the proper left upper arm.

ERASTUS SALISBURY FIELD was born in the small western Massachusetts town of Leverett, where he lived for most of his ninety-five years. He demonstrated an early talent for painting portraits, and in 1824, at the age of nineteen, he went to New York to study with Samuel F. B. Morse (1791–1872) but stayed only three months. Returning to the Leverett area, he began a career as an itinerant portrait painter. His work from this period does not demonstrate any influence from his training with Morse, relating instead to the tradition of provincial portraiture practiced in New England by self-taught painters such as his contemporary Ammi Phillips (1788–1865).

In 1831 Field married Phebe Gilmur, and the couple had their only child, Henrietta, the following year. He traveled continually for the next decade, producing an impressive number of portraits in western Massachusetts and as far south as New Haven, Connecticut. Perhaps his finest portrait was painted in 1839 in Ware, Massachusetts, *Joseph Moore and His Family* (Museum of Fine Arts, Boston). This ambitious family group demonstrates Field's careful draftsmanship, use of decorative details—including a patterned carpet—and insistence on precise likenesses, as seen in the images of the Moores and their four children.

Field returned to New York in 1841 for seven years, where he learned to make daguerreotypes, perhaps through Samuel Morse. While few documented portraits are known from this period, he painted his first literary painting, *The Embarkation of Ulysses* (c. 1844, Museum of Fine Arts, Springfield, Mass.). He left New York in 1848, returning to Massachusetts to assist with his ailing father's farm and to resume his career as a portraitist. He also practiced his new trade as a daguerreotypist and began to base his portraits on photographs. Field moved frequently in the 1850s and was living in North Amherst, Massachusetts, by 1859, when his wife died. During the later decades of his life he produced a series of fantastic and often grand-scale religious and historical paintings. His most noted work from this time was the enormous visionary work of the Civil War era, *Historical Monument of the American Republic* (Museum of Fine Arts, Springfield, Mass.), begun in the mid-1860s and completed in time for the Centennial in 1876. A few weeks before his death, a newspaper wrote of Field's career:

> Although Mr. Field was an all-around painter of the old school, his work which has been most highly appreciated is that of portrait painting; his likenesses of people of past generations are as nearly correct as can well be made in oil, and give to posterity faithful ideas of the personal appearance of their ancestors.[3]

Field's best portraits, which date from around 1836 to 1840, are characterized by a somewhat loosened brushwork, carefully designed compositions, and precise draftsmanship. During the summer of 1836 Field traveled to several towns in western Massachusetts where he sought portrait commissions. He produced an impressive group of portraits of the Bassett family of Lee, firmly attributed to the artist on the basis of their stylistic similarity to other documented works by Field.[4] The artist's use of a soft gray background and a shaded halo of space surrounding the sitter's head, characteristic of his known works, is uniformly seen in the Bassett family portraits.

Figure 10. Erastus Salisbury Field,
Joseph Bassett, *1835, oil on canvas,*
34¾ × 28½ in. (88.3 × 72.4 cm).
Shelburne Museum, Shelburne, Vt.

The Bassett portraits display rigid poses, conventional compositions, and attention to skillful modeling of facial features, traits that the artist was admired for among his middle-class New England clientele. In addition to painting the portraits of Nathaniel Bassett (1757/58–1846) and his wife, Bethiah Smith Bassett (1761–1849), Field also painted their son Joseph Bassett and his wife, Almira Dodge Bassett (figs. 10 and 11), Nathaniel's brother Anselm Bassett, nephew-in-law Amos Geer Hulbert and Cynthia Bassett Hulbert, and great-nephew Henry Carlton Hulbert. The Bassett family had helped to establish the town of Lee—Nathaniel and his two brothers settled in the town shortly after its incorporation in 1778.[5] The portraits descended in the Bassett family and were inscribed by a family member (probably early in this century) with the family history on notes attached to the back of the canvases.[6]

As a hero of the Revolutionary War, Nathaniel was noted for his role in foiling Benedict Arnold's conspiracy with Major André. He served as the town sexton and was a respected blacksmith throughout his life.[7] Field portrays him as an upstanding

man of the community. He is stiffly posed, seated on a side chair with hands folded in his lap. His advanced age of seventy-eight years is not concealed by the artist but is treated with frankness and respect.

Similarly, Bethiah Bassett is shown as the elderly matriarch of an extended family. She had married Nathaniel in their hometown of Sandwich, Massachusetts, in 1781 and became the mother of ten children, nine of whom lived to adulthood. Field portrays his sitter in a pose and background similar to those of her husband's portrait. Along with her pleasant expression, Field painstakingly records the signs of age on Bethiah's face, including wrinkles, a mustache, and double chin. She meets the viewer's gaze with a lively directness. While Nathaniel's portrait is nearly devoid of decorative elements, Bethiah's attire includes an elaborate cap and an imported silk brocade shawl, symbols of prosperity, as well as the book she holds, which distinguishes her as a member of the literate classes.

EMK

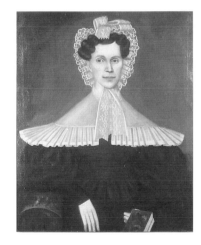

Figure 11. Erastus Salisbury Field, Almira Dodge Bassett, 1835, oil on canvas, 35 × 28½ in. (89 × 72.4 cm). Shelburne Museum, Shelburne, Vt.

Thomas Cole

BOLTON-LE-MOOR, LANCASHIRE, ENGLAND 1801–1848 CATSKILL, NEW YORK

14. Compositional study for
The Voyage of Life: Manhood, c. 1840

Oil on academy board; 12¼ ×
17³⁄₁₆ in. (31.1 × 43.7 cm); not signed,
not dated

Purchased (1950:13)

PROVENANCE: The artist's widow,
Maria Bartow Cole (1813–1884), and
son, Theodore A. Cole (1838–1929),
Catskill, N.Y., through 1859; sale,
Henry H. Leeds and Company,
New York, *A Superb Collection of
Pictures by Living Artists of Europe
and America . . . at the Rooms of the
National Academy,* Mar. 16–17, 1859,
sale 3415, lot 175B (as *Third Picture of
the Voyage of Life—Manhood*); to
John C. Henderson, Staten Island,
N.Y.; probably sold to Charles Baker
(active 1839–88), New York, by
Mar. 8, 1860; to his family, by
descent; consigned to Harry Shaw
Newman Gallery, New York, by
Jan. 1948–Oct. 1949.

EXHIBITIONS: Staten Island 1860,
no. 63 (as *First Idea of the Third
Picture in the Voyage of Life*); South
Hadley 1965; Saratoga Springs 1968;
Ames + 1975–76, no. 14, pp. 17–18,
fig. 23; Northampton 1979, ckl. p. 38;
Utica 1985, fig. 14.

LITERATURE: *NY Times* 1859
"Sale"; *NY Times* 1859 "City";
Panorama 1948, pp. 58–59, fig. 10;
Parks 1960, fig. 59; Green 1966,
pp. 266–67, fig. 4-60; Carr 1981,
p. 111 n. 12; Parry 1988, p. 253,
fig. 204.

CONSERVATION: The painting is
on academy board, with a strainer
attached to the sides and top but not
the bottom. The board appears to
have been cut to size after the ground
was applied. There is some mechani-
cal craquelure in the lower center
section, and there is some drying
crackle in the upper left. The paint-
ing is in generally good condition.

OF HIS PLAN for the four-canvas series *The Voyage of Life,* Thomas Cole wrote
on March 25, 1839: "The subject has been on my mind for several years and was con-
ceived at the time my pictures of *The Course of Empire* were exhibited . . . a few
months after the death of Mr. Reed."[1] The popular success of his first serial work
had surely strengthened Cole's resolve to paint what he called "a higher style of land-
scape," addressing epic themes on a grand scale to serve a higher moral purpose and
a greater public good.[2] Moreover, it is easy to see how the loss of Cole's close friend
and patron Luman Reed (1785–1836) might be followed by a period of rumination on
man's mortality. These forces understandably combined to inspire Cole's second great
allegorical series.

Despite these connections to that earlier series, *The Voyage of Life* differs markedly
from the complex historical series that had directly preceded it, as well as from his reli-
gious subjects and awe-inspiring New World landscapes. The new series carried a
powerful Christian message. It is the story of a lone voyager on the river of life, borne
along through the vast and verdant landscapes of promise in childhood and youth to
the difficult terrain of manhood and old age, when, hopelessly adrift, he looks to a
superior power for guidance. *The Voyage of Life* is a highly charged statement of a
deep religious faith, which guided the artist in middle age and at the height of his cre-
ative powers during what was also a time of profound self-examination. Immensely
popular, the work struck a chord in the American public in a period marked by
national economic upheaval and dramatic social change.

Just as he had attracted Reed's support for *The Course of Empire,* Cole found in
Samuel Ward (1786–1839) a sympathetic patron eager to participate in the realization
of the new series' elaborate moralizing statement. Ward, a wealthy New York banker,
was an extremely pious man devoted to a variety of educational and religious causes.
He was already an admirer of Cole and had been a season ticket holder for the artist's
1836 exhibition of *The Course of Empire.* When the painter called on him, probably
sometime in 1838 or early 1839, "bringing the designs of four pictures illustrating the
course of human life,"[3] Ward was receptive. On March 21, 1839, Ward commissioned
Cole to paint the series for him, agreeing to pay five thousand dollars, which was a
remarkable sum coming in the wake of the financial panic of 1837. Cole had just begun
work on the series when Ward died in November 1839, leaving Cole to carry out the
commission for Ward's less-than-enthusiastic heirs.

Although *The Voyage of Life* was executed as a private commission, Cole felt it had
significant meaning for public discourse, and he hoped to exhibit the series. The Ward
family was uncooperative, however, permitting him only a brief showing of the paint-
ings in November–December 1839. Frustrated, Cole created a second version of the
series in 1841–42 from tracings he had made of the original paintings; this set was
exhibited widely to great acclaim. At the time of his death, Cole was also entertaining
the idea of issuing a set of engravings after the series. *The Voyage of Life* thus repre-
sents a preoccupation of the second half of Cole's career: his increasing interest in the
possibilities of public art.[4]

Figure 12. Thomas Cole, The Voyage of Life: Manhood, *1840, oil on canvas, 52 × 78 in. (132.1 × 198.1 cm). Munson-Williams-Proctor Institute Museum of Art, Utica, N.Y., Museum Purchase (55.107).*

Manhood, the third canvas in the series, provides the climax to the moral tale of *The Voyage of Life*, in which the traveler's sudden religious awakening is revealed (fig. 12). It is in this panel that Cole alters his traditional presentation of the ages of man to embrace the Christian ideal of salvation. Cole gave a full description of its meaning in his key to the pictures:

> Storm and cloud enshroud a rugged and dreary landscape. Bare impending precipices rise in the lurid light. The swollen stream rushes furiously down a dark ravine, whirling and foaming in its wild career, and speeding toward the Ocean, which is dimly seen through the mist and falling rain. The boat is there plunging amid the turbulent waters. The voyager is now a man of middle age; the helm of the boat is gone, and he looks imploringly toward heaven, as if heaven's aid alone could save him from the perils that surround him. The Guardian Spirit calmly sits in the clouds, watching with an air of solicitude the affrighted voyager. Demon forms are hovering in the air.
>
> Trouble is characteristic of the period of manhood. In Childhood, there is no cankering care; in Youth, no despairing thought. It is only when experience has taught us the realities of the world, that we lift from our eyes the golden veil of early life; that we feel deep and abiding sorrow; and in the Picture, the gloomy, eclipse-like tone, the conflicting elements, the trees riven by tempest, are the allegory; and the Ocean, dimly seen, figures the end of life, to which the voyager is now approaching. The demon forms are Suicide, Intemperance, and Murder, which are the temptations that beset men in their direst trouble. The upward and imploring look of the voyager, shows his dependence on a Superior Power, and *that* faith saves him from the destruction that seems inevitable.[5]

The subject of pilgrimage, of progress toward salvation, has a long written and pictorial tradition, from scripture to seventeenth-century emblematic literature and works such as John Bunyan's enduring *Pilgrim's Progress*. Cole's *Manhood* derives generally from a well-established iconography. However, the precise basis of his image and narrative is difficult to determine, and there are likely several different sources of inspiration. Cole recorded that he spent the fall and winter of 1839–40 reading, in addition to *Pilgrim's Progress*, Shakespeare, Goethe, and the Romantic poets.[6]

Ellwood C. Parry notes that the artist's treatment of the subject relates more specifically to Thomas Campbell's poem "The Last Man" and that Cole's particular image of

the voyager may have originated with the illustration, after Joseph Mallord William Turner, of Campbell's "Lord Ullin's Daughter" in the 1837 edition of the Scotsman's poetical works.[7] Louis Legrand Noble, Cole's friend and first biographer, writes that sketches made in the summer of 1839 at the upper waters of the Genesee River, near Nunda, New York, provided Cole with some of the landscape material for *The Voyage of Life*. Indeed, the precipice and the deep river gorge in the *Manhood* scene recall Cole's monumental painting *Portage Falls on the Genesee River*, completed that July.[8] The extent to which *Manhood* is also autobiographical has been speculated upon by several scholars, who point to a variety of possible influences: Cole's religious conversion, sometime after his marriage in 1836, when he became active in the Episcopal church; his struggles with the Ward estate late in 1839, which cast a pall over a previously hopeful project; and another troubled commission that year and a period of ill health. Another possible influence has been seen in the general mood of pessimism and disillusionment that permeated American society in the unsettling financial environment of the late 1830s.[9]

The Museum's oil sketch is one of three extant general compositional studies for *Manhood*. The idea appears to have evolved from an early dramatic scene of a storm-tossed boat on broad, raging waters, as evinced by the study on wood panel, perhaps dating to circa 1837–39, now in the Albany Institute of History & Art (fig. 13). A second, probably subsequent sketch on wood panel, now in the Munson-Williams-Proctor Institute Museum of Art (fig. 14), sets the scene in the dark river gorge, where demons appear in the sky and the figure of the voyager is shown seated in his boat. Although the Museum's painting was referred to by a nineteenth-century owner as the first sketch for *Manhood*, it varies significantly from the intermediary study. It is the closest of the three sketches to the Ward painting, despite the fact that it is only a generalized landscape with no figure or other details.[10] It seems reasonable, therefore, that it is a later preparatory study. The profile of the cliff at left conforms to that in the Ward canvas, as does the distribution of light throughout the composition, illuminating the break in the black clouds at upper left, the vast distance beyond the cliffs at the center, and the passage to the unknown beyond at the lower right. The Museum's sketch appears in fact to be a study of apocalyptic light, Cole's effort to create that "gloomy, eclipse-like tone" that lends essential meaning to the *Manhood* scene.

Figure 13. Thomas Cole, Study for the Voyage of Life: Manhood, *c. 1837–39, oil on wood panel, 12 × 13⅝ in. (30.5 × 34.6 cm). Collection of the Albany Institute of History & Art (1942.56.3).*

PJ

Figure 14. Thomas Cole, Compositional Sketch for the Voyage of Life: Manhood, *1840, oil on wood panel, 11 × 16¾ in. (28 × 42.6 cm). Munson-Williams-Proctor Institute Museum of Art, Utica, N.Y., Museum Purchase (64.164).*

Thomas Chambers

LONDON 1808–1866 OR LATER, PLACE UNKNOWN

15. *Lake George and the Village of Caldwell*,[1]
mid–19th century

Oil on canvas; 22 × 29¾ in. (55.9 × 75.5 cm) remaining original canvas, 22 × 30 in. (55.9 × 76.2 cm) current canvas; not signed, not dated

Purchased, Annie Swan Coburn (Mrs. Lewis Larned Coburn) Fund (1942:9-1)

PROVENANCE: Albert Duveen, New York: to Arnold Seligmann, Rey and Company, New York, by 1942.

EXHIBITIONS: Geneseo 1968, pp. 46–47, repro.; Shreveport 1973, no. 31, repro.; Northampton 1979, ckl. p. 38; Northampton 1980, no. 18, repro.; Northampton 1983, ckl. no. 2; New York, IBM 1990; Northampton 1996 *Landscape;* Northampton 1996–97.

LITERATURE: Affhauser 1943, pp. 14–15, repro. cover; Barker 1950, pp. 496–97, pl. 71; Flexner 1962, pp. 258–59, pl. 72; UpJohn and Sedgwick 1963, repro. p. 283; Chetham et al. 1986, no. 112, repro.; Wilmerding 1987, pp. 29–30, fig. 20; Chotner et al. 1992, p. 52.

CONSERVATION: The painting has been wax lined (the tacking edges are missing) and mounted on a new turnbuckle stretcher. There is overall mechanical craquelure, and there are some inpainted losses along the edges.

LITTLE IS KNOWN about the early life of Thomas Chambers beyond the fact that he was born in London and emigrated to the United States in 1832. In that year he filed a Declaration of Intention at New Orleans and is listed in the New Orleans Directory for the year 1834 (printed in 1833) as a painter. Chambers soon moved to New York, where he is found in city directories listed as a marine or landscape painter from 1834 to 1840. By 1843 he was in Boston, where he lived until 1851, at which point he moved to Albany, New York, remaining there until 1857. An indication of his family life is found in the New York State census records for 1855, which record that Thomas Chambers, age forty-seven, and his wife, Harriet, age forty-six, lived in Albany at 343 State Street, in a house valued at $2,500. The place of birth of both is listed as London. Chambers continued to travel, revisiting New York, where he is listed in the city directories for 1858 and 1859, and he was in Boston from 1860 to 1861.

While approximately one hundred paintings have been attributed to Chambers, only five works are signed or dated. The painter first received attention in 1942 when Norman Hirschl and Albert Duveen brought together eighteen works, possibly including the Museum's painting, which they attributed to "T. Chambers," based on the one signed painting in their exhibition.[2] Since that time many attributions have been made, based on the few additional signed works that have surfaced and the limited knowledge of the artist's life.[3]

As a marine and landscape painter, Chambers produced imaginative compositions that were often based on print sources after works by such artists as Asher B. Durand (cat. 17) and Jacques Gérard Milbert (1766–1840). A number of depictions of naval battles are based on prints after Thomas Birch (1779–1851). For his landscapes, he relied particularly on the views produced by William H. Bartlett (1809–1854) for Nathaniel Parker Willis's *American Scenes* (London, 1840). He did not strictly adhere to the prints but departed in quite original ways, employing a highly individual sense of design, a striking palette, and a bold, distinctive treatment of landscape and seascape features in his work.

The artist's known landscapes tend to depict the popular tourist sites of American scenery featured in the widely circulated prints of the day; his reliance on print sources also suggests that Chambers probably did not travel to these regions. Chambers painted a large number of Hudson Valley and New York State subjects, often repeating the same scene in multiple depictions. The Museum's painting, also known at one time as *View of Newburgh on the Hudson* and as *Looking North to Kingston*, is one of at least four versions of this scene.[4] As a previous title of the Museum's painting suggests, this scene has long been thought to depict a view on the Hudson River including the village of Newburgh. There is no print source of the Hudson River that directly relates to this scene, however, and the village does not bear a strong resemblance to the city of Newburgh at midcentury. Instead, the scene bears a close resemblance to a print by Léon Sabatier (active by 1827–d. 1887) after Jacques Milbert's *Lake George and the Village of Caldwell* (fig. 15),[5] from Milbert's *Itinéraire pittoresque du fleuve Hudson et des parties laterales [de] l'Amérique du Nord (Picturesque Itinerary of the*

Hudson River and the Peripheral Parts of North America) of 1828–29.[6] The Museum's version is the only one that includes a shepherd and sheep on the road heading down toward the river—the print also has figures on the road with cows and sheep. The village of Caldwell, seen at the far left in the Museum's painting, includes figures walking along footpaths between the buildings and smoke rising from chimneys. Chambers's characteristic bold, saturated colors and decorative treatment of foliage are seen here, along with a brilliant blue, cloud-filled sky. Also characteristic of the artist are the dark shadows that fall across the foreground, suggesting the time of day as late afternoon. With its placid waters and settled land, it is an idyllic image of the American landscape at midcentury.

EMK

Figure 15. Léon Sabatier after Jacques Gérard Milbert, Lake George and the Village of Caldwell, *1828, lithograph, in Jacques Gérard Milbert,* Itinéraire pittoresque du fleuve Hudson et des parties laterales [de] l'Amérique du Nord *(Paris: H. Gaugain, 1828–29), pl. 24. Rare Books Division, The New York Public Library, Astor, Lenox and Tilden Foundations.*

Horace Bundy

HARDWICK, VERMONT 1814–1883 NEW HAMPSHIRE (?)

16. *Girl with a Dog,*[1] 1852

Oil on canvas; 36⅛ × 29⅛ in. (91.8 × 73.9 cm); not signed, not dated

Gift of Mrs. Brooks Shepard (Hortense Oliver, class of 1916) (1957:64)

PROVENANCE: Claremont, N.H., antiques dealer; to Mrs. Brooks Shepard, Saxtons River, Vt.

EXHIBITIONS: Springfield 1962, no. 16C; Rutland 1964, ckl. no. 100; Northampton 1976 *American;* Northampton 1979, ckl. p. 37; Northampton 1980, no. 27, repro.; Northampton 1996–97.

LITERATURE: Shepard 1964, repro. p. 448.

CONSERVATION: The painting is on a very finely woven canvas (approximately 57 threads per inch vertically). It is unlined, with short tacking edges around an original wooden stretcher. It appears to have a tan-colored oil ground. There is mechanical craquelure overall in a diagonal pattern. A scratch along the dog's nose has been inpainted. The painting is unvarnished.

AS A LARGELY self-taught itinerant portrait painter, Horace Bundy worked primarily in his home region of Vermont and New Hampshire from the 1830s to the 1870s. He produced a visual record of the tradespeople and their families in straightforward likenesses. In 1837, while living in Lowell, Massachusetts, he married Louisa Lookwood of Springfield, Vermont. The couple eventually had eight children, one of whom, Horace L. Bundy, became a professional photographer in Hartford, Connecticut.

The Bundys moved into a house in Springfield built by Louisa's father in 1841. In the following year Bundy converted to the Advent faith, a religious movement originated by William Miller that had attracted other itinerant portrait painters in New England, including William Matthew Prior (1806–1873). Bundy managed to merge his profession as a traveling portrait painter with that of his religious calling, painting and preaching throughout the northern New England states. He characteristically signed and dated his portraits and provided the location of his sitter's residence in inscriptions on the backs of his canvases. During the later 1830s, the 1840s, and the 1850s he is documented in Springfield, Claremont, and Townsend, Vermont; Nashua and Fitzwilliam, New Hampshire; and Winchendon, Massachusetts. In the 1860 census of Springfield, Vermont, he is still listed as a painter. The artist's obituary records that he also traveled to "the West."[2]

Bundy accepted an appointment as the pastor of the Second Advent Church in Lakeport, New Hampshire, in 1863. He continued painting portraits into the 1870s, when he moved to Concord and executed family portraits based on photographs, including a *Self-Portrait* (c. 1878, Bundy family). In 1883 he journeyed to Jamaica, where he painted tropical scenery and several paintings, presumably landscapes, for a wealthy planter. Shortly after his return that year he died of typhus.[3]

Girl with a Dog is one of three family portraits Bundy painted in Nashua, New Hampshire, in 1852. The Museum's portrait hung with those of the girl's parents now in the collection of the Shelburne Museum, *Portrait of a Lady* (fig. 16) and *Portrait of a Gentleman* (fig. 17), both of which bear his signature and the date on the back: *H. Bundy painter / Nashua N. H. / January 1852.*[4] The three family portraits of unidentified sitters represent the artist's mature portrait style. *Girl with a Dog* has no inscriptions and remains in its original unvarnished state. It is possible that Bundy did not have time to return to the region to varnish the canvas after the paint surface had dried sufficiently, which took a minimum of several months. As in the portraits of her parents, the young girl is placed in an oval format with a painted "porthole" opening, a device favored by more accomplished portrait painters of the day, such as Rembrandt Peale (1778–1860), who produced widely acclaimed porthole-format portraits of George Washington.

The girl in Bundy's portrait is seated on a leather upholstered side chair and affectionately holds her black-and-white spotted pet dog with a reddish ribbon around the neck. Her portrait is further enlivened by a large coral necklace and gold locket and by the lively reddish pink–patterned dress she wears, which echoes the delicate foliage

background of the painting. The girl meets the viewer's gaze directly with large almond eyes, similar to the visible right eye of the dog. The dog's left eye is awkwardly covered, painted over with its black ear, an obvious change made by the artist. While the portrait entered the Museum's collection with the title *Portrait of a Girl with a Dalmatian,* it is likely the painting probably acquired this title in this century; the breed of the dog is difficult to determine as portrayed, but it is likely that this family pet is not a purebred. The portraits of the girl's parents are more straightforward and convey the family's upper-middle-class status. They are formally attired and set against a similar landscape background.

EMK

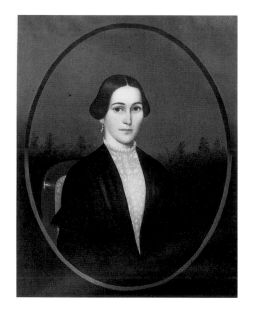
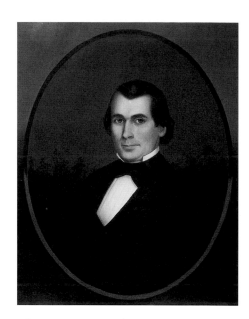

Figure. 16. Horace Bundy, Portrait of a Lady, *1852, oil on canvas, 35½ × 27¾ in. (90.2 × 70.5 cm). Shelburne Museum, Shelburne, Vt.*

Figure 17. Horace Bundy, Portrait of a Gentleman, *1852, oil on canvas, 35½ × 27¾ in. (90.2 × 70.5 cm). Shelburne Museum, Shelburne, Vt.*

Asher Brown Durand

JEFFERSON VILLAGE (NOW MAPLEWOOD), NEW JERSEY 1796–1886 NEW YORK

17. *Woodland Interior,* c. 1854

Oil on canvas; 23¹¹⁄₁₆ × 16¹³⁄₁₆ in. (60.2 × 42.7 cm); signed in black paint, lower right: *A. B. Durand*

Purchased (1952:107)

PROVENANCE: John Levy Galleries, New York.

EXHIBITIONS: Washington, Corcoran 1959, no. 3, repro. p. 8; Peoria 1965, repro.; South Hadley 1965; Montreal 1967, no. 320, repro.; Northampton 1968 *Hitchcock*, no. 9, repro. p. 10; New York, Rosenberg 1968, no. 89, repro. (as *Woodland Interior, c.* 1850); Northampton 1979, ckl. p. 39.

LITERATURE: Dorra 1959, repro. p. 24; Lawall [1966] 1977, pp. 367–69, 473–85, fig. 168 (as *Primeval Forest,* 1854); Lawall 1978, p. 179 (no. 371), fig. 214 (as *Woodland Interior,* c. 1854); Chetham et al. 1986, no. 115, repro.; Caldwell et al. 1994, vol. 1., pp. 425, 426, 428, repro.

CONSERVATION: The painting is on fine fabric attached to ¼-inch-thick paper pulp board. The pulp board has a coarser canvas backing and is attached to an unkeyed stretcher with nails through the face of the painting. There is very little crackle and the painting is in good condition; however, there are two major streaks of inpainted losses in the top and bottom left quadrants. It is varnished with Winton Retouching Varnish (Ketone resin N).

IN HIS MEMORIAL TRIBUTE to Asher Brown Durand, the artist Daniel Huntington (1816–1906) declared that the late painter had been an innovator in two realms: engraving and the practice of painting directly from nature.[1] Durand had earned a reputation as the finest engraver in America by producing such ambitious and masterly line engravings as his reproduction of John Trumbull's (1756–1843) complex history piece, *The Declaration of Independence,* published in 1823. Despite this success, Durand expanded his interests in the next decade to include the painting of portraits, historical subjects, and landscapes. Influenced by his growing friendship with Thomas Cole (cat. 14) and the encouragement of his friend and patron Luman Reed, he eventually abandoned engraving and focused exclusively on landscape painting. Such was his success that by 1848, at Cole's death, Durand was the acknowledged leader of the so-called Hudson River School. From 1845 to 1861 he served as president of the National Academy of Design; his "Letters on Landscape Painting," published in 1855 in successive issues of the newly founded art journal *The Crayon,* provided the theoretical foundation for a generation of artists.

It was in the second realm of achievement cited by Huntington—the practice of making oil sketches directly from nature—that Durand would have lasting impact. In the oil study, Durand discovered an effective tool by which to invest painting with a sense of the direct experience of nature, an ideal that held strong appeal by the 1850s. Small and careful oil studies such as this one in the Museum's collection, now titled *Woodland Interior,* served the artist as a record of observed forms, textures, and colors. Through them, he could compose larger, broader, more "picturesque" views that nevertheless maintained an intense feeling of accuracy. "Durand went directly to the fountainhead and began the practice of faithful transcripts of 'bits' for use in his studio," Huntington said of Durand's innovation, "and the indefatigable patience and the sustained ardor with which he painted these studies not only told of his elaborate works, but proved a contagious influence, since followed by most of our artists, to the inestimable advantage of the great landscape school of our country."[2]

Little is known of the history of this particular oil sketch. It was once identified as *The Primeval Forest,* a lost canvas shown at the National Academy of Design in 1854 as a pictorialization of William Cullen Bryant's "Forest Hymn."[3] Yet its relationship is clear to a subsequent canvas, *In the Woods,* 1855 (fig. 18), in the collection of the Metropolitan Museum of Art. Durand exhibited such sketches on occasion, but most remained in his studio. Eighty oil sketches were sold at auction from the artist's estate at Ortgies Art Gallery in New York in April 1887.[4]

The large canvas that followed from this sketch proved a breakthrough work in Durand's new realistic style, perhaps in part because of the aid of this highly finished study. Responding to that painting, a highlight of the National Academy's 1855 spring exhibition, an admiring critic wrote:

> it . . . leads us to a glade in the wilderness where, shut in by the eternal forest, whose giant children raise themselves around us, we see no light and hear no

Figure 18. Asher Brown Durand,
In the Woods, *1855, oil on canvas,*
60¾ × 48⅝ in. (154.3 × 123.5 cm).
The Metropolitan Museum of Art,
New York, Gift in memory of
Jonathan Sturges by his children,
1895 (95.13.1)

sound that remind us of civilization or humanity. Mouldering tree-trunks lie around us, with mosses and ferns thriving in the coolness of the shade, and a quiet brooklet welling out of the mould and winding its way among old tree roots. A squirrel crosses the stream on a prostrate tree, and on a beech tree a red-headed woodpecker is tapping. The picture might have been as carefully painted and still have only a botanical interest, but the summer has settled hazily among the trees, and the softened sunlight, falling down through the openings in the leafage overhead, breaks up the cool shade on the bolls of the trees, and warms the mossy ground with its gold.[5]

The preliminary plein air study, which seems so complete, capturing the precise character of the forest interior, must have proved a useful tool in enabling the artist to re-create in the studio not just the look of the forest interior, but its mood as well.

Woodland Interior does not approach the obsession with detail and the emphasis upon objectivity that characterize the work of the most enthusiastic followers of the British painter and theorist John Ruskin (1819–1900). This painting and other oil studies from this period, however, do suggest the impact that Ruskin's teaching had on American art by the mid-1850s, a decade before the founding of the Ruskinian Association for the Advancement of Truth in Art by American painters in 1863.[6] Philosophically, Durand had much in common with Ruskin, notably a devout reverence for nature and a respect for realism as an appropriate vehicle for conveying that devotion, as his "Letters" reveal:

> The external appearance of this our dwelling-place, apart from its wondrous structure and functions that minister to our well-being, is fraught with lessons of high and holy meaning, only surpassed by the light of Revelation. It is impossible to contemplate with right-minded, reverent feeling, its inexpressible beauty and grandeur, without arriving at the conviction . . . that the Great Designer of these glorious pictures has placed them before us as types of the Divine attributes.[7]

Durand reveals his devotion in his highly finished oil studies, to be sure. Yet, when his efforts are compared with those of William Trost Richards (1833–1905) and Aaron Draper Shattuck (1832–1928) at this same period, whose highly detailed landscapes follow the truth-to-nature tenet of Ruskin, it is clear that Durand consistently painted in a freer and looser manner. Moreover, even in his plein air sketches, Durand's landscape views typically remain poetic interpretations rather than highly veristic transcriptions of nature, which the Ruskinian painters aspired to create. His view of the forest, as it is depicted here with its soaring trees and intersecting boughs creating an unmistakable Gothic arch, is of a cathedral, after all. In Durand's art, nature is always carefully manipulated rather than randomly, unselectively transcribed.

PJ

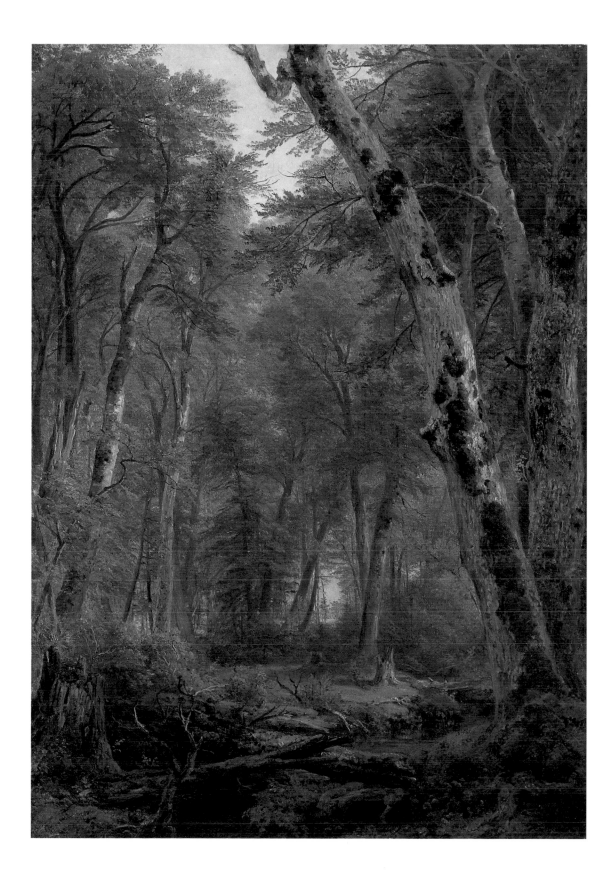

William Stanley Haseltine
PHILADELPHIA 1835–1900 ROME

18. *Natural Arch, Capri*, c. 1855–76

Oil on canvas; 15 1/16 × 23 15/16 in. (38.3 × 60.8 cm); not signed, not dated

Gift of Helen Haseltine Plowden (Mrs. Roger H. Plowden) (1952:4)

PROVENANCE: The artist's daughter, Helen Haseltine (Mrs. Roger H. Plowden), probably at his death, 1900; acquired through Doll and Richards Gallery, Boston.

EXHIBITIONS: Northampton 1979, ckl. p. 41; Framingham 1982, no. 17; San Francisco + 1992, pp. 42–43, colorpl. 42.

LITERATURE: Chetham et al. 1986, no. 116, repro.

CONSERVATION: The painting is on a linen pre-primed canvas (40 threads per inch vertically, 37 threads per inch horizontally) mounted on a keyed stretcher. There is overall mechanical crackle, and there are some stretcher creases. There are small inpainted losses along the bottom and left edges. The painting was varnished with Winton Retouching Varnish after its last conservation treatment.

WHILE CERTAINLY NOT the only American artist captivated by Italy's charms, William Stanley Haseltine was one of the most devoted expatriates to settle there.[1] For the last thirty-three years of his life (except for periodic long visits to the United States), Haseltine and his family lived in Rome, a base from which the artist made working excursions to Sicily, Naples, Venice, and other sites. Capri, that rocky island so rife with dramatic possibilities, was a favorite subject for the artist. Haseltine created numerous works that celebrated its craggy limestone shore, the clarity of its atmosphere, and the intensely blue waters that surround it.

In the earliest years of his career, Haseltine studied and painted other popular European views as well. The son of a successful Philadelphia merchant, he attended the University of Pennsylvania and graduated from Harvard in 1854.[2] Returning to Philadelphia, he studied briefly with the German-born landscape painter Paul Weber (1823–1916) and, like many aspiring artists of his generation, trained further in Düsseldorf and traveled the continent. By 1857 he was represented at the annual exhibition of the Pennsylvania Academy of the Fine Arts by scenes of the Rhineland and Switzerland. For some time after his return to the United States in 1858 he continued to exhibit European landscapes: he was represented by several Italian views in 1859. By the early 1860s, however, he would become strongly associated with American scenery.

Having taken a studio in New York in 1859, he soon established a solid reputation as a painter of the rocky shorelines of Mount Desert Island in Maine; Narragansett Bay in Rhode Island; and Nahant, just outside Boston. In painting after painting of these sites he captured the imposing presence of expansive red-brown or gray slabs of stone jutting into the ocean. Haseltine was undoubtedly conscious of the origins of these grand natural formations, and a geological subtext informs these images.[3] The accuracy of his depictions and his astute ability to convey the texture of actual rock was often commented upon. The contemporary biographer Henry Tuckerman noted that this talent applied to all of Haseltine's work, whether American or European in subject:

> Wm. S. Haseltine gives ample evidence of his Düsseldorf studies, whereof the correct drawing and patient elaboration are more desirable than the color although herein also he has *notably excelled*. Few of our artists have been more conscientious in the delineation of rocks; their form, superficial traits, and precise tone are given with remarkable accuracy. His pencil identifies coast scenery with emphatic beauty; the shores of Naples and Ostia, and those of Narragansett Bay, are both full of minute individuality, wherein one familiar with both, and a good observer, will find rare pleasure; it is the same with "Amalfi" and "Indian Rock." Italy and America are, as it were, embodied in the authentic tints of these rock-portraits set in the deep blue crystalline of the sea.... Haseltine's Capri subjects, and those painted in Normandy are very true to local atmospheric and geological traits.[4]

Haseltine's special affinity for the stark beauties of a rocky shore made the coast of Capri a natural choice of subject. The island was frequented by artists and tourists.[5]

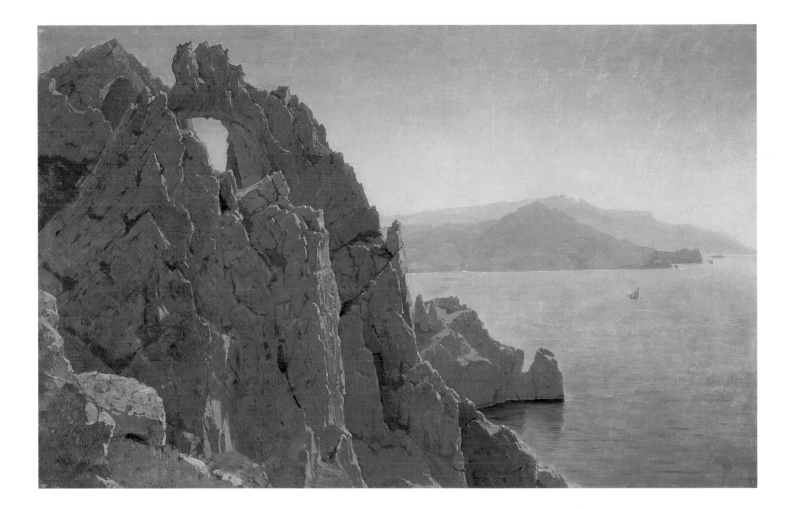

Even as tastes in America turned generally to softer, more intimate, Barbizon-inspired landscapes, visitors to renowned and ancient Italian sites still wanted both accurate and inspiring representations of the grandeur of these places. Haseltine never lacked for patronage, selling Capri views to such powerful figures as the collector William Herriman and General Crocker of California.[6] Between 1859 and 1896 the artist included Capri subjects in more than twenty-five exhibitions, including those at the Pennsylvania Academy of the Fine Arts, the National Academy of Design, the Boston Athenaeum, the Paris Salon, and the Philadelphia Centennial. *Natural Arch, Capri* is one of two extant paintings by Haseltine of the Arco Naturale, an awe-inspiring rock formation located on the southeast side of the island.

A second version of the subject, in the National Gallery of Art, Washington, D.C. (fig. 19), is larger and more ambitiously composed. It includes the Faraglioni, outcroppings actually beyond the area encompassed by the angle depicted. The Museum's painting represents reality more closely since its sense of scale is less obviously amplified. The peninsula of Sorrento across the Bay of Naples, for instance, appears nearer than in the National Gallery version; the drama of the arch itself is reduced by the

formation that looms directly in front of it, partly obscuring the gaping space that so powerfully draws the viewer into the other work. The expanse of blue sea is interrupted by a small boat. In the sky and sea short, broken strokes of rather thinly applied paint are visible, giving the painting a lightness of touch as well as a sense of immediacy and of Haseltine's process. The mass of rock at the left, however, is as solidly formed as in the larger painting. The glaring light of *Natural Arch at Capri*, which harshly illuminates the Arco Naturale, giving it an appearance suggestive of desiccated bones, is tempered in the Museum's painting by greater areas of shadow.

Despite these and other subtle differences in light and mood, both pictures evoke the sense of quiet grandeur and isolation that was so remarked upon by witnesses of the actual site. Although Capri was an attractive destination for travelers, it was not yet overrun by tourists in the 1870s and could be "a paradise of silence for those to whom silence is a delight . . . one lies on the cliff and hears a thousand feet below the dreamy wash of the sea."[7] As one nineteenth-century guidebook commented:

> The ruined palace was doubtless a marvel of splendour in those days, built at the command of an arrogant and powerful Caesar. But Nature has created greater marvels in the silence and solitude of this island. On the southeastern side of it she has piled mass upon mass, rock upon rock, hung colossal cliffs leaning over the verge of a precipice, raised pyramids, and crowned her titanic sport with a gigantic natural triumphal arch, overlooking the solitude of the sea! There it stands, a wonder to this day, the marvellous Arco Naturale towering up from the chaos of the sharp cliffs.[8]

DC

Figure 19. William Stanley Haseltine,
Natural Arch at Capri, *1871, oil on canvas, 34⅜ × 55⅛ in. (87.4 × 140 cm). Gift of Guest Services, Inc. Photograph © 1998 Board of Trustees, National Gallery of Art, Washington, D.C.*

Francis Seth Frost

WEST CAMBRIDGE, MASSACHUSETTS 1825–1902 ARLINGTON, MASSACHUSETTS

19. *South Pass, Wind River Mountains, Wyoming*, 1860

Oil on canvas; 28¼ × 50⅛ in. (71.8 × 127.2 cm); signed and dated in reddish brown paint, lower left: *F. S. Frost / 1860*

Gift of Margaret Richardson Gallagher, class of 1906 (1951:278)

PROVENANCE: Edward Richardson, Boston; to his granddaughter, Margaret Richardson Gallagher (Mrs. E. Gerald Gallagher), Northampton, Mass.

EXHIBITIONS: Manchester 1977; Northampton 1979, ckl. p. 40; Yonkers 1983–84, pl. 11.

LITERATURE: Chetham et al. 1986, no. 117, repro.; Houston 1994, p. 153, repro. p. 147.

CONSERVATION: The painting is on a pre-primed linen canvas (38 threads per inch vertically, 42 threads per inch horizontally) mounted on a simple wooden stretcher. There are several bull's-eye crackle patterns and there is mechanical craquelure from corner draws. There is some traction crackle in the area of the river, but there is no evidence of inpainting.

THIS PANORAMIC VIEW of the Wind River Mountains is one of the few extant oils resulting from Francis Seth Frost's 1859 trip westward along the Oregon Trail with the wagon road survey party of Colonel Frederick William Lander. That trip is remembered today as the first westward journey of painter Albert Bierstadt (cat. 20), celebrated as America's greatest painter of western mountain scenery. But Bierstadt's lesser-known painting companion on that trip, whose identity has only recently been established as Francis Seth Frost, was also an artist of some reputation by 1859. Frost's experience of the western frontier actually predated that of Bierstadt. Having spent two highly productive years in the gold fields of California, Frost had returned to his native Boston in 1851 with sketches of his travels, and he had exhibited a *Coast Scene on the Pacific* at the Boston Athenaeum as early as 1855.[1]

What brought the two painters together for the 1859 expedition is unknown. One biographical account relates that Frost had earlier studied with Bierstadt, possibly when the latter was offering drawing lessons in his Boston studio.[2] Bierstadt may well have appreciated Frost's frontier experience and sense of adventure, and the two artists seem to have held a common interest in photography. Lander's report of the trip makes it clear that Bierstadt and Frost did not serve in any official capacity: "A Bierstadt, esq., a distinguished artist of New York, and S. F. Frost, of Boston, accompanied the expedition with a full corps of artists, bearing their own expenses," he recorded.[3]

Lander further testifies to the artists' active painting and photographic efforts: "They [Frost and Bierstadt] have taken sketches of the most remarkable of the views along the route, and a set of stereoscopic views of emigrant trains, Indians, camp scenes, &c., which are highly valuable and would be interesting to the country," he wrote. Lander's comment raises questions about what Frost's specific role in the taking of photographs might have been.[4] The Bierstadt Brothers photographic firm of New Bedford, Massachusetts—established by the painter's brothers Charles (1819–1903) and Edward (1824–1907)—included Lander expedition photographs among the stereoscopic views offered in their 1860 sales catalogue, so it is possible that Albert may have been the principal photographer on the trip, turning over his images to his brothers for marketing.[5] But reports of Frost's subsequent work as a photographer in Boston leave room for speculation that he, too, might have contributed to the photographic record of the trip, although no examples of Frost's stereographic photography have yet been located. It is possible that his photographs were simply subsumed in the body of work sold under the Bierstadt Brothers name.

Whatever his direct involvement in stereographic photography may have been, Frost's *South Pass, Wind River Mountains, Wyoming* suggests a source in a stereoscopic view. The foreground is richly detailed, with sharply defined rocks that loom large in the composition. The expansive middle ground has been compressed, with a sizable band of Indians on horseback dotting the plain providing the only measure of scale and space. These details are viewed against the magnificent backdrop of the broad Wind River range, its tall, jagged peaks nearly engulfed in a blaze of sunlight.

Yet the painting also shows that Frost's skill at painting and designing a suitably impressive scene was highly developed by this time. His conception of the landscape combines topographical exactitude with an implied narrative offered by the Indians and a sense of drama supplied by the brilliant sunlight. In its tightly painted foreground details, its firm contours of the mountains, and its feeling for light, Frost's effort here is akin to the painting of Bierstadt and to the tradition of romantic realism associated with the Düsseldorf Academy in the middle of the nineteenth century. It is not known, however, how he might have come by his understanding of this tradition apart from his association with Bierstadt, who from 1853 to 1855 worked in Düsseldorf in the studio of Worthington Whittredge (1820–1910).

Aware of the intense public interest in their adventure, Bierstadt reported regularly and at length on the progress and experiences of the painting party attached to the Lander expedition in the popular art journal *The Crayon*. His letter of July 10, 1859, published in the September issue, notes their arrival at the South Pass of the Rockies, reports on their painting and photographic activities, and recounts their experiences with the Indians. His attempts to describe the magnificence of the Wind River range in detail and in terms that his fellow artists might understand help to explain Frost's interest in this particular scene:

> The mountains are very fine; as seen from the plains, they resemble very much the Bernese Alps, one of the finest ranges of mountains in Europe, if not in the world. They are of granite formation, the same as the Swiss mountains and their jagged summits, covered with snow and mingling with the clouds, present a scene which every lover of landscape would gaze upon with unqualified delight. As you approach them, the lower hills present themselves more or less clothed with a great variety of trees, among which may be found the cotton-wood, lining the river banks, the aspen, and several species of the fir and the pine, some of them being very beautiful. And such a charming grouping of rocks, so fine in color— more so than I ever saw. Artists would be delighted with them. . . . In the valleys, silvery streams abound, with mossy rocks. . . . We see many spots in the scenery that remind us of our New Hampshire and Catskill hills, but when we look up and measure the mighty perpendicular cliffs that rise hundreds of feet aloft, all capped with snow, we then realize that we are among a different class of mountains; and especially when we see the antelope stop to look at us, and still more the Indian, his pursuer, who often stands dismayed to see a white man sketching alone in the midst of his hunting grounds.[6]

While Bierstadt found on the Lander expedition the subject that would set the course of his distinguished career, the same cannot be said for Frost. Although Frost produced a series of western paintings immediately upon his return and sometimes exhibited them together with those of Bierstadt, he did not find the success that Bierstadt enjoyed in his celebrated "Great Pictures" of America's western mountain ranges. The small body of work that exists suggests that Frost lacked Bierstadt's sense of the sublime. Instead, his mountain landscapes consistently follow a formula set down by earlier Hudson River School painters, typically comprised of a distinct foreground, an expansive light-filled middle ground, and with distant mountains silhouetted against the horizon.

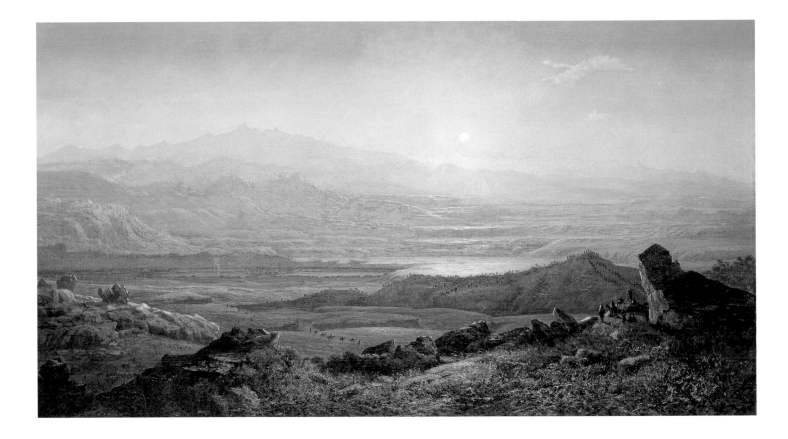

Nor, it would seem, did he find a sustaining interest from his experiences in the West. He returned again to favorite spots in the White Mountains of New Hampshire, painting idyllic views there into the 1890s, and to the landscape near his Arlington, Massachusetts, home, where he settled in 1872. From 1870 on, Frost identified himself in census records as a dealer in artists' materials, having built with Edward Adams the enduring firm of Frost and Adams.[7] A biographer reported that "although the business made demands on much of his time, he nevertheless executed a large amount of artistic work, especially in later years in the line of photography. In this branch he had few equals, perhaps no superiors."[8]

PJ

Albert Bierstadt
SOLINGEN, GERMANY 1830–1902 NEW YORK

20. *Echo Lake, Franconia Mountains, New Hampshire,* 1861

Oil on canvas; 25¼ × 39⅛ in. (64.1 × 99.3 cm); signed and dated in red paint, lower left: *ABierstadt.* [initials conjoined] / *1861.*

Purchased with the assistance of funds given by Mrs. John Stewart Dalrymple (Bernice Barber, class of 1910) (1960:37)

PROVENANCE: Henry Newell Tilton (1830–1904), Cambridge, Mass., 1861–possibly 1904; to his daughter, Elizabeth Tilton (d. 1959), Boston; sold to Vose Galleries, Boston, 1959–60 (as *A Wilderness Lake*).

EXHIBITIONS: New York, National 1861, no. 493; New Bedford 1960, no. 23, repro. (as *A Wilderness Lake*); Santa Barbara 1964, no. 18 (as *A Wilderness Lake*); South Hadley 1965 (as *A Wilderness Lake*); Washington +, National Gallery 1970, no. 2, repro. p. 9 (as *A Wilderness Lake*); Northampton 1979, ckl. p. 36 (as *A Wilderness Lake*); Framingham 1982, no. 4; New York, IBM 1990.

LITERATURE: *NY Times* 1861; *Albion* 1861, p. 189; Parks 1960, fig. 64 (as *A Wilderness Lake*); Hendricks 1974, CL-123, repro., unpag. (as *A Wilderness Lake*); Baigell 1981, pp. 12–13, fig. 4; Campbell 1981, pp. 14, 20, fig. 2; Chetham et al. 1986, no. 118, repro.; Brooklyn + 1991, p. 147.

CONSERVATION: The original canvas has been wax lined (the tacking edge has been removed) and remounted on its original keyed wooden stretcher. There is mechanical craquelure overall. There are several very small losses and inpainted losses along the edges.

THE WHITE MOUNTAINS lie in the center of the state of New Hampshire and contain the highest peaks in the Northeast. First explored in the seventeenth century, they attracted naturalists increasingly in the late eighteenth century and by the 1820s a few adventurous artists. Thomas Cole (cat. 14) visited as early as 1828, and by 1835 he celebrated the White Mountains in his "Essay on American Scenery," his famous charge to the country's landscape painters to embrace American subject matter. Cole extolled the mountains' unique beauty and the distinctive color of their wooded slopes by which they surpassed, according to his evaluation, the bare peaks of Europe. As he put it:

> But in the mountains of New Hampshire there is a union of the picturesque, the sublime, and the magnificent; there the bare peaks of granite, broken and desolate, cradle the clouds; while the vallies [*sic*] and broad bases of the mountains rest under the shadow of noble and varied forests; and the traveler who passes the Sandwich range on his way to the White Mountains, of which it is a spur, cannot but acknowledge that in some regions of the globe nature has wrought on a more stupendous scale, yet she has nowhere so completely married together grandeur and loveliness—there he sees the sublime meeting into the beautiful, the savage tempered by the magnificent.[1]

Although he had achieved unprecedented critical and commercial success with his first Rocky Mountains views, Albert Bierstadt also enjoyed painting in the White Mountains, and in *Echo Lake, Franconia Mountains, New Hampshire* he took full advantage of the varied scenery that Cole described, capturing its contrasting elements: soaring peaks and soft hills and the pleasant, still lake below.

Steeped in history and legend, the White Mountains were romanticized in the writings of Theodore Dwight, Nathaniel Hawthorne, and the Reverend Thomas Starr King, among others,[2] and were thought to be animated by the spirits of the Indians, explorers, and pioneers from the area's past. As a destination for travelers, the White Mountains continued to grow in popularity through the second half of the nineteenth century. By midcentury they figured increasingly in canvases by the second wave of artist visitors, including John Frederick Kensett (1816–1872), John Casilear (1811–1893), Benjamin Champney (1817–1907), and Bierstadt. Champney, who first encountered the charms of the White Mountains in the fall of 1850, recounted that by 1852 "there was quite a little knot of artists" gathered at North Conway. Every subsequent year brought still more painters, as news of the region's attractions quickly spread, "until," he wrote, "in 1853 and 1854 the meadows and the banks of the Saco were dotted about with white umbrellas in great numbers."[3]

Bierstadt was drawn to the White Mountains repeatedly throughout his career. His first recorded visit dates to August 1852, when he registered at the Summit House, on Mount Washington. He was in New Hampshire again in 1858 and may have made another visit at that time. The artist's greatest period of activity in the White Mountains dates to the early 1860s, when his reputation as a painter of American mountain scenery was beginning to soar. Although his grand representations of the Rockies were the basis

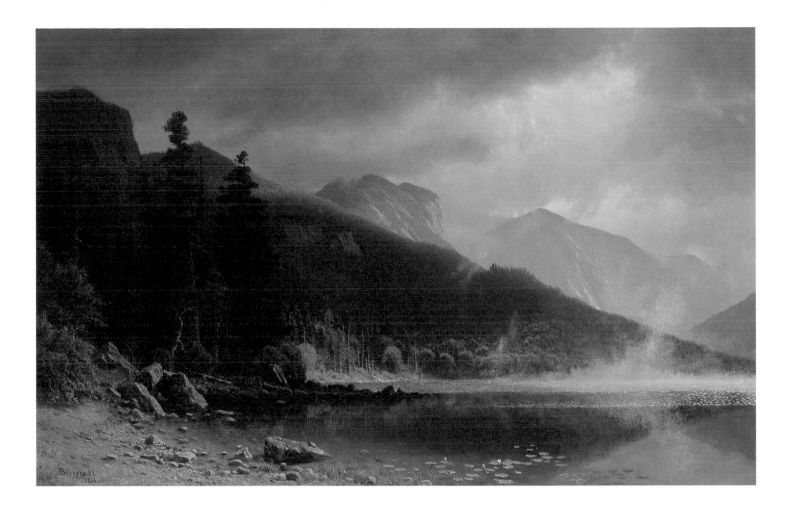

for Bierstadt's immense popularity in these years, New Hampshire's impressive, dark, pine-covered hills and peaks offered the opportunity to explore mountain scenery further, even after the painter's return home from his first trip west in 1859. That year Bierstadt accompanied the wagon road survey expedition of Frederick W. Lander as far as South Pass on the Continental Divide, making sketches and stereographic photographs of the western landscape that would serve him as the basis of a group of monumental panoramic paintings, which would come to define Bierstadt in the collective American imagination.

The summer of 1860 was marked by an extended period in the White Mountains, with Bierstadt's work there culminating in the Museum's large painting.[4] With his brothers Edward and Charles, newly established in the business of taking stereoscopic views, Bierstadt set out to survey the most picturesque spots in New Hampshire's famous range, visiting sites with which the painter was already familiar from his previous trips there. Bierstadt, as the photographic record attests, led his brothers over a large area of northern New Hampshire, from Plymouth, near Squam Lake, northward to North Conway, past Echo Lake, through Franconia Notch and Crawford Notch, and as far as Berlin Falls. Later that year the young partnership of Bierstadt Brothers of New Bedford, Massachusetts, issued a catalogue of stereographs listing many White Mountains views. In 1862 they released their *Stereoscopic Views among the Hills of New Hampshire,* an illustrated guidebook with original photographic prints. Exactly what role the painter played in this photographic enterprise is unknown, but a report in the art journal *The Crayon* in January 1861 offers a clue:

> We call the attention of admirers of photographs to a series of views and studies taken in the White Mountains published by Bierstadt Brothers of New Bedford, Mass. The plates are of large size and are remarkably effective. The artistic taste of Mr. Albert Bierstadt, who selected the points of view, is apparent in them. No better photographs have been published in this country.[5]

Bierstadt knew the value of the camera as an aid to painting from his stereographic work on the Lander expedition, and he surely approached the White Mountains project with that in mind. Photographs may well have served him in the painting of specific identifying details of a vista, especially as critics increasingly embraced the highly veristic approach of Pre-Raphaelite landscape painters in the early 1860s.[6] Yet the reportedly large body of oil sketches made on his trips to the White Mountains testifies to the complexity of Bierstadt's working method as he gathered material to aid him in the studio. His plein air studies of atmosphere, executed in oil on paper, were essential to him later in the creation of a landscape's mood and the spirit of each particular place. In January 1863 the *New York Leader* reported that the artist's White Mountains studies covered an entire wall of Bierstadt's painting room in the Tenth Street Studio Building.[7]

The mirrorlike Echo Lake, presented in all its serenity in the Museum's painting, was one of the most picturesque spots in the White Mountains. A short half-mile hike from the popular Profile House, which overlooked the rocky outcropping that formed the celebrated profile of "the Old Man of the Mountain," Echo Lake was nestled among steeply sloping pine-covered mountains, a natural formation in which even the slightest sounds reverberated—hence its name. Bierstadt's particular view of the lake was already well known, for it was taken from just below the popular vantage point known

as Artist's Bluff, a favorite spot from which to look down upon the small, still lake and see it against the broad, dark slopes of the surrounding mountains. As Echo Lake was described in the Bierstadt Brothers' photographic guidebook:

> [A]s the name implies, [it] is celebrated, and justly, for the wonderful echo that is heard there. Its location is favorable for producing such a reputation, as it is completely walled in on all sides by Mount Cannon, Bald Mountain, and Mount Lafayette, against whose rocky sides every sound is tossed back and forth until growing fainter in the distance it is borne upward and lost in thin air. Late in the afternoon when the mountains cast their shadows over the lake, it is visited by a large number from the hotel and vicinity, and boating parties row around wakening with their merry voices the echoes that lie sleeping here. But the human voice is not loud enough for many visitors, so a trumpet is kept at the boat-house to satisfy their longings with its powerful tones; or a small cannon is discharged, and then the uproar is tremendous, sounding as if a whole park of artillery were in the neighborhood.[8]

Bierstadt's view here from the water's edge emphasizes the height and the majesty of these mountains, inviting a comparison with western peaks. Indeed, for many years the precise locale represented in this canvas was unidentified. Known by the title *A Wilderness Lake* when it was acquired by the Museum, the painting was thought to depict a scene in the West.[9]

Echo Lake, Franconia Mountains, New Hampshire was one of four canvases Bierstadt chose to represent his work in the annual exhibition at the National Academy of Design in the spring of 1861, a year after his first major western canvas, the monumental *Base of the Rocky Mountains, Laramie Peak* (unlocated), had created such a stir at that same venue. Already owned by Boston banker and lumber man Henry Newell Tilton, *Echo Lake* was shown along with two eagerly awaited western scenes, *Emigrants Camping* and *Platte River—Indians Encamped*, and a large, romantic canvas, *Recollections of Capri*, inspired by Bierstadt's earlier travels in Europe. The White Mountains scene nevertheless held its own. One critic saw *Echo Lake* as showing the artist "to far better advantage" when compared to what seemed the excesses of Bierstadt's Capri view.[10] The *New York Times* critic identified *Emigrants Camping* and *Echo Lake* as "most capital specimens of his appreciated style."[11]

The National Academy exhibition closed early that spring, on April 25, two weeks after Confederates fired on Fort Sumter. Union troops required use of the Academy's Tenth Street galleries. That fall Edward Bierstadt obtained permission to open a temporary photography studio in the camp of the Army of the Potomac.[12] At the same time his painter brother went once again to the White Mountains for solace and inspiration, and he began to plan a second trip to the American West.

PJ

Thomas Charles Farrer

LONDON 1839–1891 LONDON

21. *View of Northampton from the Dome of the Hospital,*[1] 1865

Oil on canvas; 28⅛ × 36 in. (71.4 × 91.4 cm); monogrammed and dated in red paint, lower right, initials conjoined: *TCF 65*

Purchased (1953:96)

PROVENANCE: Porter Fitch, New York, 1865; found in New Haven, Conn., by unidentified New Haven antiques dealer; to Avis and Rockwell Gardiner, Stamford, Conn.

EXHIBITIONS: New York, National 1865, no. 279; Springfield + 1955, no. 14, repro. cover; Northampton 1956, ckl. no. 7; Northampton 1975 *Five*, no. 1, repro.; Sturbridge 1976, ckl., unpag.; Northampton 1979, ckl. p. 40; Springfield + 1981–82, p. 44, no. 13, repro.; New Orleans 1984, repro. p. 32; Brooklyn + 1985, no. 12, colorpl. 15; Northampton 1995.

LITERATURE: Bishop [1975] 1979, colorpl. 35; Cantor 1976, colorpl. II; Czestochowski 1982, colorpl. 100; Jones 1983, pp. 48, 105 nn. 20 and 22, 111 n. 91, fig. 35; Ferber 1985, p. 880, repro. p. 878; Chetham et al. 1986, no. 119, color repro. p. 10; Clark 1987, color repro. title page; Clark 1989, pp. 130–31, repro.; Gerdts 1990, vol. 1, pp. 80, 371 n. 49; Lockwood 1994, repro. p. 44.

CONSERVATION: The painting has been wax lined (the tacking edges have been removed) and remounted on its original keyed wooden stretcher. There are several areas of inpainted loss: in the center foreground trees, two spots in the sky on the left side of the painting, near the upper right corner in the sky, and directly above the mountain along the right edge.

WHEN THOMAS C. FARRER finished his *View of Northampton from the Dome of the Hospital* in August 1865, he was twenty-six years old and already an artist of some renown, not to say notoriety. Many paragraphs of criticism were written about the painting in the New York press when it appeared in the Artists' Fund Society exhibition, three months later. Yet in 1953, when the picture entered the Museum's collection, Farrer's name was known only to a handful of scholars. The initials and date in red paint could not be deciphered, and the picture was catalogued as an anonymous American work and dated 1850–60. The scene is clearly a view of the town of Northampton, beyond which can be seen the Connecticut River meandering past Hadley and Hatfield, with Amherst in the distance and the eastern end of the Holyoke range on the right. In the foreground are Paradise Pond and the Mill River, on the near side of which is land that became the playing fields of Smith College; what was to be its campus ten years later lies along the far side.

The picture's authorship tantalized many students of American art in the following years because it was recognized that such an accomplished work was not likely to be from the hand of an untrained or undocumented artist. Its vantage point, the dome of the Northampton Lunatic Hospital, as it was then called, led to the notion that the artist might have been an inmate, while its accurate and thorough accounting of the town suggested a photographic source. It was that very exactness of detail that permitted the present writer to identify the painter in 1979. Old photographs revealed that the building with the two hat-shaped towers near the center of the picture was the "new" high school, dedicated in August 1864. Photographs of the Smith campus in the nineties show a large building below the dam, a hoe factory erected in October 1866. The absence of this building from the picture led to the discovery of four notices of Farrer's visit in the Northampton papers. The first, from the *Northampton Free Press* (August 29, 1865), reads in part: "Farrar [*sic*] . . . has as we learn, completed two fine pictures, one of Mount Tom and the other of Northampton, from the dome of the Hospital."

Farrer, an Englishman, had come to New York in his late teens, about 1857, fired by the inspirational teaching of John Ruskin and of the Pre-Raphaelite painter Dante Gabriel Rossetti (1828–1882), with both of whom he had taken free art classes at the Working Men's College in London. His education was otherwise apparently quite limited, as were his means.[2] He was the son and grandson of artists.[3] In 1861 he obtained an appointment at the recently established School of Design for Women at the Cooper Union and taught there until 1865. Like the Working Men's College, it was a free school, and Farrer lost no time in introducing some of Ruskin's methods to his classes. By January 1863, as a result of Farrer's immense energy and proselytizing fervor for Ruskin's ideas concerning art and nature, Farrer had formed a group of like-minded artists, architects, writers, scientists, etc., into the Society for the Advancement of Truth in Art.[4] They asserted, among much else, that "the right course for young artists is faithful and loving representation of nature, 'selecting nothing and rejecting nothing,' seeking only to express the greatest amount of fact."[5]

Farrer's reasons for coming to Northampton in the summer of 1865 are not known. The town was a favorite of summer visitors, but the magnet for Farrer was probably its proximity to Ashfield, since 1863 the summer home of Charles Eliot Norton, art scholar and friend of Ruskin.[6] Norton supported the Society and praised its journal, *The New Path*, in his prestigious *North American Review*.[7]

View of Northampton is Farrer's largest and most ambitious extant painting; no known work of the period by any other Ruskinian is of this size. In 1863–64 Farrer had painted another canvas of about the same size at the urging of two fellow society members, Russell Sturgis and P. B. Wight, both architects.[8] They felt that such a work would help the cause and be more salable than the customary small-scale paintings most of the group's artists produced. The result, painted in the studio from studies from nature, was judged a failure by his fellow artist Charles Herbert Moore (1840–1930), who recommended that he destroy it.[9] Nevertheless, Farrer was apparently determined to prove that he could paint in large scale, and in *View of Northampton* he undertook a panoramic composition of great complexity.

The high vantage point chosen by Farrer was not typical of the movement's work, which was more often characterized by close observation of nature at ground level. But Farrer had used a similarly high viewpoint for a scene looking up the Hudson River from Catskill, New York, in 1863. Having in mind the criticism of his earlier effort at working large, Farrer painted *View of Northampton* directly from nature, which may account, in part at least, for the extraordinary sense of the atmosphere of the day he has captured. Although it appears to be a careful and thorough cataloguing of all the many elements of the scene, it is not simply a topographical rendition. Many subtle observations make it a living landscape: the delicate band of haze or smoke lying against the far hills, the quiet waters of Paradise Pond and the Connecticut River ruffled by passing breezes, the trees in the near meadow drenched with sun, and the rooftops almost whitened by the glare.

The local press was enthusiastic:

> The large picture of "Northampton from the Dome of the Hospital" on which we believe Mr. Farrar [*sic*] was engaged for months, has an accuracy of detail, and a natural coloring, rarely seen. The fog resting on the eastern hills is beautifully portrayed, while the mountains near and far, the wide-spread meadows and the spires and dwellings of our own town and of those lying beyond the river, are true to their originals.[10]

Farrer had at least two showings of his work in Northampton in October 1865, but of the summer's output only the *View of Northampton* and a painting of Mount Tom[11] have been found. Indeed, only five or six oils done during his fifteen-year stay in America have come to light.

If Farrer had reason to be pleased with the local reception of the picture and by the fact that he had sold it within weeks of its completion,[12] the reviews in the New York press when it was shown there in November and December were not likely to gratify him. In the *New York Daily Tribune*, Clarence Cook, of whom Farrer had been a protégé when he first came to America, wrote:

> There is no mystery in this picture, unless it be what is the meaning of the line of mist which lies against the horizon hills so late in the day, or why the water is not

all on the same level. . . . This is the Northampton the surveyor sees . . . but it is not the one the bird sings over, and that makes the poet's song. . . . It is the prose, not the poetry of landscape.[13]

Russell Sturgis, another friend, devoted most of his final column on the exhibition in *The Nation* to the painting. While commiserating with the artist over the difficulties of the subject and complimenting him on the clouds and the far distance, he accuses him of "disregarding . . . the more important truth of gradation, for the less important truth of contrast, this Rembrandtesque treatment of noonday landscape."[14] Sturgis was especially disturbed by the shadows of the trees, which are uniformly black, whether in the foreground or the distant meadows. The anonymous reviewer for *The New Path,* the journal Farrer had helped to found, shared this dislike: "Nature's shadows are shadowy, indeed, but are not black." He rhapsodizes over the handling of the clouds, the sky, and the distant landscape in "this last, most powerful, most impressive of the pictures he has exhibited." But he is annoyed by the trees in the middle distance that "stand about in scores, all alike, radiating brush strokes below and spungy [*sic*] masses above." In the end he pronounced the picture "untrue, untrue to Nature."[15] Northampton's press, with no aesthetic ax to grind and its own view of truth to nature, took a more generous view: "The whole broad valley, the town embowered in green, the far-off mountains bordering the horizon, with the river curving and gleaming at intervals through the openings in the foliage, are most admirably represented and true to nature."[16]

Today we can perhaps overlook the artist's failure to toe the mark of Ruskinian truth and see the picture as a complex, panoramic composition full of fascinating incident and delicate detail so suffused with the atmosphere of a lazy, rural summer midday that the warmth of the sun seems almost palpable.

BBJ

Martin Johnson Heade

LUMBERVILLE, PENNSYLVANIA 1819–1904 ST. AUGUSTINE, FLORIDA

22. *New Jersey Meadows*, C. 1870

Oil on canvas; 15⅛ × 30⅛ in. (38.4 × 76.5 cm); signed in black paint, lower left: *M. J. Heade*

Purchased (1951:298)

PROVENANCE: Harry Shaw Newman Gallery, New York, by Apr. 1948; Vose Galleries, Boston, by Oct. 1951.

EXHIBITIONS: New York, Newman 1948; Northampton 1979, ckl. p. 42.

LITERATURE: Comstock 1948, p. 86, fig. 2 (as *Jersey Meadows*); Parks 1960, fig. 61; Stebbins 1975,[1] pp. 49, 252, no. 202, repro. (as *Jersey Meadows*); Fogarty et al. 1985, p. 35, repro.

CONSERVATION: The painting is on a coarse canvas lined to an aluminum panel, which is backed by another canvas and mounted on the original keyed stretcher. There is some minor inpainting in the sky and along the bottom edge of the canvas in the grass.

IN HIS EFFORTS to find subjects that suited him, Martin Johnson Heade looked beyond America's wilderness and pastoral landscapes—subjects favored by his contemporaries—and ranged widely. On both the East and West coasts of this country, he painted the sea in its various moods. In South America and Florida, he studied exotic flora and hummingbirds. But it was in the coastal lowlands of Rhode Island, Massachusetts, and New Jersey that he found, in the 1860s, a subject that would fascinate him for the rest of his life: the salt marsh.

Heade's salt marsh landscapes manifest a lack of concern for locale, an approach that ran counter to the native landscape school in the first half of the nineteenth century. But his landscape subjects suggest that Heade was an artist of uncommon vision whose mature work does not follow the mainstream fascination with the recognizable and distinctly American vista.

Heade was largely self-taught, except for some painting lessons with his Lumberville, Pennsylvania, neighbor, the Quaker artist Edward Hicks (1780–1849). He associated with and learned much from such eminent landscape painters as Frederic Edwin Church (1826–1900), John Frederick Kensett (1816–1872), and others. Upon his arrival in New York in 1859, Heade had the good fortune to find quarters in the famous Tenth Street Studio Building. Yet his art was never popular with the critics, and, after his death, his highly original work was overlooked through the first half of this century. It was not until 1968 that Theodore Stebbins mounted a major exhibition of Heade's work and published the first significant reassessment of the artist's career.[2]

By 1862 the peripatetic Heade had discovered the marshes around Newburyport, Massachusetts, a locale with which the artist is now closely identified, and by 1867 he was painting similar views in Hoboken, New Jersey, near his Manhattan home. Given the indeterminate nature of the salt marsh, the specific location of Heade's subject is ambiguous, and the artist himself, in more than one hundred known marsh paintings, rarely identified the location of a scene. Essentially the same salt marsh landscape could be found all along the East Coast, and Heade painted similar views from the Northeast to Florida. All share the fundamental qualities of extreme horizontality and focus on the play of light around the stately haystacks. Hence Heade's marsh subjects remain extremely difficult to identify and, owing to the length of his interest in the genre, are equally hard to date. The Museum's canvas is a case in point. The title has been handed down from a dealer, Harry Shaw Newman, and he may well have chosen it at random, although the composition does include the large hills that appear most often in Heade's paintings of New Jersey meadows. The picture includes studies of cows taken from an early sketchbook—a specific detail that appears in other marsh paintings as early as 1863—but the date of this canvas is nevertheless difficult to determine.[3] It exhibits some of the looseness associated with Heade's later New Jersey marsh paintings of the 1870s, most notably in the simplicity of the large haystack in the left foreground and in the generalized line of hills running across the background, but it also shows an interest in varied atmospheric effects that is most prevalent in Heade's earlier marsh paintings. In this example, a rain shower passes off to the right

and gives way to the warm, late afternoon sunlight, imbuing the scene with a sense of mood and a feeling of time elapsed, qualities that distinguish Heade's most engaging works. It is this kind of painting that recalls the praise of James Jackson Jarves, who singled out the color effects of Heade's canvases for affording "sensuous gratification," even as he lamented the monotony of the painter's marsh compositions.[4]

There is evidence that Heade's marsh paintings enjoyed popular success even as they garnered scant critical appreciation. The nineteenth-century chroniclers Clara Erskine Clement and Laurence Hutton tell us that "[Heade] has been very successful in his views of the Hoboken and Newburyport meadows, for which the demand has been so great that he has probably painted more of them than any other class of subjects."[5] Stebbins has discovered that Heade's marsh paintings have been dispersed quite widely, with only one example remaining with the artist's descendants in recent years, further suggesting their popularity.[6]

The fascination that this distinctive landscape held for Heade is suggested by the character of the salt marsh itself. The flat, expansive marsh, fed by tidewaters and a web of winding streams, is characteristically lush with grasses. The marsh represents a distinct productive habitat, rich in fish, game, and wildflowers, and Heade's interest in

such places extended beyond their pictorial possibilities. An avid outdoorsman who enjoyed fishing and hunting, Heade wrote of his trips to the New Jersey marshes in *Field and Stream* in 1895:

> Even so late as twenty years ago I had some of my most enjoyable shooting days in the vicinity of New York City, days that I look back on with the greatest pleasure. I would take the Erie cars as far out as Hohokus, and sometimes to Turner's, and get back to my shooting ground by about 9 o'clock; and usually went back in the evening with several woodcock and partridges, after a most delightful autumn stroll.[7]

In Heade's day the salt marsh was typically populated by great conical stacks of marsh grasses. The fruits of the harvest of this wild crop stood on raised stakes in the swampy fields for months at a time, until the cut grass could be hauled away to nearby farms for use as fodder and straw. Pictorially, the ever-present haystacks were static elements in an otherwise changing landscape and thus functioned as convenient focal points in Heade's studies of the dynamics of sunlight and atmosphere. In *New Jersey Meadows*, for example, these solid forms render the moist afternoon air palpable through the play of color and light around them.

The salt marsh may also have held another level of meaning for Heade. Just as his floral still lifes may make personal and sexual references, as Theodore Stebbins has speculated, Heade's numerous marsh studies, produced over more than forty years, may signal an enduring mystical vision. Stebbins notes that consciously or subconsciously Heade here conjures up the unmistakable image of a bountiful Mother Earth, characterized by the warmth and abundance of these grasslands.[8] The subject seems to suggest the pure, life-giving forces of nature, offering the artist abiding comfort and inspiration.

PJ

Winslow Homer

BOSTON 1836–1910 PROUT'S NECK, MAINE

23. *Shipyard at Gloucester*, 1871

Oil on canvas; 13½ × 19¾ in. (34.3 × 50.2 cm); signed and dated in reddish brown paint, lower left: *HOMER '71*

Purchased (1950:99)

PROVENANCE: Dr. Martin Burke (1855–1933), New York, until 1933; to his son, John Burke, New York, until 1944 or 1945; to his estate, 1945; consigned to M. Knoedler and Company, New York, 1945 (as *Building a Ship*); sold to Joseph Katz (1888–1958), Baltimore, 1945–Mar. 1949; sold to Victor Spark, New York, Mar. 1949–Nov. 1950.

EXHIBITIONS: New York, Century 1877, no. 21 (as *Shipyard at Gloucester*); New London 1945, no. 82; Baltimore, Baltimore Museum of Art, extended loan, Aug. 1948–Mar. 1949 (as *Shipbuilding*, lent by Joseph Katz); Northampton + 1951, no. 22, repro. (as *Shipbuilding at Gloucester Harbor*); New York, Knoedler 1953, no. 36; Syracuse 1953, no. 17, repro.; Middletown 1954; Northampton 1964, no. 12; Richmond 1964, no. 2, repro.; Northampton 1968 *Hitchcock*, no. 11, repro.; Washington +, National Gallery 1970, no. 28, repro. p. 25; Gloucester 1973; Portland 1974, no. 12, repro.; Richmond + 1976, no. 39, repro. p. 88; Northampton 1979, ckl. p. 42; New York +, District 1979,[1] no. 13, repro. p. 31; Clinton 1983, no. 35, repro. cover; Stamford 1984–85, p. 10; Stamford 1989, pp. 8, 11; Chicago 1990, p. 24, no. 1, pl. 15; Washington +, National Gallery 1995–96,[2] no. 71, repro.; Stamford 1997.

IN THE YEARS following the Civil War, Homer's work as an illustrator for *Harper's* and other popular weekly magazines took him regularly to the popular summer spots: Newport, Saratoga, the White Mountains, the New Jersey shore. Homer responded strongly to the light and colors of the seacoast and the changing mountain atmosphere, and these trips produced paintings shining with summer's heat and brilliant optical effects. Works such as *Bridle Path, White Mountains* (1869, Sterling and Francine Clark Art Institute, Williamstown, Mass.) and *Long Branch, New Jersey* (1869, Museum of Fine Arts, Boston) testify to the artist's keen powers of observation and transcription. Even in his studio work, Homer was known to use whatever means available to recapture the transitory effects that he had observed in the out-of-doors. "Mr. Homer studies his figures from reality, in the sunshine. If you wish to see him work you must go out upon the roof and find him painting what he sees," noted the *New York Leader* in April 1864.[4]

The Museum's brilliant, light-filled scene of a fishing schooner on the stocks in the David Alfred Story shipyard documents Homer's earliest-known painting trip to Gloucester, Massachusetts, probably in 1869 or 1870, several summers before his well-known stay there in 1873.[5] In this modest canvas Homer suggests both his abiding interest in the lives of men and women who live by the sea and his understanding of human efforts to meet the challenges of nature. *Shipyard at Gloucester* is an important precursor of work that would come later in Homer's career: his Gloucester studies of 1873; the views of fisherfolk painted in Cullercoats, England, a decade later; and the expansive, pure marine paintings in oil created near the end of his life at his home at Prout's Neck, Maine.

Although scholars have long speculated that the scene might depict a shipyard in Essex, Massachusetts, naval historian Erik A. R. Ronnberg, Jr., has shown through photographic evidence (fig. 20) that the site is actually Gloucester's Story shipyard.[6] The Story yard was located at 10–14 Pearce Street, in Vincent's Cove.[7] Homer has been so true to the layout of the wharves and yard that the surrounding buildings can be easily identified. At far left Homer includes the wharf shed of William A. Friend, purveyor of coal and firewood; piles of cordwood are easily discernible in the painting. At right is the pitched-roof office of Dennis and Ayer fisheries. In the background are masts of other ships in Gloucester's distinctive narrow harbor.[8]

What took Homer to Gloucester for a brief visit in 1869 or 1870 is not known. It is possible that his stay in the resort town of Manchester, Massachusetts, in the summer of 1869 inspired a quick trip there, as Gloucester is the next town up the coast, only a few miles away.[9] Whatever his motivation to paint there, however, he chose a subject that is emblematic of that place and a symbol of Gloucester fishing and shipbuilding. Gloucester was celebrated for its fishing fleet, which spurred the local shipbuilding industry. It is true that in this period Gloucester shipbuilding was overshadowed by that in Essex, which may be why some scholars have erroneously located Homer's scene in Cape Ann's better-known shipbuilding town. But there remained significant activity in Gloucester, nonetheless, all of it centered in Vincent's Cove.

LITERATURE: Goodrich 1945,
p. 44; *Art Dig* 1951 February, p. 11,
repro.; *SCMA Bull* 1951, pp. 30, 34,
fig. 14; Gardner 1961, p. 132, repro.;
New York +, Graphic 1968, p. 32
(no. 80A), pl. 72; Wilmerding 1972,
p. 117, fig. 3-35; Hendricks 1979,
p. 298, fig. CL-280; Janson 1980,
p. 220; Chetham et al. 1986, no. 120,
repro.; Jennings 1990, color repro.
pp. 32–33; Wilmerding and Ayres
1990, p. 15; Wilmerding 1991,
pp. 210–14, fig. 140; Ronnberg 1996,
pp. 209–18, fig. 3; Little 1997, color
repro. pp. 36–37; Goodrich Homer,
object record.[3]

CONSERVATION: The painting has
been wax lined (the tacking edges
have been removed) and mounted
on a new turnbuckle stretcher. There
are two vertical scratches in the sky
and areas of inpainting in the left and
center sky as well as small spots of
inpainting in the ship.

The specificity of Homer's scene has enabled historian Ronnberg to identify the hull type and the details of the ship under construction. The Museum's canvas is evidence that Homer was well acquainted with the unique Gloucester "clipper" schooner, which he has rendered with exactitude and clear understanding of the refinements in its shape and proportions. The graceful hull of this fishing schooner is distinguished by its sharp bow and stern, a long water line, a fairly wide beam, and a shallow draft, an accommodation to the limited depths of water in Gloucester harbor. These characteristics allowed for unprecedented speed. But as the clippers grew ever longer at the waterline and increasingly shoal, they became unstable, having "a fatal ability to capsize when heeled beyond a certain point."[10]

The hull here under construction is, in Ronnberg's estimation, a schooner of approximately sixty-five tons. If newspaper accounts of local ship launchings are accurate, there were no such vessels launched from the Story yard in 1871, so the painting may represent one of two hulls completed there in the summer months of 1869 or 1870. In 1869 Homer might have seen the schooner *Chocura* (62.87 tons), launched from the Story yard in early June. In 1870 he could have seen the *Alice G. Wonson* (64.18 tons) on the stocks, as she was launched from the Story yard at midyear.[11]

Homer here shows his sharp observation and thorough knowledge of the mechanics of shipbuilding, giving details of hull construction and capturing perfectly the body language of the shipwrights. Ronnberg reads the activity as follows:

> The hull is planked, leaving only the bulwarks to be covered. The bowsprit is in place, but the carvings on the bulkhead below it have not been done. The three men on the scaffolding amidships are at work on the hull planking; the one at left is "dubbing" (fairing the rough surface with an adze) while the two at his right are driving a tight plank seam open in preparation for caulking. At the vessel's forefoot (where the dark-colored keel and stem post join at an angle), a man is painting the bottom planks with dark brown copper (antifouling) paint.

Figure 20. William A. Elwell, Ship Building:
Fishing Schooner on the Stocks at Vincent's
Cove, *1874, black-and-white photograph from
a copy negative by Erik A. R. Ronnberg, Jr.
Courtesy of Erik A. R. Ronnberg, Jr.*

Figure 21. Winslow Homer, Ship-Building,
Gloucester Harbor, *1873, wood engraving,*
9¼ × 13½ *in.* (23.5 × 34.3 cm). Smith College
Museum of Art, Purchased (1935:4-1).

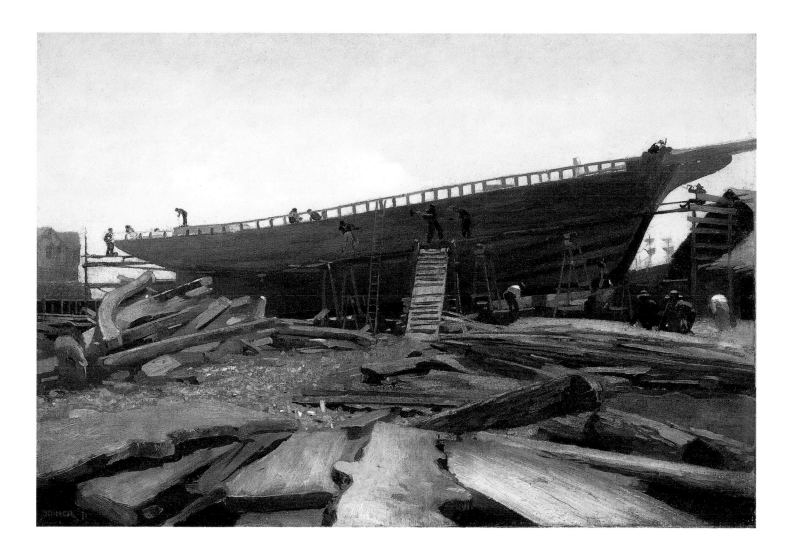

Below the scaffolding, to the right of the gangplank, a man in a stooped position is shaping the vessel's rudder with an adze. In the middle ground . . . another is sorting through a pile of oak timbers which will become the frames of other schooners. The foreground is occupied by heavy flitches of oak plank, their gnarled edges still covered with bark. The effect of perspective in these lumber piles creates strong visual guides which point insistently toward the schooner; however, there is no license in what Homer has done here.[12]

In 1873 Homer used *Shipyard at Gloucester* as the basis for an illustration for *Harper's Weekly* (fig. 21), incorporating studies of boys done subsequently in Gloucester and thus expanding upon the narrative. In the wood engraving, *Ship-Building, Gloucester Harbor,* Homer added an image of boys building boats. At first glance the juxtaposition seems casual, but it is obvious that the artist clearly intended to link the toy boats with the building of the schooner in the background. Homer's shipbuilding theme is made emphatic by pairing the boys' boat building with the men's. Here boys' play prefigures men's work, Homer's visual statement on the cycle of life in nineteenth-century Gloucester, which was inextricably bound to the sea.

PJ

Daniel Chester French

EXETER, NEW HAMPSHIRE 1850–1931 STOCKBRIDGE, MASSACHUSETTS

24. *The May Queen*, 1875

Marble; 16 × 14 × 7½ in. (40.7 × 35.6 × 19.1 cm); signed, dated, and inscribed on base: *D.C.FRENCH. / SCULP. / Florence, 1875*

Gift of Dr. and Mrs. Joel E. Goldthwait (Jessie Rand, class of 1890) (1915:8)

PROVENANCE: Joel Goldthwait (d. 1914), Boston, 1877–1914; to his widow, 1914–15; to her nephew, Dr. Joel E. Goldthwait (1866–1961), and his wife, Jessie Rand Goldthwait (d. 1932), Hyde Park, Mass., 1915.

EXHIBITIONS: Boston, Doll 1877; Northampton 1976 *American;* Northampton 1979, ckl. p. 47.

LITERATURE: Cresson 1947, p. 305 (as *Head of a Little Girl, Hayden Child?* 1876); Richman 1974, pp. 122–23 (no. 43), pl. 27; Mason 1974; Chetham et al. 1986, no. 121, repro.

CONSERVATION: The sculpture has only one minor repair to the dress in the front. The base has been broken several times and repaired. There is still one minor loss in the front and another larger loss in the back. The steel pin has been reset using polyester and coated to prevent rust.

BY 1874, when Daniel Chester French traveled to Florence for his first serious study, that city had already been eclipsed by Rome as the center for the training of American sculptors. His arrival preceded another important transition, as the Italian-inspired neoclassicism that characterized American sculpture at the time was soon to give way to a new aesthetic emanating from the Ecole des Beaux-Arts in Paris.[1] French, like other American sculptors, would embrace the modern style, and his work would come to epitomize its celebration of movement, delight in surface vitality, and preference for cast bronze, a technique that preserves the action of the modeler's hand.[2] *The May Queen,* however, produced during French's stay in Florence, exemplifies the neoclassical style of his early career, characterized by equipoise and restraint, flawless refinement, and the use of marble, carved largely by skilled artisans and not by the sculptor himself.

The attraction of Florence to French at this particular moment in time is understandable. The city had been home to the studios of Horatio Greenough (1805–1852, like French, a Bostonian) and Hiram Powers (1805–1873). Greenough, the founder of the American sculptors' colony in Florence, was the first American sculptor to seek the experience of Italy. Powers was the most famous American sculptor of the period, whose *Greek Slave* had brought unprecedented international attention to an American sculptor and success unsurpassed by any of his countrymen. In Florence, French joined the small community of American sculptors that remained there in the 1870s, including his fellow Bostonian Thomas Ball (1819–1911) and Hiram Powers's son Preston Powers (1843–1904).[3]

Joel Goldthwait was one of three Boston supporters who helped to finance French's stay in Italy in 1874–76. French had established himself as a budding local talent of considerable promise, having won the commission to create Concord's public monument *The Minute Man.* Goldthwait's assistance secured an Italian work produced by the young sculptor, as French noted in his diary on September 15, 1874: "Mr. Goldthwait thinks he will give me an order for $500.00 and Mr. Spaulding gave me a check for $250.00 for something for him. I am to make them in Florence and send them home."[4]

Not long after his arrival in Florence, French was at work on a clay model of the sculpture that would be presented to Goldthwait. "I have set up a bust of 'May Queen,'" he wrote his father, Henry Flagg French, on December 3, 1874, "and got it pretty well started."[5] Subsequently French accepted an invitation to share the studio of Thomas Ball, and he may have completed modeling *The May Queen* while working with the celebrated sculptor. *The May Queen* is reminiscent of Ball's earlier *La Petite Pensée* of 1873, a charming portrayal of a pensive child, suggesting, by Ball's title, a spring flower (a pansy). *La Petite Pensée* was one of Ball's most popular pieces, and French held it in regard as well, since he acquired a version for himself.[6] Long thought to represent a portrait of the daughter of an American tourist in Italy, *The May Queen* is, more to the point, a demonstration of French's mastery of neoclassical style, based on the emulation of antique marble sculpture, both Greek and Roman, that conformed to an ideal of human proportion, surface refinement, and morally uplifting content. The

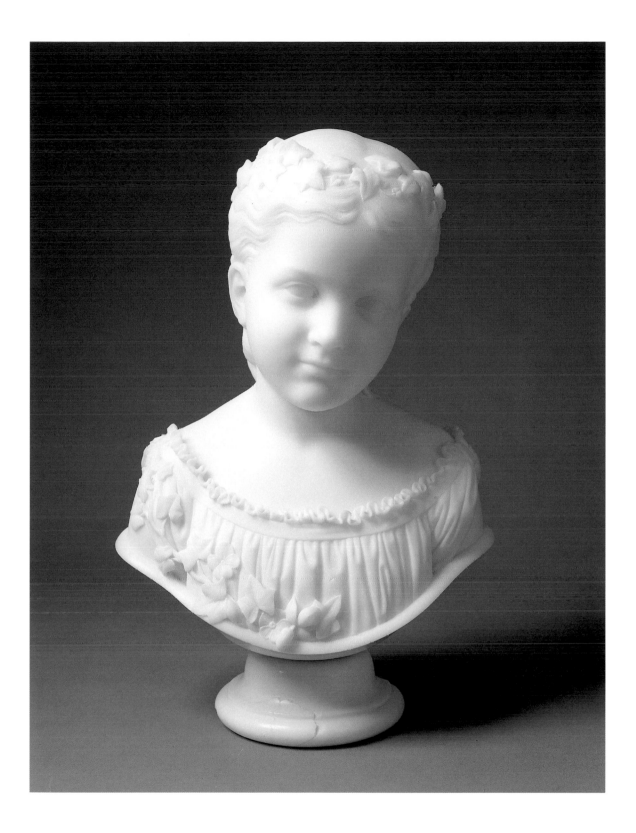

purest white Cararra marble was the only suitable material for expression of such physical and spiritual perfection.[7]

French in his *May Queen* and Ball in his *La Petite Pensée* were creating a kind of work for which there had long been a ready market among American buyers, especially those who had traveled to Italy on the Grand Tour and admired its antique marbles. These were "fancy pieces" or "conceits."[8] In contrast to the more ambitious and serious large-scale religious or classical subjects, available only to a very few patrons, these were more affordable works in small scale, often poetic, even playful designs, sometimes using children as subjects to convey a light-hearted theme. Powers had popularized the genre in his bust of *Proserpine*, the rustic goddess associated with fertility and, by extension, the coming of new life in the spring. Powers's studio made replicas of *Proserpine* for enthusiastic American buyers through the end of his life.[9] In *The May Queen* French infused Powers's familiar classical model with the seeming naturalism and charm of a living child.

Whatever his source for the child's head—and French had had by this time considerable experience modeling portrait busts—he conceived of the piece as a timeless symbol of youth and purity. The sweet child is the personification of spring; garlands of hawthorn branches, associated with May Day ritual from the Middle Ages onward, twine in her hair and across the bodice of her classical chiton. Feeling, perhaps, that he had pushed his allusions to antiquity too far in this sculpture, French wrote to a friend who had admired *The May Queen* in Doll and Richards Gallery in Boston in 1877: "I am very glad you were pleased with the head at Doll's (rather foolishly called 'The May Queen') and thank you for saying so."[10]

Production of marble statuary in such large volume in these studios in Florence was made possible by the abundance and affordability of skilled Italian stonecutters; French's *May Queen* was cut by Italian craftsmen working from his clay model. French typically made only minor changes or added surface refinements in the marble.

In subject, form, and medium, the bust of *The May Queen* thus represented well the young sculptor's Italian experience and must have seemed an especially appropriate reward for his patron's support. With the large-scale marble *The Awakening of Endymion* (1875–76, private collection), also produced in Florence, it is his most emphatic neoclassical statement.[11] *The May Queen* exemplifies the lingering taste in the third quarter of the nineteenth century for decorative parlor sculpture that was appropriately refined and morally uplifting. But it represents a mode of expression that French would soon abandon in favor of a modern style.

PJ

George Inness

NEWBURGH, NEW YORK 1825–1894 BRIDGE-OF-ALLAN, SCOTLAND

25. *Landscape,*[1] 1877

Oil on canvas; 25⅝ × 38½ in. (65.1 × 97.8 cm); signed and dated in black paint, lower right: *G. Inness 1877*

Bequest of Frank L. Harrington in honor of Louise Cronin Harrington, class of 1926 (1989:6)

PROVENANCE: Curtis R. Smith (c. 1897–1963),[2] New York and St. Albans, Vt.; on consignment to M. Knoedler and Company, New York, Sept. 1931 (consignment CA 302); returned to owner, Jan. 1933; Shore Studio Galleries, Boston; to Frank L. Harrington, Worcester, Mass., 1960.

EXHIBITIONS: Austin 1965–66, no. 25, repro.; New York, IBM 1990.

LITERATURE:[3] Ireland 1965, no. 829, repro.; *SCAQ* 1989, repro. cover and inside cover; Gustafson 1989, pp. 1022, 1042, repro.; Muehlig 1989, repro. cover, unpag.; *Gaz B-A* 1990, p. 59 (no. 292), repro.

CONSERVATION: The painting has been wax lined and remounted on its original keyed wooden stretcher. There is one small area of inpainting in the foliage in the center right. There is overall mechanical craquelure.

BORN NEAR Newburgh, New York, George Inness received little formal artistic training, first studying with the itinerant artist John Jesse Barker (active 1815–56) and later in New York with the French-born painter Régis François Gignoux (1816–1882). Although he belonged to the generation of Hudson River School artists, his work stands apart from the landscapes of Albert Bierstadt (cat. 20) and Frederic Edwin Church, who expressed the national ethos and ideals of Emersonian Transcendentalism in images of a vast wilderness. A painter instead of the "civilized landscape,"[4] Inness described a rural countryside rather than the panoramas of some of his contemporaries. Influenced by European landscape traditions and by his own artistic and religious convictions, Inness developed a body of work that culminated in the highly atmospheric, increasingly abstract landscapes of the last decade of his life.

The Museum's impressive *Landscape,* with its meadows, lone traveler, and distant hills under a serenely blue sky, was painted during a rich period of activity following Inness's third trip to Europe from 1870 to 1875. Most of that stay was spent in Italy; his previous trip abroad in 1851–52 allowed him to see the Old Master paintings that had influenced his early work through engravings and print sources. A year in Paris in 1853 introduced Inness to the artists of the Barbizon School, which would have an immediate impact on his work in a freer handling of paint, the use of brighter colors, and new emphasis on rectilinear composition. These influences are apparent in the Museum's painting, in the subtle tonality and color harmonies characteristic of Charles-François Daubigny (1817–1878) as well as in the implied sense of portent or meaning in the natural scene, a hallmark of the landscapes of Théodore Rousseau (1812–1867). Although its brightness of palette may also reflect the artist's knowledge of Impressionism, which Inness dismissed as a "mere passing fad,"[6] the Museum's canvas is ultimately more closely related to the poetic landscapes of the Barbizon painters than to the optical effects of their successors.

The inscribed date "1877" places the Museum's painting a year before Inness moved to Montclair, New Jersey,[7] where he would maintain a home, with trips to England, Florida, California, and Mexico, until his death in 1894 during a journey abroad. Before settling in New Jersey, the artist had returned in 1875 from an extended stay in Italy and France to the village of Medfield, Massachusetts. He was also active in New York City in 1876–77 and maintained a studio there. Although a number of land-scapes from 1877, the year the Museum's canvas was painted, have "Pompton" (New Jersey) in their titles, Inness scholar Michael Quick has pointed out that most of these subjects are lake or riverine landscapes, unlike the broad, sunny meadows depicted in *Landscape.*[8]

Inness would often revisit and rework certain motifs throughout his career; his place of residence at the time a canvas was painted may or may not have relevance to the subject, a fact borne out by the number of Italian landscapes produced several years after his return to the United States.[9] It is likely, as Michael Quick believes, that *Landscape* represents a synthetic, ideal composition like Inness's other works from 1877 that are "consciously composed" rather than depicting a particular site.[10] This

is supported by a comparison of *Landscape* with the work to which it is closely related, a more diffusely painted canvas titled *Leeds, New York* (fig. 22).[11] Both share the same essential features: a lone central tree paired with a solitary figure, repoussoir trees in the right foreground, and hills at the horizon, with the addition in the Museum's canvas of farmhouses nestled among the trees in the middle ground and background. Michael Quick has reassigned *Leeds, New York*, formerly dated 1864 by the artist's widow, to 1877.[12] He believes that this painting is a study from nature, which Inness used as a basis for the Museum's canvas, an aesthetically resolved studio painting in which landscape elements have been changed or adjusted to create a more harmonious composition. Whether the site of these two paintings can be identified as a specific location in New York or New Jersey is, however, ultimately less important to an understanding of *Landscape* than other considerations.

Nicolai Cikovsky, Jr., has written of the distinctly theoretical nature of the artist's landscapes during the 1870s and especially of his use of color, which was influenced not only by formal and artistic concerns but by spiritual beliefs.[13] Raised in a religious household, Inness was drawn as an adult to the philosophical tenets of the eighteenth-century Swedish visionary Emanuel Swedenborg, which became especially important in his later life and work.[14] Inness's first significant involvement with the Swedenborgian sect came during his stay in 1864–66 in Eagleswood, an intellectual community in Perth Amboy, New Jersey, where he joined the artist William Page (1811–1885), an adherent to the faith, in forming a fledgling art colony.[15] Attracted by Swedenborg's emphasis on "living religion in everyday life" and the "spiritual significance of the visible world,"[16] Inness also responded to his theories of correspondences between the material and the immaterial. The artist's inclusion of a traveler in the Museum's *Landscape*, pack on his back and stick in hand, may refer to another Swedenborgian concept of the journey of spiritual regeneration.

Inness had described the theme of spiritual journeys in relation to a painting belonging to his series of three allegorical works, *Triumph of the Cross* (1867), based on John Bunyan's *Pilgrim's Progress:*

> In this picture . . . I have endeavored to convey . . . an impression of the state into which the soul comes when it begins to advance toward a spiritual life, or toward

Figure 22. George Inness, Leeds, New York, *1877, oil on canvas, 12 × 18 in. (30.5 × 45.8 cm), private collection. Photograph courtesy of the George Inness Catalogue Raisonné.*

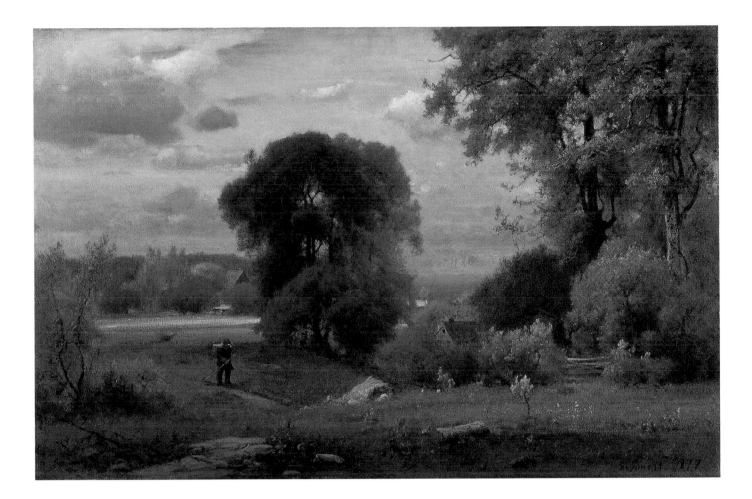

any more perfected state in its journey until it arrives to its sabbath or rest. Here
the pilgrim is leaving the natural light. . . . His light hereafter must be that of faith
alone.[17]

Without suggesting that the Museum's *Landscape* was intended as a pictorial religious
tract, it is still possible to see an implied narrative or meaning in the image of the trav-
eler, who may be engaged in a spiritual as well as earthly journey. As he walks on the
path from one light in the background of the painting toward the light of the fore-
ground, his literal progress through the landscape can also be seen as a symbolic
journey of faith. The central lone tree becomes a visual analogue for the traveler,
a relationship already made apparent in the earlier nature study *Leeds, New York*.
Although Inness used this kind of pairing as a compositional device in other paintings,
where an anonymous figure, shepherd, or farmworker might be seen in counterpoint
with a prominent tree, here the unusual use of a figure identified as a traveler may add
meaning to the scene beyond the formal concerns of composition. Like the traveler,
the tree occupies a place between two areas (and symbolically, two kinds) of light. As
a bridge between heaven and earth, the tree, rooted in the landscape, extends its crown
of branches and leaves above the horizon line and into the richly painted blues, pinks,
and lavenders of Inness's radiant, cloud-filled sky.

LM

William Morris Hunt

BRATTLEBORO, VERMONT 1824–1879 ISLES OF SHOALS, NEW HAMPSHIRE

26. *Niagara Falls*, 1878

Oil on canvas; 28 × 24 in. (71.1 × 61 cm); not signed, not dated

Purchased (1950:24)

PROVENANCE: Walter Parks, Boston; to Giovanni Castano, Boston.

EXHIBITIONS: Buffalo 1964, no. 35; Ann Arbor 1972, no. 97, pl. 45; College Park + 1976, no. 27, fig. 34; Boston, MFA 1979, no. 43, repro.; Northampton 1979, ckl. p. 42; Durham 1982, ckl., unpag.; Yonkers 1983–84, pp. 25, 107, fig. 15; Buffalo + 1985, no. 110, fig. 70; New York, IBM 1990.

LITERATURE: Knowlton 1899, pp. 122–23; Shannon 1923, pp. 133–34; *SCMA Bull* 1951, p. 34; Niagara Falls 1978, p. 54; McKinsey 1985, fig. 107; Chetham et al. 1986, no. 123, repro.; Webster 1991, pp. 140–50, fig. 128.

CONSERVATION: The painting is on a linen canvas (approximately 35 threads per inch vertically, 35 threads per inch horizontally). Circa the mid-1960s it was wax lined and mounted on a modern turnbuckle stretcher. The original resin varnish was replaced with Acryloid.

THE MOST celebrated artist and teacher in late-nineteenth-century Boston, William Morris Hunt achieved his preeminence as arbiter of taste by introducing contemporary French art to collectors and connoisseurs, first the painters of the Barbizon School and then the Impressionists. Hunt's own exposure to avant-garde French art had come during a twelve-year stay in Europe. In Rome in 1843 he studied sculpture with the American Henry Kirke Brown (1814–1886), and in 1845 he enrolled at the Düsseldorf Academy. After settling in Paris in 1846, he became one of the first American students of Thomas Couture (1815–1879). About 1853 he met Jean François Millet (1814–1875) and was inspired to work beside him in the village of Barbizon. Both Couture and Millet exerted a lasting influence on Hunt's style and choice of subjects: portraits, peasants, and landscapes. When he returned to New England in 1855, first to Newport, Rhode Island, and then to Boston, his interest in contemporary French art continued. His late works, such as *Niagara Falls*, exhibit a clear affinity with French Impressionism, which was just beginning to gain notoriety in Paris.

Hunt painted the Museum's canvas while he was on vacation in June 1878. Seeking only rest and relaxation, he had left his painting gear behind, but the beauty of the falls inspired him to send for it immediately. He painted no fewer than ten oils of various views and in the same month made sketches from nature in charcoal, pastel, and oil, which vary in format, scale, and point of view. Hunt favored the angle from below the American Falls, as seen in *American Falls Niagara* (Corcoran Gallery of Art, Washington, D.C.), *Niagara* (Museum of Fine Arts, Boston), and the Museum's painting, but he also depicted the scene from above, looking down on the Horseshoe Falls and across the rapids at Sister Island.

The spontaneity of the brushwork and relatively small scale of the Museum's *Niagara Falls* suggest that Hunt executed this canvas en plein air. Some of his preliminary studies and sketches were worked into larger oils (the Boston version and another painting owned by the Williams College Museum of Art, Williamstown, Mass., both approximately 62 by 100 in.), probably after he returned to Boston. When Hunt received word of a commission to paint murals for the Albany State House, his enthusiasm led him to propose Niagara Falls as the theme.[1] The two large views may have been executed as presentation pieces for the project, but authorities in charge of the commission preferred a traditional figurative subject.

Interest in Hunt's Niagara works grew after his untimely death by drowning in 1879. A student and early biographer refers to several of his Niagara subjects:

> Some of the smaller canvases had a strange fascination, and were among the best of the pictures painted at the Falls. One representing the opaline color of the mist was of surpassing beauty. The artist himself preferred a deep-toned picture of rocks and the Falls which he called the "brown Niagara." This painting was bought after his death, for ten thousand dollars, and presented to the Hon. John M. Forbes by [the Chicago, Burlington & Quincy Railroad].... Forbes had previously bought three of the smaller Niagaras to add to his valuable collection of Hunt's work.[2]

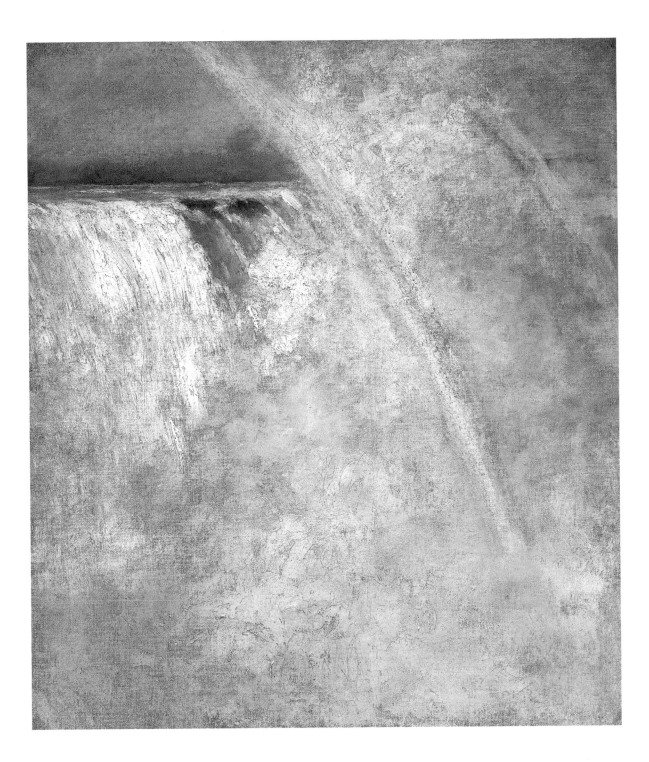

Hunt's estate held a major exhibition and sale of his works. The Studio Show (held at Hunt's Park Square studio, January 19–30, 1880), included 101 paintings and drawings from the estate, which were sold at public auction at Horticultural Hall, Boston, February 3–4, 1880. This sale included at least three Niagaras: one large *Niagara* (62 × 102 in.) and the American Falls and Horseshoe Falls (each 31 × 43 in.). Excitement and expectations of the show were so high that an offer of $25,000 for the large *Niagara* was refused.[3]

Niagara Falls had long been one of the most popular and perhaps the most often depicted scene in American landscape painting of the 1800s. Early in the century Americans looked to the grandeur of the American landscape to help define their national identity. Lacking the ancient history and traditions of Europe, Americans found their own legacy in the continent's natural wonders. Niagara Falls became a symbol of national consciousness.[4] The many artists who depicted Niagara in the earlier nineteenth century often depicted the falls with microscopic detail in a large-scale panoramic sweep emphasizing the immense power and grandeur of this natural spectacle, as in Frederic Edwin Church's *Niagara* (1857, Corcoran Gallery of Art, Washington, D.C.).

Later in the century, Hunt and others turned away from the epic depictions of the falls and instead painted the mists of Niagara as a study of color and light, in the manner of the French Impressionists.[5] The Museum's example exemplifies this approach. Here the artist has abandoned the panorama in favor of a narrower view, looking up at the water crashing over the falls, with the details of the surrounding landscape omitted from the composition. Hunt thus creates a scene in which the viewer seems ambiguously suspended in the mists of Niagara. This close-up view focuses on the asymmetrical pattern formed by the mist, the double rainbow, and the horizon line, emphasizing the abstract design of the composition. The rainbow here does not signify hope, as it might in a painting by Church, but merely illustrates the effect of light on mist, creating a subtle play of color across the hazy spume of the falls. Hunt portrays this celebrated American scene not as a symbol of national pride but as a purely aesthetic experience.

CLB

Samuel S. Carr

(?) ENGLAND 1837–1908 BROOKLYN, NEW YORK

27. *Beach Scene*, c. 1879

Oil on canvas; 12 × 20 in. (30.5 × 50.8 cm); signed in black paint, lower right: *S. S. CARR*

Bequest of Annie Swan Coburn (Mrs. Lewis Larned Coburn) (1934:3-10)

PROVENANCE: Annie Swan Coburn (Mrs. Lewis Larned Coburn), Chicago.

EXHIBITIONS: Hartford 1955; New York, Finch 1973–74, no. 12; Northampton 1976 *Carr*, no. 1, pp. 3–4, 6, repro. cover and p. 2; Brockton 1977, no. 121; Northampton 1979, ckl. p. 37; Southampton 1981, no. 9, repro.; Holyoke 1982–83; Brooklyn 1984, ckl. no. 7; Tampa 1989–90, p. 121, repro. p. 65.

LITERATURE: Parks 1960, fig. 67; Williams 1973, pp. 196–98, fig. 189; Washington, National Gallery 1981–82 *Ganz*, p. 121; Pisano 1985, p. 48, color repro. p. 53; Chetham et al. 1986, no. 124, repro.; Conrads 1990, pp. 24–26, fig. 4; Gerdts 1990, vol. 3, fig. 1.114; New York +, Metropolitan 1994, pp. 104–5, fig. 93.

CONSERVATION: The painting is on a prepared linen canvas (36 threads per inch vertically, 37 threads per inch horizontally) mounted on an original wooden keyed stretcher. It is in good condition, with a minor inpainted loss at the top center edge. It has a thin natural varnish coating.

SINCE SAMUEL S. CARR'S WORK was first exhibited at the Museum in 1976, additional facts of his life have been discovered.[1] Although his birthplace in England remains unknown, he is recorded as having studied drawing at the Royal School of Design in Chester. He was apprenticed to an engineer, possibly in 1852, and came to the United States in 1863.[2] In addition to the twenty-seven works included in the Smith College exhibition and the eight others named in its checklist, dozens of other paintings by Carr have come to light. They include a number of images with large figures and some animal pictures as well as variations on his best-known subjects: children at play, grazing sheep, and beach scenes. Of these, the last group remains his most intriguing.

Beach Scene, with its world of sunshine, blue skies, soft sands, and happily occupied excursionists, is typical of the artist's appealing seaside images. The complex placement of several groups, the numerous interesting activities depicted, and the jewel-like color accents make this one of his most successful paintings. Among the figures dressed in subdued Victorian costumes, the woman holding a parasol wears an emerald green dress and another holds up the hem of her Prussian-blue frock (a color Carr favored). The artist's skill at capturing the effects of full sunlight is apparent. Each figure and form is clearly sculpted by light and shadow. The shallow, foot-shaped depressions in the yielding sand are carefully observed and suggested. A warm ground layer visible underneath the blue sky softens its appearance and prevents the expanse from appearing opaque. On the horizon the smallest of details, steam and sailing vessels, are noted.

Yet for all his technical abilities and remarkable powers of observation, the most distinctive feature of Carr's work appears inadvertent. His characters are placed on the same expanse of beach without much apparent knowledge of, or relationship to, each other. Each vignette in the larger composition is complete unto itself, frozen in time, lending this and other beach scenes a much-commented-upon unintentionally surreal effect.

The small groups of figures clearly have been conceived independently; indeed, Carr often uses them interchangeably from one painting to another.[3] The Museum's *Beach Scene* is a particularly good example of this practice since several closely related works are known. *Beach Scene with Punch and Judy Show* (n.d., Thyssen-Bornemisza Collection),[4] in addition to sharing the general motif of the crowd gathered before a puppet stand, has in the foreground a similar crouching young girl dressed in a light bonnet and dress. The child with blue dress and braided hair who kneels opposite this figure in the Museum's picture can be found, reversed, in *Children Playing on the Beach* (1879, Sterling and Francine Clark Art Institute, Williamstown, Mass.). Another work, *The Beach at Coney Island* (c. 1879, Jo Ann and Julian Ganz Collection in 1980), contains a host of figures in common with the Smith painting and may have preceded it, although it appears too finished to be called a study for it. Smaller (6¼ × 10⅛ in.), it features the same central group of black-clad matriarch, toddler in white dress, standing woman in brown, seated girl (posed the same though dressed differently), top-hatted observer bearing an umbrella, and, most strikingly, a photographer in dark hat and shirtsleeves.

93

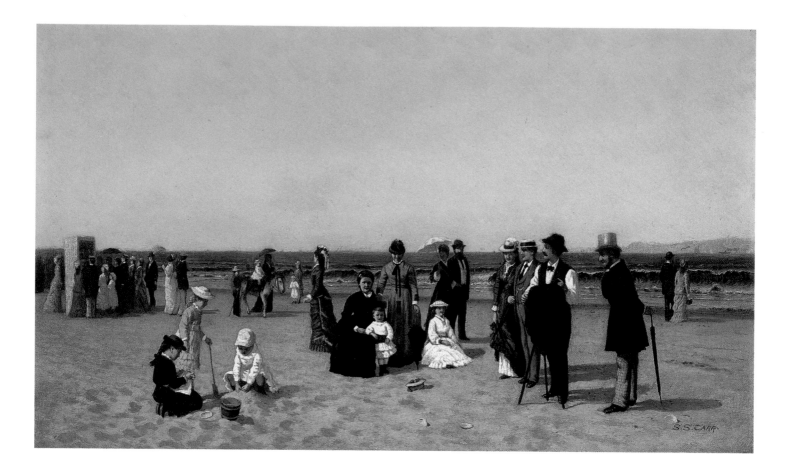

Not common in nineteenth-century genre painting, the photographer at work is a striking choice of subject. Because Carr recorded the events at the beach in a nearly encyclopedic way and because tintype makers are known to have worked at Coney Island, the activity would have been natural. The posed quality of Carr's figures and the portraitlike features of some of them, however, have caused speculation that he himself may have worked from photographs. This may well be the case; a descendant of Albert Babb Insley (1842–1937), from whom Carr took a class at the Brooklyn Art Association called "Landscape—Photographic,"[5] wrote that "Insley was also an amateur photographer" and that Carr "evidently bought a number of photographs from him.[6] None of these photographic figure studies has been found.

Whatever his methods, Carr's unusual beach scenes document in detail some of America's best-loved leisure activities at one of its most popular sites. The earliest of these scenes appear to date from 1879. In that year he exhibited (besides the dated Clark painting) a work titled *Sport on the Beach* at the Brooklyn Art Association and another called *Manhattan Beach, L.I.* shown in the Seventh Annual Utica Arts Association exhibition in 1879 (no. 193);[7] he continued to exhibit numerous works with Coney Island or beach-related titles from 1880 to 1882.

Other American artists, for instance, Winslow Homer (cat. 23), depicted figures on the beach, but none seems to have been so devoted to the subject as Carr. Carr's exact contemporary Alfred Thompson Bricher (1837–1908) often included vacationers in his views of Narragansett Bay, but they are generally subservient to the natural drama of the rocks and surf. Carr's distinctive seaside pictures are like busy stage sets, with their human participants happily and confidently amusing themselves amid bright and beautiful but modest natural settings.

DC

James McNeill Whistler
LOWELL, MASSACHUSETTS 1834–1903 LONDON

28. *Mrs. Lewis Jarvis (Ada Maud Vesey-Dawson Jarvis)*, 1879

Oil on canvas; 25 × 16 in. (63.5 × 40.7 cm); not signed, not dated

Purchased, Winthrop Hillyer Fund (1908:2-1)

PROVENANCE: Lewis Page Jarvis (1845–1900) and Ada Maud Vesey-Dawson Jarvis (d. 1919), Blunham and Sharnbrook, Bedfordshire, England, until Jan. 1907; sold by Mrs. Jarvis for £500 to Messrs. Tooth, London, Jan. 1907; sold for £750 to Thomas Agnew and Sons, London, Jan. 1907; sold to M. Knoedler and Company, New York, Jan. 1907–Apr. 1908.

EXHIBITIONS: London 1905, no. 65 (West Room, as *Portrait of Mrs. Louis Jarvis*, lent by Mrs. A. M. Jarvis); Rochester 1913, no. 134, repro. p. 50; Boston, MFA 1934, no. 13; Pittsfield 1934; New London 1949, no. 1; Columbus 1950, no. 39; Williamstown 1950; Brooklyn 1957–58, no. 59; Northampton 1962, no. 17; Chicago 1964; Chicago + 1968, no. 29, repro. p. 76; Washington +, National Gallery 1970, no. 58, repro.; Northampton 1974 *Seelye*; Northampton 1976 *American*; Ann Arbor 1978, unno. cat.; Northampton 1979, ckl. p. 6; Rochester 1988, no. 95, repro.; New York, IBM 1990; Madrid + 1998, no. 10, repro.

LITERATURE:[1] Way and Dennis 1903, p. 50; Cary 1907, p. 218 (no. 416); Sickert 1908, p. 173 (no. 170); Way 1912, p. 115; Pousette-Dart 1924, repro., unpag.; *Springfield Union* 1928, repro.; *SCMA Handb* 1925, p. 33, repro. frontispiece; Jewell 1934, p. 6x; *SCMA Cat* 1937, p. 12, repro. p. 67; Lane 1942, repro. p. 95; Barry 1968, color repro. p. 34; Houfe 1973, pp. 282–85, repro.; Young et al. 1980, vol. 1, pp. 119–20 (no. 206), vol. 2, pl. 138; Chetham et al. 1986, no. 125, repro.

CONSERVATION: The canvas is glue lined to a canvas-backed cardboard support adhered to a stretcher. There are small inpainted losses overall.

THE MUSEUM'S PORTRAIT, completed in late summer 1879, was painted during a pivotal year for James McNeill Whistler. Bankruptcy forced him that September to leave London, the center of his world for two decades. It also forced him to redirect his art. In this year he moved away from the portraiture that had dominated his art in the 1870s and that reflected his associations with London society. In Venice, where he would live for fourteen months, he moved toward the exploration of light and atmosphere in a series of city views: etchings, pastels, and watercolors of an unprecedented simplicity, delicacy, and intimacy of scale. Although he would return to London following his stay in Venice, he would never again look upon his adopted city with the fascination that it had held for him from the time he first settled there as an American expatriate in 1859.

Whistler's financial problems hit him late in 1878 and generated a great deal of publicity. That November, his famous libel suit against the critic John Ruskin was settled. The painter won a moral victory in the dispute when the court asserted that Ruskin's denigration of Whistler's daring, nearly abstract *Nocturne: Black and Gold—The Falling Rocket* (1875, Detroit Institute of Arts) was, indeed, libelous; however, he was awarded only a farthing in damages and was unable to cover court costs. Moreover, Whistler's very public break at this same time with patron Frederick Leyland over the redesign of Leyland's dining room—the famous Peacock Room for which the painter received significantly less in payment than he demanded—served to drive other patrons away. Finally, the building of his new home in Tite Street—the White House—drove the artist deeper into debt. Insolvent, Whistler was forced in May 1879 to sell the White House for the benefit of creditors, Leyland among them.

Friends lent financial help to the struggling artist when they could. In the summer of 1879, two friends who stepped forward to offer assistance were Lewis Jarvis and his wife, Ada Maud Vesey-Dawson (?–1919). Jarvis, the son of a Bedfordshire brewer, was a country gentleman, amateur artist, collector, and aesthete. Exactly how he and Whistler met is unknown, but by 1879 their friendship was such that Whistler could ask Jarvis for a loan of fifty pounds, a sum the spendthrift Jarvis could ill afford, but which he nevertheless offered graciously, never expecting to see it repaid.[2] In return for Jarvis's generosity, Whistler agreed to paint Ada, and he also presented his friend with a proof of what may have been the etching *The Pool* from the artist's "Thames Set." Whistler offered his services as well in the decoration of the Jarvises' new home, the Toft, a seventeenth-century stone house at Sharnbrook, where the couple and their growing family had recently settled.[3] A few months later, at the bankruptcy sale of Whistler's personal effects held at Sotheby's on February 12, 1880, Lewis Jarvis bought for the sizable sum of thirty pounds the artist's large, so-called Japanese bath or tub, perhaps intending to return it to his friend.[4]

Whistler's offer to paint Mrs. Jarvis in 1879 speaks of a friendship, but also suggests his keen interest in portraiture at this time. In the decade of the 1870s Whistler produced many memorable portraits, three of which now stand as signature works for the artist: his famous *Arrangement in Grey and Black: Portrait of the Painter's Mother* (1871, Musée

d'Orsay, Paris), *Arrangement in Grey and Black, No. 2: Portrait of Thomas Carlyle* (1872–73, Glasgow Museum and Art Gallery, Scotland), and *Harmony in Grey and Green: Miss Cicely Alexander* (1872–74, Tate Gallery, London). Whistler created bold aesthetic statements in these portraits, which are conceived as color patterns; while they function as poetic evocations of a personality, they are first and foremost audacious expressions of artistic vision. Throughout the decade, he enjoyed the challenge of portraiture, even if his portraits failed to attract commissions.

Mrs. Jarvis traveled to London and sat for Whistler in his studio on Saturday, August 16, 1879, just weeks before the artist was to depart for Venice.[5] The large, full-length portraits that dominated Whistler's work at this time required multiple sittings for their subjects; for example, Miss Cicely Alexander, who first sat for her portrait at the age of six, would endure more than seventy meetings over two years before Whistler completed her likeness.[6] But Mrs. Jarvis's portrait was completed in relatively short time, by September 6, when Whistler wrote to the sitter:

> Dear Mrs. Jarvis,
> You must be very much astonished at my strange silence after your most kind note—but I trust you will forgive me when I tell you that I have been overwhelmed with preparations for going abroad—and my mother has been quite ill so that I ran down to see her for a couple of days. However I had a frame made for your picture—and it goes down to you on Monday—together with the proof Mr. Jarvis chose of "the Pool"—which they had packed in the same box. The little head ought to have been far away more charming—but I did my best at the time which I am afraid was very poor.[7]

Whistler was hardly at ease when he chose to paint Mrs. Jarvis, and clearly he felt that his many distractions worked against his art at this time. Indeed, Mrs. Jarvis's portrait had been undertaken under very difficult circumstances. Whistler was packing for Venice as he worked on the painting. The constraints of time and money must have been significant factors in his decision to present his subject simply, directly, in a small half-length study, and he was not happy with the result. To this time Whistler had rarely employed the half-length format, preferring full-length, often life-size studies as "the only real way to treat a portrait so as to give a complete impression of the sitter," he reportedly told his friend T. R. Way.[8] The head study offered limited possibilities for aesthetic arrangement of the colors and compositional elements, and Whistler may well have found it in this case an insufficient format for the design possibilities presented by Mrs. Jarvis's red hair. He may also have considered it an inadequate vehicle for conveying the young Mrs. Jarvis's grace, elegance, and Irish charm.

Ada Jarvis surely had strong appeal to Whistler as a portrait subject. Her stunning red hair afforded a strong, central color note in any depiction of her. Moreover, she may well have evoked memories of Whistler's beautiful, auburn-haired Irish mistress, Joanna Heffernan, the subject of his audacious *Symphony in White No. 1: The White Girl* (1862, National Gallery of Art, Washington, D.C.).

Despite his own dissatisfaction with the picture, Whistler's portrait of Mrs. Jarvis is nonetheless a beautifully spare depiction of a woman's uncommon beauty. As painted by Whistler, she is a study of rich tonal complements: a striking all-over pattern of green-gray tones enlivened by the single muted red element of her hair. In a manner typical of Whistler's work in this period, the portrait is painted in thin layers of trans-

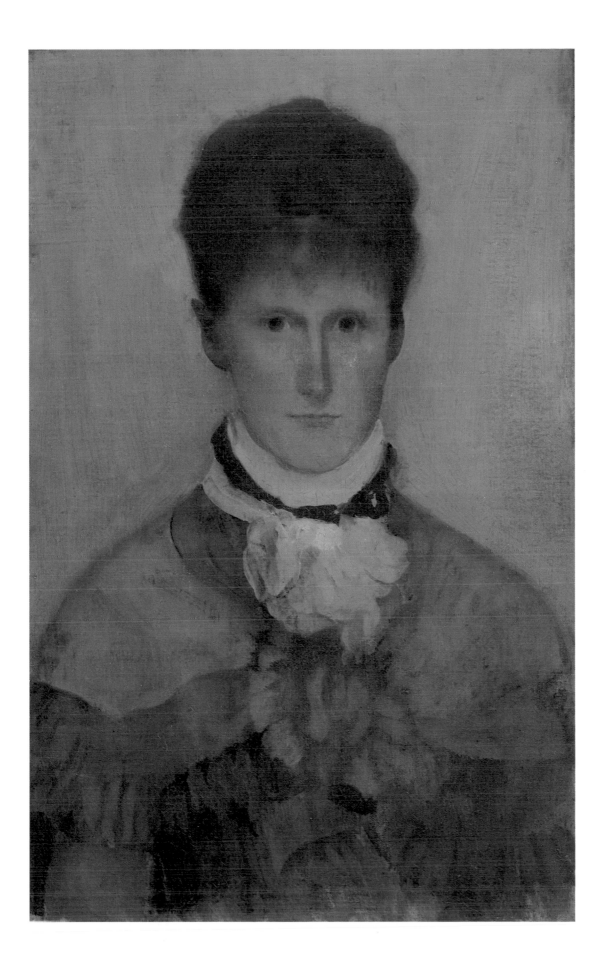

lucent paint, a technique that emphasizes the purity of hue and by extension under-scores the portrait as an artistic conceit—as a pure and pleasing color arrangement rather than a physical presence. Although she looks directly out at the viewer, Mrs. Jarvis is elusive, even ethereal.

In reality, Ada Jarvis was a woman of remarkable physical and emotional strength. She bore eleven children and managed the large country home that she and her husband enjoyed only through the generosity of her wealthy relations, as Lewis Jarvis's money was insufficient to support his family and his taste for contemporary paintings, Italian ceramics, and Chinese and Japanese porcelains. When her husband died from pleurisy in June 1900, Mrs. Jarvis was left with young children to raise on her own, and having little means to support her family, she was eventually forced to sell the Whistler portrait. She lost five of her seven sons in the First World War and suffered the tragic, violent death of another son shortly after at the hands of Bedouin mobs in Egypt. Her only surviving son, John E. Jarvis, recalled her in this way:

> I venture to say that had my mother been an American mother she would have been known widely in the States as a woman who gave everything for her country and I will now endeavor to give you briefly her tragic history. . . .

> My father died when I was quite young I being the tenth in the family there being seven sons and four daughters and my mother was left with the responsibility of educating and training this large family and I believe her example as a mother had the effect of training us in the love of one's country and the responsibilities that the average citizen should accept as such.

> During the last war my mother said to me that wherever they were all her sons would serve and this exactly did happen. . . .

> . . . The final blow to a succession of tragedies in the last of her sons came in March 1919 when my brother, Major Cecil Jarvis, D.S.O.-M.C. of the XX Deccon [sic] Horse Indian Army was, after going all through the war, murdered in Egypt by Bedouin mobs when they attacked the train in which he was traveling on his way home to my mother.

> The shock of this was the final blow that killed my mother who never had as far as I know any serious illness during her lifetime.

> She never complained to anyone, never discussed her grief with anyone outside the family and she was one of the most courageous people I have ever met.[9]

PJ

John Singer Sargent

FLORENCE, ITALY 1856–1925 LONDON

29. *My Dining Room*, c. 1883–86

Oil on canvas; 29 × 23¾ in. (73.7 × 60.3 cm); not signed, not dated

Purchased with funds given by Mrs. Henry T. Curtiss (Mina Kirstein, class of 1918) in memory of William Allan Neilson (1968:10)

PROVENANCE: Wilfred G. de Glehn, London, by 1925; with Mrs. de Glehn until 1955; to A. Richards, London; sold, Sotheby and Company, London, Dec. 13, 1961, lot 127; Ewan Phillips, London, by 1962; to Hirschl and Adler Galleries, New York, 1963.

EXHIBITIONS: London 1925; Liverpool 1925, no. 138; London 1926, no. 333; Northampton 1968 *Sargent;* Washington +, National Gallery 1970, no. 52, repro.; New York, NYU 1980, addenda, unpag.; New York, Coe 1986, p. 88, pl. XII; New York, IBM 1990.

LITERATURE:[1] Manson 1925, repro. p. 83 (as *The Lunch Table*); Downes 1926, p. 357; Charteris 1927, pp. 115, 287; Mount 1955, p. 446 (no. K8710); Mount 1957, p. 356 (no. K8710); *Gaz B-A* 1969, p. 81 (no. 328), repro.; Northampton 1979, ckl. p. 44; New York, Coe 1980, unpag. (geographical ckl.); Ratcliff 1982, fig. 167; Chetham et al. 1986, no. 127, repro.; Reynolds 1990, p. 686, pl. XI; Jennings 1991, p. 7.

CONSERVATION: The painting is glue lined to a pre-primed canvas and is mounted on a keyed wooden stretcher. There is minor inpainting in the cracking in the center of the painting. A small section of the upper right corner is missing.

JOHN SINGER SARGENT was an artist of prodigious and varied talents. Ultimately known as the most accomplished portraitist of his generation, he also produced landscape and figure subjects, watercolors, and drawings of extraordinary vigor and beauty. Born in Italy of American parents, he was raised and educated in Europe. After some limited studies with artists in Rome and Florence, he entered the studio of the important French portrait painter Emile Carolus-Duran (c. 1837–1917) at the age of only eighteen and later matriculated at the Ecole des Beaux-Arts. By the late 1870s he was building a professional reputation, and his work was being accepted at the Salon. He traveled at this time to Capri, Nice, Haarlem, and Madrid, among other places.

In the 1880s in England Sargent exhibited several commissioned portraits. The enthusiastic response to his sophisticated likenesses extended to America, where he executed portraits of some of the most prominent members of Boston, Newport, and New York society. Asked in 1893 to create murals for the Boston Public Library, he welcomed the diversion from portraiture and savored the intellectual challenge of depicting the history of religion. Late in his career he continued to work as a portraitist, although less extensively, and to travel throughout Europe, finding unlimited subjects for his watercolors. Toward the end of his life Sargent executed murals for the rotunda of the Museum of Fine Arts, Boston.

Although best known for his brilliant full-length portraits, Sargent has received increasing recognition for his less public creations.[2] One of the most successful of these is *My Dining Room*, depicting an interior in the artist's Paris home and studio at 41 boulevard Berthier. It was painted around 1883 to 1886, during a decade in which Sargent executed a number of splendid scenes of figures, particularly in shadowy alleys and palazzi of Venice, and concerned himself generally with the effects of light penetrating cool, dark spaces.

In this same decade Sargent painted at least three other dining rooms. One, *The Breakfast Table* (c. 1883–84, Fogg Art Museum, Cambridge, Mass.), shows the artist's sister Violet peeling an orange while engrossed in a book, probably at the family's home in Nice. She sits at a table covered with a crisp white cloth and decorated with a vase of pink and white roses. The brilliantly reflected surfaces of the silver coffee service and glass vases are expertly suggested. While daylight illuminates the table in the foreground, an open door behind the sitter is unreadable blackness. An unusual and totally different light dominates *A Dinner Table at Night (Mr. and Mrs. Albert Vickers)* (1884, Fine Arts Museums of San Francisco). Again the silver and glass objects on the white-covered table are prominently featured, but the room surrounding the figures glows dramatically red in the lamplight and fairly overpowers its inhabitants. Painted just a few years later, *Fête Familiale (The Birthday Party)* (1887, Minneapolis Institute of Arts) similarly features individuals enveloped in a rosy environment. Inanimate objects like the overhead lamp or the glass pitcher on the table are given emphasis nearly equal to that of the room's inhabitants.

Sargent clearly was astutely observant of the details of such rooms as well as their overall qualities of light and space. *My Dining Room* gives a vague sense that Sargent lived comfortably in his Paris home but provides no easily readable clues to his specific possessions.[3] Many nineteenth-century painters, both European and American, advertised their artistic life in painting their studios. Among the objects they depicted were references to past or foreign art and artists that revealed their owner's eclectic tastes. Despite his peripatetic existence, Sargent declines the opportunity to use the contents of his home as evidence of his remarkable cosmopolitan life. Instead, he depicts a room associated with the ordinary actions of eating and drinking; napkins left on the table are mere white blurs, rumpled and not yet cleared away. There are pictures on the wall and dishes on the shelf, but they simply impart the suggestion of a tasteful, reasonably well-ordered life.

There is a compelling sense of immediacy, of the moment, to *My Dining Room* that would have been lost in a more calculated picture. The artist's friend Edmund Gosse, who observed Sargent choosing some outdoor subjects in a seemingly haphazard fashion, learned from him that his

> object was to acquire the habit of reproducing precisely whatever met his vision without the slightest previous "arrangement" of detail, the painter's business being, not to pick and choose, but to render the effect before him, whatever it may be. . . . One of Sargent's theories at this time [1885] was that modern painters made a mistake in showing that they know too much about the substance they paint. . . . Sargent, on the other hand, thought that the artist ought to know nothing whatever about the nature of the object before him, but should concentrate all his powers on a representation of its appearance. The picture was to be a consistent vision, a reproduction of the area filed by the eye. Hence, in a very curious way, the aspect of a substance became much more real to him than the substance itself.[4]

In *My Dining Room* Sargent's legendary facility with a brush succeeded in capturing "the aspect of a substance." Dashed off with the quickest, almost calligraphic strokes, the parts of the dining chair are barely suggested, and the objects on the table are blurred beyond recognition. The curves and draping of the white tablecloth seen in meager light are skillfully formed of a few strokes of gray and taupe. The pale gold edge of the ceiling lamp is just glimpsed at the top of the canvas. The only evidence of deliberateness is the contour of the floor, which is reinforced over the edge of the tablecloth at lower left. And yet it is impossible not to feel that the execution of this painting was something more than a technical exercise for the artist. Observing his dashing brushwork, we can easily imagine Sargent's hand at work. Although this intimate image of a quiet interior was undoubtedly taken quickly from life, it conveys a sense of ageless recollection.

DC

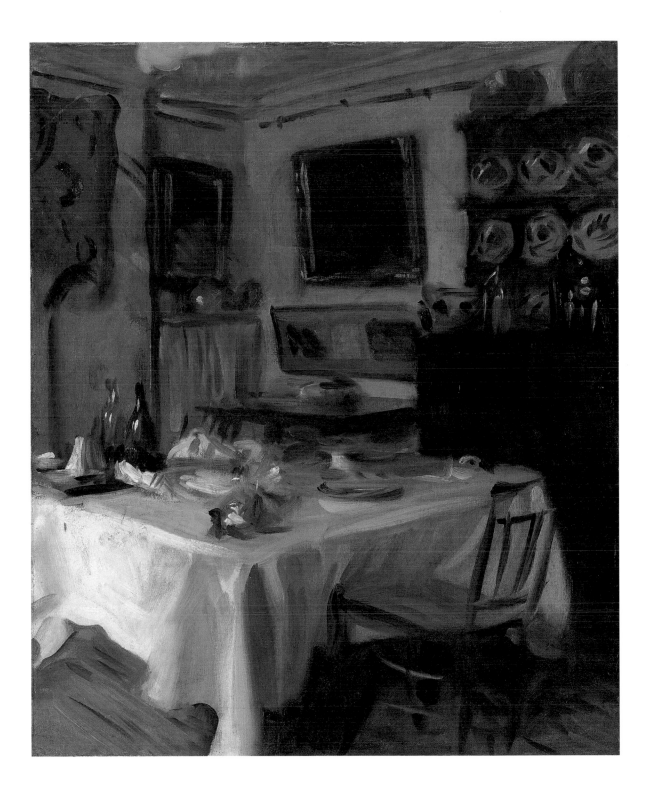

Ralph Albert Blakelock

NEW YORK 1847–1919 ELIZABETHTOWN, NEW YORK

30. *Outlet of a Mountain Lake,*[1] c. 1887

Oil on canvas; 16⅝ × 23¹⁵⁄₁₆ in. (42.2 × 60.8 cm), signed in red paint, lower right (within arrowhead pointing left): *R. A. Blakelock*

Purchased, Winthrop Hillyer Fund (1914:1)

PROVENANCE: George A. Hearn, New York; to Mrs. C. B. Smith, New York; to William Macbeth, New York.

EXHIBITIONS: New York +, CAA 1930–31; Hartford 1935, no. 12; Minneapolis 1939; Pittsburgh 1939, no. 8, repro.; New York, Whitney 1947 *Blakelock*, no. 18; Peoria 1965, repro. p. 20; South Hadley 1965; Santa Barbara + 1969, no. 72; Washington +, National Gallery 1970, no. 3, repro.; Lincoln 1975, no. 30, p. 12.

LITERATURE: Jewell 1934, p. 6x, repro.; *SCMA Handb* 1925, p. 11, repro. p. 10; *SCMA Cat* 1937, p. 2, repro. p. 45; Chetham et al. 1986, no. 126, repro.

CONSERVATION: The painting is on an artist's board mounted on a wooden (keyless) stretcher. There is a heavy traction crackle overall due to the use of asphaltum or some other nondrying oil. There are small areas that fluoresce under ultraviolet light, which may be areas of inpainting but may also be lower strata of paint showing through the traction crackle of the upper layers. The painting has a heavy varnish coating.

IN *Outlet of a Mountain Lake* Blakelock created a meditative scene, conveying a sense of peace that must have been rare in his troubled life. Blakelock was a self-taught artist; he briefly studied for two years at the Free Academy of the City of New York (now City College) in the mid-1860s. His family had hoped that he would pursue a medical career, like his father, but he left school to devote himself to painting, exhibiting his first landscape at the National Academy of Design in 1867. He traveled to Wyoming, Utah, California, and Mexico before marrying in 1877 and settling in New York, where he and his wife raised nine children. The financial pressure of trying to support such a large family on a painter's income may have contributed to his mental breakdown in 1891. He was committed to the State Hospital for the Insane in Middletown, New York, in 1899, where he stayed, except for brief periods, until 1916. He died in 1919 on a visit to the Catskills.

Blakelock's vision was so personal and eccentric that his works rarely sold early in his career. His dark, mysterious, generalized landscapes had little appeal for a public used to the topographical accuracy and minute descriptive detail of the Hudson River School or the charming subjects and pastel colors of Impressionism. Until the 1890s Blakelock sold his works for small sums that barely provided for his family. After his breakdown in 1891, a new interest in painting that conveyed subjective emotional states emerged, and enthusiasm for his work grew, too late to help his family. Certainly the image of the demented artist must have attracted attention. George A. Hearn, a prominent patron of the arts and the first owner of *Outlet of a Mountain Lake*, became an ardent supporter and collector of Blakelock's work.

While Blakelock was hospitalized, Hearn lent one of the artist's landscapes in 1900 to the Paris Exposition Universelle, where it won an honorable mention.[2] Hearn also supported an exhibition of the same year mounted to help provide for the artist's destitute family after his hospitalization.[3]

Blakelock probably painted *Outlet of a Mountain Lake* just before his commitment, but dating Blakelock's paintings remains problematic because of the great number of works, the rarity of dated canvases, and the uniformity of style. Although the quality of his work was uneven, perhaps attributable to his need to dash off works for sale at low prices to keep his family fed, *Outlet of a Mountain Lake* exemplifies the sophistication of his mature style. Dark trees silhouetted against a brilliant sunset evoke a mood characteristic of the best of Blakelock's work. He applied the paint with a thick impasto, which gives the surface a tactile, sumptuous quality. Limiting the palette to the warm, glowing colors of dusk transcends mere description and evokes the spiritual.

Like his contemporary Albert Pinkham Ryder (cat. 34), Blakelock experimented with a variety of techniques, including the use of bitumen, an asphalt, which he used to achieve a rich black. It never entirely dries and in significant amounts can settle, causing puddles of black paint on the lower portions of a canvas.[4] The sagging ridges of bituminous paint in the foreground and trees of *Outlet of a Mountain Lake* show the effects of this technique. Blakelock's interest in the painting as an object, rather than just a landscape view, and in the act of applying paint spurred him to create new tech-

niques to serve his expressive purposes. He enriched the surface of this painting with a variety of methods, from repeated glazing to abrasion; he applied the dark tones thinly, built up surface texture with lighter colors, and then scraped or rubbed to allow the dark tones to show through, creating the appearance of depth in the paint texture. The result is that chance plays a part in determining form.

A critic wrote in 1916 of Blakelock's expressionist tendencies:

> Blakelock was by nature a dreamer with a desire to record his dream. To call him a landscape painter is incorrect. No artist has used the landscape as a means to an end more than he. The landscape merely provided forms with which he expressed his moods, inspirations, and eccentricities.[5]

Along with artists like Ryder and George Inness (cat. 25), Blakelock moved away from the accurate depiction of the natural landscape common in previous American art to a new subjective vision. The natural world was seen as a vehicle for artistic expression. This, together with Blakelock's emphasis on the painting as an object rather than a window on the world, places the artist and his work on the verge of modernism.

CLB

Dwight William Tryon

HARTFORD, CONNECTICUT 1849—1925 SOUTH DARTMOUTH, MASSACHUSETTS

31. *The First Leaves*, 1889

Oil on wood panel; 32 × 40 in. (81.3 × 101.6 cm); signed in blue-green paint, lower right: *D. W. TRYON*

Purchased from the artist (1889:6-1)

PROVENANCE: The artist.

EXHIBITIONS: Chicago 1889, no. 418; New York, Fifth Avenue 1899, no. 145; Buffalo 1914; Canberra + 1998, no. 98, repro.; Northampton 1999.

LITERATURE:[1] Hartmann 1902, vol. 1, p. 128; Finley 1909, vol. 12, p. 200; Caffin 1909, p. 60; Buffalo *Acad. Notes* 1914, pp. 83, 87, repro. pp. 85, 113; *Biographical* 1915, p. 240; Churchill 1924, unpag.; White 1930, p. 150; *SCMA Cat* 1937, p. 10; Merrill 1990, pp. 49–51, 93 n. 116, fig. 44.

CONSERVATION: The painting is on a plywood panel with a diagonal cradling system designed by the artist. There are inpainted losses along the edges, but otherwise it is in excellent condition. It was cleaned in 1998 and a heavy synthetic varnish was removed from the surface.

Figure 23. Dwight W. Tryon, Twilight at Auvers, 1878, oil on canvas, 20¼ × 29¾ in. (51.4 × 75.6 cm). Collection of The Montclair Art Museum, Montclair, N.J., Gift of William T. Evans (15.43).

THE FIRST LEAVES marks Dwight W. Tryon's discovery of the theme that was to define his art: a range of tall, still, sparsely foliated trees standing at the edge of a meadow, softened by crepuscular light. "Before a Tryon," wrote the critic Sadakichi Hartmann in 1902, "one simply feels as if looking at nature herself. Its vague harmonies drift quickly and irresistibly into one's soul."[2]

Tryon had hardly ventured beyond the outskirts of his birthplace when he went to France in 1876 to pursue an education in art. In Paris he received formal training under the supervision of Jacquesson de la Chevreuse (1839–1903), a former pupil of J.-A.-D. Ingres (1780–1867), but he soon tired of the academic discipline and longed for escape to the countryside. For inspiration he turned to the art of the Barbizon School, which he considered "unquestionably the most important epoch in the history of landscape-painting which the world has yet known."[3] The only exponent of the first-generation Barbizon painters still alive in 1876 was Charles-François Daubigny, with whom Tryon studied briefly, painting the countryside near Auvers (fig. 23).

On his return to the United States in 1881, Tryon settled in New York, intending to practice his art and teach the lessons he had learned abroad. He became acquainted with several other artists recently returned from Europe. Many were members of the Society of American Artists, founded in 1877 as an alternative to the National Academy of Design, the official New York exhibition venue. Tryon himself became a member in 1882, but even with sympathetic friends and professional associations in the city, he was eager to find a country home and a landscape to portray. From the Barbizon painters he had acquired the conviction that any scene's natural beauty would be disclosed only to the constant observer. "The trouble with most artists," Tryon reflected, "is that they do not live long enough with any location to become a part and parcel of it—A painter ought to be like an enraptured swain—who sees more in his girl than is visible to any one else."[4]

Tryon finally found a landscape to love all his life at South Dartmouth, Massachusetts, a fishing village near New Bedford. He and his wife, Alice, built a cottage on the harbor where they lived six months of every year until 1925. Arriving each spring in time to glimpse the structure of the trees through the budding branches, Tryon always delayed his departure in the autumn until the leaves had fallen, wanting to observe once again the "wonderful anatomy of the trees."[5] Like James McNeill Whistler (cat. 28), whose works he admired, Tryon found inspiration for many paintings in the early hours of the day or evening, when the contours and colors of the landscape were subdued by silvery shadows.

The First Leaves was conceived one morning in early May 1889, when Tryon was taking his customary walk through the fields and suddenly seized an artistic impression of something he had seen a hundred times before: a verdant meadow bordered by a line of silver birches, their upper branches silhouetted against an opalescent sky.[6] The very ordinariness of the scene may account for its charm in Tryon's eyes, for as his student and biographer Henry C. White remarked, Tryon assiduously avoided "the obvious

subject."[7] Indeed, he adopted the aestheticist attitude propagated by Whistler and illustrated in his "nocturnes"—the belief that subjects for landscape paintings were not confined to the conventionally picturesque and that the instincts and training of the true artist permitted him to find beauty where others might fail and to truly represent it. Whistler's ambition, however, was to display his sense of superiority to nature, while Tryon's was to reveal the wonder of the world as he found it.

According to Tryon's own account, *The First Leaves* was executed "entirely from memory."[8] An avid sailor and fisherman who spent most of the summer on the water, Tryon had learned to memorize the features of the landscape to paint later, in the studio. Unlike the Barbizon artists and French Impressionists, who worked en plein air, Tryon preferred to paint indoors. The practice may have arisen from necessity, since until 1894 he had no studio in South Dartmouth, and the one he built then was used primarily for storing sailing gear and fishing tackle. Moreover, Tryon hated to miss even an hour of the outdoor season. It suited him best to carry out his work in New York during the dreary winter months, relying on his fading recollections to distill nature into art. His paintings "came direct from the fountain head of suggestion, Nature," he once assured a collector, adding that all of them passed through the alembic of his mind "before they were 'writ on canvas.'"[9]

Tryon's mature paintings were executed over many months, sometimes even years, in a protracted process of modulating the color scheme and composition with transparent veils of pigment, as in *Sunrise: April* (fig. 24). These works make wistfulness apparent: had he never lived in the city, Tryon remarked, he would not have felt the need to create an "ideal country."[10] *The First Leaves*, however, was painted rapidly

Figure 24. *Dwight W. Tryon*, Sunrise: April, *1897–99, oil on wood panel, 20 × 30 in. (50.9 × 76.3 cm). Courtesy of the Freer Gallery of Art, Smithsonian Institution, Washington, D.C. (6.79).*

Figure 25. *Dwight W. Tryon*, The Rising Moon: Autumn, *1889, oil on wood panel, 20 × 31⅝ in. (51 × 80.3 cm). Courtesy of the Freer Gallery of Art, Smithsonian Institution, Washington, D.C. (89.31).*

and completed in two days,[11] which accounts for its comparative naturalism and uncomplicated surface. If the picture was in fact produced early in May 1889, as Tryon recollected, the paint must have been barely dry when he submitted it to the Society of American Artists for that year's exhibition, which opened May 13. Tryon's determination to have *The First Leaves* immediately displayed in public suggests that he recognized it as a milestone in his career. He fleetingly considered naming it "The Resurrection," presumably to express his wonder at the annual renewal of the landscape, but perhaps also to imply that his own art had been reborn. In the end he decided that this was too dramatic for his understated picture. The more mundane title he chose captures the simplicity of the theme while fixing the painting's primacy in the long series of landscapes to follow.[12]

The First Leaves was awarded the third annual Webb Prize in the eleventh exhibition of the Society of American Artists in 1889 for the most promising landscape by an American artist under forty, previous winners having been J. Francis Murphy (1853–1921) and John Twachtman (1853–1902). Tryon felt especially proud to receive the Webb Prize as it came from the group of painters, he said, that he most respected.[13] *The First Leaves* also appears to have attracted the attention of the Detroit industrialist Charles Lang Freer (1854–1919), for it was while the painting was on exhibition that Freer called at Tryon's studio and purchased *The Rising Moon: Autumn* (fig. 25) straight off the easel. That acquisition signaled the start of a dedicated friendship. Over the next thirty years Freer acquired seventy-two of Tryon's paintings and pastels, creating the largest single collection of his works. Freer also attempted to ensure Tryon's immortality by consecrating to his works alone an exhibition gallery in the museum he pledged to build and endow for the nation, the Freer Gallery of Art in Washington.

After its debut in New York, *The First Leaves* was bought by L. Clark Seelye for Smith College. Tryon had taught at Smith since 1886, visiting once a month during the winters to critique student work (he retired in 1924), and he was also assisting Seelye in selecting works of contemporary American art for the college. *The First Leaves*, lately lauded by the New York art world, made a distinguished addition to the collection. It was shown at the Inter-State Industrial Exposition in Chicago, where to Tryon's delighted surprise it proved a popular picture. "Painting as I do without reference to public exhibition I expect little in this line," he wrote to Freer, "but am always pleased that a few appreciate it."[14]

LMERRILL

William Merritt Chase
FRANKLIN, INDIANA 1849–1916 NEW YORK

32. *Woman in Black*, c. 1890

Oil on wood panel; 15 5/16 × 10 in. (38.9 × 25.4 cm); signed in brown paint, lower left: *Wm. M. Chase*

Purchased (1900:16)

PROVENANCE: Possibly purchased from the artist.

EXHIBITIONS:[1] Andover 1932; New London 1945, no. 44; Southampton 1957, no. 64, repro. p. 80; Jacksonville + 1959; Santa Barbara + 1964 *Chase*, no. 6, repro.; Washington +, National Gallery 1970, no. 10, repro.; Northampton 1974; Northampton 1979, ckl. p. 38; Akron 1982, pp. 19, 46, fig. 11.

LITERATURE: Jewell 1934, p. 6x; *SCMA Handb* 1925, p. 11; *SCMA Cat* 1937, p. 3, repro. p. 49; Indianapolis 1949, p. 76; Milgrome 1969, pp. 76, 212 (no. 130), pl. 95; Chetham et al. 1986, no. 128, repro.

CONSERVATION: The painting is on a mahogany plywood panel. It is in very good condition, although there is some unevenness in surface gloss.

THE SON of an Indiana harness maker turned dry-goods merchant, William Merritt Chase became one of America's most versatile and cosmopolitan artists. Demonstrating a discerning eclecticism, he integrated into his own work a tremendous range of influences from old masters and contemporary Europe and America. He developed a keen eye for composition and color and a renowned technical facility, both of which were imparted to his students over the course of a thirty-seven-year career, during which he was, by all accounts, a skillful and generous teacher.

In 1872, after studying with the Indianapolis painter Barton S. Hays (1826–1914) and briefly at the National Academy of Design, Chase traveled to Europe under the sponsorship of several businessmen and connoisseurs in St. Louis, where his family had moved. Applying himself assiduously at the Royal Academy, Munich, he earned sufficient recognition to be offered a position there and at the Art Students League in New York. Declining the position in Munich, he returned to New York in 1878. He was subsequently an instructor at the Pennsylvania Academy of the Fine Arts, the Brooklyn Art School, and his own art schools in New York City and Shinnecock, Long Island, his summer home. He was a founding member of the Society of Painters in Pastel, served as the president of the Society of American Artists, enjoyed the company of his colleagues in the Tile Club, and saw his works widely exhibited.

After starting with the dark pigments and loaded brush of the Munich School, Chase came under the influence of France's plein air painters in the 1880s and produced fresh, light-filled scenes of city parks and Long Island shores and dunes. Early in his career he painted primarily still lifes, a genre to which he returned in his later years, and as a student in Europe he made numerous figure studies; simultaneously he continued to paint portraits of remarkable surety. An admirer of Frans Hals (1581/85–1666) and Diego Velázquez (1599–1660), Chase, like them, created incisive images of his subjects while manipulating the painted surface of the canvas with apparent ease.

During a trip to Europe in 1884 Chase saw the *Portrait of Miss Alexander* by James McNeill Whistler (cat. 28) and arranged to meet him. *Woman in Black* is one of many works that show the influence of Whistler upon Chase's painting. While the 1880s generally saw a lightening of Chase's palette, the portraits he painted after his encounter with the famous American expatriate often have thinly applied washes of subtle color. The curtain behind the woman in the Museum's painting sparkles with small flecks of color, much in the manner of the background of several of Whistler's portraits. The floor on which the model stands has been tilted up toward the picture plane, a compositional technique also often employed by Whistler. Her profile, especially her long, delicately curved nose, seen against the dark ground recalls the work of another of Chase's colleagues, John Singer Sargent's (cat. 29) famous *Madame X (Madame Pierre Gautreau*, 1884, Metropolitan Museum of Art, New York).

The distinctive profile of this model is seen again in *Lady in Pink* (c. 1888–89, Rhode Island School of Design, Providence), a large-scale portrait of the same attractive woman, but this time seated. Another ambitious image of her, full length and facing forward, is *Lady in Black* (1888, Metropolitan Museum of Art, New York). Chase's

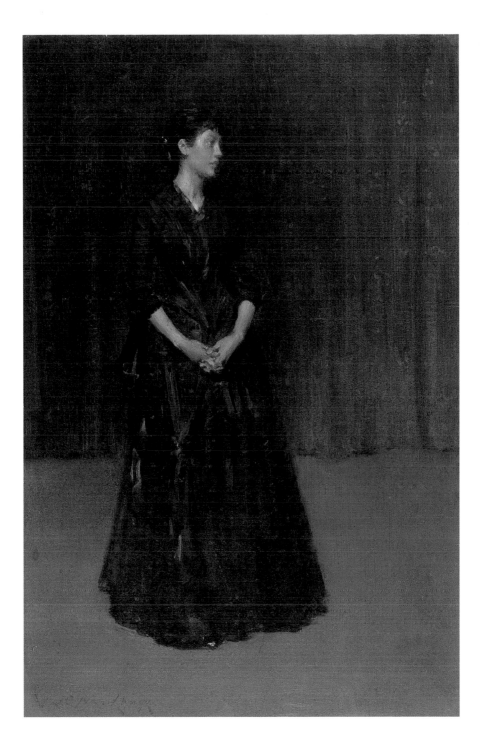

sitter for all these works was his student Marietta Benedict (1868–1947, Mrs. Leslie Cotton), who became a recognized portraitist. She had studied with the French master Carolus-Duran and with Jean Jacques Henner (1829–1905) and won an honorable mention in the Paris Salon of 1889.[2]

Woman in Black was probably painted not long after these larger portraits, since the gown can be dated to around 1890.[3] Chase's use of close tonal values (here primarily black, gray, and taupe) was an approach he favored at this time. A group of full-length female portraits he executed between 1886 and 1895 are, in the words of one critic, "all characterized by their subdued palettes, the simple soft backgrounds, the subtlety of brushstroke and delicacy of paint application."[4] Although smaller in scale, *Woman in Black* displays the best of all these elements.[5]

<div style="text-align:right">DC</div>

Edwin Romanzo Elmer

ASHFIELD, MASSACHUSETTS 1850–1923 ASHFIELD, MASSACHUSETTS

33. *Mourning Picture,*[1] 1890

Oil on canvas; 27¹⁵⁄₁₆ × 36 in. (70.9 × 91.4 cm); not signed, not dated

Purchased (1953:129)

PROVENANCE: Estate of the artist's widow, Mary Ware Elmer, Ashfield, Mass.; to the artist's niece, Maud Valona Elmer, Seattle, 1927.

EXHIBITIONS: Shelburne Falls 1890; Shelburne Falls 1946; Northampton + 1952 *Elmer*, no. 4; Frankfurt + 1953, no. 29, repro.; Houston 1956, no. 2, repro.; Brussels 1958, no. 102; Rotterdam + 1964, no. 58, repro.; New York, Whitney 1966, no. 90, repro. p. 37; Washington +, National Gallery 1970, no. 21, repro.; Berkeley + 1972, no. 93, repro.; Washington, NPG 1974, no. 46, repro.; Munich + 1974–75, no. 35, repro.; Northampton 1976 *American;* Northampton 1979, ckl. p. 40; Northampton 1980, no. 33; Northampton + 1982 *Elmer*, ckl. no. 4; Miami 1984, no. 115, repro.; New York, IBM 1990.

LITERATURE: *SCMA Bull* 1951, p. 34; Frankenstein 1952, repro. p. 271; *Antiques* 1953, repro. p. 124; Baur 1953, p. 22, repro. p. 53; Maass 1957, repro. p. 190; Bihalji-Merin 1959, p. 260, pl. 30; Dorfles 1961, pp. 53–54 (dtl.); Elmer 1964–65, pp. 136–37, repro. pp. 132–33, 134 (dtl.); Schulte Nordholt 1965, repro. no. 24b; *Ency* 1966, vol. 11, p. 715, pl. 334; Green 1966, pp. 376–77; Goodrich 1966, repro. p. 659; Frankenstein 1969, p. 151; Flexner 1970, pp. 119, 123, repro. pp. 120–21; Dasnoy 1970, p. 226, pl. 187; Praz 1971, p. 211, pl. 173; Maass 1972, pp. 96–97, repro.; Williams 1973, p. 196; Bishop [1975] 1979, pl. 38; Lipman and Franc 1976, p. 86, repro.; Schorsch 1977, pp. 42–43, repro. and cover; Frenzel 1977, pp. 29–30, fig. 16; Mathey 1978, repro. p. 104; Schorsch 1978, repro. p. 29; Jones 1979, repro. p. 16; Stony Brook + 1980, pp. 73, 85, 87, repro. p. 88; Lynes 1981, color repro. p. 54; Krum 1981, colorpl. VI; Jones 1983, no. 9, pp. 21, 22, 27, 31, 41, 58–59, 64–70, 72, 77, 84, 85, 103, 108 nn. 62 and

"IN THE POST OFFICE hangs a very fine oil painting of Edwin Elmer, wife, daughter, pet lamb, house and mountains, executed by Mr. Elmer, who is quite an artist."[2] With these few dry words the first showing of *Mourning Picture* was noted by a Shelburne Falls, Massachusetts, reporter in 1890, six or seven months after the picture was painted and some ten months after the daughter had died—a fact the writer probably relied on his readers to know. It languished in obscurity until March 1950, when the artist's niece, Maud Elmer,[3] brought it to the attention of Henry-Russell Hitchcock, director of the Smith College Museum of Art, and Bartlett Cowdrey, assistant director and a specialist in nineteenth-century American art. In the following decades the picture has become one of the most popular and most frequently reproduced paintings in the collection.

Elmer was born in the outlying Baptist Corner district of Ashfield, Massachusetts, a town of about twelve hundred inhabitants in the eastern foothills of the Berkshires. In 1863 it was chosen by Charles Eliot Norton as his summer residence. Norton, newly installed as co-editor of the venerable *North American Review,* soon lured his friend George Curtis, editor of *Harper's Weekly,* to the town. Together they immediately started a course of lectures to revive Ashfield's neglected library. Among the early additions to its shelves were books by John Ruskin. Norton was well known as a friend and confidant of Ruskin, and in the mid-1860s several young artists who were students of Ruskin's teaching visited him in Ashfield. Among them was Thomas Charles Farrer (cat. 21), an Englishman who had studied with Ruskin in London. He spent the winter of 1865–66 in Ashfield, where he gave free drawing lessons several evenings a week.[4]

According to Maud Elmer, her uncle Edwin showed an early talent for art and was very clever with mechanical problems and mathematical puzzles.[5] Evidence that Elmer was familiar with Ruskin's works is given by his wholesale borrowing of a Ruskin drawing as an architectural background for another painting in the Museum's collection, *Portrait of My Brother* (checklist no. 10). Whether he took advantage of Farrer's readily available classes to learn more of Ruskin's ideas is not known. There is no record that he had any formal art education before the age of fifty.

About 1867 Edwin and his brother Samuel went to Ohio to work on a farm, and around 1872 they joined their older brother selling sewing-machine thread in Cleveland. In this bustling, booming city they met many artists, according to Maud Elmer.[6] On their return to Massachusetts about 1875 they apparently had earned enough money to undertake construction of the large Italianate house (fig. 26) on a hill in Buckland, a town adjoining Ashfield and Shelburne Falls, the house depicted in *Mourning Picture.*

The brothers engaged in several short-lived business ventures, including making and selling washing machines, clothes wringers, and a double-acting churn invented by Elmer. By 1880, through death and departure, Elmer, his wife, Mary, and their daughter, Effie Lillian, were left as the only occupants of the large house they had originally built for their parents and themselves. Then in January 1890 the nine-year-old Effie died. According to Elmer's niece, Mary could not bear to remain in the house. "They

stayed long enough for Edwin to paint a portrait of Effie, now called *The Mourning Picture*. . . . When this was finished Edwin gave away the pet lamb, kittens, and the hen 'Dody' to me."[7] It has been suggested that the lamb (actually, it appears, a sheep) was included to symbolize innocence: lambs were often carved on tombstones of children. Elmer did not belong to any church, but even if he was an atheist, he probably would not have rejected such symbolism.

If Elmer gave the painting a title, it has not survived. Nineteenth-century American works called "mourning pictures" usually showed weeping friends and relatives at the tombstone. They did not normally include a portrait of the deceased although there was a long tradition of painting portraits from corpses to show the dead as if alive. Indeed, Elmer was at this time engaged in what might be considered a successor to this tradition. Touring the countryside, he obtained photographs of recently deceased citizens from their families, enlarged them, worked them up with black crayon and airbrush to look like drawings, and put them in heavy, funereal frames.

68–70, 118–20 (no. 9), figs. 11, 53, 55, 57, see also figs. 10, 27, 56, 58, 118; Corn 1985, repro. p. 79; Chetham et al. 1986, no. 130, repro.; Bross 1987, repro. p. 29; Lemardeley-Cunci 1993, pp. 129–45, repro.; Arnold and Gemma 1994, p. 13, repro. p. 12.

CONSERVATION: The work is painted on a pre-primed canvas (32 threads per inch vertically, 28 threads per inch horizontally) and mounted on the original keyed wooden stretcher. It is in excellent condition except for traction crackle, especially in the sky, and some penetration of oil paint through to the back of canvas.

Only a handful of works by Elmer dating from before *Mourning Picture* have been found. All are modest in scale, and none is so ambitious. All appear to predate it by more than a decade, and there is nothing to prepare the student of his work for the appearance of this imaginative and complex composition. No doubt powerful forces had brought it into being, but apart from the rather sad expression on Mary Elmer's face, the picture is emotionally reticent. Elmer seems to be trying to render with the utmost exactitude an imagined tableau. It is a memorial to his daughter and also perhaps to the youthful hopes embodied in the grand house he and his brother had built.

The picture has been reproduced and exhibited frequently in surveys of art by untrained artists. Like some folk paintings, it shows a meticulous, almost obsessive rendering of everything with the same degree of clarity, whether in the foreground or background, and a certain awkwardness in the integration of the parts. In Elmer's case these properties should probably be attributed to his use of photographs and to a mechanic's respect for precision. He may also have learned in his teens Ruskin's dictum that artists should record nature with factual accuracy, "selecting nothing, rejecting nothing."

Adjectives such as "brooding," "haunting," "disquieting," and "hallucinatory" have been used to describe *Mourning Picture*. The three figures do indeed appear entranced, lost in their own worlds, each looking in a different direction and unaware of each other. This sense of isolation and disjunction may have more to do with Elmer's struggle to fuse several different photographic sources than with any desire to lend mystery to the scene. It is understandable that he would have had to use a photograph of his daughter (fig. 27), and the many details of the house (which is still standing) probably necessitated some photographic help. The parents sit in parlor chairs, not garden furniture, and an interior photograph may have been used for their figures: the tree shadows in which Mary Elmer sits do not fall on her. The fact that there is more than one light source in the picture (or that one of Effie's legs is not there) may contribute the eeriness that some viewers sense.

Elmer's name is missing from histories of American art. His output was small, intermittent, and uneven. Nevertheless, *Mourning Picture* has become a kind of icon. It has been the subject of a poem by Adrienne Rich,[8] which has in turn been treated in a scholarly article;[9] it has been the inspiration for a musical composition;[10] and—perhaps the ultimate compliment—it has been the object of imitation.[11]

BBJ

Figure 27. *Effie Lillian Elmer, c. 1889, photograph by J. K. Patch, Shelburne Falls, Mass. Formerly in the collection of Mrs. Robert Luce, Florence, Mass. Present owner unknown.*

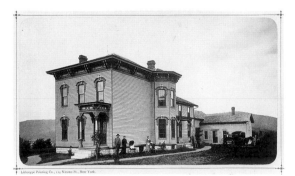

Figure 26. *Elmer House, Buckland, Mass., c. 1880–81, photograph by Lithotype Printing Company, New York. Formerly in the collection of Mrs. Robert Luce, Florence, Mass. Present owner unknown.*

Albert Pinkham Ryder

NEW BEDFORD, MASSACHUSETTS 1847–1917 ELMHURST, NEW YORK

34. *Perrette*, c. 1885–90

Oil on canvas mounted on paper composition board; 12¹³⁄₁₆ × 7¹¹⁄₁₆ in. (32.5 × 19.5 cm); signed in red paint, lower left: *A. P. Ryder*

Purchased, probably from the artist, Winthrop Hillyer Fund (1893:1)

PROVENANCE: Said to have been purchased by L. Clark Seelye, president of Smith College, directly from the artist.[1]

EXHIBITIONS: Chicago 1891, no. 316; New York, Athletic 1892, no. 52; New York, Metropolitan 1918, no. 14, repro.; Buffalo 1918, no. 69; St. Louis 1918, no. 57; Hartford 1935, no. 30; New York, Knoedler 1939, ckl. no. 15; New York, Whitney 1947 *Ryder*, no. 9;[2] New York, Knoedler 1953, no. 42; Syracuse 1953, no. 22; New Bedford 1960, no. 7, pl. 7; Chicago 1961, no. 22; Washington, Corcoran 1961, no. 32, repro. p. 34; Washington +, National Gallery 1970, no. 51, repro. p. 36; Northampton 1974; Northampton 1979, ckl. p. 44; Washington +, National Museum 1990, no. 50, pp. 85, 87, fig. 72.

LITERATURE: Eckford 1890, pp. 250–59; Clarke 1892; *NY Herald* 1892, p. 6; Sherman 1920, pp. 72 (no. 117), 77; *SCMA Handb* 1925, p. 27, repro. p. 48; White 1930, p. 90; Mumford 1931, p. 226; Price 1932, no. 133; Jewell 1934, p. 6x, repro.; *SCMA Cat* 1937, p. 8, repro. p. 60; Lane 1939, p. 9; Goodrich 1959, p. 115 (no. 55), repro.; Chetham et al. 1986, no. 129, repro.; Homer and Goodrich 1989, pp. 44–45, 148, 237, fig. 4-14.

CONSERVATION: The painting is on canvas mounted on a heavy artist's board, which is lined with another canvas and mounted on a strainer. The tacking edges are missing. Traction craquelure (alligatoring) has distorted the surface of the painting.

AMONG THE MANY late-nineteenth-century works the Museum acquired from contemporary artists, Albert Pinkham Ryder's *Perrette* exemplifies the best in American romanticism at that time. Ryder lived and worked for most of his life in New York, after spending his youth in the whaling center of New Bedford, Massachusetts. With very little formal training and only brief study trips abroad, he had established himself as one of the avant-garde in New York art circles by the mid-1870s. Rebelling against the conservative National Academy of Design, he became in 1877 a founding member of the Society of American Artists, a group that advocated the more modern, painterly styles then in vogue in Europe.

Although establishing a firm chronology of Ryder's oeuvre is impossible, *Perrette* must have been painted between about 1885 and 1890, at least three years before its acquisition by Smith.[3] The heavily brushed impasto of this canvas points to a date after the mid-1880s, when Ryder also began to depict more romantic literary subjects.[4] Other paintings of the mid-1880s, such as *A Country Girl* (Maier Museum of Art, Randolph-Macon Woman's College, Lynchburg, Va.) and *The Little Maid of Acadie* (collection of Mr. and Mrs. Daniel W. Dietrich II), share with *Perrette* a small-scale, vertical format with a standing female figure filling the picture plane and a similar literary source.[5]

Perrette depicts a young woman walking through a meadow and balancing a pail of milk on her head. To the left of the figure two cows rest near a single tree, and in the far right a fence cuts across a hill. The intertwined curve of cattle and tree, balanced by the diagonal of the steep distant hill, displays a strong sense of decorative design and flat patterning, showing the influence of Ryder's friend and dealer Daniel Cottier, a staunch supporter of the late-nineteenth-century Decorative Movement.[6]

Critics of Ryder's work have used *Perrette* both to praise and deprecate his skill in drawing. Although a 1939 article by James W. Lane cited this canvas as evidence that Ryder was "not very able" at drawing the human figure,[7] Thomas B. Clarke, an eminent collector of American art, found Ryder's drawing of the reclining cow, foreshortened from behind, to be "really a triumph." He continued, "And yet there are people who say that Albert Ryder cannot draw."[8] Ryder constantly worked and reworked his drawing; x-rays of *Perrette* show that he redrew the lines of the cattle and the tree, shortened the skirt, and changed *Perrette*'s right arm to bend across her waist (fig. 28).[9]

Discussions of Ryder as a colorist often mention *Perrette*. Lewis Mumford, writing in 1931, cited *Perrette* as an example of a work in which a "hint of this aspect of Ryder [as a colorist] can be seen."[10] *Perrette* has more variety of color than most Ryders; it has been described as "one of Ryder's finest pictures in color. The color has richness, mellowness, harmony . . . like that of Delacroix or Millet."[11] Today the color seems subdued by warm-toned glazes, as well as by changes in the surface of the painting, but close examination reveals touches of bright yellow in the skin tones, blue flowers at the base of the tree, red in the cows, dark blue in Perrette's bodice, red-purple in her skirt, a blue-green sky, and olive hills.

Figure 28. X-ray photograph of Perrette.

Ryder saw his compositions as "re-creations of poetic sentiment on canvas" and often used poetic or literary sources.[12] His romanticized depictions of women in literature include *Perrette, King Cophetua and the Beggar Maid* (c. 1900–5, National Museum of American Art, Smithsonian Institution, Washington, D.C.), *Constance* (c. 1896, Museum of Fine Arts, Boston), *Lord Ullin's Daughter* (before 1907, National Museum of American Art), and *The Little Maid of Acadie*. "The Dairy Woman and the Crock of Milk" by La Fontaine provided the subject of *Perrette*.[13] In the fable the dairy woman walks to market balancing a crock of milk on her head and daydreaming about how she will spend the money from its sale. When she carelessly trips and spills the milk, her dreams disappear.

Why did Ryder choose this story of a foolish woman who loses her livelihood through carelessness? His usual female subjects suffered for love through no fault of their own. He also frequently painted dreamlike images of women in idyllic pastoral settings as in *A County Girl* and *Perrette*, although the former lacks the clear moral message of the latter. What all these literary subjects share is a sense of longing: Perrette for wealth, King Cophetua for the beggar maid, the unjustly accused Constance for reunion with her family, and the Acadian maid Evangeline for the husband taken away from her. They also share a sense of justice: the faithful lovers all do eventually unite, and Perrette, who wishes for riches not love, also receives the reward she deserves.

CLB

Childe Hassam

DORCHESTER, MASSACHUSETTS 1859–1935 EAST HAMPTON, NEW YORK

35. *Cab Stand at Night, Madison Square,*[1] 1891

Oil on wood panel; 8¹⁵⁄₁₆ × 14⅜ in. (irregular) (22.7 × 36.4 cm); signed and dated in blue paint, lower left: *Childe / Hassam / 1891;* inscribed on back of panel, upside down, in pencil, across entire height and width of panel: *Electric Light* [illegible]

Bequest of Annie Swan Coburn (Mrs. Lewis Larned Coburn) (1934:3-2)

PROVENANCE: Annie Swan Coburn (Mrs. Lewis Larned Coburn), Chicago.

EXHIBITIONS: Boston, Doll 1893 (?) (possibly *Effect of Electric Light on the Snow [Madison Square]*); Dayton + 1951; Boston, ICA 1954; New York, Museum 1958; Washington +, Corcoran 1965, no. 16; Tucson + 1972, no. 37, repro. p. 74; Northampton 1979, ckl. p. 41.

LITERATURE:[2] Van Rensselaer 1893, repro. p. 9; *SCMA Cat* 1937, p. 6, repro. p. 54; *ICA Bulletin* 1954, p. 2; Chetham et al. 1986, no. 132, repro.; Fort 1993, colorpl. 9; Hiesinger 1994, p. 74, fig. 76.

CONSERVATION: The painting is on a wooden panel (possibly pine) that has been impregnated on back with wax to prevent warping. It is in very good condition.

FREDERICK CHILDE HASSAM (see also cat. 37) was born in 1859. His unusual surname comes from British ancestors named Horsham who settled in New England in the seventeenth century. Hassam dropped his first name Frederick early in his career, influenced by his friend Celia Thaxter.[3] Demonstrating an early interest in art, Hassam received drawing instructions while still a boy from the English artist Walter Smith (1836–1886). After leaving school, the young man worked briefly as a bookkeeper for the publishers Little, Brown and Company but quickly found more appropriate employment as a woodblock engraver. His natural talents soon enabled him to create his own illustrations for books and magazines. At the same time, he took advantage of the professional training that was available, attending classes at the Boston Art Club and Lowell Institute and studying with the German-born painter Ignaz Marcel Gaugengigl (1855–1932).

In 1883, when Hassam took his first trip to Europe, he was already an established artist, known especially for his city views. Back in Boston the next year he married Kathleen Maud Doane. The couple returned to Europe in 1886, staying primarily in Paris, where Hassam studied at the Académie Julian, made numerous visits to museums, and became increasingly aware of the art of his French contemporaries. He exhibited his work at the Paris Salon in 1887 and 1888, and was awarded a bronze medal at the Paris Exposition of 1889.

Back in the United States later that year, Hassam and his wife settled in New York. The artist continued to paint landscapes and scenes of city life but with a gradually lightened palette. He was also interested in media other than oils, contributing to the last exhibition of the Society of American Painters in Pastel in 1890 and joining the American Watercolor Society a year later. Toward the end of his career, as his work in oil became more uneven, Hassam concentrated his energies on printmaking.

After 1890 Hassam spent most of his winters in New York and his summers in a few well-chosen areas of New England. Some of his loveliest images are those he created in Gloucester, Massachusetts, Old Lyme, Connecticut, and the Isles of Shoals, off the New Hampshire coast. In the winter of 1897–98 Hassam withdrew from the Society of American Artists to form an alliance with other artists, including Theodore Robinson (1852–1896) and Frank W. Benson (1862–1951), who wanted their works to be shown in more intimate, less conservative exhibitions. This group, most of whom were inclined toward some form of Impressionism, became known as the Ten. Hassam's joyous, light-filled scenes of both city and countryside gained him a substantial reputation, were exhibited widely, and were purchased by major collectors. After 1919 the artist worked primarily in East Hampton, Long Island, where he lived until his death.

Cab Stand at Night, Madison Square was painted after Hassam's return from France, in a decade during which he produced more city views than in any other.[4] To be sure, this interest had been evidenced earlier. Works such as the softly atmospheric *Boston Common at Twilight* (1884–86, Museum of Fine Arts, Boston) demonstrate the artist's keen powers of observation, his ability to capture with sensitivity the mood of the weather or particular times of day, and his use of astutely placed figures to give life

to the landscape setting while simultaneously creating a satisfying composition. One result of Hassam's preoccupation with city life recorded under varying conditions and from challenging vantage points was *Three Cities,* a volume published in 1899 and comprising images of Paris, Boston, and New York.

The Museum's painting may have also been conceived as an illustration, as it was among those used to accompany M. G. Van Rensselaer's article on Fifth Avenue in the November 1893 *Century Magazine;* its subject corresponds only loosely to the text, however, which is more of a musing on the history of Fifth Avenue than an exposition of its modern character. Only one comment by the author six pages after the picture relates to the subject depicted. After discussing the comparative beauties of other capital cities, she comments that "certainly the now ubiquitous hansom adds greater picturesqueness to a street panorama than the low, open cabs of Paris and Vienna."[5]

Hassam also apparently thought the cabs picturesque, as he featured them in several works. Two that are closely related to each other and to *Cab Stand* are a pastel, *Horse Drawn Cabs, New York* (1891, at Christie's, New York, May 26, 1993, no. 118) and a watercolor, *Horse Drawn Cabs at Evening, New York* (c. 1890, with Berry-Hill Galleries, New York, March 1993). In all three works the curbside forms a prominent diagonal in the composition, the strong, dark shapes of the rows of cabs providing a directional

departure point for a recession into space. In the pastel and watercolor the effects of the elements are seen in the lamplight and the last light of day reflecting off the wet pavement.

The artist described the working methods applicable to these works in an article of 1892. Discussing an image that might very well be the Museum's painting, he wrote:

> If I want to observe night effects carefully, I stand out in the street with my little sketchbook, draw figures and shadows, and note down in colored crayons the tones seen in the sky, in the snow, in the reflections or in a gas lamp signing through the haze. I worked in that way for this bit of street scene in winter under the electric light.[6]

Cab Stand demonstrates this sense of casual immediacy and sensitivity to qualities of atmosphere. At the same time, the painting's almost monochromatic palette and clear areas of contrast between light and dark suggest that Hassam's training as an illustrator and wood engraver is strongly in play here. The painting is composed primarily of shades of blue enlivened with flecks of white and salmon. The wiry, delicate turquoise shadows of leafless trees fall across the snow from the corner to the feet of the drivers, whose solid figures huddle in the foreground. The high horizon of the image, cropped closely over the tops of the cabs, increases the feeling of intimacy and further pulls the viewer into the scene. Hassam's successes here are twofold and follow his observation that

> [a] true historical painter . . . is one who paints the life he sees about him, and so makes a record of his own epoch. But that is not why I paint these scenes of the street. I sketch these things because I believe them to be aesthetic and fitting subjects for pictures.[7]

DC

Edwin Romanzo Elmer

ASHFIELD, MASSACHUSETTS 1850–1923 ASHFIELD, MASSACHUSETTS

36. *A Lady of Baptist Corner, Ashfield, Massachusetts* (the Artist's Wife),[1] 1892

Oil on canvas; 32¹⁵⁄₁₆ × 24¹³⁄₁₆ in. (83.7 × 63 cm); signed and dated in brownish black paint, lower left: *E. R. Elmer / 1892*

Gift of E. Porter Dickinson (1979:47)

PROVENANCE: The artist's sister, Emeline Elmer Elmer, Ashfield, Mass.; her estate; sold to E. Porter Dickinson, Amherst, Mass., 1939.

EXHIBITIONS:[2] Shelburne Falls 1946; Washington, Corcoran 1950, no. 296, repro. p. 221; Northampton + 1952 *Elmer*, no. 7; Toronto + 1961, no. 27, pl. XIX; Northampton 1979, ckl. p. 40; Northampton + 1982 *Elmer*, pp. 1–2, ckl. no. 7.

LITERATURE: *Time* 1950, p. 53, repro.; *Art Dig* 1951 January, p. 11, repro.; *SCMA Bull* 1951, pp. 30–31; Richardson 1951, repro. frontispiece; Frankenstein 1952, pp. 270–72, repro.; Elmer 1964–65, repro. p. 130; Frankenstein 1969, pp. 151–52; Williams 1973, p. 196, fig. 188; Jones 1979, repro. p. 17; Dinnerstein 1981, pp. 116–17, 199 nn. 37–40, fig. 9; *SCAQ* 1982, repro. inside cover; Jones 1983, pp. 31, 39 nn. 98 and 100, 41, 42, 77–82, 83, 85, 103, 122–23 (no. 13), figs. 68–70; Corn 1985, repro. p. 80; Chetham et al. 1986, no. 131, repro.; Clark 1987, repro. p. 164; Gerdts 1990, vol. 1, p. 82, fig. 1.80.

CONSERVATION: The painting is on a pre-primed canvas mounted on a stretcher keyed with Shattuck metal keys. There are some minor losses inpainted on the machine, above the windowsill, and on the spools of thread. It is in very good condition.

IN 1950 *A Lady of Baptist Corner, Ashfield, Massachusetts* first brought the work of Edwin Romanzo Elmer to the notice of a public more numerous than his neighbors of Ashfield, Buckland, and Shelburne Falls who might have happened to see the work during the preceding fifty-eight years. Its discovery was the result of chance and the solicitous attentions of the donor, E. Porter Dickinson, a librarian at Amherst College, who had seen and greatly admired the painting in the home of the artist's sister not long before her death in 1939.[3] He bought it from her estate, had it photographed, and sent a print to the Frick Art Reference Library. About 1949 or 1950 the photograph came to the attention of researchers working on a large exhibition called *American Processional, 1492–1950* for the Corcoran Gallery of Art.[4] The painting attracted some attention at the show and was reproduced in *Time;*[5] it was a source of wonder that so beautiful a painting could have come from a totally unknown hand.

After Elmer and his brother Samuel returned to Massachusetts about 1875 from Cleveland, where they had sold sewing-machine thread, they engaged in a number of small business ventures in the town of Shelburne Falls while they were building the large house seen in *Mourning Picture* (cat. 33). In 1880 Edwin married Mary Jane Ware, a local girl ten years his junior. Born in the Baptist Corner district of Ashfield, about a mile away from where the Elmer family was then living, Mary Elmer was much admired for her beauty and her lively wit. She was also an excellent cook, an accomplishment that was put to the test for a few years when they took in summer boarders to help make ends meet. In January 1890, when their daughter and only child Effie died, Mary was inconsolable. In her memoir, Effie's cousin Maud recalls that Mary could not bear to look at other little children or to remain any longer in the house where Effie had lived.[6] In spring 1890, after Elmer had finished *Mourning Picture,* they stayed for a short time in her mother's house in Baptist Corner and then, before the end of 1890, took an apartment in Shelburne Falls where *A Lady of Baptist Corner* was probably painted.

Elmer's mechanical ingenuity expressed itself among other ways through inventions such as a double-acting churn and a shingle bracket for use in the roofing trade.[7] About 1886–87 he devised the whip-snap machine his wife is seen working at in *A Lady of Baptist Corner.* Whip snaps were the braided or twisted threads at the ends of horse-whips; the center for the manufacture of horsewhips at the time was the western Massachusetts town of Westfield. Elmer was the agent for the cottage industry in whip snaps that his brother had introduced to the region about 1887. Many women and children earned pocket money making whip snaps, and old-time residents of Franklin County remember twisting them outdoors in the summer.[8] Elmer's ingenious mechanism, which used a crank and gear system to braid the threads, meant the work could be done faster and more comfortably day and evening all year long.[9]

In Elmer's painting of his wife working at the machine he had invented and con-structed, he has orchestrated his love of detail with an artificer's skill so that this pro-saic activity seems invested with a kind of magic. The design of the ingrain carpet is carefully noted, and he has not overlooked the faint reflection of the large spools

in the green-painted side of the machine or even the reflection of a window on the metal handle of its upper casing. The little touches of light that define the outer forms of the dark mechanism, its parts and the threads, as well as those falling on the figure of his wife, are rendered with the greatest delicacy. The backlighting of his wife's head has the suggestion of a halo, and the glow emanating from the interior of the machine lends an air of mystery, though it may be nothing more than the light of an unseen candle. The warmth of the red inner wall contrasts with the rather cool light coming from the snowy landscape that bathes the figure of Mary Elmer, enhanced by the strong whites of her apron. In contrast to the more or less overall detail in *Mourning Picture*, here the intricacies are balanced against the flat, unarticulated areas of the wall and the machine. Although the perspective is a little skewed, *A Lady of Baptist Corner* is the artist's most accomplished and fully resolved painting. In this work he has introduced the element of light as a compositional device. Its handling seems entirely original.

A passage from the Henry James short story "A Landscape Painter" (1866) seems concisely relevant to the qualities of this painting and the artist's *Mourning Picture:*

> There is a certain purity in this Cragthorpe air which I have never seen approached—a lightness, a brilliancy, a crudity, which allows perfect liberty of self-assertion to each individual object in the landscape. The prospect is ever more or less like a picture which lacks its final process, its reduction to unity.[10]

Whereas in *Mourning Picture* Elmer may be said to have allowed "perfect liberty of self-assertion to each individual object," in *A Lady of Baptist Corner* he has taken the picture to "its final process, its reduction to unity."

BBJ

Childe Hassam

DORCHESTER, MASSACHUSETTS 1859–1935 EAST HAMPTON, NEW YORK

37. *White Island Light, Isles of Shoals, at Sundown*, 1899

Oil on canvas; 27 × 27 in. (68.6 × 68.6 cm); signed and dated in maroon, purple, and black paint, lower right: *Childe Hassam / 1899;* inscribed on back of canvas, upper right, in brown paint over pencil: *White Island Light Isles of Shoals / at Sundown. /* [initials in a circle, probably *C. H.*] */ 1899*

Gift of Mr. and Mrs. Harold D. Hodgkinson (Laura White Cabot, class of 1922) (1973:51)

PROVENANCE: Milch Galleries, New York; to Standish Bourne; to Vose Galleries, Boston, Dec. 20, 1960; to Mr. and Mrs. Harold D. Hodgkinson, Boston.

EXHIBITIONS: Northampton 1975 *Centennial,* no. 30, repro.; Durham 1978, p. 138, fig. 26; Northampton 1979, ckl. p. 41; Williamstown 1983, p. 35, no. 43, pl. 43; Framingham 1985, unno. ckl.; Boston +, MFA 1986, no. 35, repro. p. 126;[1] New York, IBM 1990.

LITERATURE:[2] Chetham 1980, repro. p. 7; Nevins 1984, color repro. p. 95; Chetham et al. 1986, no. 133, repro.; New Haven + 1990, pp. 125, 130, pl. 57; Barry 1992, color repro. p. 40; Giffen and Murphy 1992, p. 121, fig. 4.8.

CONSERVATION: The original canvas has had its tacking edges removed and is glue lined to a secondary canvas mounted on a keyed wooden stretcher. There is no evidence of inpainting, but there is a pentimento of a lighthouse in the upper left corner.

FROM 1886 ON, one of Childe Hassam's favorite warm-weather destinations was Appledore, one of the Isles of Shoals, ten miles off the New Hampshire coast. Although he also visited a number of other summer sites, the artist maintained his loyalty to this scenic area for twenty years. Some of his loveliest and most adventurous works were created on these islands.[3]

By the time Hassam first visited, the Isles of Shoals had become a popular destination for vacationers. The area's tourist industry was the creation of Thomas Leighton, former keeper of the White Island lighthouse and co-builder of Appledore House, the first hotel in the group of islands. Leighton's daughter Celia, who married his business partner Levi Thaxter, helped transform the island of Appledore into a haven for the aesthetically inclined. A writer and poet herself, she created an intellectual environment in the parlor of her inn that was as hospitable and attractive to visitors as the glorious natural environment. With sensitivity and skill, she transformed rocky, unpromising soil into a garden that was celebrated for its beauty. For one of Thaxter's books, *An Island Garden* (1894), Hassam produced delicate, fresh watercolor illustrations of her favorite beds of flowers. He depicted Thaxter's world in numerous other images as well, including one of the best known of his fully Impressionist paintings, the resplendent *Room Full of Flowers* (1894, private collection).

Until about 1894, the year of Thaxter's death, most of Hassam's Isles of Shoals paintings are filled with garden imagery. Toward the end of the decade, however, after a few years absence, the artist returned to the Isles and concerned himself increasingly with the wilder scenes of sea, sky, and shore. *White Island Light, Isles of Shoals, at Sundown* is one of the earliest of this group. Thaxter herself described the appeal of the dramatic coastline with its "rifts and chasms, and roughly piled gorges, and square quarries of stone. . . . The trap rock, softer than the granite, is worn away in many places, leaving the bare, perpendicular walls fifteen or twenty feet high."[4]

One such rugged and distinctive feature, South Gorge, is depicted in the foreground of the Museum's painting. Another visitor to this "wondrous spot" observed that

> it gives one a tolerable—one might say intolerable—idea of eternity to think how long the sea must have been gnawing and nibbling here to bring about the present state of things. There are scores of these dikes about the Shoals, but this one is the finest of them all.[5]

Hassam shows the rough-hewn walls of rock at sundown, darkened by shadows formed by a dense network of blue and ruddy brown brushstrokes. He creates an insistent tension between the three- and two-dimensional character of the work. While the dominant stone formation is solidly modeled, its outline is felt just as strongly. The vertical piece of ocean, seen at the left in the crevice between two rocks, is rendered with a thick impasto that reinforces its presence as paint rather than illusion. This narrow finger of water abuts the contour of the rock, appearing to share the same plane rather than existing in a space beyond and below it. Similarly, the horizontal bands of blue violet sea in the distance, some made with a dry, dragging brush,

are simultaneously the observed effect of late sun upon water and an implied recession into space and abstract elements of design.[6] The image as a whole is one of Hassam's most vigorous, expressive efforts.

Comparisons of Hassam's work to that of his French Impressionist predecessor Claude Monet (1840–1926) were inevitable, much to the American artist's annoyance. However, the parallels between his Appledore works and Monet's scenes of the Normandy coast, particularly those of the massive rocks at Etretat from the 1880s and 1890s, are impossible to ignore. Besides a similar choice of subject, both often favored a dramatic, sometimes precipitous placement of the viewer in relation to the scene depicted; both used widely varying brushwork within a painting to suggest the varied moods of the scene and different textures of land and sea; and both closely observed and conveyed the nuances of sunlight and shadow on the rough, rocky surfaces. Hassam would have had ample opportunity to see Monet's paintings on exhibition both in the United States and in France and might have responded to them consciously or unconsciously.[7] Whatever the influences may have been, in his Isles of Shoals images Hassam sensitively captured the unique beauty of this particular feature of New England.

DC

Augustus Saint-Gaudens

DUBLIN, IRELAND 1848–1907 CORNISH, NEW HAMPSHIRE

38. *Diana of the Tower*, 1899

Bronze on self-base; 36 × 14¼ × 11 in. (91.4 × 36.2 × 27.9 cm); inscribed on front face of tripod base: *DIANA / OF THE / TOWER*; signed and dated on top of base platform, proper right rear: *AUGUSTUS / SAINT-GAUDENS / MDCCCXCIX*; bronze or copper circular inset stamped on top of base platform, front, proper left: *COPYRIGHT / BY AUGUSTUS / SAINT-GAUDENS / M / DCCCXC / IX;* inscribed on top of base platform, proper left rear: *AUBRY BROS / FOUNDERS. N.Y.*

Purchased, Winthrop Hillyer Fund, 1915 (1900:22-1)[1]

PROVENANCE: Gorham, New York, by 1915.

EXHIBITIONS: Cambridge 1975–76, ckl. no. 39b; Northampton 1979, ckl. p. 47; Detroit 1983, no. 86, repro. p. 167; Roslyn 1985, pp. 93–94, fig. 114; Springfield 1987–88.

LITERATURE: *SCMA Cat* 1937, p. 36; Dryfhout 1982, p. 210; Chetham et al. 1986, no. 134, repro.; *Libr Mus Q* 1987, p. 9, repro.

CONSERVATION: The sculpture was cast in several sections. There are casting seams in the proper right thigh and in both arms, and where the left foot meets the ball. The bow is made in three sections; the top and bottom sections pivot within the section held in Diana's hand. The arrow was cast separately; the arrowhead is missing. There is abrasion to the back of the proper left thumb and the back of the proper right hand; there is a small dent in the right breast.

IN THE BOOM YEARS following the Civil War, American painters, sculptors, architects, and other artisans often came together in elaborate, collaborative civic projects as the revival of a Renaissance ideal. As cities grew, public spaces assumed an important place in urban planning as sites for monumental sculpture emblematic of national pride and republican virtue. In the major cities of the North—Boston, New York, and Chicago—Civil War heroes were especially appropriate models of self-sacrifice in the name of nationhood. But so were other enterprising Americans—writers, industrialists, philanthropists—who contributed to the greater public good. In the course of his career, Augustus Saint-Gaudens addressed all of these role models in his sculpture.

With architect Stanford White (1853–1906), Saint-Gaudens enlarged the idea of civic art to include not just monumental sculpture, but a larger artful space, in which sculpture and architecture were integrated with setting. His monuments were conceived as true civic landmarks meant to beautify and ennoble the urban landscape as they celebrated America's greatness.

Madison Square in New York was the site of two of Saint-Gaudens's most important public commissions: his *Farragut Monument* of 1877–80 and his *Diana*, begun a decade later and completed in 1891, two signature works that for a time shared the same setting. Both were designed in collaboration with his friend Stanford White, who worked with the sculptor on twenty-eight commissions over nearly three decades. The *Farragut Monument* was designed at the beginning of Saint-Gaudens's career; *Diana* was created when the sculptor was at the height of his profession. His *Admiral Farragut* is, like others of the sculptor's public pieces, a modern American war hero, in this case commemorating the commander of Union naval forces in the Civil War. Though executed in bronze, the figure is invested with a vitality that engages the viewer immediately. He seems to stride forward, and his coat appears blown by the wind. The naturalism of the figure reflects Saint-Gaudens's training at the Ecole des Beaux-Arts in Paris, the center of modern sculpture in the second half of the nineteenth century. *Diana*, Roman goddess of the hunt, of childbirth, and of the moon, is, by contrast, an abstraction, a timeless ideal of feminine beauty. Nevertheless, as modeled by Saint-Gaudens, she is also a solid, commanding figure that dominated the skyline above the square through the turn of the century. She was created as a weathervane, in fact, that was mounted atop White's 330-foot-high tower at Madison Square Garden at one of the windiest intersections in the city. Saint-Gaudens's friend C. Lewis Hind recalled how together these two figures exemplified the sculptor's mark on New York:

> I walked down Fifth Avenue and found Farragut the sailor, balancing himself as if still standing upon the quarter deck of his good ship, comfortably grounded in Madison Square. I looked up above his bluff, strong face, high up through the brilliant clarity of the light . . . and there, on the pinnacle of the Garden tower, was slim *Diana*, one of Saint-Gaudens' few nudes, "Diana of the Cross Winds," as she has been called, shooting an imaginary arrow at the Flatiron Building that dominates the windiest corner in New York.[2]

Saint-Gaudens's *Diana* was the most conspicuous nude in late-nineteenth-century American art. From October 1891, when the sculpture first appeared atop the tower of architect White's new Madison Square Garden, *Diana* captivated New Yorkers. Standing eighteen feet high, with her robes billowing behind her, she drew attention as the first sculpture to be artificially illuminated. The Roman moon goddess was thus transformed by Saint-Gaudens into a gilded copper symbol of an electric age.[3]

Both the sculptor and the architect found their initial conception disproportionately large, however, and the first *Diana* was removed on September 7, 1892, to be replaced by a more refined version measuring thirteen feet tall. Saint-Gaudens's second, reformed version of his monumental *Diana* weathervane was placed in early 1894,[4] and shortly thereafter the sculptor began to produce small-scale replicas of New York City's most talked-about public sculpture. In January 1895 Saint-Gaudens secured copyright for a small-scale *Diana*, and he subsequently issued reductions in, generally, three variant forms.

With his celebrated relief portrait of Robert Louis Stevenson, the earliest version of which was executed in 1887–88, Saint-Gaudens realized the financial advantage of serializing his sculptures. Domestically scaled bronzes were becoming increasingly popular among collectors, as the sculptor noted in a letter to his brother, Louis, in July 1899, the year the Museum's small *Diana* was cast:

> I have quite a little income now from the Stevensons and Diana and now I have sold two small Puritans and a small Angel with the tablet *[Amor Caritas]*. [Frederick] MacMonnies sells more of his "Boy Playing on Reeds" than anything else. . . . People see the bronze in friends' homes and that suggests their purchase to them.[5]

The casts, sold through Tiffany's in New York and Paris, Doll and Richards Gallery in Boston, and, in this instance, through Gorham in New York, may have played some part in popularizing Saint-Gaudens's art. But more to the point, the replicas also provided income to offset expenditures from his work on monumental pieces. The success of his revised *Diana*, for example, came at great expense of time and money. Critic Royal Cortissoz reported in *Harper's Weekly*, "It is said that between five and six thousand dollars will have been spent upon the new figure by Mr. Saint-Gaudens and his friend the architect, by the time the beautiful huntress points her arrow at the rising sun."[6] By 1899 Saint-Gaudens was asking $175 for his *Diana* reductions.[7]

While he recognized the financial advantages of issuing replicas of the *Diana* and other popular works, Saint-Gaudens also saw a danger in redundancy, and, in the case of *Diana*, he may have consciously worked to preserve a sense of the replicas' distinctiveness. Saint-Gaudens confided to a friend in 1901, "The fact is I am not very eager to have replicas made as I have come to the conclusion that a certain something is lost in the repetition, while on the other hand I have to consider the pecuniary advantage I may obtain in the sale of replicas."[8] The *Diana* reductions were not mechanically reproduced but were remodeled by hand, and each of the three editions is significantly different.

The Museum's *Diana* is a second variant of a reduction made from the reformed thirteen-foot-high weathervane of 1893–94. The first reduction was a figure thirty-one inches high, poised on a half-sphere; it was cast by Aubry Brothers foundry, New

York, beginning in 1895. Subsequently, Saint-Gaudens created a smaller reduction, twenty-one inches high, with the figure standing on a whole sphere. The sculptor placed some of these figures on a stepped base and others on a fifteen-inch-high bronze Renaissance-style tripod mount, with the heads of griffins in relief and inscribed with the title "Diana of the Tower." These figures were cast in Paris and, in the case of the Museum's example, again at the Aubry Brothers works. A third reduction, also twenty-one inches high, was issued in 1899, and it varies slightly in the arrangement of the figure's hair. The Museum's bronze *Diana of the Tower* is the only known kinetic version. A floral knob on the side of the bronze tripod base turns an internal mechanism that allows the figure to rotate, evoking the original *Diana* weathervane.

PJ

Alfred Henry Maurer
NEW YORK 1868–1932 NEW YORK

39. *Le Bal Bullier,* c. 1900–1901[1]

Oil on canvas; 28¹³⁄₁₆ × 36⁵⁄₁₆ in.
(73.2 × 92.3 cm); signed in black
paint, lower right: *Alfred H. Maurer*

Purchased (1951:283)

PROVENANCE: The artist; to M.
and Mme Foinet (atelier/art store),
Paris; to Maison Lucien Lefebvre
Foinet, Paris; to René Lefebvre,
Paris and Los Angeles; sold to
Paul I. Clemens, Hollywood, Calif.,
and Milwaukee; to Maynard Walker,
New York; sold to M. Knoedler and
Company, New York, Jan. 1949
(stock no. A4081).

EXHIBITIONS: Philadelphia 1902,
no. 464; Washington, Corcoran 1902,
no. 9; Paris 1903, no. 907 (as *La
Dernière Danse au Bal Bullier*);
Chicago 1903, no. 257 (as *The
Last Dance at the "Bal Bullier"*);
Philadelphia 1904, no. 24; Paris 1905,
no. 1078; Le Touquet 1913, no. 115,
repro. p. 13; London 1914, no. 268
(under Paris—American Fine Arts
section); San Francisco 1915,
no. 4398; [Paris 1933–34],[2] no. 94;
Los Angeles 1934, no. 46;
Minneapolis + 1949, no. 10; New
York, Knoedler 1951, no. 39; New
York, Knoedler 1953, no. 38; Boston,
ICA 1954; Williamstown 1954;
Amherst 1956; South Hadley 1957,
no. 1; Amherst 1958; Durham 1960,
no. 23; Northampton 1968 *Hitchcock*,
no. 15, repro. p. 27; Washington +,
National Gallery 1970, no. 35, repro.;
Washington +, National Collection
1973, no. 35, fig. 35; Pittsburgh
1974–75, fig. 28; New York, IBM
1990; Boston +, MFA 1991, no. 145,
color repro. p. 146.

LITERATURE: McCausland 1951,
pp. 70, 78, 95; *SCMA Bull* 1953, p. 25,
fig. 17; *ICA Bulletin* 1954, p. 2; Baur
1957, repro. p. 177; Madormo 1983,
pp. 22, 28, fig. 19; Chetham et al.
1986, no. 137, repro.

CONSERVATION: The painting is
on canvas wax lined to a secondary
fabric. The original tacking edges
are missing, and the painting is
mounted on a new stretcher. It is
varnished with synthetic varnish.

THE BELLE ÉPOQUE,[3] France's period of glamour and gaiety coupled with poverty and economic and political unrest, which lasted from about 1880 to 1914, provides the backdrop for Alfred Maurer's *Le Bal Bullier*. Paris, "the city of light," was its heart and the predominant European capital, a cultural magnet to which much of the Western world gravitated for inspiration and instruction. Its *café-concerts, cabarets artistiques,* and *bals* (dance halls) attracted a large clientele, including painters, writers, and musicians—Edouard Manet (1832–1883), Edgar Degas (1834–1917), Auguste Renoir (1841–1919), Henri de Toulouse-Lautrec (1864–1901), Guy de Maupassant (1850–1893), Emile Zola (1840–1902), Giuseppe Verdi (1813–1901), and Franz Lehár (1870–1948), to name only a few—who documented the lively social activities.[4]

Le Bal Bullier is one such glimpse into the period, but unlike many of the era's best-known dance-hall paintings by French artists, it was painted by an American expatriate.[5] Maurer received early training from his German-born father, a lithographer and genre painter, and at the National Academy of Design. He arrived in Paris in 1897, determined—like so many others of his generation—to establish his personal independence, to develop an individual painting style, and to create a name for himself. He attended the Académie Julian briefly but soon set about studying on his own in the city's numerous museums and galleries.

Although Maurer lived in France almost continuously until 1914, biographical records for this period are limited, and only relatively few of his early paintings have been traced. Many of these works are unsigned and undated, adding to the difficulty of establishing a firm chronology. Judging from exhibition records, contemporary reviews, and the paintings known to have been executed before 1905, when the artist's style and subject matter began to undergo a radical transformation, he appears to have concentrated on studio subjects, mostly single figures of women, and genre scenes of Parisian streets, parks, cafés, and dance halls. Such compositions suggest a variety of artistic influences ranging from the bravura brushstrokes and palette of William Merritt Chase (cat. 32), John Singer Sargent (cat. 29), and Manet to the refined canvases of James McNeill Whistler (cat. 28) and the subjects that particularly fascinated Degas and Toulouse-Lautrec.

At first a loner, Maurer eventually became an active member of the Latin Quarter bohemia,[6] which included many American artists, among them Whistler, John White Alexander (1856–1915), and later Arthur Dove (cat. 53), Maurice Stern (1877–1957), and Max Weber (1881–1961). His involvement with this group of artists intensified after May 1902, stimulated by his association with Gertrude and Leo Stein and their renowned salon at 27 rue de Fleurus, which was in his Montparnasse neighborhood. Until August 1900, however, perhaps his closest artistic friends were his neighbors Robert Henri (1865–1929) and William Glackens (cat. 44). They often painted together, and at this time their work shared stylistic similarities, including a dark-toned, sparsely highlighted palette. They also relaxed together, frequenting the same cafés, and sought out comparable subjects, among them their neighborhood entertainment center, Bullier.[7]

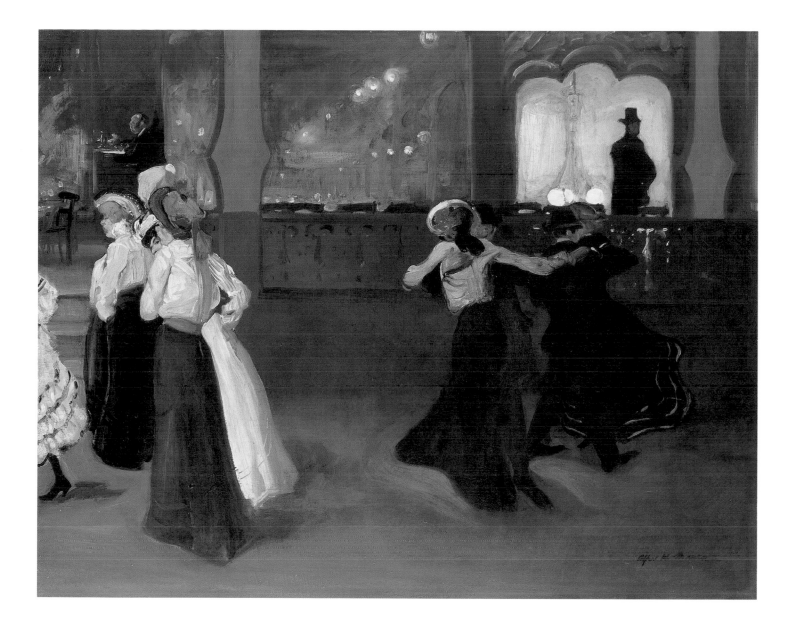

The Bullier dance hall, one of the largest and most popular institutions of its kind in the Latin Quarter, dates back at least to the 1840s.[8] Located at 33 avenue de l'Observatoire, between the Luxembourg Gardens and the Observatory, it was known as a gathering place mostly for students and visitors of both sexes to the city. Bullier was open three nights a week and offered special masked balls during Carnival time. Thursday galas were frequented by local habitués, while the weekend crowd consisted of clerks, artisans, servants, and people from the suburbs and country.[9] By the early 1900s, when Maurer and his friends were there, Bullier could be identified from the street by its red façade, sparkling lights, and high, arched entrance.[10] Inside, a broad stairway led to the spacious galleried ballroom with adjoining dining and gaming areas and expansive winter and summer gardens complete with spreading chestnut trees, alcoves, colonnades, and terraces, all occupying more than 4,500 square meters (48,400 square feet) and capable of accommodating several thousand visitors. Although the institution may have lost some of its splendor and bohemian reputation of the 1880s and 1890s, its scale was still impressive in 1900 when Maurer painted the Museum's canvas.

Maurer's only known painting of Bullier was undoubtedly sketched in situ,[11] developed in his rue de Daguerre studio in early 1900, and completed before he left for a visit to New York in the fall or, more likely, during the first part of his American stay.[12] In any case, *Le Bal Bullier* was first shown in 1902 at the Pennsylvania Academy of the Fine Arts in Philadelphia, where it appeared with the artist's *An Arrangement* (c. 1900, Whitney Museum of American Art, New York), already a highly acclaimed painting. This was followed by a rapid succession of national and international public viewings through 1915, at which time *Le Bal Bullier* may have been placed in storage in Paris.[13]

It is hard to know precisely what art Maurer saw in Paris at the turn of the century, although he undoubtedly attended the annual Salons, the Exposition Universelle of 1900, and regular gallery exhibitions. A stylistic comparison of *Le Bal Bullier* with Toulouse-Lautrec's *At the Moulin Rouge: The Dance* (fig. 29) strongly suggests that Maurer must have been familiar with this large and imposing canvas. Maurer and his colleagues were never residents of Montmartre, but it is known that they spent time there and that some of them painted scenes of the Moulin Rouge, where Lautrec's canvas had hung since just after its debut at the 1890 Salon des Indépendants. It is difficult to ignore the striking similarities in palette between the two paintings, particularly the predominance of greenish brown and brown-black tones of the floor and the background, accented throughout by areas and dashes of off-white, black, and crimson. Lautrec's canvas includes many more figures and is a more complex composition. Both paintings, however, deploy similar principal and foreground characters in comparable settings: cropped figures at the left, a central dancer (or dancers), and the indication of the dance hall space continuing into the background of the painting. The women wearing hats in the foreground of Lautrec's painting can also be compared with Maurer's female group at the left.[14] Lautrec has chosen to depict the crowd and activity at the height of the evening, while Maurer captures the Bullier's closing moments, as the painting's alternative title, *La Dernière Danse au Bal Bullier*, confirms.[15] In documenting this "modern" subject, it is not surprising that Maurer would have turned to the French master for inspiration.

Instead of emphasizing the dance-hall figures themselves over the surrounding architecture, as Lautrec has done, Maurer treats the elements even-handedly. The raised gallery and background café-garden, with its novel electric lights, are rather impressionistically rendered, but it is still possible to identify the Bullier's vast interior from contemporary descriptions.[16] Its size is further suggested by the women at the left, seemingly intent on an action beyond the canvas, of which the cutoff figure seems to be a part. The regularity of the Art Nouveau structures partitions the composition and tends to flatten out the foreground space occupied by the figures. The architectural elements not only define the space but also help to set the melancholic and disturbingly empty mood of the composition. The lateness of the hour and the essential loneliness of the scene are further suggested by the dark silhouetted male figure at the upper right, who is balanced at the upper left by a single waiter clearing tables and, below him, the group of dejected and heavily made-up women.

Maurer produced a relatively large group of Parisian café and street scenes, but besides the Smith College canvas few other dance-hall paintings by him are known, including *Le Moulin Rouge* of about 1903–4 (Curtis Galleries, Minneapolis). It depicts a raucous, crowded scene with bright lights and contrasts sharply with *Le Bal Bullier* not only in style, content, and mood but also because it apparently had no exhibition history during the artist's lifetime. *Le Bal Bullier*'s ample early exhibition history, on the other hand, suggests that Maurer was eager to use this painting to show off his technical accomplishments and to demonstrate to his American audience in particular his familiarity with contemporary French culture. Within the next two decades after completing this painting Maurer would encounter new influences and attempt new styles before his untimely death in 1932. *Le Bal Bullier*, however, remains as one of his significant accomplishments from a brief time when he enjoyed both personal happiness and professional success.

ECE-I

Figure 29. Henri de Toulouse-Lautrec,
At the Moulin Rouge: The Dance,
1890, oil on canvas, 45½ × 59 in. (115.6
× 149.8 cm). Philadelphia Museum
of Art, The Henry P. McIlhenny
Collection in Memory of Frances P.
McIlhenny (1986-26-32).

Rockwell Kent

TARRYTOWN, NEW YORK 1882–1971 AU SABLE FORKS, NEW YORK

40. *Dublin Pond*, 1903

Oil on canvas; 28 × 30 in. (71.1 × 76.2 cm); signed and dated in blue paint, lower right: *Rockwell Kent 1903*

Purchased, Winthrop Hillyer Fund (1904:2-1)

PROVENANCE: Purchased from the artist by L. Clark Seelye, president of Smith College.

EXHIBITIONS: New York, Society 1904, no. 292;[1] Brunswick 1969, p. 12, no. 1, repro.; Northampton 1974; Northampton 1979, ckl. p. 68; Yonkers 1983–84, pp. 60, 107, fig. 45; Keene + 1985, pp. 21, 93, 94, fig. 25; Santa Barbara + 1985, p. 16, no. 1,[2] color repro. p. 28; New York, IBM 1990.

LITERATURE: Traxel 1980, pp. 20–21, 23; Buff 1982, fig. 14; Johnson 1982, p. 20, color repro. p. 256; Chetham et al. 1986, no. 136, repro.

CONSERVATION: The painting has been wax lined (with the tacking edges largely intact) to a secondary support canvas and mounted on a keyed wooden stretcher. There is overall mechanical craquelure.

ROCKWELL KENT may be best remembered today for his stylized wood engravings and elegant book illustrations, his dramatic landscapes of mountains, snow, and ice, and the radical political views that brought his name to the front pages of newspapers more than once during the Cold War.[3] An early work, *Dublin Pond* may not be typical of the work for which Kent is best known, but it is an accomplished painting by a young artist, and it was a somewhat adventurous investment by the college to acquire it the year after it was painted.

When Kent entered Columbia University in 1900 as a student of architecture, he had just spent the previous summer at William Merritt Chase's (cat. 32) Art Village at Shinnecock Hills, on Long Island. The two following summers were passed there as well. Chase found him to be a student of great promise and gave him encouragement. Through Chase, Kent met Robert Henri, who was to become his teacher, probably beginning in the spring of 1903, when he evidently attended evening life-drawing classes at the School of Art, formerly known as the Chase School. Around the end of 1903 or early 1904 Kent abandoned his architectural studies and became a full-time art student, having been awarded a full scholarship at the school. By that time he had already attained some professional success. In spring 1903 two of his paintings were accepted for the Society of American Artists exhibition. Shortly thereafter the artist Abbott Thayer (1849–1921) invited him to spend the summer as his apprentice at an art colony in Dublin, New Hampshire, in the southern part of the state. When Thayer first went there in 1888, Dublin was already a thriving summer resort for Bostonians. Thayer was a friend of William James and other Boston intellectuals, and Kent later credited Thayer with having played a vital role in the formation of his cultural sensibilities.[4]

Kent's formal apprenticeship with Thayer that summer was brief. Kent recalled in his autobiography: "It was perhaps not later than the third day following my arrival that Thayer said to me, 'You are too good a painter in your own right to waste your time for me. Go ahead and paint.'"[5] Though perhaps best known for his allegorical subjects and idealized representations of women and children, Thayer was also a gifted landscape painter; no doubt his intense, almost mystical reverence for nature deeply influenced Kent's own responses to it both in his art and his life. Thayer's particular love was Mount Monadnock, near Dublin Pond, which he painted over and over again. In a letter to a fellow artist member of the Dublin colony, Thayer wrote: "The picture I want to paint with all the advantages is my old theme, winter dawn over our mountain. I *long* to do at last, a picture of it, that shall *be* and *stay* as flat and as free of half tints as the scene itself or many a Jap[anese] print."[6]

Dublin Pond, with its large, dark, almost flat and unarticulated hill, seems clearly influenced by Japanese prints, still popular among artists and collectors at the turn of the century. The houses on the shore are described sketchily, only faintly discernible in the enveloping shadow of the advancing twilight. Though the reflection of the hill is fractured as the water ripples slightly, the picture delicately captures the fleeting stillness that sometimes settles upon the end of a summer day. The cool, limited palette that

characterizes many of his later paintings is credited by Kent's biographer to Henri's influence, in part,[7] but in this painting it may owe more to Thayer's palette or Japanese prints or to the scene itself, since it is not clear that Kent had studied more than a few months with Henri before painting *Dublin Pond*. Later Kent tended to generalize nature, but in *Dublin Pond* he is responsive to what is seen and felt and thus succeeds in rendering the elusive mood of a particular time of day. Kent recalled that Thayer criticized one of his landscapes because he had softened the outline of a far hill to achieve a sense of distance, as Chase had taught him. Thayer pointed out that in fact each tree on the ridge could be clearly discerned and urged Kent to paint what he saw.[8] A painting so devoid of incident in such large, well-defined areas as *Dublin Pond* looks rather daring in retrospect, especially in the light of Kent's later work which, while often formally reductive, never came so close to abstraction.

In spring 1904 Kent again submitted works to the Society of American Artists show, this time two paintings produced during the preceding summer, *Monadnock* and *Dublin Pond*. In the Society's catalogue the latter is titled *Evening*. In the earliest extant Museum records it is known by its present title, and the reason for the change is not known. It was long erroneously supposed to be a painting called *Pond,* shown the previous year.[9] Perhaps the fuller title was preferred for its greater precision. In his autobiography, published more than fifty years after the event, Kent recalled: "Out of my summer had come two pictures of which I was sufficiently proud . . . to submit them to the jury of the following winter's National Academy exhibition. They were Dublin Pond on a still evening, with the reflection duplicating the darkly forested shores; and the cragged ridge and summit of Monadnock. . . . Within the first few days both pictures had been sold—*Dublin Pond* to Smith College."[10] The picture was singled out in press coverage of the show and its purchase by Smith College noted.[11] It was the first work by Kent to enter a museum collection. He was just twenty-one years old.[12]

BBJ

Thomas Eakins

PHILADELPHIA 1844–1916 PHILADELPHIA

41. *Edith Mahon,*[1] 1904

Oil on canvas; 20 × 16 in. (50.8 × 40.6 cm); inscribed on back of canvas: *To My Friend Edith Mahon / Thomas Eakins 1904*

Purchased, Drayton Hillyer Fund (1931:2)

PROVENANCE: The artist; given to the sitter, Edith Mahon; to Pancoast Galleries, Wellesley, Mass., c. 1922.[2]

EXHIBITIONS: New York, Knoedler 1944, no. 74, repro. p. 16; Utica 1946–47; Wellesley 1949–50; Williamstown 1950; New York, Wildenstein 1952, no. 62; Providence 1952, unno. ckl.; New York, Knoedler 1953, ckl. no. 35; Los Angeles 1953; Chapel Hill 1958, no. 109, repro.; Williamstown 1960, unno. ckl.; Chicago 1961, no. 10; Washington +, National Gallery 1961, no. 93, repro.; Northampton 1962, no. 19, repro. cover; Northampton 1964, no. 17, repro.; New York, Portraits 1968; Baltimore 1968, no. 64, repro. p. 85; Washington +, National Gallery 1970, no. 20, repro.; Northampton 1976 *American;* Northampton 1979, ckl. p. 39; Philadelphia + 1982, no. 141, repro. p. 129; Boston +, MFA 1983, no. 103, color repro.; New York, IBM 1990; London 1993–94, no. 44, pp. 34, 124, 156, 162–64, color repro. p. 165 (dtl.).

LITERATURE: *Pa Mus* 1930, no. 256; Goodrich 1933, p. 199 (no. 407), pl. 63; Jewell 1934, p. 6x; *SCMA Cat* 1937, p. 4, repro. p. 52; McKinney 1942, repro. p. 39; Larkin 1949, repro. p. 278; Faison 1958, pp. 139–40, repro.; Guitar 1959, repro. p. 115; Green 1966, p. 410; Schendler 1967, p. 226, fig. 113; Chetham 1969, p. 771; Novak 1969, p. 210, repro. p. 209; Sherrill 1973, pp. 18, 26; Hendricks 1974 *Eakins,* pp. 255, 329, pl. 52; Wilmerding 1976 *Growth,* repro. p. 163; Batterberry and Batterberry 1976, pp. 96–97, repro.; Wilmerding 1979, repro. p. 111; Faison 1982, p. 251, fig. 176; Goodrich 1982, pp. 55, 211, 215, fig. 250; Tomkins 1982, p. 108; Johns 1983, p. 167, pl. 15; Munsterberg 1983, repro. p. 132; Baigell 1984,

PURCHASED IN 1931, *Edith Mahon* was the second work by Thomas Eakins to enter Smith College's collection. The first, *In Grandmother's Time* (checklist no. 11), a small painting of an elderly woman at a spinning wheel, was bought by the president of the college, L. Clark Seelye, in 1879. This genre painting was not only one of the first works acquired for the newly established art collection, it was the first work by Eakins purchased for any public art collection.

Eakins studied for four years at the Pennsylvania Academy of the Fine Arts in Philadelphia, where he later taught. In 1866 he went to Paris and enrolled at the Ecole des Beaux-Arts as a student of Jean-Léon Gérôme (1824–1904). He also spent half a year in Spain, where the paintings of Diego Velázquez impressed him deeply. Although he made his mark early with brilliant sporting, hunting, and genre scenes, portraiture was his dominant interest. While still a student in Paris he spoke confidently of his abilities: "I will never have to give up painting, for even now I could paint heads good enough to make a living anywhere in America."[3]

Eakins did not flatter his sitters. Indeed, some felt that he did the opposite. It is not surprising, therefore, that only twenty-five of his more than two hundred known portraits were commissioned. Many sitters privately expressed their disappointment, and apparently few who were not his friends were anxious to face his uncompromising eye. Even they were not always happy. "We would expect," one biographer wrote, "from the expression on Mrs. Mahon's face, that she was a sympathetic sitter. She told John Ireland years later, however, that she did not like the portrait, but sat for it and accepted it as a favor."[4] Eakins often portrayed his subjects as older than they were. If Mrs. Mahon did indeed dislike her portrait, it may have been in part because she looks older than her actual forty or forty-one years. A native of London, she had come to America seven years earlier. She was an accompanist, an art she also taught. She also gave piano lessons and coached singers, as her advertisement in the Philadelphia Orchestra's programs for the 1907–8 season attests (fig. 30). According to Minnie Pancoast, a friend and singer, she was "one of the most prominent musicians in Philadelphia," where she lived for some twenty-five years.[5]

Many writers have pointed out that among Eakins's most telling portraits were those of sitters professionally involved in the arts or sciences, fields that engaged his own interests. He was devoted to music and went to concerts regularly. Although he did not play any instrument, he had taken voice lessons and his sisters played the piano. Friends remembered that music, especially chamber music, often moved him to tears. Edith Mahon apparently often played for the Eakinses. Eakins's wife, Susan Macdowell Eakins, herself a very good pianist, recalled that Mrs. Mahon was "learned in music" and "a remarkable accompanist."[6] Her reputation in this specialty was such that on one occasion, Mrs. Eakins recalled, she was summoned at the last moment to accompany the great contralto Ernestine Schumann-Heink at a concert with the Philadelphia Orchestra.[7]

pp. 141–42, fig. 140 and repro. cover; Chetham et al. 1986, no. 135, color repro. p. 35; Lifton 1987, p. 261, fig. 4; Simon 1987, p. 49, fig. 26; Wilmerding 1991, p. 260, fig. 182; Nochlin 1994, pp. 258, 263, fig. 254; Prettejohn 1998, p. 60, fig. 45 color.

CONSERVATION: The painting has been glue lined to an artist's board, which is mounted on an unkeyed wooden stretcher. There is an overall fine mechanical craquelure. There is inpainting in the larger drying cracks as well as an area of inpainting on the proper left shoulder and around the edges.

A friend of Mrs. Mahon's observed that "in the portrait one would imagine that she was rather a large woman but she was small and rather frail looking."[8] Not only does she seem larger, but the canvas too seems grander than its modest twenty-by-sixteen-inch format. (Eakins's more usual portrait format was twenty-four by twenty inches.) The sitter almost fills the canvas, and there is little incident except the deft but summary rendering of the chair's carving and the sequins and velvet bows of her low-cut black dress—perhaps one she wore at concerts—to draw attention from her strongly lit face. There is a striking contrast between the nearly chalk-white color of her chest, against which a bow is starkly silhouetted, and her darker, ruddier face. The picture's emotional burden is carried by the eyes. Flecks of light call attention to their moistness and for at least one observer hint at barely controlled tears.[9]

Edith Mahon comes from the last decade of Eakins's artistic activity, a period when his interest in psychological penetration was greatest. The sitter is a maker of music, an art that evoked a profound emotional response from Eakins. The portrait is also a testimony to the frequent observation that Eakins's portraits of women are far more intimate that those of men. He chose to pose Edith Mahon, not with her instrument, as he did when painting several male musician friends, but full face and close up—so close in fact that there is just a suggestion of recoil in the angle of her head, as if she were disconcerted by the artist's frank, even invasive, scrutiny. Though she seems to return the artist's gaze, it is understandable that at least one writer saw her eyes as being "turned away from the spectator," for indeed her glance is somewhat ambiguous.[10]

In any case, Edith Mahon appears to be a woman who has confronted a difficult life with stoicism and resolve. Little is known of her circumstances beyond the fact that by 1910 she was divorced and had lost one of her three children.[11] Divorce was, of course, uncommon and much stigmatized then and for many decades thereafter. Mrs. Eakins recalled hearing (not from Mrs. Mahon) that she had "suffered from great unkindness."[12] Another friend wrote that the portrait was "a *perfect* likeness and reveals in her expression the tragedies she endured. She was a valiant soul."[13]

BBJ

Figure 30. *Advertisement for Edith Mahon, accompanist, Philadelphia* Orchestra Journal, *1907–8 (8th season). Music Division, The New York Public Library for the Performing Arts, Astor, Lenox and Tilden Foundations.*

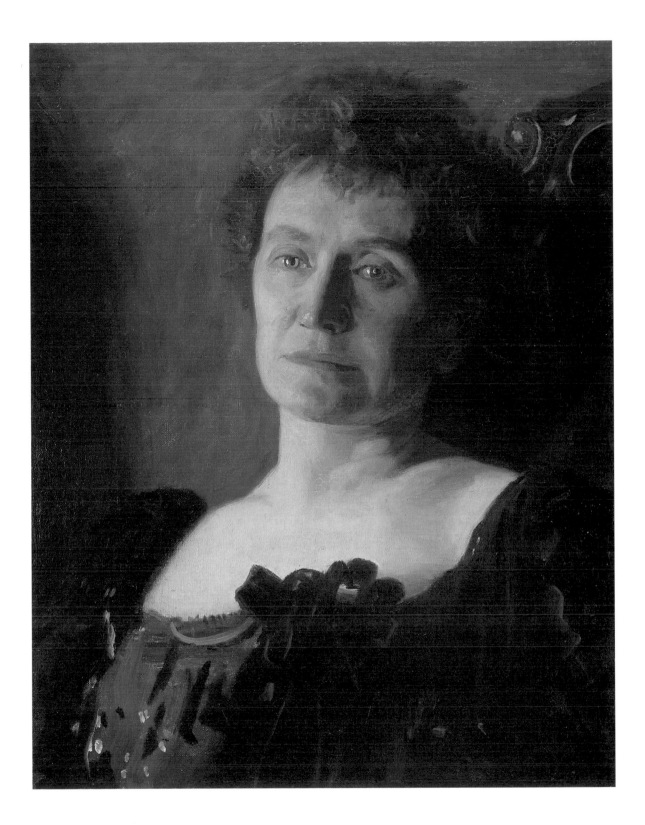

John Frederick Peto

PHILADELPHIA 1854–1907 NEW YORK

42. *Discarded Treasures*, c. 1904

Oil on canvas; 22 × 40 in. (55.9 × 101.6 cm); signed with forged signature in black paint, lower right: *WMH* [in monogram] *ARNETT*

Purchased, Drayton Hillyer Fund (1939:4)

PROVENANCE: Earle's Galleries, Philadelphia; sale, Samuel T. Freeman and Company, Philadelphia, *Three Hundred and Twenty Valuable Paintings by Eminent Artists of the American and Foreign Schools*, Jan. 30–31, 1933, lot 173 (as *Discarded Treasures* by William M. Harnett, 20 × 40 in.), sold for $40.00; Downtown Gallery, New York, 1938–May 1939.

EXHIBITIONS: New York, Downtown 1939, no. 11, repro. cover; Pittsburgh 1940, no. 129 (as by William Harnett); New York, Downtown 1948, no. 7 (as by William Harnett); Sarasota 1949; Northampton + 1950, no. 47, fig. 21; Middletown 1951, no. 7; Williamstown 1953; New York, Knoedler 1953, no. 40; Syracuse 1953, no. 29; Boston, ICA 1954; Philadelphia + 1955, no. 178 (Philadelphia, Madrid), no. 61 (Florence, Innsbruck), no. 68 (Ghent), no. 72 (Stockholm); Chicago 1961, no. 17, repro. cover; Dallas 1961, no. 69, repro. p. 54; Minneapolis 1963–64; Northampton 1964, no. 16, repro. cover; Rochester 1964–65, no. 55, repro.; La Jolla + 1965, no. 48, repro.; New York, Rosenberg 1966, no. 45, repro. p. 37; Washington +, National Gallery 1970, no. 43, repro.; Huntington 1972–73, no. 11, repro. p. 24; Katonah 1980, no. 29; Tulsa + 1981, fig. 8.11; Northampton 1983, ckl. no. 12;[1] Williamstown 1983, p. 32, no. 35, pl. 35; New York, IBM 1990; Santa Barbara 1991, p. 82, repro. p. 83.

LITERATURE: *NY Times* 1939; Best 1939, pp. 17–19, fig. 9 (as by William Harnett); *SCAQ* 1939, pp. 26–27, repro. (as by William Harnett); *Amer Mag* 1939, repro. p. 315 (as by William Harnett); Lane 1940, p. 16, repro. p. 12; *SCMA Suppl* 1941, p. 4,

DISCARDED TREASURES was acquired by the Museum in 1939 as the work of William Harnett (1848–1892) from the Downtown Gallery, where the painting served as the centerpiece of Edith Halpert's revelatory Harnett exhibition that spring. The canvas, since reattributed to John Frederick Peto, still bears the forged Harnett signature added sometime before 1933, when the painting appeared at Samuel T. Freeman's Philadelphia auction house as a Harnett work. Perhaps in an effort to hide any trace of the original Peto signature, the bottom edge of the canvas had been turned under nearly two inches, obscuring part of the lower portion of the composition. In the 1940s, when Alfred Frankenstein began to sort out Peto's paintings from the body of work attributed to Harnett, his research prompted a thorough physical examination of this and other canvases signed with spurious Harnett signatures. In 1950 *Discarded Treasures* was restored to its original size. Conservator Sheldon Keck, who undertook the treatment, reported finding traces of what he believed was once a Peto signature in an abraded area covered by the later Harnett monogram.[2]

In 1939 William Harnett was celebrated in the art press as a rediscovered native genius whose imaginative realism seemed to presage modern Surrealism. The purchase of *Discarded Treasures* by the Museum in the opening week of the Downtown Gallery exhibition was hailed as a bold move.[3] Yet within a decade the canvas would play a key part in the discovery of John Frederick Peto, Philadelphia's other great trompe l'oeil still-life painter of the late nineteenth century, proving just how felicitous, indeed, the purchase had been. In 1950 the Smith College Museum organized the first retrospective exhibition of Peto's work; today *Discarded Treasures* stands as one of the most complex compositions and richly layered subjects of Peto's late period.

Wolfgang Born first introduced Peto in his pioneering book, *Still Life Painting in America*, published in 1947, although he was unable to distinguish the painter's still lifes from those of Harnett. Subsequently, Frankenstein discovered paintings by Peto in the late artist's Island Heights, New Jersey, home—paintings that were like others he had believed represented Harnett's "soft" style. He realized then that those were also the work of Peto, even though many carried Harnett's signature. Frankenstein eventually identified twenty-one Peto paintings, including *Discarded Treasures*, that had been wrongly ascribed to Harnett. He based his reattribution on differences of style, iconography, and materials, as well as on the inconsistencies he found in the forged Harnett signatures.[4] The results of his research were first published in the *Art Bulletin* in March 1949.

The details of Peto's life and career have been most fully revealed by John Wilmerding in his 1983 monograph on the artist. A Philadelphia native, Peto enrolled in the Pennsylvania Academy of the Fine Arts in 1877 and there met and befriended Harnett. He exhibited periodically in the annual Academy exhibitions, with the Philadelphia Society of Artists, and at Earle's Galleries, a commercial establishment (*Discarded Treasures* carries an Earle's Galleries label), which also sold Harnett's paintings. In 1887 Peto began playing the cornet for the Island Heights Camp Meeting Association, and two years later he moved his family to that coastal resort town on the Toms River

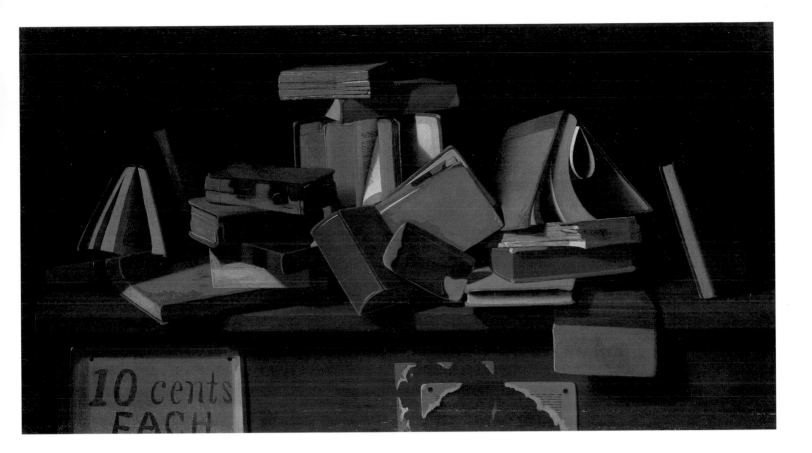

repro. p. 20 (as by William Harnett); Miller 1945, repro. p. 256 (as by William Harnett); Born 1947, p. 35, fig. 90 (as by William Harnett); Devree 1948, repro. p. 8x (as by William Harnett); Frankenstein 1949, pp. 46–50, fig. 2 (as by Peto); Goodrich 1949, pp. 57–58, fig. 2 (as by Peto); Louchheim 1949, p. 6x (as by Peto); Smith 1950; *Antiques* 1950, p. 215; *America* 1950, p. 32, repro.; Genauer 1953, p. 10, repro.; Frankenstein 1953, pp. 5, 17, 47, 107, 110–11, 176, fig. 17; *ICA Bulletin* 1954, p. 2; Sicre 1954, p. 124; *Antiques* 1965, p. 30, repro.; Frankenstein 1969, pp. 5, 16–17, 47, 107, 110–11, 184, pl. 17; Gerdts and Burke 1971, p. 144; Wilmerding 1979, p. 112, repro. p. 109; Washington +, National Gallery 1983, pp. 129–30, 253 (no. 117), repro. p. 126; Bragazzi 1984, p. 58, fig. 6; *Amer Art* 1985, p. 93; Chetham et al. 1986, no. 138, repro.; Bertram 1990, p. 39, pl. 22c; *Touchstone* 1990, p. 14; New York +, Metropolitan 1992, pp. 106, 109 n. 14.

CONSERVATION: Sometime prior to 1933 the canvas was restretched on a smaller stretcher. Tacks were driven through the paint surface on the top and bottom edges where the canvas had been turned under, obscuring part of the lower composition (the word "Each," in the sign reading "10 cents EACH," was no longer visible). In late fall 1949–January 1950, conservator Sheldon Keck wax lined and restretched the canvas on a keyed wooden stretcher of the original size. Losses were filled with gesso and inpainted in tempera. At this time traces of the original Peto signature and the later addition of the false Harnett signature were confirmed. In 1966 conservator Thornton Rockwell removed the earlier inpainting and refilled losses. The painting is in good condition, with mechanical craquelure overall.

at Barnegat Bay. There he continued to paint and also made photographs, but he exhibited his canvases only occasionally at the town drugstore. Throughout his life, Peto made no comments about his art, kept no written records, and sold few paintings.

Clearly Harnett was a major influence on Peto's art. Peto's daughter recalled to Frankenstein that her father "talked about Harnett constantly, invoking his name as the standard of perfection in still life."[5] He adopted Harnett's favorite subjects: still lifes that evoke a gentleman's world, with well-used drinking mugs and pipes, accouterments and trophies of the hunt, the clutter of the writing table, memento-filled letter racks, or the well-worn contents of a contemplative man's library. Even in the beach community of Island Heights, where *Discarded Treasures* was probably painted, Peto's view of the world remained centered on an interior landscape—on his living room, studio, and library. He painted those environments almost exclusively. Yet Peto was not a slavish copier of Harnett. Stylistically Peto's paintings exhibit softer contours, a brighter palette, and a looser application of paint. Moreover, he expanded upon Harnett's motifs. As Frankenstein has succinctly put it, "Peto also had his own world of subjects which Harnett never entered."[6]

Discarded Treasures is one of several canvases from Peto's mature period that are loosely based on Harnett's *Job Lot Cheap* (1878, Reynolda House, Winston-Salem, N.C.), in which a pile of used books is offered for sale. Peto's version of *Job Lot Cheap* (Fine Arts Museums of San Francisco), painted in 1892, was followed a decade later by the more focused *Discarded Treasures*, in which old books are advertised for sale at "10 cents each." Although books had been a component of Peto's earliest tabletop still lifes, in his later years the artist explored complex arrangements of discarded books for both their formal interest and their expressive possibilities. In *Discarded Treasures* Peto demonstrates his extraordinary ability to compose through color, line, and shape. Indeed, the interest that the painting held for Smith College Museum director Jere Abbott (a co-founder of the Museum of Modern Art) and curator Mary Best when they acquired the painting in 1939 lay in its "modernist" abstract design; as Mary Best described it:

> His delight and concern in pattern manifests itself in his compositional selection, design, and unity—in the book which hangs over the shelf, in others half-opened, in the sharp contrast between the printed type of the page and soft passages of shadow, in the diagonal emphases and the utilization of the calligraphic possibilities of curling leaves and old bindings. These abstract qualities, carried out in subtle variations of soft browns, grays, greens, rusts and yellows, call to mind the quiet and distinguished coloring of a Braque. Each volume has been considered for the relationship in form, color, and texture, which it bears to all the rest.[7]

Peto's subject is nonetheless emotionally charged. In *Discarded Treasures* the artist suggests symbolically that the value of things is relative—that one man's treasure is another man's junk. Painted a few years before his death, when he was suffering from Bright's disease, a painful kidney ailment, *Discarded Treasures* may also reflect Peto's own feelings of mortality and the painful truth that existence is finite.

PJ

Willard Leroy Metcalf
LOWELL, MASSACHUSETTS 1858–1925 NEW YORK

43. *Willows in March,* 1911[1]

Oil on canvas; 26 × 29¹⁄₁₆ in. (66 ×
73.8 cm); signed in gray paint,
lower left: *W. L. METCALF.*

Gift of Mrs. Charles W. Carl (Marie
Schuster, class of 1917) (1955:7)

PROVENANCE: F. W. Bayley
(dealer), Boston; to Winfield S.
Schuster, East Douglas, Mass.,
Feb. 1913;[2] to his daughter, Marie
Schuster (Mrs. Charles W. Carl),
Mt. Vernon, N.Y.

EXHIBITIONS: New York,
Montross 1911, ckl. no. 11; Chicago
1911, no. 239; Boston, Copley 1912,
no. 16; Chicago 1912 (exhibited,
but not in ckl.); Newport 1912,
ckl. no. 78; Boston, Copley 1913,
ckl. no. 5; Utica + 1976, no. 33, repro.
p. 42; Northampton 1979, ckl. p. 44;
Paris + 1982, no. 39, repro. p. 105;
Framingham 1985; Newport 1987,
p. 19, repro. p. 9; New York, IBM
1990; Hanover 1999, no. 6, repro.

LITERATURE:[3] *SCMA Bull* 1954–55,
p. 43; Keene + 1985, p. 95; De Veer
and Boyle 1987, fig. 277; New York,
Spanierman 1990, pp. 50–51, 157, 182.

CONSERVATION: The painting is
on a pre-primed canvas mounted on
a keyed stretcher. There is overall
mechanical craquelure. There are
stretcher creases on all sides and
some small losses.

WILLARD METCALF'S reputation as a master of Impressionist landscape and specifi-
cally as a chronicler of the New England countryside was established in the last years
of the nineteenth century and expanded during the early 1900s, when he would achieve
remarkable heights of critical acclaim and financial success. Near the end of his life
Metcalf was named "the poet laureate of these homely hills"[4] in recognition of the
scenes in all parts of New England that he recorded on canvas in all seasons, a spe-
cialty being winter landscapes.[5]

Metcalf's road to success was neither short nor direct.[6] He studied with the wood
engraver George Loring Brown (1814–1889) in Boston in the 1870s, and attended the
Académie Julian in Paris in the 1880s; there followed an intense if temporary fascina-
tion with the peasant paintings of Jules Bastien-Lepage. Underlying all this instruc-
tion was Metcalf's involvement with graphic illustration that continued, primarily
as a means of financial support, into the mid-1890s.

Nevertheless, Metcalf always had a special inclination for landscape painting, and dur-
ing his travels to various art colonies in the French countryside he began to pursue this
interest seriously. Visits to Monet's Giverny from 1885 to 1888 with American col-
leagues were among the most important of them.[7] It was not until he undertook paint-
ing expeditions to Gloucester, Massachusetts, in 1895 and Damarascotta, Maine, in
1903, however, that he really committed himself to his signature style, a blend of
Impressionism and Realism. Thereafter he almost completely abandoned the human
figure in his art.

In 1887 Metcalf established his residence in New York, where for the next thirty years
he became intensely involved in the art scene by teaching, exhibiting, and joining a
number of organizations. During this time he became associated with other artists
who would together become known as the Ten American Painters.[8] By 1911, when
the Museum's canvas was painted, Metcalf had achieved real professional success.

It has been assumed that *Willows in March* was painted in late February or early March
of 1911, although the canvas is undated and its subject, an isolated and somewhat gen-
eralized snow-covered hillside, provides no clues to its precise location. If this date
is correct, the canvas was completed during a period of both personal contentment
and artistic achievement. In January of that year Metcalf married his second wife,
the former Henriette McCrea of Chicago. Their honeymoon was spent in Cornish,
New Hampshire, at the country home of the noted New York architect, landscape
gardener, and painter Charles Adams Platt (1861–1933), where Metcalf is known to
have executed a series of landscapes.[9]

The painting made its debut, along with *Cornish Hills* (fig. 31), another winter scene,
in the annual exhibition of the Ten American Painters that opened in March of 1911 at
the Montross Gallery in New York. This pairing of canvases illustrates two separate
artistic approaches that Metcalf pursued intermittently throughout his mature career.
Most critics seemed to have preferred *Cornish Hills,* a more traditional composition
with a clearer sense of place.[10] A diagonal snowy path, delicately articulated by a sub-

tle coloristic play of light and shadow, leads the viewer into the composition. This more expansive and identifiable view of Blow-Me-Down Pond, with the row of small buildings nestled along its edge and the clearly delineated snow-covered mountain ridge beyond, was easier for both the public and the critics to "read" and identify.

In contrast, the more visually confining *Willows in March* offers a meditative message of utmost peace and quiet, with no human or anecdotal reference. The slight diagonal created by the evergreen-lined ridge on the high horizon and the freely brushed wedge of dark shrubbery at the right center of the composition provide two of the few indications of depth. The flattened space is reinforced not only by the square format and high horizon but also by the overall off-white and bluish gray tonalities and the delicately rendered trunks and branches of the bare trees. Attention is thus focused on the pure and poetic design of the composition and the abstract juxtapositions of dark mass and delicate line. Absent are any indications of road or river to draw the viewer into the composition; a subtly modulated snowy mass alone constitutes the foreground.

A comparison of Metcalf's winter landscapes[11] reveals that *Willows in March* was one of the artist's most abstract compositions, approaching more closely than most of his more realistic and panoramic views the late works of John Henry Twachtman (1853–1902), fellow member of the Ten American Painters. Twachtman, whom Metcalf greatly admired, had executed canvases in the 1890s such as *Brook in Winter* (fig. 32; also known as *February)* and *Winter Silence* (Mead Art Museum, Amherst College, Amherst, Mass.), which scrutinize nature so closely and describe it with such a bravura stroke and thick impasto that the scene almost dissolves into a pure tonal design. Although *Willows in March* is more precisely delineated with a finer brush and smoother paint quality, the loss of identifiable time or place in the overall whiteness of sky and snow echoes the art of Twachtman. Such subjects isolated from nature with near abstract design undoubtedly also take inspiration from the winter paintings of Claude Monet, such as *Snow at Argenteuil* of 1875 (Museum of Fine Arts, Boston) and particularly his series of canvases of Norway's Sadviten Village or Mount Kolsaas from 1895, which Metcalf might have seen.[12]

ECE-I

Figure 31. Willard Leroy Metcalf, Cornish Hills, *1911, oil on canvas, 35¼ × 40 in. (89.5 × 101.5 cm). Collection of Thomas W. and Ann M. Barwick.*

Figure 32. John Henry Twachtman, Brook in Winter, *c. 1892, oil on canvas, 36⅛ × 48⅛ in. (91.8 × 122.2 cm). The Hayden Collection, Courtesy, Museum of Fine Arts, Boston (07.7).*

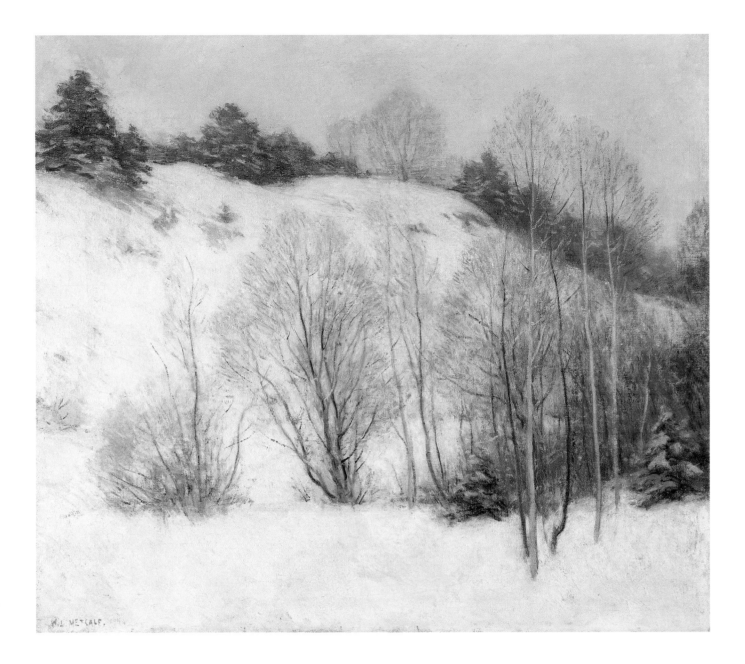

William Glackens

PHILADELPHIA 1870–1938 WESTPORT, CONNECTICUT

44. *Bathers, Bellport, No. 1*, 1913

Oil on canvas; 26 × 32 in. (66 × 81.3 cm); signed in red paint and dated in ocher paint, lower right: *W. Glackens / 1913*

Gift of Ira Glackens in memory of Anne H. Middlebrook (Nancy) Glackens, class of 1932 (1990:16)

PROVENANCE: The artist's widow, Edith Dimock Glackens (1876–1955); the artist's son, Ira Glackens (1907–1990), Shepherdstown, W.Va.

EXHIBITIONS: New York, Whitney 1938–39, no. 46; Pittsburgh 1939, *Glackens*, no. 61.

CONSERVATION: The painting is on a pre-primed linen canvas (approximately 37 threads per inch vertically, 41 threads per inch horizontally) mounted on its original keyed stretcher. There are stretcher creases and small inpainted punctures in the upper center and in the upper left and lower right corners. Acryloid B72 has been applied over the original, probably natural, varnish.

THE MUSEUM'S *Bathers, Bellport, No. 1*[1] belongs to a series of beach scenes by William Glackens painted in Bellport, on the Great South Bay in Long Island. From 1911 to 1916 the artist, his family, and friends returned in the summer to this village, where Glackens recorded the beach and crowds of bathers enjoying the water and activities on the sandy shore.[2] Motifs and recognizable landmarks are repeated from canvas to canvas: wooden jetties reaching out into the surf, slides, bathhouses or changing shacks, a barnlike "vacation home for New York shopgirls,"[3] and sailboats tacking in the breeze. Most, like the Museum's canvas, adopt a position on the shore looking past bathers and beach structures to the water; some seem to have been painted from the jetties, looking back toward the houses and vacationers on land. Glackens had been attracted to holiday bathing subjects as early as his 1906 trip to France, where he honeymooned with his new wife, Edith Dimock Glackens.[4] The Bellport paintings, with their repetition of motifs on a single theme, active brushstrokes, and high—almost Fauve—color key, are a further development of Glackens's first Impressionist beach scenes painted on Cape Cod in 1908.

Like John Sloan (1871–1951), George Luks (1866–1933), and Everett Shinn (1876–1953), Glackens began by supporting himself as a newspaper illustrator in Philadelphia while studying painting in night classes at the Pennsylvania Academy of the Fine Arts. Joining the painter Robert Henri on a trip to France in 1895, Glackens became acquainted with the work of the French Impressionists, whose paintings were also regularly on view in exhibitions at the Durand-Ruel Gallery in New York, where he resettled in 1896. In New York he continued to make his living as an artist-reporter for the *New York Herald* and as an illustrator specializing in "East Side" stories for such magazines as the *Saturday Evening Post, Scribner's,* and *McClure's,*[5] but painting remained his chief interest. For a decade Glackens painted Paris and New York scenes of public parks and leisure activities in a style heavily influenced by the dark, tonal contrasts of Edouard Manet, culminating in his early masterpiece *Chez Mouquin* (1905, Art Institute of Chicago). After his participation in the famous Macbeth Gallery exhibition in February 1908 of the Eight, a group around Henri including Glackens, Maurice Prendergast, Ernest Lawson (1873–1939), Arthur B. Davies (1862–1928), and the urban realists Shinn, Sloan, and Luks (who had also relocated to New York from Philadelphia), Glackens began to move toward a more lyrical style.[6]

This new stylistic phase marked a major shift away from the darkened palette of Manet to Auguste Renoir's lighter colorism, a transition that began with Glackens's Cape Cod paintings in 1908 and developed through the Narragansett Bay beach scenes of 1909 and the Nova Scotia paintings of 1910.[7] Typified, as William Gerdts describes it, by "soft, feathery brushwork and rich, variegated colorism, with emphasis on soft pinks, yellows, and greens,"[8] Glackens's Renoir-inflected style is fully expressed in the Bellport paintings. In the Museum's canvas, Glackens combines a variety of brushstrokes—broken and divided in the waves, and broader, overlaid strokes in the sky, beach, and dune grasses. The purple, dark blue, and black of the bathers' costumes provide the only dark accents in the composition, while the sky is an almost abstract zone of color: a corona of pink at the horizon line, overlaid with

orange strokes, rises into a blue band overlaid with light green. Pink and green striations mark the sides of the pier, and the dune grasses in the left foreground are multiple single strokes of a variety of hues. While the colors maintain their reference to nature, they are heightened beyond an Impressionist palette, suggesting the influence of Henri Matisse (1869–1954) and the brilliance but not the arbitrary character of the Fauves.

The Bellport canvases belong to a tradition of American beach scenes but in particular to the pictorial history of Long Island as a destination for both tourists and artists beginning in the latter part of the nineteenth century, when the Long Island Railroad encouraged travelers to make use of its two hundred miles of coastline.[9] Beaches closer to Manhattan—Coney Island (cat. 27), Rockaway Beach, and Far Rockaway— attracted large numbers of bathers on day trips. Coney Island and the popular entertainments of its amusement park, established in 1893, contrasted markedly with the "genteel East End" of Long Island and the Hamptons, which attracted artists seeking "characteristically American analogues" of the English and continental country villages they had visited as students.[10] Impressionist waterside leisure scenes of the late

Figure 33. William Glackens, Jetties at Bellport, *c. 1916, oil on canvas, 25 × 30 in. (63.5 × 76.2 cm). Albright-Knox Art Gallery, Buffalo, N.Y., Evelyn Rumsey Cary Fund, 1935 (35.5).*

nineteenth century, typified by decorous views of Shinnecock near Southampton by William Merritt Chase (cat. 32), were succeeded by early-twentieth-century Realist paintings of beach recreations, such as Sloan's *South Beach Bathers* (1907–8, Walker Art Center, Minneapolis), whose middle- and working-class figures lounge in up-to-date bathing apparel on the sands of Staten Island.[11]

Glackens had also visited Coney Island from 1905 to 1907, but the bathers in his Bellport canvases belong to a middle-class summer-vacation community rather than the teeming crowds on day trips filling the beaches close to Manhattan. Unlike Sloan's realistically observed bathers, Glackens paints his vacationers as anonymous figures dressed in the otherwise undifferentiated uniforms of their dark swimming costumes. While Bellport was not as popular as Coney Island and the Rockaways, according to the artist's son, Ira Glackens, who spent his childhood summers in this "unspoiled town," "almost everyone in art, literature or music appeared in Bellport sooner or later."[12] Ira Glackens specifically mentions visits by Prendergast and the great Philadelphia collector Dr. Albert C. Barnes and his wife,[13] recording that his father found new subjects to paint and sketch at Blue Point, where Mrs. Barnes's mother had a cottage. The Glackens's small rented cottage in the middle of the village was abandoned in the summer of 1916, when the fear of an infantile paralysis (polio) epidemic caused the family to move to a large, secluded house in the nearby town of Brookhaven.[14]

Rita Sanders, curator of the Bellport-Brookhaven Historical Society, has identified the scene depicted in the Museum's canvas as a small stretch of beach at the foot of Bellport Lane (now the site of the village dock and marina).[15] In *Bathers, Bellport, No. 1,* the earthworks pier or dock extending in a strong diagonal from the left side of the canvas was probably a spit of land enlarged when dredging was done at the nearby boatyard; the vertical planks along its sides, rendered in pinks and greens in the painting, are a retaining wall.[16] The wood structure at the end of the pier is a reviewing stand, or crow's nest, used by the starter and commodores for yacht club races. During regattas, the flags of competing yacht clubs were displayed from the stand on lines hanging from the yardarms of the mast. Although it would have been "out of frame" in the scene shown in the Museum's canvas, a gazebo (since rebuilt) stood at the beach end of the pier. The gazebo and pier are visible in a number of Glackens's other Bellport paintings, including *Jetties at Bellport* (fig. 33).[17] In this painting, which is a view farther down the beach from the site depicted in the Museum's canvas, the gazebo and pier are visible at the horizon line.

LM

Paul Manship

ST. PAUL, MINNESOTA 1885–1966 NEW YORK

45. *Centaur and Dryad,* 1913, cast 1915

Bronze (edition 4/5); 28 × 18½ × 11½ in. (71.1 × 47 × 29.2 cm); signed and dated on ground on which figures stand: *PAUL MANSHIP / © 1913;* inscribed on base edge, front left corner, below frieze: *ROMAN BRONZE WORKS –N-Y-*

Purchased from the artist (1915:14-1)

PROVENANCE: The artist.

EXHIBITIONS: Northampton 1916; St. Paul + 1985, no. 42, repro. p. 69.

LITERATURE:[1] Caffin 1913; Adams 1914; Gallatin 1916, p. 220, repro. p. 221; Gallatin 1917, pp. 5, 12, repro.; Adams 1923, repro. opp. p. 180; *SCMA Handb* 1925, p. 47, *repro. p. 70; Mather 1927, p. 221; Casson 1930, pp. 48, 53, figs 7, 8; *SCMA Cat* 1937, pp. 35–36, *repro. p. 123; Brookgreen 1938, repro., unpag.; Agard 1951, p. 156, *fig. 85; Murtha 1957, pp. 13, 150 (no. 28), pl. 2; Washington, National Collection 1958, p. 9; St. Paul 1972–73, pp. 12–13, 22, 42 n. 52, repro. p. 13; Rather 1984, pp. 113–14, fig. 8; Shapiro 1986, repro. p. 10; Manship 1989, pp. 31, 36–37, 43, 45–47, 49, 52, 54, 79, pls. 32, 37, 38; Rand 1989, pp. 29–31, figs. 15–18; Conner 1989, pp. 134–35, 142 n. 10; Noble 1991, repro. p. 25; Rather 1991, p. 221, pl. II; Rather 1993, pp. 76–85, 90–92, 106, 165, 233 n. 43, figs. 41, 43.

CONSERVATION: The sculpture is in excellent condition. It was cast in two sections that are loosely bolted together, and there is some wear from rubbing along the seam. There are traces of gold leafing. It is difficult to determine whether this has worn away accidentally or was deliberately removed by the artist.

IN THE FALL of 1912 the young Paul Manship returned to the United States after three years of study at the American Academy in Rome. In February 1913 he exhibited ten recent works, including a cast of the bronze *Centaur and Dryad*, at New York's Architectural League. This proved to be a watershed year for Manship, who married, had his first child, held his first major exhibition, received his first important commissions, and was awarded the Helen Foster Barnett Prize by the National Academy of Design for *Centaur and Dryad*.

This work, praised by many as Manship's early masterpiece, created considerable controversy and notoriety for the artist. In 1914 the postmaster of New York refused to allow an issue of *Metropolitan Magazine* reproducing the sculpture to go through the mail on the grounds of obscenity.[2] According to Postmaster Edward Morgan, the sculpture was "indecent" and "bestial," and depicted "the leering passions of a monster."[3] He added, "The *Metropolitan Magazine* may call me the Puritan Postmaster, but by the time I get through with them they may not be so anxious to publish pictures of this sort." After an appeal by the publisher to President Woodrow Wilson, the U.S. postmaster general rescinded the censure. The censorship resulted in fame for Manship and increased circulation for the magazine.[4]

Other contemporaries perceived a moralizing message. Smith College President Seelye interpreted the *Centaur and Dryad* as a conflict between "the beastly and the womanly," noting that Smith, as a women's college, was a most appropriate place for the sculpture.[5] While the subject derives from pagan imagery of the bacchanal, it has been used since the Renaissance to portray the struggle between chastity and desire, virtue and animal passion.

The bronze depicts a centaur, part man and part horse, grasping a dryad, or wood nymph, who struggles to pull away from him. In the low relief on the long sides of the base, satyrs chase nymphs and maenads while bacchic revelers play music and dance. Griffins stand guard on the short ends. Both the subject and the style have sources in archaic Greek art of the late sixth to early fifth century B.C., which Manship studied in Rome and on trips to Greece. Contests between centaurs and youths or maidens were ubiquitous in ancient art, the most celebrated being the *Battle of the Lapiths and Centaurs* from the Parthenon frieze. Scenes of bacchanalia, which are particularly prevalent in Greek vase painting, served as the source for the decorative linear style Manship used in the abstract patterning of the drapery and hair on *Centaur and Dryad*. The artist did not strictly copy Greek prototypes but drew his inspiration from many sources, combining the archaism of early Greek art with his own unique decorative stylization.[6]

Although the work was conceived in Rome, Manship cast it in New York. Contemporary photographs show various stages in the evolution of the work. One of Manship in his Rome studio in November 1909 (fig. 34) shows an early clay stage in which the subject and composition are nearly the same as in the final bronze cast. Another early photograph, made by Manship at about the same time (fig. 35), clearly reveals the influence of the more traditional Beaux-Arts style. A 1912 photograph by Manship

Figure 34. Paul Manship in his studio in Rome with early clay version of Centaur and Dryad, *1909. Courtesy of John Manship. (Although this photograph is inscribed "1910," another print exists that is signed by the artist and dated 1909.)*

(fig. 36) shows a revised figure group in plastilene, in Manship's developing mature style, which combined archaism with a modernist lyricism.

While still in Rome Manship made further refinements, altering the drapery and bringing the figures closer together, so that the centaur seems to kiss the dryad on the neck. In Rome he cast the final version in plaster.[7] Upon his return to New York in the fall of 1912 he had the plaster figure group cast in bronze, but the pedestal remained unfinished. A preparatory drawing (fig. 37) exists for the back side of the pedestal, which depicts satyrs chasing maenads. Comparison with the bronze shows somewhat different gestures and placement of the figures. A photograph of a November 1913 exhibition in Manship's New York studio shows the bronze group on a plaster pedestal, which appears to be the final version before casting.[8] Gaston Lachaise (cat. 51), who was working with Manship at this time, probably executed much of the work on the base and the chasing of the final bronze.[9]

Manship considered *Centaur and Dryad* one of his finest bronzes. In a 1915 letter to Alfred Vance Churchill, the artist commented:

> The "Centaur and Dryad" is the piece, of all my small bronzes, on which I have expended the greatest effort; in fact, it was in the process of making . . . for four years. I have always considered it, therefore, to be the best, in many respects, as well as the most elaborate of the small bronzes.[10]

He continued by saying that he had decided to limit the edition to four copies. In a second letter from the artist to Churchill, written after the Museum had ordered a cast, he said:

> Your bronze will be the last casting of the group. The moulds will then be broken, making four copies sold. I wish to have, as a record and for the purpose of exhibition, a copy to keep for myself, making a total of five copies extant. They are placed as follows: in the Metropolitan Museum of Art, New York; the Detroit Museum of Art; the City Art Museum of St. Louis and Smith College of Northampton.[11]

Figure 35. Paul Manship, photograph of early version of Centaur and Dryad, *c. 1909–10. Courtesy of John Manship.*

Figure 36. Paul Manship, photograph of revised figure group in plastilene for Centaur and Dryad, *1912. Courtesy of John Manship.*

Figure 37. Paul Manship, Satyr Chasing Maenad, *n.d., pencil on paper, 5¾ × 8⅝ in. (14.6 × 21.9 cm). National Museum of American Art, Smithsonian Institution, Washington, D.C., Bequest of Paul Manship (1966.47.169).*

The first four casts were in public collections within two years, quite a feat for a young artist just beginning his career. In spite of Manship's assertion that the mold would be broken after the fifth cast, seven copies are now in public collections. In addition to those listed by Manship, the Fogg Art Museum, Cambridge, acquired a cast in 1928 (almost certainly the one kept by Manship); the Phoenix Art Museum acquired one in 1960; and in 1979 the Wadsworth Atheneum in Hartford, Connecticut, acquired a 1925 replica of the 1913 original.

Centaur and Dryad represents the auspicious beginning to the career of one of the most renowned sculptors of early-twentieth-century America. With this work Manship introduced a distinctively modern approach based on the decorative stylization of form. His work influenced the development of Art Deco, and at the height of its popularity in the 1930s Manship was considered the preeminent sculptor of the movement.

<div align="right">CLB</div>

Elie Nadelman
WARSAW, POLAND 1882–1946 NEW YORK

46. *Resting Stag*, C. 1915

Gold-leafed bronze on wood-veneered base; 14⅜ × 20½ × 10 in. (36.5 × 52 × 25.4 cm); not signed, not dated

Purchased with income from the Hillyer, Tryon, and Mather Funds and funds given by Bernice Hirschman Tumen, class of 1923, in honor of the class of 1923 (1983:24)

PROVENANCE: Mrs. Henry T. Curtiss (Mina Kirstein, class of 1918), Weston, Conn.[1]

EXHIBITIONS:[2] Northampton 1975 *Centennial*, no. 56, repro. p. 32; New York, IBM 1990.

LITERATURE:[3] *Amer Art* 1917; Eddy 1917; McBride 1917, repro. p. 46; *Vanity* 1918, repro. p. 54; Pollak 1936, p. 557; Kirstein 1973, pp. 148, 305–6 (no. 188), pl. 56 (DIA cast); Chetham et al. 1986, no. 146, repro.

CONSERVATION: The sculpture was displayed outdoors by the former owner and exhibits black and green sulfide corrosion above and below the gold leaf surface. There is a casting patch in the right center of the chest.

ELIE NADELMAN established his reputation as a forerunner of modern sculpture in Paris during the first decade of the twentieth century, but it was in New York, from 1914 through the 1920s, that his art and patronage developed to their fullest.[4] Born into a cultured family in Warsaw and educated there at its Art Academy, he went in 1904 to live in Paris, where he found much to stimulate his creativity and theoretical thinking—less in the academies than in the city's wide-ranging museums, art galleries, and avant-garde art circles. Although tending to remain aloof and to work independently, Nadelman associated with avant-garde artists, including Henri Matisse, Amedeo Modigliani (1884–1920), Pablo Picasso (1881–1973), Constantin Brancusi (1876–1957), and Alexander Archipenko (1887–1964), many of whom he met at the famed 27 rue de Fleurus gatherings of Gertrude and Leo Stein.[5]

His earliest heads and nude figures, often executed in plaster or marble before being cast in bronze, reflect an attraction to the pure volumetric forms of archaic Greek sculpture, which he first saw at the Munich Glyptothek in 1904.[6] But it is in his pen-and-ink drawings, dating from as early as 1905, that his analysis of volume, form, and contour can be documented. These led to his radical antiacademic theories of "plastic beauty" or "pure plastic art," which he emphatically distinguished from analytical abstract art.[7] In 1910 the sculptor wrote: "The subject of any work of art is for me nothing but a pretext for creating significant form, relations of forms which create a new life that has nothing to do with life in nature, a life from which art is born, and from which spring style and unity."[8]

Nadelman's characteristic combinations of curves and countercurves that replaced naturalistic representation probably first took shape on paper and were undoubtedly a consequence of his exposure to the Jugendstil movement in Munich, where he had stopped in 1904, and to Art Nouveau developments in Paris up to that time.[9] But by 1908, when Leo Stein brought Picasso to his studio, and in 1909, at the time of his solo exhibition at Galerie Druet in Paris, when he was heralded as one of the most progressive of modern sculptors, it was clear that his abstract theories had begun to be reflected in his three-dimensional work. Nadelman's studies of the human figure lasted throughout his career, but for a relatively brief time in the latter part of his Paris years he applied his abstract theories of simplification and stylized vision to animal forms, which resulted in later works such as the Museum's *Resting Stag*.

In the winter of 1911 Nadelman traveled through southern France and northern Spain en route to Barcelona for an exhibition of his work. During this time, he is reported to have made drawings of bullfights and prehistoric cave paintings.[10] The sculptor's interest in such animal subjects undoubtedly was fostered by his earlier exposure to the animal collections of the Bayerisches Nationalmuseum in Munich[11] and the numerous examples of animal sculptures on view in the Parisian parks, museums, and galleries since the late nineteenth century. Such works most likely included Salon-scale and monumental sculptures by masters such as Antoine-Louis Barye (1796–1875) and Emmanuel Frémiet (1824–1910).

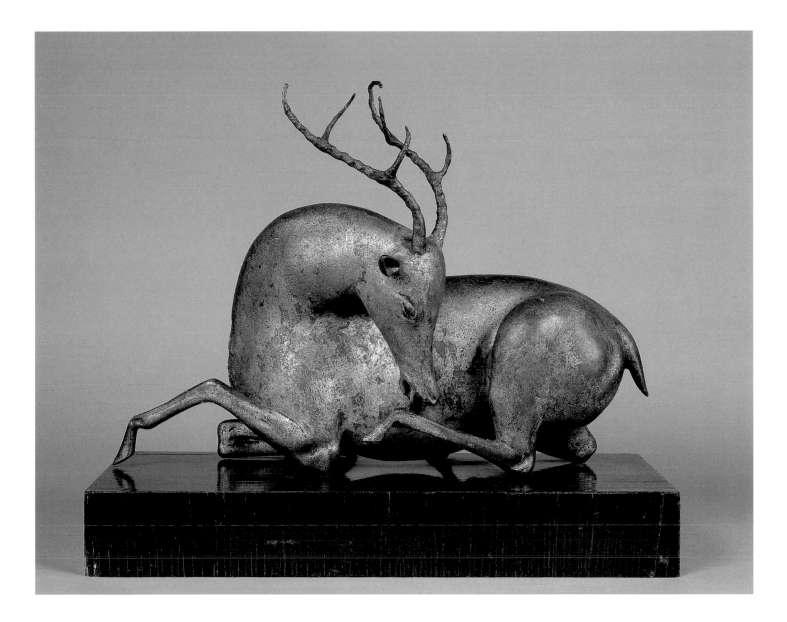

Figure 38. Elie Nadelman, Standing Fawn, *c. 1915, bronze, 19 × 16 × 19½ in. (48.3 × 40.7 × 49.5 cm). Museum of Art, Rhode Island School of Design, Providence, Bequest of Miss Ellen D. Sharpe (54.147.18).*

The horse appears to have been the first animal to capture Nadelman's creative attention; plaster casts of a sculpture simply titled *Horse* were exhibited as early as April 1911 at the Paterson Gallery in London and then again at Alfred Stieglitz's (1864–1946) 291 Gallery in New York. It seems likely that Nadelman began to add deer to his repertoire about 1915.[12] His plaques and large-scale sculptures featuring deer, such as *Buck Deer,* appear to have grown conceptually out of his work with the horse. The *Buck Deer*'s tubular neck and body in relation to the slender legs, its small curved tail and short ears are comparable to the proportions of his earlier representations of horses. Unlike the horse, however, which was captured only in a standing position, albeit in various sizes, the deer were conceived in four different poses (standing and reclining), all on approximately the same quarter-life-size scale.

The earliest published references to Nadelman's deer appear to have been in response to three important exhibitions of his work in New York in 1917, including two showings at the prestigious Fifth Avenue Scott and Fowles Gallery. *Le Cerf* and *Le Jeune Cerf* were included in the sold-out one-artist show at Scott and Fowles in February, the largest exhibition of Nadelman's work to that date in this country. These were possibly the first deer by Nadelman to be exhibited, and *Le Jeune Cerf* was especially noted by the press.[13] In a November exhibition at the gallery, Nadelman was represented by two three-dimensional bronzes, *The Dancer* and *Resting Stag* (also sometimes referred to as *Resting Deer*). At the end of the year, the *Resting Deer* was reviewed as "a leading work in the exhibition" *Allies of Sculpture,* held in the roof garden of the New York Ritz-Carlton Hotel as a war charity event.[14]

During the time Nadelman was actively involved with deer as a subject (about 1915–17), a conceptual progression can be identified from the standing type represented by *Le Jeune Cerf* and *Standing Fawn* (fig. 38, which may be the sculpture originally shown under the title *Le Jeune Cerf*) to the *Resting Stag.* The *Standing Fawn* and the *Resting Stag* each gently arches its neck backward to lick its angled and extended left hind leg delicately above the hoof; in both sculptures, the gracefully balanced full curves of the body contrast with the sharp linearity of the animal's slender limbs. *Standing Fawn* balances on three sharply attenuated legs, while the stag is supported on its hocks and other points of contact offered by the bent limbs of the reclining animal. The stag's curving antlers add height and a light decorative element comparable to the thinly tapered legs of the standing animal. The *Resting Stag* appears to have been created as a variant to the standing *Jeune Cerf,* perhaps at least in part in an attempt to satisfy the popular demand at the time for these stylized and highly refined sculptures. It is conceivable that over time Nadelman may have encountered technical difficulties in casting the standing deer with its very thin supports and therefore may have reverted to the recumbent type, while still maintaining the compact contour shape achieved by bending the head of the animal backward along the side of its body.

It has been suggested that at least one edition of six *Resting Deer* was produced by Rudier in Paris; these casts may have been made either during the sculptor's lifetime or posthumously.[15] At least seven bronze casts of the sculpture have been located, with slightly different titles, bases ranging from veneered wood to veined marble, and a variety of patinas from mottled gilt to dark polished surfaces.[16] The Museum's cast, a smaller and presumably later one, has a rubbed gold patina, worn in many places, and is mounted on a wood-veneered base. The variations in the patina add visual interest

to the overall smooth uniformity of the solid round forms of the body and haunches of the deer and its attenuated legs. The only other textures added to the form are the subtle corrugations of the surfaces of the antlers, the lines delineating muscle, the crescent closed eyes of the deer, and the small patch of curls on its chest. Whether Nadelman conceived *Resting Stag* as a unique statue or to be paired with *Wounded Stag* (fig. 39), a recumbent male deer with an arrow embedded in its neck, has not been confirmed. Interestingly, in addition to other close resemblances between the two stags, the position of the forelegs—one extended forward, the other folded under—is the same, although in *Resting Stag* a visual rhyme is created by including the elegantly extended fore and hind legs on the same side of the body. Such pairings have become a popular theme for collecting purposes and in more recent exhibitions.[17]

Nadelman created his deer and other animals at the peak of his career. Time and financial circumstances, however, overshadowed his success: the market crash of 1929 severely curtailed his resources, and his attempts to secure architectural commissions proved unsuccessful. He died almost forgotten in the mid-1940s. Since then major efforts on the part of long-time supporter Lincoln Kirstein at the Museum of Modern Art in 1948 and John Baur at the Whitney Museum of American Art in 1975 have helped to resurrect Nadelman's reputation and to convey the importance of his artistic contributions to a new generation. Considered an exponent of extreme modernism by many fellow artists, he was one of the key figures responsible for the avant-garde movement in America and for bringing Art Nouveau concepts to these shores. Despite his temporary obscurity, the tremendous influence he exerted from 1905 through the 1920s never really was ignored. The influence of his *Resting Stag* and other elegantly designed animals, with their refined, contoured forms and highly polished surfaces, lived on in the bronze deer and other "slender hoofed creatures favored by Deco-period sculptors."[18]

ECE-I

Figure 39. Elie Nadelman, Wounded Stag, *c. 1915, bronze, 12⅜ × 19⅞ × 10 in. (31.4 × 50.5 × 25.4 cm). Collection of Whitney Museum of American Art, New York, Gift of Mr. and Mrs. E. Jan Nadelman (78.109a–b). Photograph Copyright © 1998: Whitney Museum of American Art.*

Thomas Wilmer Dewing
BOSTON 1851–1938 NEW YORK

47. *Lady with Cello,*[1] before 1920

Oil on canvas; 20⅛ × 16 1/16 in. (51.1 × 40.8 cm); signed in brown paint, lower right: *T. W. Dewing*

Bequest of Annie Swan Coburn (Mrs. Lewis Larned Coburn) (1934:3-4)

PROVENANCE: Milch Galleries, New York, by 1920; to Annie Swan Coburn (Mrs. Lewis Larned Coburn), Chicago.[2]

EXHIBITIONS: New York, Milch [1920], p. 22, repro. p. 23;[3] South Hadley 1975–76; Brockton 1977, no. 160; Northampton 1979, ckl. p. 39; Framingham 1985.

CONSERVATION: The painting is on a pre-primed canvas support (62 threads per inch vertically, 76 threads per inch horizontally) with strip lining attached. It has its original keyed stretcher. There are stretcher creases especially at top and a bull's-eye mechanical crack at top center. Examination under ultraviolet light indicates possible inpainting along the edge of the top left corner.

FEMALE FIGURES, alone or in small groups, were a favorite compositional theme of many turn-of-the century artists, including Mary Cassatt (1844–1926), John Singer Sargent (cat. 29), and James McNeill Whistler (cat. 28). These paintings tended to be portraits, but in time the focus on identity and particular character gave way to portrayals of the idealized woman, especially among painters of the Boston School,[4] including Thomas Wilmer Dewing. Dewing, it might be argued, became the most dedicated and single-minded practitioner of this genre.

After training in Paris in the 1870s, Dewing taught in Boston and New York and exhibited with the Society of American Artists and the Ten American Painters, among other groups of artists.[5] Although he executed some traditional portraits and mural and ceiling decorations,[6] his most characteristic subjects were elegantly dressed women,[7] usually unidentified, in atmospheric landscape settings (before about 1905) or in relatively bare but spacious and softly lit interior settings (from the mid-1890s to the early 1920s).[8]

Lady with Cello clearly falls into this second broad category, which included women listening to or making music. Dewing had an early interest in music and regularly incorporated lutes, violins, violoncellos, mandolins, spinets, and pianos into his figure paintings. Although this habit may have been supported by his interest in the paintings of the seventeenth-century artist Johannes Vermeer,[9] none of the Dutch painter's figures, women or men, actually plays the cello. The instrument served instead as a decorative element or as an object with social, cultural, or metaphoric meaning. Paintings of cellists actually playing the instrument are rare, but during the nineteenth century structural changes in the cello, like the addition of the stabilizing end pin, made the instrument more popular. The awkward position and challenging techniques involved, however, limited it almost exclusively to men until the end of that century.

Dewing apparently was one of the first painters to document the appearance of women cellists, although it seems that he neither portrayed professional musicians nor posed his models in the correct playing position. His ladies are either lost in thought, passively contemplating their cellos, or posed to look as if they are playing. Before about 1920, holding the cello between the knees, the most effective position musically, would have been considered unladylike—not to say cumbersome in an era of long, full-skirted fashions. The alternative, a sidesaddle position, required the musician to place the instrument to the right of the knees.[10]

Dewing's cello-playing women, in contrast, consistently place the instrument on the left, leading the informed viewer to question the stability of the instrument (especially when the end pin is downplayed or ignored entirely), the ability of the right-handed player to bow the instrument, and the seriousness of the music making. These ladies may have been considered "modern" in taking up an instrument previously played mostly by men, but they form a sharp contrast to such professional contemporaries as Madame Suggia (1888–1950), a student and later wife of Pablo Casals, admired for her "masculine" technique and power, so well expressed in Augustus John's (1878–1961)

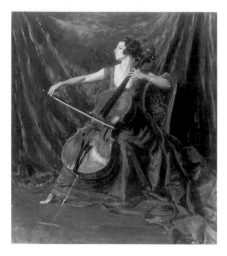

painting of her (fig. 40). Whether Dewing's depictions of women playing the cello were intentionally ambiguous or resulted from his apparently limited knowledge of the instrument, it is clear that he was more interested in evoking a refined mood than in factual illustration.

Dewing's compositions of women and cellos include an undated pastel of the same title (10½ × 10 in., Minneapolis Institute of Arts) and *The Song and the Cello*, c. 1910 (fig. 41),[11] which is perhaps most closely related to the Museum's *Lady with Cello*. Neither the Museum's painting nor *The Song and the Cello* has an early exhibition record, although both were associated with the Milch Galleries in New York in the early 1920s. Technical and compositional similarities suggest that the canvases may have been executed during the same period, possibly in the late teens. The cello-playing figures in both the Museum's painting and *The Song and the Cello* are dressed similarly, hold the cellos sidesaddle to the left, and share certain facial features; in fact, they may be the same model.[12] This could lead to speculation that *The Song and the Cello* was a recomposition of one or two previously painted single figures, including the one in the Museum's canvas. Since another late oil by Dewing, *The White Dress* (1921, Berkshire Museum, Pittsfield, Mass.), appears to have been created by deliberate self-quotation, the technique may have been one the artist repeated.[13]

The vaguely brushed landscape painting behind the model in the Museum's *Lady with Cello* may provide further support for a later date. Like the cello itself, the Tonalist painting in the background helps to define the cultural interests and pastimes of the social group with which Dewing was associated, particularly in terms of a nostalgic vision of nature. Its hazy scene, vertical shape, proportions, and relatively simple molding frame[14] bear marked similarities to the framed picture on the background wall of *The White Dress*, known to have been painted in 1921. Barbara Gallati views the "painting within a painting" in the latter as a possible quotation from the artist's Cornish period in the 1890s, and Susan A. Hobbs identifies it as Dewing's *Summer Evening* (not located).[15]

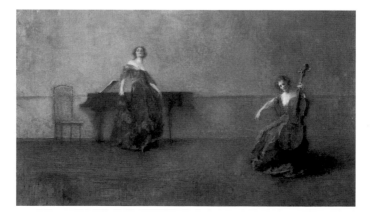

Figure 41. *Thomas Wilmer Dewing*, The Song and the Cello, *c. 1910, oil on canvas, 13¾ × 23¾ in. (35 × 60.3 cm). Private collection, courtesy of Berry-Hill Galleries, New York.*

The formal structure of *Lady with Cello* reflects Dewing's inclination to order his compositions around strong horizontal and vertical elements, again reflecting his debt to Vermeer. Placing the figure exactly in the center of the canvas, her head emphasized by the picture frame behind it, he develops contrasts between the hard, straight edges and right angles of the architectural molding, picture frame, and bench, on the one hand, and the rigid curves of the cello, the softer, less precisely shadowed forms of the model's upper body, and the folds of her gown, on the other. This dialogue is carried further in the subtle arched form and horizon line of the Tonalist landscape. The placement of the seductive curves of the female body against the decorative concavities and convexities of the cello obviously struck Dewing as both appealing and provocative. These contrasting features are further strengthened by what has been described as the "subtle beauty of the delicate color scheme of grey and pale gold, and faded blue of the fabrics, with the rich contrasting color of the wood of the cello."[16] The significance of the painting, therefore, lies not in the identity of the sitter, the melody she plays, or whether she is technically capable of bowing a single note—tangentially interesting though these facts may be—but in the delicate and sometimes ambiguous balance between the purely artistic elements of line, form, and tonality.

After the Armory Show and World War I, Dewing's work fell increasingly out of favor because of his inability to assimilate the new social and artistic trends of the time. As a result, paintings such as *Lady with Cello* received diminishing critical attention and exhibition exposure. Royal Cortissoz, a sympathetic critic of Dewing's work throughout his career, may have been one of the few among the artist's contemporaries to recognize how Dewing had taken painting from character identity and specific anecdote to abstract, symbolic reference. As early as 1910 he observed that Dewing's objective was to paint "not so much beauty observed . . . as beauty invented."[17]

ECE-I

Florine Stettheimer
ROCHESTER, NEW YORK 1871–1944 NEW YORK

48. *Henry McBride, Art Critic*, 1922

Oil on canvas; 30 × 26 in. (76.2 × 66 cm); inscribed in green paint, within composition, middle left: *B / HENRY H / McBRIDE Mc / Stetthei* [obscured] *Florine S;* signed and dated on stretcher in black paint: *By Florine Stettheimer 1922*

Gift of Ettie Stettheimer (1951:198)

PROVENANCE: The artist's sister, Ettie Stettheimer, New York, 1944.

EXHIBITIONS: New York, Independent 1926; New York +, MoMA 1946, p. 54, repro. p. 29; New York, Durlacher 1951; Northampton 1952 *Stettheimer;* Boston +, ICA 1954; Northampton 1962, no. 21; New York, Durlacher 1963; Chicago 1964; Northampton 1968 *Hitchcock,* no. 23; Saratoga Springs 1972; Northampton 1976 *American;* Düsseldorf + 1979, no. 17, repro. p. 59; Boston +, ICA 1980, no. 14, fig. 11; New York, IBM 1990; Washington, NPG 1991; Katonah 1993, pp. 7–8, fig. 4; New York, Whitney 1995, repro. p. 11.

LITERATURE: McBride 1946, repro. p. 337; *ICA Bulletin* 1954, p. 2; Devree 1955, repro. p. 42; Tyler 1963, repro. opp. p. 130; McBride 1975, pl. 32; Kramer 1980, sec. D, p. 33, repro.; Chetham et al. 1986, no. 154, repro.; Watson 1991, p. 257, repro. p. 114; Bloemink 1995, pp. 126–29, fig. 71.

CONSERVATION: The painting is on canvas that is wax lined and mounted on a new constant tension stretcher. There is some overall mechanical craquelure, but the painting is in good condition with no apparent losses. It is very thinly varnished.

FLORINE STETTHEIMER, painter, poet, and designer of theatrical sets and costumes, was active in New York during the 1920s and 1930s. Born into a wealthy German-Jewish family, the youngest of five children, she studied at the Art Students League with H. Siddons Mowbray (1858–1928) and Kenyon Cox (1856–1919) from 1892 to 1895. Between 1906 and 1914 she and her family lived for long periods in Europe, where she studied painting with various instructors and experimented with a range of styles, from Pointillism to Surrealism.

After their return to New York in 1914, the Stettheimer sisters and their mother began holding regular social gatherings of artists, critics, writers, and other intellectuals.[1] Their guests included Alfred Stieglitz, Marsden Hartley (cat. 56), Marcel Duchamp (1887–1968), Carl Van Vechten (1880–1964), and Henry McBride (1867–1962), important cultural figures who became Stettheimer's principal subjects for her portraits. McBride later asserted that the Stettheimers' salon "had considerable to do with shaping the intellectual and artistic impulses of the period just past " and that at their home "hardy ideas were put into words which echoed sooner or later in other parts of the city."[2]

In 1916 the only lifetime solo exhibition of Stettheimer's career, at Knoedler's in New York, presented works from her years in Europe and was shown in gallery spaces that she redesigned to mimic a domestic interior. The exhibition, at which nothing sold, was a disappointment. As McBride later suggested, "this was early in her career . . . before her style had crystallized."[3] It was not until after 1915 that this crystallization came about with a series of portraits depicting her family members and friends.

The Museum's portrait of McBride is characteristic of the paintings from this series in that it features, at center, a dominant image of McBride surrounded by small vignettes in which he appears again. Stettheimer used this convention, which Duchamp dubbed "multiplication virtuelle,"[4] either to create episodes within a larger narrative or, as here, to evoke the multifaceted character of a subject. The objects and activities that surround McBride are based on facts in his life, but the portrait is a fantasy created by the artist. In Stettheimer's portraits, as McBride described it, "the sitters . . . never actually sat, for the portraits were imaginative portraits and sometimes exceedingly whimsical."[5] Her "sitters" often appear younger and more androgynous than in real life; McBride asserted, "She rejected age in all her friends . . . and in the portraits turned us into the essences of what we were."[6] McBride came closer to sitting for his portrait than most subjects. During the summer of 1922 he visited the Stettheimer family in Sea Bright, New Jersey, and attended an international tennis tournament. He later recalled that "one evening I detected the artist over in one corner of the salon furtively jotting down, presumably, some of my lineaments, but I was not permitted to see what hieroglyphics she had acquired nor how many."[7] Following Stettheimer's customary practice, he saw the portrait only after its completion.

A prominent art critic who wrote for the *New York Sun*, the *Dial, Creative Art,* and *Art News,* McBride was an early and faithful champion of Stettheimer's work as well as that of Gaston Lachaise (cat. 51), John Marin (1870–1953), and Charles Demuth

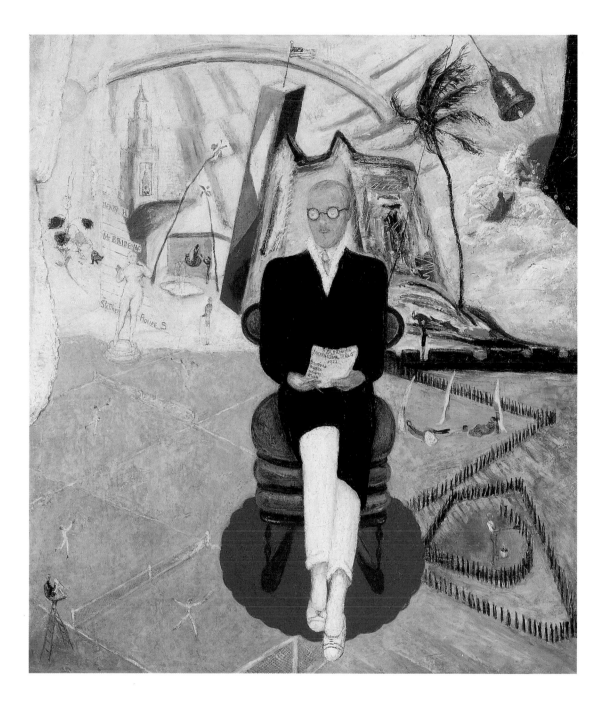

(1883–1935). At the center of the canvas he appears as an elegant gentleman in black jacket, tennis whites, and tennis shoes sitting stiffly in an unusual antique rocking chair, holding a score sheet with players' names. The tennis motif makes direct reference to McBride's sporting passion, but beyond that his position as umpire (he appears again at lower left in the umpire's chair) alludes to his role as art-world judge and scorekeeper.[8] As Barbara Bloemink suggests, tennis also may function as a metaphor for McBride's eclectic taste as evidenced in his reviews, which "jumped back and forth across time between renowned American artists from the turn of the century to relatively unknown contemporary artists."[9]

McBride's professional pursuits are depicted in the upper region of the painting, where passages from some of his favorite works of art form a kaleidoscopic backdrop. At upper left he stands erect with a walking stick and studies a white church resembling a Demuth watercolor. In the tiny vignettes in front of McBride, an elderly woman looks out of the steeple window while below, in a plaza with a fountain, a man offers a rose to a woman leaning from a wrought-iron terrace. Bloemink suggests that this scene, framed by two leaning palm trees, resembles watercolors made by Winslow Homer (cat. 23) in Santiago de Cuba in 1885. Next to McBride stands Lachaise's bronze *Standing Woman (Elevation)* of 1912–27, and farther to the left Stettheimer leaves her personal mark in the form of a floral still life. The fragmented, repeated words running around a pyramid suggest the writings of Gertrude Stein; indeed, a link can be made between Stettheimer's object portraits and the "word portraits" of Stein.[10] In the upper center Stettheimer has painted a group of buildings that resemble Marin's cityscapes, particular favorites of McBride. The Homer allusion aside, as a whole, the upper left and center represent McBride as supporter of contemporary American art.

A rainbow bridges the upper left and right regions, where McBride's interest in nineteenth-century American art is signified by several images drawn from Homer. Dressed as a dandy in top hat, the critic stands stiffly gazing out over the turbulent sea in a Homer marine.[11] A palm tree echoes watercolors Homer made in the Bahamas and Key West, Florida, in 1885 and 1886. To the right of the tree a large ship's bell swinging in the breeze makes reference to the artist's well-known nautical paintings. The rope, which extends from the bell out of the picture plane, through an unseen pulley, and back to the center of the canvas, links these parts of the painting, performing the same formal function as the rainbow. The lone rower in another Homeresque seascape echoes shipwreck pictures the artist painted in England during the early 1880s.

At the lower right McBride's personal pursuits are depicted. He appears as a gentleman farmer, clad in overalls and painting a black picket fence that represents the farm he owned in West Chester, Pennsylvania. The black rails of the fence stitch together the fragmented episodes of the right side of the canvas, just as the white lines of the tennis court do at the left. Partly enclosed by the fence are three figures leaning against stumpy white trees. It has been suggested that they are beachgoers who simply indicate another of McBride's leisure activities.[12]

Stettheimer's paintings were viewed and enjoyed principally by her friends and family during her lifetime; she preferred to exhibit at home.[13] Financial independence meant that she could shun gallery representation, although Stieglitz repeatedly offered to show and sell her work. In 1931 her close friend Marsden Hartley (cat. 56) wrote: "I suppose no painter has been persistently permitted so much of refined obscurity as Miss Florine Stettheimer among the artists of this day."[14] After her death Duchamp organized a memorial retrospective in 1946 at the Museum of Modern Art, New York, for which McBride wrote the exhibition catalogue, but little critical attention was aroused. Her virtual obscurity might have persisted had her wish to have her paintings destroyed after her death been honored by her sister Ettie. With the assistance of McBride and other friends, however, Ettie Stettheimer distributed Florine's work through sales and donations to museums and universities throughout America, including the Smith College Museum of Art.

KE

John Storrs

CHICAGO 1885–1956 MER, LOIR-ET-CHER, FRANCE

49. *Auto Tower (Industrial Forms),* c. 1922

Painted plaster; 12⅞ × 3¼ × 2⅞ in.
(32.7 × 8.3 × 7.3 cm); inscribed
in plaster on rear of sculpture
above base: *R.S* [conjoined initials,
s reversed] *2550*

Purchased with funds given by
Mr. and Mrs. Duncan Boeckman
(Elizabeth Mayer, class of 1954)
(1989:1)

PROVENANCE: Descended through
the family of the artist; to his grand-
daughter, Monique Storrs Booz; her
estate; Robert Schoelkopf Gallery,
New York.[1]

EXHIBITIONS: New York, Société
1923 (probable); New York +,
Whitney 1986–87, pp. 38, 48–52;
New York, IBM 1990.

LITERATURE: Frackman 1987,
pp. 130–32, pl. 108; *Gaz B-A* 1990,
p. 92.

CONSERVATION: There is a small
loss in the center of the base, and
earlier repairs are evident at the cor-
ners of the base. There is a small loss
in the zigzag detailing near the top
underside of the car. The plaster is
slightly discolored. There is a black
accretion near the base on the upper
surface of the car.

JOHN STORRS'S personal and professional lives were divided between his native Chicago and his adopted home in France.[2] His first trip to Europe in 1905 included studies with the sculptor Arthur Bock (1875–?) in Hamburg and a brief enrollment at the Académie Julian in Paris. Storrs returned to Chicago in 1908 to assist in the real estate business of his father, the architect David W. Storrs, and took classes at the School of the Art Institute of Chicago. In 1909 he attended the School of the Museum of Fine Arts, Boston, and a year later the Pennsylvania Academy of the Fine Arts in Philadelphia, where he studied sculpture with Charles Grafly (1862–1929). With his return to France he was invited to study with Auguste Rodin (1840–1917) in 1912 and maintained a relationship with the elder artist until his death. During this decade Storrs's work evolved from a naturalistic style to figurative and nonobjective sculpture influenced by Futurism, Vorticism, and most importantly, Cubism. His streamlined and often witty sculptures of the 1920s, including *Auto Tower (Industrial Forms)* of about 1922, merge architectural motifs and European avant-garde modernist styles in ways that anticipated Art Deco.

Auto Tower (Industrial Forms) exists in at least three versions: a preparatory drawing (fig. 42), the Museum's plaster, a bronze with brass plating and enamel (location unknown), and possibly a wooden model.[3] As Storrs scholar Noel Frackman has pointed out, *Auto Tower (Industrial Forms)* is a triple visual pun, combining a touring car set on end, an architectural tower, and the suggestion of a totemic figure, which becomes more evident in profile.[4] As she notes, Storrs's incorporation of an automobile in this work reflects the Machine Age fascination with industrial and mechanical elements, an interest shared by European artists associated with Dada and Surrealism as well as the American Precisionists. The decade of the 1920s in the United States marked a new era in automotive design as increased importance was given to body styling.[5] In Storrs's case, his fascination with machines ranged from the most utilitarian machinery (a 1922 diary entry admires a French display of farm equipment) to sleek roadsters, which he especially loved.[6] The Museum's plaster not only delights in the lines of the car but also extends them in flares above the rear wheels, as if to indicate speed. The wheels also incorporate "motion lines," simulating spinning tires, that may borrow from Futurist "force lines."[7]

The humor of *Auto Tower (Industrial Forms)* derives both from its multiple identities and from Storrs's subtle manipulations of form. From the "front" of the sculpture (combining a clockface tower, an overhead view of the car, and the "face" of the totem), a set of vertical incisions is placed off center on the car's hood, which also becomes a single, quizzical mark above the "totem's" right eye. This detail signals that the sculpture is not entirely symmetrical either in form or painted decoration. From this vantage point it is possible to see that the upended body of the car does not sit squarely on its chassis but is off center to the right (or passenger) side. Storrs further plays on this imbalance by reversing carved and relief elements on either side; e.g., the left front wheel is rendered in relief while the right wheel is carved. When the sculpture is viewed in profile, it is not immediately apparent that the two sides do not match

Figure 42. John Storrs, Study for Auto Tower (Industrial Forms), *1920, pencil and ink on paper, 12⅛ × 9 in. (30.8 × 22.9 cm). Collection of Terese and Alvin S. Lane. Photograph by John D. Schiff, courtesy of Noel Frackman.*

exactly in their painted details: for the most part, black is used on the relief elements on the left side and is painted inside the carved portions of the right side. Since these differences cannot be seen from the front of the sculpture, the viewer must walk around it in order to compare the two sides and tease out their differences.

Auto Tower anticipates Storrs's more purely architectural "column towers" (a series of sculptures titled *Forms in Space)* and "skyscraper" sculptures.[8] Storrs's sculptures of the 1920s did not simply reflect a current popular obsession with the American skyscraper but expressed his long-standing interest in, and knowledge of, architecture and architectural theory.[9] Although Storrs knew many Chicago architects, his philosophical and aesthetic approach shared close affinities with the work of Frank Lloyd Wright (1867–1959).[10] As Frackman notes, Storrs often followed Wright in playing solid against void and positive against negative.[11] The side-to-side inversions of relief and carved areas in *Auto Tower* are a playful interpretation of this formal concept. Like Wright, Storrs considered architecture to be fundamentally organic and found a natural link between architecture and sculpture, writing in his diary in 1919, "Architecture is the plant and sculpture is the blossom as the sea has waves and the sky has clouds."[12] In *Auto Tower,* this relationship is cleverly realized in the overall form of the sculpture, which adumbrates a building, and more specifically stated by the sculpture's rear view, which suggests the undercarriage of a car and at the same time strongly resembles the façade of an Art Deco skyscraper, with its entryway and door at the base of the sculpture.

The totemic reference in *Auto Tower* is more general than the quotation of a particular form or object. The great ethnographic collections of the Field Museum of Natural History in Chicago and the Musée de l'Homme in Paris were available to Storrs, who himself collected African, Inuit, and Mexican Indian art.[13] Storrs moved in avant-garde circles in which "primitive" art was mined for inspiration by Western artists from the Cubists to the Surrealists. His preparatory drawing for *Auto Tower,* with its pronounced brow, eye, nose, and chin, more clearly suggests facial features than the

Auto Tower (Industrial Forms), *view of right side, front view, view of left side, and rear view.*

Figure 43. Unknown artist, Haida people, Northwest Coast, Model Crest Pole, late 19th–early 20th century, argillite, 18½ × 2⅛ × 3 in. (47 × 5.3 × 7.6 cm). Smith College Museum of Art, Anonymous gift (1960.122).

sculptural versions, but both the drawing and the sculptures share a hieratic quality that may have been inspired by Native American crest (totem) poles, especially those from Northwest Coast traditions. The carved crest poles created by Northwest Coast ethnic groups have a variety of meanings and functions, including distinctively architectural uses as house posts for beam supports and frontal poles, whose bases served as house entrances.[14] This union of sculpture and architecture might have appealed to Storrs, as well as the double meanings of many of the designs and the transformational nature of much of the imagery of mythic beings and animals.

While carved wooden crest poles were of great size, argillite models of crest poles were carved from the latter part of the nineteenth century and were readily available as objects for sale (fig. 43).[15] These are close in scale to the *Auto Tower* and miniaturize in great (but not fully faithful) detail the large wooden poles. In a sense the *Auto Tower* adopts the same strategy of reducing a large-scale object of cultural significance—a car, a building—to the size of a model. Storrs's incorporation of polychromy in his sculptures has precedents in Northwest Coast art, but his use of black as a defining and decorative element in *Auto Tower* can be seen as analogous in function to the formline, a stylistic hallmark of Northwest Coast art, consisting of a swelling and tapering black (or secondary red) line that delineates each design unit and defines anatomical forms and features.[16] The *Auto Tower*'s reference or nod to formlines can be seen in the black line from fender to fender and the stylization of the eyelike wheels. Like the formline, which is an essentially graphic two-dimensional element defining forms that can be "wrapped" around a three-dimensional object, Storrs uses black in *Auto Tower* to elaborate a sculptural form.[17]

The Museum's plaster version of *Auto Tower* was probably shown in 1923 in Storrs's one-artist exhibition at the Société Anonyme arranged by Katherine Dreier, whom Storrs met while he was in New York for his exhibition at the Folsom Gallery in 1920–21.[18] The figurative aspect of Storrs's sculpture reappeared in major architectural commissions at the end of the decade following the tower and skyscraper sculptures, for example, in the artist's streamlined metal goddess *Ceres*, erected as a finial for the Chicago Board of Trade Building. In the 1930s Storrs produced a series of Surrealistic paintings and sculpture combining machine and architectural forms with primitivizing human profiles but in a blockier and more compressed style than his work of the previous decade.[19]

During the Second World War Storrs was arrested in France and interned for six months in a German concentration camp. He was unable to recover his health or return to work before his death in 1956.

LM

Lyonel Feininger
NEW YORK 1871–1956 NEW YORK

50. *Gables I, Lüneburg,*[1] 1925

Oil on canvas; 37¾ × 28½ in. (95.9 × 72.4 cm); signed and dated in green paint, upper right: *Feininger / 25;* inscribed on stretcher in artist's hand: *Lyonel Feininger / "Old Gables" (Lüneburg)*

Gift of Nanette Harrison Meech, class of 1938 (Mrs. Charles B. Meech), in honor of Julia Meech, class of 1963 (1985:20)

PROVENANCE:[2] Mr. and Mrs. Lyonel Feininger; consigned to Nierendorf Gallery, New York, by 1939 (unsold); consigned to Van Diemen-Lilienfeld Galleries, New York, by 1948 (unsold); consigned to Curt Valentin Gallery (Buchholz Gallery until 1951), New York; sold to Mr. and Mrs. Charles B. Meech, Minneapolis, 1954; Nanette Harrison Meech (Mrs. Charles B. Meech), Santa Fe.

EXHIBITIONS: Dresden 1926, no. 2 (as *Architektur II*); Berlin 1926, no. 2, repro. cover (as *Architektur II*); Braunschweig 1926, repro.; Berlin 1936, no. 26; Oakland 1937 (as *Architecture of Lüneburg*); San Francisco 1937 (as *Architecture of Lüneburg*); Andover 1938, no. 7 (as *Architecture of Lüneburg*); Boston, ICA 1939, no. 9 (as *Architecture of Lüneburg*); New York, MoMA 1944–45, repro. p. 29; Minneapolis 1948, no. 8 (as *Gables I*); Boston +, ICA 1949, no. 48, repro. p. 31; Cleveland 1951, no. 9, pl.III; New York, Willard 1956, unno. ckl., repro., unpag.; San Francisco + 1959, no. 29; Northampton 1985, ckl. no. 7, repro.; Northampton 1989, ckl. no. 3, color repro. cover; New York, IBM 1990; Lüneburg 1991, no. 10, repro. p. 47 and cover.

LITERATURE: Hess 1949, repro. p. 49; Hess 1961, pp. 104, 105, 272 (no. 257), pl. 32; Chetham et al. 1986, no. 157, color repro. p. 58.

CONSERVATION: The painting is on a pre-primed canvas mounted on a keyed wooden stretcher. There are small inpainted losses in the top center and in the upper right quadrant.

© 1998 Artists Rights Society (ARS), New York/VG Bild Kunst, Bonn

LYONEL FEININGER'S career was divided between America, where he was born, and Europe, particularly Germany, the land of his grandparents. His parents were musicians, and as a child he played the violin. In 1887 he went to Leipzig for formal music study but instead enrolled in the art school at Hamburg. He continued his studies in Berlin, Liège, and Paris, after which he began a successful career as an illustrator and cartoonist. He did not make his first oil painting until he was thirty-six.

In Paris in 1911 he became familiar with the work of Paul Cézanne and the Cubists, and especially of Robert Delaunay (1885–1941). On his way to finding an art of pure painting, Delaunay was investigating theories of color and light, involving the correlation of music and colors, the dematerialization of form by light, and the liberation of color from a dependence on form. Feininger was also interested in the interaction of color and light, including the properties of light refracted through a prism. Indeed, at the time he offered the term "prism-ism" to describe the delicate transparencies of overlapping planes of color in his paintings and to distinguish his manner from mainstream Cubism.[3] Unlike the more cerebral Cubist view of nature as material for analysis and reconstitution as art, Feininger's approach to nature was lyrical, almost mystical. He is often cited as a twentieth-century successor to the great German Romantic landscape painter Caspar David Friedrich (1774–1840).

Feininger first visited Lüneburg with his wife, Julia, in August 1921. She recalls that he was "war-weary and exhausted" and that they wanted to visit towns in northern Germany—Hildesheim, Lübeck, and Lüneburg—where the Backstein (brick) Gothic was still well preserved.[4] This architectural style came into being in the fourteenth century because there was no suitable building stone in the region. The use of brick, which did not lend itself to carved ornamentation, resulted in colorful buildings, including tall churches with enormous vertical windows and façades of great simplicity.

Gothic architecture had fascinated Feininger since childhood. He recalls being taken to the Metropolitan Museum of Art at the age of six or seven: "of all the paintings I saw the only ones to make a deep impression on me . . . represented Gothic architecture with figures, bright and beautiful in color and clearly silhouetted. For many years I carried the recollection of these pictures with me. It seems to me they influenced my development as a painter."[5] Throughout his life he carved and painted whole miniature villages of Gothic houses inhabited by oversized, whimsical figures. About his 1921 visit to Lüneburg, his wife writes:

> Feininger felt stimulated by the architectural array of these towns: strange combination, though, of Gothic and Baroque at times; by the rhythmical partitioning of beautiful façades on old gabled houses, especially in Lüneburg. . . . For days he went around taking in and trying to hold, in sketches, what impressed him so deeply. In the noble church of St. John's we were fortunate to make the acquaintance of the organist. He showed and explained to us the magnificent organ; one of the very few then still in service since the time when Johann Sebastian Bach was organist in Lüneburg.[6]

Figure 44. Lyonel Feininger, Lüneburg, Wendischendorfe Street, Nos. 27 and 28, *August 18, 1921, graphite on paper, 7³/₁₆ × 5⁵/₈ in. (18.3 × 14.3 cm). Courtesy of the Busch-Reisinger Museum, Harvard University Art Museums, Gift of Julia Feininger (BR63.1919). © 1998 Artists Rights Society (ARS), New York/VG Bild Kunst, Bonn.*

Feininger, who played and composed for the organ, had a lifelong passion for music, especially Bach's. He said: "Music has always been the first influence in my life, Bach before all others. . . . Without music I cannot see myself as a painter. . . . Polyphony, paired with delight in mechanical construction went far to shape my creative bias."[7] Like Bach, Feininger sought a fusion between intellectual structure and emotional expressiveness.[8]

In 1922 Feininger paid a second and last visit to Lüneburg, again making many sketches. It was his habit to return over and over to a motif, making many variations on the theme. The gabled houses and other buildings of Lüneburg became one such subject.[9] In a study of Feininger's working methods, using *Gables I* and *Lüneburg II (Gables III)* (private collection) as models,[10] Thomas Hess noted that the artist always put aside his preliminary on-site sketches (figs. 44 and 45), which he called "nature notes," to allow his first impressions to mature. Working from these sketches later in the studio, he would make a charcoal-and-ink drawing as a spatial study (fig. 46). After a period came a watercolor, a study of "volumes of light," which also functioned as an independent work of art. The time between his first sketches and *Gables I*, the first oil painting of this particular architectural grouping, was rather short—scarcely three years. The painting retains many more specific details of the buildings than are to be found in the much more abstract second oil treatment of them, *Lüneburg II (Gables III)*, from four years later.[11] In *Gables I* the artist is still perhaps very much in the thrall of the picturesque architecture itself.

Though *Gables I* is not carried as far beyond his preliminary impressions as was typical of Feininger's work, it departs from the earlier studies in many ways. A second Gothic building has been introduced at the left, providing with its rose brick mate a counterpoint to the bright orange Baroque building between them and the yellow house at the far right. The street area has been enlarged and canted at an angle, imparting a hint of movement to the otherwise quite still scene. Even the figures, which are formed from geometric elements, are more like immobilized automatons than living beings. The whole composition is laid upon a net of planes. A number of Cubist devices are used: multiple points of view in the rendering of the façade of the Baroque house and the overlapping translucent green panes of its oriel windows; the careful grada-

Figure 45. Lyonel Feininger, Lüneburg, Wendischendorfe Street, No. 27, *August 10, 1922, graphite on squared paper, 7⁵/₈ × 6⁷/₁₆ in. (19.3 × 16.4 cm). Courtesy of the Busch-Reisinger Museum, Harvard University Art Museums, Gift of Julia Feininger (BR63.2147). © 1998 Artists Rights Society (ARS), New York/VG Bild Kunst, Bonn.*

Figure 46. Lyonel Feininger, Lüneburg, *August 27, 1924, charcoal and ink on paper, 9³/₄ × 7⁷/₈ in. (24.8 × 20 cm). Marlborough Fine Art (London) Ltd. © 1998 Artists Rights Society (ARS), New York/VG Bild Kunst, Bonn.*

tion of large, flat areas with many small touches of the brush; and the interpenetration of planes and the dissolution of forms. The twisted-brick mullions of the right-hand Gothic house are transformed into a scaffolding that appears to float in front of its façade. In counterpoint to the broad, flat areas are the small repeated rhythms of the stepped ribs on the window and door openings. An ethereal mood is suggested by the shafts of light that seem to dissolve the tops of the buildings.

In 1937 Feininger came back to the United States, and although the architecture of Manhattan soon began to fill his canvases, that of Lüneburg continued to figure in his art until shortly before his death. His wife wrote: "The force of circumstances, architecture and music in accord, may have been among the reasons which bound Feininger's memory with such loving intensity to Lüneburg."[12]

BBJ

Gaston Lachaise

PARIS 1882–1935 NEW YORK

51. *Garden Figure*, c. 1927–31, cast c. 1935

Concrete (edition of 5); 79½ × 28 × 17¼ in. (201.9 × 71.1 × 43.8 cm); not signed, not dated

Gift of Mrs. Henry T. Curtiss (Mina Kirstein, class of 1918) (1982:22)

PROVENANCE: Sold to Lincoln Kirstein, New York, 1935; given to his sister, Mrs. Henry T. Curtiss (Mina Kirstein), Weston, Conn.

EXHIBITION: Northampton 1979, ckl. p. 86.

LITERATURE: Goodall 1969, pp. 504–6, 508; Lerner 1974, pp. 248, 710, pl. 295 (Hirshhorn cast, as *The King's Bride [Garden Figure]*); Portland 1984 no. 85, repro. p. 25 (Portland cast); Burleigh 1994, repro. p. 85.

CONSERVATION: There are some small losses along the bottom edge and a hairline crack in the neck of the figure. There is a patch of a different-colored concrete behind the proper left leg. The sculpture was displayed outdoors for many years by the former owner and is weathered on the upper surfaces; there appears to be some erosion of the concrete from the top of the head and shoulders. There are inactive lichen colonies on the upper part of the body.

GASTON LACHAISE was the son of an accomplished cabinetmaker who encouraged him from a young age to pursue a career as a sculptor. After demonstrating proficiency in his father's workshop he was enrolled at the age of thirteen in the Ecole Bernard Palissy in Paris, a school of applied arts that provided drawing and painting classes and the rudiments of wood and stone carving. Three years later he was accepted at the Ecole des Beaux-Arts and soon thereafter began submitting his work to the annual French Salons and competing for the prestigious Prix de Rome, which he later referred to as "the dream of 'Rome' at the end of the rainbow."[1] By the age of eighteen he showed promise of becoming one of the most important French sculptors of the twentieth century.

That Lachaise became an important American sculptor instead is due to his chance encounter on a Paris street with Isabel Dutaud Nagle, a Canadian-American woman who, despite being married and the mother of a young son, became Lachaise's constant companion and the primary inspiration for his work. When she returned to America in 1904, Lachaise left the Ecole des Beaux-Arts in order to raise money to follow her. After working briefly in the studio of René Lalique (1860–1945), he left France in December 1905, following his father's death, for Isabel's home in Boston. He never returned.

Lachaise supported himself as a studio assistant, first to sculptor Henry Hudson Kitson (1863/65–1947) and then to Paul Manship (cat. 45), executing ornamental details and fragments for their public commissions. This work took him to New York, where he was able to establish himself as a sculptor of portrait busts of prominent members of society. From the time he met Isabel, however, his preferred subject was the female figure, inspired both physically and spiritually by her.

Of his first encounter with the woman who would become his muse, Lachaise wrote: "At twenty, in Paris, I met a young American person who immediately became the primary inspiration which awakened my vision and the leading influence that has directed my forces. Throughout my career, as an artist, I refer to this person by the word 'Woman.'"[2]

Garden Figure is among the last of his monumental nudes, and although its facial features do not resemble Isabel's, its voluptuousness and majestic bearing are typical of his full-length works, including *Standing Woman (Elevation)*, begun in 1912 but not cast until finances permitted in 1927. The completion of the latter work and a monumental nude female figure commissioned for a garden in Rochester, New York,[3] in that same year encouraged Lachaise's efforts in large-scale figures after a long period limited to portraits and smaller full-length works. The original plaster from which *Garden Figure* was cast probably dates from 1927–31, as it resembles in pose the Rochester garden sculpture, which was not specifically modeled after Isabel but whose features reappear in the *Standing Woman* of 1932 (fig. 47).

Lachaise was regarded by critics sympathetic to his work as a passionate and single-minded pursuer of beauty, inspired by his adoration for a sensual woman. In the catalogue for the 1935 retrospective at the Museum of Modern Art, Lincoln Kirstein, the

Figure 47. Gaston Lachaise, Standing Woman, *1932, bronze, 88 × 41⅛ × 19⅛ in. (223.6 × 104.3 × 48.4 cm). The Museum of Modern Art, New York, Mrs. Simon Guggenheim Fund. Photograph © 1999 The Museum of Modern Art, New York.*

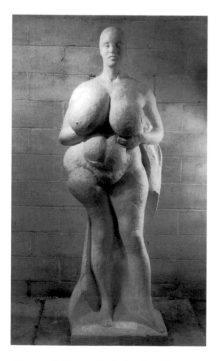

Figure 48. Gaston Lachaise, Standing Woman, *1935, plaster model, 79 × 28 × 18 in. (200.7 × 71.1 × 45.7 cm). Lachaise Foundation, Boston.*

artist's friend and patron, wrote: "He is an idol maker. He risks the dangers, derisions, and rewards of man, not creating a religion, but at least supplying the documents corroborating a religion."[4] Kirstein considered him one of the most important living sculptors,[5] and after Lachaise died suddenly from undiagnosed leukemia, the critic Henry McBride would write that Lachaise was the only sculptor of his generation who could be cited in connection with Michelangelo.[6] E. E. Cummings was particularly emphatic, stating in his first published essay on art: "To get rid altogether of contemporary sculpture is perhaps the surest way of appreciating the achievement of Lachaise." Cummings singled out Paul Manship (cat. 45), one of the most successful sculptors of the time, for disdain. In contrast, he saw Lachaise as "inherently naif, fearlessly intelligent, utterly sincere" and considered his work the result of "a crisp and tireless searching for the truths of nature as against the facts of existence."[7]

While the work of both sculptors reflected archaic Greek influences in vogue in the 1920s and 1930s, Manship's nudes evoked the rationality and sexual distance of Greek sculpture, while many of Lachaise's figures were overtly, even primally, sexual, recalling ancient fertility symbols such as the Paleolithic *Venus* of Willendorf.[8] As Kirstein recognized, the sexual implications of the artist's work were obstacles to achieving broad appeal and acceptance of his role as an innovator.[9] In fact, Lachaise's career was marked by a relative lack of commercial success. After leaving Manship's studio, Lachaise would simultaneously pursue two distinct paths, one motivated by his need to support himself and Isabel and the other by his desire to give full expression to his artistic inspiration. During the same period that he produced *Garden Figure* and a number of portrait busts he also created fragments of figures that are sometimes shocking, with exaggerated breasts, buttocks, and genitalia, such as the Museum's small *Torso* (checklist no. 65), a limbless, truncated figure composed almost entirely of greatly swollen forms of breasts and haunches carved from pristine white marble.

Corresponding to the dual nature of his work at this time, a second state of *Garden Figure* exists in which the hips and breasts are increased dramatically in size (fig. 48).[10] Neither *Garden Figure* nor the second state (now called *Standing Woman*) was cast in the artist's lifetime.[11] Together they provide a view of the two extremes of his art: on the one hand restrained and based on sculptural precedent, on the other overtly erotic and highly original. While the gesture of *Garden Figure,* in which the breast is cupped in one hand, is similar to that of preclassical figurines representing a nude goddess (possibly Aphrodite),[12] the reticence of this gesture is completely transformed in the second state. In the later version, the engorged breasts overflow the supporting hand, and the midsection of the figure bulges with the fecund and almost abstractly distended forms of belly and hips.

Despite their exaggerated proportions, Lachaise's nudes represent a modernist interpretation of woman as genetrix and muse based on a single individual: Isabel, the artist's ideal of femininity and sexuality. Following Lachaise's death the painter Marsden Hartley (cat. 56) wrote of the artist's unique ability to combine the present and the past in service to this ideal:

> Lachaise was that singular being of today and of yesterday, the worshiper of beauty, he thought of nothing else, beauty was his meat and bread, it was his breath and his music, it was the image that traversed his dreams, and troubled his sleep, it was his vital and immortal energy.[13]

DS

Alexander Calder

PHILADELPHIA 1898–1976 NEW YORK

52. *Mobile,* 1934[1]

Nickel-plated wood, wire, and steel;[2] height: 42½ in. (107.9 cm); base diameter: 11⅞ in. (30.2 cm); not signed, not dated

Purchased, Director's Purchase Fund (1935:11)

PROVENANCE: Pierre Matisse Gallery, New York, 1935.

EXHIBITIONS: Boston, ICA 1954; New Brunswick + 1979,[3] no. 17, p. 109, fig. 173; Northampton 1979, ckl. p. 82; Northampton 1983, ckl. no. 24; New York, Whitney 1987–88, pp. 34–35, 54, repro. p. 35; New York, IBM 1990.

LITERATURE: Abbott 1936, pp. 16–17, fig. 12; *SCMA Cat* 1937, p. 34, repro. p. 120; *ICA Bulletin* 1954, p. 2; Chetham 1969, p. 774; Chetham et al. 1986, no. 161, repro.; Marter 1991, pp. 157–58, fig. 109.

CONSERVATION: The sculpture is in good condition. The strings have been replaced several times and were recently adjusted in length based on analysis of an early photograph of the piece. There are minor cracks in one of the suspended elements. See below for a discussion of the nickel plating of the sculpture.

© 1998 Estate of Alexander Calder/ Artists Rights Society (ARS), New York

FROM 1926 TO 1933 Alexander Calder divided his time between the United States and Paris, where he came to know many members of the various avant-garde movements flourishing there. Joan Miró (1893–1983), Jean (Hans) Arp (1886–1966), and Fernand Léger (1881–1955) were among the artists who became his friends. He was making, among other things, witty wire portraits and figures. These deft caricature drawings in space attest to his early awareness of a principle of Constructivism—the rejection of carving and modeling, of volume and mass, in favor of constructed works incorporating the space around them.

The course of Calder's art was given a new direction in the fall of 1930 by a visit to the studio of the de Stijl master Piet Mondrian (1872–1944). "This one visit gave me a shock that started things. . . . Though I had heard the word 'modern' before, I did not consciously know or feel the term 'abstract.' So now, at thirty-two I wanted to paint and work in the abstract."[4] Calder soon began to relax the strict geometry of his forms, inspired by the abstract Surrealism of his friend Miró, whose biomorphic imagery combined with Mondrian's primary colors plus black, gray, and white gradually became the visual vocabulary from which Calder formed his own unique art.

In 1931 Calder began to make kinetic works that were activated by hand cranks or motors. His friend Marcel Duchamp, who suggested the name "mobile" for Calder's first kinetic works, had already used the term to describe his own kinetic sculpture, *Bicycle Wheel* (1913). The Russian brothers Naum Gabo (1890–1977) and Antoine Pevsner (1886–1962), both active in Paris at this time, had proposed an art based on space and time with "the kinetic rhythms as the basic forms of our perception of real time."[5] Besides the Constructivists Gabo and Pevsner, other artists had also explored the possibility of motion in art. These included Vladimir Tatlin (1885–1953) and László Moholy-Nagy (1895–1946), who created motorized works, Alexander Rodchenko (1891–1956), who made hanging structures, and Thomas Wilfred (1889–1968), whose *Clavilux* "played" colored shapes on a screen. Calder's wish to add motion to sculpture's three dimensions may have been stimulated, in part, by Einstein's theory of relativity, propounding time as the fourth dimension.

Calder found motor-driven and hand-cranked mobiles to be limited and repetitive in their compositional variety (and the motors tended to break down). He began making objects that depended for their movement solely on air currents or the touch of the hand, thus producing continually changing formal relationships. He wrote at the time of his interest in "composing various motions just as one composes volumes, spaces and colors, etc.," adding, "This I consider rather a natural turn for me, for I was once an engineer."[6]

These new works, using the forces of equilibrium, balance, and counterbalance, contained all the compositional elements that would inform the artist's mobiles from then on. The unpredictability of their changing compositional format may have pleased Calder, who was familiar with the many works by his friend Jean Arp composed according to the laws of chance.

The Museum's *Mobile*, created in 1934, reflects the lively innovation that characterized this crucial period in Calder's work. He was experimenting with many different materials—pendants in some mobiles were pieces of colored glass, pottery shards, found objects, or kitchen utensils. *Mobile* seems to represent an experiment almost unique in Calder's work. Its polished steel ring with a tapered steel rod subtly joined to it has a streamlined look, and the whole piece has a kind of machine precision and shiny elegance rarely seen in his work thereafter. A likely explanation was offered by one of the editors of the Alexander Calder catalogue raisonné: "The nickel plating [of the wooden pendants] was applied by an interior designer named Donald Desky [*sic*] of New York. Calder had loaned him this work to display in his booth at a design show in 1934. Desky took it and had it plated without Calder's collaboration. I know of no other wooden works that are plated."[7] Donald Deskey (1894–1989) was a major Art Deco designer in New York in the thirties, best known for the interior decor of Radio City Music Hall in 1932. Deskey's work was influenced by the machine style of the Bauhaus. He favored polished metal surfaces and pioneered the use of chromium plating.[8] The metal parts of *Mobile* also come out of the abstract machine aesthetics of Constructivism, while the five dangling biomorphic carved wood forms connect it to abstract Surrealism.[9]

The threads from which the objects in *Mobile* are suspended are quite long, so that the forms seem to hover in space. Their movements can be very subtle. The piece almost embodies Calder's later prescription for cosmic movements: "the idea of an object floating—not supported—the use of a very long thread, or a long arm in cantilever as a means of support seems to best approximate this freedom from the earth."[10] Four years after his first visit to Mondrian in 1930, he wrote to the collector Albert Gallatin: "the underlying sense of form in my work has been the system of the Universe, or part thereof. For that is a rather large model to work from."[11]

BBJ

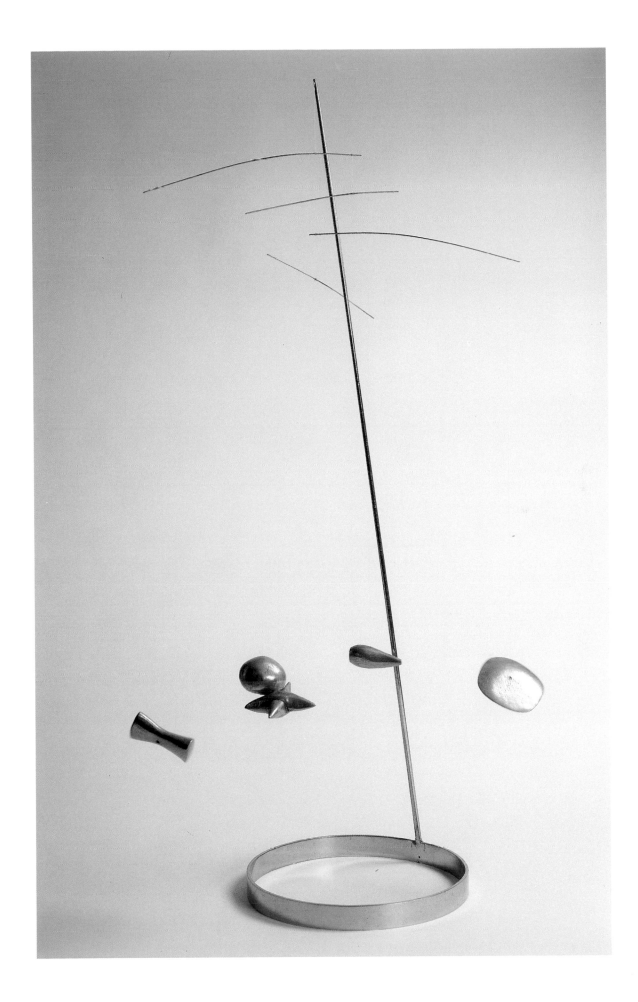

Arthur G. Dove

CANANDAIGUA, NEW YORK 1880–1946 HUNTINGTON, NEW YORK

53. *Happy Landscape,* 1937

Oil on canvas; 10 × 13¹⁵⁄₁₆ in.
(25.4 × 35.4 cm); signed in black
paint, lower center: *Dove;* printed
label, with title and date handwritten
in ink, affixed at upper center of
stretcher: *TITLE HAPPY LAND-
SCAPE / By ARTHUR G. DOVE /
Care of ALFRED STIEGLITZ /
1937 / 509 MADISON AVENUE /
NEW YORK CITY*; inscribed at
bottom left of stretcher in crayon:
Georgia O'Keefe [*sic*] */ OK / AS*

Gift of Dr. and Mrs. Douglas
Spencer (Daisy Davis, class of 1924)
(1982:33)

PROVENANCE: Purchased through
Georgia O'Keeffe at An American
Place, New York, by Dr. and Mrs.
Douglas Spencer, Piermont-on-
Hudson, N.Y., Apr. 6, 1944.

EXHIBITIONS: New York,
American 1937 *Dove*, no. 19;[1] New
York, Dintenfass 1984, p. 241, col-
orpl. and fig. 37.8; Waterville 1985,
ckl. no. 8, repro. p. 2; Birmingham +
1987, no. 46, fig. 83.

LITERATURE: Chetham et al. 1986,
no. 162, repro.; Morgan 1988,
pp. 374, 509.

CONSERVATION: The painting is
on a linen canvas (48 threads per inch
vertically, 38 threads per inch hori-
zontally) mounted on a commercial
stretcher with wooden keys. The
paint surface has minor cracks, some
minor discoloration, and no evidence
of varnish. The painting was surface
cleaned in 1985 at the Center for
Conservation and Technical Studies,
Harvard Art Museums. There is no
evidence of inpainting.

A DETERMINING EVENT in Arthur Dove's career as a painter occurred in 1910, when his *Abstractions No. 1–6,* six small oils, were exhibited in New York under the auspices of Alfred Stieglitz.[2] The forward-looking gallery owner and photographer was to serve as Dove's lifeline to the art world for over thirty-five years. Often considered aloof, the artist disliked city life, preferring the country, from which he derived both artistic inspiration and peace of mind. Recognizing the importance of Dove's work soon after their first meeting in 1909, Stieglitz was quick to give him encouragement and a sense of purpose. The two men developed a close friendship that sustained them professionally and personally until 1946, the year both died. The long correspondence between them, which began in 1914, is a rich source of information.[3]

Dove's works were viewed with a combination of wonder, interest, and distrust by critics and public alike at the 1910 exhibition. Two years later the *Arthur G. Dove First Exhibition Anywhere,* held by Stieglitz at his gallery at 291 Madison Avenue, left the reviewers still unable to make sense of his nature-oriented but nonrepresentational compositions.[4] "What is it all about? No one can tell—and yet the result is strangely agreeable," wrote one critic.[5] These small exhibitions, which established Dove's commitment to abstraction, predated the Armory Show of 1913, in which avant-garde work was introduced to the American public (none of Dove's works was included in this landmark event).

Although occasionally inspired by outside influences, Dove's artistic development was primarily propelled by his own intuition. His first years were spent in upper New York State, where he was introduced to the basic techniques of landscape painting by a neighbor, Newton Weatherly. After more formal studies at Hobart College and Cornell University, he attempted, like many others, to launch a career in New York through illustration jobs with periodicals. A trip to Paris and Cagnes from 1907 to 1908 included acceptance in two Salon exhibitions (in 1908 and 1909) and introduced him to a range of modern developments in European art.[6] Like his colleague and friend Alfred Maurer (cat. 39) and other American pioneers in modern art, he experimented with Post-Impressionist techniques, but such investigations were short-lived. On his return to New York in July of 1909, Dove was committed to painting as a career and resolute in directing his energies toward nonfigurative explorations, paralleling Wassily Kandinsky's (1866–1944) *Improvisations,* which were widely considered the first abstract works to dispense entirely with figuration.[7]

Aside from a series of humorous collage abstract portraits of friends and colleagues created in the 1920s, Dove's abstract compositions, small in size but monumental in impression, are all similar in their interpretation of nature's forms and forces. Although the subject changes with Dove's immediate surroundings—a farm in Westport, Connecticut, the family property in Geneva, New York, a houseboat on the Harlem River, the shoreline at Huntington on Long Island—his paintings tend to represent direct responses to nature expressed in an abstract language rather than products of his memory or imagination. As one critic wrote: "It is the idea, not the reality, that Dove translates, with decorative brevity and color in his work."[8]

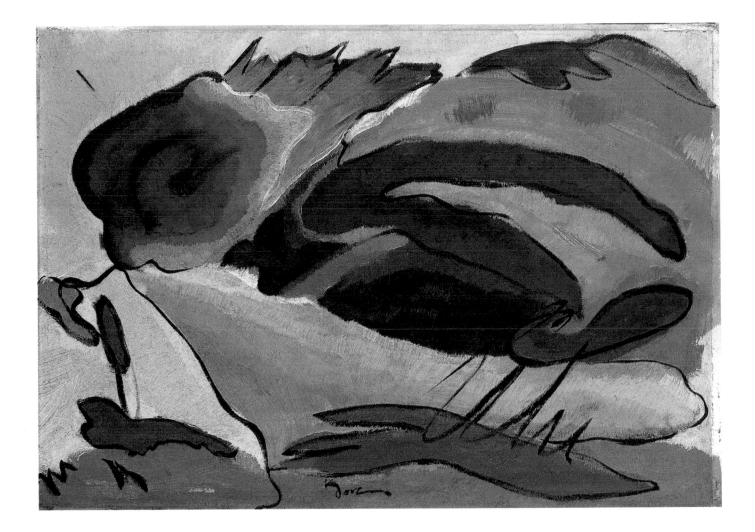

This is certainly true of *Happy Landscape*, a fluid image of natural forms with suggestions of a plowed field on a gentle slope in a brilliant light, partially shadowed by a passing cloud, with trees, plants (possibly a cattail), and grasses blowing in the wind. Botanical identification in such a composition is unimportant.[9] Whatever the exact source of the image, Dove's abstractions "looked just like that country" (the Finger Lakes), claimed Georgia O'Keeffe (cat. 59), and "could not have been done anywhere else."[10]

The depression years of the 1930s in Geneva, New York, though financially difficult for Dove, were productive—many watercolors and mixed-media compositions were created during this time. Most of these works, framed by the artist himself, were regularly exhibited at An American Place in New York, the Phillips Memorial Gallery in Washington (now the Phillips Collection), and elsewhere; they received a share of critical attention but rarely sold. The watercolors not only stand on their own but performed a transitional role in the creative process. Often, as with *Happy Landscape*, the artist recorded his original conception of a composition in watercolor, which was sometimes no larger than a postcard. Later he would transfer the images in his studio with the help of a pantograph or magic lantern, perhaps enlarging them onto a self-ground tempera or half-chalk-ground prepared canvas. Then he would meticulously develop the final surface, layering many transparent coats of the thinnest possible oils. This deliberate process is reflected in, as one reviewer noted, "a remark he is reported to have made, that a painting isn't really a painting until it has layers and layers of paint."[11]

Neither *Happy Landscape* nor its related watercolor is dated,[12] but they were finished by March 1937, in time for Dove's annual exhibition at An American Place.[13] The reviews generally praised Dove's individual vision and remarked on his curious neglect. "Dove is one of the least derivative painters of abstraction now working in America . . . a painter whose force, decision, and originality give his latest work the full stamp of maturity," wrote Lewis Mumford, who felt that the New York show was a brilliant accomplishment.[14] Elizabeth McCausland, one of the artist's staunchest champions, considered it "cause for profound disquiet that a hard-working, sincere artist like Dove goes so long unrecognized while any number of lesser men command the eye—and the purse—of the public." She ended with the comment that thanks to the quality of his work, "Dove will certainly have to be included in the grand total of contemporary American art. Too bad, the museums and collectors are so slow waking up to the truth."[15]

One forward-looking collector and art patron, however, had been quietly acquiring works by Dove with Stieglitz's encouragement since 1926, corresponding with the artist regularly and assisting him financially. Duncan Phillips and Dove met only in 1936 at An American Place.[16] A year later, at the same time as the annual New York Dove exhibition, Phillips held a larger showing of his own at the Washington, D.C., gallery he had established in 1918 and opened to the public in 1921.[17] In the catalogue Phillips wrote:

> Arthur G. Dove is one of the few lyrical individualists among the many contemporary painters of abstraction. He is as unique in his expressive response to experience as he is inimitable in his resulting inventions of pattern. . . . This art is American to the core—old American, like the arts of Whitman and Ryder and Marin.[18]

Sixty years later, at the close of the twentieth century, Dove is recognized as one of the most important pioneers of American abstract painting.

ECE-I

Edward Hopper

NYACK, NEW YORK 1882–1967 NEW YORK

54. *Pretty Penny*,[1] 1939

Oil on canvas; 29 × 40 in. (73.6 × 101.6 cm); signed in green paint, lower right: *EDWARD HOPPER*

Gift of Mrs. Charles MacArthur (Helen Hayes, L.H.D., class of 1940) (1965:4)

PROVENANCE: Commissioned by Mr. and Mrs. Charles MacArthur, Nyack, N.Y., 1939.

EXHIBITIONS: Chicago 1943, no. 17, pl. IV; Nyack 1947;[2] Haverstraw 1951;[3] Syracuse 1965, ckl. no. 24; Nyack 1972; New York +, Whitney 1980–81, p. 44, pl. 228;[4] Nyack 1985; Essen 1992, p. 43.

LITERATURE: Ratcliff 1971, p. 55; McQuiston 1976; Goodrich et al. 1981, fig. 6;[5] Elovich 1981, p. 111; Fox 1981; Anderson 1982; Levin 1985, p. 21; Weston 1986; Levin 1995 *Biography*, pp. 316–18, 321, 364; Levin 1995 *Catalogue*, vol. 3, no. O-311, repro.; Costantino 1995, color repro. pp. 80–81.

CONSERVATION: The painting was executed on a pre-primed canvas that is wax lined and mounted on a keyed, probably original, wooden stretcher. There is no evidence of losses or inpainting. The varnish is uneven and yellowed.

BY THE TIME he painted *Pretty Penny* in 1939, Edward Hopper had achieved considerable success with his depictions of the American scene. The 1920s had seen the development of his mature style and iconography, marked by his use of light on architecture to create a sense of loneliness and isolation. His essay on Charles Burchfield (1893–1967), another painter of the American scene, evinces Hopper's fascination with the architecture of the American past:

> Our native architecture with its hideous beauty, its fantastic roofs, pseudo-Gothic, French-Mansard, Colonial, mongrel or what not, with eye-searing color or delicate harmonies of faded paint, shouldering one another along interminable streets that taper off into swamps or dump heaps—these appear again and again, as they should in any honest delineation of the American scene.[6]

Although Hopper's interest in American, particularly Victorian, architecture would seem to make the Italianate house in *Pretty Penny* an ideal subject for him, he nearly refused to paint it when the owners, actress Helen Hayes and her playwright husband, Charles MacArthur, offered him twenty-five hundred dollars to do so.

Hopper's reluctance to accept commissions probably stems from his commercial work; early in his career he had supported himself as an illustrator, but he considered these works as mere potboilers. He resented the time this commercial work had taken away from his real passion, painting. He preferred "not to be beholden or compromised, to be able to make art freely, [to] suit himself."[7] Hopper sought to represent reality through his inner experience, as he explained in 1953: "Great art is the outward expression of an inner life in the artist, and this inner life will result in his personal vision of the world. No amount of skillful invention can replace the essential element of imagination."[8]

A subject not of his own choosing and the constraints of patronage may have made Hopper feel that he would have had to deny his "personal vision of the world." Only after considerable coaxing from his wife, Jo, and his dealer, Frank Rehn, did he accept the commission. On November 3, 1939, Hopper reluctantly went to Nyack, where he had grown up, to visit his sister and see the MacArthur house.[9] Helen Hayes's impression of Hopper on this first visit was less than positive.

> I guess I had never met a more misanthropic, grumpy, grouchy individual in my life, and as a performer I shriveled under the heat of his disapproval. . . . Really, I was utterly unnerved by this man. . . . [He was] like a big hellcat of anger and resentment at the whole thing.[10]

Hopper's wife accompanied him on the visit and recorded a much more positive impression of the actress, whom she admired: "It was so nice to meet her, very simple, real genuine, like her work. She's very nice—& friendly & interested."[11] After the meeting Hopper maintained his unwillingness to accept the commission, saying: "I can't do this house. I don't want to paint this house. It does nothing for me. . . . I can't paint it. There's no light and there's no air that I can find for that house."[12] Nevertheless, Hopper relented and agreed to do the painting.

On November 8 and 9 he made two unannounced trips to Nyack to sketch the house (much to Helen Hayes's surprise) and produced eight carefully rendered preparatory drawings in conté crayon—some of the entire house and some of architectural details with color notations (all now in the Whitney Museum of American Art, New York). He chose the second drawing of the entire house (fig. 49) as the basis of the painting, and by December 16, after several more trips to Nyack to study the house, the canvas was finished. In her diary, Jo recorded her opinion of the sketch and the method used to transfer the composition:

> He's taking it from his 2″ [no. 2] sketch in crayon—which is a beautiful drawing. If the canvas can be successful, as full of mood as the sketch, it should be very fine. Besides it is helping E. a lot to have made this fine drawing at the very start when he was so bored & unwilling to undertake the project.... He squared off the canvas to reproduce the sketch as closely as possible.[13]

The painting reproduces the chosen sketch faithfully, copying the composition in virtually every detail except that the house is set slightly farther back in the canvas, showing more of the lawn in the foreground. Although his usual method allowed for free interpretation of his drawings to achieve the desired aesthetic effect in oil, for this commission he transferred his drawing almost exactly.

Hopper's atypical working methods for *Pretty Penny* reflect his different conception of this architectural subject. For this portrait of a particular house, Hopper focused more on architecturally specific details instead of simplifying to emphasize geometric clarity. Hopper characteristically employs a generalized approach to his subject, but portraiture requires specificity; this necessary attention to detail may have added to his reluctance to accept the commission. He also all but eliminated the spaces around the house, filling the picture plane almost entirely with the building itself. Only the gable end of the house next door, visible on the far left, provides a sense of setting, giving *Pretty Penny* the atmosphere of a cozy neighborhood. This creates a mood quite unlike that in such works as *House by the Railroad* (1925, Museum of Modern Art, New York), in which the barren landscape and empty space surrounding the house evoke a sense of alienation and loneliness.

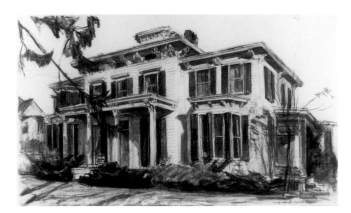

Figure 49. Edward Hopper, Study for Pretty Penny, *1939, conté crayon on paper, 15⅟₁₆ × 25⅟₁₆ in. (38.3 × 63.7 cm). Collection of Whitney Museum of American Art, New York, Josephine N. Hopper Bequest (70.658). Photograph Copyright © 1998: Whitney Museum of American Art.*

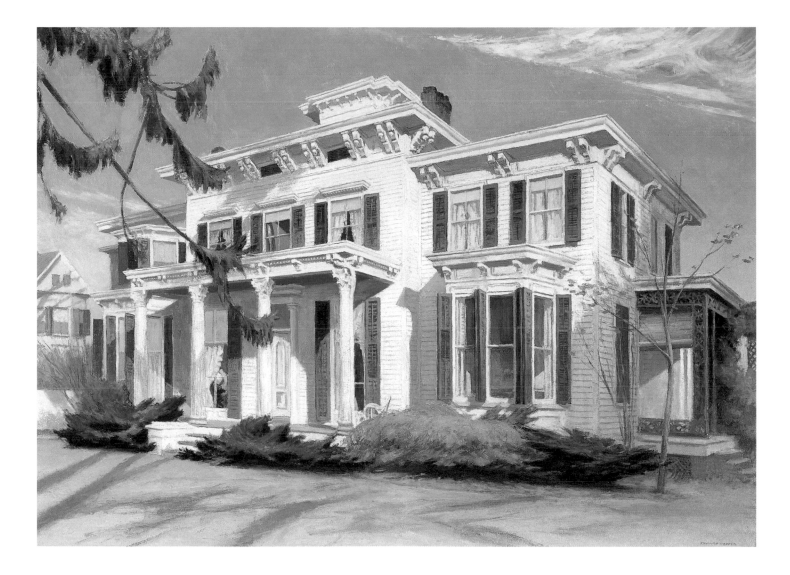

Hopper's architectural paintings often have a feeling of isolation, which he intensified by showing little or no evidence of human residence. The presence of a lone human figure in many of Hopper's works only serves to exaggerate this sense of alienation. Here, however, without using the human form, Hopper clearly shows that *Pretty Penny* is occupied—with open curtains and lights in the windows—creating a warmer, more inviting presence. These differences undoubtedly reflect the nature of a commissioned work. Hopper presumably departed from his usual approach to suit his patrons, who would almost certainly have been pleased to have their home rendered as a welcoming, hospitable place.

CLB

Charles Sheeler

PHILADELPHIA 1883–1965 DOBBS FERRY, NEW YORK

55. *Rolling Power,* 1939

Oil on canvas; 15 × 30 in. (38.1 × 76.2 cm); signed and dated in black paint, lower right: *Sheeler—1939*

Purchased, Drayton Hillyer Fund (1940:18)

PROVENANCE: Downtown Gallery, New York.

EXHIBITIONS: New York, Downtown 1940, no. 4; Chicago 1941–42, no. 183; Deerfield 1945; Deerfield 1946; Andover 1946; Dayton 1949, no. 66, repro.; Hanover 1950; Houston 1951; Middletown 1951, no. 17; Brooklyn 1951–52, no. 121; Minneapolis 1952; Los Angeles + 1954, no. 22; Fort Worth 1958, no. 97, fig. 36; Middletown 1958; Minneapolis + 1960, p. 58, repro. p. 39; Middletown 1961, unno. ckl.; Allentown 1961, no. 25; Iowa City 1963, no. 45, fig. 12; Minneapolis 1963–64, repro., unpag. (listed in ckl.); Northampton 1964, no. 19, repro.; Waltham + 1964, no. 42a, repro.; Bridgeport 1965, no. 20; Cedar Rapids 1967, no. 15; Washington +, National Collection 1968, no. 90, repro.; Washington +, National Gallery 1970, no. 54, repro.; Katonah 1976, no. 61, repro.; Zurich 1977; Huntington 1978, repro. p. 33; Northampton 1979, ckl. p. 76; Berlin 1980, no. 310, pl. 66; Paris + 1980–81; Wellesley 1981, no. 62, pp. 60–61, 128, repro. p. 129; San Francisco + 1982, no. 103, pl. 19; Northampton 1983, ckl. no. 19;[1] Boston +, MFA 1987–88, no. 59, repro.;[2] New York, IBM 1990.

LITERATURE: Sheeler 1940, pp. 78–79, repro.; *Art Dig* 1940, p. 35, repro.; Abbott 1940, pp. 12, 17, repro. p. 6; *Parnassus* 1941 "Smith," repro. p. 35; *SCAQ* 1941, p. 83; *Parnassus* 1941 "Sheeler," p. 46; Abbott 1941, pp. 3–4, fig. 1; *SCMA Suppl* 1941, p. 6, repro. p. 21; Kootz 1943, no. 77, repro.; Born 1947, pp. xiv, 47–48, fig. 134; *Art Dig* 1949, p. 16, repro.; *Brooklyn Mus Bull* 1951, repro. cover; *Time* 1955, p. 64, repro.; Craven 1959, p. 138, fig. 3; Baur 1960, repro. pp. 82–83; Kramer 1961, repro. p. 37; Maloney 1963,

ON DECEMBER 8, 1938, Charles Sheeler wrote to his friend the poet William Carlos Williams: "I am about to start a portfolio of paintings for Fortune under the heading of sources of power—steam, hydro, etc. They have planned eleven to be delivered next December—but something will have to be done about eliminating some of them to make it possible for me to do them in that time."[3] Something was done: there are just six paintings in the series and it was not completed until March 1940. *Fortune,* a magazine of business and industry with a policy of commissioning and reproducing works by well-known artists, gave Sheeler complete freedom to choose his subjects and ownership of the resulting works. The magazine stipulated only that it have the right of first publication.[4] The series appeared in a special portfolio, titled *Power,* with the December 1940 issue.[5] The six paintings were shown at the Downtown Gallery in New York in 1940, when *Rolling Power* was purchased.[6]

Sheeler began his art studies at the School of Industrial Arts in Philadelphia[7] and continued them at the Pennsylvania Academy of the Fine Arts, where he studied with William Merritt Chase (cat. 32). On a visit to Paris in 1908 he first saw the work of Paul Cézanne and, at the apartment of the American art collector Michael Stein (older brother of Gertrude and Leo Stein), the Cubists—artists who shaped the direction of his art from then on. Early in his career as a painter Sheeler began to make photographs, first as a means of earning a living, then as another medium for art. He had become acquainted with leaders of avant-garde photography in America, including Alfred Stieglitz, Edward Weston (1886–1958), Paul Strand (1890–1976), and Edward Steichen (1879–1973). He shared their aim of establishing photography as an independent, legitimate art form, freed from the necessity of imitating painting. Throughout the twenties Sheeler's commercial photography—including work for *Vanity Fair* and *Vogue*—earned him a good living, and his photographs were widely admired. His paintings at this time reflected an interest in Cubism's reductive tendencies, as did those of Charles Demuth, Georgia O'Keeffe (cat. 59), and a number of others, who became known as Precisionists. They produced paintings, primarily of urban and industrial America, in which forms were simplified through the use of flat planes and sharp edges and rendered with an idealized clarity.

After 1931, at the urging of Edith Halpert, whose Downtown Gallery he joined that year, Sheeler began to spend less time on photography, gave up his commercial work, and virtually stopped showing his photographs. Halpert thought that photography would interfere with his production of paintings and drawings. Even more, she feared that because Sheeler so often used photographs as "blueprints" (his word) for his paintings and drawings, potential buyers might be put off by too close similarities between them. She never showed his photographs.[8]

Sheeler traveled widely in the country to select subjects for the *Power* series, making many photographs; no consideration of his work can ignore the close relationship between his paintings and photographs. He himself often compared the two media: "Photography is nature seen from the eyes outward, painting from the eyes inward. Photography records inalterably the single image while painting records a plurality of images willfully directed by the artist."[9]

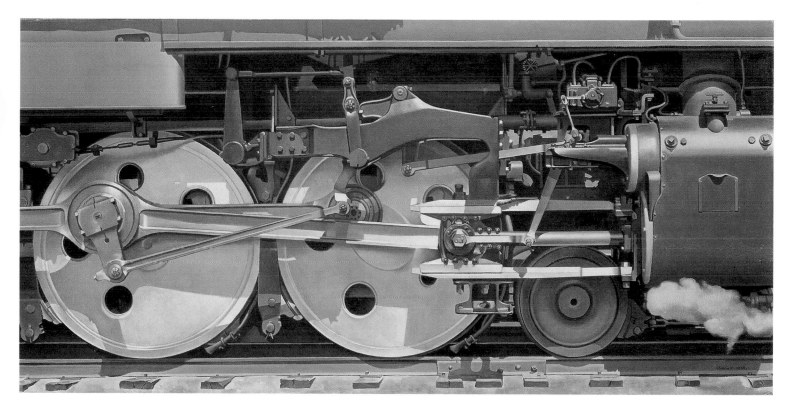

Later, he wrote:

> My interest in photography, paralleling that in painting, has been based on admiration for its possibility of accounting for the visual world with an exactitude not equaled by any other medium. The difference in the manner of arrival at their destination—the painting being the result of a composite image and the photograph being the result of a single image—prevents these media from being competitive.[10]

In *Rolling Power* and other works of the series the two media came closer than at any other time in Sheeler's work. If he had earlier wished to liberate photography from the aesthetics of painting, he now seemed intent on making his paintings more like photographs. The work of the hand and the brush is concealed. In the catalogue of his 1939 retrospective at the Museum of Modern Art he wrote: "Today it seems to me desirable to remove the method of painting as far as possible from being an obstacle in the way of consideration of the content of the picture."[11]

pp. 36–37, repro.; Coke 1964, p. 217, fig. 444; Millard 1968, unpag.; Novak 1969, p. 274, fig. 15-14; Kramer 1969, repro. p. 36; London 1970, pp. 8–9, repro.; Davidson 1973, p. 169, repro.; Friedman 1975, pp. 129–31, repro. p. 120; Bush 1975, pp. 78–79, fig. 68; Ellis 1977, repro. pp. 130–31; New York, Hirschl 1977, unpag.; Mathey 1978, repro. p. 137; Crawshaw 1979, repro. pp. 38–39; Vaizey 1982, fig 52; Tarshis 1982, repro. p. 64; Thomas 1983, pl. 6b; Jodidio 1983, fig. 4; Carré 1984, repro. p. 36; Deak 1985, p. 220; Fisher 1985, pp. 160–61, repro.; Arnason 1986, p. 371, fig. 543; Chetham et al. 1986, no. 166, repro.; Brooklyn + 1986–87, fig 5.24, repro. p. 143; Rawson 1987, fig. 7.23; Danly and Marx 1988, pp. 147–63, figs. 109, 110; Henry 1988, fig. 18; Grant 1989, repro. p. 105; Gladstone 1990, p. 29, fig. 20; Lucic 1991, fig. 59; Cosgrove 1991, p. 19, repro. p. 16; Geldzahler 1991, fig. 14; Smith 1993 *Modern*, pp. 435–40, repro.; Kranzfelder 1994, pp. 67, 74, repro. p. 66; Barnes et al. 1996, p. 425, color repro.; New London 1997, repro. p. 7; Dennis 1998, p. 227, fig. 140; Serwer 1998, p. 19, fig. 14; Arnason 1998, p. 419, fig. 481.

CONSERVATION: The painting has been wax lined and is mounted on a turnbuckle stretcher. There is no evidence of losses or inpainting.

Figure 50. Charles Sheeler, Wheels, *1939, silver print, image: 6¹¹⁄₁₆ × 9¹⁄₁₆ in. (17 × 24.6 cm). Smith College Museum of Art, Gift of Dorothy C. Miller, class of 1925 (Mrs. Holger Cahill) (1978:34).*

The photograph Sheeler worked from in painting *Rolling Power* is not extant, but a comparison with *Wheels* (fig. 50), taken just before or after the one he used, shows many differences besides the obvious ones of format and composition.[12] The value relationships throughout are not the same. Many details of the train's parts, catalogued in the painting with such precision and clarity, apparently omitting nothing but the grime, are, in the photograph, lost in deep shadow. Even the transparent steam vapor, a hint of life and movement in the photograph, has been solidified and stilled in the painting.

The series received considerable attention in the press, not all of it favorable. In *Parnassus* magazine Milton Brown was especially caustic:

> These six paintings are probably the most photographic of Sheeler's works. . . . *Yankee Clipper* and *Rolling Power,* for instance, have nothing to offer beyond the colored photograph and the question may legitimately be raised as to whether these paintings are art. However, if photography is art, then these pictures may find some minor justification, for they are, if nothing else, good photographs.[13]

On the same page the magazine reproduced another of the series, *Conversation—Sky and Earth,* with the caption "Is this a photograph or a painting?"[14]

That Sheeler was and remained sensitive to the charge that his paintings, especially the *Power* series, relied too heavily on their photographic sources can be inferred from an exchange of letters in the Museum's files. In May 1953 the director of the Museum, Henry-Russell Hitchcock, wrote the artist to ask how the Museum could "obtain for our collection a print of the photograph of the same subject."[15] Sheeler replied:

> In reference to my painting "Rolling Power" at the Museum. If it is a photograph of the painting, that I can supply. If you mean a photograph of the locomotive that I cannot supply. Fortune arranged for me to see it at Harmon, at that time and I have no means of identification of the locomotive, where it might be now.[16]

Rolling Power depicts two drive wheels, a bogie wheel, and engine parts of a Hudson-type New York Central locomotive (fig. 51), designed by Henry Dreyfuss. Donald J. Bush writes of it:

> One of the finest torpedo-type streamlined steam engines was designed in 1938 by Henry Dreyfuss to haul the *20th Century Limited.* . . . The engines were

emblematic of speed and power combined with aerodynamic efficiency. . . .
[Sheeler's] painting *Rolling Power* (1939) focused on the complex geometry
of drivers, siderods and pistons and their attendant cranks and levers.[17]

Sheeler's aesthetic reserve is reflected in his decision to render the wheels as the con-
veyors of speed, rather than the engine's shiny shell, the stereotypical symbol of it.

Rolling Power is like a detail of a frieze in low relief, its somber grays and sepias recall-
ing stone or the tones of photographs as much as metal. It has something in common
with Sheeler's series of beautiful detail photographs of an Assyrian relief (1942,
Metropolitan Museum of Art, New York).[18] It is hard to recall many other paintings
in which Sheeler used the close-up device, and it was evidently not as common in
his photography as in that of his contemporaries. The format, exactly twice as long
as it is high, is also unusual, if not unique, in Sheeler's work. The picture's subject is
very near and exactly parallel to the picture plane. This shallow space, with little fore-
ground and no background, eliminates a focal point and produces an overall effect.
The eye is encouraged to roam the whole surface of the painting, where it is rewarded
with infinite detail immaculately transcribed. *Fortune*'s editors characterized it as "an
anatomical study."[19]

Milton Brown faulted the *Power* pictures for their failure

> to capture the nature of power. . . . The dynamic energy hidden within these
> engines of power, the potentialities of movement, creation, or destruction are
> beyond the scope of Sheeler's vision. He is interested only in the static shell in its
> beauty and economy of form without its throbbing internal life. . . . Sheeler may
> be said to have overlooked the soul of the machine.[20]

Perhaps Sheeler was not looking for the soul of the machine but for the soul of man
and finding it in the capacity to conceive and construct machines of such exquisite
complexity and gigantic scale. He always described the *Power* series as paintings of
the "sources of power," and it might be argued, too, that he did not intend to capture
the nature of power but rather to present instruments by which man had captured the
power of nature. *Rolling Power* does this with reticent beauty.

BBJ

*Figure 51. New York Central class
J3a #5450 20th-Century Limited
steam locomotive (designed by Henry
Dreyfuss), 1938. Photograph courtesy
of Cal's Classics.*

Marsden Hartley
LEWISTON, MAINE 1877–1943 ELLSWORTH, MAINE

56. *Sea Window—Tinker Mackerel,* 1942

Oil on masonite; 40 × 30 in. (101.6 × 76.2 cm); signed and dated in black paint, lower right: *M H / 42;* inscribed on back: *Sea Window— Tinker Mackerel*

Purchased, Sarah J. Mather Fund (1947:8-1)

PROVENANCE: Estate of the artist; Paul Rosenberg and Company, New York.

EXHIBITIONS: New York, Rosenberg 1944, no. 17 (?);[1] Baltimore 1945, no. 57, repro. p. 18; Rochester + 1946; Hanover 1950; Boston, ICA 1954; Buffalo 1954, no. 39, repro. p. 51; Amherst 1956; Los Angeles + 1968, no. 66, color repro.; Northampton 1979, ckl. p. 67; New York +, Whitney 1980, no. 101, pl. 66; Munich 1981–82, no. 10, color repro. p. 29; Purchase + 1986–87, pp. 20, 101, repro. p. 54; Northampton 1987–88; New York, iBM 1990.

LITERATURE: Upton 1944, p. 9, col. 4 (as *Sea Window*); Hartt 1947, p. 41, fig. 24; McCausland 1952, p. 30; *ICA Bulletin* 1954, p. 2; Chetham et al. 1986, no. 170, repro.; Robertson 1995, pp. 111, 144, color repro. p. 112.

CONSERVATION: The painting is on the smooth side of a piece of ¼-inch masonite. There is no evidence of losses or inpainting.

COMPLETED, SIGNED, AND DATED about a year before the death of the artist, *Sea Window—Tinker Mackerel* was one of a small group of paintings that served as a summation and culmination of Marsden Hartley's life and career.[2] This composition—five fish on a table in front of an unframed window overlooking a rough sea—has universal connotations in its simplicity and directness. In the context of the artist's life it reflects the peace and serenity he finally found in his native state of Maine and in his mature painting style. Indeed, after a lifetime of wanderlust and artistic searching, marked by scant success, it was in Corea, a small Maine coastal village near Mount Desert, that Hartley painted and wrote with his greatest personal strength and conviction. *Sea Window—Tinker Mackerel,* like other paintings from this late, rich period, embodies the hardiness of the people of northern New England and their relationship to the isolation of their Spartan surroundings.[3]

The youngest of a large family, Hartley was raised in Lewiston, an inland mill town on the Androscoggin River, about 150 miles southwest of Corea. After the death of his mother, Hartley moved with his family in 1893 to Cleveland, Ohio, where his artistic education began. A scholarship from the Cleveland School of Art allowed him to study in New York in the late 1890s at the Chase School and the National Academy of Design. In the spring of 1909 an introduction to Alfred Stieglitz, whose influential Photo-Secession Gallery had opened the year before, proved to be a major turning point in his career.[4] This meeting led to Hartley's first solo exhibition a month later and signaled the beginning of his exposure to modern art and his association with the Stieglitz circle.[5]

Financial assistance from Stieglitz and the painter Arthur B. Davies (1862–1928) made Hartley's first trip abroad possible in 1912. His traveling experiences began in Paris, but over the next twenty-two years he spent time in numerous other European cities, including Berlin, Munich, Florence, Rome, Aix-en-Provence, and Hamburg. Intermittently during these years he returned to America, where he frequently used New York as his winter base, with stays in Provincetown, Bermuda, Taos, Santa Fe, Gloucester, Mexico, Nova Scotia, and various places in Maine. Hartley made many influential and lasting contacts abroad, notably Gertrude and Leo Stein in France,[6] and Wassily Kandinsky and the Blaue Reiter group in Germany. He experimented with a variety of avant-garde styles from Post-Impressionism, Cubism, and Fauvism to Expressionism.

During his career Hartley painted a wide range of subjects; multifaceted though his artistic interests were, however, certain subjects and themes recurred, for example, the sea, the mountains, and still lifes. One format to which Hartley often returned was a window framing a sea view with a still life in the foreground. So regularly did he return to this subject from the late 1910s into the 1940s, in fact, that it became a refrain in the artist's stylistic development. The architectural nature of a window probably appealed to Hartley both as an ideal method of structuring a composition and as a means of combining two of his favorite subjects, landscape and still life.[7] Additionally, as Suzanne Delehanty has pointed out:

Figure 52. André Derain, Window at Vers, *1912, oil on canvas, 51½×35¼ in. (130.8×89.5 cm). The Museum of Modern Art, New York, Abby Aldrich Rockefeller Fund, purchased in memory of Mrs. Cornelius J. Sullivan. Photograph © 1998 The Museum of Modern Art, New York. © 1998 Artists Rights Society (ARS), New York/ADAGP, Paris.*

At the beginning of the twentieth century, the window offered the pioneers of modernism a way to mediate between the openly acknowledged fiction of the flat canvas and the exhilarating, if unsettling, overthrow of perspective.... The canvas and the window were analogues for the artist's imagination and their desire to mediate between and, at the same time, reveal the duality of the object seen and its pictorial representation.[8]

Precisely which artist or source, if any, inspired Hartley to use this compositional format has not been definitely established. In 1952 Elizabeth McCausland stated that Hartley's use of the window motif was not a case of artistic borrowing, but was instead a "parallelism of development."[9] More recent scholarship, however, has strengthened the suggestion made by Barbara Haskell[10] and others that Hartley may have been inspired to use this compositional format by several Fauve artists, specifically Henri Matisse and André Derain (1880–1954), who were among the first painters in this century to experiment with the structural and contrasting spatial features that a window can suggest within a composition. Works such as Derain's *Window at Vers* of 1912 (fig. 52) make a provocative comparison with Hartley's early window still lifes.[11]

Regardless of the roots of Hartley's window imagery, he apparently first used this motif around 1917, on a trip to Bermuda with Charles Demuth, when he painted *Bermuda Window in a Semi-Tropic Character* (M. H. de Young Memorial Museum, Fine Arts Museums of San Francisco) and *Atlantic Window in a New England Character* (Harvey and François Rambach Collection). These works established the basic compositional format he followed intermittently, with minor variations, for the next twenty-five years.[12] Hartley's window subjects, like Derain's but in this case unlike Matisse's, never incorporate the human figure, concentrating instead on inanimate objects, for example, a vase of flowers, pieces of fruit, books, or dead fish, arranged on a foreground table in strictly rectangular compositions and framed fairly symmetrically by curtains or the bare wall surfaces. These interior domestic elements are juxtaposed with an open expanse of water usually defined by a coastline or series of islands on the horizon. The sea, sometimes highlighted by small sailboats, is mirrored by a blue sky often enriched by the addition of a few clouds.

Hartley's early window paintings,[13] which are usually pastel in tonality, have a cheerful atmosphere. A strong sense of depth between foreground and background elements is often created through subtle color changes; perspective is indicated by angling the side of the table so that it converges diagonally toward a vanishing point. In *Sea Window—Tinker Mackerel,* however, all edges of the table conform to the rectangular composition, accentuating its flatness and creating a striking impression of collage. The illusion of depth is created by the classical technique of contrast between the darker foreground (the interior) and the lighter background (the image through the window); the clouds decreasing in size further generate a sense of distance beyond the horizon, and the sky reaches the top of the painting. A different sense of space is given by the texture of the sea, which is rendered in agitated, expressive brushstrokes that become smooth near the islands in the distance. The window itself is a sashless opening, defined by dark walls with the suggestion of curtains. The five mackerel are presented in a tight pattern, as if they were a streamlined school of fish, but this time displayed on a simple, reddish brown table rather than swimming in the ocean.

The palette of *Sea Window—Tinker Mackerel* takes another cue from classical technique;[14] the foreground interior is dominated by warm tones and the background win-

dow view by cool ones. If the interior is stark and represents domestic life, the blue seascape serves as a reminder that nature offers an escape. The fish on the table, which may have religious connotations, repeat the colors of the ocean,[15] mediating between the indoors and outdoors in the painting in a perpetual relationship.

There was much to make Hartley happy in the early 1940s. His paintings were finally being exhibited, appreciated, and purchased, and his reputation seemed to be firmly established. In December 1942 he wrote to his niece:

> I have a high position as a painter—as high as anyone—but I never did get hold of much money and probably never will—. . . . [I] do not paint pretty pictures— but when I am no longer here my name will register forever in the history of American art and so that's something too.[16]

Among other positive events was an invitation in August 1942 to show his work for the first time at the renowned Rosenberg Gallery in New York. For Hartley this was the culmination of his career. He wrote: "I am vain enough or foolish enough to get a thrill out of the idea of seeing a picture of mine put in their grand window . . . alternating now and then with a Renoir, a Corot, or whatever."[17] His first exhibition at Rosenberg's was held in February 1943; consisting of a group of seventeen of his recent works, the show was generally well received. A critic, writing for the *Sun*, noted: "The reappearance of Marsden Hartley in the Paul Rosenberg Gallery reads like a success story, for this exhibition, in a way, makes him international, the Paul Rosenberg Gallery being just a bit of Paris."[18] Included in this exhibition was an oil painting titled *Tinker Mackerel* (22 × 28 in.), a close-up portrait of seven neatly arranged dead fish on a table.[19]

It is likely that the Museum's painting was an elaboration of the earlier, smaller canvas and was painted with a second exhibition at Rosenberg's in mind. Such a showing did indeed take place in December 1944, but because of Hartley's death in September 1943 it became a large memorial retrospective of over forty paintings, pastels, and drawings, jointly organized by the Rosenberg Gallery and M. Knoedler and Company. *Sea Window*, most probably the Museum's painting,[20] was singled out by the press as an outstanding example of his work.[21] Two and one-half years later, when *Sea Window—Tinker Mackerel* was acquired by the Museum, then-director Frederick Hartt wrote admiringly of the painting: "Such a vision, in which simple natural objects and scenes set off a rich train of feeling, is a worthy representation of the style of this mourned leader of modern art in America."[22]

ECE-I

Jacques Lipchitz[1]

DRUSKIENIKI, LITHUANIA 1891–1973 CAPRI, ITALY

57. *Barbara*, 1942[2]

Gilded bronze; 15⅝ × 8 × 9½ in.
(39.7 × 20.3 × 24.1 cm); signed
(incised) lower back: *Lipchitz*

Gift of Philip L. Goodwin (1948:9-1)

PROVENANCE: Mrs. Stanley Resor,
1942; to Museum of Modern Art,
New York, 1942; to the artist by
exchange; to Buchholz Gallery, New
York, 1943; to Philip L. Goodwin,
New York.

EXHIBITIONS: New York,
Buchholz 1943, no. 4, repro.;
Boston, ICA 1954; New York +,
MoMA 1954, p. 92, repro. p. 70;
Northampton 1976 *American;*
Northampton 1979, ckl. p. 86;
Hempstead 1985–86, p. 32, repro.
p. 28.

LITERATURE: Hess 1954, repro.
p. 36; Guitar 1959, repro. p. 114;
Hammacher 1960, pp. 52, 178, fig. 69;
Hammacher 1975, p. 88, fig. 116;
Chetham et al. 1986, no. 169, repro.

CONSERVATION: The sculpture is
in generally good condition. There is
light green copper sulfide tarnishing
on the back center section both on
the inside and outside. There are
spots of black tarnish overall on
the lower section.

BARBARA was made in 1942, the year after Jacques Lipchitz moved to the United States to escape the war in Europe. During his thirty years in Paris he had become one of the foremost sculptors of the avant-garde. A friend of Pablo Picasso and Juan Gris (1887–1927), Lipchitz adapted the principles and subject matter of Cubist painting to sculpture, inspired at first by Picasso's own essays in three dimensions. Once he arrived in America, where Lipchitz would spend the rest of his productive years in a studio on the Hudson River, his work continued to diverge from the formal concerns of Cubism toward explorations of the extremes of human triumph and tragedy, drawn primarily from his personal experience. In addition to his many monumental commissions for heroic, religious, and allegorical figures were small-scale sculptures such as *Barbara,* a body of work that demonstrates the broad range of the artist's interests, his experimental approach to his chosen medium of bronze, and the increasingly personal nature of his art.

Although Lipchitz had little exposure to art in his native Lithuania, he decided early in life to become an artist. He was not encouraged by his father, a building contractor, to pursue his artistic interests but received help from his sympathetic mother in making the pivotal move to Paris at age eighteen. Arriving in October 1909 with no formal art training, he enrolled, like many foreign artists before him, first at the Ecole des Beaux-Arts and soon after at the Académies Julian and Colarossi. At these less structured art academies he learned the basic skills he lacked but also, more importantly, gained access to the art world beyond the academy, where his more important contacts were to be made.

As a movement in painting, Cubism had already grown from its formative period in the hands of Picasso and Georges Braque (1882–1963) and become a springboard for a wider circle of artists, notably Juan Gris, Fernand Léger, Albert Gleizes (1881–1953), and Jean Metzinger (1883–1956), by the time Lipchitz and Picasso met at the behest of Diego Rivera (1886–1957) in 1914. Yet the development of Cubist sculpture had lagged behind, in the opinion of Lipchitz, who expressed skepticism of Picasso's sculptural achievements to the Spaniard himself at their first meeting.[3] Admiring the experiments of the Italian Futurist Umberto Boccioni (1882–1916) and continuing to draw inspiration from Picasso, Lipchitz adapted Cubism's syntax of faceted planes and abstraction to three-dimensional form. He also borrowed Cubist subject matter of musicians and commedia dell'arte figures, while reserving a more traditional, academic style for portrait heads of his friends.

It is for his Cubist works that Lipchitz remains most celebrated despite its clear dependence on the innovations of other artists. The degree of this dependence was not lost on Lipchitz, who first hinted at his break from the Cubist pack in *Pierrot Escapes.* "Pierrot is myself," Lipchitz asserted, "escaping from the iron rule of syntactical cubist discipline."[4] His self-declared freedom, characterized by the increasingly personal choices of subject matter, a more fluid approach to modeling (exploiting the full potential of wax and its casting in bronze), and an intensified interest in the interplay of solid and void, resulted in creation of the "transparents." These works opened up

the traditional solid form of sculpture to "reveal" (actually, to create) an interior rela-
tionship of planes, shapes, and open spaces that suggest the inner "life" of a subject,
which in reality is unknowable, always hidden from view.

Lipchitz's first transparents, dating from 1925, were later declared by Clement
Greenberg to be "the best works of this period," representing "the new draftsman's
language of modernist sculpture even more clearly in some ways than do Picasso's
earlier Cubist constructions."[5] Greenberg criticized their diminutive form, yet
Lipchitz perceived the transparents as personal experiments unsuited to large-scale

and multiple casting; most are under twenty inches in height and were not cast in editions. Less concerned with the academic conception of finish, Lipchitz emphasized that "these works have the quality of a sketch, except they are the final work."[6]

In reference to the transparents of the 1940s, such as *Barbara*, Lipchitz offered only tantalizing statements that unfortunately remained unelaborated. He cited nostalgia as his reason for returning to the format of the transparents, which had heralded his artistic freedom almost twenty years previously. As he further explained:

> These [transparents] were different from the earlier ones in the sense that I had now solved all the technical problems so I could work in an extremely free, lyrical manner. They also had a very close personal association, since they were related to someone with whom I was in love at that time. Most of them, thus, are made to express the sense of an exaltation of the woman. They are works inspired by passion and I think they reflect this fact.[7]

It is not known for certain who Barbara may have been. It has been suggested that she was the daughter of a New York businessman who had commissioned from Lipchitz a realistic portrait of his daughter Barbara in 1941 (unlocated). When asked in 1962 to clarify the relationship between the Museum's sculpture and the earlier commission, still in a private collection, Lipchitz responded only that *Barbara* was not a portrait at all and should not be exhibited as such. In a letter requesting that it be removed from a 1962 exhibition of portraits in the Smith College collection, Lipchitz declared: "[M]y sculpture 'Barbara' is not a portrait. . . . I was always fighting with my friends who made Cubist portraits about this matter. And I personally never made a portrait other than realistic."[8] Indeed, while Lipchitz had created a number of "realistic" portraits of his contemporaries, notably Gertrude Stein, Jean Cocteau (1889–1963), and Marsden Hartley (cat. 56), the assignment of a personal name to this otherwise abstract sculpture is unusual in Lipchitz's oeuvre. Other works in the 1940s transparents series, such as *Blossoming* (1941–42, Museum of Modern Art, New York) and *Myrah* (1942, Marlborough International AG, Vaduz), resemble *Barbara* in form and have been interpreted, in the spirit of Lipchitz's own explanation, as representations of female sexuality and the broader ideals of fertility and creation.[9] It is more likely that for Lipchitz, in creating *Barbara* not as a portrait but as a lyrical, seemingly ephemeral form, issues of sexuality were secondary to a more personal mining of a woman's spirit, intellect, and emotions.

Lipchitz declared late in his life, "I have always been a Cubist," a statement that demonstrates both his tendency to speak in absolutes and the liberties he took with artistic definitions. Perhaps to unify the influences and inspirations of his long career, he rejected the notion of a Cubist formula or canon, saying, "Cubism is a philosophy, a point of view in the universe."[10] As he told one of his biographers, "I wanted to introduce space and light into sculpture itself and make it quickly, as quickly as my inspiration came and my imagination dictated."[11] The transparents thus serve as insights into the artist's understanding of, or at least his reconciliation with, the intangible presence hidden within human form.

DS

Adolph Gottlieb
NEW YORK 1903–1974 NEW YORK

58. *Descent into Darkness,* 1947

Oil on masonite; 30 × 25 in. (76.2 × 63.5 cm); signed and dated in pink paint, upper left: *Adolph Gottlieb;* inscribed in red paint on back: *ADOLPH GOTTLIEB / 1947 / "DESCENT INTO DARKNESS" / 30 × 24*

Acquired by exchange (1951:121)

PROVENANCE: Kootz Gallery, New York; acquired by exchange for William Baziotes, *Falcon,* 1947 (oil on canvas, 24 × 30 in.).

EXHIBITIONS: Aurora + 1953, no. 74; Northampton 1979, ckl. p. 66; New York, IBM 1990.

LITERATURE: Parks 1960, fig. 84; Janson 1995, p. 795, fig. 1095.

CONSERVATION: The painting is on the smooth side of a piece of tempered masonite. There are losses around the edge from frame rub, slight abrasion near the top center, and some minor losses. It is unvarnished.

© Adolph and Esther Gottlieb Foundation/Licensed by VAGA, New York, N.Y.

DESCENT INTO DARKNESS belongs to the postwar period of Adolph Gottlieb's pictographs, a series of paintings from 1941 to 1953 combining a complex lexicon of signs and symbols within a gridlike format. As a response to the creative impasse experienced by the artist in 1939–40, the pictographs reflect Gottlieb's self-described dilemma of being "caught between the provincialism of the American art scene and the power of what was happening in Europe,"[1] during a period when work that fell outside the movements of regionalism and social realism was further overshadowed in New York exhibitions by the dominance of European Surrealism. In the creative and cultural ferment of the 1930s, Gottlieb began to experiment with a version of pictorial Surrealism, with automatic writing, and with abstraction. *Descent into Darkness* and other pictographs represent a synthesis of many different sources and the artist's new approach to image making, which was neither figurative nor wholly abstract but combined the abstract order of a grid composition with imagery and "signs" with multiple meanings.

A student of John Sloan (1871–1951), Gottlieb traveled in 1921 to Europe, where he lived for six months in Paris, and again in 1935 as a mature artist. His interest in and knowledge of world art ranged widely from classical to modern art and included the arts of Africa, Oceania, and Native America, which he was able to study in the great ethnographic museums of Europe and in the rich resources of the Museum of Natural History and the Brooklyn Museum in New York. Gottlieb's *Oedipus* series of the early 1940s and many of the pictographic paintings of that decade contain rectilinear or ovoid masklike forms reminiscent of an eye-nose matrix that is a stylistic convention of much of African art.[2] In some cases Gottlieb made more direct references to identifiable objects, but more often the relation is general and always modified or abstracted, not only in form but in meaning.

A number of abstract forms in *Descent into Darkness* may reflect a source in African masks or the shield arts of Oceania. For example, at the lower right, the large teardrop-shaped form with the suggestion of an eye-nose matrix echoes Kota reliquary figures of Central Africa, whose features are simple geometric indications within an oval format. The funerary significance of the Kota figure, as the embodiment of the dead and guardian of clan relics, may also have appealed to Gottlieb in the context of this picture, which suggests mediation with a spirit- or underworld. Gottlieb and his wife, Esther, were collectors of ethnographic arts and owned at least one Kota figure, documented by an Aaron Siskind (1903–1991) photograph of the artist at home with objects from his African collection.[3]

The proliferation of eye forms in *Descent into Darkness* and other symbols and shapes used in the canvas may point toward sources in Native American art as well. Gottlieb and his wife lived briefly in 1937–38 in Tucson, where he became interested in the southwestern Indian ceramics collection at the Arizona State Museum. Exhibitions of Native American art at the Museum of Modern Art in New York in 1937 and 1941 were also influential. Gottlieb's title for his pictographs was undoubtedly drawn from the term "petroglyph," used to describe Native American rock carvings or drawings.

Evan Maurer cites Northwest Coast art as a precedent for eye motifs ranged across a pictorial field, in particular Chilkat dancing blankets, which in addition to lozenge-shaped eyes like those in the central lower portion of *Descent into Darkness*, register forms in cell-like divisions.[4] In many pictographs, including the Museum's panel, Gottlieb appropriated zigzag lines, representative of serpents, lightning, and rain in Southwest Native American art. The diamond shapes and cross in *Descent into Darkness* may also have been influenced by similar forms in (among others) Navajo wearing blankets.

Gottlieb's eclectic borrowings from image sources are matched by the variety of thematic references in the pictographs, many of which are based on literature and mythology.[5] Sanford Hirsch relates the Museum's canvas to works such as *Mariner's Incantation* (1945, Adolph and Esther Gottlieb Foundation, New York) and *Voyager's Return* (1946, Museum of Modern Art, New York), which equally evoke odysseys of ancient myth and modern life.[6] As he points out, *Descent into Darkness*, painted in blues, greens, violets, and black with pink accents, shares a similar palette of watery blues and greens with other paintings relating to the theme of sea voyages, such as *Night Voyage* (1946, Hirshhorn Museum and Sculpture Garden, Washington, D.C.).[7] In the Museum's panel, however, the mythological journey has less to do with sea-faring than with a descent into the underworld of fear and death, which found its real-life counterpart in the historical events of the Second World War.[8]

The importance of Pablo Picasso's *Guernica* (1937, now Museo Nacional Centro de Arte Reina Sofia, Madrid), an internationally influential work of art that confronted the brutality of war in contemporary terms, has often been cited as a precedent for Gottlieb's postwar pictographs. (Indeed, one of them, *Expectation of Evil* [1945, Los Angeles County Museum of Art], even contains fragments of figures from *Guernica*.)[9] Like *Descent into Darkness*, many of the post-1945 pictographs reflect a response to the war in a general way, in their subdued or darkened palettes as well as somber titles,[10] but Gottlieb may have intended a more specific reference with the Museum's painting. Hirsch has noted a similarity of composition and imagery between *Descent into Darkness* and an earlier work by William Baziotes (1912–1963), *The Parachutists* of 1944 (fig. 53),[11] whose title refers to the airborne troops who parachuted behind enemy lines in the early hours of D-day, June 6, 1944, suffering heavy casualties.[12]

Figure 53. William Baziotes, The Parachutists, 1944, Duco enamel on canvas, 30 × 40 in. (76.2 × 101.6 cm). Collection of Ethel Baziotes. Photograph courtesy of Joseph Helman Gallery, New York.

In comparing the Museum's painting and *The Parachutists*, it is possible to read the conical forms in *Descent into Darkness* as abstract parachutes, with shroud lines and umbrella-like canopies. Both paintings share similar pictorial elements: a chalice-shaped form appears in the central portion of the Baziotes painting and in the top row, second cell from the left, in Gottlieb's panel; both have an X contained in a cell; and each has a wedge-shaped form containing an "eye" surmounted by a lid or ellipse. In this context, the title of the Museum's painting takes on extended meaning as a possible reference to the nighttime descent of the paratroopers, who were the targets of relentless machine-gun fire during the drop.[13] The chalice and central cross may be read as Christian symbols associated with the sacrifice of the many soldiers who were killed as they hung suspended below their parachutes.[14]

Gottlieb considered the postwar pictographs to be not only a response to historic evil but a creative expression that was not entirely intellectually determined by the artist or subject to his control:

> The role of the artist, of course, has always been that of image maker. Today when our aspirations have been reduced to a desperate attempt to escape from evil and times are out of joint, our obsessive subterranean and pictographic images are the expression of the neurosis which is our reality.[15]

This statement, published the year the Museum's pictograph was painted, also reflects Gottlieb's more general interest in psychology and the subconscious, variously influenced by Surrealism and by Freudian concepts and by Carl Jung's theory of the collective unconscious. His beliefs in this area were both eclectic and personal and were the product of his own studies, which included the ideas and writings of the artist-émigré and theorist John Graham (1890–1961), whom he knew. As an expression of a need, even obsession, to create images, *Descent into Darkness* and other pictographs may have been viewed by the artist as having a cathartic as well as responsive role.

In a joint letter of June 1943 to the editor of the *New York Times*, Gottlieb and Mark Rothko (1903–1970) asserted the validity of artistic "subject matter which is both timeless and tragic."[16] Seen in the context of universal continuities, the pictographs represent an impulse as enduring as myth and as basic as the human impulse to communicate through marks and signs. However, as Hirsch has cautioned, the pictographs were not meant to be understood in terms of narrative constructions;[17] they cannot be parsed and deciphered. Like all of Gottlieb's pictographs, *Descent into Darkness* draws from many different languages and systems to accumulate form and meaning, which are transformed from their original sources to create a new pictorial syntax.

LM

Georgia O'Keeffe

SUN PRAIRIE, WISCONSIN 1887–1986 SANTA FE, NEW MEXICO

59. *Grey Tree, Fall,* 1948[1]

Oil on canvas; 39⅞ × 29⅞ in. (101.3 × 75.9 cm); not signed, not dated; inscribed in artist's hand in pencil on stretcher, at bottom under canvas tacking edge: *2 Glue size 10/25/47;* at top under canvas tacking edge: *Turpentine & Little Linseed Oil 5/28/48 Dutch Boy zinc white*

Gift of the Robert R. Young Foundation in memory of the family of Robert R. Young (1987:13)

PROVENANCE: The artist's sister, Anita Natalie O'Keeffe Young (Mrs. Robert R. Young), Newport, R.I., Palm Beach, Fla., and New York.[2]

EXHIBITIONS: New York, American 1950, ckl. no. 11; Northampton 1987–88; New York, IBM 1990.

LITERATURE:[3] *Gaz B-A* 1989, p. 44, fig. 247.

CONSERVATION: The painting is on fabric (34 threads per inch vertically, 29 threads per inch horizontally) mounted on an unkeyed stretcher. The canvas is wrapped around the back of the stretcher and tacked on the back. There are no losses or inpainting. The original backing board is inscribed: "1950 sprayed with Butyl Methacrelate Polymer."

© 1998 The Georgia O'Keeffe Foundation/Artists Rights Society (ARS), New York

GEORGIA O'KEEFFE was fifty-eight years old, nationally recognized, and well established when her husband, Alfred Stieglitz, died in 1946. A noted photographer and progressive New York gallery owner, Stieglitz was famous for introducing European modernism to the American public. He was, in fact, the driving force behind the first half of O'Keeffe's career, regularly showing her work from 1917 until his death.[4] Despite some differences and strains of independence, they shared a great deal—artistically, professionally, and personally. Their initial meeting in 1908, Stieglitz's enthusiastic reaction to O'Keeffe's work that he first saw in early 1916, their marriage in 1924, and subsequent life together are all well documented.[5] O'Keeffe became an active and outspoken member of Stieglitz's circle of American avant-garde artists, which included, among others, Arthur Dove (cat. 53) and Marsden Hartley (cat. 56).

In 1945 O'Keeffe bought an adobe house in Abiquiu, New Mexico, on a three-acre hilltop property in the northern part of the state.[6] Among the series of contrasting motifs she painted there were the sprawling cottonwood trees in the dry Chama River Valley; the Museum's *Grey Tree, Fall* is one among a number of paintings of these trees.[7] In this context, O'Keeffe was challenged, as she had been in earlier paintings of chestnut, birch, and maple trees of the 1920s, to resolve compositions that were artistically satisfying while also capturing the essence of the natural form. She painted the cottonwoods in fall, winter, and spring and usually specified the season of a particular canvas—most commonly winter.[8] There is no absolute compositional progression in the cottonwood paintings, a continuing focus of interest until 1954, when she turned to other themes. Instead, the artist alternated between two broadly defined compositional types: groups of trees set in a landscape of receding plains and individual trees enlarged to fill the entire canvas. In *Dead Tree with Pink Hills* (1945, Cleveland Museum of Art), which belongs to the first compositional type, O'Keeffe provides context in a landscape of rocks, hills, and horizon. In the case of the Museum's painting, which belongs to the second compositional type and may be a formal echo of an earlier example of this kind, *Grey Tree, Lake George* (1925, Metropolitan Museum of Art, New York), the viewer is presented with an abstract impression of a tree under a specific light, but without background details to locate it in a particular setting.

During the three years it took to settle Stieglitz's estate O'Keeffe had less time and energy to devote to her painting. But by 1948, when she completed the Museum's large and imposing *Grey Tree, Fall* and the even larger *Spring* (48 × 84 in., private collection), she was able to spend at least some time in New Mexico. As she wrote from Abiquiu to her long-time friend Russell Vernon Hunter (1900–1955) on October 30, 1948, "Ive [sic] been living here about three weeks— My first painting—a dead tree surrounded by the autumn is very gentle and pleasant and high in key but it holds its place on the wall alone more than forty feet away."[9] The tree depicted in the Museum's painting, with its silvery crown accented by darker, curving branches, may or may not appear to be dead;[10] however, its central and isolated placement on the canvas relates this work to a number of O'Keeffe's similarly-titled paintings that could be considered portraits, of which some seem to have memorial or commemorative connotations.

O'Keeffe was probably first inspired to paint what Charles C. Eldredge terms "individual arboreal 'portraits'" by Stieglitz.[11] He was particularly fond of a giant chestnut tree on his family's summer estate in Lake George; when it died in 1924, two years after his mother's death, he grieved for both, capturing his mood in mournful photographic studies of the tree. O'Keeffe followed with two "memorial portraits," one being *Chestnut Tree—Red* (1924, private collection).

O'Keeffe's pencil notations on the top and bottom sides of the stretcher underneath the tacking edge of the Museum's painting reveal that she primed the canvas at the end of October 1947 and prepared it with a ground of zinc white at the end of May 1948. The stretched canvas, therefore, may have traveled with her between Lake George and the Southwest before she began work on the composition, no earlier than the beginning of summer; she undoubtedly finished it in October. Autumnal subjects had long been a favorite theme of O'Keeffe's, but *Grey Tree, Fall* appears to be one of the few works specifically identified by the title as a tree in the fall season. It is difficult, of course, for those unfamiliar with the seasonal changes of the cottonwood in the Abiquiu climate to distinguish one evanescent, misty tree from another as O'Keeffe paints them.[12] In *Grey Tree, Fall*, however, the dominant colors of the composition are enlivened by small areas of bright cadmium yellow and soft pinks that appear at the edges, creating a halo effect from the characteristic fall color of surrounding cottonwoods. A striking yellow-green bushlike shape, suggesting new life, in the lower center of the canvas anchors the composition chromatically.

Beyond the interwoven realism and semiabstraction in the painting, typical of O'Keeffe's oeuvre, there is a possibility that the Museum's painting, like the chestnut tree paintings of the 1920s, may be a memorial portrait. When she painted it, she was still dealing with the loss of her husband. As she wrote Russell Hunter on October 30, 1948: "It is odd—Stieglitz was never out here but there are certain places that he always seems with me here. I wrote him so often from here and thought to [*sic*] him so often."[13] O'Keeffe may have projected in *Grey Tree, Fall* Stieglitz's determination and strength of character. She once wrote:

> There are people who have made me see shapes. . . . I have painted portraits [of them] that to me are almost photographic. I remember hesitating to show the paintings, they looked so real to me. But they have passed into the world as abstractions—no one seeing what they are.[14]

Such may also have been the case with *Grey Tree, Fall*. In October 1950 when it was shown publicly for the first time in O'Keeffe's last exhibition at An American Place[15]—an event that marked the gallery's closing—Henry McBride commented in his review: "There does seem to be an increased urge to dispense with all fripperies and to do in paint what Brancusi does in sculpture, that is to say, to reduce everything to its essential principle, polishing the surfaces until they have an elegance strictly hygienic."[16] *Grey Tree, Fall* may in fact be an emotional recognition of her past and at the same time a harbinger of the artist's new and totally independent life in her beloved Southwest.

ECE-I

Robert Motherwell

ABERDEEN, WASHINGTON 1915–1991 PROVINCETOWN, MASSACHUSETTS

60. *La Danse*, 1952

Oil on canvas; 30 × 38 in. (76.2 × 96.5 cm); not signed, not dated

Purchased with the gift of Jane Chace Carroll, class of 1953, and Eliot Chace Nolen, class of 1954, and gift of the Dedalus Foundation (1995:7-1)

PROVENANCE: Dedalus Foundation, 1991.

EXHIBITIONS: New York, Kootz 1952, no. 9;[1] Northampton 1996; Barcelona 1996–97, no. 14, p. 297, repro.[2]

LITERATURE: Geldzahler 1965, p. 221.

CONSERVATION: The painting is on a linen canvas (30 threads per inch vertically, 31 threads per inch horizontally) with a fairly open weave. It has been strip lined with a very light canvas and mounted on a new wooden keyed stretcher. There are inpainted losses along the bottom edge and three small repaired tears that have been inpainted. Varnish appears to have been selectively applied.

Figure 54. Robert Motherwell, Wall Painting No. 1, 1952, oil on masonite mounted on linen, 8 × 10 in. (20.3 × 25.4 cm). Art Gallery of Ontario, Toronto. © Dedalus Foundation/Licensed by VAGA, New York, N.Y.

THE MUSEUM'S *La Danse* of 1952 is closely related to a larger painting of the same date, composition, and palette titled *La Danse II*, in the collection of the Metropolitan Museum of Art, New York.[3] In both paintings, three black torsolike forms are linked by two smaller black shapes and floated on a rectangle of brilliant orange-red against a larger rectangle of more thinly brushed ocher. Rather than a study for the larger work, *La Danse* should be considered Motherwell's first essay on this motif and the Metropolitan's painting, as its title states, the second. Their association as independent but related paintings, and not as preparatory study and final version, is reinforced by the fact that Motherwell chose to keep *La Danse* in his studio until his death, which was in keeping with his practice of retaining the primary work that inaugurated a motif or series.[4] Influenced by Henri Matisse both in style and theme, Motherwell's *Danse* canvases are related to his *Wall Paintings* and also forecast the development of the archetypal forms of the *Spanish Elegies*.

La Danse and its larger counterpart were painted during a transitional period in the artist's work, marked by the comparatively fewer paintings that remain from the early 1950s.[5] In the previous decade Motherwell had become associated with the European Surrealist artist-exiles who had emigrated to New York during the Second World War, joining with Max Ernst (1891–1976) and André Breton (1896–1966) as founding co-editors of the new Surrealist magazine *VVV*. His first connections with the artists who would later become known as the Abstract Expressionists were also made during this time, through their experimentations with Surrealism and their participation together in exhibitions, including a major collage show at Peggy Guggenheim's Art of This Century Gallery in 1943. This exhibition spurred Motherwell's interest in collage, which would remain an important medium throughout his career.

H. H. Arnason has noted the formal and stylistic precursors of the *Elegies* in the suspended ovals and vertical rectangles of Motherwell's paintings from the 1940s as well as in the simplified shapes of the designs of the collages from this period.[6] *La Danse* and *La Danse II* are also inheritors of these influences as well as links in the further evolution of the series that began in 1948 with the ink sketch accompanying a Harold Rosenberg poem, *Elegy to the Spanish Republic No. 1* (Museum of Modern Art, New York). This drawing introduced the black ovals and verticals against a white ground that Motherwell would develop in rich permutations in later works such as the Museum's *Elegy Study* (1959, checklist no. 41). Arnason associated the shapes of the Metropolitan Museum's *La Danse II* (and, it may be assumed by extension, the forms in *La Danse*) with the development of the *Elegies* toward a more organic direction and more generally with other experiments of the early 1950s, which represented, according to Arnason, "an important phase of reflection and reexamination" for the artist.[7] During this time Motherwell increased his lecturing, teaching, and writing activities and also became involved in mural painting as a result of his participation in the 1950 exhibition *The Muralist and the Modern Architect* at the Kootz Gallery.[8] *Wall Painting No. 1* (fig. 54),[9] a diminutive oil sketch from 1952, adopts virtually the same composition as the *Danse* canvases but is more freely painted compared to their harder-edged forms.

When *La Danse II* was shown at the Kootz Gallery in April 1953, reviewers remarked on its relationship with the *Elegies* but also noted its stylistic connections with Matisse.[10] One writer made a specific association between Matisse's paper cutouts and Motherwell's canvas *The Painter's Wife, Pregnant* (1953) shown in the same exhibition.[11] This canvas silhouettes a nude female torso, with the head of the figure placed in a succession of abstract shapes across the canvas that closely resemble the shapes and configuration of forms in the *Danse* paintings.

Like Motherwell's abstract portrait of his pregnant wife, the *Danse* paintings also reflect the influence of Matisse's *papier découpages,* in particular the *Jazz* series, published in 1947 by Emmanuel Tériade with *pochoir* (stencil) plates based on the original paper cutouts.[12] While the *Danse* paintings do not adopt the narrative content and circus themes of *Jazz,* they are compositionally similar in the way sharply contoured abstract shapes and figurative motifs are posed against rectangular fields of brilliant local color. Closer connections can be made with individual works in the series, includ-

ing *Formes,* with its double silhouettes of torso- or vaselike shapes, and especially
Le Cow-boy, whose playful abstract figures (a cowboy on horseback lassoing a female
figure) stand out as black shapes against a background of vertical rectangles of blue,
yellow, green, and white.

Motherwell's wide knowledge of and admiration for Matisse are well documented. In
his 1949 lecture "A Personal Expression" at the Museum of Modern Art, New York,
the artist cited the early and lasting influence of the French master: "in those days, fif-
teen years ago, I was greatly taken as I still am by the work of Henri Matisse."[13] In the
years just before the creation of Motherwell's *Danse* paintings, there were two exhibi-
tions of the work of Matisse at the Museum of Modern Art that may have provided a
more direct inspiration and immediate stimulus.[14] The published edition of *Jazz,* which
was given to the Museum of Modern Art by Matisse, was shown there in October
1948. In 1951 the museum hosted a nationally touring Matisse exhibition that included
other examples of cutouts, among them the monumental *Thousand and One Nights*
(1950, Carnegie Museum of Art, Pittsburgh) and designs for the windows for the
Chapel of the Rosary for the Dominican nuns of Vence. Significantly, this exhibition
also included the great first version of *La Danse* of 1909 (Museum of Modern Art),
then in the collection of Walter P. Chrysler (fig. 55). While Matisse's paper cutouts
are stylistically reflected in Motherwell's *La Danse* and *La Danse II,* it is this Matisse
painting and its related works that almost certainly influenced Motherwell's choice of
theme and composition for these paintings.

Matisse's two versions of *La Danse,* painted in 1909–10 as a commission from Sergei
Shchukin, are both based on a ring of five dancers. The version now owned by the
Museum of Modern Art (referred to in the literature as *La Danse I*) is a more lyrical
treatment, while the second version, now in the Hermitage Museum, Leningrad
(referred to as *La Danse II),* though the same composition, evokes a more vigorous
dance. Motherwell's *Danse* canvases are not as figuratively specific, but, as in the
Matisse paintings, five forms are used to create a sense of motion related to the dance
and are placed against backgrounds of more or less unified color areas. Motherwell's
paintings appear to be related in very much the same way as the Matisse paintings, that
is, as a first and a designated second version of the theme (rather than as a study and a
final version).

Motherwell's further debt to Matisse can be seen in Matisse's dance mural project
for the Barnes Foundation in 1931–33, which, as Jack Flam has pointed out, took the
Shchukin *Danse* paintings as its point of departure and was the first time the artist used
large paper cutouts as a technique to plan his composition.[15] Many of Motherwell's
current interests when he painted *La Danse* and *La Danse II* in 1952 are encapsulated
in Matisse's dance mural project, which resulted in the creation of two murals, one
for the Barnes Foundation in Merion, Pennsylvania (fig. 56), and another (with a
third, unfinished version) owned by the Musée d'Art Moderne de la Ville de Paris.
Motherwell's own mural projects and *Wall Paintings* from the early 1950s may have
been influenced by the example of Matisse in enlarging easel painting to monumental
or architectural scale.

In the early years of Abstract Expressionism, Motherwell's *Danse* paintings represent
a creative intersection of experimentation and acknowledgment if not direct quotation
of the work of another modern master. Although the sharper contours and decorative
impulse of these essentially planar compositions would be succeeded by the more
expressionist *Je t'aime* paintings and the greater freedom of the *Elegies*, *La Danse* and
La Danse II are both painted in the palette that would remain Motherwell's hallmark:
ocher "for the earth,"[16] red "rooted in blood, glass, wine,"[17] and black as the great
protagonist.

LM

Figure 56. Henri Matisse, The Dance
(Merion Dance Mural) (La Danse),
*1932–33, oil on canvas, left section:
133¾ × 173¾ in. (339.7 × 441.3 cm),
center section: 140⅛ × 198⅛ in.
(355.9 × 503.2 cm), right section:
133⅜ × 173 in. (338.8 × 439.4 cm).
Main Gallery, South Wall. Photograph
© Reproduced with the Permission
of The Barnes Foundation.™ All
Rights Reserved. © 1999 Succession H.
Matisse, Paris/Artists Rights Society
(ARS), New York.*

Josef Albers

BOTTROP, GERMANY 1888–1976 NEW HAVEN, CONNECTICUT

61. *Study to Homage to the Square: Layers*, 1958

Oil on masonite panel; 24 × 24 in. (61 × 61 cm); signed and dated lower right (incised in paint layer): [monogram] *58;* inscribed on back of masonite panel, upper left: *24 × 24;* upper right: *Study to / Homage to the Square: / "Layers" / Albers' 1959* [*sic*]; inscribed on back, right side:[1] *Ground 1 [Crambat] Luminalt (Casein) / + 2"""with additions of / Linseed oil, Damar varnish & Turpentine / Painting: paints used— from center: / Baryx Green (Lefebvre) / Cobalt Green (Winsor & Newton) / Reidy's Gray #4 (Grumbacher) / Ochre Rouge (Lefebvre) / all in one primary coat /" directly from the tube: / no additional mixing /"" painting medium / Varnish: probably Melacrylite resins / in Xyleene* [*sic*]

Gift of Mr. and Mrs. John R. Jakobson (Barbara Petchesky, class of 1954) (1964:40)

PROVENANCE: Sidney Janis Gallery, New York; to Mr. and Mrs. John R. Jakobson, New York, 1960.

EXHIBITIONS: Amherst 1966; Boston +, ICA 1967, no. 22; Northampton + 1978, no. 1.

LITERATURE: Chetham et al. 1986, no. 179, repro.

CONSERVATION: The painting is on the textured side of a tempered masonite board, which is not reinforced although there is an unattached strainer that secures the board in the frame. The ground is casein based. The painting is in good condition, with some small losses along the edges and in the corners.

STUDY TO HOMAGE TO THE SQUARE: LAYERS is from the series of works for which Josef Albers is best known. Although he did not begin it until he was in his sixties, the *Homage to the Square* series can be said to have been in development from the beginning of his life as an artist. Albers's long career took him from the Bauhaus to Yale University and bridged virtually every art movement of the twentieth century from German Expressionism to Pop art. Nevertheless, he remained committed to a near-scientific approach to the study of visual perception, refining his early woodcuts and geometric glass designs to the simple squares-within-squares format of the over one thousand works comprising the *Homages.*

The purpose of the *Homage* series, and one of the steadfast interests of Albers's career as both artist and teacher, was to demonstrate the illusionistic effects colors have on each other as perceived by the human eye, or as he put it, the "discrepancy between physical fact and psychic effect."[2] Albers juxtaposed the colors of his squares and the squares themselves in order to activate an uneasy, constantly shifting balance between advance and recession and to reveal the relative impact that colors have on the visual perception of other colors. In the Museum's *Layers,* for example, owing to the tendency of warm colors to advance and cool colors to recede, the red-ocher of the outermost square appears at first to be nearer the viewer than the adjacent gray. Countering this effect, however, are the two inner shades of green, which advance to form successively receding layers, with the innermost square perceived as being closest to the viewer.

Simultaneously, the green shades tend to bring the gray forward as a third layer beneath them, thereby binding them together in a unit of three squares that appears to be placed on top of the red-ocher outer square. Thus, depending on whether one reads the painting from the edge to the center or vice versa, the red either advances or recedes. Of course, qualifying this analysis—as Albers instructed and as unscientific viewer surveys prove—is the fact that different eyes see differently. As quickly as the viewer mentally resolves the effects, the resolution falls into doubt and its opposite becomes possible.

Throughout the 1930s and 1940s, Albers exploited the boundaries and possibilities of visual perception—the ability of the eye to see one thing in many ways. Seemingly coherent solids appear first one way and then the next, or upon closer inspection, prove incapable of existing anywhere but in the imagination. *Rolled Wrongly,* of 1931 (fig. 57), is an example of this effect. Albers produced this work in glass during his tenure at the German Bauhaus, where he was first a pupil and then an instructor until the school closed in 1933 and he moved to America. The plausible depth established by the underpassing and overlapping curved lines causes the viewer to strive to find a three-dimensional existence possible for what appears to be simple, graspable rolls of paper or tin. It is a futile effort, of which the title has already warned.

In the introduction to his *Interaction of Color,* which Albers called "a record of an experimental way of studying color and of teaching color,"[3] he offered the theorem that the remainder of his career would be devoted to proving. While impossible

Figure 57. Josef Albers, Rolled Wrongly (Falsch Gewickelt), *1931, sandblasted opaque flashed glass, 16⁹⁄₁₆ × 16⁹⁄₁₆ in. (42.1 × 42.1 cm). © 1998 The Josef Albers Foundation/ Artists Rights Society (ARS), New York.*

shapes can ultimately be seen for what they really are, as his earlier works had shown, "color," Albers proposed, "is almost never seen as it really is—as it physically is." In simpler terms, "color deceives continually."[4]

In the *Homages* there are few clues to direct a definitive perception, and where they exist they are deceptive, like the colors themselves. The Museum's painting is not composed in layers at all but follows the artist's standard method of painting a small solid square within larger "hollow" squares, never mixing colors or overlapping forms. If the viewer sees layers, it is primarily the result of the way the visual material is interpreted by the brain, abetted by the title of the painting, *Layers*. More often these paintings have no subtitle, and the viewer is left to resolve the mysterious interactions of the colors with no clues whatsoever.[5]

Albers's variations in the square format, of which there are many, alter the controls of his experiment—affecting the depth of field and the range of the colors available— but do not dictate the possible results. The *Homages* are composed of either three or four squares, the "absent" square only occasionally being the innermost. The Museum's painting is typical of the four-square variety, in which the distance between the square's edges is equal at the bottom, doubled at either side, and tripled at the top. Albers applied the pigments with a palette knife and always worked from the center square outward, following advice he had received from his father and later recounted: "That way you catch the drips, and don't get your cuffs dirty."[6] In order to dismiss the notion that the artist is playing visual games with the viewer and to increase the sense of the viewer's eye controlling the painting's ultimate effect, Albers treated the *Homages* not as unique products of artistic genius but as the repeatable experiments of a scientist. In the Museum's painting and other works from the series, he catalogued exactly which pigments he used, including brand names. In the inscription on the Museum's painting, he states that the colors were used directly from the tube, in one primary coat, without mixing.

Such an experimental approach to the craft of painting contributed to Albers's effectiveness as an educator, first at the Bauhaus, later at Black Mountain College in North Carolina, and finally at Yale University, where he began the *Homages*, which would dominate the last twenty-six years of his life. Far from being simple, mechanistic formulations on a single theme, the works in the *Homage to the Square* series renew the artist's original perceptual experiments with each viewer and with each subsequent viewing.

DS

Franz Kline

WILKES-BARRE, PENNSYLVANIA 1910–1962 NEW YORK

62. *Rose, Purple and Black,* 1958

Oil on canvas; 45 × 36⅛ in. (114.3 × 91.8 cm); signed and dated on back: *Franz Kline 1958*

Gift of Mrs. Sigmund W. Kunstadter (Maxine Weil, class of 1924) (1965:27)

PROVENANCE: Sidney Janis Gallery, New York, 1959; to Mr. and Mrs. Sigmund W. Kunstadter, Highland Park, Ill.

EXHIBITIONS: Amsterdam + 1963, no. 40; Boston +, ICA 1967, no. 24; Amherst 1968; Washington +, National Gallery 1970, no. 32, repro.; Northampton + 1978, no. 15; Northampton 1991, p. 42, repro.

LITERATURE: Hess 1951, p. 137; Chetham 1969, p. 775; Chetham et al. 1986, no. 180, repro.

CONSERVATION: The painting is on a pre-primed linen canvas (approximately 26 threads per inch vertically, 37 threads per inch horizontally) mounted on a keyed stretcher. There is traction crackle in some areas, and there are planar distortions created by differences in the thickness of the paint application. The painting was probably not varnished or at most only varnished in some areas.

DESCRIBED BY CRITICS in the 1950s as "ungainly scaffoldings"[1] and "blurtings of black calligraphy on white and gray grounds,"[2] the paintings of Franz Kline rank among the great confrontations of black and white staged on canvas by the Abstract Expressionists. These works and late paintings that reintroduce color such as *Rose, Purple and Black,* were produced during a relatively short period between 1950 and Kline's death in 1962. His first solo exhibition in 1950 at the Charles Egan Gallery in New York marked the decisive moment in a transformation toward abstraction that had begun three to five years earlier, as Kline moved away from his more conservative beginnings at Boston University and Heatherly's Art School in London and his early career as an illustrator and Realist painter. Influenced by Jackson Pollock (1912–1956) and Willem de Kooning (cat. 66), whose black-and-white paintings had preceded Kline's, and by other artists and photographers, Kline's new painting style was negotiated through drawing.[3] Whether, as Elaine de Kooning (1920–1989) claimed, this occurred as a revelation while mechanically enlarging a sketch to canvas scale,[4] or, more likely, as a series of gradual discoveries made through working on paper, Kline's painting developed a signature style that was at once graphic, dynamic, and personal, in which, as one critic describes it, "every sort of geometry [was] taken and broken."[5]

Rose, Purple and Black was painted during the last phase of Kline's career, when color was reintroduced to his palette. Although color is used here as an active agent and claims a place in the title, the painting still depends on the essential opposites of black and white. Black is used to establish the two dominant central forms and the uppermost paint layer; a version of a square, which appears in many of Kline's paintings as an open or densely painted shape, is embedded with purple and surmounted by black horizontal slashes crossing the canvas. Whites, creams, and grays are layered below and around the black in broad swathes of paint. The rose of the painting's title underlies gray on the right and is brushed more thinly above a white layer on the left, invading the central black form in a wet-on-wet stroke. Orange appears in the underlayers of paint and again as bright, small details on top of the black. The tracks of the brush are evident everywhere. The medium is built up in a series of paint strata, and the surface is vigorously textured and uneven.[6]

The use of gray and the increased surface texture in the Museum's canvas reflect changes in Kline's work in 1958 that were noted by contemporary critics and later writers. In a 1958 review, Dore Ashton remarked on Kline's "new element [gray, which] . . . comes to assist in making black blacker. . . . Gray, which must always incur a third dimension, creeps into the Kline image. . . . There is a veritable battle of elements enveloping the surface and charging back into the depths of the canvas."[7] In this regard, she specifically mentions two "tall, raging paintings" from 1958, *Siegfried* (Carnegie Museum of Art, Pittsburgh) and *Requiem* (Albright-Knox Art Gallery, Buffalo, N.Y.).

Kline's biographer, Harry Gaugh, who paired the artist's use of gray and greater surface texture as related interests, interpreted these paintings in terms of their *sfumato,* or atmospheric effects.[8] Common to both interpretations, however, is the perception

of a greater sense of dimensionality or space in Kline's work. The Museum's canvas, like other paintings from this period, can be seen to suggest amplification beyond the surface of the painting (although not the illusion of depth). This was achieved not only through the use of gray but by layering effects increasingly involving colors, which were applied "on top" of the black and white or were allowed to show through from paint layers below.

Kline had begun to reintroduce color in his paintings as early as 1955–56, but it was in 1958–59 that color began to be used as a frequent component and structural equivalent to black and white. Kline did not consider color to be an "addition" to his palette, stating that in "using color I never feel I want to add to or decorate a black and white painting. I simply want to feel free to work both ways."[9] Like the Museum's canvas, other works from the late 1950s employ a palette that includes color but in which black and white still predominate, including the monumental *C & O* (1958, National Gallery of Art, Washington, D.C.). At the same time Kline was producing paintings in which color replaced the white ground, culminating in such works as *Red Painting* (1961, Sidney Janis Gallery, New York), a black window of strokes against fiery red, and *Scudera* (1961, private collection), which floats black forms on blue. Both "all-color" and "pure" black-and-white works were painted during this period.

Philip Pavia (b. 1912), Kline's friend and fellow member of the Downtown community of artists and writers in New York in the 1950s, described Kline's paintings in terms of what they were not: "not geometrical, not decorative, no subject matter . . . no dreams, no Jungian monsters."[10] Kline himself did not conceive his art in theoretical terms, explaining that he painted "an organization that becomes a painting."[11] *Rose, Purple and Black* can be considered in light of the artist's description of his working methods, in which one painting becomes a response to—and may engender—another. At times this process was planned through preliminary sketches, in other instances it was played out, as it seems to have been in *Rose, Purple and Black*, in direct painting on the canvas, a state of possibility when a work could "become another painting or nothing at all."[12]

LM

Lee Bontecou

BORN PROVIDENCE, RHODE ISLAND 1931

63. *Untitled,* 1959

Canvas and metal; 20½ × 20¹³/₁₆ × 7¼ in. (52.1 × 52.8 × 18.4 cm); signed and dated lower right: *BONTECOU 59*

Purchased with a gift from the Chace Foundation, Inc. (1960:14)

PROVENANCE: Leo Castelli, New York.

EXHIBITIONS: South Hadley + 1960, repro., unpag.; South Hadley 1962, no. 6; Durham 1963, no. 1, repro.; Amherst 1968; New York, Kennedy 1975, p. 60; Middletown 1975, no. 30; Boston +, ICA 1976, repro. p. 28; Saratoga Springs 1977; Northampton + 1978, no. 5; Northampton 1979, ckl. p. 82; Coral Gables + 1991, no. 22, pp. 22, 23, repro.; Los Angeles + 1993,[1] no. 1, repro.

LITERATURE: Parks 1960, fig. 90; Munsterberg 1975, pp. 101–3, repro.; Chetham et al. 1986, no. 181, repro.; McEvilley 1994, repro. p. 91.

CONSERVATION: The sculpture is in good condition. There is some rust, particularly at the welds or braising points, and there is some staining of the fabric at these rust sites.

THE MUSEUM'S small untitled relief, created in 1959, is one of the first in a series of Lee Bontecou's shaped canvas sculptures, which gained an immediate public when they were first shown in New York at the Leo Castelli Gallery in 1960.[2] These works, stretched and stitched with wire over steel frames, represented a departure from Bontecou's figurative sculptures produced during a Fulbright year in Rome in 1957–58. As the reliefs developed from relatively simple, small-scale formats to more aggressively complex engines of accrued objects, they also remained apart from the mainstream movements of Abstract Expressionism, Pop art, and Minimalism. Although ostensibly made from castoff, found, or unrefined materials, they cannot be comfortably or wholly contained within the assemblage or "junk" aesthetic of the late 1950s and early 1960s; instead, as one critic has written, they should be considered the product of a major talent whose "mixture of resolve and hesitation . . . provided the necessary conceptual conditions for an art that is quite unable to lose its meaning."[3]

Bontecou studied at the Art Students League from 1952 to 1955 under William Zorach (1887–1966) and John Hovannes (1900–1973). Her early sculptures of animals and birds, a combination of naturalistic and abstract forms, were made from terra cotta, cement, or bronze. In one of several reviews of Bontecou's work, however, Donald Judd saw in the segmented construction and blackened edges of these early sculptures a homologous relationship to the canvas reliefs, which he considered an assertion of the artist herself in "primitive, oppressive and unmitigated individuality."[4] Another writer considers the "soot drawings" made during Bontecou's Fulbright year in Italy and a group of tiny boxes with welded frames and hanging spheres created in New York in 1958–59 to be the direct precedents of the canvas relief sculptures.[5] Like the reliefs, the boxes were made with wire, metal frames, and canvas or muslin; some included a central hole or void.

While Bontecou's diminutive boxes adopted a simple, framelike format, their recessive or reliquary quality was succeeded in the wall-mounted reliefs by an assertion of their presence as sculptural objects. The reliefs took as their basic form a square or rectangular outer perimeter. Steel rods were welded together to form a projecting armature for the canvas or fabric pieces, which were stitched to the armature with wire; the black metal rods and wire attachments were not hidden but became a visible graphic element on the surface of the object. Although the artist is reticent about ascribing meaning to the reliefs, stating in a letter of 1960 that "the individual is welcome to see and feel in them what he wishes in terms of himself,"[6] the sculptures seem to invite associations with topographic forms of plateaus, hills, and chasms as well as sexual references in the swell of forms above an often velvet-lined passage or recess. As the reliefs developed and became more complex, writers noted a sexual bimorphism of the "feminine" internal space with an aggressively "male" array of found objects in the reliefs of 1961 and 1962, which included weapons, gas masks, zippers, and industrial components.[7] By the mid-1960s, color was incorporated in the reliefs, which had retreated from their more bellicose and warlike posturing, and in the 1970s Bontecou returned to more naturalistic forms with vacuum-formed plastic sculptures of exotic, plantlike structures.[8]

While the aggressive armament of the reliefs of the early 1960s appeared to announce a political stance, later confirmed by the artist as her response to the threat of war and global destruction,[9] the Museum's relief is a more hermetic and enigmatic construction. As a work on an intimate, as opposed to heroic scale, it discomfits only in close proximity, when the viewer realizes that the plush interior well is surrounded by fabric held in place by metal sutures and by twisted, crimped filament bristling like barbed wire. Variations in the weave of the canvas patches—some smooth, some rough—create a subtle surface texture under and next to the dark metallic elements.

The monochromatic aspect of this and other reliefs has been compared to the reduced palette of Analytic Cubism,[10] but the neutrality of its coloration complicates the experience of the object. The Museum's relief combines abstract form with motifs that could be equally construed as figurative or topographical signs, but refrains from giving color cues that might define meaning. The relief projects outward into the viewer's space—the offset and angled void surrounded by the canvas escarpment evokes associations with a mountainous, cratered landscape but also suggests bodily, specifically female, terrain and orifices. Both organic and industrial, focal and asymmetrical, *Untitled* combines contradictory elements, images, and materials in a work that realizes the artist's ambition to give physical form to the "fear, hope, ugliness, beauty and mystery that exist in us all."[11]

LM

Joan Mitchell

CHICAGO 1926–1992 PARIS

64. *Untitled,* c. 1960[1]

Oil on canvas; 50 × 38 in. (127 × 96.5 cm); signed in brown paint, lower right: *J. Mitchell*

Purchased with funds given by Mrs. John W. O'Boyle (Nancy Millar, class of 1952) (1981:30)

PROVENANCE: Jacques Kaplan, New York, by trade;[2] to Nancy Schwartz, Fine Art Ltd., New York, c. 1966.

EXHIBITIONS: New York, Stable 1961, no. 300-3; Cambridge 1962, no. 14; Northampton 1991, repro. p. 46.

LITERATURE: Chetham et al. 1986, no. 184, repro.

CONSERVATION: The painting is on a pre-primed canvas mounted on an unkeyed wooden stretcher. There are drying cracks, especially in the ocher-colored impasto sections, and there is some cleavage in the thicker impasto areas. The painting is unvarnished.

JOAN MITCHELL was a prolific painter of vibrant abstractions that she described as "remembered landscapes which involve my feelings."[3] Born in Chicago, she attended Smith College from 1942 to 1944 and received a B.F.A. from the School of the Art Institute of Chicago, where she received a "straight academic training"[4] and worked primarily in a figurative mode. An admirer of Vincent van Gogh, Paul Cézanne, Henri Matisse, and Wassily Kandinsky, she described her early style as "Cezanne-ish in school. Moving Cubistically . . . into abstraction."[5] Mitchell spent the year 1948–49 studying in France on an Art Institute fellowship, staying first in Paris and then in Le Lavandou, a profound experience that led her to embrace nature as the primary inspiration for her art. A decade later she made France her permanent home.

Mitchell lived in New York during the early 1950s, and many of her paintings of that period are dynamic all-over compositions of sweeping, curved lines and angular planes that evoke urban landscapes. One of the few women in the Abstract Expressionist "Club," she generally is considered a second-generation member of the group because she was younger than Willem de Kooning (cat. 66), Jackson Pollock, Franz Kline (cat. 62), and the others, but since she was active during the same period, she objected to being labeled second generation.[6] Her inclusion in the important Ninth Street Show, the first major exhibition of Abstract Expressionist art, organized by the Club and Leo Castelli in 1951, firmly established her reputation in New York. Her first New York solo exhibition was held in 1952, and in 1953 the Stable Gallery became her principal dealer.[7]

With her move to Paris in 1959 and her eventual relocation to the rural village of Vétheuil on the Seine north of Paris, Mitchell became removed from the New York avant-garde and from the Abstract Expressionist movement. From 1955 until 1979 Canadian painter Jean-Paul Riopelle (b. 1923) was her companion. It seems likely she was content to remain in France because, as she said, she was "not concerned with 'isms' or what's à la mode."[8]

In the Museum's untitled painting, a tangled web of radiant colors—gold, earthy greens and reds, ocher, blue-green, and mauve—coalesces in the upper center of the canvas. Arm-long brushstrokes, short daubs of paint, and fluid drips dance above static horizontal bands that anchor the space but also imply instability in the way they are precariously stacked. The painting is a play of oppositional forces: paint drips freely from thick, decisive brushstrokes; a lighthearted spray of pink paint extends upward to the right, away from the commotion at the center. The dialogue between transitory and static elements results in a sense of temporary equilibrium. Mitchell stated that she wanted her paintings "to hold one image, despite all the activity."[9] Her spatters and meandering drips suggest both motion and stopped time and are evidence of activity left to chance. Vigorous brushwork interrupts these drips and checks their unpredictable movement.

Mitchell laid out the structure of her paintings with charcoal on canvas, then painted over these marks using house painters' and artists' brushes, her fingers, and rags. An additive painter, she avoided scraping down her paintings, preferring to destroy a

work that was not progressing satisfactorily. She once explained: "I paint from a distance . . . the freedom in my work is quite controlled. I don't close my eyes and hope for the best. If I can get into the act of painting, and be free in the act, then I want to know what my brush is doing."[10]

Paintings of the early 1960s, including this work, are among her most explosive and turbulent. Linda Nochlin has asserted that during these years Mitchell was in touch with her own anger and aware of her inner rage and the rage to paint.[11] The emotive power of these canvases may relate to Mitchell's sadness about the illness of her mother, who was diagnosed with cancer in 1960. By 1964 she was struggling to "get out of a violent phase and into something else."[12]

Although Mitchell's works of the early 1960s betray a certain violence, the palette she employed during the period was luminous. Of Mitchell's paintings from 1960–61 Irving Sandler writes, "Never has the light pervading Miss Mitchell's work been so radiant and sunny."[13] While light was an important element in her work, she generally painted with little natural illumination, preferring to work from late afternoon to late at night. She usually studied the results of these sessions in daylight but resumed painting again in the evening. Although her works capture "feeling states" that sometimes arose from an experience in nature, she insisted that her paintings present an "outer vision" that "leaves nature to itself."[14] Poetry inspired some of Mitchell's works and, though many paintings remained untitled, some drew titles from verse. As a child she met such prominent literary figures as Ezra Pound (1885–1972), T. S. Eliot (1888–1965), and Edna St. Vincent Millay (1892–1950) through her mother, a poet and editor of *Poetry* magazine. "Music, poems, landscape, and dogs make me want to paint," Mitchell once explained, "And painting is what allows me to survive."[15]

KE

Claes Oldenburg

BORN STOCKHOLM, SWEDEN 1929

65. *Sketch for a Soft Fan,*[1] 1965

Kraft paper and rope, painted with spray enamel; 19¼ × 22⅛ × 21⅞ in. (48.9 × 56.8 × 54.9 cm); painted plywood base: ¾ × 14 × 19½ in. (1.8 × 35.5 × 49.5 cm); inscribed on bottom of base: *SOFT FAN / 1965 / Claes Oldenburg*

Purchased (1979:49)

PROVENANCE: Sidney Janis Gallery, New York; to Mrs. Mary Gayley Strater, New York, 1966; to Robert Miller Gallery, New York, 1979.

EXHIBITIONS: New York, MoMA 1969, ckl. no. 77; Northampton 1985, ckl. no. 51, repro.; Northampton 1991, p. 82, repro.

LITERATURE: Hunter 1972, p. 284, repro.; Chetham et al. 1986, no. 188, repro.

CONSERVATION: The sculpture had undergone a radical alteration from its original configuration before it was acquired by the Museum. Conservation treatment to restore it to its original state included cutting through the base and removing the newspaper stuffing from the paper bag that constitutes the body of the fan. The paper bag was deacidified and repaired from within and restuffed with foam beads. The cardboard fan blades were reinforced with wire to add support. Since treatment, the sculpture has remained stable with the exception of the appearance of an unknown white crystalline material that developed on its surface. This was removed in 1997.

THE SON of a member of the Swedish diplomatic corps posted to the United States, Claes Oldenburg has spent most of his life in this country. After an early education in Chicago, in 1946 he entered Yale University, where he took studio art courses only in his senior year. Back in Chicago he worked as a newspaper reporter on the police beat while attending classes at the School of the Art Institute of Chicago. In 1956 he returned to New York, which has been his home base since.

Almost from the start of his career as an artist (he began as a painter), the subjects of Oldenburg's sculpture have been ordinary household objects and consumer products: vacuum cleaners, ironing boards, cigarette butts, light switches, spades, pies, ice cream sundaes, baseball mitts, fans, etc. In the early sixties, when he created the Store on the Lower East Side of New York, where he lived, the objects were shaped on a wire armature, with muslin or burlap dipped in plaster and painted brightly in a loose, Abstract Expressionist manner. In 1962, as he was preparing for his first major one-man show at the Green Gallery on Fifty-seventh Street, and using the gallery as a studio during its summer closing, he realized that the works from the Store that he had planned to show in September, all fairly close to actual size, would not begin to fill the gallery's ample space. Going to the gallery each day, he passed a nearby automobile showroom, where he admired the satisfying way the cars filled the display space. He set about making a new group of objects, among them a huge piece of cake and a gigantic ice cream cone that sat directly on the floor like the cars. Made of stitched and painted canvas filled with foam rubber and other pliable materials, these objects initiated two major phases in his work: soft sculpture and monument projects.

Oldenburg's introduction of the concept of softness to sculpture has been compared in terms of innovation to Alexander Calder's (cat. 52) application of motion to the medium. The works of both artists are pervaded with humor, though of quite different kinds. In one of his many notebooks, Oldenburg recorded in 1966:

> The "soft" aspect of these works was not part of the original intention. I discovered that by making ordinarily hard surfaces soft I had arrived at another kind of sculpture and a range of new symbols.

> Soft sculpture is in a primitive state. . . . The best examples are still the giant balloons that Macy's takes down Broadway every Thanksgiving Day. . . . The possibility of movement of the soft sculpture, its resistance to any one position, its "life" relate it to the idea of time and change.[2]

Oldenburg's mature work does not usually treat the human figure (except in fragments), but the soft sculptures are often metaphors for the body and have greater tactile reality than traditional "hard" sculptures of bronze or marble.

Sketch for a Soft Fan is the earliest surviving treatment of the subject, which culminated in 1967 in the *Giant Soft Fan* in black vinyl (fig. 58) and the similarly sized *Giant Soft Fan— "Ghost" Version* in canvas painted white (Museum of Fine Arts, Houston).[3] In 1965, the year *Sketch for a Soft Fan* was made, Oldenburg also conceived a fan mon-

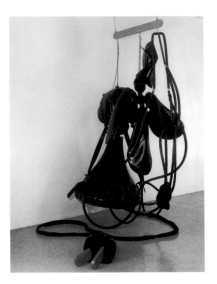

Figure 58. Claes Oldenburg, Giant Soft Fan, *1966–67, construction of vinyl filled with foam rubber, wood, metal, and plastic tubing; fan: 120 × 58⅞ × 61⅞ in. (305 × 149.5 × 157.1 cm) (variable), cord and plug: 291¼ in. (739.6 cm) long. The Museum of Modern Art, New York, The Sidney and Harriet Janis Collection. Photograph © 1999 The Museum of Modern Art, New York. © 1998 Claes Oldenburg/Artists Rights Society (ARS), New York.*

ument. He had lived abroad for about six months and had come back filled with an interest in landscape and sculpture. The idea of enlarging some of his works to colossal scale and siting them in appropriately chosen landscapes led to the first proposals for monuments.

The form of the fan had grown out of a banana monument proposal for Times Square, the four fan blades the equivalent of banana peels. The fan monument was first proposed for Staten Island and later as a replacement for the Statue of Liberty. The artist noted a certain similarity in the bases and felt that Liberty's halo rays almost suggested a fan. The gigantic fan, which could provide the workers of Lower Manhattan with a steady breeze on hot, humid summer days, had historical precedents. "I recently discovered," he wrote in 1967, "that the windmill is the logos of New York City. There were once many, many fans on the hills around the bay."[4]

Oldenburg, who has called gravity his "favorite form creator," hopes that owners of his soft pieces feel free to reshape them at will. He wrote: "The built-in changeableness of the work demands of its owner or someone who displays it, a sense of the work's possibilities and a sense of the factors that can cause change, and decisions on the position, sometimes daily (soft pieces will fall and change in a night)."[5]

Sketch for a Soft Fan is not a soft piece but a semihard study for one; nevertheless it experienced the creativity of gravity in a dramatic way. Originally conceived as an upright piece, it collapsed not long after its execution, and what had been its base became a panel from which to hang it on a wall.[6] To keep it from slowly tearing itself apart under its own weight, it was restored to its original posture shortly after the Museum acquired it.

When Pop art burst on the scene in the early sixties, among its many shortcomings cited by critics was its abandonment of "high" art and its apparent capitulation to the standards of popular or commercial art. Oldenburg's choice of objects of ordinary domestic life rendered with comic and satirical aplomb seemed to suggest an irreverent attitude toward the rhetoric of Abstract Expressionism. As he wrote in 1963:

> When I say Pop art is an "attitude," I mean it is a reaction to the painting before it . . . appearance[s] are not what count. It is the forms that count. It is the same to me whether my material image is a cathedral or a girdle . . . a telephone dial or a stained glass window . . . the resemblance, while amusing, means nothing. You could say I have aimed at neutralizing meaning . . . to eliminate appearances seems to me impossible, and therefore artificial. Simply grasp them and show how little they mean—this is what Cézanne did.[7]

BBJ

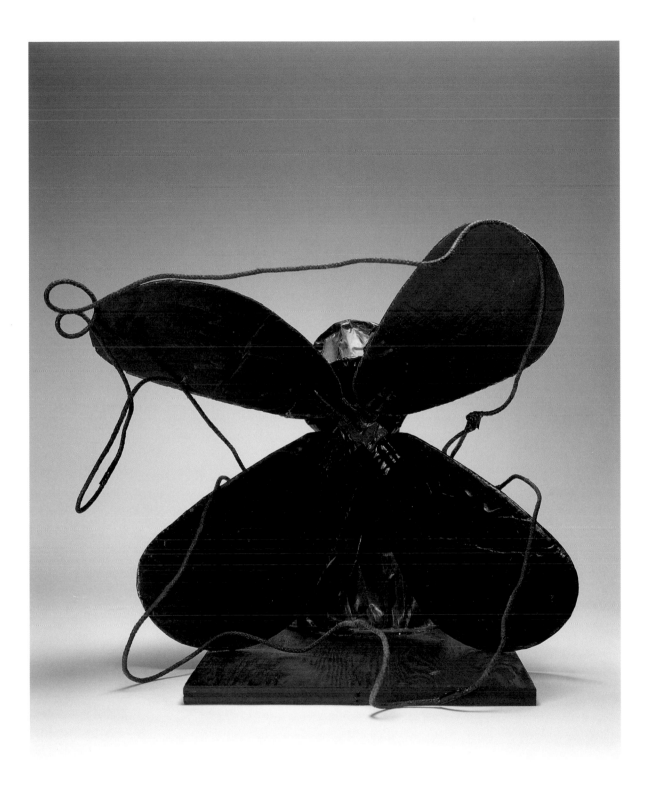

Willem de Kooning

ROTTERDAM, NETHERLANDS 1904–1997 EAST HAMPTON, NEW YORK

66. *Woman in Landscape X,* 1968

Oil over charcoal on laid paper mounted on canvas; 23⅜ × 18½ in. (59.4 × 47 cm); signed in brown ink, lower right: *de Kooning*

Gift of the artist in memory of Louise Lindner Eastman, class of 1933 (1969:84)

PROVENANCE: Acquired from the artist.

EXHIBITIONS: New York, Knoedler 1969, no. 22;[1] Northampton + 1978, no. 9, repro.; Northampton 1979, ckl. p. 68.

LITERATURE: Chetham et al. 1986, no. 190, repro.

CONSERVATION: The painting is on laid paper mounted on linen canvas mounted on a stretcher. There is no evidence of a ground. It is in excellent condition.

© 1998 The Willem de Kooning Revocable Trust/Artists Rights Society (ARS), New York

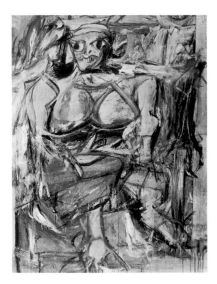

Figure 59. Willem de Kooning, Woman I, *1950–52, oil on canvas, 75⅞ × 58 in. (192.7 × 147.3 cm). The Museum of Modern Art, New York, Purchase. Photograph © 1999 The Museum of Modern Art, New York. © 1998 The Willem de Kooning Revocable Trust/Artists Rights Society (ARS), New York.*

THIS ELUSIVE, semiabstract painting of a single female figure by the Abstract Expressionist painter Willem de Kooning belongs to a group of works called "woman in a landscape," completed in 1968 after the artist had moved from Manhattan to East Hampton on Long Island. De Kooning began painting women in the late 1930s, generally depicting them singly or in pairs, paralleling a similar series of solitary or paired men. In the late 1940s he began a series that included the monumental *Woman I* of 1950–52 (fig. 59), first shown at the Sidney Janis Gallery in 1953. *Woman I* and the other women of the early 1950s are gargantuan figures characterized by bulging eyes, buoyant breasts, talonlike fingers, and broad, toothy grins.[2] Their strangely distorted bodies and mad expressions make them at once comical and menacing. Critics writing in the 1950s commonly identified de Kooning's women as monsters, goddesses, or "femmes fatales." His struggle to capture them on canvas—he was famous for his inability to finish a picture—was likened to a violent conflict or sexual encounter. Sidney Geist, for example, wrote: "In a gesture that parallels the sexual act, [de Kooning] has vented himself with violence on the canvas,"[3] while Hubert Crehan joked, "Frankly he's had his hands full getting her down on canvas."[4]

Debates about the changing role of women following their entry into the work force during World War II informed critical perceptions of the women paintings during the 1950s. Crehan saw *Woman I* as "the new American woman, a formidable type, who is in the avant-garde of her sex in the contemporary world."[5] For these works de Kooning borrowed directly from images of women in popular culture, including advertisements and pin-up photographs. He constructed his paintings out of assemblages of his own drawings, fragments of advertisements, and monotypes, or oil transfers of passages from other paintings. In 1950 he pasted a mouth cut from a Camel cigarette advertisement into a painting, transferring the preexisting cultural meanings encoded in a model's mouth to his own work.

In contrast to the blocky, aggressive forms of the 1950s women, those of the 1960s, including the Museum's painting, are soft and flabby. The figure in *Woman in Landscape X* seems to stand with her back to the viewer, one foot and one round buttock providing the strongest indications of this orientation. Equally convincing is the frontality of her face and the sideways glance she casts from large, crudely delineated eyes. In his women paintings, the artist emphasized certain parts of the female body, usually eyes, mouths, breasts, genitalia, and feet, and blurred the distinction between these elements. He also repeated eyes, mouths, and breasts within a single painting—toothy mouths double as threatening vaginas, for example. He gave some women additional legs, which lend ambiguity to their sexuality by suggesting phalluses. He liked to twist his figures around, finding them interesting only if they were a mystery, and often opened up his female forms to present multiple viewpoints, a practice that reflected his appreciation for Cubism.

In the Museum's painting, the woman's left arm snakes away from her body and back toward her face, while her other arm is hidden under a cloth—possibly a beach towel (after his move to East Hampton, de Kooning often studied women at the beach).

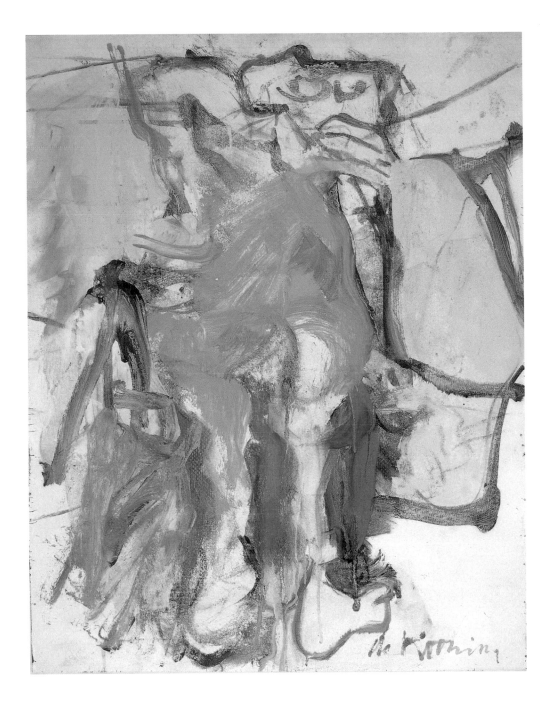

From this cloth emerges a clawlike hand that functions also as a bold, red painted mouth appearing to slip off the side of the woman's face. Close inspection reveals that this hand-mouth obscures another mouth drawn in charcoal underneath.

De Kooning's ferocious deconstruction of the female figure—sometimes by literally ripping a drawing or a painting on paper into pieces—and his reconstruction of her as a collage of disjointed body parts were seen as evidence of hatred toward women, but the artist consistently denied this charge. It seems more likely that these works express a certain anxiety about the availability of women as sex objects and the taboo associated with their "use" or consumption. One may read into the fanged mouth-vagina a fear of castration, associated in Freudian theory with the Oedipal complex and with guilt concerning sexual desire for one's mother. Suggesting deep psychological ori-

gins for the artist's women paintings, his wife, painter Elaine de Kooning, commented: "That ferocious woman he painted didn't come from living with me. It began when he was three years old."[6] Although de Kooning did not acknowledge a link between the women in his paintings and his relationship with his own mother, he alluded to their role as Earth Mother figures when he stated in 1953: "The landscape is in the Woman, and there is Woman in the landscape."[7] In the Museum's painting, like others in the series, woman is fused with natural elements; she occupies the landscape but also becomes the landscape. Both primordial and passive, she is a site to be acted upon. What is clear from these bizarre, complex paintings is that the artist intended for multiple meanings to be present and to be working in constant tension with one another.

Fulfilling the role of "action painter," de Kooning painted aggressively with brushes and rags, rubbing and scraping out areas of wet paint, sometimes even sanding down areas of dry paint. Photographer Robert Frank, who for a time occupied a Manhattan studio near de Kooning's, watched him at work through his window: "I could see him walk to the easel and walk back, pacing like an animal in a cage. Every day I would see that scene. It was inspiring, the struggle."[8] His perpetual desire to rework an image was paralleled by his interest in slippery, malleable materials, including graphite, pastel, and oil paint. Lucy Lippard has pointed out that "De Kooning's style is characterized by an intense unrest, manifested most strongly in the shifting, anxiously arrested motion of the figure and, later, of the entire surface."[9] He sometimes used newspapers to blot his oil paints and keep them wet, occasionally leaving newsprint or unintentional "decals." Seeking to extend the drying time of his paints, he eventually mixed pigments into an emulsion of safflower oil, water, and one or more solvents; as the water evaporated, small bubbles were created that left an unusual pattern in the paint. He often painted on paper and generally preferred smooth papers that allowed him to paint and draw with great velocity and make rapid changes of direction. However, *Woman in Landscape X* is executed on laid paper tacked down on canvas; the laid paper lends texture to his surface, and additional patterns are created by at least two different types of fabric that were pressed into the paint near the figure's left leg and the bottom of her cloth at right. Pulsating, dripping brushstrokes, smeared across paper, suited his fleshy women of the 1960s, which he described as "floating, like reflections in the water."[10] "My latest work is getting more and more baroque," he stated in 1968.[11]

De Kooning returned repeatedly to the woman theme because "it could change all the time,"[12] and because, during periods of difficulty with landscape, it provided "a way out of an impasse."[13] The figure offered him greater freedom than purely abstract works because it "eliminated composition, arrangement, relationships, light . . . all this silly talk about line, color, and form, you know."[14] Although considered one of the first artists to commit to pure abstraction, de Kooning never fully renounced figuration, remaining committed to two main themes: women and the landscape. He was criticized by Jackson Pollock and Clement Greenberg for his refusal to abandon the figure, but de Kooning believed that "even abstract shapes must have a likeness."[15]

KE

Frank Stella
BORN MALDEN, MASSACHUSETTS 1936

67. *Damascus Gate (Variation III),* 1969

Polymer and fluorescent polymer paint on canvas; 10 ft. × 40 ft. 3 in. (3 × 12.3 m); not signed, not dated

Gift of the artist (1969:76)

PROVENANCE: The artist.

EXHIBITIONS: Northampton 1979, ckl. p. 77; Northampton 1991, p. 55, repro.

LITERATURE: Chetham et al. 1986, no. 192, repro.

CONSERVATION: The painting is on unprimed cotton canvas mounted on a shaped strainer. There are some scuff marks in the center blue panel and along the bottom edge.

DAMASCUS GATE (VARIATION III) is one of over ninety paintings constituting Frank Stella's *Protractor* series of 1967 to 1971.[1] The works in this series combine curvilinear format, abstract design, and architectural scale with bursts of highly charged color; their titles are based on the names of ancient cities from Asia Minor built on circular plans. The *Protractors* represent the climax of Stella's shaped canvases of the 1960s, which redefined the traditional rectangular or square boundaries of the painted surface, beginning with the indentations and perimeter incursions of his *Aluminum* series in 1960. More radical structural reconfigurations followed as paintings assumed the shape of crosses, L's, and zigzags *(Copper* series, 1960–61), polygons *(Purple* series, 1963), stars *(Dartmouth* series, 1963), flying wedges *(Notched-V* series, 1964–65), and multilaned "pictorial highways"[2] *(Running-V* series). In Stella's development away from the Abstract Expressionists who had been his early influence at Princeton, the *Protractors* are the decorative and chromatic counterpoint to the hermetic elegance of the stripes and lines of the early *Black* paintings (1958–60).

Stella's trip to Iran in 1963 with Henry Geldzahler, then an associate curator at the Metropolitan Museum of Art, influenced the creation of a small group of canvases known as the *Persian* paintings whose titles, like those of the *Protractors,* derive from Islamic cities. These works from 1965 combined what Robert Rosenblum has called "a rapidly oscillating surface of abrupt jumps in color and tonal value" with "a streamlined velocity" to create a new visual dynamic.[3] William Rubin cites the *Persian* paintings as the first appearance of wide bands of color in a single painting in Stella's work and the *Irregular Polygons* begun in the same year as the first of his paintings with large geometric areas of unbroken color.[4] The hallmarks of both series are reflected in the *Protractors;* these works are based on broad color ribbons, whose pathways sometimes intersect or overlap, and large wedges or segments of color.

The basic unit of the series is the protractor shape, a semicircle set on the flat base of the diameter, which Stella inscribed on his canvases with the aid of a ten-foot beam compass.[5] Each work belongs to one of three design groups—interlaces, rainbows, and fans. The interlace paintings weave bands of color under and over each other in ways that both suggest and deny spatial illusion and depth, while the rainbow paintings make use of concentric arcs of colors radiating outward from the midpoint of the protractor's base. The fans are composed of segments or wedges of color extending upward from points along the base of the protractor. *Damascus Gate (Variation III)* is a fan painting whose composition is formed by two contiguous protractors overlapped by a third, inverted, with its base at the top of the canvas; the color wedges of the protractors fan out and meet, forming the distinctive internal design of the two polygons in the center of the painting. The shape of the Museum's canvas, one of thirty-one different configurations in the series,[6] is a variation on the *Damascus Gate* type, which is formed by two side-by-side protractors bridged by a third in the middle, resulting in a canvas profile resembling three hillocks. In the Museum's variation, the canvas shape more aptly conveys the sense of a monumental gate or grand entrance than the other configurations in the series.

For the *Protractors* the artist abandoned his practice of following a few preliminary sketches with careful color-coded scale drawings, which became too complex to be helpful.[7] He depended instead on more intuitive color choice and placement and hand-mixed his paints, sometimes combining acrylic and fluorescent pigments, rather than using unmixed commercial paint as he had in the past.[8] The color "areas," generally applied in this series in a single coat for greater transparency,[9] are separated by thin lines of white unprimed canvas (graphite underdrawing lines are visible in the center of their channels). In the fan paintings, a border of color surrounds and acts as a framing element for the internal design fields. In *Damascus Gate (Variation III)* the "border" is blue, and the florid palette of the color wedges includes lavender, peach, teal, two different greens, two different grays (slate and blue), a red-brown, an umber, two reds and a pink, yellows, and black. The force of the colors in combination with the swelling and tapering forms within the two central fields distends energy outward from the wall. While the flatness of the paint application reinforces the two-dimensional surface of the canvas, the jousting colors clash and jangle to create the sense—if not the optical illusion—of projection into space.

As Rosenblum has written, Stella's work of the 1960s combines many of the identifying characteristics of abstract art of the decade, from the exploration of new media to anti-relational compositions and a more impersonal facture. Ultimately, however, it derives from a much longer tradition of abstract painting including the Bauhaus, Wassily Kandinsky, Piet Mondrian, and the color disks of Robert and Sonia Delaunay.[10] Stella has acknowledged influences as diverse as Islamic art and the intricately entwined patterning of Hiberno-Saxon illumination, but he cites Henri Matisse as his inspiration for making "what is called decorative painting truly viable in unequivocal abstract terms."[11]

LM

George Rickey

BORN SOUTH BEND, INDIANA 1907

68. *Four Lines Oblique Gyratory Rhombus,* 1972–73

Stainless steel; height: 28 ft. (c. 8.5 m); blades: 15 ft. (c. 4.6 m); signed and dated on base: *Rickey 1973*[1]

Gift of the Robert H. and Ryda H. Levi (Ryda Hecht, class of 1937) Foundation, Inc. (1988:53)

PROVENANCE: Staempfli Gallery, New York; to Robert H. and Ryda H. Levi, Baltimore, 1975; to the Robert H. and Ryda H. Levi Foundation, September 1983.[2]

EXHIBITION: Newport 1974, pp. 48, 49, repro.

CONSERVATION: The sculpture is in excellent condition. The bearings were replaced in 1993.

© George Rickey/Licensed by VAGA, New York, N.Y.

ONE OF THE foremost practitioners of kinetic sculpture, George Rickey began to develop his "art of motion" in the 1940s following a career as a painter and teacher. His early training included study at Balliol College, Oxford, where he read history, and the Ruskin School of Drawing and Fine Art in Oxford; this was followed by further studies in Paris in 1929–30 at the Académie Lhote and with Fernand Léger and Amédée Ozenfant (1886–1966) at the Académie Moderne.[3] The next dozen years were spent in international travel, teaching in the United States, a brief stint in the editorial department at *Newsweek,* and his work as a painter and Depression-era muralist.[4] Rickey's transition to sculpture began during army service in 1942–45, when duty assignments required him to make use of the mechanical aptitude inherited from his father, a mechanical engineer, and his grandfather, a clockmaker. This experience influenced his first experimentations with creating mobiles, based on the same catenary system used by Alexander Calder (cat. 52). From that beginning, Rickey continued his sculptural exploration of what he termed "gravity, momentum, inertia, moments of rotation, acceleration"[5] using a variety of basic geometric forms. Activated by the artist's own idiosyncratic motorless technology in collaboration with the wind and weather, Rickey's elegantly spare metal sculptures make drawings that move through time and space.

The title of the Museum's sculpture, *Four Lines Oblique Gyratory Rhombus,* describes both its form and action. Rising from a sixteen-foot-tall vertical post, the sculpture opens into a Y shape, mounted with movable spars or blades at the uppermost ends to complete the outline of a rhombus when the sculpture is at rest. These blades and another pair mounted like crossed swords at the midpoint of the arms of the Y (the four oblique lines of the title) are balanced and counterweighted to rotate in pendular motion through a full 360 degrees in either direction. This gyratory motion or revolution through a circle is elaborated by the gyratory movement of the entire upper configuration of the sculpture on the axis of the post. In response to random air currents, the blades move independently, creating constantly changing profiles in nearly infinite variations; the worked surfaces of the stainless steel reflect and scatter light as the sculpture silently turns and gestures. Although the artist does not consider his work to be mimetic of nature, the sculpture is related in scale and movement to the tall copper beech and sycamore trees that are its near neighbors on the open lawn behind the Museum and to the trees that form a living backdrop along the campus roadway behind.[6]

Four Lines Oblique Gyratory Rhombus is part of an extended family of sculptures in Rickey's long career that use lines as their basic vocabulary, translated into long, tapering stainless-steel blades with a triangular cross section. As Nan Rosenthal has written, Rickey developed sculptures based on lines beginning in the 1960s, influenced by Gian Lorenzo Bernini's *Ecstasy of Saint Teresa* in the Coronaro Chapel (1645–52, Santa Maria della Vittoria, Rome). The shower of golden rays behind and above the marble figures of the saint and angel provided direct inspiration for Rickey's long blades and spars.[7] Rickey conceived a series of sculptures titled *Omaggio a Bernini* and in the 1960s developed a way in which Bernini's lines could "become animated and cross each other" by re-engineering the mounts and bearings of his blades to allow

them to move in independent pendular motion.[8] The blades were used in configurations from relatively spare and simple constructions, for example *Two Lines Leaning IV (A.h.c.)*, 1973, in the Museum's collection (checklist no. 78), to more complex arrays with multiple blades, which increased the variety of visual images presented by the sculpture in motion. As Rickey wrote of his work after 1968, the lines allowed for a kind of "kinetic drawing in space, first planar, then defining volume—space cut up by lines, pierced by lines, limited by lines. . . . Opportunities appeared for engagements outdoors, confrontations with big scale and high winds, with shockabsorbers and foundation, with ballbearings and engineer's calculations."[9]

Rickey introduced oblique lines to his work in the early 1960s, but (according to Rosenthal) returned to explore the possibilities of oblique lines on a large scale in 1968,[10] when he created *Two Lines Oblique—Albany Mall*, a commission from the State of New York, and *Four Lines Oblique Gyratory*, an outdoor sculpture at the Düsseldorf headquarters of Henkel and Compagnie. Both works anticipate the Museum's sculpture, employing a Y-form post mounted with oblique movable spars at the uppermost ends of the post arms; at rest, the sculptures present the outline of a quadrilateral form balanced on a straight shaft by the tip of one of its corners. The German sculpture, a nearer relation to the Museum's, elaborates the basic form with another pair of oblique spars mounted midway on the arms of the Y post.

In planning the work for the site in Düsseldorf, which includes a pool of water, Rickey conceived of a sculpture "with four blades, each [rotating] 360 degrees without touching, so that [the] sculpture would be silent. In a brisk wind they would occasionally go completely around. . . . The whole sculpture could rotate around a vertical axis."[11] This description accords equally well with the Museum's sculpture; the principal difference separating the German *Four Lines Oblique Gyratory* and its related (nongyratory) maquettes from the Museum's sculpture is the evolution from a surmounting square with 90-degree corner angles to a rhombus with 120-degree angles at its apex and base. This change in appearance represents a further exploration of possibilities afforded by different geometrical shapes and lines in motion; however, Rickey does not accord significance to the shapes in and of themselves but requires that they be "highly visible" and at the same time "self-effacing" in order to create the effect of drawing in space and to add "color" to the sculpture's movement.[12]

Although *Four Lines Oblique Gyratory Rhombus* is a unique work, it was followed by two variations, *Four Lines Oblique Gyratory Rhombus Variation II* in 1976 and *Four Lines Oblique Gyratory Rhombus Variation III* in 1988.[13] These sculptures differ from the Museum's version in size, but as their titles state, they are based on the same or virtually the same geometries with the same possible permutations of kinetic movement in space.

Created in the artist's sixty-fifth year and installed and dedicated on the Smith College campus more than twenty years later, *Four Lines Oblique Gyratory Rhombus* belongs to Rickey's long and distinguished international career as an artist, articulate spokesman, author, and scholar of the history of Constructivism and kinetic sculpture, which his own work has enlarged.

LM

Sol LeWitt

BORN HARTFORD, CONNECTICUT 1928

69. *Cube Structure Based on Nine Modules (Wall/Floor Piece #2), 1976–77*

Painted birch; 43 × 43 × 43 in. (109.2 × 109.2 × 109.2 cm); not signed, not dated; fabricated by Akira Hagihara

Purchased (1977:64)

PROVENANCE: John Weber Gallery, New York.

EXHIBITIONS: Northampton + 1978;[1] Northampton 1979, ckl. p. 86; Northampton 1991, p. 77, repro.

LITERATURE: New York +, MoMA 1978, fig. 106;[2] Chetham et al. 1986, no. 196, repro.; Barris 1990, pp. 24–25, fig. 3.

CONSERVATION: The sculpture is in excellent condition. In 1997 it was surface cleaned and several small losses, especially along the bottom outside edges, were inpainted.

SOL LEWITT'S work is associated with both Minimalism and Conceptualism. Historically considered a reaction to the gestural, direct, and personal imprimatur of the Abstract Expressionists of the 1950s, Minimalism emphasized the essential "objecthood" of the work of art and the use of industrial materials, modular geometric forms, mute or uninflected surfaces, and seriality.[3] Conceptualism, which emerged later in the 1960s with the related movements of earthworks, performance, and process art, was more "acceptively open ended" in terms of its expression, positing that an idea itself can become a work of art without the necessity of being realized in physical form.[4] LeWitt's sculptures, such as the Museum's *Cube Structure Based on Nine Modules (Wall/Floor Piece #2)*, share certain values or aesthetic hallmarks of Minimalism, notably geometric modular form and seriality. But LeWitt is primarily an exponent of Conceptual art; in his work content and idea take precedence over visible form.

Among the widely diverse methods and media grouped under the umbrella term Conceptual or "idea" art, LeWitt's practice and philosophy have been articulated in various writings.[5] For LeWitt, art is premeditated in the precise meaning of that word: all decisions concerning the idea and execution are made beforehand. Accordingly, the "idea is the machine that makes the art," while its "execution [is] a perfunctory affair" entrusted to fabricators other than the artist.[6] LeWitt's mature work, described by one critic as "the look of thought,"[7] includes wall drawings, books, and three-dimensional works he terms "structures."

LeWitt began his career as a painter. Incorporating Eadweard Muybridge's (1830–1904) serial photographs of movement studies with text, he adopted a three-dimensional format that he considered both painting and sculpture.[8] In the early 1960s he began to produce wall reliefs as well as suspended and tabletop structures. These were square or boxlike constructions made of painted canvas and wood that included pierced or projecting forms as an exploration and further extension of the picture plane into space. During this early period he also experimented with the idea of seriality and the relation of intervals within individual structures. His first modular or unit-based structures of 1964–65 were painted black, which the artist ultimately found too expressive; by the end of 1965 the structures were painted white, a change that allowed the wall pieces to integrate visually with the wall and, as he believed, suppressed their emotive content. At the same time he arbitrarily decided on a ratio of 8:5:1 representing the measurements of space intervals to the structural elements within individual works.

LeWitt's first modular cube structure, six by six by six feet and based on large open-framework cubes in rows of three, was made in the winter of 1965–66. The 1976–77 series, to which the Museum's *Cube Structure Based on Nine Modules* belongs, includes eighteen structures, each containing at least one row of each of nine possible row lengths: the smallest row consists of one cube (the modular unit) and the longest nine cubes. While the artist might resist such a comparison, the physical manifestations of this idea resemble pristine honeycombs with portions precisely removed to create pyramids, wedge forms, and inversions in contained pockets of negative space. Six

of the structures in the series are wall mounted and extend outward into the viewer's space; the other thirteen, including the Museum's structure (the second in the series), rest on the floor, rising to just above waist height; thus the perceptual and spatial encounter differs with each work. In each structure the plane of the wall or floor restates a side (or sides, in the case of a corner piece) of the overall cube, and the remaining sides are implied, left to be visualized or mentally completed by the viewer.

The Museum's structure presents one "façade" in which the rows are stepped from a base of nine modular units to one unit at the apex; each succeeding row has one unit less than the row below. (This face is matched by the same configuration on the "top" of the structure.) The opposite "façade" is a side composed of full rows of nine units, as is the base or side on which the structure rests. From one viewing point the perimeter outlines a triangle backed by a square; from the opposite view, or "side," the structure appears to be a wedge or prow shape. The height of the structure complicates the viewing experience. At eye level with the sculpture (achieved only by bending down or kneeling) there is an unimpeded view through the form. From the perspective of a standing adult, the lattice of open cubes creates distinctly different geometrical patterns that optically shift in corridors of receding perspectives as the viewer moves or changes vantage point.

The Museum's sculpture strongly suggests an architectural form, in particular a stepped pyramid or ziggurat. LeWitt had worked for the architect I. M. Pei (b. 1917) in the 1950s and would later affirm that architectural structures were a greater influence in his work than sculpture.[9] In 1966 he wrote admiringly of New York City's ziggurat-style office buildings, acknowledging that some of them could be seen as works of art.[10] His description of the development of these buildings, whose configuration was determined by the parameters of style adjusted to purpose and city zoning codes from 1916 to 1960, closely parallels the tenets of his own "multiple modular method."[11] He draws the comparison himself by equating the zoning code with an idea that would give a work of art its defining "outer boundaries." His description of the ziggurats could be equally applied to the Museum's sculpture: "There is also a logic in the continually smaller set-backs, which allow for intricate geometric patterns. By having to conform to this rather rigid code, aestheticism was avoided, but the code was flexible enough to allow great originality of design."[12]

LeWitt, however, drew distinctions between the essentially "opposite natures" of architecture and three-dimensional art not only on the basis of utilitarian function but based on size and emotive power, which he considered desirable and even necessary attributes of architecture but not of Conceptual art. For LeWitt, objects could facilitate or become conduits of an idea, but their sensory appeal was an impediment to the communication of the underlying concept.

By LeWitt's definition, the serial artist "does not attempt to produce a beautiful or mysterious object but functions merely as a clerk cataloguing the results of the premise."[13] Although the artist claims no particular interest in the visual impact or appearance of the work—stressing content (idea) over formal concerns—the viewer may still experience an aesthetic or even emotional response in an encounter with the object, whether it takes shape as a three-dimensional structure or a two-dimensional wall drawing. Once the idea is commuted as physical form it becomes subject to a number of influences, including those endemic to its construction or execution, for

example, variations or imperfections introduced by the fabricator, as well as the external effects of the environment. This is true of the Museum's sculpture, which changes as shadows are cast by, across, or within the latticed grid. Its spare white traceries and form could easily be perceived by a viewer to have an evocative or even "beautiful" appearance. While Conceptual art prizes the idea rather than the physical form it may engender, as Robert Rosenblum has written, it is "finally the visible works of art that dominate our attention."[14] Indeed, it is difficult to deny the sensory appeal of LeWitt's more recent wall drawings, which are lushly colorful and even theatrical in impact.[15]

Intended to speak to the intellect, LeWitt's ideas are expressed in forms that have a basis in mathematics but may find a closer counterpart in music, which combines a theoretical as well as "applied" process: music can exist as composed text (notation) on the page or as an idea, but it is also realized as sound, with differences introduced by individual performers.[16] This analogy is especially applicable to LeWitt's wall drawings, which begin as instructions to be translated and to some extent interpreted through execution by others. As LeWitt has claimed, "Conceptual artists are mystics rather than rationalists,"[17] and it is this creative tension—between idea and object, between precise definition and the sometimes subtle variables introduced through their implementation—that informs works such as the Museum's sculpture.

LM

Joan Snyder
BORN HIGHLAND PARK, NEW JERSEY 1940

70. *My Temple, My Totems*, 1983–84

Mixed media on canvas; 60⅛ × 120⅛ in. (152.7 × 305.1 cm); signed and dated on right tacking edge in pencil: *Joan Snyder* [added by the artist, March 9, 1995] *end of January 1984*

Gift of Mr. and Mrs. William A. Small, Jr. (Susan Spencer, class of 1948) (1994:11-87)

PROVENANCE: Yares Gallery, Scottsdale, Ariz.; to Mr. and Mrs. William A. Small, Jr., Tucson, Ariz., 1988.

EXHIBITIONS: Northampton 1991, p. 54, repro.; Tucson 1992; Northampton 1994–95, no. 28, p. 4.

CONSERVATION: The painting is on a heavy cotton canvas mounted on a wooden strainer. It is in good condition with very little mechanical craquelure.

MY TEMPLE, MY TOTEMS belongs to the personal landscapes painted by Joan Snyder following her abstract, critically acclaimed *Stroke* paintings of 1969 to 1973. From the formalist concerns of "painting paint strokes"[1] that dripped and ran in luxurious counterpoint to their modernist grid background, Snyder began to paint works in 1973–74 that incorporated her own iconography of signs and symbols. Deciding at that crossroads in her career to maximize rather than minimize her images by returning to her past,[2] Snyder began to stuff, sew, and slash her canvases, adding collage elements of handwritten texts on paper, fabrics, wallpaper, and linoleum to their surfaces.[3] Her involvement with feminist issues in the 1970s is reflected in the titles and the narrative development of paintings such as *Small Symphony for Women I* (1974, Wichita Art Museum), a triptych combining "political ideas, dreams, colors, materials, angers, rage,"[4] and the eight-part *Resurrection* (1977, Museum of Fine Arts, Boston), which recounts the story of a violent rape. Other works are more specifically autobiographical in intent and subject, including the Museum's canvas, which represents a raw, Expressionist self-portrait created during a difficult period in the artist's life.

My Temple, My Totems was completed in January 1984, following the dissolution of the artist's marriage to the photographer and filmmaker Larry Fink (b. 1941). The Museum's canvas can be interpreted as the visual amalgam of pain related to Snyder's painting *Mourning/Oh, Morning* of 1983 (Reeds Hill Foundation, Carlyle, Mass.), which the artist has described as an essay on her personal history of loss, including her failed marriage, an earlier abortion and miscarriage, and the separation from her Martins Creek farm in rural Pennsylvania, where she had lived with her husband and their daughter.[5]

In the Museum's painting, a screaming head, painted in a jarring cacophony of colors, dominates the central portion of the canvas. Masks and anguished faces had begun to appear as part of the artist's imagery in 1980, based on a small wood African sculpture the artist had acquired in the mid-1970s.[6] As an expression of rage or as the manifestation of a "primal scream,"[7] the tortured face in *My Temple, My Totems* wears the physical wounds Snyder has scratched into its mouth and eyes. The artist has also embedded and painted over gauze in the face and on other areas of the canvas, as though her injury can be neither bandaged nor cured. Small patches of purple velvet fleck the painting, and larger pieces of stiffened cloth and canvas are collaged on its surface.

The screaming face is barely contained within the simplified form of a yellow house, the almost childlike version of the pictograph that Snyder had adopted in many of her earlier paintings. Snyder has identified yellow as the color of anxiety,[8] and her choice to use yellow for the house form, the "temple" referred to in the painting's title, serves not only to silhouette the mask against the dark background of the painting but to signal her distress at the loss of her home. To the right and left of the central image, the artist has erected "sad totems." At the lower-right corner a Y-shaped twig is embedded in paint fanning out in winglike strokes and spattering downward in tear shapes. Snyder considers this totem to be a crucifix, another symbol for loss. The small artificial grape positioned in the crook of the twig relates the Museum's painting to two

other works of the same period, *Love's Pale Grapes* (1982, collection of the artist) and *Love's Deep Grapes* (1983–84, collection of the artist). In these paintings full bunches of grapes were added to the canvas, suggesting an erotic ripeness and, in a Christian context, blood and sacrifice. In the earlier work, fruit burgeons from a vulvate opening in the canvas, while in *Love's Deep Grapes,* of the same date as the Museum's canvas, grapes are placed against a purple velvet backdrop accompanied by the text "there is a sadness in things *apart* from *connected* with human suffering."

Other totems in the Museum's painting consist of bare-branched tree forms constructed from wood and sticks applied to the canvas and covered with paint. Trees appear in many of Snyder's paintings and first became a motif in 1978, following her miscarriage, when she also began to create totems that she considered to be symbols of the collective unconscious.[9] Her landscapes of the 1980s include references to the apple trees of the old orchard at the Martins Creek farm, which remained as symbol of struggle and life after Snyder's divorce, or the bean fields near her Eastport, Long Island home, where she later moved. The tree totems in the Museum's painting are displayed on a black ground, which might otherwise connote a richly fertile soil or field but here suggests a barren or ruined landscape. At the upper right, a piece of worm-eaten wood from a dead tree or possibly a barn is a direct and nearly unedited statement of decay and loss.

Snyder's work as it has evolved has both joined mainstream movements and departed from them. Positioned by her *Stroke* paintings within the modernist tradition, her media-rich, collaged canvases that succeeded them relocated her work with feminist imagery and ideologies of the 1970s, a characterization that has persisted through a second generation of feminist art. "Praised for its technical virtuosity [and] forgiven for its emotive content," as Sarah Anne McNear puts it,[10] Snyder's work has remained personal, at the same time widening its scope to address more global concerns, such as children's rights. Refusing to disguise joy, anger, or strong opinion, Snyder posits a female sensibility that she believes differentiates her work, as women's lives differ from men's experience.[11] *My Temple, My Totems* is a painting the artist considers as unlike any she has created before or since, executed with a roughness she associates with later paintings in her career.[12] In this work, the tenor of grief, expressed in primitivizing, totemic signs, finds its equivalent in the intense physicality of media scraped, scratched, and sculpted onto the canvas. The artist resists identification as a tragic figure, however, regarding the act of painting and its outcome as an essentially optimistic pursuit.[13]

LM

Louise Nevelson

NEAR KIEV, UKRAINE, RUSSIA 1899–1988 NEW YORK

71. *Mirror-Shadow XIII,* 1985

Painted wood; 84½ × 84½ × 16 in. (214.6 × 214.6 × 40.6 cm); not signed, not dated

Gift of Mr. and Mrs. William A. Small, Jr. (Susan Spencer, class of 1948) (1994:11-62)

PROVENANCE: Pace Gallery, New York; Elaine Horwitch Gallery, Scottsdale, Ariz.; to Mr. and Mrs. William A. Small, Jr., Tucson, Ariz., 1985.

EXHIBITION: Northampton 1991, p. 81, repro.

CONSERVATION: The sculpture is in generally good condition, with some small losses along the back edge where the sculpture makes contact with the hanging surface.

LOUISE NEVELSON, born Leah Berliawsky, began her studies at the New York Art Students League in 1929, but struggled for several years to find her artistic voice and recognition. Nevelson had grown up in Maine, after moving as a child with her family from Russia to the United States in 1905. Marriage and child-rearing forced postponement of her professional training and first steps as an artist. During her early career she experimented with various media, especially terra cotta, before turning in the mid-1950s to the found-wood assemblages of her mature style. The Museum's four sculptural works by Nevelson illustrate the evolution of her work, from relatively early terra-cotta pieces to wood constructions painted one flat color, her experiments with other media, and finally her return to black wood assemblages.[1] *Mirror-Shadow XIII,* created when she was eighty-five, can be seen as the culmination of these experiments and her creative life.

Nevelson constructed *Mirror-Shadow XIII* from found and prefabricated pieces of wood, painted with a matte black finish. The idea of unifying her work through the use of flat black paint began in the 1950s with her terra-cotta sculptures, as seen in the Museum's 1955 version of *Moving-Static-Moving* (checklist no. 66), which is composed of twenty-one roughly formed and surfaced terra-cotta pieces. This sculpture—part of a series from the mid-1950s—was intended to be rearranged to yield a different aesthetic experience with each change. The artist apparently felt no compulsion to control the installation, indicating instead that seemingly important aesthetic decisions could be made by the owner of the work.[2] She later transformed this early reliance on chance and randomness into a controlled aesthetic arrangement, as in *Mirror-Shadow XIII.*

The element of chance plays an important role in Nevelson's found-wood constructions. In the 1950s she began collecting scraps of used wood—bits of furniture, old wooden crates, things she found on the streets of Manhattan—which she put together into totemic images such the Museum's *Distant Column* of 1963 (checklist no. 70), and then painted in her signature matte black. With Nevelson's black assemblages of the 1950s and 1960s, she finally found her artistic voice, her mature style, and her first true critical and financial success. Although she also experimented with different effects by painting some pieces white or gold, black had for her the power of transformation and was always the essence of her style. She wrote:

> When I fell in love with black, it contained all color. It wasn't a negation of color. It was an acceptance. Because black encompasses all colors. Black is the most aristocratic color of all. The only aristocratic color. For me this is the ultimate.... There is no color that will give you the feeling of totality. Of peace. Of greatness. Of quietness. Of excitement. I have seen things that were transformed into black that took on just greatness.... Now, if it does that for things I've handled, that means that the essence of it is just what you call—alchemy.[3]

Nevelson believed that her black wood sculpture revealed the fourth dimension, that it was not primarily a construction of matter and color but of the ambiguous world that lies between the material elements of the third dimension. In discussions recorded by her assistant, Diana MacKown, she explained this belief:

> So the work that I do is not the matter and it isn't the color. I don't use color, form, wood as such. It adds up to the in-between place, between the material I use and the manifestation afterwards; the dawns and the dusks, the places between the land and the sea. The place of in-between means that all of this that I use—and you can put a label on it like "black"—is something I'm using to say something else.[4]

Titles of works such as *Distant Column* and *Mirror-Shadow* imply this mysterious world of "dawns and dusks" lying somewhere beyond the prosaic, material third dimension.

Nevelson's sense of mystery may have been enhanced by her interest in the art of ancient or non-Western cultures, especially African and Pre-Columbian.[5] In 1950 she visited the Mayan ruins of Mexico and an exhibition of Mayan sculpture at the New York Museum of Natural History, where she saw replicas of stelae, whose geometric low-relief carving may have inspired her columns.[6] The title *Distant Column* may be intentionally evocative of remote, ancient cultures.

Besides the freestanding columns, Nevelson created assemblages in small boxes— modules that she stacked into the walls and environments for which she became famous. As the demand for her work increased, she began to use carpenters and assistants to construct new wooden boxes for her stacked constructions, introducing a cleaner, more hard-edged aesthetic. She then extended the idea of using manufactured forms as modules to new materials such as plastic. For these Plexiglas structures, such as the Museum's *Canada Series III* of 1968 (checklist no. 73), she constructed a maquette of one module, which she sent to the manufacturer to have twenty copies replicated. When they came, she taped them together, marked where they were to be joined with screws, and sent them back to the manufacturer to be assembled. Although the cool, Minimalist aesthetic of these works was praised by critics, the constraints of this approach may have stifled Nevelson's creative process, and she soon returned to wood constructions.[7]

In the mid-1980s, just as some critics were beginning to see Nevelson's black assemblages as repetitive, she began a series of over fifty wall reliefs titled *Mirror-Shadow*, some of which were shown in a critically successful Pace Gallery exhibition in 1985. Like *Mirror-Shadow XIII* of that year, the works in this series retain something of the Minimalist hard edge of her work in the 1960s and 1970s, thanks to the appearance of a carpenter-constructed matrix. Here Nevelson opened the modular structure of her early work, causing one critic to claim that it appeared as if "the innards of her boxes had burst out."[8] Another remarked that in the *Mirror-Shadow* series,

> compression and containment give way to a tornadolike animation which pushes the elements out of alignment and lifts them off the surfaces of the armatures. Light moves through the pieces, creating highlights and shadows and pulling the gallery's white wall into the composition of shifted, splayed components.[9]

In *Mirror-Shadow XIII* Nevelson rotated a fabricated square grid on one corner, creating a diamond shape. Bits of wood molding, lathe-turned fragments of furniture, and

precut geometric shapes were superimposed over the diagonal matrix in largely hori-
zontal and vertical patterns, creating one of the most harmonious and elegant works
in the series. Through the use of found and fabricated wood applied in a random but
aesthetically controlled composition with an underlying geometric structure, *Mirror-
Shadow XIII* exemplifies the culmination of Nevelson's career. At the age of eighty-
five she continued to create surprisingly innovative works, employing her established
language of wood constructions transformed into statements of universal mystery by
the color black.

CLB

233

Donald Sultan
BORN ASHEVILLE, NORTH CAROLINA 1951

72. *Ferry, Sept. 17, 1987,* 1987

Tar (butyl rubber), spackle, and latex on tile over masonite (four panels); 95¾ × 95⅞ in. (243.2 × 243.5 cm) overall; signed and dated in graphite (partially incised) along left edge, upper left panel: *Ferry Sept 17 1987 DS*

Gift of Mr. and Mrs. William A. Small, Jr. (Susan Spencer, class of 1948) (1994:11-88)

PROVENANCE: BlumHelman Gallery, New York; to Mr. and Mrs. William A. Small, Jr., Tucson, Ariz., 1987.

EXHIBITIONS: New York, BlumHelman 1987; Northampton 1991, p. 56, repro.; Tucson 1992; Northampton 1994–95, no. 29, p. 4.

CONSERVATION: The painting is on four masonite panels mounted on plywood frames. It is in good condition.

Figure 60. Photograph of the damaged stern of the British ferry Herald of Free Enterprise, *reproduced on the front page of the Paris edition of the* International Herald Tribune, *April 8, 1987. Photograph courtesy of the* International Herald Tribune.

DONALD SULTAN'S paintings of the 1980s and 1990s fall into two groups: bold, iconic shapes silhouetted against a background, and portentous pictures of industrial landscapes or actual events, which recast newspaper images of disaster in a menacing palette of blacks and sulfurous yellows.[1] The Museum's *Ferry, Sept. 17, 1987* is based on a newspaper photograph of the British ferry *Herald of Free Enterprise,* which capsized in the North Sea off the Belgian port of Zeebrugge on March 6, 1987. The accident was originally believed to have been caused by a collision with a sea wall, but later it was discovered that the ferry's forward doors had not been secured; the ship flooded and keeled over as it left port, claiming over one hundred lives.[2] Although the painting refers to an actual event, recorded in an *International Herald Tribune* photograph of the hull of the ferry, listing to port and viewed from the stern during salvage operations (fig. 60), it is not essentially documentary in nature.[3] Representational form and recognizable image in the painting equally emerge from, and are concealed by, dark, media-rich surfaces. As a kind of contemporary history painting, *Ferry, Sept. 17, 1987* and Sultan's other event pictures represent what Barbara Rose has termed the "re-emergence of a critical dimension" and the "awakening of an historical consciousness" in American painting of the 1980s.[4]

In Sultan's event pictures, media and process are important (and evident) components of the finished work of art. As a student at the Art Institute of Chicago in 1975, Sultan worked outside the current trends of Conceptualism and Post-Minimalism. During this time he made "thick" paintings of multiple layers of the same color, splatter and poured works influenced by Jackson Pollock, and stripe paintings using Rhoplex as a medium. His "debris" works progressed toward a more sculptural elaboration of the traditional painted surface, incorporating objects and cutout shapes, including copies of Sultan's own paintings and Audubon reproductions, which the artist glued onto his support and then painted over.[5] The bridge to elements of Sultan's later painting style—pictures that are as much built as painted—was in part provided by the freelance construction work the artist did to support himself after moving to New York.[6] His chance observation of workmen laying floor tiles in the lobby of a gallery building led to the creation of paintings in the late 1970s using vinyl tile laid down on wood supports with the added elements of oil, pencil, and spackling compound, which allowed the patterns of the tile to become part of the overall composition.

The heavily textured surface and layered structure of *Ferry, Sept. 17, 1987* and other Sultan paintings from his mature style combine industrial elements and more traditional art materials as equivalent media. Their foundation begins with the modular unit of a four-by-four-foot wooden stretcher, which is used in combinations of two panels or four panels, as in the Museum's painting. A heavy plywood frame of the same dimensions and faced with masonite is bolted above each base unit with steel rods (in side profile, two to three inches of clear space show between the base and the plywood). Vinyl tiles are glued to this support, followed by a dense layer of tar or roofing material (butyl rubber) over gesso. Sultan draws his image and then scrapes into the tar, sometimes burning it with a blowtorch or working in plaster or other materials to

build the surface, and then adds color.[7] For paintings based on a newspaper photograph, like *Ferry*, the image is drawn with reference to the photograph but without using it as a direct template (the photographic image is not mechanically projected onto the painting support).[8] The color of the vinyl is sometimes used for the background of the painting, and the tile layout creates a regular gridwork of lines that restate the two-dimensional surface of the support. In *Ferry, Sept. 17, 1987* Sultan has gouged deeply into the tiles, creating trenches and troughs on the surface of the painting. The tar is agglomerated into mounds, as though the medium itself threatens to engulf the foundered ship.

Sultan's silhouette paintings and event pictures all begin with a photograph, whether appropriated or a Polaroid of his own making. The theatricality of the fires, explosions, and other apocalyptic imagery of the event pictures may draw upon Sultan's own training as an actor and his brief period of filmmaking before turning to painting, as well as the ubiquitous influence of television.[9] Nevertheless, Sultan's works draw not only from topical images, which are appropriated and then transformed, but from art historical sources as well. His borrowings from old and modern masters may be direct or referential. Works such as *Poison Nocturne, Jan. 31, 1985* (collection of the artist), for example, present a hellish version of James McNeill Whistler's (cat. 28) poetic nightscapes.[10]

Sultan may not have quoted a particular painting in *Ferry, Sept. 17, 1987;* however, there are many art historical images associated with shipwreck or danger at sea, including Théodore Géricault's *Raft of the Medusa* (1819, Louvre, Paris). A work such as J. M.W. Turner's *Slave Ship* (1839, Museum of Fine Arts, Boston), with its dark waves, yellow horizon, and storm-tossed vessel, provides a precedent in both subject and palette. Sultan's *Ferry* can also be seen as a dark, contemporary counterpart to the blue and white world of Caspar David Friedrich's icebound ship in *The Polar Sea* (1824, Kunsthalle, Hamburg). This painting was also based on an event and represents Friedrich's artistic interpretation of the accounts of Sir William Parry's Arctic expeditions.[11] *Ferry* was preceded in Sultan's own work by *Battleship, July 12, 1983* (Eli Broad Family Foundation, Santa Monica), based on a photograph of a World War II battleship returned to service, with the fire power of its great guns restored.[12] The tilted poles and tangled lines of Sultan's *Lines Down, Nov. 11, 1985* (collection of the artist),[13] a picture of downed electrical lines in the aftermath of a guerrilla bombing, become an abstract pattern that forecasts the similar composition but even further abstraction of *Ferry*. In the Museum's painting the representational image is nearly subsumed: the ship's towers are translated as diagonal wedges of tar, and the cables of the massive cranes used in the salvage operations become a series of lines scored into the painting's surface.

Although Sultan's paintings are image based, they tend toward ultimate abstraction, reflecting the artist's philosophy that "images [need] to be put back into abstraction."[14] In this regard, *Ferry, Sept. 17, 1987* is especially enigmatic, because the photograph on which it is based, already difficult to read as an image of a literally deconstructed vessel, has been further reduced to its essential angles, planes, and contrasts. *Ferry* accomplishes Sultan's ambition to encompass many possibilities in the same work, including representation and abstraction, as well as traditional and nontraditional formats and materials. *Ferry* and other event pictures extend the chronology of the incidents and accidents on which they are based by communicating the actual historical moment of disaster and associating it with yet another date, the completion date of the work of art incorporated in the paintings' titles. Acts of destruction are therefore repaired in creative acts, and topicality becomes history as the painting remains and the event that inspired it recedes from memory.

LM

Jaune Quick-to-See Smith

BORN ST. IGNATIUS, MONTANA 1940

73. *The Red Mean: Self-Portrait*, 1992

Acrylic, collage, and mixed media on canvas (two panels); 90 × 60 in. (228.7 × 152.5 cm) overall; top panel: 42 × 60 in. (106.7 × 152.4 cm); lower panel: 48 × 60 in. (122 × 152.5 cm); signed, dated, and inscribed across stretcher bar of top panel: *JQTS Smith 92 THE RED MEAN: SELF PORTRAIT*; across stretcher bar of lower panel: *JQTSSMITH SELF PORTRAIT*

Part gift from Janet Wright Ketcham, class of 1953, and part purchase from the Janet Wright Ketcham, class of 1953, Fund (1993:10a,b)

PROVENANCE: Bernice Steinbaum Gallery, New York.

EXHIBITIONS: New York, Steinbaum 1992; Norfolk + 1993, no. 14; Jersey City + 1996–97,[1] pp. 52, 67–68, repro. p. 53.

LITERATURE: Kandell 1997, p. 12; Watkins 1997, pp. 6–7.

CONSERVATION: The painting is on two cotton duck canvases mounted on wooden strainers. There is no evidence of losses; however, there is some wrinkling in the newspaper glued to the surface.

THE RED MEAN: SELF-PORTRAIT belongs to a group of works created by the Native American artist and activist Jaune Quick-to-See Smith in response to the Columbian quincentenary in 1992. The anniversary became the focus of controversy for many Native peoples and groups, who disputed the Eurocentric history of the "discovery" of America by Christopher Columbus and rejected the idea that his arrival on this continent was a cause for commemoration and celebration. As her response to the quincentenary, Quick-to-See Smith organized the ironically backward-titled exhibition *The Submuloc or Columbus Wohs,* comprising works by Native American artists. She also created her own *Quincentenary Non-Celebration* series, including the Museum's canvas and seven other paintings, which, according to the artist, "describe Indian life today through the use of large icons meaningful to my tribe": *Trade (Gifts for Trading with White People), Buffalo, Indian Map, Target, Indian Horse, Flathead Dress,* and *War Shirt.*[2] These works are formally and thematically related through the use of large outline pictograms and collage elements from the artist's tribal newspaper, *Char-Koosta News,* magazine articles, photocopies, fabrics, and other applied materials and objects. Among the works in the *Quincentenary Non-Celebration* series, however, only *The Red Mean* is both a political and cultural statement as well as a personal reflection of the artist.

Quick-to-See Smith was born in Montana on the Flathead reservation of the confederated Salish and Kootenai tribes; her background includes Salish, Metis, Cree, and Shoshone-Bannock as well as European ancestry. Her early years and memories were shaped by her father, a horse trader, whose nomadic life she shared and who remains an important metaphor in her work, as she travels and trades between two worlds.[3] Quick-to-See Smith's childhood determination to become an artist was tested by frequent moves, temporary stays with foster families, and financial hardship. These obstacles did not prevent her from attaining her goal to attend college, although her degree in art education from Framingham State College had to be earned over a period of years while she supported the children of her first marriage by working at a variety of jobs.[4] By the time the artist had earned an M.F.A. degree from the University of New Mexico in 1980, she had already established herself as an exhibiting artist in New York and co-founded the Grey Canyon Artists in Albuquerque in 1977 (she is also the co-founder of the Coup Marks cooperative on her own tribal lands). In addition to her career as an artist, she has acted as a mediator between Native cultures and the arts establishment through her work as a lecturer, curator, and mentor for young artists.

In her paintings and works on paper, Quick-to-See Smith consciously adopts and combines the visual languages of Native American traditions and twentieth-century European and American art. As she has pointed out, "mixing abstraction with tribal motifs is hardly new," citing Jackson Pollock and Barnett Newman (1905–1970) as artists who borrowed images from Native traditions.[5] She admires folk painting for its directness, Paul Klee (1879–1940), the CoBrA group, and the "more spiritual" Abstract Expressionists, and feels that by appropriating aspects of artistic styles familiar to American mainstream culture she is better able to communicate with a greater

number of viewers.[6] In *The Red Mean: Self-Portrait* the artist quotes an icon of Western European art, Leonardo da Vinci's (1452–1519) *Vitruvian Man* (Accademia, Venice), but transforms the image by substituting the outlines of her own body, traced by her husband, for the male figure of the Renaissance drawing. She also subverts the square and circle that describe ideal bodily proportion by exchanging them for the rectangular sheets of the *Char-Koosta News* and a red medicine wheel, in the process replacing Leonardo's universe with her own. The "spokes" of the medicine wheel, symbolizing the cardinal directions, accord with the outstretched arms and legs of the artist's self-portrait; however, the wheel, here in the form of a circle enclosing an X placed over the body, has also been construed by some viewers as a symbol of negation.[7] The motif is repeated in miniature in the image of an eagle shield with crossed tomahawks in the newspaper advertisement for "Sobriety on 93" in the upper-left quadrant of the wheel.

In *The Red Mean* the image of the artist is literally embedded in the current issues, news, and images of her tribe. Most of the *Char-Koosta News* pages that form the background of the painting are from the June 5, 1992, edition and include, for example, articles headlined "Indians denounce Columbus exhibit" (a protest against the exhibition *First Encounters: Spanish Exploration in the Caribbean and United States, 1492–1570* at the Science Museum of Minnesota) and "Indian sovereignty's a misunderstood doctrine." There are also notices concerning health issues (AIDS and alcoholism), education, and employment. In her outline self-portrait, the artist's head appears below the masthead of the *Char-Koosta News*, and the text fragment "focuses on cooperation," from the headline of the article "Treaty conference focuses on cooperation," replaces the features of her face at eye-nose level. The text fragment, with its reference to mutual understanding and the sight-related verb "focuses" (a play both on the eyes for which it substitutes and on the artist's name), can be seen as a statement of purpose or even as the artist's personal credo.

Within the outlines of the tracing, the artist has used her body as a map or billboard, locating images and text on her torso and lower extremities that are intended to be read for their message as well as for their formal use in the overall composition. As she maps her own frame, she transforms the exploration and discovery celebrated by the Columbian quincentenary by staking claim to her identity and territory (both of her body and her tribal lands). Quick-to-See Smith includes an actual map in her portrait: a newspaper schematic of Montana Indian reservations, including her own, is collaged at waist level just above the central crossing of the medicine wheel. Above the map the artist has affixed a slip of paper with the text "Montana-made" near the bumper sticker "Made in the USA" emblazoned across the chest of her traced form. These literally true statements are put to ironic use: intended as a patriotic advertisement to be mounted on a car or truck, the sticker has been co-opted by the artist as a proclamation of self. She also edits its red-white-and-blue message by applying the text fragment "Better Red" to the red field at the lower right of the sticker. As in the title of the painting, the color red is asserted not only as a racial identifier but as a way of life.[8] Quick-to-See Smith consciously follows the "Red Road" by carrying on family and tribal traditions:[9] seen in this context "Better Red" is a statement of ethnic pride and the "Red Mean" replaces the "Golden Mean" as a standard of measure.

The wry text patch "Coyote Made Me Do It" above the bumper sticker reminds the viewer of the clever trickster of Native American legend, which the artist alludes to

here as part of her persona. Lower on the body she has collaged the words "female tribal member" on the right hip of the tracing. The artist has placed another typescript fragment—"Bush administration asserts power to declare tribes extinct"—just above the genital area, countering the statement with a declaration of her own fertility and procreativity. On the legs are photocopies or newspaper pictures of wearing blankets and other textiles, and on the left knee Quick-to-See Smith has collaged a photocopied image of an Indian man mounted on horseback, possibly a reference to her father. A constellation of words, phrases, and other texts surrounds the perimeter of the tracing: "Treaty Rights," "We are together by choice," "Wild Horse," "Bear," "Fox,"

"Buffalo," "Shinny stick," "Jumpdance," and quotations from Ronald Reagan ("Eighty per cent of pollution is caused by plants and trees") and Crowfoot ("What is life? It is the flash of a firefly in the night. It is the breath of a buffalo in the winter time. It is the little shadow which runs across the grass and loses itself in the sunset"). These fragments create an evocative mix of images and impressions, almost as disconnected phrases of a conversation.

Of the many signs and signifiers of identity in this portrait, however, the most controversial marker is the number 7137 painted in red across the chest of the artist's figure. This is the artist's registration number, assigned to her at birth, which not only records her identity as an enrolled member of her tribe but "qualifies" her as a Native American artist under the 1990 Indian Arts and Crafts law enacted by the U.S. Congress. The legislation introduced by Colorado Representative Ben Nighthorse Campbell was originally intended to protect the market for art and artifacts produced by Native Americans against forgeries made by non-Native fabricators, but a number of artists and craftspeople who were not enrolled or registered members of a tribal group were placed in the anomalous position of risking a large fine or jail term for producing and selling their work because they lacked the required proof of their ethnic identity. Exhibitions of contemporary Native American artists were affected as well, as institutions retreated from the possible legal implications of showing an artist who was unregistered or who could not provide documentation of tribal affiliation or descent.[10]

Created two years after the passage of the Arts and Crafts law, Quick-to-See Smith's self-portrait, with her centrally placed registration number, cuts to the heart of the matter: the question of who is and who is not Native American. The Federal Census Bureau counts any individual who identifies himself or herself as Native American, but to be eligible for Bureau of Indian Affairs services a person must belong to a tribe recognized by the federal government or must satisfy certain requirements.[11] Different tribal groups also have varying criteria and requirements for membership recognition. A common standard of determination of Native American lineage is based on ancestral enrollment in the Dawes Commission Rolls of 1898–1906, a census and registration process undertaken by the federal government in connection with the Dawes General Allotment Act of 1887, which served to disrupt communal tribal life, government, and traditions by partitioning land among individuals. Applications for enrollment were vetted by the government to determine eligibility.[12] The role of the government in "authenticating" or denying the identity of Native Americans at the turn of the century has had lasting effects on their descendants, whose status and access to services often depend on their ability to trace their lineage to an enrolled relative or forebear.

In Quick-to-See Smith's family, while the artist is registered, her sister, who was born in a hospital off the Flathead reservation, is not. The inclusion of her registration number in her self-portrait immediately flags this contested site of identity, summoning to mind the debates concerning the political status of Native Americans. *The Red Mean* is Quick-to-See Smith's unequivocal assertion of her lineage, her involvement in the current life of her tribe, and her identity as an artist. As part of the *Quincentenary Non-Celebration* series, it pointedly declines to celebrate an anniversary that is a benchmark for cultural change and loss for Native Americans, honoring instead the more ancient heritage of this country's original inhabitants and their survival as a people. As a self-portrait, it is equally a declaration of personal survival.

LM

Betye Saar

BORN LOS ANGELES 1926

74. *Ancestral Spirit Chair*, 1992

Painted wood chair, glass, bones, plastic, metal, and dried creeper vine; 60 × 46 × 32 in. (152.4 × 116.9 × 81.3 cm); signed and dated under seat: *Betye Saar 1992*

Purchased from the artist out of proceeds from the sale of a work donated by Mr. and Mrs. Alexander Rittmaster (Sylvian Goodkind, class of 1937) in 1958 and with funds realized from the sale of a work donated by Adeline F. Wing, class of 1898, and Caroline R. Wing, class of 1896, in 1961 (1992:42a,b,c)

PROVENANCE: Purchased from the artist.

EXHIBITIONS: Los Angeles 1992 (as part of the installation *Diaspora)*; Northampton 1993.

LITERATURE: Hewitt 1992, p. 19, repro. pp. 15, 16, and cover.

CONSERVATION: The sculpture is in excellent condition.

BETYE SAAR'S work crosses and combines cultures, reflecting her own African American, Irish, and Native American heritage. An inveterate traveler, collector, and *bricoleur*, Saar gathers materials for her work from a global flea market. Her selections are made from a variety of ethnic and international sources, the natural world, and the realm of computer technology, whose artifacts and castoffs are mined for materials that will later be incorporated in a sculptural assemblage. These found or manipulated objects are transformed in a ritual process that develops through a series of stages, beginning with the imprint of ideas, thoughts, memories, and dreams.[1] Guided by intuition and her selective eye, the artist gathers objects, which are accumulated and recycled, each contributing form and energy to the final work. The ritual is completed as the work of art is relinquished by the artist and shared with an audience.

Best known for her intricate and exquisite assemblages, Saar began her career as a printmaker. Simon Rodia's *Watts Towers* (1921–54) in Los Angeles, a fantastic architectural construction made from broken tiles, glass, and found objects, was a lasting visual memory from her childhood. Saar's early assemblages, such as *Black Girl's Window* (1969, collection of the artist), a self-portrait of her own shadow pressed against a window pane, were influenced by an exhibition of Joseph Cornell's (1903–1973) box and window assemblages at the Pasadena Art Museum in 1966–67.[2] During a visit to Chicago's Field Museum of Natural History in 1972, the African, South Seas, and Caribbean collections inspired an interest in objects from traditional societies, not as a source to be imitated but as objects whose power of communication she hoped to convey in her own work.[3] Saar's "power gathering" now draws from a rich mix of dreams, her studies of tarot, palmistry, and vodun (voodoo), and eclectic cultural borrowings, especially from Asia, Egypt, and Africa.

Saar usually works on a small scale, but she also creates large sculptures and room-size installations. *Ancestral Spirit Chair* was originally part of a larger installation titled *Diaspora* (fig. 61) conceived for the exhibition *500 Years: With the Breath of Our Ancestors* at the Los Angeles Municipal Art Gallery in 1992, the year of the Columbian quincentenary.[4] Saar was one of eleven artists chosen for the exhibition whose work demonstrated, "through a variety of media, a critical and aesthetic involvement with the precolonial past, transforming ancestral elements into new acculturated forms."[5] In *Diaspora,* Saar's self-portrait as an elongated shadow placed the artist in the context of her ancestral past, symbolized by a diagrammatic slave ship painted in silver on the floor, a specific reference to the Middle Passage and the dislocation of Africans to slavery in the Americas. Within a magical precinct defined by torn netting and lighted along its boundaries by hidden neon, Saar positioned four sculptures symbolizing her spiritual ancestry. *Ancestral Spirit Chair,* recycled wooden palm furniture with a vesti-ture of painted silver spots, glass, metal, tree branches, and other organic objects, stood on a mound of redwood chips at one corner of the installation. Two small neon assemblages were placed to the right and left of the chair, and suspended directly in front of it was the *Spirit Door*, a French door screen painted with "mystical eyes . . . and parts of vèvès"[6] (Haitian vodun designs or symbols). Visible through the sym-

Figure 61. Betye Saar, Diaspora, *mixed media installation for the exhibition* 500 Years: With the Breath of Our Ancestors, *Los Angeles Municipal Art Gallery, 1992. Photograph by William Nettles, courtesy of the artist.*

bolic entryway of the *Spirit Door, Ancestral Spirit Chair* represented the soul's destination and empowerment in a realm mediated by spirits.

In keeping with the title of the installation, *Ancestral Spirit Chair* itself represents a diaspora, literally a "scattering" and "sowing," of cultural traditions. The word "diaspora," which refers to the dispersion of the Jews after the Babylonian exile, has also been applied to the dispersion and forced migrations of indigenous African peoples to the New World. According to the artist, *Ancestral Spirit Chair* was first inspired by a lecture by the Africanist scholar Robert Farris Thompson. The chair's triumphant crown of branches and bottles is a reference to an African, specifically Kongo-derived, tradition in the rural American south of placing bottles in trees to protect the household from harm: evil spirits, attracted by the glinting glass, become entrapped in the bottles, and good spirits might be enticed to protect the householders.[7] As Thompson explains, this custom was transported to America from the Kongo peoples of present-day Zaire and other culturally related areas of Central Africa by way of New Orleans, Charleston, and the West Indies.[8] Bottle trees were first made by African Americans in this country (and later by Anglo-Americans as well); bottles were substituted for the pierced or broken pottery originally used in Africa. Saar's bottles, an array of salt and pepper shakers, inkwells, insulators, and other miscellaneous glass vessels, were gathered in the Northampton area (a fact unknown to the Museum when the sculpture was acquired).[9]

Grey Gundaker has referred to Saar's chair as "purposefully Africanesque" in that it refers to a "textually mediated past," in which Africa is part of a resource pool that provides an "originating" source that may include many different traditions and influences transmitted by a variety of interpreters. According to Gundaker, *Ancestral Spirit Chair* should be seen not in terms of a linear relationship of derivation but as a constellation of influences, some of which are directly quoted or signified (that is, meant to be "decoded" by the viewer).[10] This is reinforced by Saar herself, who has specifically identified the function of the objects she has added to invest the chair with certain protections and powers: bracelets looped in the branches are gifts to the spirits; animal bones—a jawbone positioned in the chair back, bones lashed to or extending the branches, and tiny bones contained in bottle reliquaries—are meant to honor the dead.

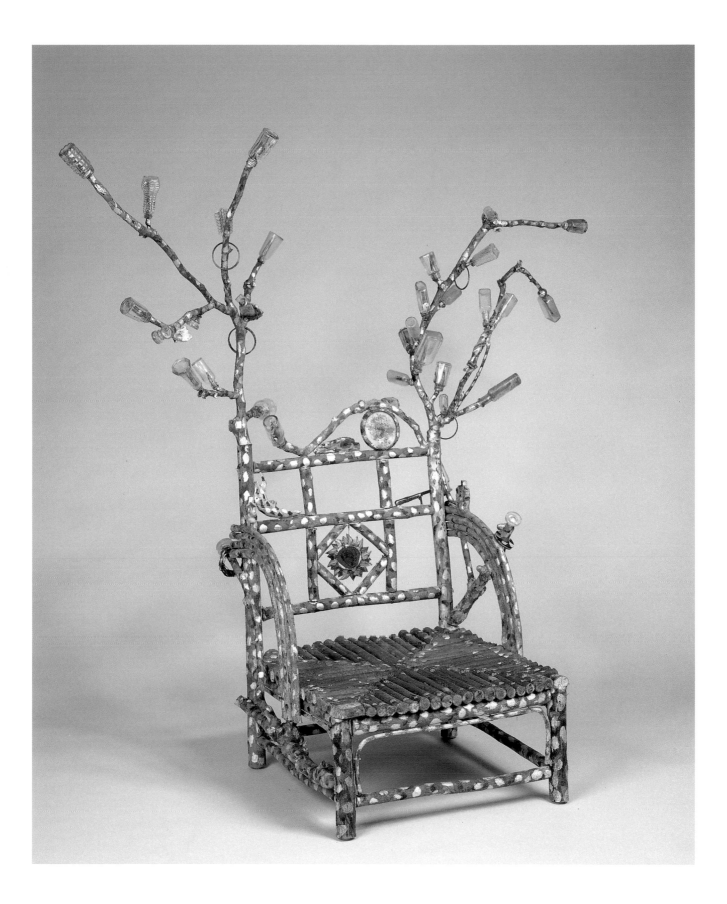

To reflect away evil spirits, Saar has incorporated small mirrors on the tips of the branches, while a closed jackknife inserted in the chair back is a symbol of protection.[11]

The rebus-like back of the chair forms a diamond shape at its center, which frames a jagged sunburst surrounding a heart pendant. Literally the "heart" of the chair, this detail manifests the Creole nature of its cultural borrowings. As Gundaker points out, the diamond shape is a reference to the sign of the "four moments of the sun,"[12] described by Thompson as the "Kongo emblem of spiritual continuity and renaissance."[13] Saar, in this case, makes a specific reference to this basic, African-derived form and emblem but has directly stated an association with the sun by creating a solar corona from metal—her own sculptural pictograph, which she has embellished with a heart. At the top of the backrest, a branch arches above a circular glass frame, suggesting the outline and iris of an all-seeing eye, a connection reinforced by a painted eye under the wooden "brow" and an eye amulet attached to the back of the glass frame. Although eyes appear as signs and signifiers in many cultures, the eye's importance as a structural part of Saar's chair may be related to what Gundaker notes as a function of African American yard chairs, which sometimes serve as a "lookout" or guardian.[14]

Ancestral Spirit Chair also implies the presence of the artist, in keeping with the overall intentions of her work: "I do want to put in something autobiographical, a hand print, or perhaps a shadow—something about me, so I'm there but not there."[15] A throne of humble origins, transformed from the mundane, *Ancestral Spirit Chair* represents power and protection, rest and renewal, with the artist as amanuensis to the spirit world:

> I cast a long shadow
> Backwards, my spirits wander.
> From Willow Glen gardens to zigzag
> to Louisiana to Iowa to Missouri
> to Virginia's Shores.
>
> Blue Illusions beckon and my spirits sail.
> Some to Irish Seas
> and some crawl deep into the belly of
> a slave ship.
>
> In search of the unknown
> my spirits pass through the Spirit Door,
> Seek the dark corner of the Ancestral Chair,
> Breathe on the embers of Africa and
> Recall the memory of fire.[16]

LM

Notes

Introduction

1. A history of the collections, collecting policy, and the four buildings that have housed the Museum's holdings can be found in Chetham et al. 1986, pp. 11–34. Most of the American paintings and sculpture in that catalogue are included in this publication, and this introduction draws extensively from its chronology section. Other useful publications that address the Museum's history include Chetham 1969 and Chetham 1980.

2. See Washington +, National Gallery 1970 for a listing of the fifteen institutions to which the exhibition toured.

3. The Museum closed in 1990 for asbestos abatement.

4. Artists and paintings mentioned in the article include: William Holbrook Beard (*The Tender Passion Universal* and *The American Eagle*), Albert Fitch Bellows (*A Village School in New England*), J. Appleton Brown (*Spring*), J. G. Brown (*Blind Musician*), C. C. Burleigh (copy of a Rubens self-portrait), Samuel Colman (*The Caravan of the Desert*), Lockwood De Forest (*Ramesseum at Thebes*), Thomas Eakins (*In Grandmother's Time*), John Enneking (*Twilight*), Henry A. Ferguson (*Evening, Andes of Chile*), Robert Swain Gifford (*Old Orchard by the Sea*), R. De Haas (*A Squall off the New England Coast*), James McDougal Hart (*Rising Thunderstorm/Approaching Thunderstorm*), Winslow Homer (*Song of the Lark*), George Inness (*Morning*), Walter F. Lansill (*Fishermen's Boats*), Will H. Low (*All Saints Day*), George W. Maynard (*A Soldier of the Revolution*), James Craig Nicoll (*Closed In*), William Sartain (*Narcissus*), Walter Satterlee (*The Young Dominican*), R. M. Shurtleff (*A Race for Life*), Thomas Smith (*Nightfall in Winter*), Louis Comfort Tiffany (*Old New York*), and Alexander H. Wyant (*Scene in County Kerry, Ireland*). The article also lists *Death and the Miser* by Champney, undoubtedly James Wells (rather than Benjamin)

Champney, who lived in Deerfield, Mass., and taught at Smith College from 1877 to 1884.

5. Research conducted by Patricia (Anderson) Junker in the College Archives while on staff at the Museum.

6. Quoted in the chronology in Chetham et al. 1986, pp. 15–16.

7. Lists and correspondence concerning the works deaccessioned are held in a general file in the Museum's curatorial archives; in addition, many of the individual works that were sold have individual object files. An undated synopsis of the sale, apparently made years later by Director Charles Chetham, is also in the file.

8. See Franklin Kelly's entry on Dewing's *Lady with a Lute* in Kelly et al. 1996, pp. 127–30, repro. In his letter to Frederick Hartt (May 16, 1947, Museum files), Dr. Walter Timme strenuously objected to the Gimbel's sale and said of the Dewing painting: "It so happens that I am now the fortunate owner, having paid nearly three times what Gimbels sold it for, but I considered it cheap at the price. To own it is not only a great pleasure and privilege, but I considered it my duty, if I could afford it, to rescue it from undeserved oblivion."

9. For example, Helen Knox, class of 1913, wrote to President Herbert Davis (Dec. 4, 1946, Museum files): "My interest in the college centered in the Hillyer Gallery, where I took all possible lecture courses, and practical work, and was a member of Studio Club. The shock, therefore, was almost insupportable when I read in Sunday's New York Times that Gimbel's Department Store is selling our paintings by Childe Hassam, Inness, Blakelock, Benson, Weir, etc."

10. Deborah Chotner, Patricia (Anderson) Junker, and the present writer were also on staff as curatorial assistants.

11. Deborah Chotner organized the first exhibition of Samuel S. Carr (Northampton 1976) and remains the authority on his work. Betsy

Jones prepared an exhibition of Edwin Romanzo Elmer's work (Northampton 1982), followed by her monograph in 1983. Patricia Junker organized and cowrote the catalogue for the 1991 nationally touring exhibition *Winslow Homer in the 1890s: Prout's Neck Observed*. Elizabeth Mankin Kornhauser was responsible for the exhibition and extensive catalogue *Ralph Earl: The Face of the Young Republic* (Washington +, NPG 1991–92). Additionally, Deborah Chotner, Patricia Junker, and Elizabeth Kornhauser are all co-authors of collection catalogues of American art for their respective institutions.

12. For example, Carmen Lomas Garza's *Blessing on Wedding Day* (checklist no. 56) and Pat Ward Williams's *Ghosts That Smell Like Cornbread* (checklist no. 83).

13. The Marin collection includes over 170 works by such artists as Marsden Hartley, Arthur Dove, Georgia O'Keeffe, Charles Sheeler, Gaston Lachaise, Willem de Kooning, Jackson Pollock, Mark Rothko, and others. The future gift is particularly strong in twentieth-century photography. Cape Split Place, the family's summer home in Addison, Maine, will become the center for the Norma Marin Foundation.

14. A comprehensive overview of the American collections, and all the Museum's holdings as well as those of Amherst College, Mount Holyoke College, Hampshire College, the University of Massachusetts, and Old Deerfield, will be eventually accessible to the public through a database accompanied by digital images.

JOHN SMIBERT

1. Mrs. John Erving (Abigail Phillips)

1. The most comprehensive biographical source is Saunders 1995.

2. Smibert 1969, pp. 91, 110.

3. Foote 1950, p. 75.

JOSEPH BLACKBURN

2a. Gillam Phillips
2b. Mrs. Gillam Phillips (Marie Faneuil)
2c. Andrew Faneuil Phillips
2d. Ann Phillips

1. Quoted in Stevens 1967, p. 101; the original letter is in the Newport Historical Society.

2. For biographical information, see Park 1923, pp. 308–11; Phillips 1885, pp. 188–89.

3. Comments on the costume of Mrs. Phillips were supplied by Madelyn Shaw, curator, National Textile Museum. For a discussion of Van Dyck dress, see Ribeiro 1995, pp. 203–4.

4. Comments on Ann Phillips's costume were provided by Madelyn Shaw; see also Ribeiro 1995, pp. 181–235.

THOMAS McILWORTH

3. Dr. William Samuel Johnson

1. For biographical information, see Wayne Craven in Quimby 1971, pp. 251–97, esp. pp. 270–74; Sawitzky 1951, pp. 117–39; Washington, NPG 1987–88, pp. 31, 32, 42, 60–62, 281.

2. *New York Gazette*, Aug. 21, 1758, quoted by Wayne Craven in Quimby 1971, p. 270.

3. Cited in Northampton 1980, p. 3.

4. See Groce 1937; Jacqueline Anderson in Northampton 1980, pp. 2–3, 5; Kammen 1968, pp. 196, 199, 201, 221–24, and passim.

5. Sawitzky 1951, p. 119.

6. Groce 1937, pp. 195, 198.

JOHN SINGLETON COPLEY

4. The Honorable John Erving

1. For biographical information, see Prown 1966; Copley [1914] 1970; Boston +, MFA 1995.

2. Prown 1966, vol. 1, pp. 48–49.

3. Further biographical information can be found in *Erving 1984*, p. 5; Wilson and Fiske 1894, vol. 2, p. 367; Parker and Wheeler 1938, pp. 69–70.

4. As quoted in Parker and Wheeler 1938, p. 70.

5. Ibid. A handwritten note (Feb. 5, 1982, Museum files) from a descendant of the sitter indicates that Charles Curran painted the copies in 1917.

RALPH EARL

5. A Master in Chancery Entering the House of Lords

1. For biographical information, see Kornhauser 1989; Washington +, NPG 1991–92.

2. Graves 1905–6, vol. 3, p. 2, lists the work as "no. 52. A Master in Chancery entering the House of Lords."

3. Aileen Ribeiro, costume note in Washington +, NPG 1991–92, p. 121.

4. The subject's identity as Lord Bathurst was first suggested by Helen Davey (Museum files). Further discussion is in Washington +, NPG 1991–92, pp. 121–23.

GILBERT STUART

6. Henrietta Elizabeth Frederica Vane

1. For biographical information, see Whitley 1932; Mount 1964 *Gilbert;* McLanathan 1986.

2. Mount 1964 *Gilbert*, p. 362; Museum files.

3. See Whitley 1932, pp. 37–38, who was the first to uncover the exhibition of the nine portraits by Stuart. As Whitley explains: "they have been unnoticed by [Stuart's] preceding biographers, because they were omitted by [Algernon] Graves from his well-known dictionary of exhibitors at the Incorporated Society's gallery. Graves in his turn was led into error by the misspelling of the artist's name in the original catalogue of 1783—'G. Steuart' for 'G. Stuart'—and assigned all the portraits to George Steuart, a painter chiefly of landscape." Whitley's 1932 monograph indicates that the full-length portrait of the young girl had "disappeared." For William Sawitzky's research, see the William and Susan Sawitzky Papers (New-York Historical Society) and the object file for the portrait of Henrietta Vane (Museum files).

4. *St. James's Chronicle* 1783, quoted in Whitley 1932, p. 38.

5. Reproduced in Sabin 1901, p. 25.

BENJAMIN WEST

7. Preliminary design for the painted window in St. Paul's Church, Birmingham: **The Conversion of St. Paul** (center); **St. Paul Persecuting the Christians** (left); **Ananias Restoring St. Paul's Sight** (right)

1. Erffa and Staley 1986 (no. 392, pp. 382–83) suggest that the Museum's version may represent the 1791 entry into the Royal Academy show, but they do not speculate as to its place in the development of the painted window. In his catalogue entry on what is now the Dallas version, Donald Garstang argues that it is that triptych that is the "finished sketch" exhibited by West in 1791 and that remained in the artist's studio to his death (London 1989, pp. 108–9).

2. For an excellent discussion of the laborious process of glass enameling in the eighteenth century, see Meyer 1981, pp. 220, 222.

3. For information on the commission for St. George's chapel, see Meyer 1979, pp. 53–65. *St. Paul Shaking the Viper from His Hand after the Shipwreck*, 1789, is described in Erffa and Staley 1986, no. 397, pp. 384–86.

4. There are signs that the composition was altered and that previously it may have been an arched-top design with the figure of Christ in a different position.

5. Letter from Martin Ellis, assistant keeper, City of Birmingham City Museums and Art Gallery, Nov. 3, 1982 (Museum files).

6. "St. Paul's, An Old Birmingham Church," reprint from the *Birmingham Post*, undated (Museum files).

7. Provenance is derived from sources listed in the entries for nos. 391 and 392 in Erffa and Staley 1986, p. 382.

8. *Public Characters of 1805* (London: privately printed for Richard Phillips, 1805), p. 562.

9. In Erffa and Staley 1986 (no. 392, pp. 382–83), the authors suggest that Henry Hope likely would have been attracted to the work that West exhibited at the Royal Academy in 1801, after Hope's arrival in London in 1794, and not necessarily to the version that remained in West's studio. Hope presumably would not have seen the entry at the Royal Academy in 1791.

UNKNOWN ARTIST

8. Eagle (architectural ornament)

1. The dating has been suggested by Philip M. Isaacson. In a letter of Oct. 26, 1981 (Museum files), he conjectured, on the basis of a photograph, that if the eagle was carved in New England, where it was found, it was probably made about twenty years later than the eagle attributed to Charles Bulfinch, now in the Massachusetts State House and dated 1790 (reproduced in Isaacson 1975, fig. 51).

2. Isaacson 1975, p. 47. Benjamin Franklin did not share this enthusiasm. His candidate for national bird was the turkey because, though the bald eagle was indeed native to North America, eagles are found worldwide. In a famous letter to his daughter of Jan. 26, 1784 (quoted in Isaacson 1975, p. 43), he reasons that the turkey is "a true original native of America . . . besides (though a little vain and silly it is true, but not the worse emblem for that) a bird of courage." He called the bald eagle "a rank coward" and a bird of "bad moral character" that steals the catch of other birds.

3. Arthur Risser, former curator of birds at the San Diego Zoo, in a letter of Nov. 13, 1994 (Museum files), points out that had the carving originated in Asia, the bird might be taken for a Steller's eagle, which has a more prominent brow than the bald eagle.

4. *Old Print Portf* 1957, pp. 78–79.

5. Lahvis 1992.

6. Lahvis, letter of Dec. 27, 1995 (Museum files).

7. Ibid.

8. Isaacson 1975.

9. See note 1 above.

10. Brewington 1962, p. 141 n. 17, notes that the *Hornet*, built in Baltimore in 1805, used the eagle with escutcheon when the ship was in port, but replaced it with a simple billethead when at sea. Such a practice might account for the detail of the Museum's carving, if it had been a figurehead. Its modern mounting places it in a generally horizontal position. The dealer who sold it presented it in his publication photographs as almost vertical (see note 4 above). The configuration of a ship's prow dictated the attitude of its figurehead.

11. "American Flag Merchant Vessels / Port of New York, 1789–1867," pp. 185–88, typewritten compilation at James Duncan Phillips Library, Essex Institute, Salem, Mass.

UNKNOWN ARTIST

9. Bridget Duncan

1. The first research to be undertaken on the painting by Smith College student Sarah Mason, class of 1974, convincingly establishes the subject as Bridget Duncan. See her entry in the catalogue for Northampton 1975 *Five* (unpag.).

2. Genealogical information on Bridget Duncan is found in the following: Wal 1877, pp. 381–82; Rice 1894, pp. 77–78, 332; Hemenway 1863, pp. 92–94; *Billerica* 1908, pp. 247, 304; Hazen 1883, pt. 2, genealogical register, p. 43.

WILLIAM JENNYS

10a. Lieutenant David Billings
10b. Mabel Little Billings

1. The portraits remained on the Billings family homestead in Hatfield, Mass., until they were given to the Museum by the Billings sisters. Louisa Billings, class of 1905, was a professor of physics at Smith College from 1906 until her retirement in 1947.

2. *Connecticut Journal,* Nov. 20, 1792.

3. For biographical information on William Jennys, see Warren 1955; Warren 1956, pp. 33–64; Hartford 1985–86, pp. 138, 165; Washington +, NPG 1991–92, pp. 58–59.

4. Washington +, NPG 1991–92, pp. 58–59.

5. The Billingses are buried in the old burying ground in Hatfield. David Billings's tombstone reads: "This monument is erected in memory of Lt. David Billings, who ended a useful and exemplary life . . . aged 78 years. The esteem and confidence of his fellow citizens was manifested in his repeated election to offices of honor and trust . . . those virtues . . . were produced by that Holy Religion which he professed and practiced." Mabel Billings's tombstone reads: "She eminently possessed the gentler virtues of her sex in the exercise of which she endeared herself to her friends. The principles and precepts of Jesus governed her conduct. . . . "

UNKNOWN ARTIST

11. Ceres (ship's figurehead)

1. A previous owner tentatively attributed the carving to Isaac Fowle (active 1806–43), an apprentice to the famed Boston carvers John and

Simeon Skillin. Sylvia Lahvis, author of a dissertation on the Skillins (Lahvis 1992), states in a letter of Mar. 21, 1995 (Museum files): "The piece is definitely not that of anyone in the Skillin workshop. The carving is linear and striated, while the Skillins' work is softer and more natural in appearance."

2. Dating suggested by Sylvia Lahvis in the letter cited in note 1 above.

3. Not in catalogue; mentioned p. 18.

4. The conservation note was compiled by David Dempsey and the author.

5. Rogers 1985, p. 158, offers several theories for this usage, e.g., that a sailor held a ship on which his life depended as dear as his wife or that he considered a ship "as capricious, demanding and absorbing" as a woman.

6. Typewritten ship registers in the James Duncan Phillips Library, Essex Institute, Salem, Mass.

7. "American Flag Merchant Vessels, Port of New York, 1789–1867," typewritten compilation in the James Duncan Phillips Library, Essex Institute, Salem, Mass.

8. Quoted in Brewington 1962, pp. 34–35.

9. Documentary record sheet, American Folk Art Gallery, Edith Gregor Halpert Papers, AAA.

10. Breuning 1933.

11. Keyes 1933, p. 228.

12. Elements containing the suffix "–head" projected beyond the ship's stern and bow. This area also included a platform for wringing out swabs and the crew's toilet facilities—hence the name for the latter in use to this day.

MARGARETTA ANGELICA PEALE

12. Still Life with Watermelon and Peaches

1. Lance Humphries is gratefully acknowledged for providing provenance and exhibition information from his research on paintings by the Peales that descended through the line of James Peale, Jr., whose grandson, Clifton Peale, sold the Museum's still life and other family works through Walker Galleries, New York. Paintings from this group were exhibited together at the Walker Galleries in 1939, in Baltimore at the Municipal Museum in 1941, and then in Philadelphia at

the McClees Gallery in 1944. The Museum's still life was not shown in Baltimore, but it was exhibited in Philadelphia, where it was listed as being owned by M. Knoedler and Company, which apparently acquired many of these works. (Letters to Linda Muehlig, Sept. 10 and Oct. 3, 1998, Museum files, and telephone conversations.)

2. Raphaelle Peale's life and work are discussed in Washington + National Gallery 1988–89.

3. Bantel in ibid., p. 13.

4. One of the clearest examples of such interest, Rembrandt Peale's portrait of his brother *Rubens Peale with a Geranium* (1801, National Gallery of Art, Washington, D.C.), prominently displays the first example of this plant cultivated in America.

5. Cobbett 1821, chap. 4, no. 234.

6. See, for example, Burr 1863, pp. 184–87, and Downing and Downing 1886, p. 563.

7. Edward H. Dwight, "Still Life Paintings by the Peale Family," in Detroit 1967, p. 38.

8. Reproduced in Detroit 1967, no. 197, p. 60.

9. Rutledge 1955, p. 165.

ERASTUS SALISBURY FIELD

13a. Nathaniel Bassett
13b. Bethiah Smith Bassett

1. A note formerly attached to the back of the frame by a family member (N.B.M., thought to be the subjects' great-granddaughter) is inscribed: "Nathaniel Bassett—7th generation from William, who came over in ship Fortune with his wife Elizabeth Tilden (1621) Born at Sandwich Mass. Jan.-26 1758—Enlisted in Revolutionary Army at age of 17—served under Arnold at West Point and assisted in the capture of André—married Bethia Smith of Sandwich and returned by horse-back to settle for 2 years in Lenox Furnace 1781—they returned to Lee and settled on the farm which became the Bassett homestead for many years—now occupied by Harriet Moore—later he built his son Joseph the house where Chas.-Hollister (a descendant) now lives where my father James Watson Bassett was born—Died May 6, 1846—at the age of 88, buried in Lee . . . in . . . trip N.B.M."

2. A note by N.B.M. formerly attached to the back of the frame is inscribed: "[Be]thiah Smith—

daughter of John [S]mith was born at Sandwich Oct-16, [1]761—Married [N]athaniel Bassett . . . Sept. 27, 1781—removed with him to Lee where she made her home . . . till her death March 20 1849—She and Nathaniel were the parents of Joseph Bassett and grandparents of my father James Watson Bassett N.B.M.—"

3. *Greenfield Gazette and Courier*, June 9, 1900, quoted in Williamsburg 1963, p. 36. Additional sources of biographical information on Field include French and Dods 1963; Springfield + 1984.

4. Springfield + 1984, p. 20.

5. Ibid., pp. 20, 41, 100.

6. See notes 1 and 2 above; Hyde and Hyde 1878, p. 314.

7. See Hyde and Hyde 1878, pp. 152–54, 237, 314; Sturbridge 1992–93, pp. 76–77.

THOMAS COLE

14. Compositional study for The Voyage of Life: Manhood

1. Quoted by Paul D. Schweizer in Utica 1985, p. 8.

2. Cole in a letter to patron Robert Gilmore, in Truettner and Wallach 1994, p. 42.

3. Ward's daughter, Julia Ward Howe, recalled this in her memoir, published in 1899, quoted in Utica 1985, p. 9.

4. That concern would culminate in the creation of his monumental canvas *Prometheus Bound* (1847, Fine Arts Museums of San Francisco), painted for an exhibition designed to spur the production of murals for the renovated Westminster Hall, London. See Junker 1997–98, pp. 15–19.

5. *Cole's Pictures of the Voyage of Life, Now Exhibiting at the New Building, Corner of Leonard-Street and Broadway, New-York* (New York, 1840), p. 2, quoted in Parry 1988, p. 255.

6. Parry 1988, p. 237.

7. Ibid., fig. 185, pp. 231, 237. Cole, however, did not acknowledge this influence.

8. Noble [1856] 1964, p. 205. Parry has discussed the possible connection between these two works (Parry 1988, pp. 221–24). *Portage Falls on the Genesee River* (oil on canvas, 84 × 60 in.) is in the collection of the Governor William Seward House, Auburn, N.Y. New York State Commissioner Samuel Ruggles,

who commissioned the painting, was a friend and neighbor of Samuel Ward.

9. See Parry 1988, pp. 255–57; Wallach 1977, pp. 234–41; Truettner and Wallach 1994, pp. 98–101.

10. See the exhibition catalogue for Staten Island 1860, no. 63, where the painting is described as *First Idea of the Third Picture in the Voyage of Life*. The dating of these sketches is given by Parry (Parry 1988, pp. 230–31, 254) and by Schweizer (Utica 1985, p. 15). In addition to these sketches, other related works include: *Study for the Voyager in the Voyage of Life: Manhood* (1839–40, oil on canvas, 10¾ × 8½ in., private collection); *Study for the Face of the Voyager in the Voyage of Life: Manhood* (1840, graphite on paper, 8⅞ × 11⅝ in., Detroit Institute of Arts); replica of *The Voyage of Life: Manhood* (1840–41, oil on canvas, 25 × 37 in., formerly collection of the late John W. Merriam, Wynnewood, Pa.); *Figure Study for the Voyage of Life: Manhood* (1841, graphite on paper, 11⅝ × 17⁷⁄₁₆ in., Detroit Institute of Arts); *Figure Study for the Voyage of Life: Manhood* (1841, graphite on paper, 11³⁄₁₆ × 16⅞ in., Art Museum, Princeton University); *Figure and Head Studies for the Voyage of Life: Manhood* (1841, graphite on paper, 14¾ × 10⁷⁄₁₆ in., Detroit Institute of Arts); a second set of *The Voyage of Life: Manhood* (1841–42, oil on canvas, 52⅞ × 79¾ in., National Gallery of Art, Washington, D.C.); Robert Hinshelwood, after Cole, *The Voyage of Life: Manhood* (1850, etching, 5¼ × 8⅛ in. [based on the Ward painting]); John Halpin, after Cole, *The Voyage of Life: Manhood* (1852, engraving, 3¼ × 5⁵⁄₁₆ in. [based on the Ward painting]); James Smillie, after Cole, *The Voyage of Life: Manhood* (1854–56, engraving with etching, 15¹⁵⁄₁₆ × 22¾ in. [based on the Ward painting]).

THOMAS CHAMBERS

15. Lake George and the Village of Caldwell

1. Formerly titled *Looking North to Kingston* and *View of Newburgh on the Hudson*.

2. New York, Macbeth 1942. The Albert Duveen Papers (AAA, NDU 1-148) contain a photograph of the Museum's painting for the 1942 exhibition, which suggests its inclusion in that show.

3. For information on Chambers, see Little 1948 March; Little 1948 April; Little 1951; Merritt 1956; Rochester

247

1976; Rumford 1988, pp. 19–21; Chotner et al. 1992, pp. 43–53.

4. The other versions include *The Hudson Valley, Sunset* (National Gallery of Art, Washington, D.C., Gift of Edgar William and Bernice Chrysler Garbisch); *Hudson River, Looking North to Kingston* (New-York Historical Society); *Stony Point, New York* (Metropolitan Museum of Art, New York); and *A View of West Point* (private collection; sale, Sotheby's, New York, Nov. 16–18, 1972, lot 426).

5. Entry for Thomas Chambers, *Lake George and the Village of Caldwell*, in Caldwell et al. 1994, vol. 1, p. 524.

6. An annotated English translation by Constance D. Sherman was published in 1968 by the Gregg Press, Ridgewood, N.J.

HORACE BUNDY
16. *Girl with a Dog*

1. Formerly titled *Portrait of a Girl with a Dalmatian*.

2. *Boston Evening Transcript*, June 16, 1883, p. 2.

3. The major biographical source is Shepard 1964, who states (p. 447) that the artist died at the home of a daughter.

4. Muller 1976, pp. 37–38.

ASHER BROWN DURAND
17. *Woodland Interior*

1. Huntington 1887, p. 28.

2. Ibid., pp. 28–29.

3. New York, National 1854, no. 356 (*The Primeval Forest*, owned by E. D. Nelson). The entry was accompanied by this excerpt from Bryant: "These dim vaults / These winding aisles of human pomp or pride / Report not." Lawall identified the Museum's oil sketch as *The Primeval Forest* (Lawall [1966] 1977, fig. 168), but later revised that identification and in 1978 published the sketch with the descriptive title *Woodland Interior* and dated it to c. 1854. In their catalogue entry on *In the Woods*, John Caldwell and Oswaldo Rodriguez Roque accept the Smith College oil study as *The Primeval Forest* of 1854, based on Lawall's earlier work and not on his revised study (Caldwell et al. 1994, p. 428). Lawall's reidentification of the Museum's painting as one of Durand's many unidentifiable forest interiors rather than as the painter's 1854 National Academy entry seems reasonable. It is questionable

whether Durand would have exhibited two nearly identical works—even canvases of dramatically different sizes, such as *Woodland Interior* and *In the Woods*—in National Academy shows in successive years.

4. New York, Ortgies 1887. The Museum's painting has been relined, and it is not known if the canvas ever bore an estate stamp.

5. *Putnam's Monthly*, May 1855, quoted in Lawall 1978, p. 108.

6. The Association for the Advancement of Truth in Art was founded on January 27, 1863, in the New York studio of the English expatriate artist Thomas Charles Farrer (cat. 21), in emulation of the English Pre-Raphaelite Brotherhood, who came together in 1848, and whose work was championed by Ruskin. See the catalogue for Brooklyn + 1985.

7. Durand 1855, pp. 34–35, quoted in McCoubrey 1965, pp. 111–12.

WILLIAM STANLEY HASELTINE
18. *Natural Arch, Capri*

1. On American artists in Italy, see Theodore E. Stebbins, Jr., in Boston +, MFA 1992.

2. For biographical information on the artist, see the work by his daughter (Plowden 1947) and the excellent and detailed chronology in San Francisco + 1992.

3. At Harvard the artist was a member of the Natural History Club, presided over by Alexander Agassiz, son of the famous geologist Louis (Marc Simpson, "Noble Rock Portraits: Haseltine's American Work," in San Francisco + 1992, p. 17).

4. Tuckerman 1867, pp. 556–57.

5. Jasper F. Cropsey visited the island in 1848 with fellow artist C. P. Cranch and made at least one pencil sketch (Yonkers 1979–80, fig. 29) and one watercolor of the Arco Naturale (Boston, MFA 1962–63, fig. 59). Albert Bierstadt (cat. 20) and Sanford Gifford spent two weeks sketching there in 1857 (Washington, National Gallery 1991, p. 164).

6. Andrea Henderson, "Haseltine in Rome," in San Francisco + 1992, p. 49 n. 49.

7. "Capri," in *Appleton's* 1873, p. 631.

8. Trollope 1877, p. 428.

FRANCIS SETH FROST
19. *South Pass, Wind River Mountains, Wyoming*

1. For a full biography of Frost and a summary of his career, see Houston 1994, pp. 146–57. Frost has long been misidentified as Francis Shedd Frost, but Jourdan Houston documents his correct middle name as Seth. A list of Frost's works exhibited at the Boston Athenaeum is published in Perkins and Gavin 1980, p. 60.

2. See the biographical account in the Frost family genealogy included in Cutter 1908, p. 491; also see Houston 1994, p. 148.

3. From Lander's official report, Mar. 1, 1860, *House Executive Document 64, 34th Congress, 2nd Session*, quoted in Hendricks 1964, p. 334.

4. Lander, quoted in Hendricks 1964, p. 334.

5. See Nancy K. Anderson in Brooklyn + 1991, p. 106 n. 13.

6. Bierstadt's letter of July 10, 1859, from the Rocky Mountains appears in *The Crayon*, vol. 6, no. 9 (Sept. 1859), p. 287.

7. See Houston 1994, pp. 154–56.

8. Cutter 1908, p. 492.

ALBERT BIERSTADT
20. *Echo Lake, Franconia Mountains, New Hampshire*

1. Cole, "Essay on American Scenery," 1835, in McCoubrey 1965, p. 103. The essay was first published in *American Monthly Magazine*, n.s., vol. 1 (January 1836), pp. 1–12.

2. See Dwight 1826; Hawthorne 1882; King 1860. Hawthorne's first tales of the White Mountains, "The Ambitious Guest" and "The Great Carbuncle," were published in *Twice Told Tales* in 1835. Durham + 1980 provides a comprehensive survey of the history, literature, and art of the region.

3. Champney 1900, pp. 105–6. For this and other references to artists in the White Mountains and a general outline of Bierstadt's work there, see Lipke and Grime 1973, pp. 20–37.

4. The painting was identified by Catherine H. Campbell in 1980 on the basis of photographic views of Echo Lake, including those taken by the Bierstadt Brothers (correspondence with the author, Museum files). Also see Campbell 1981, p. 14.

5. Campbell 1981, p. 15.

6. Campbell has placed emphasis upon the artist's interest in photography as an aid to his painting, especially in his White Mountains subjects, but the extant Bierstadt Brothers stereographs offer few direct links to specific paintings. See Campbell 1981.

7. Brooklyn + 1991, p. 149.

8. *Gems of American Scenery: White Mountains* (New York, 1878), p. 30. This is a later edition of the guidebook first published in 1862.

9. Notes and correspondence (Museum files).

10. *Albion* 1861, p. 189.

11. *NY Times* 1861.

12. Brooklyn + 1991, p. 147.

THOMAS CHARLES FARRER
21. *View of Northampton from the Dome of the Hospital*

1. The present title has been taken from a contemporary account in the *Northampton Free Press*, Oct. 13, 1865. It was titled simply *Northampton* when it was shown in the Artists' Fund Society exhibition at the National Academy of Design in 1865. In a letter of Oct. 17, 1865, to Mrs. Gordon L. Ford (Gordon L. Ford Collection, AAA), Farrer referred to it as "my large painting of Northampton and Amherst."

2. Farrer's obituary in the *New York Tribune* (June 18, 1891, p. 7) states that he was not permitted by his father to read until he was seventeen. In a letter of May 18, 1861, to Mrs. Clarence Cook (Gordon L. Ford Collection, New York Public Library, Manuscripts Division [not microfilmed]), he attributes his "mistakes in grammar" to "not having ever been at school."

3. Koke 1982. See the entry for Henry Farrer, Thomas's younger brother.

4. In the group's records and publications their name is sometimes given as "Association for the Advancement of Truth in Art," but "Society" is the more common form. Artist members included Charles Herbert Moore (1840–1930), John Henry Hill (1839–1922) and his father John William Hill (1812–1879), William Trost Richards (1833–1905), and Henry Roderick Newman (1843–1919). The American Ruskinians have been largely omitted from general histories of American art. The first

extended study of the movement (Dickason 1953) was published the same year the Museum acquired the Farrer painting. The most comprehensive study of the movement (Brooklyn + 1985) includes essays by Linda S. Ferber, William H. Gerdts, Kathleen A. Foster, and Susan P. Casteras, with extensive biographical entries by Annette Blaugrund. There is also a lengthy discussion of this painting by May Brawley Hill.

5. Wight 1884, first Article of Organization, p. 63.

6. Among those who came to try the water cure at Northampton was the young Henry James, who may also have been drawn by Norton's presence, during the summer at least, in nearby Ashfield in 1864. He had just submitted his first journalistic effort to Norton for publication in the *North American Review*. Northampton was the model for the town where James's *Roderick Hudson* (1875) opens.

7. Norton 1864, pp. 303–4. Norton and James Russell Lowell were co-editors.

8. Russell Sturgis to Farrer, Sept. 17, 1863; P. B. Wight to Farrer, Aug. 19, 1963; both Ford Collection, AAA.

9. Charles Herbert Moore to Farrer, Apr. 25, 1864, Ford Collection, AAA.

10. *Northampton Free Press*, Oct. 13, 1865.

11. Farrer's painting of Mount Tom was formerly in the collection of Wilbur L. Ross, Jr. As of 1996 the painting was being offered for sale by Hirschl and Adler Galleries, New York. It is reproduced in Brooklyn + 1985, pl. 2.

12. Cf. letter cited in note 1 above, written from Northampton: "I have to . . . take my large painting of Northampton and Amherst, to its owner in New York."

13. "The Artists' Fund Society Sixth Annual Exhibition," *New York Daily Tribune*, Dec. 27, 1865, p. 5.

14. *Nation* 1865, pp. 692–93.

15. *New Path* 1865, pp. 193–94. "Spungy" may refer to the sponges some landscape painters used instead of brushes to render foliage.

16. *Hampshire Gazette*, Sept. 26, 1865, p. 2.

MARTIN JOHNSON HEADE
22. *New Jersey Meadows*

1. The Museum's painting will also be included in the revised edition, scheduled for publication in 1999.

2. Boston +, MFA 1969. Catalogue text by Theodore E. Stebbins, Jr.

3. *Two Sketches of Cattle*, graphite on paper, 3⁷⁄₁₆ × 5¹¹⁄₁₆ in., Archives of American Art, Smithsonian Institution, Washington, D.C. The same detail appears in *Sunset, Newburyport Meadows*, 1863, reproduced in Stebbins 1975, p. 49.

4. Jarves [1864] 1960, p. 193.

5. Clement and Hutton 1893, p. 340.

6. Stebbins 1975, p. 102.

7. Quoted in ibid., p. 97.

8. Ibid., pp. 55–56.

WINSLOW HOMER
23. *Shipyard at Gloucester*

1. The Museum's painting was shown at the New York venue only.

2. The Museum's painting was not shown in Boston.

3. Lloyd Goodrich, catalogue raisonné of the works of Winslow Homer, courtesy of the City University of New York, Lloyd Goodrich and Edith Havens Goodrich, Whitney Museum of American Art Record of the Works of Winslow Homer.

4. Washington +, National Gallery 1995–96, p. 393.

5. See, for instance, Washington +, National Gallery 1995–96, p. 139, and D. Scott Atkinson in Chicago 1990, p. 24.

6. Ronnberg 1996, p. 209. The author is grateful to Mr. Ronnberg for sharing his research. The print for Elwell's photograph is from a copy negative owned by Mr. Ronnberg.

7. Ronnberg explains that Vincent's Cove was originally Vinson's Cove, named for one of Gloucester's first settlers. By 1945 Vincent's Cove was completely filled in (Ronnberg 1996, p. 209).

8. The author is grateful to Mr. Ronnberg for identifying all of the surrounding buildings. See his key in Ronnberg 1996, p. 213, fig. 51. He notes that additional buildings have been edited out of Homer's view, as they created a visually confusing background to the schooner's profile.

9. Homer's summer at Manchester in 1869 inspired the oil *Eagle Head, Manchester, Massachusetts* (Metropolitan Museum of Art, New York), exhibited at the National Academy of Design in the spring of 1870.

10. Chapelle 1935, p. 254.

11. Ronnberg 1996, p. 217. Having surveyed the *Cape Ann Weekly Advertiser*, Ronnberg was unable to identify a schooner launched from the Story yard in 1871 that matches the hull shown in Homer's painting. He writes: "In early March of that year, Story launched a vessel, reportedly of 100 tons . . . for Provincetown owners; newspaper accounts do not give the vessel's name. The yard seems to have been idle for the balance of the year and only one other vessel has been recorded as built in Gloucester in 1871, but not by Story. On this evidence, it is unlikely that Homer began this painting in 1871. For the Provincetown-owned schooner to be the subject, the painting would have had to be done in mid-February to capture that stage in the vessel's construction. Weather conditions at that time of year are seldom conducive to outdoor sketching and painting, nor do they offer the warm summer light which Homer so effectively conveyed" (Ronnberg 1996, pp. 216–17).

12. Ibid., p. 216.

DANIEL CHESTER FRENCH
24. *The May Queen*

1. For a concise overview of the Italian experience for American sculptors in this period, see especially Gerdts in Boston +, MFA 1992, pp. 66–93; see also Gerdts 1973.

2. For a review of French's career, see Richman in New York +, Metropolitan 1976–77.

3. Gerdts (in Boston +, MFA 1992) has identified nine American sculptors then working in Florence: Ball, Preston Powers, Pierce Connelly (c. 1840–?), Thomas Gould (1818–1881), Joel Hart (1810–1877), John Jackson (1825–1879), Larkin Mead (1835–1910), Richard Park (1832–after 1890), and William Turner (c. 1832–1917).

4. Richman 1974, p. 122, see also p. 123, no. 43, pl. 27.

5. Ibid., p. 122.

6. The sculpture is in the collection of Chesterwood, the home and stu-

dio of Daniel Chester French, in Stockbridge, Mass.

7. French's daughter incorrectly assumed that this was the portrait bust of Miss Mary Hayden, of New York State, executed in Florence in 1876; see Cresson 1947, p. 305. The Hayden bust is reproduced in Richman 1974, pl. 33, no. 48.

8. See Gerdts 1973, pp. 136–37.

9. The first version was carved in 1839 and countless replicas followed. See Crane 1972, p. 192.

10. French to W. O. Henshaw, Apr. 4, 1877, quoted in Richman 1974, p. 123.

11. See New York +, Metropolitan 1976–77, p. 6, fig. 3.

GEORGE INNESS
25. *Landscape*

1. When the Museum acquired the painting, its title was given as *New Jersey Landscape*, but Ireland 1965 records it simply as *Landscape* without suggestion of a specific site. The bill of sale (Museum files) of Apr. 20, 1960, from Shore Studio Galleries, Boston, to Frank L. Harrington lists the painting as "Landscape painting by George Inness . . . probably painted around Montclair N.J."

2. Curtis Ripley Smith was a retired automobile dealer from St. Albans, Vt., the son of Edward Curtis Smith (1854–1935), president of the Central Vermont Railroad Company and former governor of the state from 1898 to 1900 (obituary, *New York Times*, Apr. 27, 1963). The Museum's landscape was known to be in Curtis R. Smith's possession by 1931, when he consigned it to Knoedler's for sale (it was returned to him in 1933). Although it remains unconfirmed at this writing, it is possible that the painting formerly belonged to his father, a man of scholarly pursuits in addition to his political and business careers. If so, this would account for the approximately fifty-year lacuna in the painting's early provenance.

3. A catalogue raisonné of the work of George Inness is in preparation by Michael Quick, sponsored by the Frank and Katherine Martucci Endowment for the Arts.

4. For Inness's early training and career see Cikovsky in New York +, Metropolitan 1985, pp. 10–43. The present essay is indebted to this scholar's work, including Cikovsky 1971 and Cikovsky 1993, and espe-

cially to the assistance of Michael Quick, Project Director, Inness catalogue raisonné.

5. Cikovsky, 1971, pp. 28–31.

6. *New York Herald*, Aug. 22, 1894. Although Inness was in Paris in 1874, it is not known whether he saw the First Impressionist exhibition then or discovered the Impressionists later. (Cikovsky 1971, p. 44, adds, however, that Inness's later style and increased colorism may have owed something to the influence of the Impressionist palette.)

7. Gail Stavitsky, in Montclair + 1994, p. 9, describes Montclair during Inness's residency as a "rural township of four thousand residents . . . composed of farms, vast fields and large old orchards, which fired the artist's intense powers of observation, memory and imagination." She also states that Inness joined a "thriving art community" that over the years included Charles Parsons (1821–1910), Harry Fenn (1838/45–1911), Thomas Ball (1819–1911), Jonathan Scott Hartley (1845–1911), Thomas R. Manley (1853–1938) and Frederick Ballard Williams (1871–1956).

8. In a letter to the author (Sept. 18, 1996, Museum files), Michael Quick wrote: "We know that Inness, still residing in New York, painted in New Jersey during the summer of 1877. These paintings, which often have 'Pompton' in their titles, generally are river or lake scenes unlike [the Museum's landscape]."

9. Cikovsky, in Los Angeles +, 1985, p. 96 (notes on no. 10, *On the Delaware*, c. 1861–63; Ireland 1965, no. 231).

10. Regarding the issue of identifying the site of the Museum's painting, Quick wrote (letter cited in note 8 above): "Other paintings of 1877, such as Ireland 819, 820 and 821, have been identified as Medfield, Massachusetts, but do not bear a persuasive resemblance to the place as I know it. What is characteristic of these last-mentioned paintings is that they are quite consciously composed out of landscape elements made to fit into a geometrical order. My sense of [the Museum's painting] is that it is a synthetic, ideal composition, in which some may see a resemblance to Medfield, others to Leeds, and yet others to some part of New Jersey."

11. Ireland 1965, no. 291. Ireland lists a number of paintings that are specifically identified as "Leeds," a town off the Hudson River in the northern Catskill region. Almost all the Leeds or Catskill subjects catalogued by Ireland are dated between 1860 and 1870, although Leeds reappears in the title of a painting of 1883. It is interesting to note that another painting dated 1887, *The Red Oak*, a cloudy autumnal scene (Ireland 1965, no. 1242), is based on the same compositional format as the Museum's painting and its cognate, *Leeds, New York* (no. 291).

12. Telephone conversation with the author, Feb. 15, 1999.

13. Cikovsky, 1971, pp. 57–59; New York +, Metropolitan 1985, pp. 30–31. See also Quick in Montclair + 1994, pp. 29–32.

14. For a recent discussion of Inness's association with Swedenborgianism, see Promey 1994. She extends the critical knowledge of the artist's involvement with the Swedenborgian religion and its effect on his color theory as well as providing extensive bibliographical references to the literature on this topic.

15. See ibid., p. 47, for a description of Eaglewood and Inness's association with this community, established at Perth Amboy following the utopian Raritan Bay Union.

16. Ibid., p. 55.

17. Ibid., pp. 52–53.

WILLIAM MORRIS HUNT
26. *Niagara Falls*

1. Boston, MFA 1979, p. 79.

2. Knowlton 1899, p. 123.

3. Ibid., pp. 204–5.

4. See McKinsey 1985 and Buffalo + 1985 for the importance of Niagara Falls in the iconography of American art.

5. Buffalo + 1985, p. 73.

SAMUEL S. CARR
27. *Beach Scene*

1. The biographical information available at that time was the dates of the artist's birth (Oct. 15, 1837) and death (Feb. 25, 1908), the fact that he studied mechanical drawing at the Cooper Union in 1865, that he resided in Brooklyn with his sister and her family from at least 1870, that he had been president of the Brooklyn Art Club, that he had exhibited at the Brooklyn Art Association, and that he was a member of the local Masonic lodge.

2. This information was found in 1977 by Betsy B. Jones in the catalogue of the *Eighth Annual Artists' Exhibition* at the Gill Galleries, Springfield, Mass., in 1885, which stated that Carr was apprenticed in 1842, a date that must be a misprint.

3. For a discussion of this practice, see Northampton 1976 *Carr*, p. 7.

4. Reproduced in ibid., no. 4.

5. Blankenship 1982, p. 24.

6. Roy Blankenship, letter of Apr. 22, 1977 (Museum files).

7. Part of Coney Island, "Manhattan Beach, at the far eastern end of the Island, was the most exclusive and expensive section of the resort" (Morris 1951, p. 114).

JAMES MCNEILL WHISTLER
28. *Mrs. Lewis Jarvis (Ada Maud Vesey-Dawson Jarvis)*

1. In addition to the literature listed, there is an unidentified clipping (Museum files) by Alfred Vance Churchill, titled "New Portraits at the Hillyer Gallery."

2. Houfe 1973, p. 283.

3. Houfe (ibid., p. 284) reports that Whistler, upon his return from Venice in November 1880, went to the Toft and decorated the Jarvises' drawing room with a vividly colored ornamental frieze, described as "lovely gold and green; squares merging into each other."

4. Ibid., p. 283. The bath, now identified as a Chinese Soochow tub, remained with the Jarvis family.

5. According to Houfe, Whistler wrote to Mrs. Jarvis setting the appointment. Houfe discovered the letter and provided a copy for the Museum's object file.

6. Whistler to Mrs. Lewis Jarvis, Sept. 6, 1879 (copy, Museum files).

7. See the account of the commission in London 1994–95, pp. 140, 146–47.

8. Way 1912, p. 115.

9. John E. Jarvis to the director of the Smith College Museum of Art, Nov. 25, 1944 (Museum files).

JOHN SINGER SARGENT
29. *My Dining Room*

1. A catalogue raisonné of Sargent's work, *John Singer Sargent: The Complete Paintings*, is being prepared by Elaine Kilmurray and Richard Ormond. *The Early Portraits*, the first volume, was published in 1997 (New Haven: Yale University Press).

2. See, for instance, New York, Coe 1980; Hills in New York +, Whitney 1986–87.

3. The setting was identified by Richard Ormond, letter of July 11, 1983 (Museum files): "Recently going through pictures, etc. formerly belonging to Count William de Belleroche, son of the artist and friend of Sargent Albert de Belleroche, I came across a photograph of a painting by Albert de Belleroche which clearly shows the same room as *"My Dining Room."* The picture in question is in a London private collection [photograph in Museum files]. . . . Mr. Anderson who inherited Count William's property assured me that the latter had told him it represented Sargent's dining room in Paris. This could only be his studio at 33 [*sic*] Boulevard Berthier which he occupied c. 1883–86."

4. Charteris 1927, pp. 77–78.

RALPH ALBERT BLAKELOCK
30. *Outlet of a Mountain Lake*

1. The painting has been assigned University of Nebraska Blakelock inventory number 226.

2. Lloyd Goodrich in New York, Whitney 1947, p. 32.

3. New York, Lotos 1900 (gallery leaflet, New York Public Library clipping file); New York, National 1980–81, p. 152.

4. For a general discussion of Blakelock's techniques, see Goodrich in New York, Whitney 1947, p. 19.

5. Wyer 1916, p. xix.

DWIGHT WILLIAM TRYON
31. *The First Leaves*

1. An important unpublished manuscript catalogue is Linda Merrill, "Dwight William Tryon: Paintings, Pastels, Drawings," compiled in 1981 (Museum archives and Hillyer Art Library, Smith College); see no. 44, pp. 57–58.

2. Hartmann 1902, vol. 1, p. 128.

3. Dwight W. Tryon, "Charles-François Daubigny," in Van Dyke 1896, p. 157.

4. Tryon to Beulah Strong, associate professor of art, Smith College, July 15, 1923, Alfred Vance Churchill Papers, Smith College Archives.

5. Tryon to Charles Lang Freer, Apr. 18, 1897, Charles Lang Freer Papers, Freer Gallery of Art, Smithsonian Institution, Washington, D.C.; Tryon to Beulah Strong, Sept. 29, 1910, Dwight William Tryon Papers, Smith College Archives (typescript copy).

6. Tryon to Beulah Strong, Apr. 12, 1912, Churchill Papers, Smith College Archives.

7. White 1930, p. 150.

8. Tryon to Strong, Apr. 12, 1912 (see note 6 above).

9. Tryon to G. A. Williams, Apr. 11, 1916, Nelson C. White Papers, AAA.

10. Tryon to G. A. Williams, Nov. 12, 1916, Nelson C. White Papers, AAA.

11. Tryon to Strong, Apr. 12, 1912 (see note 6 above).

12. Tryon to Alfred Vance Churchill, May 8, 1924, Churchill Papers, Smith College Archives; White 1930, p. 150.

13. Tryon to Charles Lang Freer, May 20, 1889, Freer Papers, Freer Gallery of Art.

14. Tryon to Charles Lang Freer, Sept. 18, 1889, Freer Papers, Freer Gallery of Art.

WILLIAM MERRITT CHASE
32. Woman in Black

1. A memorandum (Museum files) states that Woman in Black may have been exhibited at the American Art Galleries, New York, on Apr. 17, 1890.

2. Amer Art 1905, p. 343.

3. Costume consultant Nancy Rexford indicates that "the dress is datable to 1889 and corresponds almost exactly to Ackerman's fashion plate for that year" (notes from a conversation with Linda Muehlig, June 9, 1986, and photocopy of the fashion plate, Museum files).

4. Akron 1982, p. 18.

5. Peat's checklist of Chase's known work (Indianapolis 1949) lists twenty-six paintings on small panels, almost all of them landscapes. The diminutive format of Woman in Black appears to be a rarity among Chase's portraits although not surprising given his proficiency with the more intimate media of watercolor and pastel.

EDWIN ROMANZO ELMER
33. Mourning Picture

1. The title was probably given to the picture about 1950 by Museum director Henry-Russell Hitchcock or curator Bartlett Cowdrey, perhaps with the help of Maud Elmer, niece of the artist. Eugene O'Neill's play Mourning Becomes Electra may have suggested it. When it was put on loan at the Museum that year, Hitchcock wrote to his friend James Thrall Soby, an authority on Surrealism and later author of monographs on Balthus and René Magritte: "Press Release: The Smith College Museum of Art announces the arrival on extended loan of 'Mourning Becomes Shelburne Falls,' one of two masterpieces by the Balthus of the Berkshires, the Magritte of the Pioneer Valley, the late Edwin Romanzo (sic!) Elmer..." (Aug. 24, 1950, copy, Museum files).

2. Greenfield Gazette and Courier, Nov. 15, 1890.

3. Maud Elmer retired as supervisor of art for the Seattle Public Schools in 1945 and returned to Massachusetts, where she worked to bring recognition to her late uncle, whose work she knew was of a special order. In the spring of 1950 the Smith College Museum of Art had an exhibition of the work of John F. Peto (cat. 42) with a catalogue text by Alfred Frankenstein, who was then working on After the Hunt, his book that disentangled the works of Peto and William M. Harnett. Frankenstein gave a lecture that Miss Elmer attended, bringing with her photographs of Mourning Picture and A Lady of Baptist Corner (cat. 36). The Museum immediately began to plan an Elmer exhibition, with a catalogue text by Frankenstein, which became the first published study of Elmer's work (Frankenstein 1952).

4. Mrs. Thomas Farrer to Mrs. Gordon L. Ford (Gordon L. Ford Collection, AAA). Although the letter is headed only "February 15, Ashfield," internal evidence makes it clear that the year is 1866.

5. Elmer 1964–65, p. 128.

6. Ibid., p. 124.

7. Ibid., pp. 136–37.

8. "Mourning Picture" in Gelpi and Gelpi 1975, pp. 31–32.

9. Lemardeley-Cunci 1993, pp. 129–47.

10. Mourning Picture was the visual source for one of twelve piano pieces composed in 1975 by Seymour Bernstein for his work American Pictures at an Exhibition. Each of the twelve paintings was also the subject of a poem by Owen Lewis.

11. A Christie's (London) auction on Oct. 29, 1980, included a work described as "J. L. T. 'The York Family at Home, Pepperhill, Massachusetts'" (lot 127). The title is taken from a work by Joseph H. Davis in the Abby Aldrich Rockefeller Folk Art Center, but the painting is a free copy of Mourning Picture.

ALBERT PINKHAM RYDER
34. Perrette

1. In unpublished notes, 1948 (Museum files), Lloyd Goodrich noted that he could find no documentation or proof that Seelye had purchased Perrette from Ryder; however, he reports that Alfred Vance Churchill (the first director of the Museum) had been told that Seelye purchased the painting from the artist for $125.

2. Misprint for 29.

3. A firm ending date is established by the discussion of the painting in Eckford 1890.

4. Homer and Goodrich 1989, p. 68.

5. In Washington +, National Museum 1990, p. 214, Eleanor L. Jones argues that the subject of A Country Girl probably derives from an English or Scottish ballad and relates (pp. 243–44) The Little Maid of Acadie to Longfellow's Evangeline: A Tale of Acadie, arguing that only recently has the title sometimes been altered to read The Little Maid of Arcady.

6. See "Ryder and the Decorative Movement," in Washington +, National Museum 1990, pp. 42–55.

7. Lane 1939, p. 9.

8. Clarke 1892.

9. Goodrich, unpublished notes, 1948 (Museum files), on x-rays taken in 1947 at the Whitney Museum of American Art, New York.

10. Mumford 1931, p. 226.

11. Goodrich, unpublished notes, 1948 (Museum files).

12. Homer and Goodrich 1989, p. 148.

13. In Washington +, National Museum 1990 (pp. 85–87, 239–40), Elizabeth Broun argues that the source is Thomas Percy's Reliques of Ancient English Poetry (1765).

CHILDE HASSAM
35. Cab Stand at Night, Madison Square

1. Formerly called Street Scene, Cab Stand, the Museum's painting may also once have been titled Electric Light, as suggested by the pencil inscription on the back of the panel support. If so, it may be the work exhibited at Doll and Richards Gallery, Boston, in 1893 as Effect of Electric Light on the Snow (Madison Square). A painting with the title Electric Light was shown as early as April and May 1891 at the Society of American Artists (Kathleen Burnside, Hassam catalogue raisonné project, Hirschl and Adler Galleries, New York, letter of Sept. 1, 1982 [Museum files]).

2. A catalogue raisonné is in preparation by Stuart Feld et al. (see note 1).

3. Adams 1938, p. 6.

4. Noted in Fort 1993, p. ix.

5. Van Rensselaer 1893, p. 15.

6. Ives 1892, p. 116.

7. Ibid.

EDWIN ROMANZO ELMER
36. A Lady of Baptist Corner, Ashfield, Massachusetts (the Artist's Wife)

1. The title was given to the painting by its owner of nearly forty years, E. Porter Dickinson. Though it was probably painted when the Elmers were living in Shelburne Falls, Dickinson first saw the picture in the house of Emeline Elmer Elmer in Baptist Corner. Elmers had occupied farms in that section of Ashfield from 1773, when the artist's great-grandfather bought lands there, until at least 1939.

2. Dickinson remembered bringing the picture to the Museum in June 1940 and believed it had been put on exhibition then. The Museum's records, however, do not list the picture as a loan at that time, but it might have been an impromptu addition to the exhibition Aspects of Twentieth-Century American Painting (June 14–22, 1940).

3. Dickinson had gone to Emeline Elmer's house with a couple of Mount Holyoke College alumnae who wanted to mine her memories about her girlhood years in the house of the college's founder, Mary Lyon, in Buckland. The Elmers had owned and lived in that house from 1851 to 1863. It was torn down shortly after they left, but in 1891

Elmer painted, from memory, one of his finest oils, *The Mary Lyon Birthplace*, which is in the Museum's collection (checklist no. 21). After the turn of the century he made a number of sepia pastels of it for sale to alumnae. The Elmers were distantly related to Mary Lyon.

4. Washington, Corcoran 1950.

5. *Time* 1950.

6. Elmer 1964–65, p. 136.

7. Ibid., p. 128.

8. Recollection of Mrs. Robert Luce, a great-niece of Mary Elmer, in conversation with the author, c. 1981.

9. Only one example of the machine has survived. It is in the collection of the Edwin Smith Historical Museum, Westfield Athenaeum, Westfield, Mass., and is illustrated in Jones 1983, fig. 67.

10. James 1866 [1919], pp. 50–51, quoted in Baur 1954.

CHILDE HASSAM
37. *White Island Light, Isles of Shoals, at Sundown*

1. Not exhibited at the Chicago venue.

2. A catalogue raisonné of Hassam's work is being prepared by Stuart Feld et al. (Hirschl and Adler Galleries, New York).

3. The Isles of Shoals and Hassam's interpretation of that site are discussed in detail by David Park Curry in New Haven + 1990, who estimates (p. 13) that approximately 10 percent of Hassam's work, nearly four hundred images, is devoted to Isles subjects.

4. Thaxter 1873, p. 18.

5. *Harper's* 1874, p. 666.

6. Thaxter describes this streaked effect, particularly pronounced in autumn: "The slanting light at sunrise and sunset makes a wonderful glory across [Appledore]. The sky deepens its blue; beneath it the brilliant sea glows into violet, and flashes into splendid purple where the 'tide-rip,' or eddying winds, make long streaks across its surface" (Thaxter 1873, p. 93).

7. These opportunities are discussed by Curry in New Haven + 1990, p. 199 n. 77.

AUGUSTUS SAINT-GAUDENS
38. *Diana of the Tower*

1. The accession number was retroactively assigned and incorrectly

represents the actual date of acquisition in 1915.

2. Hind 1908, p. xix.

3. See John Dryfhout's detailed accounts of the evolution of the *Diana* in Cambridge 1975–76, pp. 201–14, and in Dryfhout 1982, pp. 205–10.

4. The reformed *Diana*, which remained in place until 1925 when Madison Square Garden was torn down, is now preserved in the Philadelphia Museum of Art.

5. Dryfhout 1982, p. 34.

6. Cortissoz 1893, p. 1124.

7. Saint-Gaudens wrote to Doll and Richards Gallery in 1899 describing his latest cast and asking that the price of his replicas be raised to reflect increased production costs: "As you will see I have had a new pedestal for the small Dianas and an entirely new model. This has added a good deal to the expense of production and if you think it could be done I should like to have the price raised to $175.00" (Cambridge 1975–76, p. 209).

8. Saint-Gaudens to William A. Coffin. Nov. 2, 1901, quoted in Dryfhout 1982, p. 35.

ALFRED HENRY MAURER
39. *Le Bal Bullier*

1. The painting was formerly dated c. 1901–4 on stylistic grounds. The new date is based primarily on its early exhibition history.

2. Both the exact location and exact dates are unknown.

3. For a particularly helpful chronology of the period, see New York, MoMA 1985–86, pp. 255 ff.

4. For information on Parisian dance halls and other French entertainments, see Rearick 1985 and New York, MoMA 1985–86.

5. The major sources for Maurer include Minneapolis + 1949; McCausland 1951; Washington +, National Collection 1973; New York, Danenberg 1973; and Madormo 1983. No study of Maurer should ignore the Elizabeth McCausland Papers (AAA).

6. McCausland 1951, p. 52. This source documents Maurer's various Parisian studios, including their locations (see pp. 53, 70).

7. The Bal Bullier was a subject for a number of artists besides Maurer, e.g., the Americans Maurice Prendergast (1859–1924), Frederick

Carl Frieseke (1874–1939), Glackens (cat. 44), and Henri and the French artists Pierre Bonnard (1867–1947), Jean-Emile LaBoureur (1877–1943), and Sonia Delaunay (1885–1979). The entertainment center on the Left Bank where the Bal Bullier was located should be distinguished from Montmartre, to the north, home of the famed Moulin Rouge, Moulin de la Galette, Folies Bergères, and Le Chat Noir. French artists tended to be drawn more to the Montmartre establishments than the Americans were.

8. Known initially as La Chartreuse in the 1840s under the ownership of M. Carnaud, the popular *bal* became Closerie des Lilas in 1847 under its new owner, François Bullier, who also owned Le Bal du Prado. In 1859, under his nephew Théodore Bullier's jurisdiction, it became Bal Bullier or Jardin Bullier. For further historical facts regarding the dance hall, see Samesate 1861; Mahalin c. 1863; Day 1903, pp. 110–13; *Un Bal* 1908.

9. Day 1903, p. 112.

10. Perlman 1991, pp. 34–35.

11. "He painted at night also, sketching street scenes. To do so he laid out a simple palette so that he would not be deceived by the illusions of night lighting. Then he sat in cafes and painted directly from nature.... A few of Maurer's night sketches have survived. He often used to invite Mrs. E. L. (Fra Dinwiddie) Dana to accompany him on the expeditions" (McCausland 1951, p. 71). No sketches are known for *Le Bal Bullier*.

12. Maurer probably returned to America in late November or early December 1900 to accept the Inness Prize from the Salmagundi Club (*New York Sun*, Nov. 8, 1901, p. 7). He then remained on this side of the Atlantic, testing the American critical reaction to his work for another year and a half. During this time he collected several more awards, including the prestigious Gold Medal from the *Sixth Annual International Exhibition* at the Carnegie Institute in Nov. 1901 for *An Arrangement*. Interest in his work was undoubtedly created by the acceptance of *The Fortune Teller* and *The Red Shawl* in the Paris spring Salons of 1899 and 1900, respectively. To encourage and focus critical attention on his work, Maurer set up a hectic and sometimes overlapping exhibition schedule for his paintings, including venues in New

York, Philadelphia, Washington, D.C., Worcester, Buffalo, Cincinnati, Pittsburgh, and Chicago, until his return to Paris in May 1902.

13. By World War I Maurer's artistic interests had shifted from his Whistlerian figurative compositions to Fauvist and Cubist subjects and techniques. When he left Paris in 1914 to avoid the political turmoil, it is likely that *Le Bal Bullier* was placed in storage or given to a friend, where it remained until 1934. Following the artist's death that year, the painting was exhibited in Paris and then Los Angeles under the ownership of the Maison Lucien Lefebvre Foinet (see the introduction to Los Angeles 1934). McCausland (1951, p. 64) notes that "most of [his early pictures] were lost when hundreds of his paintings vanished in Paris about 1925" or before. In 1973 Bernard Danenberg was credited with the recovery of a number of these works, which were exhibited in his New York gallery.

14. Richard Thomson makes an interesting case for other contemporary uses/exchanges of this basic compositional format. See London + 1991–92, pp. 244–46.

15. This title was used twice, at Paris 1903 and (in English) at Chicago 1903.

16. See the sources cited in note 8, above.

ROCKWELL KENT
40. *Dublin Pond*

1. Following a review of this exhibition, a notice in the *New York Art Bulletin* (vol. 3, no. 25, Apr. 23, 1904, unpag.) cites Smith College President Seelye's acquisition of "two pictures, Couse's 'Under the Trees' and Rockwell Kent's 'Evening,'" from the show. Regarding the acquisition of the Kent painting by the Museum and the subsequent change of title, see notes 9 and 12 below.

2. The painting was not shown at the Columbus venue.

3. In 1953 Kent was summoned before the U.S. Senate Permanent Subcommittee on Investigations after one of his books had been found in a government-sponsored overseas library. He was already considered a dangerous radical. Though he later maintained that he was a Socialist, not a Communist, he refused to answer when Senator Joseph McCarthy asked him if he was a Communist.

4. In his autobiography (Kent 1955, pp. 109–10), Kent wrote: "My association with the Thayers remains one of the richest cultural experiences of my whole life. Vastly enlarging my fields of interest, it gave me true standards for the evaluation of the arts and of life, while at the same time sharpening my critical appreciation of both."

5. Ibid., p. 110.

6. Thayer to George deForest Brush, Jan. 6, 1917, quoted by Doreen Bolger Burke in Burke 1980, p. 102.

7. Traxel 1980, pp. 20–21: "If one looks . . . at his early paintings like *Dublin Pond* or *Winter (Berkshire)* it can be seen that they show the same somber dark hues used by Henri and other contemporary Realists."

8. Kent 1955, pp. 99–100.

9. Richard West (in Santa Barbara + 1985, p. 28) first pointed out that *Dublin Pond* was the picture called *Evening* shown in 1904 and not, as previously supposed, the one titled *Pond*, shown in 1903. The Society shows were held in the spring, and *Dublin Pond* was not painted until the summer of 1903.

10. Kent 1955, p. 111. Actually Kent did not show at the National Academy of Design for the first time until the following year.

11. *New York Times*, Apr. 3, 1904, p. 9, and Apr. 28, 1904, p. 10. In the former issue, the reviewer, whose memory of the picture was a little hazy, wrote: "The Shaw Fund of $1,500 has not been apportioned. . . . Should [Mr. Shaw] wish to encourage one of the beginners who shows two excellent landscapes this year, there is in the Vanderbilt Gallery at no. 292 an 'Evening' view of lake or wide river, with shoulder of hill reflected in the still water and moon turning from yellow to white, which calls attention by its large composition and color feeling. It is by Rockwell Kent."

12. The circumstances of the Museum's purchase of an early work by a young, still untried artist are not recorded, but it is possible that Chase or Thayer (both already represented in the College's growing collection of American art) called it to President Seelye's attention. Both artists were in the 1903 Society of American Artists exhibition, and Chase was in the 1904 show. He was also on the Selections Committee, as was Dwight W. Tryon (cat. 31),

then teaching at Smith and advising Seelye on acquisitions.

THOMAS EAKINS
41. Edith Mahon

1. Recently discovered biographical information reveals that the sitter's maiden name was Mahon, so that the omission of "Mrs." (long used in the title) seems called for. She was born Edith Kate Mahon in London in 1863. Her father was a journeyman "paper stainer." In 1885, at the age of twenty-one, she married a bank clerk named John Smith. In the 1910 Philadelphia census, the only one in which she has been found, she is listed as Edith K. Mahon, divorcée, mother of three children of whom two were then living. She had come to America in 1897. It is not known where the divorce took place or indeed if it took place at all. When she died in 1923 in London, to which she had evidently returned not long before, her brother identified her on the death certificate as the widow of John Smith.

2. Morris and Minnie L. Pancoast opened galleries in Wellesley and Rockport, Mass., among other places, after leaving Philadelphia about 1919. She had been a singer, and Edith Mahon was a friend who sometimes accompanied her in concerts. This friendship probably accounts for the decision to give the picture to the Pancoasts for sale. Although Mrs. Eakins speculates that the picture may have passed through several hands before the Museum acquired it (Susan Macdowell Eakins to Alfred Vance Churchill, Apr. 27, 1931, Museum files), Morris Pancoast states (letter, Apr. 26, 1931, Museum files): "We acquired it from Mrs. Mahon personally when she disposed of all her things and went back to England to live—a few months before her death in 1923 or 1924 I think it was." He believed the portrait was painted "not as a commission but as a present from one artist to another."

3. Letter to his father, quoted in Hendricks 1974 *Eakins*, p. 52.

4. Ibid. p. 255. Hendricks does not document this quotation, but it seems likely that the source was not John but Leroy Ireland, a Philadelphia artist, art dealer, author, and sometime conservator of works belonging to Eakins, among others. He first met Eakins while taking life classes as a young man. About 1910 Mrs. Eakins painted a portrait of him.

5. Minnie L. Pancoast to Alfred Vance Churchill, Jan. 7, 1931 (Museum files).

6. Susan Macdowell Eakins to Alfred Vance Churchill, Apr. 27, 1931 (Museum files).

7. Ibid. The passage reads "On an occasion [*sic*], at which I was present, Madame Schumann Heink was engaged to sing with the Phila. Ochestra [*sic*], some unfortunate happening made it necessary to use a piano, necessitating finding an accompanist. I remember the pleasure it gave us, to see Mrs. Mahon appear on the stage following the great singer. Mrs. Mahon had never played these songs Madame Heink was engaged to sing that night. So accurate and sympathetic was her playing, Madame Heink was delighted and declared she now knew where to find a perfect accompanist." The "unfortunate happening" was a rebellion by some orchestra members against a temporary replacement for their dying conductor. At a Saturday rehearsal concert on Feb. 22, 1907, as Schumann-Heink was singing the Waltraute scene from *Götterdämmerung*, some instrumentalists deliberately misplayed the score, so noticeably that the singer was completely rattled and even joined in the conducting to try to bring order. For the formal concert the next day, she substituted some Schubert songs with piano accompaniment. Although Mrs. Mahon is not named in the rather extensive front-page coverage of the scandal and its denouement, there was no other such occurrence in the orchestra's history involving Schumann-Heink and the last-minute need for a skilled accompanist. Edith Mahon placed an ad for her services in the orchestra's programs for the following season, 1907–8 (fig. 30), and for that season only.

8. Celeste Heckscher Troth to Patricia Milne-Henderson, June 2, 1962 (Museum files).

9. David Lubin in London 1993–94, p. 164.

10. Schendler 1967, p. 226.

11. Thirteenth Census of the United States: 1910—Population. Also see note 1 above.

12. Letter in note 6 above.

13. Letter in note 8 above.

JOHN FREDERICK PETO
42. Discarded Treasures

1. *Discarded Treasures* was removed from the exhibition on Aug. 11 for another exhibition (Williamstown 1983).

2. Sheldon Keck to Mary Bartlett Cowdrey, Jan. 19, 1950 (Museum files): "Would you let Mr. Hitchcock [Henry-Russell Hitchcock, Museum director] know that we only found traces of what I believe was once a Peto signature on the painting. . . . There is no doubt in my mind . . . that the Harnett signature is not only later, but half of it extends over the repaint which covered an abraded area in the original paint. It was in this shaded area that the traces were found."

3. Notices of the Museum's acquisition of the painting appeared in several major art journals; see especially the report in the *New York Times* for Sunday, Apr. 23, 1939: "It is gratifying, though not surprising, to learn that the little box of red stars had at once to be opened. These sales, as I write, have been announced: To the Smith College Museum of Art, 'Discarded Treasures'; 'Old Scraps,' as a gift to the Museum of Modern Art's permanent collection; acquired by Nelson Rockefeller and Alfred Barr Jr., respectively, still-lifes entitled 'With the New York Times' and 'Old Books.'"

4. Frankenstein 1953, p. 17.

5. Ibid., p. 101.

6. Ibid.

7. Best 1939, p. 18.

WILLARD LEROY METCALF
43. Willows in March

1. "Since the painting was exhibited in March 1911, it is difficult to see how it would have been painted that month. It is probable that Metcalf painted it in late January or in February, during his honeymoon with Henriette in Cornish, or a year earlier at Falls Village, Conn." (Elizabeth G. de Veer, notes enclosed in a letter, Mar. 5, 1986, Museum files).

2. According to ibid.: "F. W. Bayley, Boston dealer, secured consignment [of *Willows in March*] after [the] Copley show, selling it to W. S. Schuster, E. Douglas, Mass. in February 1913—$1,500 (artist's cash book)." Metcalf's cash book, which he began keeping in 1905, is with the artist's papers (now presumably held

by the Metcalf catalogue raisonné project; see note 3 below).

3. There were numerous early reviews and newspaper references to *Willows in March:* Hoeber 1911, p. 110; *Brooklyn Daily Eagle*, vol. 72, no. 79 (Mar. 21, 1911), p. 11; Cary 1911, p. 6; Townshend 1911, p. 2; Dorr 1911, p. M7; Monroe 1911, pt. 2, p. 6; Oliver 1911, sec. 8, p. 6; *Boston Evening Transcript*, vol. 83, no. 26 (Jan. 30, 1912), p. 11; Nutting 1912, p. 5; *Boston Evening Transcript*, vol. 83, no. 175 (July 25, 1912), p. 12. A catalogue raisonné of Metcalf's works by Ira Spanierman, Bruce W. Chambers, William H. Gerdts, and Elizabeth G. de Veer is to be published by Spanierman.

4. Walter Jack Duncan in Washington, Corcoran 1925, p. 4.

5. The relatively rare paintings of winter scenes before the third quarter of the nineteenth century were generally marked by figural and anecdotal content. Numerous turn-of-the-century artists, however, discovered that winter subjects offered aesthetic possibilities. See Deborah Chotner in Washington +, National Gallery 1989–90, pp. 71–85.

6. Details of Metcalf's education and career can be found in De Veer and Boyle 1987, which has a comprehensive bibliography. Recent sources with significant information on Metcalf are New York, Spanierman 1990, pp. 50–51, 157, 182; New York +, Metropolitan 1994, pp. 63–66, 353–54; New York, Spanierman 1995–96.

7. See Giverny 1992, pp. 45–46.

8. The Ten (from their first exhibition in 1898) include: Frank W. Benson, Joseph R. De Camp (1858–1923), Thomas Wilmer Dewing (cat. 47), Childe Hassam (cats. 35, 37), Metcalf, Robert Reid (1862–1929), Edward Simmons (1852–1931), Edmund Tarbell (1862–1938), John Henry Twachtman, and J. Alden Weir (1852–1919). After Twachtman died in 1902, he was replaced by William Merritt Chase (cat. 32), who first exhibited with the group in 1906. For information on the Ten and Metcalf's association with the group, see New York, Spanierman 1990.

9. For more information on the Cornish art colony and Metcalf's connection with it between 1909 and 1920, see De Veer 1984 and John H. Dryfhout in Keene + 1985.

10. For example, Joseph Edgar Chamberlin in the *New York Evening Mail* (Mar. 22, 1911, p. 8), and a critic in the *New York Times Magazine* (Mar. 26, 1911, p. 15). Of the opposite opinion were James Huneker, in the *New York Sun* (Mar. 22, 1911, p. 6), and Royal Cortissoz, who wrote in the *New York Tribune* (Mar. 21, 1911, p. 7) that *Willows in March* represented: "one of those works of sheer loveliness which point to a moment of creative force. The still air of the scene, its pure sentiment, Mr. Metcalf has brought into his canvas very subtly and yet with what we can only describe as a sort of wholesome directness. It is an honest piece of painting, fine in spirit. There is, indeed, nothing finer in the show, and there is nothing quite so rich in the truth of nature."

11. Metcalf's most significant snowscapes, over twenty painted between 1906 and 1923, include *The First Snow (No. 2)* (1906, Museum of Fine Arts, Boston); *The White Veil (No. 1)* (Detroit Institute of Arts) and *Icebound* (Art Institute of Chicago), products of his first Cornish visit in 1909; and *Winter Afternoon (No. 3)* (1923, National Museum of American Art, Washington, D.C.). In 1911 alone Metcalf painted five important winter scenes documenting his second Cornish visit.

12. Monet painted snowscapes throughout his career, beginning in the mid-1860s with works such as *Cart on the Snowy Road at Honfleur* (1865, Musée d'Orsay, Paris). Snowscapes continued as a subject throughout the period the artist spent along the Seine at Argenteuil, Pontoise, and Vétheuil. From the 1890s there were numerous opportunities for Americans to see paintings by Monet, including his snowscapes, in art galleries and exhibition halls in this country. A large Monet exhibition was hosted by the Museum of Fine Arts, Boston, in 1911, the first such showing at an American museum. Individual snowscape paintings by Monet are recorded as being exhibited at the St. Botolph Club, Boston, in 1892 and 1899, the Lotos Club, New York, in 1899, the Durand-Ruel Gallery, New York, in 1902, and Copley Hall, Boston, in 1905.

WILLIAM GLACKENS
44. *Bathers, Bellport, No. 1*

1. When the museum acquired this painting in 1990 as the gift of Ira Glackens, he referred to it in correspondence as *Bathers at Bellport*. However, the painting was shown in 1939 under the title *Bathers, Bellport,* *No. 1* (New York, Whitney 1938–39; Pittsburgh 1939). In Ira Glackens's card catalogue of works by his father, the Museum's painting seems to be the canvas listed as no. 22: "H 26 × 32 / 22 / BATHERS — BELLPORT #1 / Black figures in water — breakwater stretching from left / Date: 1913 / Signed FLR" (with handwritten notation "Portland 8/9/67"). The catalogue is included in the William and Ira Glackens Papers, 1902–90, AAA, reels 4708–10. The designation of this canvas as "no. 1" is somewhat puzzling since this was not the first of the artist's many Bellport paintings, nor does it appear to have a cognate among the other paintings in the series in terms of its composition or the particular features of the small stretch of beach depicted. Carole Pesner, director of the Kraushaar Galleries, New York (telephone conversation with the author, Oct. 8, 1996), has suggested that "no. 1" may have been added by either Ira Glackens or Antoinette Kraushaar with the idea of differentiating the painting from other Bellport bather scenes; however, none of the other Bellport pictures appears to have such sequential numbers. She identified the reference to "Portland" in Ira Glackens's card catalogue as a storage notation.

2. Wattenmaker 1988 is a principal study of the artist's Bellport paintings.

3. Glackens 1957, p. 170.

4. Gerdts 1996, p. 109.

5. Ira Glackens in Washington, National Collection 1972, unpag.

6. For a discussion of the Eight and the New Generation of American Impressionists, see Gerdts 1984, pp. 275–99.

7. See ibid., pp. 280–81; Gerdts 1996, p. 109.

8. Gerdts 1984, p. 281.

9. See New York +, Metropolitan 1994, pp. 102–16, for a discussion of the development of Long Island as an artistic subject. See Pisano 1985 for a survey of over sixty artists, including Glackens (p. 154), who depicted Long Island.

10. New York +, Metropolitan 1994, pp. 105–6; for a discussion of nineteenth-century artists who painted in the Hamptons, see pp. 105–16.

11. Ibid., pp. 117–22.

12. Glackens 1957, p. 170.

13. William Glackens and Albert C. Barnes (1872–1951) formed a friendship and collecting partnership, in which the artist advised the physician and scouted for additions to what would become one of the most important private collections in the United States. They shared an admiration for Renoir; Glackens was instrumental in Barnes's acquisition of his first Renoir painting in 1912 (Glackens 1957, pp. 158–59). The Barnes Foundation in Merion, Pa., is the single greatest repository of paintings by the Impressionist master (see Barnes and Mazia 1935).

14. Glackens 1957, p. 177. The family had rented the Petty cottage on Bellport Avenue and spent the summers of 1912 through 1915 at the Carman cottage. They returned to the Carman cottage in 1916 and moved from there to the Cook house in Brookhaven to escape the epidemic (Wattenmaker 1988, p. 91 n.1).

15. The author is grateful to Rita Sanders for the information cited here from her letter of June 10, 1996 (Museum files), in which she identifies the site, the pier, and other structures depicted in the Museum's canvas.

16. Sanders to the author (see note 15 above), quoting Emily Czaja, village historian.

17. Sanders to the author (see note 15 above) notes that the pier, reviewing stand, and gazebo are also visible in *Bathers at Bellport* (c. 1912, Orlando Museum of Art, Orlando, Fla.) and that the gazebo appears in the distance in *Bath House, Bellport* (1914, Sotheby's, New York, sale, Nov. 30, 1989, lot 220) and *Summer Day, Bellport, Long Island* (1912, Mitchell Museum, Mount Vernon, Ill.).

PAUL MANSHIP
45. *Centaur and Dryad*

1. An asterisk indicates that the Museum's cast is reproduced; other sources reproduce or refer to other casts of *Centaur and Dryad*.

2. See the Jan. 1914 issue of *Metropolitan Magazine* for the original spread.

3. *New York Tribune*, Jan. 21, 1914, p. 5. Other accounts record the ensuing debate and the progress of the lawsuit brought by *Metropolitan Magazine* against the postmaster, e.g., "The Blushing Post-Office and the Fine Arts," *Metropolitan Magazine*, vol. 39 (Mar. 1914), p. 6; "Sues Postmaster Morgan," *New York Times*, Mar. 3, 1914, p. 8; and

"Postmaster Files Answer," *New York Times,* May 1, 1914, p. 5.

4. Manship 1989, p. 52.

5. Transcription of a conversation between Seelye and Alfred Vance Churchill, Nov. 8, 1915 (Museum files).

6. The most thorough study of Manship's ancient sources is Rather 1984; for the cultural context of archaism in modern American art, see Rather 1993.

7. Another 1912 photograph shows the finished plaster of just the figure group in his Rome studio, and one taken in his New York studio in 1913 shows the figure group cast in bronze atop a plaster base (reproduced in Manship 1989, pp. 36, 49).

8. Reproduced in Manship 1989, pl. 40.

9. Conversation with John Manship, Aug. 10, 1993.

10. Manship to Churchill, Mar. 27, 1915 (Museum files). At the time of the letter Churchill was chair of the History and Interpretation of Art at Smith College. He also oversaw the art collection and in 1919 was appointed director of the Museum.

11. Manship to Churchill, May 12, 1915 (Museum files).

ELIE NADELMAN

46. Resting Stag

1. Mina Stein Kirstein Curtiss, an author on the fringes of the Bloomsbury group, editor, translator, and teacher, was the older sister of Lincoln Edward Kirstein (1907–1995). Co-founder, with George Balanchine, of the New York City Ballet, Lincoln Kirstein was a man of protean talents. A distinguished author, he was an authority on the work of Nadelman, among other artists.

2. It is not known which cast(s) of *Resting Stag* were shown in the exhibition *A Small Collection of Contemporary Art in America* at Scott and Fowles Gallery, New York, in November 1917 (no. 16) and in the exhibition *Allies of Sculpture,* roof garden of the Ritz-Carlton Hotel, New York (Dec. 4, 1917–Jan. 5, 1918), and they are therefore not listed as part of the exhibition history of the Museum's cast. The sculpture has also been exhibited and referred to as *Resting Deer.*

3. It is sometimes unclear in the literature which cast of the *Resting Stag* is referred to or reproduced; the literature here includes general references to *Resting Stag* as well as to the Museum's cast.

4. Nadelman was "the first of [the European artists and scholars] to come to America after the war began, and his presence here was immediately felt by his confrères" (Birnbaum 1915, p. LIII). The primary published source on Nadelman is Kirstein 1973, while the most significant exhibitions to date are New York +, MoMA 1948 and New York +, Whitney 1975. Important unpublished sources on the artist include the Nadelman Scrapbooks at the Museum of Modern Art, New York, and the Nadelman files at the Whitney Museum of American Art, New York.

5. The Steins were among the first in the Parisian art world to recognize Nadelman's talent; they owned a number of his early drawings as well as a small plaster female nude (New York +, MoMA 1948, p. 10). Nadelman was also the subject of one of Gertrude Stein's "portraits," written in 1911 and included in her unpublished "Making of Americans."

6. New York +, MoMA 1948, p. 7.

7. Nadelman always felt that he, not Picasso, was the innovator of abstract form and that in the development of modern sculpture his "pure plastic art" was more significant and meaningful than Cubism in revolutionizing the art of our time; indeed, Nadelman may have been the only artist of his time to analyze abstract form consciously, as opposed to experimenting with it visually. He wrote: "This principle discovered by me was that of Abstract Forms in Plastic Art, but I did not depart from nature, I merely interpreted Nature through Abstract Form, and which I introduced into my sculpture and drawings Plastic beauty entirely lacking in the plastic art of our times before this discovery" (Nadelman 1925, p. 148).

8. Nadelman 1910, p. 41. This was an explanation of a group of his drawings that were to have been exhibited at Stieglitz's New York gallery in 1910; their actual showing was delayed until the Armory Show in 1913 because of a conflicting show in London.

9. As Nadelman stated: "I employ no other line than the curve, which possesses freshness and force. I compose these curves so as to bring them in accord or in apposition to one another. In that way I obtain the life of form, ie. [*sic*], harmony" (Nadelman 1910, p. 41).

10. New York +, MoMA 1948, p. 27.

11. He must also have been affected by the flourishing Jugendstil expressions of Aubrey Beardsley (1872–1898) and others on the same occasion (New York +, MoMA 1948, p. 7). For a more recent discussion of these and other influences on Nadelman at the time, see New York, Salander 1997, p. 8. The artist's early introduction to the Germanic folk arts, as well as examples from his native Polish culture, undoubtedly also later influenced Nadelman's dedication to folk art and led to his formation, between 1923 and 1928, of a large collection of such works, considered to be the first of its kind in America. Nadelman and his wife, the former Mrs. Joseph A. Flannery, were forced to disperse their "museum" in the mid-1930s, but ultimately parts of it were to form the basis of the Museum of American Folk Art in New York. See MoMA 1948, p. 52, and New York +, Whitney 1975, p. 15.

12. As noted in New York +, Whitney 1975, p. 16, "Nadelman rarely dated his work and kept no records."

13. *Le Jeune Cerf* is the same or very similar to the sculpture now known as *Doe with Lifted Leg* (which is also called *Standing Fawn).* Whether *Le Cerf* was also a standing deer, and if it is, in fact, the work currently identified as *Standing Buck* (c. 1915, bronze, Kirstein 1973, p. 305, no. 187) is not clear.

14. "Blue-Haired Figures out in Light Again; Nadelman's Statuettes Back in Their Place in Ritz-Carlton Sculpture Show," *New York World,* Dec. 20, 1917, p. 9. Nadelman's other entries, plaster caricatures of unnamed society figures, were the subject of intense public and critical debate. Interestingly, Nadelman considered the caricatures "better embodiments of true art" than his *Resting Deer* (ibid.). They represented a new and probably more challenging artistic direction for him, demonstrating the increased influence of American folk art, which he continued to develop in a variety of media through the 1920s. Documentation of the public debate, the temporary removal of Nadelman's entries, and Nadelman's response can be found in the Nadelman Scrapbook microfiche at the Museum of Modern Art Library, New York.

15. In 1917 Nadelman set up an enlarged studio-shop, staffed with three assistants, including Albert Boni, his *practicien* from Paris, for the purpose of producing editions of up to six wood or bronze figures. See New York, Salander 1997, p. 28. A letter of Dec. 17, 1957, from Dorothy C. Miller to Lincoln Kirstein (Museum of Modern Art, Painting and Sculpture Department, Nadelman file) states that Mrs. Nadelman reserved the right to have posthumous casts made of her husband's sculptures.

16. Other casts of *Resting Stag* are in the collections of Brookgreen Gardens (South Carolina), the Brooklyn Museum of Art, Detroit Institute of Arts, Honolulu Academy of Arts, Philadelphia Museum of Art, and the Dr. Milton J. Reisbeck Living Trust.

17. As early as 1919 the Detroit Institute of Arts purchased *Resting Stag* and *Wounded Stag* as a pair; the Honolulu Academy of Arts also owns a pair, acquired by gift in 1957. New York +, Whitney 1975 featured the stag sculptures as well as other pairs. Both stags were included in Washington, National Collection 1965–66. Both Kirstein (1973, no. 190) and Baur (notes in Nadelman file, Whitney Museum of American Art, N.Y.) list an additional, larger (height 38 in.) variant of the stag pairs: two reclining fawns dated 1941 and commissioned for Kellingsworth, Myron Taylor's estate in Locust Valley, Long Island, New York. Whether a direct stylistic connection can be made between this pair and the earlier *Resting Stag* has not been established.

18. Busco 1988, p. 170.

THOMAS WILMER DEWING

47. Lady with Cello

1. The painting was formerly known as *Girl with a 'Cello.*

2. Mrs. Coburn (1856–1932), the former Annie Swan, was a prominent social leader of Chicago and owned one of the finest private collections of French and American paintings in America, including works by Paul Cézanne (1839–1906), Edgar Degas, Edouard Manet, Pablo Picasso, Auguste Renoir, Childe Hassam (cats. 35, 37), John Singer Sargent (cat. 29), and James McNeill Whistler (cat. 28). She probably started acquiring pictures around the turn of the century, but to date little is known about the dealers or galleries from whom she made her purchases or if she instead dealt directly with artists. See Chicago 1932.

3. This undated catalogue is endorsed 1920. It accompanied an exhibition that presumably included the Museum's *Lady with Cello*, although this has not been confirmed. (The exhibition dates after Mar. 20, 1920, since a quote of the same date from the *New York Tribune* regarding Willard Metcalf's (cat. 43) *Moonlight* is published in the catalogue.) Susan A. Hobbs is preparing a catalogue raisonné of Dewing's works, which may shed further light on the history of this canvas.

4. This school included the figure painters Frank Benson, Joseph R. De Camp, Philip Leslie Hale (1865–1931), William Paxton (1869–1941), and Edmund Tarbell and the landscapists John Leslie Breck (1860–1899) and Theodore Wendel (1859–1932). See Gerdts 1984, pp. 201–20.

5. Although Dewing resigned from the Society of American Artists in 1891 to join the Ten American Painters, he was rarely considered a "certified" American Impressionist, as were his colleagues Hassam, Metcalf, and John Twachtman. His own aesthetic inclinations had more in common with the atmospheric qualities of Tonalism. The most recent and comprehensive sources on Dewing are Brooklyn + 1996; Gerdts 1984, pp. 171, 175, 178–80, 326; Hobbs in New York, Spanierman 1990, pp. 99–101, 151–52, 172.

6. Brooklyn + 1996, pp. 9–10.

7. The Dewing type was a woman "intellectual enough to be worthy of Boston, aristocratic enough to be worthy of Philadelphia, well enough dressed to be a New Yorker, but seldom pretty enough to evoke the thought of Baltimore" ("The Fine Arts; Mr. Dewing's Exhibition at the St. Botolph Club," *Boston Evening Transcript*, Jan. 25, 1898, p. 6, quoted in Brooklyn + 1996, p. 28 n. 143). Wanda Corn (in San Francisco 1972, p. 11) suggests that Dewing's figures were "American cousins of the unfathomable *fin de siècle* women painted by Klimt, Beardsley or Munch."

8. All derived from his summers at the Cornish (N.H.) art colony, where he worked closely with such notable artists as the sculptor Augustus Saint-Gaudens (cat. 38), the architect and designer Stanford White, and the painters George de Forest Brush (1855–1941) and Henry O. Walker (1843–1929). See John H. Dryfhout in Keene + 1985,

pp. 33–55; Hobbs 1985; Brooklyn + 1996, pp. 19–20, 26, 29, 127, 129–30, 136–37, 138, 141.

9. Kenyon Cox (1856–1919), quoted in Brooklyn + 1996, p. 30 n. 152. The Vermeer revival influenced many painters of the period, especially the Boston School. For more information on the Vermeer revival, see Meltzoff 1942; Leader 1980.

10. The straddle position is documented in at least one instance, in De Camp's *Cellist* of 1908 (Cincinnati Art Museum); however, in this painting the awkwardness of the position is masked by shadow and by the side view. The sidesaddle position is adopted by the figure in Lilla Cabot Perry's *Violincellist* [*sic*] (private collection). For the historical development of cello playing, see Straeten [1914] 1971. For more on Dewing and the general context of music making in America, see Celia Betsky's article in Clinton + 1984.

11. The date was supplied by Hobbs in 1991 to the Berry-Hill Galleries, New York, the painting's last known location.

12. Nothing has been found to securely identify the figure in *Lady with Cello*, but she and the cellist in *The Song and the Cello* may be either Ingi Olsen or Gertrude McNeill, part-time actress-models with whom Dewing became ambiguously involved, socially and professionally. For details, see Brooklyn + 1996, pp. 178, 213 (Olsen), and pp. 41, 71, 72, 181–83, 186–87, 190–91 (McNeill).

13. Ibid., pp. 77–78.

14. Simple frames such as this offer a striking contrast to the elaborate frames by Stanford White that Dewing characteristically used for his paintings until White's death in 1906. See ibid., pp. 83–85.

15. See ibid., pp. 77–78, n. 89.

16. New York, Milch [1920], p. 22.

17. Cortissoz 1910, p. 7, in reference to Dewing's *Musician* (1909, collection of Mrs. Richard E. Davidson, Jr.).

FLORINE STETTHEIMER
48. *Henry McBride, Art Critic*

1. Joseph Stettheimer, the artist's father, abandoned the family while they were in Europe.

2. New York +, MoMA 1946, p. 10.

3. Ibid., p. 18.

4. Duchamp to the Stettheimer sisters, May 3, 1919, quoted in Boston +, ICA 1980, unpag.; see also Bloemink 1995, p. 85.

5. McBride 1945, p. 13.

6. Ibid.

7. Ibid.

8. Bloemink 1995, p. 127, credits Hilton Kramer with pointing out that "keeping score" has multiple meanings for an art critic.

9. Ibid., p. 86.

10. Ibid., p. 129. Elizabeth Sussman (in Boston +, ICA 1980, unpag.) suggests that it is not clear whether Stettheimer knew of Stein's word portraits. Sussman links Stettheimer's portraits with the Dada object portrait, which she certainly would have known through Duchamp. A connection could also be made with Demuth's poster portraits of the mid-1920s, which used words and other symbols to evoke the character of acquaintances and friends, among them Gertrude Stein.

11. Stettheimer painted another portrait of McBride over a postcard of a Homer watercolor from the Bahamas; see Bloemink 1995, pp. 270–71, n. 33, where it is reproduced.

12. Ibid., p. 128.

13. Early in her career Stettheimer designed her own ballet, which was never realized. She was later invited to design sets and costumes for Gertrude Stein's and Virgil Thompson's *Four Saints in Three Acts*, which premiered at the Wadsworth Atheneum, Hartford, in 1934. See ibid., chap. 7, for a thorough discussion.

14. Hartley 1931, p. 9.

JOHN STORRS
49. *Auto Tower (Industrial Forms)*

1. In a letter to the author, Sept. 23, 1996 (Museum files), Michelle Storrs Booz, granddaughter of the artist, related the history of *Auto Tower*, indicating that the sculpture remained in the family's home until it was placed in storage with other artworks at Lefebvre-Foinet in Paris. It was later sent on consignment to Robert Schoelkopf Gallery in New York with works that became part of the Monique Storrs Booz estate.

2. For a valuable study of the life and work of Storrs, see New York +, Whitney 1986–87.

3. The bronze version of the sculpture is reproduced in ibid., fig. 48. Bryant 1969, pp. 66–71, reproduces a version of the sculpture shown in an exhibition of Storrs's work at the Downtown Gallery, New York, in 1965 (Mar. 23–Apr. 17) and identified in the caption as gilded bronze. The photograph shows the addition of paint, which is textured and peeling in a pattern indicative of a wood rather than bronze support. Noel Frackman (letter to the author, Sept. 3, 1996, Museum files) believes that this photograph may indeed record a wooden model, noting that Storrs enjoyed carving in wood and occasionally made wood models for his sculptures (he also made woodcuts). But, as she points out, it is difficult to determine whether this was Storrs's regular practice because so few wooden models have been located. Abraham Davidson (1974, p. 45) refers to a sculpture he saw in the Robert Schoelkopf Gallery: "a metal sculpture of a skyscraper, about two feet high, which can be read as well as a fire engine; on its top are wheels, lights and fenders. So cleverly were the two images fused that two years went by, Schoelkopf reports, before he noticed that the vertical building, placed horizontally, became something entirely different." It is possible that Davidson is referring to a bronze version of *Auto Tower*.

4. New York +, Whitney 1986–87, pp. 49–52; Frackman 1987, p. 131.

5. Wilson, "Transportation Machine Design," in Brooklyn + 1986–87; see also pp. 131–35 in ibid., "Machines for the Road."

6. New York +, Whitney 1986–87, pp. 51, 55 n. 18 (diary entry, Jan. 31, 1922).

7. Ann Rosenthal, "John Storrs, Eclectic Modernist," in Williamstown 1980, pp. 11–22; see p. 12 for comments on Storrs's use of Futurist force lines.

8. New York +, Whitney 1986–87, p. 57. See chap. 4, "Architectural Forms in Sculpture 1922–1928," pp. 57–75, for a discussion of Storrs's column towers and skyscraper cities.

9. Rosenthal in Williamstown 1980, p. 16.

10. Ibid., pp. 16–17; New York +, Whitney 1986–87, pp. 58–63.

11. New York +, Whitney 1986–87, p. 62.

12. Diary entry, Feb. 22, 1919, Storrs Papers, AAA, roll 1548.

13. See New York +, Whitney 1986–87, pp. 20, 36 n. 7, which lists objects that Storrs owned, including Navajo rugs and baskets, an ivory tusk, a number of small objects of Mexican Indian origin, as well as an object described as "possibly from the Pacific Northwest." A 1923 letter from Storrs to his wife expresses regret at leaving behind the American Indian collections at the Field Museum (undated letter postmarked Chicago, May 21, 1923, John and Margaret Storrs correspondence, AAA).

14. Jonaitis 1988; see p. 37 for a description of the function of crest (totem) poles. In addition to the architectural purposes of crest or totem pole types, Jonaitis also notes their use as memorial poles to honor the deceased, mortuary poles to contain human remains, and grave markers. Poles also had the additional function of indicating wealth, especially when erected in numbers. Feder 1982, p. 280, describes the poles of northern groups (Tlingit, Haida, and Tsimshian) as characterized by carved figures "wrapped around" the surface of the column so that the cylindrical shape of the tree trunk is retained. This contrasts with the southern style, which includes projecting elements and voids.

15. See, for example, Seattle 1983–84, pp. 111–14. It is not known whether Storrs ever owned an example of an argillite crest pole, but these objects were produced in great numbers and were readily available to collectors. Frackman has no knowledge of any list of the objects Storrs collected (undated letter to the author, received Aug. 26, 1996, Museum files). She personally has not seen any argillite crest poles in Storrs's estate but does not discount that his changing collection could once have included such an object.

16. Holm 1965, pp. 35, 37.

17. The author is grateful to N. C. Christopher Couch, a former member of the Smith College art history faculty, for confirming the idea that Storrs may have quoted both argillite model crest poles and formlines in *Auto Tower* and for pointing out the use of formline in wrapping a two-dimensional design around a three-dimensional support or object.

18. Herbert 1984, p. 639.

19. New York +, Whitney 1986–87, pp. 91–99.

LYONEL FEININGER
50. Gables I, Lüneburg

1. The painting has had a number of titles over the years. Its first title was evidently *Architecture II*. In a letter to his wife (Dec. 8, 1925) the artist writes: "I am working on six paintings alternately . . . for Dresden. . . . Also I am painting *Architecture II* (Lüneburg) as a big and most important one which is marked for Mannheim" (Ness 1974, p. 148). The picture is reproduced on the cover of one of the exhibition brochures for two nearly identical shows held in Dresden and Berlin in 1926 and catalogued as *Architecture II*. In the Hess catalogue raisonné (Hess 1961) this title is erroneously assigned to a 1921 painting, which has a subtitle *Man from Potin*. Annotations, probably by the artist or his wife, in a copy of the Berlin 1926 brochure at the library of the Busch-Reisinger Museum, Harvard University, give the 1921 picture the title *Architecture I*. The confusion no doubt arose from the fact that the stretcher of the 1921 painting bears an inscription: *Architecture II*. The painting does not derive from the architecture of Lüneburg.

In several exhibitions in the thirties the Museum's painting appears as *Architecture of Lüneburg*. The inscription in English on the stretcher in the artist's hand may have been added around 1937, when the artist returned to this country. During the forties the painting was usually listed simply as *Gables I*. In an exhibition at the Cleveland Museum of Art (Cleveland 1951), it was called *Gables I, Lüneburg (Hanover)*. The present title was first used in print in a 1956 exhibition catalogue (New York, Willard 1956).

2. Achim Moeller, director of the Lyonel Feininger catalogue raisonné project, is gratefully acknowledged for providing provenance information for *Gables I, Lüneburg* (letter to Linda Muehlig, Sept. 17, 1998, Museum files). Karl Nierendorf represented Feininger beginning in 1938, when he established a gallery in New York (listed as the owner of the Museum's painting in the catalogue for Boston, ICA 1939). In the 1940s and early 1950s, the painting was consigned by the artist to the Van Diemen-Lilienfeld Galleries, New York (credited as owner in the catalogues for Minneapolis 1948 and Boston +, ICA 1949), and then to Curt Valentin. (Valentin's Buchholz Gallery changed its name to the Curt Valentin Gallery by 1952.) The painting remained unsold until 1954,

when it was purchased from Valentin by Mr. and Mrs. Charles Meech.

3. Letter of Feb. 3, 1913, Alfred Vance Churchill Collection, AAA. Churchill had been a fellow student of Feininger's at the Royal Academy in Berlin. In 1906 he joined the art faculty of Smith College and was director of the Smith College Museum of Art from 1919 to 1932.

4. Lüneburg, a Prussian town formerly part of Hanover, now in Lower Saxony, was already settled in Charlemagne's time. It is situated on the Ilmenau River in the vast marshes that, up until the seventeenth century, produced the salt that made it a town of wealth and influence. It was a member of the Hanseatic League, and the Duke of Brunswick-Lüneburg was made an elector of the Holy Roman Empire in 1692. The town's fortunes had already begun to wane by then, however. Many of its Gothic and Baroque buildings remain intact thanks to its escape from bombing in World War II.

5. New York, MoMA 1944–45, p. 8.

6. Julia Feininger in New York, Willard 1956, unpag. Bach lived in Lüneburg for about two years beginning in 1700. An orphan, the fifteen-year-old Bach obtained a position at St. Michael's church that gave him schooling in return for services in the choir. His voice changed shortly after he arrived, but his considerable musical skills evidently made him useful in other capacities. Although he knew the organist at St. John's and may have played and even assisted in repairing its organ (built 1553), he is not known to have been the organist at either St. John's or St. Michael's.

7. New York, MoMA 1944–45, p. 7.

8. Andreas Hüneke, "Das Wesen Bachs in der Malerei Feiningers Bezug zur Musik," in Lüneburg 1991.

9. In 1991 the town of Lüneburg mounted a Feininger exhibition treating Lüneburg sites. Preliminary research for the show identified 87 sketches and drawings, 18 watercolors, 2 woodcuts, and 13 oil paintings on this subject.

10. Hess 1949, pp. 48–50, 60–61.

11. The second Gables picture, *Architecture III (Gables II)*, 1927 (private collection, Switzerland), depicts a different group of buildings in the town.

12. Julia Feininger in New York, Willard 1956, unpag.

GASTON LACHAISE
51. Garden Figure

1. Nordland 1974, p. 10.

2. Ibid., p. 8.

3. For information concerning *Standing Woman (Fountain Figure)* of 1927, originally commissioned for the Rochester garden of Charlotte Whitney Allen, see Rochester 1979, pp. 15–16, no. 27, repro.

4. New York, MoMA 1935, p. 13.

5. Ibid.

6. McBride in Kramer et al. 1967, p. 37.

7. Cummings 1920, pp. 194–96. In his assessment Cummings disregarded the fact that Lachaise had worked for Manship until that very year and that the work of both reflected common sources in classical antiquity. For a discussion of archaic influences on Manship and Lachaise and similarities between them, see Rather 1993, pp. 172–77.

8. See Nordland 1974, pp. 65, 180 n. 4.

9. New York, MoMA 1935, p. 13.

10. Nordland has stated that both *Garden Figure* and its second state, previously called *Garden Figure, State 2*, were found in plaster molds in Lachaise's studio at the time of his death. In a letter to the Portland Museum of Art, Maine (copy, Museum files), he states that *Garden Figure, State 2* existed in 1973 in only one cast. It has since (1991) been cast again for New York, Salander 1991 (no. 35), where it was titled *Standing Woman*.

11. Anecdotal information (Museum files) indicates that permission to cast *Garden Figure* was given by Lachaise to Lincoln Kirstein, who supervised the casting. No documentary evidence of this transaction has been found. The figure was cast in an edition of five; in addition to the Museum's cast, others are owned by the Portland Museum of Art, the Hopkins Center at Dartmouth College (a gift from the collection of Nelson A. Rockefeller), the University of Virginia, and the Hirshhorn Museum and Sculpture Garden, Smithsonian Institution, Washington, D.C. (as of spring 1998 on consignment at Salander O'Reilly Galleries, New York). The extant top half of the plaster, in the collection of the Lachaise Foundation, Boston, was cast as a bust-length figure for New York +, Salander 1992

(no. 34). The plaster for the second state is also in the collection of the Lachaise Foundation.

12. See Havelock 1995, fig. 7; see also Ammerman 1991, pp. 203–30. Specific examples of such figurines that Lachaise might have known are as yet unidentified.

13. Kramer et al. 1967, p. 27.

ALEXANDER CALDER
52. Mobile

1. Although the sculpture was bought in Nov. 1935, within less than two years of its likely date of execution, the dating used from the start was always circa 1934. In a letter of Jan. 3, 1996 (Museum files), Alexander S. C. Rower, the artist's grandson and editor of the forthcoming Alexander Calder catalogue raisonné (which will include the Museum's mobile), states that Calder lent the work to the designer Donald Deskey for use in a show in 1934. Joan M. Marter wrote in a letter of Jan. 1994 (Museum files) that the piece "should be dated no earlier than 1934." The Calders returned from France in June 1933 and took up residence in Roxbury, Conn., where Marter thinks *Mobile* was probably made.

The artist wrote (Calder 1966, p. 154): "In 1936 I had another *vernissage* at Matisse's. . . . At one of my earlier Matisse shows, Jere Abbott had bought an object for Smith College." According to Matisse Gallery archives and scholars, there was only one earlier show at Matisse, Apr. 2–28, 1934. No checklist of this show is extant, but Abbott, at that time the Museum's director, did not buy the work until November 1935.

2. In response to an inquiry from the Museum, Calder replied that the wood pieces were "dusted with graphite and then plated with nickel or chrome or some such" (quoted in a letter from Mrs. Klaus G. Perls, the wife of his dealer, Sept. 24, 1964). Long before, in a letter to Abbott, Nov. 22, 1935 (Museum files), Calder referred to it as "the nickeled object at Pierre Matisse's." The threads that suspend the objects have been broken and replaced over the years, and the lengths and kind of thread (including transparent line) have undoubtedly varied from the original version (see conservation notes above). According to Rower, the material originally used by the artist was black mercerized cotton.

3. The mobile was shown in New Brunswick but not at the subsequent venues.

4. Calder 1966, p. 113.

5. From the *Realistic Manifesto*, 1920, from the English trans. by Gabo in Read and Martin 1957, pp. 151–52.

6. Calder to Albert Gallatin, Nov. 4, 1934, quoted in Marter 1976, p. 4.

7. Letter from Rower, Jan. 3, 1995 (Museum files). Rower's assistant, Debra Stasi (letter, Feb. 2, 1996, Museum files), reports that this information comes from "notes for an unpublished Calder autobiography c. 1953. . . . The passage we draw from does not reveal if Calder's permission was sought prior to the nickel-plating of the standing mobile. In any case, Deskey took the work and had it nickel-plated without Calder's collaboration, then chose not to use the work in his design show after all. Calder expresses anger towards this last fact but doesn't express an opinion either way regarding the nickel-plating. So we don't know exactly how Calder felt about the result of Deskey's actions, but Calder did allow the work to be sold through Pierre Matisse Gallery where Smith College acquired it." It might be added that Calder evidently left the work unchanged and that Abbott was a good friend. He was among the first museum directors to buy Calder's work.

Another frustrated collaboration between Deskey and Calder in 1934 is recorded in Hanks 1987, p. 11, in reference to a dining room by Deskey that was part of the Metropolitan Museum of Art's *Contemporary American Industrial Art* exhibition in 1934: "Deskey invited Alexander Calder to create a small stabile for the corner pedestal. Because of the artist's delay, however, Deskey produced a wood sculpture as a substitute."

8. Deskey studied art in Paris at La Grande Chaumière, at the Académie Colarossi, and with Léger, who later wrote glowingly of his Radio City work.

9. Many other sculptors were working in polished metals at the time, including Moholy-Nagy, Alexander Archipenko, and Rudolf Belling (1886–1972) in Europe and Theodore Roszak (1907–1981), José de Rivera (b. 1904), and John Storrs (cat. 49) in America.

10. Calder 1951, pp. 8–9.

11. See note 6 above. For an extended examination of Calder's interest in and exploration of cosmic imagery and of the general popular interest in astronomy at the time (provoked by the discovery of Pluto), see Marter 1991.

ARTHUR G. DOVE
53. Happy Landscape

1. Under "Oil-Temperas 1937."

2. The exhibition was *Young American Painters*, Mar. 9–21, 1910, at the Photo-Secession Gallery, New York.

3. See Morgan 1988.

4. This New York showing (Feb. 27–Mar. 12, 1912) consisted of several oils and a group of pastels that later came to be known as "the Ten Commandments." The same works were shown again in Chicago at the W. Scott Thurber Galleries (Mar. 14–30, 1912) under the title *The Paintings of Arthur G. Dove . . . and the More Defining Term of "Expressionism."*

5. Joseph Edgar Chamberlin, "Pattern Paintings by A. G. Dove," *New York Evening Mail*, Mar. 2, 1912, p. 8.

6. The most comprehensive source for Dove's oil paintings is New York, Dintenfass 1984, which includes an extensive bibliography. San Francisco + 1974–75; Cohn 1985; Morgan 1988; and Washington +, Phillips 1997–98 are important sources as well. Also helpful to the study of the Museum's painting are the Downtown Gallery Papers, AAA, reel ND31, frs. 450–51, and the Suzanne Mullett Smith Papers, AAA, reel 2425 (frame nos. illegible).

7. A debate exists as to which artist experimented with abstraction first. Haskell (San Francisco + 1974–75) believes that the first Kandinsky abstract Dove could have seen probably was *Improvisation 27 (Garten der Liebe II)* (1912, Metropolitan Museum of Art, New York), which Stieglitz acquired from the Armory Show. Dove's own Abstraction series, exhibited in 1910, predates the Armory Show. Further details of the Dove-Kandinsky connection can be found in ibid., pp. 16, 20, and Haskell in Birmingham + 1987, pp. 21–22. For information on Kandinsky's early abstract paintings and their exposure, see New York +, MoMA 1995.

8. Burrows 1937.

9. Many of his forms do suggest an inventive assembly of photographically enlarged shapes, which may have been inspired by the work of Stieglitz and other photographers.

10. Haskell in San Francisco + 1974–75, p. 77 n. 66.

11. McCausland 1937, p. E6.

12. *Happy Landscape* (or *Landscape*), 1937, watercolor and ink on paper, 5½ × 9 in. (location unknown); exhibited New York, American 1937 *Dove*, no. 10 ("unframed watercolor list"). See Suzanne Mullett Smith Papers, AAA, reel 2425 (frame nos. illegible).

13. *Paintings by Arthur G. Dove* consisted of twenty oil temperas and at least thirty-two watercolors, all recently completed: "water swirls, suns and moons—free verse hymns to golden daylight and the deep night sky" (Washington +, Phillips 1997–98, p. 107).

14. Mumford 1937.

15. McCausland 1937, p. E6.

16. Phillips, who acquired over seventy-nine of Dove's works, was his only great patron. For details of the relationship, see Washington +, Phillips 1981 and Morgan 1988.

17. This showing (Washington, Phillips 1937) of fifty-seven collages, pastels, oils, and watercolors was the first major Dove retrospective at the gallery and the only one held there during the artist's lifetime.

18. Washington, Phillips 1937 (unpag. brochure). Phillips seriously considered buying *Happy Landscape* (Morgan 1988, pp. 374, 376) but instead settled on a 1925 collage, with the title *A Nigger Goin' Fishin'*. *Happy Landscape* remained at An American Place without further showings until it was sold in 1944.

EDWARD HOPPER
54. Pretty Penny

1. Also known as *Helen Hayes' House at Nyack, N.Y.* and *The MacArthurs' Home "Pretty Penny."*

2. Exhibition listed in Levin 1995 *Catalogue* (vol. 3, O-311) but unconfirmed by the Museum at this writing.

3. See note 2. Levin 1995 *Catalogue* also lists the Museum's painting as part of the exhibition *Edward Hopper's Nyack Years*, Historical Society of Rockland, New City, N.Y., July 22–Sept. 26, 1982; however, *Pretty Penny* was not lent to that show.

4. See also pls. 229 and 230, studies for *Pretty Penny*. A separate, smaller catalogue by Ian Jeffrey was published for the London venue of the Whitney exhibition, in which *Pretty Penny* is no. 91.

5. See Goodrich et al. 1981, pp. 128–30, for Helen Hayes's commentary on the commission.

6. Hopper 1928, p. 7.

7. Levin 1995 *Biography*, p. 113.

8. Hopper 1953, p. 8.

9. A friend nicknamed the house "Pretty Penny" because the high cost of renovating it had forced Hayes into a prolonged engagement in "The New Penny" radio series (Helen Hayes in Goodrich et al. 1981, p. 129).

10. Ibid.

11. Jo Hopper's unpublished diary, Nov. 3, 1939, quoted in Levin 1995 *Biography*, p. 316.

12. Quoted by Hayes in Goodrich et al. 1981, p. 129.

13. Jo Hopper's unpublished diary, Nov. 16, 1939, quoted in Levin 1995 *Biography*, p. 318.

CHARLES SHEELER
55. Rolling Power

1. *Rolling Power* was temporarily removed from San Francisco + 1982 to be included in SCMA's memorial exhibition honoring former Museum director Jere Abbott (Northampton 1983), where it was shown through May 15.

2. Extensive references in both volumes of this catalogue (Troyen and Hirshler, Stebbins and Keyes) make it the fullest published discussion of the Museum's painting.

3. Charles Sheeler Papers, AAA. The year is not given in the letter, but internal evidence dates it to 1938.

4. Sheeler to Walter Arensberg, Aug. 7, 1939 (Arensberg Archives, The Francis Bacon Foundation, Claremont, Calif.).

5. Sheeler 1940.

6. The other paintings exhibited were *Steam Turbine* (1939, oil on canvas, 22 × 18 in., Butler Institute of American Art, Youngstown, Ohio); *The Yankee Clipper* (1939, oil on canvas, 24 × 28 in., Museum of Art, Rhode Island School of Design, Providence); *Primitive Power* (1939, tempera on paper, 5 × 7 in., Regis Collection, Minneapolis); *Suspended Power* (1940, oil on canvas, 33 × 26

in., Dallas Museum of Art); and *Conversation—Sky and Earth* (1940, oil on canvas, 28 × 23 in., Regis Collection, Minneapolis).

7. Although he later disparaged the teaching of the school, founded in the 1880s to promulgate John Ruskin's educational and aesthetic ideas, Sheeler's love of machinery may have begun there. Sheeler's life and work exhibited a deep respect for the aesthetics of craftsmanship, for approaching nature without preconceived academic notions, and for a faithful recording of nature, all Ruskinian tenets. Ruskin urged young artists to work directly from nature, "selecting nothing and rejecting nothing." Ruskin also used photographs as an aid in making drawings.

8. Halpert apparently did not object to museum exhibitions; of the 196 works in his retrospective (New York, MoMA 1939), 73 are photographs.

9. Quoted by Troyen and Hirshler in Boston +, MFA 1987–88, p. 1.

10. New York, MoMA 1939, p. 11.

11. Ibid.

12. Stebbins and Keyes (in Boston +, MFA 1987–88, p. 57 n. 18) note the slight change in the location of the shadows between *Wheels* and *Rolling Power* to confirm the existence of another photograph.

13. Unsigned article by Milton Brown, *Parnassus* 1941 "Sheeler," p. 46.

14. The painting does indeed correspond very closely to the photograph, though there are many small alterations. This is the only photograph still extant that more or less exactly reproduces the composition of a *Power* painting. *Wheels* is only part of *Rolling Power*'s image. Another view of *The Yankee Clipper*, a photograph titled *Propeller*, exists, but not that used for the painting. A photograph titled *Installation* shows the turbine in *Suspended Power* already lowered into place and was used for part of the composition, but there is none known showing the turbine suspended, as it is in the painting. No photographs of any kind for *Steam Turbine* or *Primitive Power* appear to have survived. *Primitive Power*, a tiny tempera on paper, may have been painted on site. Sheeler's method was to take a number of shots of a subject, of which some, or perhaps none, might later be selected for printing as works of art. In the case of the pho-

tographs used to paint the *Power* pictures, it may be that after the reproduction of *Conversation—Sky and Earth* in *Parnassus*, the others were suppressed or destroyed.

15. Letter, May 7, 1953 (Museum files).

16. Letter, May 14, 1953 (Museum files). Ten years later Sheeler acknowledged that a photograph had preceded the painting. In a letter to Lucius Beebe, Feb. 11, 1963 (Photography Department files, Museum of Modern Art, New York), Sheeler wrote: "The locomotive was one of a series commissioned by *Fortune* magazine on the subject of sources of power. It was a painting. It now belongs to Smith College. Since I could not camp beside [it] for the three months I required to paint it, I made a photo." A bon vivant and railroad buff, Beebe was the author of a number of works on railroads, including *20th Century Limited* (1962).

17. Bush 1975, pp. 76–79. The large, elegantly simplified wheels, known as Scullin double-disk drivers, were evidently factory issue, not redesigned by Dreyfuss, a well-known industrial designer.

18. The photographs were taken while Sheeler was a kind of photographer-in-residence at the Metropolitan Museum of Art from 1942 to 1945. They were included in a museum publication of 1945 titled *The Great King, King of Assyria*. They resemble the work of the scholar-photographer Clarence Kennedy, who taught art history at Smith College for many years. From the early twenties on, Kennedy, a master of lighting, photographed classical and Renaissance sculpture. His close-ups of details are especially beautiful in their exploitation of the camera's ability to isolate details and call attention to passages of great beauty, eliminating peripheral elements as the eye cannot. Probably Sheeler, who had photographed sculpture for a number of New York dealers over the years, knew Kennedy's photographs, many of them published. Both were invited by Ansel Adams to have solo shows at the Golden Gate Exposition in San Francisco in 1940.

19. Sheeler 1940, p. 78.

20. *Parnassus* 1941 "Sheeler," p. 46.

MARSDEN HARTLEY
56. Sea Window—Tinker Mackerel

1. See note 20 below.

2. He was named Edmund but changed it to Marsden, his stepmother's maiden name, in 1906 (Ludington 1992, p. 16). The best source on the artist's life, Ludington 1992, includes an excellent selected bibliography. Important unpublished sources on the artist include the Marsden Hartley Archive in the Yale Collection of American Literature, Beinecke Rare Book and Manuscript Library, Yale University, and the Elizabeth McCausland Papers, AAA. A catalogue raisonné is in preparation by Gail Levin. Further information specifically on the Museum's painting can be found in the Elizabeth McCausland Papers (Marsden Hartley Notes), AAA, reel D270, fr. 722, and reel D273, fr. 1583, and in the Whitney Museum of American Art Papers, Artists Files—Marsden Hartley, AAA, reel N665, fr. 506.

3. Hartley wrote in 1937: "The opulent rigidity of this north country, which is a kind of cousin to Labrador and the further ice-fields, produces a simple, unaffected conduct and with it a kind of stark poetry exudes from their behaviours, that hardiness of gaze and frank earnestness of approach which is typical of all northerners.... Maine is likewise a strong, simple, stately and perhaps brutal country, you get directness of demeanor, and you know where you stand, for lying is a detestation, as it is not in the cities" (in New York, American 1937 Hartley, pp. 1–2, reprinted in Scott 1982, pp. 112–13).

4. Stieglitz's gallery at 291 Fifth Avenue was already a haven for those interested in modern art, and its reputation for exhibiting avant-garde artists was growing rapidly. For information on Stieglitz and his galleries, see Homer 1977; Homer 1983.

5. This group of artists included Arthur Dove (cat. 53), John Marin, Georgia O'Keeffe (cat. 59), Paul Strand, Abraham Walkowitz (1880–1965), and Max Weber (1881–1961). Between 1909 and 1937 Hartley had a total of eight solo shows and some group exposure as well at Stieglitz's galleries, but he never relied totally on Stieglitz for support or promotion. The critical reception and sales of his paintings from 291, the Anderson Galleries, and An

American Place were lukewarm. Hartley's final exhibition with Stieglitz in April 1937 was not a critical or financial success and was followed by bitterness between the two men that caused a rift.

6. Contact between Hartley and Gertrude Stein, which lasted from 1912 to 1934, is documented in Gallup 1948. See also Stavitsky 1990, pp. 19–22. Stein had a particular fondness for Hartley, both as one of the foremost American artists of the twentieth century and as a fellow writer.

7. By creating such a combination, Hartley was also paying tribute to two of the artists he most admired, Albert Pinkham Ryder (cat. 34) and Paul Cézanne.

8. Purchase + 1986–87, p. 18. This source outlines a long history of artists' interest in this compositional format, from the Renaissance to the present.

9. McCausland 1952, p. 30.

10. Haskell in her catalogue entry for Hartley's *Summer—Sea Window No. 1*, in Schweizer 1989, no. 73, p. 158.

11. Matisse painted his first window compositions, such as *Open Window, Collioure* (1905, National Gallery of Art, Washington, D.C.), during a summer he spent in Collioure on the French Riviera with Derain in 1905 and continued to use the compositional format throughout his career. Derain experimented with the still-life-before-a-window theme between 1911 and 1914 (*Window at Vers* is also called *Vers (Lot): Nature Morte devant la fenêtre* and *La Fenêtre sur le parc [Fenêtre à Vers]*). Hartley is likely to have seen such paintings on exhibition in Paris, perhaps at the Kahnweiler Gallery, or through reproductions, although specific documentation of such a connection is not known.

12. The window paintings were executed in the mid-1930s in Gloucester, Mass.; Bermuda again; and Nova Scotia. The last group, in the early 1940s, resulted from his Mount Desert experiences.

13. Works of the Gloucester period (1930s), e.g., *Sea View, New England* (1934, Phillips Collection, Washington, D.C.), are painted with a rougher brushstroke and earthier coloration and have a more primitive quality; the inanimate objects clearly related to fishing and the sea are treated with a strong, masculine approach more symbolic than realis-

tic. In contrast, *Summer Sea Window No. 1* (Munson-Williams-Proctor Institute Museum of Art, Utica, N.Y.) and *Sea Window Summer No. 2* (Sotheby's, New York, sale 4365, Apr. 25, 1980, lot 223), both of 1939–40, return to the gentler, more feminine arrangement of objects and the use of pastel shades.

14. Haskell (in New York +, Whitney 1980, p. 123) suggests that the darker palette of many of the 1940s paintings may have been a result of deteriorating eyesight.

15. Tinker mackerel, also known as chub mackerel, are a fish of the North Atlantic and other oceans, but the name may be applied as well to small specimens of the common mackerel.

16. Ludington 1992, p. 273.

17. Hartley to Hudson D. Walker, Aug. 25, 1942, quoted in Ludington 1992, pp. 277, 299 n. 14.

18. A.M.B. 1943, p. 27. It is possible that the author of this article is Henry McBride.

19. Paintings of dead fish, dating primarily from the 1930s and 1940s, provide yet another example of a thematic refrain that recurs throughout Hartley's career. In general, the compositions of tropical fish inspired by his Bermuda visits are pastel and more haphazard in arrangement. The Gloucester, Nova Scotia, and Maine fish paintings, in contrast, tend to be somber in palette and are ordered in more regular patterns.

20. The inclusion of the Museum's painting in the Rosenberg portion of the memorial exhibitions (New York, Rosenberg 1944) has not been conclusively established, since the title *Sea Window* given in the checklist may refer either to the Museum's painting or to a similarly titled work, whose provenance is incompletely documented, or to an untraced painting. In addition to the Museum's painting, two known works that might qualify are *Summer Sea Window No. 1* and *Sea Window No. 2* (see note 13 above). A fourth candidate, *Sea Window, Red Curtain* (formerly known as *Summer Sea Window*), might have qualified as well; however, it was acquired in early 1944 by the Addison Gallery of American Art, Phillips Academy, Andover, Mass., and was shown at a concurrent Hartley exhibition at the Museum of Modern Art, New York, Oct. 1944–Jan. 1945.

21. Upton 1944, p. 9.

22. Hartt 1947.

JACQUES LIPCHITZ
57. Barbara

1. Born Chaim Jacob Lipchitz.

2. Date given by Lipchitz in a letter to Robert Parks, former director of the Smith College Museum of Art, Sept. 16, 1959 (Museum files).

3. Lipchitz, in referring to a sculpture in Picasso's studio believed to be *The Glass of Absinthe*, declared it was not a sculpture because of its seemingly arbitrary application of color. See Lipchitz 1972, p. 8.

4. Ibid., p. 95.

5. Greenberg 1961, p. 107.

6. Lipchitz 1972, p. 85.

7. Toronto + 1989–90, p. 39.

8. Lipchitz to Anne Mannarino, Museum secretary, Aug. 24, 1962 (Museum files).

9. Toronto + 1989–90, p. 131.

10. Van Bork 1966, p. 199.

11. Toronto + 1989–90, p. 23.

ADOLPH GOTTLIEB
58. Descent into Darkness

1. Gottlieb interview with Andrew Hudson, "Dialogue with Adolph Gottlieb—May 1968," transcript, Adolph and Esther Gottlieb Foundation, New York.

2. Evan Maurer in Washington +, Phillips 1994–95, pp. 31–39.

3. Polcari 1991, fig. 96.

4. Maurer in Washington +, Phillips 1994–95; however, also see Polcari 1991, p. 158, who challenges the emphasis of some writers on the influence of "primitive" sources, including Chilkat motifs, as too limiting.

5. See Mary Davis MacNaughton in Washington +, Corcoran 1981, pp. 29–53, esp. pp. 35–38.

6. Sanford Hirsch, executive director of the Adolph and Esther Gottlieb Foundation, to the author, July 11, 1996 (Museum files).

7. Hirsch (ibid.) also notes that the artist was "an avid and accomplished sailor, although of small sailboats rather than larger ships."

8. Polcari 1991, pp. 166–71.

9. Hirsch in Washington +, Phillips 1994–95, pp. 18–19.

10. For example, *Expectation of Evil* as well as *Evil Omen* (1946,

Neuberger Museum of Art, State University of New York, Purchase), *Evil Eye* (1946, Lang/Davis collection), *Pursuer and Pursued* (1947, Yale University Art Gallery, New Haven), and *The Terrors of Tranquillity* (1948, Adolph and Esther Gottlieb Foundation, New York).

11. Hirsch, letter cited in note 6 above.

12. Polcari 1991, pp. 217, 387 n. 15.

13. Hirsch, letter cited in note 6 above, states: "it is certain that in 1947 the image of a parachutist would, in the most direct way, convey the sense of a descent into darkness." The author is grateful to John Eldredge, who seconded the possible association of the Museum's painting with D-day and pointed out that George L. K. Morris (1905–1975) had also treated the subject of parachutists abstractly (undated note, winter 1996, Museum files).

14. The author is grateful to Ethel Baziotes, widow of the artist, who shared the following insights concerning the relationship between the Museum's painting and *The Parachutists* (letter to the author, May 7, 1998, Museum files): "The Very title, 'Descent into Darkness,' could be a portrait of an Artist's psyche—the specter of Fear and Death. In his notes Baziotes describes painting as a labrynthian [sic] journey. He also notes that very often there is an unconscious collaboration between Artists. . . . My sense leads me to believe Gottlieb and Baziotes tangent each other in the arts of Africa, Oceana [sic] and Native America—the under- or spirit-world is overwhelming in these arts—clairvoyance of life, death and nature."

15. Gottlieb in *Tiger's* 1947, p. 43.

16. Jewell 1943, p. 9.

17. Hirsch in Washington +, Phillips 1994–95, p. 25; he notes (p. 29 n. 65) that "tragic and timeless" were actually Rothko's additions to the letter, according to Gottlieb's assertion in a taped interview with Martin Friedman in 1962 (typescript, Adolph and Esther Gottlieb Foundation, New York).

GEORGIA O'KEEFFE
59. Grey Tree, Fall

1. When the painting was acquired by the museum in 1987, its title was given as *Grey Tree*; however, the painting was shown as *Grey Tree, Fall* in its first exhibition of record

in 1950 at An American Place. The Museum has, therefore, chosen to restore the earlier title, especially as seasonal references are important to O'Keeffe's work and to this painting in particular.

2. Anita Natalie O'Keeffe Young (1891–1985) was the second youngest of Georgia's four sisters. She also had two brothers.

3. A catalogue raisonné of the artist's work by Barbara Buhler Lynes, the joint project of the National Gallery of Art, Washington, D.C., and the Georgia O'Keeffe Foundation, Abiquiu, N.M., is scheduled for publication in 1999. The author is grateful to Lynes for her comments and suggestions when she examined *Grey Tree, Fall* at the Smith College Museum of Art on Sept. 4, 1997.

4. The account of O'Keeffe's first exhibition by Stieglitz is well known. Her classmate and friend Anita Pollitzer took some of O'Keeffe's abstract charcoal drawings to Stieglitz, who was eager to exhibit them. The artist, who had been hesitant about showing her work to anyone, was ambivalent. Her displeasure later increased when fellow students informed her that the drawings were on exhibit at Stieglitz's gallery 291; see, among others, Eisler 1991, pp. 1–8.

5. The number of books, articles, and exhibition catalogues devoted to O'Keeffe still grows. Among the most recent are Robinson 1989; Eldredge 1991; Hogrefe 1992; London + 1993; Benke 1995; Hassrich 1997; Hoffman 1997. On the O'Keeffe-Stieglitz relationship, see Eisler 1991; Washington +, Phillips 1992–93.

6. O'Keeffe had spent most of the preceding fifteen summers in the Southwest without Stieglitz, and much has been written about her fascination with that part of the country. See particularly Robinson 1989, pp. 320–36, 355–57, 359–61, 406–10, 425–26. Her first visit to north central New Mexico took place on vacation from her Texas teaching job at West Texas State Normal School in 1917. Regular visits began in 1929. After 1934 she stayed at Ghost Ranch in a magnificent setting, where in 1940 she purchased some acreage. The house at Abiquiu was in a remote Hispano-Indian village about twenty miles to the southeast of the ranch.

7. The cottonwood is a member of the poplar family; the species growing in Texas and New Mexico

is characterized by a large, wide-crowned shape with stout, smooth, orange twigs and leathery yellow-green leaves (Rogers 1935, p. 145). No inscriptions or other specific documentation exist to identify the Museum's *Grey Tree, Fall* as a cottonwood. The assumption that it is a tree of this type is based on visual comparison with other O'Keeffe paintings of the period, which are identified by title as cottonwoods, such as *Winter Cottonwood I* (1950, private collection).

8. The cottonwood tree paintings, including both horizontal and vertical formats, are for the most part composed on canvases 16 by 20 inches to 40 by 36 inches; several are painted on canvas measuring 30 by 36 inches.

9. Washington +, National Gallery 1987–88, pp. 249, 283 n. 57.

10. O'Keeffe painted dead trees, which are obviously lifeless, among them: *Chestnut Tree—Red* (1924, private collection), *Dead Tree, Bear Lake* (1929, private collection), *Gerald's Tree II* (1937, Hirschl and Adler Galleries, New York, as of 1986), *Dead Cottonwood Tree, Abiquiu* (1943, Santa Barbara Museum of Art), and *Dead Tree with Pink Hills* (1945, Cleveland Museum of Art). The gray tones O'Keeffe often used to define her trees, and sometimes underscored in their titles, were occasionally, but not always, associated with dead trees.

11. Eldredge 1991, p. 43. Eldredge also writes: "This interest in abstract portraiture was shared by many of the avant-garde, in the United States and elsewhere, in the years during and after World War I" (London + 1993, pp. 172 ff.).

12. A telephone conversation (Sept. 23, 1996) between the author and Joellyn Duesberry, class of 1966, a landscape painter who has painted in northern New Mexico, was helpful in clarifying the extent to which O'Keeffe combined realism and abstract invention in this painting. She explained that it is the reflection of the brilliant southwestern light from the multitude of tiny, mauve-gray branches that, more realistically than not, produces the ghostly off-white evanescent impression.

13. Washington +, National Gallery 1987–88, p. 249.

14. O'Keeffe 1976, opp. pl. 55. Precedents for O'Keeffe's association of a tree with a particular per-

son include *Birch and Pine Trees—Pink* (1925, collection of Paula and M. Anthony Fisher), which was associated with the writer Jean Toomer, and *The Lawrence Tree* (1929, Wadsworth Atheneum, Hartford, Conn.), named for a tree outside D. H. and Frieda Lawrence's house on Kiowa Ranch, where O'Keeffe stayed with her friend Dorothy Brett in the summer of 1929. *Gerald's Tree I* (1937, Georgia O'Keeffe Museum, Santa Fe) and *Gerald's Tree II* (1937, Hirschl and Adler Galleries, New York, as of 1986) were named for Gerald Heard, who visited O'Keeffe's Ghost Ranch in 1937 and left his footprints and an inscription in the sand at the base of this tree. Among other sources, see Eldredge 1991, pp. 40–44; London + 1993, pp. 172–74; Kornhauser 1996, vol. 2, pp. 577–78, no. 346; New York, Hirschl 1986, p. 52, no. 23; and Hoffman 1997, pp. 52 ff.

15. Thirty-one works, ten of which were trees, were included in the exhibition (New York, American 1950).

16. McBride 1950, p. 56.

ROBERT MOTHERWELL
60. *La Danse*

1. The measurements given for the painting titled *La Danse* (no. 9) in the Kootz exhibition catalogue do not accord with the Museum's canvas. Joan Banach of the Dedalus Foundation (established by Motherwell with the mission of placing his remaining works, including *La Danse*, in museums) has confirmed that the Museum's painting was included in this show (telephone conversation with the author, Feb. 4, 1998). Therefore, the measurements listed in the catalogue, 24 by 48 inches, are incorrect. She further disputes their accuracy on the basis that Motherwell did not favor a 1:2 format. No other exhibitions are recorded for *La Danse* until it was shown at the Smith College Museum in 1996; however, the Dedalus Foundation provided a partial sticker with the text "University of . . ." from the painting's backing board when the Museum acquired *La Danse*, and it is possible that it was shown at a university gallery or museum in the intervening thirty-nine years, during which time it remained in Motherwell's possession.

2. *La Danse* was shown only in Madrid.

3. According to the Metropolitan Museum of Art files, *La Danse II*

was purchased in 1953 from the Kootz Gallery, New York, in exchange for *Ile de France* (52.182). A notation in the Metropolitan's files records that the "artist writes that there is a very closely related version, ¼ size," undoubtedly a reference to *La Danse*. The Museum's canvas, painted on 1,140 square inches of canvas, is exactly one quarter the size of the Metropolitan's painting (4,560 square inches).

4. The author is grateful to Joan Banach (telephone conversation, Feb. 4, 1998) for defining the relationship of the Museum's painting and the Metropolitan's painting according to Motherwell's studio and working practices.

5. Arnason 1982, pp. 31–33.

6. Ibid., p. 29.

7. Ibid., pp. 32–33.

8. A number of artists in the Kootz Gallery stable created murals and related works for architectural settings in the early 1950s, when the gallery advertised itself as "the exclusive representative for murals and sculptures" for Motherwell, Adolph Gottlieb (cat. 58), and others. The 1950 Kootz Gallery exhibition *The Muralist and the Modern Architect* was followed in 1951 by *Art for a Synagogue*. Among other projects, Motherwell created a tapestry for Congregation Beth El in Springfield, Mass., and a mural for B'nai Israel Congregation in Millburn, N.J.

9. This work is reproduced and discussed in Arnason 1982, pp. 33, 34, 36, fig. 25, and is included in Storrs 1980, no. 2, repro. p. 23.

10. In her review of the exhibition in the *New York Herald Tribune* (Apr. 12, 1953), Emily Genauer pronounced *La Danse II* the "piece [*sic*] de resistance in the show" and a work "in which the forms of the black and white sketches have been purified, ordered, precisely related." S. Lane Faison, in his review in the *Nation* (Apr. 18, 1953), noted that the painting's title "suggested Matisse" and its "rhythms and chords of color [were] doubtless based on Matisse."

11. Fitzsimmons 1953, p. 17.

12. The published *pochoir* plates for *Jazz* were made from stencils based on the paper cutouts. The original cutouts, or maquettes, were created from papers painted with Linel gouache colors; the printed edition of the series also used the same gouache colors. Although the

Matisse bibliography is too vast to be cited here, for further information on *Jazz*, see Elderfield 1978, pp. 21–24; Schneider 1984, pp. 661–69.

13. Terenzio 1992, pp. 56–63. As she notes (p. 52), during the 1940s Motherwell had written on the work of numerous artists, produced a Dada anthology, and, in a five-year span, had taught at Black Mountain College, written essays, lectured, produced a magazine, and directed the publication of eight titles in the Documents of Modern Art series.

14. Motherwell stated, however, that he did not see the Matisse drawings exhibition in February 1948 at the Pierre Matisse Gallery, New York (interview with Terenzio in Storrs 1980, p. 136).

15. For the history and development of this project, see Jack Flam's *Matisse: The Dance* (Washington +, National Gallery 1993).

16. Robert Motherwell, "Robert Motherwell: A Conversation at Lunch" in Northampton 1963, unpag.

17. Robert Motherwell, "Beyond the Aesthetic," *Design*, vol. 47, no. 8 (Apr. 1946), pp. 14–15, quoted in Terenzio 1992, p. 38.

JOSEF ALBERS
61. *Study to Homage to the Square: Layers*

1. Brackets within the inscription are in the original.

2. Albers [1963] 1971, p. 2.

3. Ibid., p. 1.

4. Ibid.

5. The "study to" prefixed to the present title demonstrates the artist's acknowledgment that while he could bring the interaction of colors to the viewer's attention, he had no foreknowledge of what those interactions would be. To find out, he had to paint them. There is generally n° difference in the degree of finish between a "study" to an *Homage* and an *Homage* itself.

6. Nicholas Fox Weber, "The Artist as Alchemist," in New York, Guggenheim 1988, p. 14.

FRANZ KLINE
62. *Rose, Purple and Black*

1. Campbell 1954, p. 54.

2. Greenberg 1952, p. 101.

3. See Stephen C. Foster in Barcelona + 1994, pp. 15–39, esp. pp. 22–27, for a discussion of the

reconceptualization and change in Kline's work from his early career. David Anfam (in Houston + 1994, pp. 20–27) stresses the importance of the New York School photographers, particularly Aaron Siskind and Robert Frank (b. 1924), to Kline's transition to abstraction and to his work from 1950 on.

4. De Kooning 1962. She writes of a "total and instantaneous conversion" that occurred in Kline's art in 1949 when he enlarged some of his sketches in a Bell-Opticon (pp. 68–69).

5. Anfam in Houston + 1994, p. 18.

6. *Sawyer*, 1959 (82 × 62½ in., reproduced in New York, Marlborough 1967, no. 12), though much larger than the Museum's painting, has a similar composition and palette. Its black central form is more of an "open" square suspended on two vertical black struts, and rose-red is applied in broad strokes on the right-hand side of the canvas.

7. Ashton 1958, p. 32.

8. Harry F. Gaugh in Cincinnati + 1985–86, p. 140.

9. Kuh 1962, p. 152.

10. Barcelona + 1994, p. 46.

11. Kuh 1962, p. 144.

12. Ibid., p. 145.

LEE BONTECOU
63. *Untitled*

1. Not shown at the Southampton venue.

2. The Museum's sculpture was not included in the Castelli exhibition, which was held in November, but had been purchased earlier in the year (invoice from Castelli Gallery, Feb. 25, 1960, Museum files).

3. Myers 1990, p. 61.

4. Judd 1965, p. 20.

5. Hadler 1992, pp. 38–39.

6. New York, MoMA 1964, p. 12.

7. McEvilley 1994, p. 91.

8. Smith 1993 "Abstract," pp. 82–87.

9. See Munro 1972, p. 384; Hadler 1992, pp. 41–42.

10. Smith 1993 "Abstract," p. 84.

11. Hadler 1992, pp. 38–39.

JOAN MITCHELL
64. *Untitled*

1. Xavier Fourcade stated, "I agree with you that the work should be

dated 1960–62," letter to Betsy Jones, July 31, 1986 (Museum files).

2. Nancy Schwartz (telephone conversation with Corinna Jaudes, curatorial intern, SCMA, Nov. 8, 1993) states that Mitchell traded this painting with Jacques Kaplan for a fur coat. He was a well-known French furrier and art collector who moved to New York around 1950 and created and exhibited his own fur sculptures. The author is grateful to Judy Throm of the Archives of American Art, Smithsonian Institution, for her assistance in verifying this painting's exhibition history and provenance.

3. Mitchell 1957, p. 76.

4. Conversation with Marcia Tucker, Dec. 1973, Vétheuil, France, cited in New York, Whitney 1974, p. 6.

5. Interview with Linda Nochlin, Apr. 16, 1986, Joan Mitchell Papers, AAA, p. 15.

6. Conversation with Judith Bernstock, in Washington +, Corcoran 1988, p. 53.

7. Her first solo exhibition was at the St. Paul Gallery, St. Paul, Minn., in 1950.

8. New York, Whitney 1974, p. 6. Barbara Rose asserts that being outside New York gave second-generation Abstract Expressionists a freedom the first generation lacked (Rose 1965, pp. 61–62).

9. New York, Whitney 1974, p. 9.

10. Sandler 1957, pp. 47, 69.

11. Nochlin 1996.

12. Washington +, Corcoran 1988, p. 60.

13. Sandler 1961, p. 11.

14. Washington +, Corcoran 1988, p. 67. Tucker (in New York, Whitney 1974, p. 6) uses the term "feeling states."

15. New York, Whitney 1974, p. 7.

CLAES OLDENBURG
65. *Sketch for a Soft Fan*

1. This is the title under which the sculpture was shown at the artist's retrospective at the Museum of Modern Art (New York, MoMA 1969) and is the one preferred by the artist. The work has been published several times as *Soft Fan*, the title inscribed by the artist on the bottom of the base. Preliminary loan records for the retrospective give the title as *Fan, Hard Model (Falling Fan)*, and a Sidney Janis Gallery

sticker on the bottom of the base reads *Falling Fan, Model*.

2. Rose 1970, p. 194.

3. According to David Platzker, who was in charge of Oldenburg's extensive archives, the artist made at least six other small-scale versions of the fan, besides the Museum's. One, *Study for a Hanging Soft Fan*, resembles the Museum's fan in its "falling" stage. There were also separate studies for parts of the fan—the cord, the motor, the plug, and the nut.

4. Barbara Haskell in Pasadena + 1971–72, p. 52.

5. From the artist's notebooks, 1968, quoted in Rose 1970, p. 194.

6. *Sketch for a Soft Fan* was shown as a wall piece in the 1969 retrospective. The previous owner, Mary Gayley Strater, had bought the work from the Sidney Janis Gallery in 1966, and the fact that the gallery's label calls it *Falling Fan, Model* suggests that the collapse may have occurred before Mrs. Strater purchased it.

7. Rose 1970, p. 192.

WILLEM DE KOONING
66. *Woman in Landscape X*

1. This work has been given two Knoedler numbers, 5567 and 5899; the numbers 5647 and 5567 also appear on the backing. The gallery facilitated the gift of the painting to the Museum.

2. The Museum owns a de Kooning drawing, *Women*, c. 1950 (1969:46), depicting four women drawn with jagged, angular graphite strokes. It is most likely a preliminary study for *Woman I*.

3. Geist 1953, p. 15.

4. Crehan 1953, p. 4. The literature on de Kooning's women paintings, particularly those of the 1950s, is vast. For an excellent study of the various critical responses to the women paintings, see Cateforis 1991; see also Washington +, National Gallery 1994; Siegel 1990; and, for a study of the early women series, Yard 1980. Hess 1953, Amsterdam + 1968, and Sylvester 1968 and 1995 discuss the creation of *Woman I* in detail. For feminist analyses of the women paintings, see Duncan 1989; Vogel 1976.

5. Crehan 1953, p. 5.

6. Pepper 1983, p. 79.

7. Amsterdam + 1968, p. 100.

8. Frank quoted in Woodward 1994, p. 34.

9. Lippard 1965, p. 30.

10. De Kooning quoted in Willard 1964, p. 44.

11. Bibeb 1968, p. 4, cited in Washington +, National Gallery 1994, p. 177.

12. De Kooning, interview with David Sylvester, 1960, cited in Washington +, National Gallery 1994, p. 34.

13. Washington +, National Gallery 1994, p. 127.

14. De Kooning, interview with David Sylvester, 1960, cited in Washington +, National Gallery 1994, p. 127. This statement appears in slightly different form in Sylvester 1995, p. 223.

15. De Kooning, quoted in Amsterdam + 1968, p. 47. Pollock and Greenberg verbally attacked de Kooning after the exhibition of a series of women paintings at the Sidney Janis Gallery in 1953.

FRANK STELLA

67. Damascus Gate (Variation III)

1. This essay is adapted from the author's entry on *Damascus Gate (Variation III)* in Northampton 1991, p. 55.

2. Rosenblum 1971, p. 39.

3. Rosenblum in Rubin 1986, p. 25.

4. New York +, MoMA 1987–88, p. 157.

5. Guberman 1995, pp. 108–9; for the *Protractors*, see pp. 120–33.

6. Rubin 1970, pp. 136–37.

7. Ibid., p. 135; Guberman 1995, p. 122.

8. Rubin 1970, p. 135.

9. Ibid., p. 138. According to Rubin, the colors of the *Irregular Polygons* were applied in two or three coats, producing greater density and depth. The single-coat application in the *Protractors* "gave the color a less substantial, slightly disembodied quality, which made it readily assimilable to the decorative patterning of these canvases."

10. Rosenblum 1971, pp. 47–50.

11. Quoted in Rubin 1970, p. 149.

GEORGE RICKEY

68. Four Lines Oblique Gyratory Rhombus

1. In a telephone conversation with the author (Feb. 16, 1999), Birgit Mieschonz, of the George Rickey Workshop, stated that the Museum's sculpture was probably begun in 1972 (the date of execution according to the Workshop's records) and completed in 1973 (the date incised on the sculpture's base).

2. Acquired by the Museum by agreement of transfer, 1988; installed and dedicated on the grounds of Smith College on Nov. 15, 1993.

3. Lecture by Rickey, University Art Gallery, State University of New York, Albany, Feb. 1987, in Merkert and Prinz 1992, pp. 344–56 (with revisions).

4. See Rosenthal 1977, a work indispensable to the study of Rickey's career; for his early training and evolution toward sculpture, see pp. 20–32.

5. South Bend 1985, p. 9.

6. The sculpture was originally intended to come to the Museum as the bequest of Robert H. and Ryda H. Levi. She wrote of their plans and also mentioned the artist's reaction to the news: "Mr. Rickey is well aware of our intentions [to bequeath the sculpture]. He would only sell it to us with the understanding that we would give it to 'a museum.' . . . He became enraptured by the idea of one [of two sculptures purchased by Mr. and Mrs. Levi] going to Smith, since his mother had attended the College" (Ryda H. Levi to Charles Chetham, director of the Museum, Sept. 18, 1975, Museum files). Rickey's associations with the college include not only his mother, Grace Landon Rickey, class of 1893, but his sister, Jane Rickey de Vall, class of 1934; his aunt, Mary Landon, class of 1893; and two cousins, Helen Cass Fisher, class of 1920, and Katherine Landon Colie, class of 1926.

7. Rosenthal 1977, pp. 56–59.

8. Rickey, quoted in Rosenthal 1977, p. 59. See p. 62 for a description of Rickey's invention of paired knife-edged and reversed knife-edged bearings, which allowed new possibilities of motion in space for the blades of his sculptures.

9. Letter to *Art Monthly*, no. 69 (Sept. 1983), in Merkert and Prinz 1992, p. 325.

10. Rosenthal 1977, pp. 67–68.

11. Merkert and Prinz 1992, p. 171, quoting letter from Rickey to Dr. Konrad Henkel, July 7, 1968. See pp. 171–75, no. 10, *Four Lines Oblique*, 1968, for the history of the commission and the maquettes.

12. Rickey, letter to *Art Monthly* (see note 9 above), in Merkert and Prinz 1992, p. 332.

13. Information provided by the George Rickey Workshop on Aug. 21, 1996. According to workshop records, *Four Lines Oblique Gyratory Rhombus Variation II* (1976) was created in an edition of three. Its height at rest is about 18 ft., the blade length is 8 ft., and the supporting (stationary) arm angle is 120 degrees. *Four Lines Oblique Gyratory Rhombus Variation III* (1988) was intended as an edition of three; as of August 1996, one sculpture in the edition had been completed. *Variation III* is 21 ft. 10 in. (with a maximum extended height of 26 ft. 7 in.), with a blade length of 10 ft. and a supporting arm angle of 120 degrees.

SOL LEWITT

69. Cube Structure Based on Nine Modules (Wall/Floor Piece #2)

1. Not shown at Montclair; not in catalogue.

2. Illustrated in the catalogue but not included in the exhibition.

3. See Sandler 1988, pp. 242–81.

4. Los Angeles 1995–96, p. 27.

5. For example, the artist's well-known "sentences" and "paragraphs" on conceptual art; see LeWitt 1967; LeWitt 1969.

6. LeWitt 1967, par. 2.

7. Subtitle of Kuspit 1975.

8. New York +, MoMA 1978, pp. 50–59.

9. Colpitt 1990, p. 81

10. LeWitt 1966 *Arts*, p. 25.

11. LeWitt 1967, par. 8.

12. LeWitt 1966 *Arts*, p. 24.

13. LeWitt 1966 *Aspen*, unpag.

14. Rosenblum, "Notes on Sol LeWitt," in New York +, MoMA 1978, pp. 15–16.

15. As Ulrich Loock states in Bern + [1989] 1992, pp. 7–9, in the more recent wall drawings the balance has been shifted toward perceptual issues rather than rigor of concept. In their execution, "taste" sometimes becomes a criterion by which some decisions are made: "the precision of verbally formulated plans appears to decrease in the extent to which the visual phenomenon . . . increasingly acquires sensorial complexity" (pp. 8–9).

16. Rosenblum in New York +, MoMA 1978, p. 20; Lippard in ibid., pp. 24–25.

17. LeWitt 1969, sentence 1.

JOAN SNYDER

70. My Temple, My Totems

1. Snyder in Purchase 1978, p. 8.

2. Purchase 1978, pp. 2, 20. Snyder's early work at Douglass College, where she discovered painting, was reminiscent of German Expressionists whose work she had not yet seen. During graduate work at Rutgers, she created collage paintings made of kitschy materials. See Gill 1987, pp. 129–35.

3. Waltham + 1994, p. 15.

4. Purchase 1978, p. 2.

5. Gill 1987, p. 135.

6. Ibid., pl. 135.

7. Allentown 1993–94, p. 17.

8. Conversation with the artist, Mar. 9, 1995, while she was creating monotypes at Smith College as part of the annual Print Workshop series. The comments that follow concerning totems in the Museum's painting are from that conversation.

9. Gill 1987, p. 135.

10. Allentown 1993–94, p. 21.

11. Tarlow 1987, pp. 14–15, 22; see esp. p. 14.

12. Conversation with the artist, see note 8 above.

13. Tarlow 1987, p. 22.

LOUISE NEVELSON

71. Mirror-Shadow XIII

1. The Smith College Center for Performing Arts owns a fifth Nevelson sculpture, a 1961 gold-painted assemblage titled *Half Moon II*.

2. ". . . you generously said that we should use our own judgment in organizing [*Moving-Static-Moving*]" (Museum director Charles Chetham to Louise Nevelson, June 18, 1973, Museum files).

3. Nevelson 1976, p. 126.

4. Ibid., p. 125.

5. Glimcher 1976, p. 65; Wilson 1981, pp. 34–35, 78–83.

6. Wilson 1981, p. 189.

7. Lisle 1990, pp. 255–56.

8. Paradiso 1986–87, p. 21.

9. Phillips 1985, p. 104.

DONALD SULTAN
72. *Ferry, Sept. 17, 1987*

1. Ian Dunlop in Chicago + 1987, pp. 8–25.

2. The news of the disaster was carried with photographs of the ferry before and after the accident in the *New York Times*, Mar. 7, 1987, pp. 1, 6. The headline read "Ferry with over 500 People Capsizes near Belgian Port; 350 are Safe, Many Trapped." The accident was caused by negligence: in an article in the *Times* of Apr. 28 ("Britain Opens Ferry Inquiry"), it was reported that a seaman had failed to secure the forward doors of the vessel. The ship was ultimately salvaged, refloated (*New York Times*, May 4, photograph and caption), and towed to a pier.

3. The photograph appeared in the *International Herald Tribune*, Apr. 8, 1987, p. 1. The caption read: "STERN DAMAGE—The badly damaged stern of the British Ferry *Herald of Free Enterprise* rising from the sea Tuesday during the salvage operation off the Belgian coast at Zeebrugge. The boat sank March 6 with the loss of more than 134 lives." The accompanying article by Peter Maass (p. 6) describes the salvage operations, which involved "three barges equipped with reinforced cranes, two pontoons carrying hydraulic winches and a flotilla of support vessels."

4. Rose 1986, pp. 17, 19.

5. Henry 1987, pp. 104–11; see esp. p. 107.

6. Ibid., p. 110.

7. Chicago + 1987, pp. 13–15; Henry 1987, p. 111.

8. Telephone conversation with the artist, Aug. 11, 1996.

9. Lynne Warren in Chicago + 1987, pp. 26–39.

10. Henry 1987, p. 106, cites an Edouard Manet still life Sultan had seen in the 1983 Manet retrospective at the Metropolitan Museum of Art, New York, as the inspiration for Sultan's series of paintings of lemons isolated and aggrandized as erotic icons. Dunlop (Chicago + 1987, pp. 19–22) cites Francisco de Zurbarán (1598–1664) as a partial inspiration for Sultan's lemon imagery.

11. Schmied 1995, pp. 108–10. The ship depicted in *The Polar Sea* was the *Griper*, one of Parry's ships from his polar expeditions in 1819–20 and 1824. The ship was not in fact wrecked but had survived a number of dangerous situations, according to Parry's accounts. As Schmied also points out, Friedrich's shipwreck has often been compared in the literature to Géricault's *Raft of the Medusa* as a contrast between German and French Romanticism.

12. Chicago + 1987, pp. 21–22, fig. 11.

13. Ibid., pp. 10–11, fig. 3.

14. Rose 1988, pp. 94–95.

JAUNE QUICK-TO-SEE SMITH
73. *The Red Mean: Self-Portrait*

1. The Museum's painting was shown only at the Jersey City and Bethlehem venues of the exhibition.

2. The artist, quoted in Trinkett Clark's essay-interview in the exhibition brochure for Norfolk + 1993, unpag.

3. Ibid.

4. Lucy Lippard in Jersey City + 1996–97, pp. 79–92; for the artist's early history, see pp. 79–83.

5. Cembalest 1992, p. 89.

6. The artist, interview with Alejandro Anreus, in Jersey City + 1996–97, p. 111.

7. This reading of the medicine wheel by viewers who do not recognize the reference is common among museum visitors and some writers. For example, one reviewer of Jersey City + 1996–97 (Watkins 1997, pp. 6–7) writes of *The Red Mean*: "A red X nullifies the figure at the center of 'The Red Mean: Self-Portrait.'" Quick-to-See Smith undoubtedly would have recognized that some viewers might understand the symbol differently; rather than being a misreading, the projection of an entirely different meaning on the sign by some viewers expands the dialectic of the painting.

8. The text fragment "Better Red" is a play on "Better Red than dead" and the reverse phrase, "Better dead than Red," both of which originally referred to Communism. Quick-to-See Smith appropriates the slogan and changes its meaning to refer to Native Americans.

9. Norfolk + 1993, unpag.

10. Cembalest 1992, pp. 90–91.

11. Information as of February 1998 issued by the Bureau of Indian Affairs (BIA), U.S. Department of the Interior "On the Web" (http://www.doi.gov/bureau-indian-affairs.html), lists the following criteria under "Who is an Indian?": "To be eligible for [BIA] services, an Indian must (1) be a member of a Tribe recognized by the Federal Government, (2) [be] one-half or more Indian blood of tribes indigenous to the United States (25USC 479); or (3) must, for some purposes, be of one-fourth or more Indian ancestry. . . . Most of the BIA's services and programs, however, are limited to Indians living on or near Indian reservations."

12. The Dawes act of 1887 provided grants of land to eligible Native American individuals, with 160 acres given to each head of household and 80 acres to each unmarried adult (other grants were made to individuals falling into different age or status categories). The lands thus assigned were held in trust for twenty-five years, after which time the individual would become the sole owner of the property and take on U.S. citizenship; however, "surplus" land could be sold outside the tribe to other settlers. The Dawes Commission was established in 1893 to negotiate with the "Five Civilized Tribes" (Cherokee, Choctaw, Creek, Chickasaw, and Seminole Nations) in order to dissolve tribal governments and implement the redistribution of tribal lands. For information on the history of the Dawes act, also called the Dawes General Allotment act and the Dawes Severalty act, see Otis 1973 (pp. 177–88 give the texts of the Dawes act of 1887 and the act of 1891, which extended the terms of the Dawes act). For a shorter synopsis, see Henry E. Fritz in Smith and Kvasnicka 1972, pp. 57–78. The author is grateful to Professor John D. Berry, Oklahoma State University, and to Professor Neal Salisbury, Smith College, for providing additional information on the Dawes Commission Rolls.

BETYE SAAR
74. *Ancestral Spirit Chair*

1. The artist's process is described in New York, Studio 1980, unpag. Saar's "prescribed series or sets of acts" are also enumerated in Los Angeles + 1990, p. 11 (see Lucy Lippard's "Sapphire and Ruby in the Indigo Gardens," pp. 10–20, for a description of Saar's career and a comparison of her work with that of her daughter, Alison Saar).

2. Pasadena 1966–67, catalogue introduction by James Demetrion.

3. Buffalo 1989, pp. 50–59.

4. Los Angeles 1992. The exhibition included eleven artists representing African American, Chicano, Native American, Pacific Island, and Asian American communities.

5. Sybil Venegas, guest curator of Los Angeles 1992, quoted in the press release for the exhibition.

6. Hewitt 1992, p. 19.

7. Robert Farris Thompson (New York +, African 1993–94, pp. 82–84) describes the relation of American bottle trees to what is essentially a Kongo funerary practice of placing pottery in trees and branches near grave sites. He points out that the usual definition of American bottle trees as a lure for evil spirits, which are then trapped in the glass, is substantially correct but may not reflect the original "richer message" of the tradition.

8. Washington, National Gallery 1981–82 *Four*, pp. 178–81.

9. While Betye and Alison Saar were in Northampton in 1991 to oversee the installation of *Secrets, Dialogues and Revelations* (a later venue of Los Angeles + 1990), Betye Saar and artist Sheila Pepe, then an intern at the Museum, took the opportunity to explore the surrounding area for objects and materials. During that expedition Ms. Pepe acquired a box of assorted bottles, which she later sent to Saar in California. After *Ancestral Spirit Chair* was acquired by the Museum and installed, Pepe on a return visit was surprised to discover that her bottles had been incorporated in the sculpture.

10. Gundaker to the author, Jan. 19, 1995 (Museum files).

11. Saar to the author, Sept. 12, 1995 (Museum files).

12. Letter cited in note 10, above.

13. Washington, National Gallery 1981–82 *Four*, pp. 27–33, quoted p. 28. Thompson notes a variety of shapes coded as the four moments of the sun, including a cross, a quartered circle, a spiral, or a cross with solar emblems at each ending.

14. Letter cited in note 10, above.

15. Los Angeles + 1990, p. 16.

16. Betye Saar, "Diaspora," 1992, quoted in Hewitt 1992, pp. 18–19, and excerpted here with the permission of the artist.

Checklist of Important American
Paintings and Sculpture
from the Smith College Museum of Art

Paintings

This chronological checklist includes important works not treated in the essay section of the catalogue. It is not a comprehensive listing of the American collection; however, a database of the collections of this Museum and other area college collections has been constructed and in the future will be available for access by scholars and the general public not only on site but through the internet.

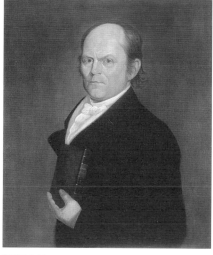

WILLIAM JENNYS
active in America 1793–1807

1. *David Coffin*, c. 1807
Oil on canvas, 29¾ × 24⅝ in. (75.6 × 62.5 cm) remaining original canvas; 30 × 25⅛ in. (76.2 × 63.8 cm) current canvas
Purchased with the Anne Dalrymple Hull, class of 1938, Fund and the gift of Mrs. Max Seltzer (Selma Pelonsky, class of 1919) (1995:2-1)

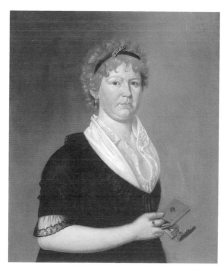

WILLIAM JENNYS
active in America 1793–1807

2. *Elizabeth Stone Coffin*, c. 1807
Oil on canvas, 30⅛ × 25⅛ in. (76.5 × 63.8 cm)
Purchased with the Kathleen Compton Sherrerd, class of 1954, Acquisition Fund for American Art (1995:2-2)

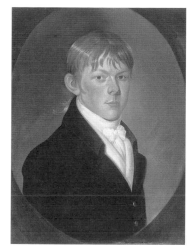

WILLIAM JENNYS
active in America 1793–1807

3. *Nathaniel Coffin*, c. 1807
Oil on canvas, 24¹/₁₆ × 17¾ in. (61.1 × 45.1 cm)
Purchased (1975:5-2)

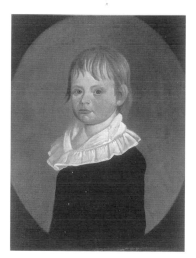

WILLIAM JENNYS
active in America 1793–1807

4. *Isaac Stone Coffin*, c. 1807
Oil on canvas, 24 × 17⅝ in. (61 × 44.8 cm)
Purchased (1975:5-1)

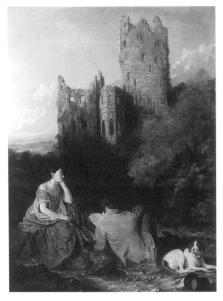

LILLY MARTIN SPENCER
Exeter, England 1822–1902
New York

5. *Reading the Legend,* 1852
Oil on canvas, 50⅜ × 38 in. (127.9 × 96.5 cm)
Gift of Adeline F. Wing, class of 1898, and
Caroline R. Wing, class of 1896 (1954:69)

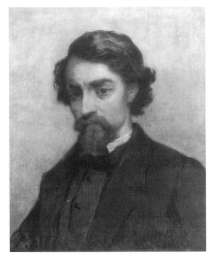

WILLIAM MORRIS HUNT
Brattleboro, Vermont 1824–1879 Isles of
Shoals, New Hampshire

7. *William Sidney Thayer,* c. 1865
Oil on canvas mounted on wallboard,
21⅞ × 18 in. (55.5 × 45.7 cm)
Gift of Sarah S. Thayer, 1897 or 1898 (1900:8)

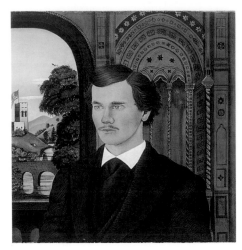

EDWIN ROMANZO ELMER
Ashfield, Massachusetts 1850–1923 Ashfield,
Massachusetts

10. *Portrait of My Brother,* c. 1875
Oil on canvas, 11 × 10⅞ in. (28 × 27.5 cm)
Bequest of Maud V. Elmer, daughter of
Samuel Elmer, the sitter, and niece of the
artist (1963:92)

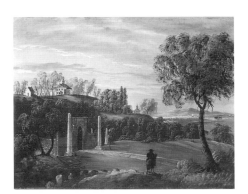

WILLIAM MATTHEW PRIOR
Bath, Maine 1806–1873 East Boston,
Massachusetts

6. *Mount Vernon and the Tomb of
Washington,* after 1852
Oil on canvas, 18¾ × 28¾ in. (47.7 × 73 cm)
Purchased (1950:72)

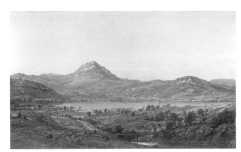

JASPER CROPSEY
Staten Island, New York 1823–1900
New York

8. *Sugar Loaf and Wickham
Pond,* 1867
Oil on canvas, 12 × 20 in. (30.5 × 50.8 cm)
Purchased with the Eleanor Lamont
Cunningham, class of 1932, Fund (1952:18)

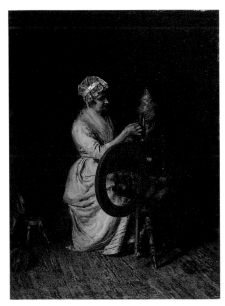

THOMAS EAKINS
Philadelphia 1844–1916 Philadelphia

11. *In Grandmother's Time,* 1876
Oil on canvas, 16 × 12 in. (40.6 × 30.5 cm)
Purchased from the artist (1879:1-1)

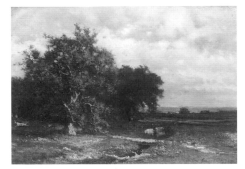

GEORGE INNESS
Newburgh, New York 1825–1894
Bridge-of-Allan, Scotland

9. *Cloudy Day,* 1868
Oil on canvas, 14 × 20 in. (35.6 × 50.8 cm)
Gift of Mrs. John Stewart Dalrymple
(Bernice Barber, class of 1910) (1960:41)

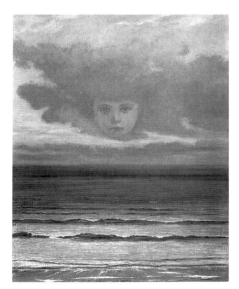

ELIHU VEDDER
New York 1836–1923 Rome, Italy

12. *Memory*, c. 1876–78
Oil on canvas, 13 × 10¼ in. (33 × 25.9 cm)
Gift of Charles E. Buckley (1986:37)

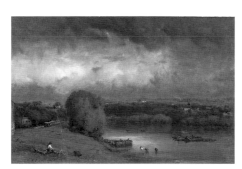

GEORGE INNESS
Newburgh, New York 1825–1894 Bridge-of-
Allan, Scotland

13. *Along the Delaware*, 1878
Oil on canvas, 16 × 24 in. (40.6 × 61 cm)
Purchased (1951:193)

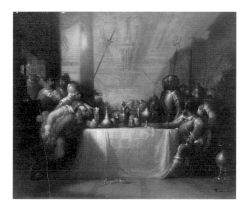

WILLIAM RIMMER
Liverpool, England 1816–1879 South Milford,
Massachusetts

14. *The Gamblers, Plunderers of Castile*,
1878–79
Oil on canvas, 14 × 17 in. (35.6 × 43.2 cm)
Purchased (1950:107)

JAMES WELLS CHAMPNEY
Boston 1843–1903 New York

15. *Boon Companions*, 1879
Oil on canvas, 17¼ × 21¼ in. (43.8 × 53.9 cm)
Purchased from the artist (1900:29)

FREDERIC EDWIN CHURCH
Brooklyn, New York 1826–1900 New York

16. *Morning in the Tropics*, 1883
Oil on canvas, 16 × 24 in. (40.7 × 61 cm)
Purchased with the Winthrop Hillyer Fund
(1891:2-1)

CHARLES SPRAGUE PEARCE
Boston 1851–1914 Auvers-sur-Oise, France

17. *A Cup of Tea*, 1883
Oil on canvas, 27 × 22½ in. (68.6 × 57.1 cm)
Bequest of Annie Swan Coburn (Mrs. Lewis
Larned Coburn) (1934:3-6)

DE SCOTT EVANS (S.S. David)
(?) Indiana 1847–1898 at sea en route to
France

18. *Try One*, late 1880s–early 1890s
Oil on canvas, 11¾ × 10 in.
(29.8 × 25.4 cm)
Gift of Mr. and Mrs. John W. Gude (Sallylee
Jansen, class of 1948) (1991:41)

JOHN FREDERICK PETO
Philadelphia 1854–1907 New York

19. *Old Friends*, 1880s
Oil on academy board, 6⅛ × 9¼ in.
(15.5 × 23.5 cm)
Gift of Dorothy C. Miller, class of 1925 (Mrs.
Holger Cahill), in honor of Alfred H. Barr,
Jr. (1986:26)

JOHN FREDERICK PETO
Philadelphia 1854–1907 New York

20. *Still Life with Books and Candle*,
c. 1890–1900
Oil on canvas, 12¼ × 20⅜ in. (31.1 × 51.7 cm)
Gift of Mrs. Malcolm Chace, Jr. (Beatrice
Oenslager, class of 1928) (1991:27)

EDWIN ROMANZO ELMER
Ashfield, Massachusetts 1850–1923 Ashfield,
Massachusetts

21. *The Mary Lyon Birthplace*, 1891
Oil on canvas, 21¾ × 28³⁄₁₆ in. (55.3 × 71.6 cm)
Purchased (1976:37)

CHILDE HASSAM
Dorchester, Massachusetts 1859–1935 East
Hampton, New York

23. *Union Square in Spring*, 1896
Oil on canvas, 21½ × 21 in. (54.5 × 53.3 cm)
Purchased (1905:3-1)

WILLIAM MERRITT CHASE
Franklin, Indiana 1849–1916 New York

26. *View of Fiesole*, 1907
Oil on panel, 11¾ × 16 in. (29.8 × 46.2 cm)
Purchased (1952:109)

CHILDE HASSAM
Dorchester, Massachusetts 1859–1935 East
Hampton, New York

22. *Street Scene, Christmas Morn*, 1892
Oil on panel, 11¾ × 8 in. (29.8 × 20.3 cm)
Bequest of Annie Swan Coburn (Mrs. Lewis
Larned Coburn) (1934:3-3)

JOHN SINGER SARGENT
Florence, Italy 1856–1925 London

24. *Hell*, c. 1909–14
Oil on canvas, 33¼ × 66¼ in. (84.5 × 168.2 cm)
Gift of Mrs. Dwight W. Morrow (Elizabeth
Cutter, class of 1896) (1932:14-1)

MORTON LIVINGSTON SCHAMBERG
Philadelphia 1881–1918 Philadelphia

27. *Landscape*, 1915
Oil on canvas, 14 × 10⅛ in. (35.6 × 25.6 cm)
Purchased out of proceeds from the sale of
a work donated by Mr. and Mrs. Alexander
Rittmaster (Sylvian Goodkind, class of 1937)
in 1958 (1991:18-1)

JOHN SINGER SARGENT
Florence, Italy 1856–1925 London

25. *Heaven*, c. 1909–14
Oil on canvas with applied cloth and gilding,
33¼ × 66¼ in. (84.5 × 168.2 cm)
Gift of Mrs. Dwight W. Morrow (Elizabeth
Cutter, class of 1896) (1932:14-2)

MORTON LIVINGSTON SCHAMBERG
Philadelphia 1881–1918 Philadelphia

28. *Victory*, 1915
Oil on board, 13¾ × 10 in. (34.9 × 25.4 cm)
Purchased out of the proceeds from the sale
of a work donated by Mr. and Mrs. Alexander
Rittmaster (Sylvian Goodkind, class of 1937)
in 1958 (1991:18-2)

ISABEL BISHOP
Cincinnati, Ohio 1902–1988 New York

31. *Self-Portrait*, c. 1928
Oil on canvas, 9⅞ × 7⅞ in. (25.1 × 19.4 cm)
Gift of Mr. and Mrs. Joseph H. Hazen
(1955:54)

JOHN WILSON
b. Boston 1922

33. *My Brother*, 1942
Oil on panel, 12 × 10⅝ in. (30.5 × 27 cm)
Purchased from the artist (1943:4-1)

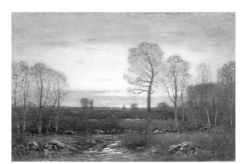

DWIGHT WILLIAM TRYON
Hartford, Connecticut 1849–1925 South
Dartmouth, Massachusetts

29. *November Evening*, 1924
Oil on panel, 20 × 30 in. (50.8 × 76.2 cm)
Gift of Dwight William Tryon (1925:6-1)

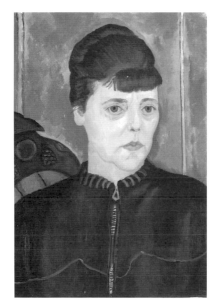

HELEN TORR
Roxbury, Pennsylvania 1886–1967 Bayshore,
New York

32. *I*, 1935
Oil on canvas, 19¼ × 13¼ in. (48.9 × 33.6 cm)
Gift of Nancy Stein Simpson, class of 1963,
in memory of Samuel Stein (1993:18)

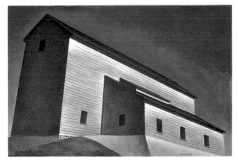

CHARLES SHEELER
Philadelphia 1883–1965 Dobbs Ferry,
New York

34. *Powerhouse*, 1943
Oil on canvas, 15½ × 22¾ in. (39.4 × 56.5 cm)
Bequest of Louise W. Kahn (Louise Wolff,
class of 1931) and Edmund J. Kahn (1996:5-1)

GEORGIA O'KEEFFE
Sun Prairie, Wisconsin 1887–1986 Santa Fe,
New Mexico

30. *Squash Flowers No. 1*, 1925
Oil on cardboard, 13¾ × 18¹/₁₆ in. (35 × 45.9 cm)
Gift of Mr. and Mrs. Allan D. Emil (1955:46)
© 1998 The Georgia O'Keeffe Foundation/
Artists Rights Society (ARS), New York

BEN SHAHN
Kovno, Lithuania 1898–1969
New York

35. *Sound in the Mulberry Tree*, 1948
Tempera on paper on canvas, mounted on
panel, 48 × 36 in. (121.9 × 91.5 cm)
Purchased (1948:5-1)
© Estate of Ben Shahn / Licensed by VAGA,
New York

MILTON AVERY
Albany, New York 1893–1965
New York

36. *Surf Fisherman*, 1950
Oil on canvas, 30 × 42 in. (76.2 × 106.7 cm)
Gift of Roy R. Neuberger (1953:51)
© 1998 Milton Avery Trust / Artists Rights
Society (ARS), New York

KAY SAGE
Albany, New York 1898–1963 Woodbury,
Connecticut

37. *Remote Control*, 1951
Oil on canvas, 10¼ × 12 in. (26 × 30.5 cm)
Gift of the estate of Kay Sage Tanguy
(1964:43)

GRACE HARTIGAN
b. Newark, New Jersey 1922

38. *Bride and Owl*, 1954
Oil on canvas, 72⅛ × 54⅛ in. (182.6 × 137.5 cm)
Anonymous gift (1997:17)

JOAN MITCHELL
Chicago 1926–1992 Paris

39. *Keep the Aspidistra Flying*, 1956
Oil on canvas, 31¾ × 45⅝ in. (80.7 × 115.9 cm)
Gift of Mr. and Mrs. Philip Von Blon (Joanne
Witmer, class of 1945) (1988:36)

LOREN MACIVER
New York 1909–1998 New York

40. *Subway Lights*, 1959
Oil on canvas, 50 × 35 in. (127 × 89 cm)
Purchased with funds given by friends of
the artist (1973:11)

ROBERT MOTHERWELL
Aberdeen, Washington 1915–1991
Provincetown, Massachusetts

41. *Elegy Study,* 1959
Oil on canvasboard, 10 × 13¾ in.
(25.4 × 34.9 cm)
Purchased with the gift of Enid Silver
Winslow, class of 1954, and the Madeline H.
Russell, class of 1937, Fund and the Dedalus
Foundation (1995:7-2)
© Dedalus Foundation/Licensed by VAGA,
New York

RICHARD ARTSCHWAGER
b. Washington, D.C. 1923

42. *High Rise Apartment,* 1964
Liquitex on celotex with formica,
63 × 48 × 4½ in. (160 × 122 × 11.4 cm)
Gift of Philip Johnson (1972:6-2)
© 1998 Richard Artschwager/Artists Rights
Society (ARS), New York

ALICE NEEL
Merion Square, Pennsylvania 1900–1984
New York

43. *Anthony Barton,* 1968
Oil on canvas, 46 × 30 in. (116.9 × 76.2 cm)
Gift of Richard Neel and Hartley S. Neel
(1995:42)
© The Estate of Alice Neel

MARK ROTHKO
Dvinsk, Russia 1903–1970 New York

44. *Untitled,* 1968
Acrylic on paper mounted on masonite,
32⅞ × 25¼ in. (83.2 × 64.5 cm)
Gift of the Mark Rothko Foundation, Inc.
(1986:3-1)
© 1998 Kate Rothko Prizel and Christopher
Rothko/Artists Rights Society (ARS),
New York

MARK ROTHKO
Dvinsk, Russia 1903–1970 New York

45. *Untitled,* 1968
Acrylic on paper mounted on masonite,
24¹⁄₁₆ × 18³⁄₁₆ in. (61.1 × 46.2 cm)
Gift of the Mark Rothko Foundation, Inc.
(1986:3-2)
© 1998 Kate Rothko Prizel and Christopher
Rothko/Artists Rights Society (ARS),
New York

SYLVIA PLIMACK MANGOLD
b. New York 1938

46. *Yardstick Margin Being Painted,* 1976
Acrylic on canvas, 25¼ × 25⅜ in.
(64.2 × 64.5 cm)
Gift of Mr. and Mrs. William A. Small, Jr.
(Susan Spencer, class of 1948) (1994:11-73)

NEIL G. WELLIVER
b. Millville, Pennsylvania 1929

47. *Winter Stream*, 1976
Oil on canvas, 96 × 96 in. (243.8 × 243.8 cm)
Gift of Mrs. Leonard S. Mudge in memory of
Polly Mudge Welliver, class of 1960 (1978:13)

CHERYL LAEMMLE
b. Minneapolis, Minnesota 1947

49. *Two Sisters*, 1984
Oil on canvas with wood fence, 73 × 84 ×
3½ in. (193.5 × 238.9 × 8.9 cm)
Gift of Arthur G. Rosen in honor
of Deborah R. Sonzogni, Ada Comstock
Scholar, class of 1993 (1991:67)

GEORGE MCNEIL
New York 1908–1995 New York

52. *Spring Street*, 1987
Acrylic on canvas, 77½ × 64 in.
(196.9 × 162.6 cm)
Gift of Mr. and Mrs. William A. Small, Jr.
(Susan Spencer, class of 1948) (1994:11-77)

PHILIP GUSTON
Montreal, Canada 1913–1980 Woodstock,
New York

48. *Sunrise*, 1978
Oil on canvas, 68½ × 88¼ in. (174 × 224.3 cm)
Bequest of Musa Guston (1992:40-2)

SANDY SKOGLUND
b. Boston 1946

50. *Tools of Expression*, 1986
Acrylic on canvas, 72 × 108 in. (183 × 274.6 cm)
Gift of Castelli Graphics (1991:31)

CHRISTOPHER BROWN
b. Camp Lejeune, North Carolina 1951

53. *China*, 1987
Acrylic on canvas, 87 × 72 in. (221 × 182.9 cm)
Gift of Mr. and Mrs. William A. Small, Jr.
(Susan Spencer, class of 1948) (1994:11-58)

GEORGE MCNEIL
New York 1908–1995 New York

51. *Darkling Disco*, 1986
Acrylic on canvas, 78 × 64¼ in.
(198.1 × 163.2 cm)
Gift of Mr. and Mrs. William A. Small, Jr.
(Susan Spencer, class of 1948) (1994:11-60)

STEPHEN ANTONAKOS
b. Agios Nikolaos, Lakonia, Greece 1926

54. *Archangel Gabriel*, 1989
White gold leaf on wood with neon tubing,
30 × 25 × 4½ in. (76.2 × 63.5 × 11.4 cm)
Purchased (1997:27)

CARMEN LOMAS GARZA
b. Kingsville, Texas 1948

56. *The Blessing on Wedding Day (La Bendición en el Día de la Boda)*, 1993
Alkyd on canvas, 24 × 32 in. (61 × 81.3 cm)
Purchased with the Josephine A. Stein, class of 1927, Fund in honor of the class of 1927
(1995:31)

STEPHEN HANNOCK
b. Albany, New York 1951

57. *The Oxbow, after Church, after Cole, Flooded: 1979–1994 (Flooded River for the Matriarchs, E. and A. Mongan)*, 1994
Polished oil on canvas, 54 × 81 in.
(137.2 × 205.8 cm)
Gift of Irene Mennen Hunter, class of 1939
(1995:1)

SAM GILLIAM
b. Tupelo, Mississippi 1933

55. *Uli Montage*, *You Come Flying*, and *Higher Windows*, 1992–93
Triptych, acrylic on polypropylene on board,
88 × 44 in. (223.6 × 111.8 cm), 89 × 45 in.
(226.1 × 114.3 cm), 88 × 47 in. (223.6 × 119.5 cm)
Gift of Ann Winkelman Brown, class of 1959, and Donald A. Brown (1994:33-1,2,3)

JANET FISH
b. Boston 1938

58. *Herb Tea*, 1995
Oil on canvas, 36 × 60 in. (91.5 × 152.4 cm)
Purchased with the Janet Wright Ketcham, class of 1953, Art Acquisition Fund, the Class of 1990 Art Fund, and with gifts made in honor of President Mary Maples Dunn
(1996:8)

Sculpture

THOMAS BALL
New York 1819–1911 New York

59. *Daniel Webster*, 1853
Parian ware, 26 × 9¼ × 8¾ in.
(66 × 23.5 × 22.2 cm)
Purchased with funds from the Eleanor
Lamont Cunningham, class of 1932, Fund
(1952:11)

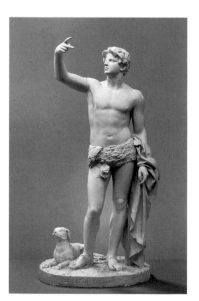

ANNE WHITNEY
Watertown, Massachusetts 1821–1915 Boston

60. *Chaldean Shepherd*, c. 1868
Plaster, 34 × 15½ × 14⅝ in.
(84.5 × 39.4 × 37.2 cm)
Gift of Mrs. Hugh Stratton Hince (Marion L.
Stone, class of 1913) (1967:50)

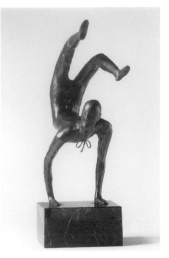

ELIE NADELMAN
Warsaw, Poland 1882–1946 New York

61. *Acrobat*, c. 1916
Bronze with dark patina on marble base,
14⅛ × 5 × 9⁷⁄₁₆ in. (35.9 × 12.7 × 24.6 cm)
Bequest of Mrs. Richard H. Pough (Moira
Flannery, class of 1929) (1986:61)

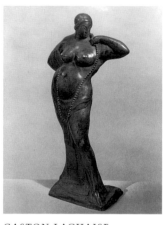

GASTON LACHAISE
Paris 1882–1935 New York

62. *La Force Eternelle (Woman with
Beads)*, 1917
Bronze, 12½ × 4 × 5½ in. (31.1 × 10.2 × 14 cm)
Gift of Stephan Bourgeois (1923:6-1)

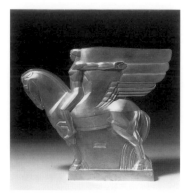

JOHN STORRS
Chicago 1885–1956 Mer, Loir-et-Cher, France

63. *Winged Figure*, c. 1919
Bronze, 11½ × 12¾ × 2¾ in. (29.2 × 32.4 × 7 cm)
Gift of Marcella Harrington Loveless, class
of 1945 (1992:12-1)

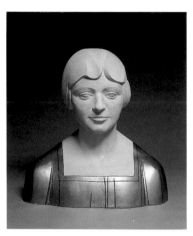

JOHN STORRS
Chicago 1885–1956 Mer, Loir-et-Cher, France

64. *Edna Harrington*, 1920s
Plaster with gold and red paint,
16 × 15½ × 7½ in. (40.6 × 39.5 × 19 cm)
Gift of Marcella Harrington Loveless, class
of 1945 (1992:12-2)

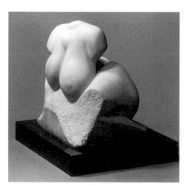

GASTON LACHAISE
Paris 1882–1935 New York

65. *Torso*, 1933
Marble, 11¾ × 12 × 9 in. (29.8 × 30.5 × 22.9 cm)
Anonymous gift (1935:6-1)

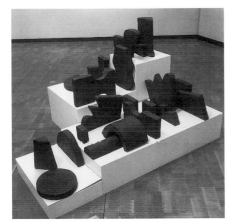

LOUISE NEVELSON
Near Kiev, Ukraine, Russia 1899–1988
New York

66. *Moving-Static-Moving*, 1955
Terra cotta, 21 pieces of various sizes
Gift of the artist (1973:27-3)
© 1998 Estate of Louise Nevelson/Artists
Rights Society (ARS), New York

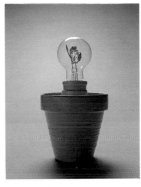

DAN FLAVIN
New York 1933–1997 Wainscott, New York

SONJA FLAVIN
b. New York 1936

68. *The Barbara Roses 3D*, 1962–65
Mixed media, edition 5/10, 8¼ × 4¾ × 4¾ in.
(21 × 12 × 12 cm)
Gift of Philip Johnson (1975:36-4)
© 1998 Estate of Dan Flavin/Artists Rights
Society (ARS), New York

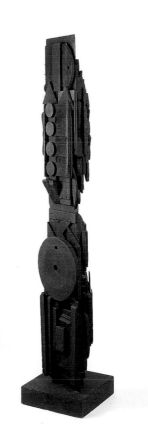

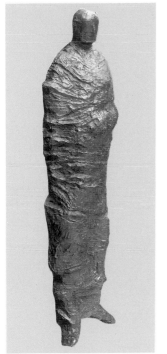

LEONARD BASKIN
b. New Brunswick, New Jersey 1922

67. *Great Bronze Dead Man*, 1961
Bronze, height 72 in. (190 cm)
Gift of Mr. and Mrs. Leonard Baskin
(1964:30)

MARY BAUERMEISTER
b. Frankfurt, Germany 1934

69. *Eighteen Rows*, 1962–68
Pebbles and epoxy on linen-covered board,
17⅝ × 17¾ × 2⅞ in. (44.6 × 45.1 × 7.4 cm)
Gift of Dorothy C. Miller (Mrs. Holger
Cahill, class of 1925) (1972:42-1)

LOUISE NEVELSON
Near Kiev, Ukraine, Russia 1899–1988
New York

70. *Distant Column*, 1963
Wood, painted black, 80 × 15 × 12½ in.
(203.2 × 38.1 × 31.7 cm)
Purchased with funds given by Donald Millar
in honor of his daughters, Brenda M. Baldwin
(Brenda Millar, class of 1949) and Mrs. John
W. O'Boyle (Nancy Millar, class of 1952)
(1972:10)
© 1998 Estate of Louise Nevelson/Artists
Rights Society (ARS), New York

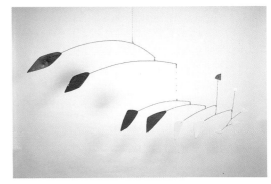

ALEXANDER CALDER
Philadelphia 1898–1976 New York

71. *White Spray*, 1964
Painted metal, 34 × 73 × 40½ in.
(86.5 × 185.4 × 102.8 cm)
Purchased with funds given by the estate
of Mrs. Chapin Riley (Mary Alexander, class
of 1930) (1965:9)
© 1998 Estate of Alexander Calder/Artists
Rights Society (ARS), New York

DONALD JUDD
Excelsior Springs, Missouri 1928–1994
New York

72. *Untitled*, 1965
Iron and lacquer, 24 × 27⅛ × 6 in.
(61 × 68.9 × 15.2 cm)
Gift of Jane Timken, class of 1964 (1992:35-1)
© Estate of Donald Judd/Licensed by
VAGA, New York

LARRY BELL
b. Chicago 1939

74. *Untitled*, 1969
Vacuum-plated glass with chrome binding,
18¼ × 18¼ × 18¼ in. (46.1 × 46.1 × 46.1 cm)
Purchased (1972:7)

CHRISTO (Christo Javacheff)
b. Gabrovo, Bulgaria 1935

77. *Double Show Window*, 1972
Wood, paint, Plexiglas, and aluminum,
edition 33/65, each window 35¾ × 32⅞ × 3 in.
(90.8 × 83.5 × 7.6 cm)
Gift of Rosa Esman (Rosa Mencher, class of
1948) in honor of her fortieth reunion
(1987:36-1a, b)

ELLIOT OFFNER
b. Brooklyn, New York 1931

75. *Helmeted Head*, c. 1970
Bronze, 11 × 7½ × 9 in. (28 × 19.1 × 22.9 cm)
Gift of Richard B. Trousdell and Craig M.
Felton in memory of Lt. Col. Clifford R.
Kaiser (1904–1996) (1997:19)

LOUISE NEVELSON
Near Kiev, Ukraine, Russia 1899–1988
New York

73. *Canada Series III*, 1968
Plexiglas with metal screws and bolts,
44⅝ × 31 × 11½ in. (113.3 × 78.8 × 29.2 cm)
Gift of Valerie Tishman Diker,
class of 1959 (1994:34)
© 1998 Estate of Louise Nevelson/Artists
Rights Society (ARS), New York

MICHAEL DE LISIO
b. New York 1911

76. *Shakespeare and Company*, 1970–73
Bronze with oak base, edition 1/5,
48 × 30⅛ × 2 in. at base (121.9 × 76.5 × 5.1 cm)
Purchased (1979:15)

GEORGE RICKEY
b. South Bend, Indiana 1907

78. *Two Lines Leaning IV (A.h.c)*, 1973
Stainless steel, 11½ feet (350.5 cm) high, each
blade 8 feet (243.8 cm) long
Gift of George Rickey in honor of Charles
Chetham (1987:37)
© George Rickey/Licensed by VAGA,
New York

YURIKO YAMAGUCHI
b. Osaka, Japan 1948

84. *Origin #1*, 1989
Wood, wire, glass jars (32 sections), 64 × 84 × 9½ in. (162.6 × 213.4 × 24.1 cm) overall
Purchased with funds from the National Endowment for the Arts and the Museum members, Smith College Museum of Art (1989:26)

RICHARD STANKIEWICZ
Philadelphia 1922–1983 Worthington, Massachusetts

79. *Untitled*, 1975
Steel, 64⅜ diam. × 2 in. (163.5 diam. × 5.1 cm)
Purchased with funds given in honor of Mildred and Frederick Mayer by their daughter, Elizabeth Mayer Boeckman, class of 1954 (1977:22)

VIOLA FREY
b. Lodi, California 1933

82. *World Civilization #5*, 1987
Glazed ceramic, 56 × 23 × 16 in. (142.2 × 58.4 × 40.6 cm)
Purchased with funds contributed by Friends of the Smith College Museum of Art in honor of Charles Parkhurst (1992:49a, b)

JACKIE FERRARA
b. Detroit, Michigan 1929

80. *1/4 M 161 C, A/C3, C*, 1976
Masonite (3 sections), 7½ × 25¾ × 25¾ in. (19 × 65.4 × 65.4 cm) overall
Gift of Michael and Leslie Engl (1994:6a, b, c)

PAT WARD WILLIAMS
b. Philadelphia 1948

83. *Ghosts That Smell Like Cornbread*, 1987
Cyanotype, Vandyke, family snapshots, window frames, fabric, stones, broken cup, 67 × 42 × 42 in. (170.2 × 106.7 × 106.7 cm)
Purchased with funds from the Beatrice Oenslager Chace, class of 1928, Fund and the Janet Wright Ketcham, class of 1953, Art Acquisition Fund (1993:1)

HAIM STEINBACH
b. Rechvot, Israel 1944

81. *no wires, no power cord #2*, 1986
Formica, wood, Nike athletic shoes, five black-painted Conran's trays, 28¾ × 46½ × 18½ in. (73 × 118.1 × 47 cm)
Gift of Barbara Jakobson (Barbara Petchesky, class of 1954) in memory of Constance Ellis (1991:43)

GRACE KNOWLTON
b. Buffalo, New York 1932

85. Three forms from the *Brooklin* series, 1991 (photographed by the artist on her property)
Copper, each c. 45–55 in. (114.3–139.7 cm) in height
Gift in honor of the 40th reunion of the class of 1954 from the artist (Grace Farrar Knowlton, class of 1954) and class members Nancy Grinnell Barnum, Rena Glazier Bransten, Joan Lebold Cohen, Barbara Jakobson, Eliot Chace Nolen, Constance Wurtele Packard, Kathleen Compton Sherrerd, Isabel Brewster Van Dine, Elsie Trask Wheeler, Enid Silver Winslow, and an anonymous member of the class (1994:10-1,2,3)

References

A plus sign (+) after the city location indicates multiple venues for an exhibition. In the short titles for exhibitions, the date refers to that of the first venue of the exhibition. Unless noted otherwise in the entry, exhibitions are assumed to be organized by the institution at which they first appeared. Places that are self-evident, either from the short-title listing or from the name of the venue, are not repeated within the entries. (See also "A Note on the Catalogue," p. 14.)

Abbott 1936. J[ere] A[bbott]. "A Collage and a Mobile." *Smith College Museum of Art Bulletin*, no. 17 (June), pp. 16–17.

———— 1940. Jere Abbott. "Burchfield and Sheeler for the U.S. Collection at Smith College." *Art News*, vol. 39, no. 11 (Dec. 14), pp. 12, 17.

———— 1941. J[ere] A[bbott]. "Rolling Power." *Smith College Museum of Art Bulletin*, no. 22 (June), pp. 3–4.

Adams 1914. Herbert H. Adams. "Paul Manship." *Art and Progress*, vol. 6, no. 1 (Nov.), pp. 20–24.

Adams 1923. Adeline Adams. *The Spirit of American Sculpture*. New York.

———— 1938. Adeline Adams. *Childe Hassam*. New York.

Affhauser 1943. M[yrtle] A[ffhauser]. "T. Chambers." *Smith College Museum of Art Bulletin*, no. 24 (Oct.), pp. 14–15.

Agard 1951. William R. Agard. *Classical Myths in Sculpture*. Madison, Wis.

Akron 1951. *Figurehead and Weathervane*. Akron (Ohio) Art Institute, Feb.–Mar. 4.

Akron 1982. *William Merritt Chase Portraits*. Akron (Ohio) Art Museum, June 5–Aug. 29.

Albers [1963] 1971. Josef Albers. *Interaction of Color*. Rev. ed. New Haven and London.

Albion 1861. "National Academy of Design: Concluding Notice." *Albion*, Apr. 20, 1861, p. 189.

Allentown 1961. *Charles Sheeler: Retrospective Exhibition*. Allentown (Pa.) Art Museum, Nov. 17–Dec. 31.

Allentown 1993–94. Sarah Anne McNear. *Joan Snyder: Works with Paper*. Allentown (Pa.) Art Museum, Oct. 8–Jan. 2.

Amer Art 1917. "American Contemporary Art Display." *American Art News*, vol. 16, no. 6 (Nov. 17), p. 3.

Amer Art 1985. "Letters." *American Art Journal*, vol. 17, no. 1 (winter), p. 93.

Amer Coll 1948. *American Collector*, vol. 16 (Jan.).

Amer Mag 1939. "Exhibition Reviews." *American Magazine of Art*, vol. 32, no. 5 (May), pp. 294–302, 314–15.

America 1950. "Realistic Still Life." *America*, no. 39 (Apr.), pp. 32 35.

Ames + 1975–76. *American Art in the Making: Preparatory Studies for Masterpieces of American Painting, 1800–1900*. Organized by Smithsonian Institution Traveling Exhibition Service. Brunnier Gallery, Iowa State University, Ames, Dec. 15–Jan. 26; San Jose (Calif.) Museum of Art, Feb. 7–Mar. 7; J. B. Speed Art Museum, Louisville, Ky., Mar. 27–Apr. 25; Charleston (W.Va.) Gallery of Sunrise, May 15–June 13; Davison Art Center, Wesleyan University, Middletown, Conn., July 3–Aug. 1; Beaumont (Tex.) Art Museum, Aug. 21–Sept. 19; Wichita (Kans.) State University, Nov. 27–Dec. 26; Corcoran Gallery of Art, Washington, D.C., Jan. 11–Feb. 6, 1977.

Amherst 1956. *20th-Century American Painting*. Mead Art Gallery, Amherst (Mass.) College, May.

Amherst 1958. *American Art II: An Exhibition in Connection with the Armory Retrospective*. Jones Library, Amherst (Mass.) College, Feb. 14–Mar. 17.

Amherst 1966. *Op Art*. University of Massachusetts, Amherst, Mar. 13–Apr. 1.

Amherst 1968. *Art for Study: The Modern Tradition*. Mead Art Museum, Amherst (Mass.) College, Sept. 11–Oct. 16.

Amherst 1974. *American Folk Art*. Mead Art Museum, Amherst (Mass.) College, Oct. 1–30.

Amherst 1980. *Women Artists, 1600–1980: Selections from Five College Collections*. Mead Art Museum, Amherst (Mass.) College, Mar. 12–Apr. 21.

Amherst 1995. *In Two Worlds: The Graphic Work of Modern Sculptors*. Mead Art Museum, Amherst (Mass.) College, Oct. 20–Dec. 20.

Ammerman 1991. Rebecca Miller Ammerman. "The Standing Naked Goddess: A Group of Archaic Terracotta Figurines from Pæstum." *American Journal of Archaeology*, vol. 95, pp. 203–30.

Amsterdam + 1963. *Franz Kline*. Organized by International Council, Museum of Modern Art, New York. Stedelijk Museum, Amsterdam, Sept. 20–Oct. 20; Galleria Civica d'Arte Moderna, Turin, Nov. 5–Dec. 1; Palais des Beaux-Arts, Brussels, Dec. 13–Jan. 19, 1964; Kunsthalle Basel, Jan. 31–Mar. 1; Museum des 20. Jahrhunderts, Vienna, Mar. 16–Apr. 12; Whitechapel Art Gallery, London, May 13–June 14; Musée National d'Art Moderne, Paris, June 30–Sept. 30. Separate catalogues for each venue.

Amsterdam + 1968. Thomas B. Hess. *Willem de Kooning*. Stedelijk Museum, Amsterdam, Sept. 19–Nov. 17; Tate Gallery, London, Dec. 5–Jan. 26, 1969; Museum of Modern Art, New York (organizer), Mar. 6–Apr. 27; Art Institute of Chicago, May 17–July 6; Los Angeles County Museum of Art, July 29–Sept. 14.

Anderson 1982. *Hopper*. Susan Heller Anderson. "Exhibition Stresses Edward Hopper Boyhood." *New York Times*, July 26, p. C12.

Andover 1932. *American Paintings in New England*. Addison Gallery of American Art, Phillips Academy, Andover, Mass., May 25–June 22.

Andover 1938. *Lyonel Feininger*. Addison Gallery of American Art, Phillips Academy, Andover, Mass., Feb. 19–Mar. 20.

Andover 1946. *Charles Sheeler: Paintings, Drawings and Photographs*. Addison Gallery of American Art, Phillips Academy, Andover, Mass., Oct. 25–Nov. 25.

Ann Arbor 1972. *Art and the Excited Spirit: America in the Romantic Period.* Museum of Art, University of Michigan, Mar. 19–May 14.

Ann Arbor 1978. *Whistler: The Later Years.* Museum of Art, University of Michigan, Aug. 27–Oct. 8.

Antiques 1933. "Early Wood Sculpture." *The Magazine Antiques,* vol. 24, no. 6 (Dec.), pp. 228–29.

Antiques 1950. "John F. Peto Exhibition." *The Magazine Antiques,* vol. 57, no. 3 (Mar.), p. 215.

Antiques 1953. "Folk Art Here and There." *The Magazine Antiques,* vol. 64, no. 2 (Aug.), pp. 124–33.

Antiques 1955. "A Benjamin West 'Altarpiece' at Smith College." *The Magazine Antiques,* vol. 67, no. 3 (Mar.), p. 240.

Antiques 1965. "Trompe l'Oeil in California." *The Magazine Antiques,* vol. 88, no. 3 (Sept.), p. 306.

Appleton's 1873. "Capri." *Appleton's Journal,* vol. 9, no. 216 (May 10), pp. 630–31.

Arnason 1982. H. H. Arnason. *Robert Motherwell.* New York.

———— 1986. H. H. Arnason. *History of Modern Art.* 3d ed. New York.

Arnold and Gemma 1994. Joan Hagan Arnold and Penelope Buschman Gemma. *A Child Dies: A Portrait of Family Grief.* 2d ed. Philadelphia.

Art Dig 1940. "Sheeler Paints Power." *Art Digest,* vol. 15, no. 5 (Dec. 1), p. 8.

Art Dig 1949. P. L. "Dayton Presents the Railroad in Paint." *Art Digest,* vol. 23, no. 15 (May 1), p. 16.

Art Dig 1951 January. "American Luminism." *Art Digest,* vol. 25, no. 7 (Jan. 1), p. 11.

Art Dig 1951 February. "Winslow Homer's Illustrative Side." *Art Digest,* vol. 25, no. 10 (Feb. 15), p. 11.

Art Newsletter 1957. *Art Newsletter* (American Federation of Arts), Dec., unpag. Brochure.

Art Q 1955. "Accessions of American and Canadian Museums, January–March 1955." *Art Quarterly,* vol. 18, no. 3 (autumn), pp. 301–9.

Art Q 1957. "Accessions of American and Canadian Museums, October–December, 1956." *Art Quarterly,* vol. 20, no. 1 (spring), pp. 93–105.

Ashton 1958. Dore Ashton. "Art." *Arts and Architecture,* vol. 75, no. 7 (July), pp. 10, 31–33.

Aurora + 1953. *Smith College Collects No. 1.* Circulated by the American Federation of Arts. Wells College, Aurora, N.Y., Oct. 6–27; Fine Arts Gallery, San Diego, Nov. 7–28; Pasadena (Calif.) Art Institute, Dec. 1–31; Stanford (Calif.) Art Gallery, Jan. 12–31, 1954; Portland (Ore.) Art Museum, Feb. 5–Mar. 7; Tacoma (Wash.) Art League, Mar. 12–Apr. 4; University of Washington, Seattle, Apr. 11–May 2; San Francisco Museum of Art, May 24–June 14; Saginaw (Mich.) Museum, June 28–July 19; Minnesota State Fair, St. Paul, Aug. 28–Sept. 6.

Austin 1965–66. *The Paintings of George Inness (1844–94).* University of Texas Art Museum, Dec. 12–Jan. 30.

A.M.B. 1943. A.M.B. "Antiques & Art: Attractions in the Galleries." *New York Sun,* Feb. 5, p. 27.

Baigell 1981. Matthew Baigell. *Albert Bierstadt.* New York.

———— 1984. Matthew Baigell. *A Concise History of American Painting and Sculpture.* New York.

Baker 1945. C. H. Collins Baker. "Notes on Joseph Blackburn and Nathaniel Dance." *Huntington Library Quarterly,* vol. 9, no. 1 (Nov.), pp. 33–47.

Baltimore 1945. *Still Life and Flower Paintings.* Baltimore Museum of Art, Nov. 2–Dec. 9.

Baltimore 1968. *From El Greco to Pollock: Early and Late Works by European and American Artists.* Baltimore Museum of Art, Oct. 22–Dec. 8.

Baltimore 1976. *Maryland Heritage: Five Baltimore Institutions Celebrate the American Bicentennial.* Walters Art Gallery *(European Art at the Time of the Revolution),* Baltimore Museum of Art *(American Painting and Decorative Arts of the Revolutionary Period),* Maryland Historical Society *(From Feudalism to Freedom);* Peale Museum *(Baltimore in the Revolutionary Generation);* Maryland Academy of Sciences, Baltimore *(Explorers of Time and Space),* Apr. 20–June 20.

Barcelona + 1994. *Franz Kline: Art and the Structure of Identity.* Fundacío Antoni Tàpies, Barcelona, Mar. 18–June 5; Whitechapel Art Gallery, London, July 6–Sept. 11; Museo Nacional Centro de Arte

Reina Sofia, Madrid, Sept. 27–Nov. 21; Saarland Museum, Saarbrücken, Dec. 11–Feb. 5, 1995.

Barcelona + 1996–97. *Robert Motherwell.* Fundacío Antoni Tàpies, Barcelona, Nov. 12–Jan. 12; Museo Nacional Centro de Arte Reina Sofia, Madrid, Mar. 5–May 5.

Barker 1950. Virgil Barker. *American Painting: History and Interpretation.* New York.

Barnes and Mazia 1935. Albert C. Barnes and Violette de Mazia. *The Art of Renoir.* New York.

Barnes et al. 1996. Rachel Barnes, Martin Croomer, Carl Freedman, Tony Godfrey, Simon Grant, Melissa Larner, Simon Morley, and Gilda Williams. *The 20th-Century Art Book.* London.

Barris 1990. Roann Barris. "Peter Eisenman and the Erosion of Truth." *20/1,* vol. 1, no. 2 (spring), pp. 20–37.

Barry 1968. Edward Barry. "The Intemperate Mr. Whistler." *Chicago Tribune Magazine,* Jan. 14, pp. 32–35.

Barry 1992. William David Barry. "The Lady and the Painter." *Down East Magazine,* vol. 38, no. 6 (Jan.), pp. 40–44.

Batterberry and Batterberry 1976. Ariane Ruskin Batterberry and Michael Batterberry. *The Pantheon Story of American Art for Young People.* New York.

Baur 1953. John I. H. Baur. *American Painting in the Nineteenth Century.* New York.

———— 1954. John I. H. Baur. "American Luminism: A Neglected Aspect of the Realist Movement in Nineteenth-Century American Painting." *Perspectives USA,* vol. 9 (autumn), pp. 90–98.

———— 1957. John I. H. Baur, ed. *New Art in America.* New York.

———— 1960. John I. H. Baur. "Beauty or the Beast? The Machine and American Art." *Art in America,* vol. 48, no. 1 (spring), pp. 82–87.

Bayley 1915. Frank W. Bayley. *The Life and Works of John Singleton Copley, Founded on the Work of Augustus Thorndike Perkins.* Boston.

———— 1929. Frank W. Bayley. *Five Colonial Artists of New England.* Boston.

Belknap 1959. Waldron Phoenix Belknap, Jr. *American Colonial Painting: Materials for a History.* Cambridge, Mass.

Benke 1995. Britta Benke. *Georgia O'Keeffe, 1887–1986: Flowers in the Desert.* Cologne.

Berkeley + 1972. Jane Dillenberger and Joshua C. Taylor. *The Hand and the Spirit: Religious Art in America, 1770–1900.* University Art Museum, University of California, Berkeley, June 28–Aug. 27; National Collection of Fine Arts, Washington, D.C., Sept. 29–Nov. 5; Dallas Museum of Fine Arts, Dec. 10–Jan. 14, 1973; Indianapolis Museum of Art, Feb. 20–Apr. 15.

Berlin 1926. *Lyonel Feininger.* Galerie Dr. Goldschmidt Dr. Wallerstein, Nov. 22–Dec.

Berlin 1936. *Lyonel Feininger: Gemälde und Aquarelle.* Galerie Nierendorf.

Berlin 1980. *Amerika: Traum und Depression, 1920/40.* Neue Gesellschaft für Bildende Kunst, Akademie der Künste, Nov. 9–Dec. 28.

Bern + [1989] 1992. Ulrich Loock. *Sol LeWitt: Wall Drawings, 1984–1992.* Kunsthalle Bern, Jan. 27–Mar. 12, 1989. *Sol LeWitt: Wall Drawings, 1984–1992.* Rev. ed. Sala Recalde, Bilbao, May 29–July 31 and Aug. 15–Sept. 13, 1992. *Sol LeWitt, 1968–1993* [in English]. Addison Gallery of American Art, Phillips Academy, Andover, Mass., Apr. 16–June 20, 1993.

Bertram 1990. Helmut Bertram. *Stilleben Ergänzungsband.* Behörde für Schule, Jugend und Berufsbildung. Hamburg.

Best 1939. M[ary] B[est]. "Discarded Treasures by William Harnett." *Smith College Museum of Art Bulletin,* no. 20 (June), pp. 17–19.

Bibeb 1968. Bibeb. "Willem de Kooning: Ik vind dat alles een mond moet hebben en ik zet de mond waar ik will." *Vrif Nederland* (Amsterdam), Oct. 5, p. 3. English translation, Archives of American Art, Smithsonian Institution, Washington, D.C.

Bihalji-Merin 1959. Oto Bihalji-Merin. *Das Naive Bild der Welt.* Cologne.

Billerica 1908. *Vital Records of Billerica, Massachusetts, to the Year 1850.* Boston.

Biographical 1915. *Biographical Sketches of American Artists.* 3d ed. Lansing, Mich.

Birmingham + 1987. *The Expressionist Landscape.* Birmingham (Ala.) Museum of Art, Sept. 11–Nov. 4; IBM Gallery of Science and Art, New York, Nov. 24–Jan. 30, 1988; Everson Museum of Art, Syracuse, N.Y., Feb. 14–Mar. 27; Akron (Ohio) Art Museum, Apr. 9–June 5; Vancouver Art Gallery, June 30–Aug. 21.

Birnbaum 1915. Martin Birnbaum. "Elie Nadelman." *International Studio,* vol. 57, no. 226 (Dec.), p. LIII.

Bishop [1975] 1979. Robert Bishop. *World of Antiques, Art and Architecture in Victorian America.* New York.

Bishop and Coblentz 1974. Robert Bishop and Patricia Coblentz. *American Folk Sculpture.* New York.

Blankenship 1982. Roy Blankenship. *The Delicate Palette of Albert Babb Insley.* Wilmington, Del.

Bloemink 1995. Barbara J. Bloemink. *The Life and Art of Florine Stettheimer.* New Haven.

Bolton and Binsse 1930 "Blackburn." Theodore Bolton and Harry Lorin Binsse. "American Artist of Formula: Joseph Blackburn." *Antiquarian,* vol. 15 (Nov.), pp. 50–53, 88 ff.

———— 1930 "Copley." Theodore Bolton and Harry Lorin Binsse. "John Singleton Copley." *Antiquarian,* vol. 15 (Dec.), pp. 76–83, 116, 118.

Born 1946. Wolfgang Born. "The Female Peales: Their Art and Its Tradition." *American Collector,* Aug., pp. 12–14.

———— 1947. Wolfgang Born. *Still-Life Painting in America.* New York.

Boston, Copley 1912. *Landscapes by Willard L. Metcalf.* Copley Gallery, Jan. 29–Feb. 10.

Boston, Copley 1913. *Paintings by Willard L. Metcalf.* Copley Gallery, Jan. 20–Feb. 3.

Boston, Doll 1877. Exhibition. Doll and Richards Gallery, Mar.

Boston, Doll 1893. *Exhibition and Private Sale of Paintings by Childe Hassam.* Doll and Richards Gallery, Mar.

Boston, ICA 1939. *Contemporary German Art.* Institute of Modern Art (later Institute of Contemporary Art), Boston, Nov. 2–Dec. 9.

Boston +, ICA 1949. *Jacques Villon/Lyonel Feininger.* Institute of Contemporary Art, Boston, Oct. 7–Nov. 20; Phillips Gallery, Washington, D.C., Dec. 11–Jan. 1950; Delaware Art Center, Wilmington, Mar. 8–26.

Boston, ICA 1954. *Forty-four Major Works from the Smith College Collection.* Institute of Contemporary Art, Boston, Jan. 5–Feb. 9.

Boston +, ICA 1967. *New Directions in Collecting: Part One—Museum Acquisitions.* Institute of Contemporary Art, Boston, Apr. 7–May 7; Berkshire Museum, Pittsfield, Mass., July 4–31.

Boston +, ICA 1976. *A Selection of American Art: The Skowhegan School, 1946–1976.* Institute of Contemporary Art, Boston, June 15–Sept. 5; Colby College Museum of Art, Waterville, Maine, Oct. 1–30.

Boston +, ICA 1980. Elizabeth Sussman. *Florine Stettheimer: Still Lifes, Portraits, and Pageants, 1910–1942.* Institute of Contemporary Art, Boston, Mar. 4–Apr. 27; Marion Koogler McNay Art Institute, San Antonio, July 7–Aug. 15; Vassar College Art Gallery, Poughkeepsie, N.Y., Sept. 28–Nov. 9.

Boston, MFA 1934. *Exhibition of Oils, Water-Colors, Drawings, and Prints by James McNeill Whistler.* Museum of Fine Arts, Boston, Apr. 24–May 13.

Boston, MFA 1962–63. *The M. and M. Karolik Collection of Water Colors and Drawings.* Museum of Fine Arts, Boston, Oct. 18–Jan. 6.

Boston +, MFA 1969. Theodore E. Stebbins, Jr. *Martin Johnson Heade.* Museum of Fine Arts, Boston, July 19–Aug. 24; Art Gallery, University of Maryland, College Park (organizer), Sept. 14–Oct. 23; Whitney Museum of American Art, New York, Nov. 10–Dec. 21.

Boston, MFA 1976. *John Singleton Copley 1738–1815, Gilbert Stuart 1755–1828, Benjamin West 1738–1820 in England and America.* Museum of Fine Arts, Boston, July 22–Oct. 17.

Boston, MFA 1979. Martha J. Hoppin. *William Morris Hunt: A Memorial Exhibition.* Museum of Fine Arts, Boston, June 26–Aug. 26.

Boston +, MFA 1983. Theodore Stebbins. *A New World: Masterpieces of American Painting, 1760–1910.* Museum of Fine Arts, Boston, Sept. 7–Nov. 13; Corcoran Gallery of Art, Washington, D.C., Dec. 7–Feb. 12, 1984; Grand Palais, Paris, Mar. 16–June 11.

Boston +, MFA 1986. *The Bostonians, Painters of an Elegant Age, 1870–1930.* Museum of Fine Arts, Boston, June 11–Sept. 14; Denver Art Museum, Oct. 25–Jan. 18, 1987; Terra Museum of American Art, Chicago, Mar. 13–May 10.

Boston +, MFA 1987–88. Carol Troyen and Erica E. Hirshler. *Charles Sheeler: Paintings and Drawings.* Theodore E. Stebbins, Jr., and Norman Keyes. *Charles Sheeler: Photographs.* (Two exhibition catalogues.) *Charles Sheeler: Paintings, Drawings, Photographs.* Museum of Fine Arts, Boston, Oct. 13–Jan. 3; Whitney Museum of American Art, New York, Jan. 28–Apr. 17; Dallas Museum of Art, May 15–July 10.

Boston +, MFA 1991. Barbara Shapiro et al. *Pleasures of Paris: Daumier to Picasso.* Museum of Fine Arts, Boston, June 5–Sept. 1; IBM Gallery of Science and Art, New York, Oct. 15–Dec. 28.

Boston +, MFA 1992. Theodore E. Stebbins, Jr. *The Lure of Italy: American Painters and the Italian Experience.* Museum of Fine Arts, Boston, Sept. 16–Dec. 13; Cleveland Museum of Art, Feb. 3–Apr. 11, 1993; Museum of Fine Arts, Houston, May 23–Aug. 8.

Boston +, MFA 1995. Carrie Rebora, Paul Staiti, et al. *John Singleton Copley in America.* Museum of Fine Arts, Boston, June 7–Aug. 27; Metropolitan Museum of Art, New York, Sept. 26–Jan. 7, 1996; Museum of Fine Arts, Houston, Feb. 4–Apr. 28; Milwaukee Art Museum, May 22–Aug. 25.

Boston, Vose 1961. *Loan Exhibition Honoring Robert Churchill Vose.* Vose Galleries, Mar. 7–25.

Bragazzi 1984. Olive Bragazzi. "The Story behind the Rediscovery of William Harnett and John Peto by Edith Halpert and Alfred Frankenstein." *American Art Journal,* vol. 16, no. 2 (spring), pp. 51–65.

Braunschweig 1926. *Lyonel Feininger.* Gesellschaft der Freunde Junger Kunst, Braunschweig, Germany, Mar. 26–May 2.

Breuning 1933. Margaret Breuning. "Art World Events." *New York Evening Post,* Oct. 3.

Brewington 1962. M. V. Brewington. *Shipcarvers of North America.* New York.

Bridgeport 1965. *The Machine in Art.* Bridgeport (Conn.) Museum of Art, Science and Industry, Oct. 15–Dec. 15.

Brockton 1969. *Three Centuries of New England Art from New England Museums.* Brockton (Mass.) Art Center, Jan. 15–Mar. 3.

Brockton 1977. *American Pastimes.* Brockton (Mass.) Art Center, Jan. 27–Apr. 17.

Brookgreen 1938. *Sculpture by Paul Manship.* Brookgreen Gardens, Murrells Inlet, S.C.

Brooklyn 1939. *Popular Art in America.* Brooklyn Museum, May 18–Oct. 1.

Brooklyn 1951–52. *Revolution and Tradition.* Brooklyn Museum, Nov. 15–Jan. 6.

Brooklyn 1957–58. *The Face of America: The History of Portraiture in the United States.* Brooklyn Museum, Nov. 14–Jan. 26.

Brooklyn 1984. *Fun and Fantasy: Brooklyn's Amusement Parks and Leisure Areas.* Museum of the Borough of Brooklyn, Brooklyn College, Apr. 26–June 5.

Brooklyn + 1985. Linda S. Ferber, William H. Gerdts, et al. *The New Path: Ruskin and the American Pre-Raphaelites.* Brooklyn Museum, Mar. 29–June 10; Museum of Fine Arts, Boston, July 3–Sept. 8.

Brooklyn + 1986–87. Richard Guy Wilson, Dianne H. Pilgrim, and Dickran Tashjian. *The Machine Age in America, 1918–1941.* Brooklyn Museum, Oct. 17–Feb. 16; Carnegie Museum of Art, Carnegie Institute, Pittsburgh, Apr. 4–June 28; Los Angeles County Museum of Art, Aug. 16–Oct. 18; High Museum of Art, Atlanta, Dec. 1–Feb. 14, 1988.

Brooklyn + 1991. Nancy K. Anderson and Linda S. Ferber. *Albert Bierstadt: Art and Enterprise.* Brooklyn Museum, Feb. 8–May 6; Fine Arts Museums of San Francisco, June 8–Sept. 1; National Gallery of Art, Washington, D.C., Nov. 3–Feb. 17, 1992.

Brooklyn + 1996. Susan A. Hobbs with Barbara Dayer Gallati. *The Art of Thomas Wilmer Dewing: Beauty Reconfigured.* Brooklyn Museum, Mar. 21–June 9; National Museum of American Art, Washington, D.C., July 19–Oct. 14; Detroit

Institute of Arts, Nov. 9–Jan. 19, 1997.

Brooklyn Mus Bull 1951. *Brooklyn Museum Bulletin*, vol. 13, no. 1 (fall).

Bross 1987. Tom Bross. "Small Towns, Big Art." *Travel-Holiday*, vol. 167, no. 1 (Jan.), pp. 29–31.

Brunswick 1969. *Rockwell Kent: The Early Years*. Museum of Art, Bowdoin College, Brunswick, Maine, Aug. 15–Oct. 5.

Brussels 1958. *American Folk Art*. World's Fair, United States Pavilion, Brussels, Apr. 17–Oct. 18.

Bryant 1969. Edward Bryant. "Rediscovery: John Storrs." *Art in America*, vol. 57, no. 3 (May–June), pp. 66–71.

Buff 1982. Barbara Ball Buff. "Dublin, New Hampshire." *The Magazine Antiques*, vol. 121, no. 4 (Apr.), pp. 942–51.

Buffalo 1914. *Ninth Annual Exhibition of Selected Paintings by American Artists*. Buffalo Fine Arts Academy, Albright Art Gallery, May 16–Aug. 31.

Buffalo 1918. *Annual Exhibition of American Artists*. Albright Art Gallery, May 11–Sept. 9.

Buffalo 1954. *Painters' Painters*. Albright Art Gallery, Apr. 16–May 30.

Buffalo 1964. *Three Centuries of Niagara Falls*. Albright-Knox Art Gallery, May 2–Sept. 7.

Buffalo + 1985. Jeremy Elwell Adamson et al. *Niagara: Two Centuries of Changing Attitudes, 1697–1901*. Albright-Knox Art Gallery, July 13–Sept. 1; Corcoran Gallery of Art, Washington, D.C. (organizer), Sept. 21–Nov. 24; New-York Historical Society, Jan. 22–Apr. 27, 1986.

Buffalo 1989. *The Appropriate Object*. Albright-Knox Art Gallery, Mar. 5–Apr. 23.

Buffalo *Acad. Notes* 1914. "The Summer Exhibition of American Paintings at the Albright Art Gallery." *Academy Notes* [Buffalo Fine Arts Academy], vol. 9, no. 3 (July), pp. 82–107, 110–15.

Burke 1980. Doreen Bolger Burke. Edited by Kathleen Luhrs. *American Paintings in the Metropolitan Museum of Art*. Vol. 3. *A Catalogue of Works by Artists Born between 1846 and 1864*. New York.

Burkett 1987. Mary F. Burkett. "Christopher Steele." *Walpole Society Journal*, vol. 53, pp. 193–225.

Burleigh 1994. Mutén Burleigh, ed. *Return of the Great Goddess*. Boston.

Burr 1863. Fearing Burr, Jr. *The Field and Garden Vegetables of America*. Boston.

Burrows 1937. Carlyle Burrows. "Notes and Comment on Events in Art: Arthur G. Dove." *New York Herald Tribune*, Mar. 28, sec. VII, p. 8.

Busco 1988. Marie Busco. "Manship Sales Away: A Sophisticated Sashay through American Art Deco Sculpture." *Art and Auction*, vol. 11, no. 4 (Nov.), pp. 166–73.

Bush 1975. Donald J. Bush. *The Streamlined Decade*. New York.

Caffin 1909. Charles H. Caffin. *The Art of Dwight W. Tryon: An Appreciation*. New York.

——— 1913. [Charles H. Caffin]. "Great Promise Shown in Young Sculptor's Work." *New York American*, Feb. 17, p. 8.

Calder 1951. Alexander Calder. "What Abstract Art Means to Me." *Museum of Modern Art Bulletin*, vol. 18 (spring), pp. 8–9.

——— 1966. Alexander Calder. *Calder: An Autobiography with Pictures*. New York.

Caldwell et al. 1994. John Caldwell and Oswaldo Rodriguez Roque with Dale T. Johnson. Edited by Kathleen Luhrs. *American Paintings in the Metropolitan Museum of Art*. Vol. 1. *A Catalogue of Works by Artists Born by 1815*. New York.

Cambridge 1962. *Paintings by Joan Mitchell*. New Gallery, Hayden Library, Massachusetts Institute of Technology, Apr. 2–29.

Cambridge 1975–76. Jeanne L. Wasserman, ed. *Metamorphoses in Nineteenth-Century Sculpture*. Fogg Art Museum, Harvard University, Nov. 19–Jan. 7.

Campbell 1954. L[awrence] C[ampbell]. "Franz Kline." *Art News*, vol. 53, no. 4 (summer), p. 54.

Campbell 1981. Catherine H. Campbell. "Albert Bierstadt and the White Mountains." *Archives of American Art Journal*, vol. 21, no. 3, pp. 14–23.

Canberra + 1998. *New Worlds from Old: 19th Century Australian and American Landscapes*. National Gallery of Australia, Canberra, Mar. 7–May 17; National Gallery of Victoria, Melbourne, June 3–Aug. 10; Wadsworth Atheneum, Hartford (co-organizer), Sept. 12–

Jan. 4, 1999; Corcoran Gallery of Art, Washington, D.C., Jan. 26–Apr. 18.

Cantor 1976. Jay E. Cantor. "The Landscape of Change: Views of Rural New England, 1790–1865." *The Magazine Antiques*, vol. 109, no. 4 (Apr.), pp. 772–83.

Carr 1981. Gerald L. Carr. "Beyond the Tip: Some Addenda to Frederic Church's 'The Icebergs.'" *Arts Magazine*, vol. 55, no. 3 (Nov.), pp. 107–11.

Carré 1984. Dominique Carré. "Winston Link Archéologique de l'Amérique." *Photographies*, no. 5 (July), pp. 36–39.

Cary 1907. Elisabeth Luther Cary, *The Works of James McNeill Whistler: A Study, with Tentative List of the Artist's Work, in Oil, Lithograph and Etching*. New York.

——— 1911. Elisabeth Luther Cary. "New York Art Letter: The Exhibition of the 'Ten American Painters.'" *Cincinnati Times-Star*, vol. 73, no. 72 (Mar. 25), p. 6.

Casson 1930. Stanley Casson. *XXth-Century Sculptors*. London.

Cateforis 1991. David Christos Cateforis. "Willem de Kooning's 'Women' of the 1950s: A Critical History of Their Reception and Interpretation." Ph.D. diss., Stanford University.

Cedar Rapids 1967. *Charles Sheeler: A Retrospective Exhibition*. Cedar Rapids (Iowa) Art Center, Oct. 25–Nov. 26.

Cembalest 1992. Robin Cembalest. "Native American Pride and Prejudice." *Art News*, vol. 91, no. 2 (Feb.), pp. 86–91.

Champney 1900. Benjamin Champney. *Sixty Years' Memories of Art and Artists*. Woburn, Mass.

Chapel Hill 1958. *Paintings, Drawings, Prints and Sculpture from American College and University Collections: Inaugural Exhibition of the William Hayes Ackland Memorial Art Center*. University of North Carolina, Chapel Hill, Sept. 20–Oct. 20.

Chapelle 1935. Howard I. Chapelle. *The History of American Sailing Ships*. New York.

Charteris 1927. Evan Charteris. *John Sargent*. London.

Chetham 1969. Charles Chetham. "The Smith College Museum of Art." *The Magazine Antiques*, vol. 96, no. 5 (Nov.), pp. 768–75.

——— 1980. Charles Chetham. "Why the College Should Have Its Gallery of Art." *Smith College Alumnae Quarterly*, vol. 71, no. 2 (Feb.), pp. 3–10.

Chetham et al. 1986. Charles Chetham, David F. Grose, and Ann H. Sievers, eds. *A Guide to the Collections*. Smith College Museum of Art, Northampton, Mass.

Chicago 1889. *Inter-State Industrial Exposition of Chicago, Seventeenth Annual Exhibition*. Art Institute of Chicago, Sept. 4–Oct. 19.

Chicago 1891. *The Fourth Annual Exhibition of American Oil Paintings and Sculpture*. Art Institute of Chicago, Oct. 26–Nov. 29.

Chicago 1903. *Sixteeenth Annual Exhibition of Oil Paintings and Sculpture by American Artists*. Art Institute of Chicago, Oct. 20–Dec. 25.

Chicago 1911. *Twenty-fourth Annual Exhibition of American Oil Paintings and Sculpture*. Art Institute of Chicago, Nov. 14–Dec. 27.

Chicago 1912. *Paintings by Willard L. Metcalf*. Art Institute of Chicago, Mar. 5–27.

Chicago 1932. *Exhibition of the Mrs. L. L. Coburn Collection of Modern Paintings and Water Colors*. Art Institute of Chicago, Apr. 6–Oct. 9.

Chicago 1941–42. *The Fifty-second Annual Exhibition of American Paintings and Sculpture*. Art Institute of Chicago, Oct. 30–Jan. 4.

Chicago 1943. *The Fifty-fourth Annual Exhibition of American Paintings and Sculpture*. Art Institute of Chicago, Oct. 28–Dec. 12.

Chicago 1961. *Smith College Loan Exhibition*. Arts Club of Chicago, Jan. 10–Feb. 15.

Chicago 1964. *Exhibition of Portraits*. Sponsored by the Smith College Club of Chicago. National Design Center of Marina City, Sept. 25–Oct. 15.

Chicago + 1968. Frederick A. Sweet. *James McNeill Whistler*. Art Institute of Chicago, Jan. 13–Feb. 25; Munson-Williams-Proctor Institute Museum of Art, Utica, N.Y., Mar. 17–Apr. 28.

Chicago 1981. Sarah Bradford Landau. *P. B. Wight, Architect, Contractor and Critic, 1838–1925*. Art Institute of Chicago, Jan. 22–July 31.

Chicago + 1987. *Donald Sultan*. Museum of Contemporary Art,

Chicago, Sept. 12–Nov. 8; Museum of Contemporary Art, Los Angeles, Nov. 24–Jan. 10, 1988; Fort Worth (Tex.) Art Museum, Jan. 24–Mar. 20; Brooklyn Museum, Apr. 9–June 13.

Chicago 1990. *Winslow Homer in Gloucester*. Terra Museum of American Art, Oct. 20–Dec. 30.

Chotner et al. 1992. Deborah Chotner with Julie Aronson, Sarah D. Cash, and Laurie Weitzenkorn. *American Naive Paintings*. Washington, D.C.

Churchill 1924. Alfred Vance Churchill. "Dwight W. Tryon, M.A., N.A.: Professor of Art, Smith College, 1886–1923." *Bulletin of the Smith College Hillyer Art Gallery*, no. 5 (Mar. 30).

Cikovsky 1971. Nicolai Cikovsky, Jr. *The Life and Work of George Inness*. New York.

——— 1993. Nicolai Cikovsky, Jr. *George Inness*. New York.

Cincinnati 1954. *Paintings by the Peale Family*. Cincinnati Art Museum, Oct. 1–31.

Cincinnati + 1985–86. Harry F. Gaugh. *The Vital Gesture: Franz Kline*. Cincinnati Art Museum, Nov. 27–Mar. 2; San Francisco Museum of Modern Art, Apr. 17–June 9; Pennsylvania Academy of the Fine Arts, Philadelphia, June 26–Sept. 28.

Clark 1987. Judith Freeman Clark. *Massachusetts: From Colony to Commonwealth: An Illustrated History*. Northridge, Calif.

Clark 1989. H. Nichols B. Clark. "Fidelity to Nature: The American Pre-Raphaelites." *Art and Auction*, vol. 11, no. 6 (Jan.), pp. 130–37.

Clarke 1892. [Thomas B. Clarke]. "New Paintings by Americans." *New York Times*, Mar. 21, p. 9.

Clement and Hutton 1893. Clara Erskine Clement and Laurence Hutton. *Artists of the Nineteenth Century and Their Works: A Handbook*. 6th ed. Boston.

Cleveland 1951. *The Work of Lyonel Feininger*. Cleveland Museum of Art, Nov. 2–Dec. 9.

Clinton 1983. *Art from the Ivory Tower: Selections from College and University Collections*. Fred L. Emerson Gallery, Hamilton College, Clinton, N.Y., Apr. 9–May 29.

Clinton + 1984. *The Art of Music: American Paintings and Musical Instruments, 1770–1910*. Fred L. Emerson Gallery, Hamilton College, Clinton, N.Y., Apr. 7–June 3; Whitney Museum of American Art at Philip Morris, New York, July 19–Sept. 19; Duke University Museum of Art, Durham, N.C., Oct. 1–Nov. 5; Lamont Gallery, Phillips Exeter Academy, Exeter, N.H., Nov. 18–Dec. 16.

Cobbett 1821. William Cobbett. *The American Gardener*. London.

Cohn 1985. Sherrye Cohn. *Arthur Dove: Nature as Symbol*. Ann Arbor.

Coke 1964. Van Deren Coke. *The Painter and the Photograph from Delacroix to Warhol*. Albuquerque, N.Mex. Rev. ed., 1972.

College Park + 1976. *The Late Landscapes of William Morris Hunt*. Art Gallery, University of Maryland, College Park, Jan. 15–Feb. 29; Albany Institute of History and Art, Mar. 13–Apr. 25.

Colpitt 1990. Frances Colpitt. *Minimal Art: The Critical Perspective*. Ann Arbor.

Columbus 1950. *Twentieth Anniversary Exhibition: Masterpieces of Painting—Treasures of Five Centuries*. Columbus (Ohio) Gallery of Fine Arts, Oct. 1–Nov. 5.

Comstock 1948. Helen Comstock. "Portraits of Places—The Hudson River School." *Harry Shaw Newman Gallery Panorama*, vol. 3, no. 8 (Apr.), pp. 86–96.

——— 1958. Helen Comstock. "The Connoisseur in America: Ralph Earl: A Newly Discovered Portrait." *Connoisseur* (American ed.), vol. 141, no. 567 (Mar.), pp. 64–65.

Conner 1989. Janis Conner. *Rediscoveries in American Sculpture*. Austin, Tex.

Connoisseur 1926. "Current Art Notes." *Connoisseur*, vol. 76, no. 304 (Dec.), pp. 258–66.

Connoisseur 1956. "Portrait by Thomas McIlworth: Dr. William Samuel Johnson." *Connoisseur* (American ed.), vol. 136, no. 550 (Jan.), p. 310.

Conrads 1990. Margaret C. Conrads. *American Paintings and Sculpture at the Sterling and Francine Clark Art Institute*. New York.

Cooper 1970. Douglas Cooper. *The Cubist Epoch*. London.

Copley [1914] 1970. *Letters and Papers of John Singleton Copley and Henry Pelham 1739–1776*. New York. Reprint from *Massachusetts Historical Society Collections*, vol. 71.

Coral Gables + 1991. *Abstract Sculpture in America, 1930–1970*. Organized by the American Federation of Arts. Lowe Art Museum, University of Miami, Coral Gables, Feb. 7–Mar. 31; Museum of Arts and Sciences, Macon, Ga., Apr. 19–June 30; Akron (Ohio) Art Museum, Aug. 24–Oct. 20; Fort Wayne (Ind.) Museum of Art, Nov. 9–Jan. 4, 1992; Musée du Québec, Jan. 25–Mar. 21; Terra Museum of American Art, Chicago, Apr. 11–June 7.

Corn 1985. Alfred Corn. "Home-made Visions." *Art and Antiques*, May, pp. 78–82.

Cortissoz 1893. Royal Cortissoz. "The Metamorphosis of Diana." *Harper's Weekly*, vol. 37, no. 1927 (Nov. 25), p. 1124.

——— 1910. Royal Cortissoz. "Art Exhibitions." *New York Daily Tribune*, Mar. 23, 1910, p. 7.

Cosgrove 1991. Bob Cosgrove. "High-Priced Wheels: The New York Central and the Arts." *Central Headlight*, vol. 21, no. 1 (Jan.–Mar.), pp. 16–29.

Costantino 1995. Maria Costantino. *Edward Hopper*. New York.

Crane 1972. Sylvia E. Crane. *White Silence: Greenough, Powers, and Crawford—American Sculptors in Nineteenth-Century Italy*. Coral Gables, Fla.

Craven 1959. George M. Craven. "Sheeler at Seventy-Five." *College Art Journal*, vol. 18, no. 2 (winter), pp. 136–43.

Crawshaw 1979. Andrew F. B. Crawshaw. "Maschinenästhetik im viktorianischen England." *Du*, vol. 39, no. 4, pp. 40–45.

Crehan 1953. Hubert Crehan. "A See Change: Woman Trouble." *Art Digest*, vol. 27, no. 14 (Apr. 15), pp. 4–5.

Cresson 1947. Margaret French Cresson. *Journey into Fame: The Life of Daniel Chester French*. Cambridge, Mass.

Cummings 1920. E. E. Cummings. "Gaston Lachaise." *Dial*, vol. 68, no. 2 (Feb.), pp. 194–204.

Cutter 1908. William Richard Cutter, ed. *Historic Homes and Places and Genealogical and Personal Memoirs Relating to the Families of Middlesex County, Massachusetts*. New York.

Czestochowski 1982. Joseph S. Czestochowski. *American Landscape Tradition: A Study and Gallery of Paintings*. New York.

Dallas 1961. *The Art That Broke the Looking Glass*. Dallas Museum for Contemporary Arts, Nov. 14–Dec. 31.

Danly and Marx 1988. Susan Danly and Leo Marx, eds. *The Railroad in American Art: Representation of Technological Change*. Cambridge, Mass.

Dasnoy 1970. Albert Dasnoy. *Exegèse de la Peinture Naïve*. Brussels.

Davidson 1955. Ruth B. Davidson. "In the Museums: A Portrait by McIlworth." *The Magazine Antiques*, vol. 68, no. 3 (Sept.), pp. 278, 280.

Davidson 1973. Marshall B. Davidson. *The American Heritage History of the Artists' America*. New York.

Davidson 1974. Abraham A. Davidson. "John Storrs: Early Sculptor of the Machine Age." *Artforum*, vol. 13, no. 3 (Nov.), pp. 41–45.

Day 1903. George Day. *Pleasure Guide to Paris for Bachelors*. London and Paris.

Dayton 1949. *The Railroad in Painting*. Dayton (Ohio) Art Institute, Apr. 19–May 22.

Dayton + 1951. *America and Impressionism*. Dayton (Ohio) Art Institute, Oct. 19–Nov. 11; Columbus (Ohio) Gallery of Fine Arts, Nov. 15–Dec. 16.

Deak 1985. Gloria-Gilda Deak. *Kennedy Galleries' Profiles of American Artists*. New York.

Deerfield 1945. Exhibition. Hilson Gallery, Deerfield (Mass.) Academy, Feb. 3–27.

Deerfield 1946. Exhibition. Hilson Gallery, Deerfield (Mass.) Academy, Mar. 19–Apr. 24.

Deitz 1982. Paula Deitz. "The First American Landscape." *Connoisseur*, vol. 212, no. 850 (Dec.), pp. 28–37.

DeKalb + 1974. *Near-Looking*. Art Gallery, Northern Illinois University, DeKalb, Oct. 27–Nov. 22; University of Notre Dame Art Gallery, Notre Dame, Ind., Dec. 1–Jan. 26, 1975.

De Kooning 1962. Elaine de Kooning. "Franz Kline: Painter of

His Own Life." *Art News*, vol. 61, no. 7 (Nov.), pp. 28–31, 64–69.

DeLorme 1979. Eleanor Pearson DeLorme. "Gilbert Stuart, Portrait of an Artist." *Winterthur Portfolio*, vol. 14, no. 4 (winter), pp. 339–60.

Dennis 1998. James M. Dennis. *Renegade Regionalists: The Modern Independence of Grant Wood, Thomas Hart Benton and John Steuart Curry*. Madison, Wis.

Detroit 1967. Charles H. Elam, ed. *The Peale Family: Three Generations of American Artists*. Detroit Institute of Arts, Jan. 18–Mar. 5.

Detroit 1983. *The Quest for Unity: American Art between World's Fairs, 1876–1893*. Detroit Institute of Arts, Aug. 22–Oct. 30.

De Veer 1984. Elizabeth G. de Veer. "Willard Metcalf in Cornish, New Hampshire." *The Magazine Antiques*, vol. 126, no. 5 (Nov.), pp. 1208–15.

De Veer and Boyle 1987. Elizabeth G. de Veer with Richard J. Boyle. *Sunlight and Shadow: The Life and Art of Willard L. Metcalf*. New York.

Devree 1948. Howard Devree. "Harnett, 1848–1948." *New York Times*, Apr. 18, p. 8x.

Devree 1955. Charlotte Devree. "Henry McBride: Dean of Art Critics." *Art in America*, vol. 43, no. 3 (Oct.), pp. 42–43, 58–62.

Dickason 1953. David H. Dickason. *The Daring Young Men: The Story of the American Pre-Raphaelites*. Bloomington, Ind.

Dillenberger 1976. John Dillenberger. *Benjamin West: The Context of His Life's Work*. San Antonio.

Dinnerstein 1981. Lois Dinnerstein. "The Industrious Housewife: Some Images of Labor in American Art." *Arts Magazine*, vol. 55, no. 8 (Apr.), pp. 109–19.

Dods 1945. Agnes M. Dods. "Newly Discovered Portraits by J. William Jennys." *Art in America*, vol. 33, no. 1 (Jan.), pp. 4–12.

Dorfles 1961. Gillo Dorfles. "L'Arte dei'primitivi-contemporanei." *Domus*, no. 379 (June), pp. 53–54.

Dorr 1911. Charles Henry Dorr. "American 'Ten' Make Fine Show with Paintings: Exhibition at the Montross Galleries Takes Rank with More Pretentious Displays." *New York World*, vol. 51, no. 18, 114 (Mar. 26), p. M7.

Dorra 1959. Henri Dorra. "Parallel Trends in Literature and Art." *Art in America*, vol. 47, no. 2 (summer), pp. 20–47.

Downes 1911. William Howe Downes. *The Life and Works of Winslow Homer*. Boston.

——— 1926. William Howe Downes. *John S. Sargent: His Life and Work*. Rev. ed. London.

Downing and Downing 1886. A. J. Downing and Charles Downing. *The Fruits and Fruit Trees of America*. New York.

Dresden 1926. *Lyonel Feininger: Neue Gemälde, Aquarelle, Graphik*. Neue Kunst Fides, Dresden, Feb. 24–Mar. 15.

Dryfhout 1982. John H. Dryfhout. *The Work of Augustus Saint-Gaudens*. Hanover, N.H.

Duncan 1989. Carol Duncan. "The MoMa's Hot Mamas." *Art Journal*, vol. 48, no. 2 (summer), pp. 171–78. Reprinted in Carol Duncan, *The Aesthetics of Power*, Cambridge, 1993.

Durand 1855. Asher B. Durand. "Letters on Landscape Painting: II." *Crayon*, Jan. 17, pp. 34–35.

Durand 1894. John Durand. *The Life and Times of A. B. Durand*. New York.

Durham 1960. *Art in New England Colleges*. Paul Arts Center, University of New Hampshire, Durham, Oct. 13–Nov. 15.

Durham 1963. *Women in Contemporary Art*. Women's College Gallery, Duke University, Durham, N.C., Feb. 19–Mar. 22.

Durham 1978. *A Stern and Lovely Scene: A Visual History of the Isles of Shoals*. University of New Hampshire, Durham, Mar. 13–Apr. 20.

Durham + 1980. Catherine Campbell et al. *The White Mountains: Place and Perceptions*. University Art Galleries, University of New Hampshire, Durham, Sept. 8–Oct. 29; New-York Historical Society, Dec. 1–Jan. 30, 1981; Dartmouth College Museum and Galleries, Hanover, N.H. (organizer), Mar. 6–Apr. 19.

Durham 1982. *An American Icon: Niagara Falls*. University Art Galleries, University of New Hampshire, Durham, Jan. 21–Mar. 10.

Düsseldorf + 1979. *2 Jahrzehnte amerikanische malerei, 1920–1940*.

Städtische Kunsthalle Düsseldorf, June 10–Aug. 12; Kunsthaus Zurich, Aug. 23–Oct. 28; Palais des Beaux-Arts, Brussels, Nov. 10–Dec. 30.

Dwight 1826. Theodore Dwight. *The Northern Traveller*. New York.

Eckford 1890. Henry Eckford, pseud. [Charles de Kay]. "A Modern Colorist, Albert Pinkham Ryder." *Century Magazine*, vol. 40 (June), pp. 250–59.

Eddy 1917. Frederick W. Eddy. "News of the Art World." *New York World*, Nov. 18, p. 5.

Eisler 1991. Benita Eisler. *O'Keeffe and Stieglitz: An American Romance*. New York.

Elderfield 1978. John Elderfield. *The Cut-Outs of Henri Matisse*. New York.

Eldredge 1991. Charles C. Eldredge. *O'Keeffe*. New York.

Ellis 1977. C. Hamilton Ellis. *Railway Art*. London.

Elmer 1964–65. Maud Valona Elmer. "Edwin Romanzo Elmer as I Knew Him." *Massachusetts Review*, vol. 6, no. 1 (autumn/winter), pp. 121–43.

Elovich 1981. Richard Elovich. "Current and Forthcoming Exhibitions." *Burlington Magazine*, vol. 123, no. 935 (Feb.), pp. 110–12.

Ency 1966. *Encyclopedia of World Art*. New York, Toronto, and London.

Erffa and Staley 1986. Helmut von Erffa and Allen Staley. *The Paintings of Benjamin West*. New Haven.

Erving 1984. *The History of Erving Massachusetts, 1938–1988*. Erving, Mass.

Essen 1992. *Die Wahrheit des Sichtbaren: Edward Hopper und die Photographie*. Museum Folkwang, June 28–Sept. 27.

Evans 1959. Grose Evans. *Benjamin West and the Taste of His Times*. Carbondale, Ill.

Faison 1958. S. Lane Faison, Jr. *A Guide to the Art Museums of New England*. New York.

——— 1982. S. Lane Faison, Jr. *The Art Museums of New England*. Boston.

Feder 1982. Norman Feder. *American Indian Art*. New York.

Ferber 1985. Linda S. Ferber. "An Introduction to the American

Pre-Raphaelites." *The Magazine Antiques*, vol. 127, no. 4 (Apr.), pp. 878–87.

Ferris 1990. Jean Ferris. *America's Musical Landscape*. Dubuque, Iowa.

Finley 1909. John H. Finley, ed. *Nelson's Perpetual Loose-Leaf Encyclopaedia*. 14 vols. New York.

Fisher 1985. Leonard Everett Fisher. *Masterpieces of American Painting*. New York.

Fitzsimmons 1953. James Fitzsimmons. "Robert Motherwell." *Art Digest*, vol. 27, no. 14 (Apr. 15), p. 17.

Flexner 1962. James Thomas Flexner. *That Wilder Image*. Boston.

——— 1970. James Thomas Flexner. *Nineteenth-Century American Painting*. New York.

Fogarty et al. 1985. Catherine M. Fogarty, John E. O'Connor, and Charles F. Cummings. *Bergen County: A Pictorial History*. Norfolk, Va.

Foote 1950. Henry Wilder Foote. *John Smibert: Painter*. Cambridge, Mass.

Fort 1993. Ilene S. Fort. *Childe Hassam's New York*. San Francisco.

Fort Worth 1958. *The Iron Horse in Art*. Fort Worth (Tex.) Art Center, Jan. 6–Mar. 2.

Fox 1981. Celina Fox. "The Wide Open Spaces." *Times Literary Supplement*, Feb. 13, p. 167.

Frackman 1987. Noel Frackman. "The Art of John Storrs." Ph.D. diss., New York University. Reprint, Ann Arbor, 1988, not illustrated.

Framingham 1982. *American Artists in Düsseldorf, 1840–1865*. Danforth Museum of Art, Framingham, Mass., Sept. 12–Nov. 28.

Framingham 1985. *The Ten American Painters: An Impressionist Tradition*. Danforth Museum of Art, Framingham, Mass., May 5–June 30.

Frankenstein 1949. Alfred Frankenstein. "Harnett, True and False." *Art Bulletin*, vol. 31, no. 1 (Mar.), pp. 38–56.

——— 1952. Alfred Frankenstein. "Edwin Romanzo Elmer." *Magazine of Art*, vol. 45, no. 6 (Oct.), pp. 270–72.

——— 1953. Alfred Frankenstein. *After the Hunt: William Harnett and Other American Still-Life Painters*. Berkeley.

——— 1969. Alfred Frankenstein. *After the Hunt: William Harnett and Other American Still-Life Painters.* Rev. ed. Honolulu.

Frankfurt + 1953. *Hundert Jahre Amerikanische Malerei.* Städelsches Kunstinstitut, Frankfurt, Mar. 14–May 3; Bayerische Staatsgemäldesammlungen, Munich, May 15–June 28; Kunsthalle, Hamburg, July 18–Aug. 30; Schloss Charlottenburg, Berlin, Sept. 8–Oct. 13; Kunstsammlungen der Stadt, Düsseldorf, Nov. 1–Dec. 15; Galleria Nazionale d'Arte Moderna, Rome, Jan. 16–Feb. 6, 1954; Palazzetto Reale, Milan, Feb. 18–Mar. 15; Whitney Museum of American Art, New York, Apr. 22–May 23.

French and Dods 1963. Reginald F. French and Agnes M. Dods. "Erastus Salisbury Field, 1805–1900." *Connecticut Historical Society Bulletin,* vol. 28, no. 4 (Oct.), pp. 97–104.

Frenzel 1977. Rose-Marie Frenzel. *Beim Spiel: Ein Kunstbuch für Kinder/Ein Kinderbuch über Kunst.* Leipzig.

Friedman 1975. Martin Friedman. *Charles Sheeler.* New York.

Gallatin 1916. A. E. Gallatin. "The Sculpture of Paul Manship." *Bulletin of the Metropolitan Museum of Art,* vol. 11, no. 10 (Oct.), pp. 218–22.

——— 1917. A. E. Gallatin. *Paul Manship: A Critical Essay on His Sculpture and an Iconography.* New York.

Gallup 1948. Donald Gallup. "The Weaving of a Pattern: Marsden Hartley and Gertrude Stein." *Magazine of Art,* vol. 41, no. 7 (Nov.), pp. 256–61.

Gardner 1961. Albert Ten Eyck Gardner. *Winslow Homer, American Artist: His World and His Work.* New York.

Gaz B-A 1969. "La Chronique des arts." *Gazette des Beaux-Arts,* vol. 73, no. 1201 (Feb.).

Gaz B-A 1989. "La Chronique des arts." *Gazette des Beaux-Arts,* vol. 113, no. 1442 (Mar.).

Gaz B-A 1990. "La Chronique des arts." *Gazette des Beaux-Arts,* vol. 115, no. 1454 (Mar.).

Geist 1953. Sidney Geist. "Work in Progress." *Art Digest,* vol. 27, no. 13 (Apr. 1), p. 15.

Geldzahler 1965. Henry Geldzahler. *American Painting in the Twentieth Century.* New York.

——— 1991. Henry Geldzahler. *Charles Bell: The Complete Works, 1970–1990.* New York.

Gelpi and Gelpi 1975. Barbara Charlesworth Gelpi and Albert Gelpi, eds. *Adrienne Rich's Poetry.* New York.

Genauer 1953. Emily Genauer. "A New Look at a Realist." *New York Herald Tribune* (June 21), p. 10.

Geneseo 1968. Agnes Halsey Jones. *Hudson River School.* Fine Arts Center, State University of New York, Geneseo, Feb. 27–Apr. 6.

Gerdts 1973. William H. Gerdts. *American Neo-Classic Sculpture: The Marble Resurrection.* New York.

——— 1984. William H. Gerdts. *American Impressionism.* New York.

——— 1990. William H. Gerdts. *Art across America: Two Centuries of Regional Painting, 1710–1920.* 3 vols. New York.

——— 1996. William H. Gerdts. *William Glackens.* New York.

Gerdts and Burke 1971. William H. Gerdts and Russell Burke. *American Still-Life Painting.* New York.

Giffen and Murphy 1992. Sarah L. Giffen and Kevin D. Murphy. *A Noble and Dignified Stream: The Piscataqua Region in the Colonial Revival, 1860–1930.* York, Maine.

Gill 1987. Susan Gill. "Painting from the Heart." *Art News,* vol. 86, no. 4 (Apr. 1), pp. 128–35.

Giverny 1992. William H. Gerdts. *Lasting Impressions: American Painters in France, 1865–1915.* Musée Américain, Giverny, June 1–Nov. 1.

Glackens 1957. Ira Glackens. *William Glackens and the Ashcan Group.* New York.

Gladstone 1990. John Gladstone. "The Romance of the Iron Horse." *Journal of Decorative and Propaganda Arts,* winter/spring, pp. 7–37.

Glimcher 1976. Arnold B. Glimcher. *Louise Nevelson.* 2d ed. New York.

Gloucester 1973. *Portrait of a Place: Some American Landscape Painters in Gloucester.* Cape Ann Historical Association, Gloucester, Mass., July 25–Sept. 5.

Goodall 1969. Donald Goodall. "Gaston Lachaise, Sculptor." Ph.D. diss., Harvard University.

Goodrich 1933. Lloyd Goodrich. *Thomas Eakins: His Life and Work.* New York.

——— 1945. Lloyd Goodrich. *Winslow Homer.* New York.

——— 1949. Lloyd Goodrich. "Harnett and Peto: A Note on Style." *Art Bulletin,* vol. 31, no. 1 (Mar.), pp. 57–58.

——— 1959. Lloyd Goodrich. *Albert P. Ryder.* New York.

——— 1964. Lloyd Goodrich. "Homer and the Sea." *Arts in Virginia,* vol. 5, no. 1 (fall), pp. 12–21.

——— 1966. Lloyd Goodrich. "American Art and the Whitney Museum." *The Magazine Antiques,* vol. 90, no. 5 (Nov.), pp. 655–61.

Goodrich 1967. Laurence B. Goodrich. *Ralph Earl: Recorder for an Era.* Oneonta, N.Y.

Goodrich 1982. Lloyd Goodrich. *Thomas Eakins.* 2 vols. Cambridge, Mass.

Goodrich et al. 1981. Lloyd Goodrich with John Clancy, Helen Hayes, Raphael Soyer, Brian O'Doherty, and James Flexner. "Six Who Knew Edward Hopper." *Art Journal,* vol. 41, no. 2 (summer), pp. 125–35.

Goodrich Homer. Lloyd Goodrich. Catalogue raisonné of the works of Winslow Homer. Manuscript, City University of New York.

Grant 1989. H. Roger Grant, ed. *We Got There on the Train: Railroads in the Lives of the American People.* Washington, D.C.

Graves 1905–6. Algernon Graves. *The Royal Academy of Arts: A Complete Dictionary of Contributors and Their Work from Its Foundation in 1769 to 1904.* Vol. 3. London.

Green 1966. Samuel M. Green. *American Art: A Historical Survey.* New York.

Greenberg 1952. Clement Greenberg. "Art Chronicle: Feeling Is All." *Partisan Review,* vol. 19, no. 1 (Jan.–Feb.), pp. 97–102.

——— 1961. Clement Greenberg. *Art and Culture: Critical Essays.* Boston.

Groce 1937. George C. Groce, Jr. *William Samuel Johnson: A Maker of the Constitution.* New York.

Guberman 1995. Sidney Guberman. *An Illustrated Biography of Frank Stella.* New York.

Guitar 1959. Mary Anne Guitar. "Treasures on Campus." *Mademoiselle,* vol. 49 (May), pp. 112–15.

Gustafson 1982. Eleanor H. Gustafson. "Museum Accessions." *The Magazine Antiques,* vol. 122, no. 5 (Nov.), pp. 986 ff.

——— 1989. Eleanor H. Gustafson. "Museum Accessions." *The Magazine Antiques,* vol. 136, no. 5 (Nov.), pp. 1022 ff.

Hadler 1992. Mona Hadler. "Lee Bontecou: Heart of a Conquering Darkness." *Notes in the History of Art,* vol. 2, no. 1 (fall), pp. 38–44.

Hammacher 1960. Abraham Marie Hammacher. *Jacques Lipchitz.* Amsterdam.

——— 1975. Abraham Marie Hammacher. *Jacques Lipchitz.* Trans. James Brockway. New York.

Hanks 1987. David A. Hanks with Jennifer Toher. *Donald Deskey: Decorative Designs and Interiors.* New York.

Hanover 1950. *Contemporary Painting.* Exhibition in conjunction with lecture by Meyer Shapiro for the Great Issue course. Dartmouth College, Hanover, N.H., May.

Hanover 1999. *Winter's Promise: Willard Metcalf in Cornish, New Hampshire, 1909–1920.* Hood Museum of Art, Dartmouth College, Hanover, N.H., Jan. 9–Mar. 14.

Harper's 1873. "Ship-Building." *Harper's Weekly,* vol. 17, no. 876 (Oct. 11), pp. 900, 902.

Harper's 1874. "The Isles of Shoals." *Harper's New Monthly Magazine,* vol. 49, no. 293 (Oct.), pp. 663–76.

Hartford 1935. *American Painting and Sculpture of the 18th, 19th, and 20th Centuries.* Wadsworth Atheneum, Feb.

Hartford 1955. *Off for the Holidays.* Wadsworth Atheneum, Apr. 14–June 6.

Hartford 1985–86. *The Great River: Art and Society of the Connecticut River Valley.* Wadsworth Atheneum, Sept. 22–Jan. 6.

Hartley 1931. Marsden Hartley. "The Paintings of Florine Stettheimer." *Creative Art,* vol. 9, no. 1 (July), pp. 18–23.

Hartmann 1902. Sadakichi Hartmann. *A History of American Art.* 2 vols. Boston.

Hartt 1947. F[rederick] H[artt]. "A Marsden Hartley." *Smith College Museum of Art Bulletin*, nos. 25–28 (June), p. 41.

Hassrich 1997. Peter H. Hassrich, ed. *The Georgia O'Keeffe Museum*. New York.

Havelock 1995. Christine Mitchell Havelock. *The Aphrodite of Knidos and Her Successors*. Ann Arbor.

Haverstraw 1951. *County Art Show*. Central Presbyterian Church, Haverstraw, N.Y., Oct.

Hawthorne 1882. Nathaniel Hawthorne. *The Great Stone Face and Other Tales of the White Mountains*. Boston.

Hazen 1883. Henry A. Hazen. *History of Billerica, Massachusetts, with a Genealogical Register*. Boston.

Heller 1987. Nancy G. Heller. *Women Artists: An Illustrated History*. New York.

Hemenway 1863. Abby Maria Hemenway, ed. *Vermont Quarterly Gazetteer*. Vol. 5.

Hempstead 1985–86. *Avant-Garde Comes to New York*. Emily Lowe Gallery, Hofstra Cultural Center, Hofstra University, Hempstead, N.Y., Nov. 5–Jan. 2.

Hendricks 1964. Gordon Hendricks. "The First Three Western Journeys of Albert Bierstadt." *Art Bulletin*, vol. 66, no. 3 (Sept.), pp. 333–65.

——— 1974 *Bierstadt*. Gordon Hendricks. *Albert Bierstadt: Painter of the American West*. New York.

——— 1974 *Eakins*. Gordon Hendricks. *The Life and Work of Thomas Eakins*. New York.

——— 1979. Gordon Hendricks. *The Life and Work of Winslow Homer*. New York.

Henry 1987. Gerrit Henry. "Dark Poetry." *Art News*, vol. 86, no. 4 (Apr.), pp. 104–11.

Henry 1988. Steven P. Henry. "Charles Sheeler: Paintings, Drawings, Photographs." *Dallas Museum of Art Bulletin*, spring/summer, pp. 16–19.

Herbert 1984. Robert L. Herbert et al. *The Société Anonyme and the Dreier Bequest at Yale University: A Catalogue Raisonné*. New Haven.

Hess 1949. Thomas B. Hess. "Feininger Paints a Picture." *Art News*, vol. 48, no. 4 (summer), pp. 48–50, 60–61.

——— 1951. Thomas B. Hess. *Abstract Painting: Background and American Phase*. New York.

——— 1953. Thomas B. Hess. "De Kooning Paints a Picture." *Art News*, vol. 52, no. 1 (Mar.), pp. 30–33, 64–67.

——— 1954. Thomas B. Hess. "Lipchitz: Space for Modern Sculpture." *Art News*, vol. 53, no. 4 (summer), pp. 34–37, 61–62.

Hess 1961. Hans Hess. *Lyonel Feininger*. New York.

Hewitt 1992. M. J. Hewitt. "Betye Saar: An Interview." *International Review of African American Art*, vol. 10, no. 2, pp. 6–23.

Hiesinger 1994. Ulrich W. Hiesinger. *Childe Hassam*. Munich.

Hind 1908. C. Lewis Hind. *Augustus Saint-Gaudens*. New York.

Historical 1939. Historical Records Survey. *American Portraits (1620–1825) Found in Massachusetts*. Boston.

Hitchcock 1951 *Art*. Henry-Russell Hitchcock. "Recent Important Acquisitions of American Collections: An Altarpiece by Benjamin West, P.R.A." *Art Quarterly*, vol. 14, no. 3 (autumn), pp. 268–69. Excerpt from Hitchcock 1951 *SCMA*.

——— 1951 *SCMA*. Henry-Russell Hitchcock. "An 'Altarpiece' by Benjamin West, P.R.A., in the Smith College Museum of Art." *Smith College Museum of Art Bulletin*, nos. 29–32 (June), pp. 12–17.

——— 1954–55. Henry-Russell Hitchcock. "An Eighteenth-Century American Portrait." *Smith College Museum of Art Bulletin*, nos. 35–36, pp. 18–19.

Hobbs 1985. Susan A. Hobbs. "Thomas Dewing in Cornish, 1885–1905." *American Art Journal*, vol. 17, no. 2 (spring), pp. 2–32.

Hoeber 1911. Arthur Hoeber. "Art and Artists." *New York Globe and Commercial Advertiser*, vol. 114, no. 142 (Mar. 20), p. 110.

Hoffman 1997. Katherine Hoffman. *Georgia O'Keeffe: A Celebration of Music and Dance*. New York.

Hogrefe 1992. Jeffrey Hogrefe. *O'Keeffe: The Life of an American Legend*. New York.

Holm 1965. Bill Holm. *Northwest Coast Indian Art: An Analysis of Form*. Seattle.

Holyoke 1982–83. *Sun, Sand and Wild Uproar: American Marine Paintings and Prints*. Holyoke (Mass.) Museum, Nov. 14–Jan. 27.

Homer 1977. William Innes Homer. *Alfred Stieglitz and the American Avant-Garde*. Boston.

——— 1983. William Innes Homer. *Early Modernism in America: The Stieglitz Circle*. Minneapolis.

Homer and Goodrich 1989. William Innes Homer and Lloyd Goodrich. *Albert Pinkham Ryder: Life, Art, and Influence*. New York.

Hopper 1928. Edward Hopper. "Charles Burchfield: American." *Arts Magazine*, vol. 14, no. 1 (July), pp. 5–12.

——— 1953. Edward Hopper. "Statements by Four Artists." *Reality*, vol. 1, no. 1 (spring), p. 8.

Houfe 1973. Simon Houfe. "Whistler in the Country: His Unrecorded Friendship with Lewis Jarvis." *Apollo*, vol. 98, no. 140 (Oct.), pp. 282–85.

Houston 1951. *Sheeler/Dove: Exhibition*. Contemporary Arts Association, Houston, Jan. 7–28.

Houston 1956. *American Primitive Art*. Museum of Fine Arts, Houston, Jan. 6–29.

Houston + 1994. David Anfam. *Franz Kline: Black and White, 1950–1961*. Menil Collection, Houston, Sept. 8–Nov. 27; Whitney Museum of American Art, New York, Dec. 16–Mar. 5, 1995; Museum of Contemporary Art, Chicago, Mar. 25–June 4.

Houston 1994. Jourdan Houston. "Francis Seth Frost (1825–1902): Beyond Bierstadt's Shadow." *American Art Review*, vol. 6, no. 4 (Apr.), pp. 146–57.

Hunter 1972. Sam Hunter. *American Art of the 20th Century*. New York.

Huntington 1887. Daniel Huntington. *Asher B. Durand: A Memorial Address*. New York.

Huntington 1972–73. *Mistaken Identity*. Heckscher Museum, Huntington, N.Y., Dec. 17–Jan. 28.

Huntington 1975. *The Drama of the Sea*. Heckscher Museum, Huntington, N.Y., May 11–June 15.

Huntington 1978. *The Precisionist Painters, 1916–1949: Interpretations of a Mechanical Age*. Heckscher Museum, Huntington, N.Y., July 7–Aug. 20.

Hyde 1961. Mary C. Hyde. "Two Distinguished Dr. Johnsons." *Columbia Library Columns*, vol. 10, no. 3 (May), pp. 2–10.

Hyde and Hyde 1878. C. M. Hyde and Alexander Hyde. *The Centennial Celebration and Centennial History of the Town of Lee, Mass*. Springfield, Mass.

ICA Bulletin 1954. "The Smith College Collection." *Institute of Contemporary Art (Boston) Bulletin*, vol. 3, no. 3 (Jan.–Feb.), pp. 1–2.

Indianapolis 1949. *Chase Centennial Exhibition Commemorating the Birth of William Merritt Chase*. John Herron Art Museum, Indiana University, Nov. 1–Dec. 11.

Inness 1878. George Inness and unidentified interviewer. "A Painter on Painting." *Harper's New Monthly Magazine*, vol. 56, no. 333 (Feb.), pp. 458–61.

Iowa City 1963. *The Quest of Charles Sheeler: 83 Works Honoring His 80th Year*. Department of Art, University of Iowa, Iowa City, Mar. 17–Apr. 14.

Ireland 1965. Leroy Ireland. *The Works of George Inness: An Illustrated Catalogue Raisonné*. Austin, Tex.

Isaacson 1975. Philip M. Isaacson. *The American Eagle*. Boston.

Ives 1892. A. E. Ives. "Talks with Artists: Mr. Childe Hassam on Painting Street Scenes." *Art Amateur*, Oct., p. 116.

Jacksonville + 1959. *Major Work in Minor Scale*. Organized by the American Federation of Arts. Jacksonville (Fla.) Art Museum, Dec. 4–24; Des Moines Art Center, Jan. 5–25, 1960; Philbrook Art Center, Tulsa, Okla., Feb. 2–23; Charles and Emma Frye Art Museum, Seattle, Mar. 10–31; Art Gallery of Greater Victoria, Victoria, B.C., Apr. 13–May 2; Andrew Dickson White Museum of Art, Ithaca, N.Y., May 17–June 30; Miami Art Center, Miami Beach, July 18–Aug. 3; Spiva Art Center, Joplin, Mo., Aug. 17–Sept. 11; Evansville (Ind.) Museum of Arts and Science, Sept. 21–Oct. 11; Chatham College, Pittsburgh, Oct. 29–Nov. 19; Art Museum of the New Britain Institute, New Britain, Conn., Dec. 1–22.

James 1866 [1919]. Henry James. "A Landscape Painter." *Atlantic Monthly*, vol. 18, no. 100 (Feb.), pp. 182–202. Reprinted in *A Landscape Painter*, New York, 1919.

Janson 1980. Anthony F. Janson with A. Ian Fraser. *100 Masterpieces of Painting in the Indianapolis Museum of Art*. Indianapolis.

Janson 1995. H. W. Janson. *History of Art*. 5th ed. New York.

Jarves [1864] 1960. James Jackson Jarves. *The Art-Idea*. Cambridge, Mass.

Jennings 1990. Kate F. Jennings. *Winslow Homer*. Greenwich, Conn.

———— 1991. Kate F. Jennings. *John Singer Sargent*. New York.

Jersey City + 1996–97. *Subversions/Affirmations: Jaune Quick-to-See Smith, A Ten-Year Survey*. Jersey City (N.J.) Museum, Dec. 11–Feb. 15; Lehigh University Art Galleries, Bethlehem, Pa., Apr. 2–Oct. 12; Art Museum of Misssoula, Mont., Dec. 10–Feb. 14, 1998.

Jewell 1934. Edward Alden Jewell. "Realm of Art: Notable Collection at Smith College." *New York Times*, Sept. 9, p. 6x.

———— 1943. Edward Alden Jewell. "The Realm of Art: A New Platform and Other Matters: 'Globalism' Pops into View." *New York Times*, June 13, p. 9x.

Jodidio 1983. Philip Jodidio. "Le Temps de la magie." *Connaissance des arts*, July–Aug., pp. 82–89.

Johns 1983. Elizabeth Johns. *Thomas Eakins. The Heroism of Modern Life*. Princeton.

Johnson 1982. Fridolf Johnson. *Rockwell Kent*. New York.

Jonaitis 1988. Aldona Jonaitis. *From the Land of Totem Poles: The Northwest Coast Indian Art Collection of the American Museum of Natural History*. Seattle.

Jones 1979. Betsy B. Jones. "Edwin Romanzo Elmer in the Collection of the Smith College Museum of Art." *Smith College Alumnae Quarterly*, vol. 70, no. 3 (Apr.), pp. 14–19.

———— 1983. Betsy B. Jones. *Edwin Romanzo Elmer, 1850–1923*. Hanover, N.H.

Judd 1965. Donald Judd. "Lee Bontecou." *Arts Magazine*, vol. 39, no. 7 (Apr.), pp. 17–21.

Junker 1997–98. Patricia Junker. "New Acquisition—Thomas Cole's *Prometheus Bound*." *Fine Arts* (Fine Arts Museums of San Francisco), no. 7 (winter 1997–98), pp. 15–19.

Kammen 1968. Michael G. Kammen. *A Rope of Sand: The*

Colonial Agents, British Politics, and the American Revolution. Ithaca, N.Y.

Kandell 1997. Leslie Kandell. "Forging Bonds between Nature and Culture." *New York Times* (New Jersey ed.), Feb. 2, p. 12.

Katonah 1976. *American Painting, 1900–1976: The American Scene and New Forms of Modernism, 1936–1954*. Katonah (N.Y.) Gallery, Jan. 17–Mar. 14.

Katonah 1980. *Plane Truths: American Trompe l'Oeil Painting*. Katonah (N.Y.) Gallery, June 7–July 20.

Katonah 1993. *Friends and Family: Portraiture in the World of Florine Stettheimer*. Katonah (N.Y.) Museum of Art, Sept. 19–Nov. 28.

Keene + 1985. *A Circle of Friends: Art Colonies of Cornish and Dublin*. Thorne-Sagendorph Art Gallery, Keene (N.H.) State College, Mar. 9–Apr. 26; Saint-Gaudens National Historic Site, Cornish, N.H., June 22–Aug. 18; Hood Museum of Art, Dartmouth College, Hanover, N.H., June 28–Aug. 18; University Art Galleries, University of New Hampshire, Durham (co-organizer), Sept. 9–Oct. 30.

Kelly et al. 1996. Franklin Kelly, Nicolai Cikovsky, Jr., Deborah Chotner, and John Davis. *American Paintings of the Nineteenth Century*. Collections of the National Gallery of Art Systematic Catalogue, I. Washington, D.C.

Kent 1955. Rockwell Kent. *It's Me O Lord*. New York.

Keyes 1933. Homer Eaton Keyes, ed. [and uncredited author?]. "Early Wood Sculpture." *The Magazine Antiques*, vol. 24, no. 5 (Dec.), pp. 226, 228–30.

King 1860. Thomas Starr King. *The White Hills: Their Legends, Landscape and Poetry*. Boston.

Kirstein 1973. Lincoln Kirstein. *Elie Nadelman*. New York.

Knapp 1989. Lewis G. Knapp. *In Pursuit of Paradise: History of the Town of Stratford, Connecticut*. West Kennebunk, Maine.

Knowlton 1899. Helen M. Knowlton. *The Art-Life of William Morris Hunt*. Boston.

Koke 1982. Richard Koke. *American Landscape and Genre Painting in the New-York Historical Society*. Boston.

Kootz 1943. Samuel M. Kootz. *New Frontiers in American Painting*. New York.

Kornhauser 1989. Elizabeth Mankin Kornhauser. *Ralph Earl: Artist-Entrepreneur*. Ann Arbor.

———— 1996. Elizabeth Mankin Kornhauser. *American Paintings before 1945 in the Wadsworth Atheneum*. New York and London.

Kramer 1961. Hilton Kramer. "The American Precisionists." *Arts Magazine*, vol. 35, no. 6 (Mar.), pp. 32–37.

———— 1969. Hilton Kramer. "Charles Sheeler: American Pastoral." *Artforum*, vol. 7, no. 5 (Jan.), pp. 36–39.

———— 1980. Hilton Kramer. "Florine Stettheimer's Distinctive Vision of Society." *New York Times*, Mar. 16, p. D33.

Kramer et al. 1967. Hilton Kramer et al. *The Sculpture of Gaston Lachaise*. New York.

Kranzfelder 1994. Ivo Kranzfelder. *Hopper, 1882–1967: Vision der Wirklichkeit*. Cologne.

Krum 1981. Werner Krum. *USA Ostküste*. Munich.

Kuh 1962. Katharine Kuh. *The Artist's Voice: Talks with Seventeen Artists*. New York.

Kuspit 1975. Donald B. Kuspit. "Sol LeWitt: The Look of Thought." *Art in America*, vol. 63, no. 5 (Sept.–Oct.), pp. 42–49.

La Follette 1935. Suzanne La Follette. "American Art: Its Economic Aspects." *American Magazine of Art*, vol. 28, no. 6 (June), pp. 337–44.

Lahvis 1992. Sylvia L. Lahvis. *The Skillin Workshop: The Emblematic Image in Federal Boston*. Ph.D. diss., University of Delaware, 1990. Reprint, Ann Arbor.

La Jolla + 1965. *The Reminiscent Object: Paintings by William Harnett, John Frederick Peto, and John Haberle*. La Jolla (Calif.) Museum of Art, July 11–Sept. 19; Santa Barbara (Calif.) Museum of Art, Oct. 1–31.

Lane 1939. James W. Lane. "A View of Two Native Romantics." *Art News*, vol. 38, no. 6 (Nov. 11), pp. 9, 16.

———— 1940. James W. Lane. "This Year: The Carnegie National/Pittsburgh's Brilliant Survey of 160 Years of U.S.

Painting." *Art News*, vol. 39, no. 4 (Oct. 26), pp. 6–18.

———— 1942. James W. Lane. *Whistler*. New York.

Larkin 1949. Oliver W. Larkin. *Art and Life in America*. New York.

Lawall [1966] 1977. David B. Lawall. *Asher Brown Durand. His Art and Art Theory in Relation to His Times*. Ph.D. diss., Princeton University. Reprint, *Outstanding Dissertations in the Fine Arts*, New York.

———— 1978. David B. Lawall. *Asher B. Durand: A Documentary Catalogue of the Narrative and Landscape Paintings*. New York.

Leader 1980. Bernice Kramer Leader. "The Boston School and Vermeer." *Arts Magazine*, vol. 55, no. 3 (Nov.), pp. 172–76.

Lemardeley-Cunci 1993. Marie-Christine Lemardeley-Cunci. "Le Deuil de l'image dans 'Mourning Picture' d'Adrienne Rich." *Polysèmes: Arts et Littératures* (Paris), no. 4, pp. 139–45.

Lerner 1974. Abram Lerner, ed. *The Hirshhorn Museum and Sculpture Garden*. New York.

Le Touquet 1913. *Exposition des Beaux-Arts*. Société Artistique de Picardie, Chateau du Touquet, Le Touquet, France.

Levin 1985. Gail Levin. *Hopper's Places*. New York.

———— 1995 *Biography*. Gail Levin. *Edward Hopper: An Intimate Biography*. New York.

———— 1995 *Catalogue*. Gail Levin. *Edward Hopper: A Catalogue Raisonné*. 3 vols. New York.

Levy 1905. Florence N. Levy, ed. "Directory of Painters, Sculptors, Illustrators." *American Art Annual*, vol. 5, pp. 319–445.

LeWitt 1966 *Arts*. Sol LeWitt. "Ziggurats." *Arts Magazine*, vol. 41, no. 1 (Nov.), pp. 24–25.

———— 1966 *Aspen*. Sol LeWitt. "Serial Projects No. 1." *Aspen Magazine*, nos. 5–6, sec. 17, unpag.

———— 1967. Sol LeWitt. "Paragraphs on Conceptual Art." *Artforum*, vol. 5, no. 10 (June), pp. 79–83.

———— 1969. Sol LeWitt. "Sentences on Conceptual Art." *Art-Language*, vol. 1, no. 1 (May), pp. 11–13.

Libr Mus Q 1987. "Exhibitions: At the Connecticut Valley Historical

Museum." *Library and Museums Quarterly*, Dec., p. 9.

Lifton 1987. Norma Lifton. "Thomas Eakins and S. Weir Mitchell: Images and Cures in Late Nineteenth-Century Philadelphia." In Mary Mathews Gedo, ed. *Psychoanalytic Perspectives on Art*, vol. 2, pp. 247–74. Hillsdale, N.J.

Lincoln 1975. Norman Geske. *Ralph Albert Blakelock, 1847–1919*. Sheldon Memorial Art Gallery, University of Nebraska, Lincoln, Jan. 14–Feb. 9.

Lipchitz 1972. Jacques Lipchitz with H. H. Arnason. *My Life in Sculpture*. London.

Lipke and Grime 1973. William C. Lipke and Philip N. Grime. "Albert Bierstadt in New Hampshire." *Currier Gallery of Art Bulletin*, no. 2 (1973), pp. 20–37.

Lipman and Franc 1976. Jean Lipman and Helen M. Franc. *Bright Stars: American Painting and Sculpture since 1776*. New York.

Lippard 1965. Lucy Lippard. "Three Generations of Women: De Kooning's First Retrospective." *Art International*, vol. 9, no. 8 (Nov. 20), pp. 29–31.

———— 1973. Lucy Lippard. *Six Years: The Dematerialization of the Art Object from 1966 to 1972*. New York.

Lisle 1990. Laurie Lisle. *Louise Nevelson: A Passionate Life*. New York.

Little 1948 March. Nina Fletcher Little. "T. Chambers, Man or Myth." *The Magazine Antiques*, vol. 53, no. 3 (Mar.), pp. 194–96.

———— 1948 April. Nina Fletcher Little. "Earliest Signed Picture by T. Chambers." *The Magazine Antiques*, vol. 53, no. 4 (Apr.), p. 285.

———— 1951. Nina Fletcher Little. "More about T. Chambers. . . . " *The Magazine Antiques*, vol. 60, no. 5 (Nov.), p. 469.

———— 1965. Nina Fletcher Little. *Country Art in New England, 1790–1840*. Sturbridge, Mass.

Little 1997. Carl Little. *Winslow Homer: His Art, His Light, His Landscapes*. Cobb, Calif.

Liverpool 1925. *Fifty-third Autumn Exhibition (Including a Collective Exhibit of Work by the Late John S. Sargent, R.A.)*. Walker Art Gallery, Liverpool.

Lockwood 1994. Allison Lockwood. *No Ordinary Man: Judge Forbes and His Library: Forbes Library 1894–1994*. Northampton, Mass.

London 1783. Exhibition. Gallery of Incorporated Society of Artists, May.

London 1791. Exhibition of the Royal Academy. Somerset House.

London 1905. *Memorial Exhibition of the Works of the Late James McNeill Whistler*. International Society of Sculptors, Painters and Gravers, New Gallery, Feb. 22–Mar. 31.

London 1910. *Exhibition of Works by the Old Masters*. Royal Academy, winter.

London 1914. *Anglo-American Exposition*. London, summer.

London 1925. Exhibition. Chenil Galleries.

London 1926. *Exhibition of Works by the Late John S. Sargent, R.A.* Royal Academy, winter.

London 1970. Robert Melville. *Alex Colville*. Marlborough Fine Art, Jan.–Feb.

London + 1989. Donald Garstang. *Master Paintings, 1350–1800*. P. and D. Colnaghi and Company, London, Nov. 8–Dec. 16; Colnaghi USA, New York, Jan. 10–Feb. 10, 1990.

London + 1991–92. Richard Thomson et al. *Toulouse Lautrec*. Hayward Gallery, Oct. 10–Jan 19; Grand Palais, Paris, Feb. 21–June 1.

London + 1993. Charles C. Eldredge. *Georgia O'Keeffe: American and Modern*. Hayward Gallery, Apr. 8–June 27; El Museo del Palacio de Bellas Artes, Mexico City, July 15–Oct. 1; Yokohama Museum of Art, Oct. 30–Jan. 6, 1994.

London 1993–94. John Wilmerding, ed. *Thomas Eakins (1844–1916) and the Heart of American Life*. National Portrait Gallery, Oct. 8–Jan. 25.

London 1994–95. Richard Dorment and Margaret MacDonald. *James McNeill Whistler*. Tate Gallery, Oct. 3–Jan. 8; Musée d'Orsay, Paris, Feb. 6–Apr. 30; National Gallery of Art, Washington, D.C., May 28–Aug. 20.

Los Angeles 1934. *European and American Paintings*. Los Angeles Museum, Aug.

Los Angeles 1953. *Painting in the U.S.A. 1721–1953 (Pace Setters in American Art)*. Los Angeles County Fair Association, Sept. 18–Oct. 24.

Los Angeles + 1954. *Charles Sheeler: A Retrospective Exhibition*. University of California Art Galleries, Los Angeles, Oct. 11–Nov. 7; M. H. de Young Memorial Museum, San Francisco, Nov. 18–Jan. 2, 1955; Fine Arts Gallery, San Diego, Jan. 14–Feb. 11; Fort Worth (Tex.) Art Center, Feb. 24–Mar. 24; Pennsylvania Academy of the Fine Arts, Philadelphia, Apr. 7–30; Munson-Williams-Proctor Institute, Utica, N.Y., May 8–June 15.

Los Angeles + 1968. *Marsden Hartley; Painter/Poet, 1877–1943*. University Galleries, University of Southern California, Los Angeles, Nov. 20–Dec. 20; Tucson (Ariz.) Art Center, Jan. 10–Feb. 16, 1969; University Art Museum, University of Texas, Austin, Mar. 10–Apr. 27.

Los Angeles + 1990. *Secrets, Dialogues and Revelations: The Art of Betye and Alison Saar*. Wight Art Gallery, University of California, Los Angeles, Jan. 9–Feb. 25; Museum of Contemporary Art, Chicago, July 14–Sept. 16; Smith College Museum of Art, Jan. 6–Mar. 3, 1991; Contemporary Arts Center, Cincinnati, Mar. 22–May 25; Oakland (Calif.) Museum, June 29–Aug. 25.

Los Angeles 1992. *500 Years: With the Breath of Our Ancestors*. Municipal Art Gallery, Barnsdall Art Park, July 1–Aug. 16.

Los Angeles + 1993. *Sculpture and Drawings of the 1960s*. Museum of Contemporary Art, Los Angeles, Mar. 28–May 19; Parrish Art Museum, Southampton, N.Y., Sept. 19–Nov. 14; Nelson Atkins Museum of Art, Kansas City, Mo., Jan. 2–Feb. 27, 1994.

Los Angeles 1995–96. Ann Goldstein and Ann Rorimer. *Reconsidering the Object of Art, 1965–1975*. Museum of Contemporary Art, Oct. 15–Feb. 4.

Louchheim 1949. Aline B. Louchheim. "Attributed to Whom?" *New York Times*, Aug. 14, p. 6x.

Lucic 1991. Karen Lucic. *Charles Sheeler and the Cult of the Machine*. Cambridge, Mass.

Ludington 1992. Townsend Ludington. *Marsden Hartley: The Biography of an American Artist*. Boston.

Lüneburg 1991. *Lyonel Feininger: Begegnung und Erinnerung Lüneburger Motive, 1921–1954*. Kulturforum, Lüneburg, Oct. 12–Nov. 11.

Lynes 1981. Russell Lynes. "Art in Academe." *Architectural Digest*, vol. 38, no. 10 (Oct.), pp. 50–58 ff.

Maass 1957. John Maass. *The Gingerbread Age*. New York.

———— 1972. John Maass. *The Victorian Home in America*. New York.

Madormo 1983. Nick Madormo. "The Early Career of Alfred Maurer: Paintings of Popular Entertainments." *American Art Journal*, vol. 15, no. 1 (winter), pp. 4–34.

Madrid + 1998. *James McNeill Whistler, Walter Richard Sickert*. Fundación "la Caixa," Madrid, Mar. 17–May 17; Museo de Bellas Artes, Bilbao, May 27–July 19.

Mahalin c. 1863. Paul Mahalin. *Au Bal masque*. Paris.

Maloney 1963. Tom Maloney. "Charles Sheeler." *U.S. Camera Annual 1964* (New York), pp. 36–37.

Manchester 1977. *Go West, America!* Currier Gallery of Art, Manchester, N.H., Mar. 9–Apr. 24.

Manship 1989. John Manship. *Paul Manship*. New York.

Manson 1925. J. B. Manson. "Notes on the Works of J. S. Sargent." *Studio International*, vol. 90, no. 389 (Aug. 15), pp. 78–87.

Marter 1976. Joan M. Marter. "Alexander Calder: Ambitious Young Sculptor of the Thirties." *Archives of American Art Journal*, vol. 16, no. 2, pp. 2–8.

———— 1991. Joan M. Marter. *Alexander Calder*. Cambridge and New York.

Mason 1974. Sarah R. Mason. "Pristine Marble Bust of Little May Queen Arrived Here in 1914." *Northampton (Mass.) Daily Hampshire Gazette*, Feb. 9.

Mather 1927. Frank Jewett Mather et al. *The American Spirit in Art*. Vol. 12. New Haven.

Mathey 1978. François Mathey. *American Realism: A Pictorial Survey from the Early Eighteenth Century to the 1970s*. New York.

McBride 1917. Henry McBride. "Exhibitions at New York Galleries." *Fine Arts Journal*, vol. 35, no. 12 (Dec.), pp. 46–63.

————— 1945. Henry McBride. "Florine Stettheimer: A Reminiscence." *View*, ser. 5, no. 3 (Oct.), pp. 12–15.

————— 1946. Henry McBride. "Artists in the Drawing Room." *Town and Country*, vol. 100, no. 429 (Dec.), pp. 74–77, 336–37.

————— 1950. Henry McBride. "Georgia O'Keeffe of Abiquiu." *Art News*, vol. 49, no. 7 (Nov.), pp. 56–57.

————— 1975. Henry McBride. *The Flow of Art: Essays and Criticisms of Henry McBride*. New York.

McCausland 1937. Elizabeth McCausland. "Arthur G. Dove's Showing of Oils and Water Colors." *Springfield (Mass.) Sunday Union and Republican*, Mar. 28, 1937, p. E6.

————— 1951. Elizabeth McCausland. *A. H. Maurer*. New York.

————— 1952. Elizabeth McCausland. *Marsden Hartley*. Minneapolis.

McCoubrey 1965. John W. McCoubrey, ed. *American Art, 1700–1960: Sources and Documents*. Englewood Cliffs, N.J.

McEvilley 1994. Thomas McEvilley. "Lee Bontecou, Parrish Art Museum." *Artforum*, vol. 32, no. 6 (Feb.), pp. 90–91.

McKinney 1942. Roland J. McKinney. *Thomas Eakins*. New York.

McKinsey 1985. Elizabeth McKinsey. *Niagara Falls: Icon of the American Sublime*. New York.

McLanathan 1960 "Museum." Richard B. K. McLanathan. "The Museum in the Smaller Community." *Museum News*, vol. 39, no. 1 (Sept.), pp. 24–27.

————— 1960 "Art." Richard B. K. McLanathan. "Art across America." *The Magazine Antiques*, vol. 78, no. 5 (Nov.), pp. 456–58.

————— 1986. Richard B. K. McLanathan. *Gilbert Stuart*. New York.

McQuiston 1976. John T. McQuiston. "Hopper Exhibition at His Home." *New York Times*, June 11.

Meltzoff 1942. Stanley Meltzoff. "The Rediscovery of Vermeer." *Marsyas*, vol. 2 (1942), pp. 145–66.

Merkert and Prinz 1992. Jörn Merkert and Ursula Prinz, eds.

George Rickey in Berlin, 1967–1992. Berlin.

Merrill 1990. Linda Merrill. *An Ideal Country: Paintings by Dwight William Tryon in the Freer Gallery of Art*. Washington, D.C.

Merritt 1956. Howard S. Merritt. "Thomas Chambers, Artist." *New York History*, vol. 37 (Apr.), pp. 212–22.

Meyer 1979. Jerry D. Meyer. "Benjamin West's Window Designs for St. George's Chapel, Windsor." *American Art Journal*, vol. 11, no. 3 (July), pp. 53–65.

————— 1981. Jerry D. Meyer. "The Painter and the Craftsman: Late Eighteenth-Century Stained Glass in England." *Stained Glass*, vol. 76, no. 3 (fall), pp. 220–23.

Miami 1984. *In Quest of Excellence: Civic Pride, Patronage, Connoisseurship*. Center for the Fine Arts, Miami, Jan. 14–Apr. 22.

Middletown 1951. *Aspects of American Realism: An Exhibition Lent by Museums and Private Collections*. Davison Art Rooms, Wesleyan University, Middletown, Conn., May 21–June 2.

Middletown 1954. *Winslow Homer*. Davison Art Center, Wesleyan University, Middletown, Conn., Oct. 24–Nov. 30.

Middletown 1958. *Summer Exhibition*. Davison Art Center, Wesleyan University, Middletown, Conn., July–Aug.

Middletown 1961. *The City and the Land*. Davison Art Center, Wesleyan University, Middletown, Conn., Oct. 20–Nov. 9.

Middletown 1975. *Works by Lee Bontecou*. Davison Art Center, Wesleyan University, Middletown, Conn., May 2–June 15.

Milgrome 1969. David Milgrome. "The Art of William Merrit [*sic*] Chase." Ph.D. diss., University of Pittsburgh.

Millard 1968. Charles W. Millard III. "Charles Sheeler: American Photographer." *Contemporary Photographer*, vol. 6, no. 1, unpag.

Miller 1945. Dorothy C. Miller. "Discovery and Rediscovery." *Art in America*, vol. 33, no. 4 (Oct.), pp. 255–60.

Minneapolis 1939. *History of American Painting*. University Art Museum, University of Minnesota, Jan. 23–Feb. 28.

Minneapolis 1948. *Displaced Paintings/Refugees from Nazi Germany*. Minneapolis Institute of Arts, Apr. 9–May 9.

Minneapolis + 1949. Elizabeth McCausland. *A. H. Maurer, 1868–1932*. Walker Art Center, Sept. 11–Oct. 16; Whitney Museum of American Art, New York, Nov. 6–Dec. 11; Institute of Modern Art, Boston, Dec. 19–Jan. 21, 1950.

Minneapolis 1952. *Charles Sheeler*. Walker Art Center, May 18–June 15.

Minneapolis + 1960. *The Precisionist View in American Art*. Walker Art Center, Nov. 13–Dec. 25; Whitney Museum of American Art, New York, Jan. 15–Feb. 28, 1961; Detroit Institute of Arts, Mar. 21–Apr. 23; Los Angeles County Museum, May 17–June 18; San Francisco Museum of Art, July 2–Aug. 6.

Minneapolis 1963–64. *Four Centuries of American Art*. Minneapolis Institute of Arts, Nov. 27–Jan. 19.

Mitchell 1957. Joan Mitchell. "Women Artists in Ascendence: Young Group Reflects Lively Virtues of U.S. Painting." *Life*, May 13, pp. 74–77.

Mongin 1965. Alfred Mongin. "Forgotten Founding Fathers." *The Magazine Antiques*, vol. 88, no. 4 (Oct.), pp. 516–21.

Monroe 1911. Harriet Monroe. "Prize Winners at the Autumn Exhibit." *Chicago Sunday Tribune*, vol. 70, no. 47 (Nov. 19), pt. 2, p. 6.

Montclair + 1994. William Gerdts et al. *George Inness: Presence of the Unseen, a Centennial Celebration*. Montclair (N.J.) Art Museum, Sept. 11–Nov. 6; Parrish Art Museum, Southampton, N.Y., Nov. 20–Jan. 8, 1995; Mount Holyoke College Art Museum, South Hadley, Mass., Feb. 3–Mar. 17; Hudson River Museum of Westchester, Yonkers, N.Y., June 2–Sept. 3.

Montreal 1967. *The Painter and the New World: A Survey of Painting from 1564 to 1867 Marking the Founding of Canadian Confederation*. Montreal Museum of Fine Arts, June 9–July 30.

Morgan 1919. John Hill Morgan. "Further Notes on Blackburn." *Brooklyn Museum Quarterly*, vol. 6, no. 3 (July), pp. 147–55.

Morgan 1984. Ann Lee Morgan. *Arthur Dove: Life and Work with a*

Catalogue Raisonné. Newark, Del., and London.

————— 1988. Ann Lee Morgan, ed. *Dear Stieglitz, Dear Dove*. Newark, Del.

Morgan and Foote 1936. John Hill Morgan and Henry Wilder Foote. "An Extension of Lawrence Park's Descriptive List of the Work of Joseph Blackburn." *Proceedings of the American Antiquarian Society*, n.s., vol. 46 (Apr.), pp. 15–79.

Morris 1951. Lloyd Morris. *Incredible New York: High Life and Low Life of the Last Hundred Years*. New York.

Mount 1955. Charles Merrill Mount. *John Singer Sargent: A Biography*. New York.

————— 1957. Charles Merrill Mount. *John Singer Sargent: A Biography*. London.

————— 1964 *Gilbert*. Charles Merrill Mount. *Gilbert Stuart*. New York.

————— 1964 *Country*. Charles Merrill Mount. "An American Artist in London, Gilbert Stuart—I." *Country Life*, vol. 125, no. 3494 (Feb. 10), pp. 373–82.

Muehlig 1989. Linda Muehlig. *Inness: New Jersey Landscape*. Northampton, Mass.

Muller 1976. Nancy C. Muller. *Paintings and Drawings at the Shelburne Museum*. Shelburne, Vt.

Mumford 1931. Lewis Mumford. *The Brown Decades: A Study of the Arts in America, 1865–1895*. New York.

————— 1937. Lewis Mumford. "The Art Galleries: Academicians and Others." *New Yorker*, vol. 13, no. 8 (Apr. 10), p. 66.

Munich + 1974–75. *Art of the Naïves: Themes and Affinities*. Haus der Kunst, Munich, Nov. 1–Jan. 12; Kunsthaus, Zurich, Jan. 25–Mar. 13.

Munich 1981–82. *Amerikanische Malerei, 1930–1980*. Haus der Kunst, Munich, Nov. 14–Jan. 31.

Munro 1972. Eleanor Munro. *Originals: American Women Artists*. New York.

Munsterberg 1975. Hugo Munsterberg. *A History of Women Artists*. New York.

————— 1983. Hugo Munsterberg. *The Crown of Life: Artistic Creativity in Old Age*. New York.

Murtha 1957. Edwin Murtha. *Paul Manship*. New York.

Myers 1990. Terry Myers. "From the Junk Aesthetic to the Junk Mentality." *Arts Magazine*, vol. 64, no. 6 (Feb.), pp. 60–64.

Nadelman 1910. Elie Nadelman. "Photo-Secession Notes: The Photo-Secession Gallery." *Camera Work*, no. 32 (Oct.), p. 41.

————— 1925. Elie Nadelman. "Letter to the Editor of the Forum." *Forum*, vol. 74, no. 1 (July), p. 148.

Nation 1865. "Fine Arts: The Sixth Annual Exhibition of the Artists' Fund Society of New York." *The Nation*, vol. 1, no. 22 (Nov. 30), pp. 692–93.

Ness 1974. June L. Ness. *Lyonel Feininger*. New York.

Nevelson 1976. Louise Nevelson. *Dawns + Dusks: Taped Conversations with Diana MacKown*. New York.

Nevins 1984. Deborah Nevins. "Poet's Garden, Painter's Eye." *House and Garden*, vol. 156, no. 8 (Aug.), pp. 92–97.

Newark 1958. *Nature's Bounty and Man's Delight*. Newark (N.J.) Museum, June 15–Sept. 28.

New Bedford 1960. *A Selection of Paintings by Albert Pinkham Ryder and Albert Bierstadt*. William W. Crapo Gallery, Swain School of Design, New Bedford, Mass., Apr. 23–May 15.

New Brunswick + 1979. Joan M. Marter. *Vanguard American Sculpture, 1913–1939*. Rutgers University Art Gallery, New Brunswick, N.J., Sept. 16–Nov. 4; William Hayes Ackland Art Center, University of North Carolina, Chapel Hill, Dec. 4–Jan. 20, 1980; Joslyn Art Museum, Omaha, Feb. 16–Mar. 30; Oakland (Calif.) Museum, Apr. 15–May 25.

New Haven + 1990. David Park Curry. *Childe Hassam: An Island Garden Revisited*. Yale University Art Gallery, New Haven, Apr. 4–June 10; Denver Art Museum (organizer), July 4–Sept. 9; National Museum of American Art, Washington, D.C., Oct. 5–Jan. 7, 1991.

New London 1945. *Men of the Tile Club*. Lyman Allyn Museum, New London, Conn., Mar. 11–Apr. 23.

New London 1949. *James McNeill Whistler*. Lyman Allyn Museum, New London, Conn., May 1–June 13.

New London 1997. *David Smalley: Retrospective Exhibition*. Lyman

Allen Museum of Art, New London, Conn., Sept. 12–Nov. 16.

New Orleans 1984. *The Waters of America: 19th-Century American Paintings of Rivers, Streams, Lakes, and Waterfalls*. Historic New Orleans Collection with the New Orleans Museum of Art, May 6–Nov. 18.

New Path 1865. "The Artists' Fund Society." *The New Path*, vol. 2, no. 12 (December), pp. 193–94.

Newport 1912. *First Annual Exhibition of Pictures by American Painters*. Art Association of Newport, R.I., July 19–28.

Newport 1974. *Monuments: An Exhibition of Outdoor Sculpture*. Newport, R.I., Aug. 17–Oct. 13.

Newport 1987. *1912 Revisited: The 75th Anniversary Exhibition*. Newport (R.I.) Art Museum and Art Association, July 10–Sept. 27.

New York +, African 1993–94. Robert Farris Thompson, *Face of the Gods: Art and Altars of Africa and the African Americas*, Museum for African Art, Sept. 24–Jan. 7; Seattle Art Museum, Feb. 17–Apr. 17; DuSable Museum of African-American History, Chicago, June 12–Aug.; University Art Museum, University of California, Berkeley, Sept. 27–Feb. 19, 1995; Montgomery (Ala.) Museum of Art, Mar. 19–May 14; National Museum, Copenhagen, June 14–July 31, 1996; Kulturhuset, Stockholm, Nov. 2–Jan. 12, 1997; Afrika Museum, Berg en Dal, The Netherlands, Mar. 30–Aug. 31; Fundación César Manrique, Teguise, Lanzarote, Canary Islands, Oct. 17–Nov. 28; Haus der Kulturen der Welt, Berlin, Jan. 10–Mar. 30, 1998; Contemporary Arts Museum, Houston, Aug. 11–Sept. 20; Clocktower Museum, Croydon, United Kingdom, Feb. 19–May 16, 1999; Museum of Ethnograpy, Budapest, Oct. 1–Jan. 3, 2000.

New York, American 1937 *Dove*. *Arthur G. Dove: New Oils and Watercolors*. An American Place, Mar. 23–Apr. 16.

New York, American 1937 Hartley. Marsden Hartley. "On the Subject of Nativeness—A Tribute to Maine." In *Exhibition of Recent Paintings, 1936*. An American Place, Apr. 20–May 17.

New York, American 1950. *Georgia O'Keeffe Paintings, 1946–1950*. An American Place, Oct. 16–Nov. 25.

New York, Athletic 1892. *Sixth Annual Loan Exhibition: A Collection of American Paintings Never Before Publicly Exhibited*. New York Athletic Club, Mar. 19.

New York, BlumHelman 1987. *Donald Sultan*. BlumHelman Gallery, Nov. 4–28.

New York, Buchholz 1943. Curt Valentin. *Twelve Bronzes by Jacques Lipchitz*. Buchholz Gallery.

New York +, CAA 1930–31. *American Painting*. Circulated by the College Art Association of America, various venues, Dec. 1930–June 1931.

New York, Century 1877. Exhibition. Century Association.

New York, Century 1953. *Exhibition of Paintings by Members of the Peale Family*. Century Association, Mar. 4–May 3.

New York, Coe 1980. Warren Adelson. *John Singer Sargent: His Own Work*. Coe Kerr Gallery, May 28–June 27.

New York, Coe 1986. *Sargent at Broadway: The Impressionist Years*. Coe Kerr Gallery, May 2–June 14.

New York, Columbia 1954. *Bicentennial Celebration*. Lowe Library, Columbia University, Oct.

New York, Danenberg 1973. Peter Pollack. *Alfred Maurer and the Fauves: The Lost Years Rediscovered*. Bernard Danenberg Galleries, Feb. 27–Mar. 31.

New York, Dintenfass 1970–71. *Edith Gregor Halpert Folk Art Collection*. Terry Dintenfass Gallery, c. 1970–71.

New York, Dintenfass 1984. *Arthur Dove: Paintings, Watercolors, Drawings, Collages*. Terry Dintenfass Gallery, Nov. 3–Dec. 29. Concurrently with Barbara Mathes Gallery and Salander-O'Reilly Galleries.

New York +, District 1979. *The Working American*. Circulated by Smithsonian Institution Traveling Exhibition Service. District 1199 Cultural Center, National Union of Hospital and Health Care Employees, Oct. 19–Nov. 24; Detroit Historical Museum, Jan. 12–Feb. 24, 1980; Memorial Art Gallery, University of Rochester, N.Y., Mar. 15–Apr. 27; Chicago Historical Society, May 17–June 29; Birmingham (Ala.) Museum of Art, July 19–Aug. 31; New Jersey State Museum, Trenton, Sept. 20–Nov. 2; Museum of Our National Heritage,

Lexington, Mass., Nov. 22–Jan. 4, 1981.

New York, Downtown 1933. *American Ancestors—Second Exhibition: Masterpieces by Little Known and Anonymous American Artists, 1720–1870*. Downtown Gallery, Oct. 3–14.

New York, Downtown 1939. *"Nature-Vivre" by William M. Harnett*. Downtown Gallery, Apr. 18–May 6.

New York, Downtown 1940. *Charles Sheeler: Power*. Downtown Gallery, Dec. 2–21.

New York, Downtown 1948. *Harnett Centennial Exhibition*. Downtown Gallery, Apr. 13–May 1.

New York, Durlacher 1951. *Portraits by Florine Stettheimer*. Durlacher Brothers, Mar.

New York, Durlacher 1963. *Florine Stettheimer*. Durlacher Brothers, Oct. 29–Nov. 23.

New York, Fifth Avenue 1899. *Society of American Artists, Eleventh Exhibition*. Fifth Avenue Art Galleries, May 13–June 15.

New York, Finch 1973–74. *Twice as Natural: 19th-Century American Genre Painting*. Finch College Museum of Art, Dec. 11–Jan. 20.

New York +, Graphic 1968. Lloyd Goodrich. *The Graphic Art of Winslow Homer*. Organized by the Museum of Graphic Art, New York. Whitney Museum of American Art, New York, Oct. 31–Dec. 16; National Collection of Fine Arts, Washington, D.C., Jan 8–Feb. 23, 1969; Akron (Ohio) Art Institute, Mar. 11–Apr. 15; Detroit Institute of Arts, May 7–June 8; Museum of Art, Bowdoin College, Brunswick, Maine, June 20–Aug. 3; Parrish Art Museum, Southampton, N.Y., Aug. 6–26; Everson Museum of Art, Syracuse, N.Y., Sept. 3–24; Cincinnati Art Museum, Oct. 3–29; Oklahoma Art Center, Oklahoma City, Nov. 10–30; Minneapolis Institute of Arts, Dec. 11–Jan. 4, 1970; Museum of Fine Arts, Houston, Jan. 14–Feb. 22; University of Kansas Museum of Art, Lawrence, Mar. 9–25; Fine Arts Gallery, San Diego, Apr. 7–May 5; Santa Barbara (Calif.) Museum of Art, May 19–June 16; Achenbach Foundation for Graphic Arts, San Francisco, July 1–29.

New York, Guggenheim 1988. *Josef Albers: A Retrospective*. Solomon R. Guggenheim Museum, Mar. 24–May 29.

New York, Hirschl 1977. James H. Maroney, Jr. *Lines of Power.* Hirschl and Adler Galleries, Mar. 12–Apr. 9.

New York, Hirschl 1986. *Georgia O'Keeffe: Selected Paintings and Works on Paper.* Hirschl and Adler Galleries, Apr. 26–June 6.

New York, IBM 1990. *Highlights from the Smith College Museum of Art.* IBM Gallery of Science and Art, Oct. 2–Nov. 24.

New York, Independent 1926. *Annual Exhibition.* Society of Independent Artists, Waldorf-Astoria Hotel, Mar.

New York, Kennedy 1975. *Art Students League of New York 100th Anniversary Exhibition.* Kennedy Galleries, Mar. 6–29.

New York, Kennedy 1987. *Summits II: American Master Paintings, Watercolors, Drawings, and Prints.* Kennedy Galleries, Oct. 21–Nov. 28.

New York, Knoedler 1939. *Two American Romantics of the Nineteenth Century: Robert Loftin Newman, 1827–1912, Albert Pinkham Ryder, 1847–1917.* M. Knoedler and Company, Nov. 13–Dec. 2.

New York, Knoedler 1944. *Thomas Eakins Centennial, 1844–1944.* M. Knoedler and Company, June 3–July 13.

New York, Knoedler 1948. *American Paintings of the 18th and 19th Centuries.* M. Knoedler and Company, Jan. 5–31.

New York, Knoedler 1951. *A Short Survey of American Painting.* M. Knoedler and Company, Sept. 5–21.

New York, Knoedler 1953. *Paintings and Drawings from the Smith College Collection.* M. Knoedler and Company, Mar. 30–Apr. 11.

New York, Knoedler 1969. *Willem de Kooning, January 1968–March 1969.* M. Knoedler and Company, Mar. 4–22.

New York, Kootz 1952. *Robert Motherwell: Paintings, Drawings and Collages.* Kootz Gallery, Apr. 1–19.

New York, Lotos 1900. *Exhibition of Paintings by R. A. Blakelock.* Lotos Club, Dec. 8.

New York, Marlborough 1967. *Franz Kline.* Marlborough-Gerson Gallery, May.

New York, Metropolitan 1909. *The Hudson Fulton Exhibition.*

Metropolitan Museum of Art, Sept.–Nov.

New York, Metropolitan 1918. *Loan Exhibition of the Works of Albert P. Ryder.* Metropolitan Museum of Art, Mar. 11–Apr. 14.

New York +, Metropolitan 1976–77. Michael Richman. *Daniel Chester French: An American Sculptor.* Metropolitan Museum of Art, Nov. 4–Jan. 10; National Collection of Fine Arts, Washington, D.C., Feb. 11–Apr. 17; Detroit Institute of Arts, June 15–Aug. 18; Fogg Art Museum, Harvard University, Cambridge, Sept. 30–Nov. 30.

New York +, Metropolitan 1985. Nicolai Cikovsky, Jr., and Michael Quick. *George Inness.* Metropolitan Museum of Art, Apr. 1–June 9; Cleveland Museum of Art, Aug. 21–Oct. 6; Minneapolis Institute of Arts, Nov. 10–Jan. 12, 1986; Los Angeles County Museum of Art (organizer), Feb. 20–May 11; National Gallery of Art, Washington, D.C., June 22–Sept. 7.

New York +, Metropolitan 1992. Doreen Bolger, Marc Simpson, and John Wilmerding, eds. *William M. Harnett.* Metropolitan Museum of Art, Mar. 14–June 14; Amon Carter Museum, Fort Worth, Tex., July 18–Oct. 18; Fine Arts Museums of San Francisco, Nov. 14–Feb. 14, 1993; National Gallery of Art, Washington, D.C., Mar. 14–June 13.

New York +, Metropolitan 1994. H. Barbara Weinberg, Doreen Bolger, and David Park Curry. *American Impressionism and Realism: The Painting of Modern Life, 1885–1915.* Metropolitan Museum of Art, May 10–July 24; Amon Carter Museum, Fort Worth, Tex., Aug. 21–Oct. 30; Denver Art Museum, Dec. 3–Feb. 5, 1995; Los Angeles County Museum of Art, Mar. 12–May 14.

New York, Milch [1920]. *Important Works in Paintings and Sculpture by Leading American Artists.* Milch Galleries.

New York, MoMA 1935. Lincoln Kirstein. *Gaston Lachaise: Retrospective Exhibition.* Museum of Modern Art, Jan. 30–Mar. 7.

New York, MoMA 1939. *Charles Sheeler.* Museum of Modern Art, Oct. 4–Nov. 1.

New York, MoMA 1944–45. *Lyonel Feininger—Marsden Hartley.* Museum of Modern Art, Oct. 24–Jan. 14.

New York +, MoMA 1946. *Florine Stettheimer.* Museum of Modern Art, Oct. 1–Nov. 17; Artists Club of Chicago, Jan. 3–25, 1947; M. H. de Young Memorial Museum, San Francisco, Feb. 10–Mar. 8; Wadsworth Atheneum, Hartford, Jan. 9–Feb. 1, 1948; Vassar College Art Gallery, Poughkeepsie, N.Y., Jan. 1949; Wellesley College Museum, Wellesley, Mass., Mar. 1950.

New York +, MoMA 1948. Lincoln Kirstein. *The Sculpture of Elie Nadelman.* Museum of Modern Art, Oct. 5–Nov. 28; Baltimore Museum of Art, Dec. 19–Feb. 15, 1949; Institute of Contemporary Art, Boston, Mar. 1–Apr. 19.

New York +, MoMA 1954. *The Sculpture of Jacques Lipchitz.* Museum of Modern Art, May 18–Aug. 22; Walker Art Center, Minneapolis, Oct. 1–Dec. 12; Cleveland Museum of Art, Jan. 25–Mar. 13, 1955.

New York, MoMA 1964. Dorothy Miller, ed. *Americans 1963.* Museum of Modern Art, May 20–Aug. 18.

New York, MoMA 1969. *Claes Oldenburg.* Museum of Modern Art, Sept. 22–Nov. 23. Checklist. See also Rose 1970.

New York +, MoMA 1978. Alicia Legg et al. *Sol Lewitt.* Museum of Modern Art, Feb. 3–Apr. 4; Musée d'art contemporain, Montreal, Sept. 5 Oct. 24; Krannert Art Museum, University of Illinois, Champaign, Mar. 4–Apr. 8, 1979; La Jolla (Calif.) Museum of Contemporary Art, May 11–June 24.

New York, MoMA 1985–86. Riva Castleman and Wolfgang Wittrock, eds. *Henri de Toulouse-Lautrec: Images of the 1890s.* Museum of Modern Art, Oct. 16–Jan. 26.

New York +, MoMA 1987–88. William S. Rubin. *Frank Stella: Paintings, 1970–1987.* Museum of Modern Art, Oct. 12–Jan. 5; Stedlijk Museum, Amsterdam, Feb. 12–Apr. 10; Musée Nationale d'Art Moderne, Paris, May 17–Aug. 18.

New York +, MoMA 1995. Magdalena Dabrowski. *Kandinsky Compositions.* Museum of Modern Art, Jan. 25–Apr. 25; Los Angeles County Museum of Art, June 1–Sept. 3.

New York, Montross 1911. *14th Annual Exhibition: Ten American Painters.* Montross Gallery, Mar. 17–Apr. 8.

New York, Museum 1958. *Paintings of New York, 1850–1950.* Museum of the City of New York, Apr. 16–Sept. 1.

New York, National 1854. *Catalogue of the Twenty-ninth Annual Exhibition.* National Academy of Design.

New York, National 1861. *Thirty-sixth Annual Exhibition.* National Academy of Design, Mar. 20–Apr. 25.

New York, National 1865. *Sixth Annual Exhibition of the Artists' Fund Society of New York.* National Academy of Design, Nov.–Dec.

New York, National 1980–81. Barbara Novak and Annette Blaugrund, eds. *Next to Nature: Landscape Paintings from the National Academy of Design.* National Academy of Design, Nov. 12–Feb. 22.

New York, Newman 1948. *The Hudson River School.* Harry Shaw Newman Gallery, Apr.

New York, Newman 1949–50. *American Still Life Painting.* Harry Shaw Newman Gallery, c. Dec.–Jan.

New York, NYU 1980. *Walter Gay: A Retrospective.* Grey Art Gallery and Study Center, New York University, Sept. 16–Nov. 1.

New York, Ortgies 1887. *Studies in Oil by Asher B. Durand.* Ortgies Art Gallery, Apr. 13 14.

New York, Portraits 1968. *Portraits of Yesterday and Today.* Portraits Incorporated, Apr. 23–May 21.

New York, Rosenberg 1944. *Drawings and Paintings by Marsden Hartley, 1877–1943.* Paul Rosenberg and Company with M. Knoedler and Company, Dec. 11–30.

New York, Rosenberg 1966. *Seven Decades, 1895–1965: Crosscurrents in Modern Art.* Sponsored by the Public Education Association. Paul Rosenberg and Company (1895–1904), M. Knoedler and Company (1905–1914), Perls Galleries and E. V. Thaw and Company (1915–1924), Saidenberg Gallery and Stephen Hahn Gallery (1925–1934), Pierre Matisse Gallery (1935–1944), André Emmerich Gallery and Galleria Odyssia (1945–1954), Cordier and Ekstrom (1955–1965), Apr. 26–May 21.

New York, Rosenberg 1968. *The American Vision, 1825–1875.* Sponsored by the Public Education Association. Paul Rosenberg and

Company (*Landscapes*), M. Knoedler and Company (*Figure and Still Life*), Hirschl and Adler Galleries (*Genre*), Oct. 8–Nov. 2.

New York +, Salander 1992. Barbara Rose. *Gaston Lachaise: Sculpture.* Salander-O'Reilly Galleries, Jan. 2–Feb. 22; Meredith Long and Company, Houston, Mar. 4–28.

New York, Salander 1997. Gail Levin and John B. Van Sickle. "Elie Nadelman's New Classicism." In *Elie Nadelman (1882–1946)*, pp. 3–10. Salander-O'Reilly Galleries, Nov. 13–Dec. 13.

New York, Société 1923. *Exhibition of Sculpture by John Storrs.* Société Anonyme, Feb. 23–Mar. 22.

New York, Society 1904. *26th Annual Exhibition of the Society of American Artists.* Galleries of the American Fine Arts Society, Mar. 26–May 1.

New York, Spanierman 1990. William H. Gerdts et al. *Ten American Painters.* Spanierman Gallery, May 8–June 9.

New York, Spanierman 1995–96. *Willard L. Metcalf (1858–1925): An American Impressionist.* Spanierman Gallery, Nov. 21–Jan. 27.

New York, Stable 1961. *Joan Mitchell.* Stable Gallery, Apr. 24–May 13.

New York, Steinbaum 1992. *The Quincentennary [sic] Non-Celebration.* Beatrice Steinbaum Gallery, Oct. 10–Nov. 14.

New York, Studio 1980. *Rituals: The Art of Betye Saar.* Studio Museum in Harlem, Apr. 13–June 29.

New York, Walker 1939. *Paintings and Water Colors by James Peale and His Family, 1749–1891.* Walker Galleries, Feb. 13–Mar. 11.

New York, Whitney 1938–39. *Memorial Exhibition of Works by William J. Glackens.* Whitney Museum of American Art, Dec. 14–Jan. 15.

New York, Whitney 1947 *Blakelock. Ralph Albert Blakelock Centenary Exhibition.* Whitney Museum of American Art, Apr. 22–May 29.

New York, Whitney 1947 *Ryder. Albert P. Ryder Centenary Exhibition.* Whitney Museum of American Art, Oct. 18–Nov. 30.

New York, Whitney 1966. *Art of the United States: Dedicatory Exhibition.* Whitney Museum of American Art, Sept. 27–Nov. 27.

New York, Whitney 1974. Marcia Tucker. *Joan Mitchell.* Whitney Museum of American Art, Mar. 26–May 5.

New York +, Whitney 1975. *The Sculpture and Drawings of Elie Nadelman.* Whitney Museum of American Art, Sept. 23–Nov. 30; Hirshhorn Museum and Sculpture Garden, Washington, D.C., Dec. 18–Feb. 15, 1976.

New York +, Whitney 1980. Barbara Haskell. *Marsden Hartley.* Whitney Museum of American Art, Mar. 4–May 25; Art Institute of Chicago, June 10–Aug. 3; Amon Carter Museum, Fort Worth, Tex., Sept. 5–Oct. 26; University Art Museum, University of California, Berkeley, Nov. 12–Jan. 4, 1981; Portland (Ore.) Art Museum, Jan. 28–Mar. 8.

New York +, Whitney 1980–81. Gail Levin. *Edward Hopper: The Art and the Artist.* Whitney Museum of American Art, Sept. 16–Jan. 25 (second floor), Sept. 23–Jan. 18 (third floor); Hayward Gallery, London, Feb. 11–Mar. 29; Stedelijk Museum, Amsterdam, Apr. 22–June 17; Städtische Kunsthalle, Düsseldorf, July 10–Sept. 6; Art Institute of Chicago, Oct. 3–Nov. 29; San Francisco Museum of Modern Art, Dec. 16–Feb. 10, 1982.

New York +, Whitney 1986–87 *Sargent.* Patricia Hills. *Painted Diaries: Sargent's Late Subject Pictures.* Whitney Museum of American Art, Oct. 7–Jan. 4; Art Institute of Chicago, Feb. 7–Apr. 19.

New York +, Whitney 1986–87 *Storrs.* Noel Frackman. *John Storrs.* Whitney Museum of American Art, Dec. 11–Mar. 22; Amon Carter Museum, Fort Worth, Tex., May 2–July 5; J. B. Speed Art Museum, Louisville, Ky., Aug. 28–Nov. 1.

New York, Whitney 1987–88. *Alexander Calder: Sculpture of the Nineteen Thirties.* Whitney Museum of American Art, Nov. 14–Jan. 17.

New York, Whitney 1995. *Florine Stettheimer: Manhattan Fantastica.* Whitney Museum of American Art, July 13–Nov. 5.

New York, Wildenstein 1952. *Seventy Twentieth-Century American Painters.* Wildenstein and Company, Feb. 21–Mar. 22.

New York, Willard 1956. *Gables: A Comprehensive Exhibition of Work from 1921 to 1954 Based on One Theme by Lyonel Feininger.* Willard Gallery, Nov. 27–Dec. 29.

Niagara Falls 1978. Niagara Falls Heritage Foundation. "300 Years since Father Hennipen: Niagara Falls in Art, 1678–1978." Niagara Falls, Ont. Typescript.

Noble [1856] 1964. Louis Legrand Noble. *The Life and Works of Thomas Cole.* Cambridge, Mass.

Noble 1991. Joseph Veach Noble. "Nude . . . or Naked?" *Sculpture Review,* vol. 40, no. 3, pp. 20–27.

Nochlin 1974. Linda Nochlin. "By a Woman Painted: Eight Who Made Art in the Nineteenth Century." *Ms.,* vol. 3, no. 1 (July), pp. 68–75.

——— 1994. Linda Nochlin. "Issues of Gender in Cassatt and Eakins." In Stephen F. Eisenman et al., *Nineteenth-Century Art: A Critical History,* pp. 254–73. London.

——— 1996. Linda Nochlin. "A Rage to Paint: Joan Mitchell and the Issue of 'Femininity.'" 84th Annual Conference of the College Art Association, Boston, Feb. 21–24. *Abstracts,* College Art Association, New York, 1996, p. 190.

Nordland 1974. Gerald Nordland. *Gaston Lachaise: The Man and His Work.* New York.

Norfolk + 1993. *Jaune Quick-to-See Smith.* Chrysler Museum of Art, Norfolk, Va., Jan. 17–Mar. 14; Smith College Museum of Art, Northampton, Mass., Apr. 3–May 30.

Northampton 1916. *Exhibition of Sculpture by Paul Manship.* Smith College Museum of Art, May.

Northampton 1947. *Art in Our Town: American Portraits from Local Collections.* Smith College Museum of Art, Nov. 5–30.

Northampton + 1950. Alfred Frankenstein. *John F. Peto.* Smith College Museum of Art, Mar. 1–24; Brooklyn Museum, Apr. 11–May 21; California Palace of the Legion of Honor, San Francisco, June 10–July 9.

Northampton + 1951. *Winslow Homer: Illustrator, 1860–1875.* Smith College Museum of Art, Feb. 5–28; Lawrence Art Museum, Williams College, Williamstown, Mass., Mar.

Northampton + 1952 *Elmer. Edwin Romanzo Elmer, 1850–1923.* Smith College Museum of Art, Oct. 1–24; Connecticut Valley Historical Museum, Springfield, Mass., Nov. 1–30.

Northampton 1952 *Stettheimer. Paintings by Florine Stettheimer.* Smith College Museum of Art, Mar. 2–21.

Northampton 1956. *American Problem Pictures.* Smith College Museum of Art, Sept. 14–Oct. 5.

Northampton 1959. *Paintings from Smith Alumnae Collections.* Smith College Museum of Art, Oct. 14–Nov. 18.

Northampton 1962. *Portraits from the Collection of the Smith College Museum of Art.* Smith College Museum of Art, Sept. 5–Oct. 17.

Northampton 1963. *An Exhibition of the Work of Robert Motherwell.* Smith College Museum of Art, Jan. 10–28.

Northampton 1964. *An Exhibition of American Painting for a Professor of American Art.* Smith College Museum of Art, May 14–June 14.

Northampton 1968 *Hitchcock. An Exhibition in Honor of Henry-Russell Hitchcock.* Smith College Museum of Art, Apr. 11–28.

Northampton 1968 *Sargent.* "*My Dining Room*" *and Preparatory Sketches and a Drawing for the Murals in the Boston Public Library by John Singer Sargent.* Smith College Museum of Art, Feb. 25–Mar. 15.

Northampton 1974. *The Seelye Years, 1879–1910.* Smith College Museum of Art, Sept. 12–Nov. 3.

Northampton 1975 *Centennial. One Hundred: An Exhibition to Celebrate the Centennial Year of Smith College.* Smith College Museum of Art, May 1–June 1.

Northampton 1975 *Five.* Sarah Richardson Mason. *Five Anonymous American Paintings in the Collection of the Smith College Museum of Art.* Smith College Museum of Art, Mar. 6–Apr. 20.

Northampton 1976 *American. American Faces/Faces by Americans.* Smith College Museum of Art, Apr. 23–Oct. 10.

Northampton 1976 *Carr.* Deborah Chotner. *S. S. Carr.* Smith College Museum of Art, Apr. 2–May 30.

Northampton + 1978. *Two Decades: American Art from the Collection of the Smith College Museum of Art.* Smith College Museum of Art, Sept. 20–Oct. 22; Montclair (N.J.) Art Museum, Nov. 3–Jan. 7, 1979.

Northampton 1979. *The Exhibition of the Century: 100 Years of Collecting*

at the Smith College Museum of Art, 1879–1979. Smith College Museum of Art, Sept. 6–Dec. 21.

Northampton 1980. Betsy B. Jones, ed. Great Explorations: Research into American Folk Art Conducted by Students in the Museum Seminar. Smith College Museum of Art, May 2 Oct. 19.

Northampton + 1982 Elmer. Edwin Romanzo Elmer (1850–1923). Smith College Museum of Art, Apr. 8–July 18; Shelburne (Vt.) Museum, July 30–Oct. 17.

Northampton 1982 Smibert. Patricia Anderson. To Mr. Smibert on the Sight of His Picture. Smith College Museum of Art, Feb. 4–Mar. 8.

Northampton 1983. In Memoriam: Jere Abbott (1897–1982). Smith College Museum of Art, Apr. 30–Oct. 23.

Northampton 1985. Dorothy C. Miller: With an Eye to American Art. Smith College Museum of Art, Apr. 19–June 16.

Northampton 1987–88. Georgia O'Keeffe and Artists from the Stieglitz Circle. Smith College Museum of Art, Oct. 28–Jan. 17.

Northampton 1988. The Bassetts of Lee: Two Recently Acquired Portraits by Erastus Salisbury Field (1805–1900) with Folk Paintings from the Collection. Smith College Museum of Art, Jan. 21–Mar. 20.

Northampton 1989. Recent Accessions. Smith College Museum of Art, Apr. 13–June 30.

Northampton 1991. Smith Collects Contemporary. Smith College Museum of Art, May 3–Sept. 15.

Northampton 1993. Recent Contemporary Accessions. Smith College Museum of Art, Jan. 26–Mar. 7.

Northampton 1994. The Tradition Continues: Native American Art from New England Collections. Smith College Museum of Art, Mar. 10–May 29.

Northampton 1994–95. Creative Collecting: Gifts from the Collection of Mr. and Mrs. William A. Small, Jr. (Susan Spencer '48). Smith College Museum of Art, Oct. 14–Jan. 22.

Northampton 1995. Local Places, Local Faces. Smith College Museum of Art, June 2–Oct. 8.

Northampton 1996. Robert Motherwell. Smith College Museum of Art, Apr. 3–May 5.

Northampton 1996 Landscape. Surveying the Landscape. Smith College Museum of Art, July 11–Sept. 15.

Northampton 1996–97. A Sampling: Nineteenth-Century American Folk Art from the Collection. Smith College Museum of Art, Nov. 19–Jan. 27.

Northampton 1999. Linda Merrill with Michael Goodison. Dwight William Tryon, 1849–1925. Smith College Museum of Art, May 1–Sept. 5.

Norton 1864. Charles Eliot Norton. "Critical Notices: The New Path." North American Review, vol. 98, no. 202 (Jan.), pp. 303–4.

Novak 1969. Barbara Novak. American Painting of the Nineteenth Century. New York.

Nutting 1912. John Nutting. "In the Art Galleries." Boston Daily Advertiser, vol. 201, no. 28 (Feb. 1), p. 5.

Nyack 1947. Second Annual Exhibition of the Rockland Foundation. Rockland Foundation Building, Nyack, N.Y., Sept.

Nyack 1972. Edward Hopper/Nyack. Edward Hopper Landmark Preservation Committee, Presidential Life Insurance Company, Nyack, N.Y., Jan. 16–Feb. 12.

Nyack 1985. Exhibition in Honor of Helen Hayes. Hopper House Art Center, Nyack, N.Y., Oct. 12–Nov. 17.

NY Herald 1892. "Art at the New York Athletic." New York Herald, Mar. 21, p. 6.

NY Herald Trib 1939. "The Peale Family." New York Herald Tribune, Feb. 19.

NY Times 1859 "City." "City Intelligence—Close of the Auction Sale of Pictures." New York Times, Mar. 18.

NY Times 1859 "Sale." "A Sale of Pictures." New York Times, Mar. 16.

NY Times 1861. "National Academy of Design." New York Times, Mar. 22.

NY Times 1939. "Other Shows." New York Times, Apr. 23.

Oakland 1937. Second Feininger Exhibition. Mills College, Oakland, Calif., June 2–Aug. 7.

O'Keeffe 1976. Georgia O'Keeffe. O'Keeffe. New York. Reprint, 1985.

Old Print Portf 1957. The Old Print Shop Portfolio, vol. 17, no. 4 (Dec.).

Oliver 1911. Maude I. G. Oliver. "Large Attendance and Intelligent Enthusiasm Mark Annual Art Exhibit." Chicago Sunday Record-Herald, vol. 31, no. 29, (Nov. 26), sec. 8, p. 6.

Otis 1973. D. S. Otis. The Dawes Act and the Allotment of Indian Lands. Norman, Okla.

Pa Mus 1930. "Catalogue of the Works of Thomas Eakins." Pennsylvania Museum Bulletin, vol. 25, no. 133 (Mar.), pp. 17–33.

Panorama 1948. "A Sketch for Cole's Voyage of Life." Harry Shaw Newman Gallery Panorama, vol. 3, no. 5 (Jan.), pp. 58–59.

Panorama 1949–50. "Exhibition of American Still Life Paintings." Harry Shaw Newman Gallery Panorama, vol. 5, no. 3 (Dec.–Jan), pp. 26–36.

Paradiso 1986–87. Kathleen Paradiso. "Exhibitions." Women Artists News, vol. 11, no. 5 (winter), p. 21.

Paris 1903. XIIIe Exposition de la Société Nationale des Beaux-Arts. Grand Palais, Apr. 16–June 30.

Paris 1905. 3e Exposition du Salon d'Automne. Grand Palais, Oct. 18–Nov. 25.

[Paris 1933–34]. Exhibition of the Fiftieth Anniversary of the Founding of the Maison Lucien Lefebvre Foinet, Paris, France.

Paris + 1980–81. Les Réalismes entre revolution et réaction, 1919–1939. Centre Georges Pompidou, Dec. 17–Apr.; Staatliche Kunsthalle, Berlin, May 10–June 30.

Paris + 1982. American Impressionism. Organized by Smithsonian Institution Traveling Exhibition Service. Musée du Petit Palais, Mar. 30–May 30; Staatliche Museen, East Berlin, June 15–July 25; Museum des 20. Jahrhunderts, Vienna, Aug. 12–Sept. 25; Art Museum of the Socialist Republic of Romania, Bucharest, Oct. 24–Dec. 4; National Art Gallery, Sofia, Dec. 15–Jan. 31, 1983.

Park 1923. Lawrence Park. "Joseph Blackburn—Portrait Painter." Proceedings of the American Antiquarian Society, Apr. 12–Oct. 18, 1922, n.s., vol. 32 (1923), pp. 270–329.

Parker and Wheeler 1938. Barbara Neville Parker and Anne Bolling

Wheeler. John Singleton Copley: American Portraits in Oil, Pastel, and Miniature, with Biographical Sketches. Boston.

Parks 1957 College. Robert O. Parks. "Smith College Museum, Recent Accessions." College Art Journal, vol. 17, no. 1 (fall), pp. 73–75.

——— 1957 SCAQ. Robert O. Parks. "Five Recent Acquisitions." Smith College Alumnae Quarterly, vol. 49, no. 1 (fall), pp. 12–13.

——— 1960. Robert O. Parks. "Unpublished Works and Recent Acquisitions." Smith College Museum of Art Bulletin, no. 40, pp. 1–91.

Parnassus 1941 "Smith." "Smith." Smith College Museum of Art." Parnassus, vol. 13, no. 1 (Jan.), p. 35.

Parnassus 1941 "Sheeler." "Sheeler and Power." Parnassus, vol. 13, no. 1 (Jan.), p. 46.

Parry 1988. Ellwood C. Parry III. The Art of Thomas Cole: Ambition and Imagination. Newark, Del.

Pasadena 1966–67. An Exhibition of Works by Joseph Cornell. Pasadena (Calif.) Art Museum, Dec. 27–Feb. 11.

Pasadena + 1971–72. Barbara Haskell. Claes Oldenburg: Object into Monument. Pasadena (Calif.) Art Museum, Dec. 7–Feb. 6; Art Museum, University of California, Berkeley, Feb. 28–Apr. 9; William Rockhill Nelson Gallery of Art, Kansas City, Mo., May 11–June 18; Fort Worth (Tex.) Art Center, July 10–Aug. 20; Des Moines Art Center, Sept. 18–Oct. 29; Philadelphia Museum of Art, Nov. 15–Dec. 27; Art Institute of Chicago, Jan. 17–Feb. 25, 1973.

Paviljoen 1989. Paviljoen Welgeleden, 1789–1989: Van buitenplats van de Bankier Hope tot zetel van de province Noord Holland. Haarlem, the Netherlands.

Peoria 1965. Two Hundred Years of American Painting. Lakeview Center for the Arts and Sciences, Peoria, Ill., Mar. 27–Apr. 28.

Pepper 1983. Curtis Bill Pepper. "The Indomitable de Kooning." New York Times Magazine, Nov. 20, pp. 43–47 ff.

Perkins 1873. Augustus Thorndike Perkins. Sketch of the Life and a List of Some of the Works of John Singleton Copley. Boston.

Perkins and Gavin 1980. Robert F. Perkins, Jr., and William J. Gavin III. The Boston Athenaeum

Art Exhibition Index, 1827–1874. Boston.

Perlman 1991. Bennard B. Perlman. *Robert Henri: His Life and Art.* New York.

Philadelphia 1902. *Seventy-first Annual Exhibition.* Pennsylvania Academy of the Fine Arts, Jan. 20–Mar. 1.

Philadelphia 1904. *Seventy-third Annual Exhibition.* Pennsylvania Academy of the Fine Arts, Jan. 25–Mar. 5.

Philadelphia 1944. *The Peales of Philadelphia.* McClees Galleries, Feb. 11–Mar. 4.

Philadelphia + 1955. *The One Hundred and Fiftieth Anniversary Exhibition.* Pennsylvania Academy of the Fine Arts, Jan. 15–Mar. 13; Sala de la Direccion General de Belles Artes, National Library, Madrid, [Apr./May]; Palazzo Strozzi, Florence, June; Tiroler Landesmuseum Ferdinandeum, Innsbruck, July 16–Aug. 20; Museum Arnold Vander Haeghen, Ghent, Sept. 3–Oct. 2; Kgl. Akademien for de Fria Konsterna, Stockholm, Nov. 4–27.

Philadelphia + 1982. Darrel Sewell. *Thomas Eakins: Artist of Philadelphia.* Philadelphia Museum of Art, May 29–Aug. 1; Museum of Fine Arts, Boston, Sept. 22–Nov. 28.

Philadelphia + 1996–97. *The Peale Family: Creation of a Legacy, 1770–1870.* Organized by the Trust for Museum Exhibitions. Philadelphia Museum of Art, Nov. 3–Jan. 5; M. H. de Young Memorial Museum, San Francisco, Jan. 25–Apr. 6; Corcoran Gallery of Art, Washington, D.C., Apr. 26–July 6.

Phillips 1885. Albert Merritt Phillips. *Phillips Genealogies.* Auburn, Mass.

Phillips 1985. Patricia C. Phillips. "Reviews." *Artforum,* vol. 23, no. 10 (summer), pp. 104–5.

Pict Exh 1948. *Pictures on Exhibit,* vol. 10, no. 4 (Jan.).

Pinckney 1940. Pauline A. Pinckney. *American Figureheads and Their Carvers.* New York.

Pisano 1985. Ronald G. Pisano. *Long Island Landscape Painting, 1820–1920.* Boston.

Pittsburgh 1939 *Century. A Century of American Landscape Painting, 1800–1900.* Department of Fine

Arts, Carnegie Institute, Mar. 22–Apr. 30.

Pittsburgh 1939 *Glackens. Memorial Exhibition of Works by William J. Glackens.* Carnegie Institute, Feb. 1–Mar. 15.

Pittsburgh 1940. *Survey of American Painting.* Carnegie Institute, Oct. 24–Dec. 15.

Pittsburgh 1974–75. *Celebration.* Carnegie Institute, Oct. 25–Jan. 5.

Pittsburgh 1976. *American Cornucopia: 19th-Century Still Lifes and Studies.* Hunt Institute for Botanical Documentation, Carnegie Mellon University, Apr. 5–July 30.

Pittsfield 1934. *Exhibition Commemorating the 100th Anniversary of the Birth of James McNeill Whistler.* Berkshire Museum, Pittsfield, Mass., Nov. 15–30.

Plowden 1947. Helen Haseltine Plowden. *William Stanley Haseltine: Sea and Landscape Painter (1835–1900).* London.

Polcari 1991. Stephen Polcari. *Abstract Expressionism and the Modern Experience.* Cambridge and New York.

Pollak 1936. Francis M. Pollak, ed. *The Index of Twentieth-Century Artists, 1933–1937,* vol. 3, no. 6 (Mar.).

Portland 1974. *Winslow Homer.* Portland (Maine) Museum of Art, June 8–July 21.

Portland 1984. *Gaston Lachaise: Sculpture and Drawings* Portland (Maine) Museum of Art, May 16–Sept. 16.

Pousette-Dart 1924. Nathaniel J. Pousette-Dart. *James McNeill Whistler.* New York.

Praz 1971. Mario Praz. *Conversation Pieces: A Survey of the Informal Group Portrait in Europe and America.* University Park, Pa.

Prettejohn 1998. Elizabeth Prettejohn. *Interpreting Sargent.* London.

Price 1932. Frederick Newlin Price. *Ryder (1847–1917): A Study of Appreciation.* New York.

Promey 1994. Sally M. Promey. "The Ribband of Faith: George Inness, Color Theory and the Swedenborgian Church." *American Art Journal,* vol. 26, nos. 1–2, pp. 44–65.

Providence 1952. *Sculpture by Painters.* Rhode Island School of Design, Providence, Apr. 30–May 25.

Prown 1966. Jules David Prown. *John Singleton Copley.* Vol. 1. *Copley in America, 1738–1774.* Cambridge, Mass.

Public 1807. *Public Characters of 1805.* London.

Purchase 1978. Hayden Herrera. *Joan Snyder: Seven Years of Work.* Neuberger Museum, State University of New York, Purchase, Jan. 17–Mar. 4.

Purchase + 1986–87. Suzanne Delehanty. *The Window in Twentieth-Century Art.* Neuberger Museum, State University of New York, Purchase, Sept. 21–Jan. 18; Contemporary Arts Museum, Houston, Apr. 24–June 29.

Quimby 1971. Ian Quimby, ed. *American Painting to 1776: A Reappraisal.* Winterthur, Del.

Rand 1989. Harry Rand. *Paul Manship.* Washington, D.C.

Ratcliff 1971. Carter Ratcliff. "New York Letter." *Art International,* vol. 15, no. 9 (Nov.), pp. 50–59, 66.

——— 1982. Carter Ratcliff. *John Singer Sargent.* New York.

Rather 1984. Susan Rather. "The Past Made Modern: Archaism in American Sculpture." *Arts Magazine,* vol. 59, no. 3 (Nov.), pp. 111–19.

——— 1991. Susan Rather. "Paul Manship, Archaism, and the Dance." *The Magazine Antiques,* vol. 140, no. 2 (Aug.), pp. 218–27.

——— 1993. Susan Rather. *Archaism, Modernism, and the Art of Paul Manship.* Austin, Tex.

Rawson 1987. Philip Rawson. *Creative Design: A New Look at Design Principles.* London.

Read and Martin 1957. Herbert Read and Leslie Martin. *Gabo: Constructions, Sculpture, Paintings, Drawings, Engravings.* Cambridge, Mass.

Rearick 1985. Charles Rearick. *Pleasures of the Belle Epoque.* New Haven.

Reynolds 1990. Gary A. Reynolds. "The Spirit of Empty Rooms: Walter Gay's Paintings of Interiors." *The Magazine Antiques,* vol. 137, no. 3 (Mar.), pp. 676–87.

Ribeiro 1995. Aileen Ribeiro. *The Art of Dress: Fashion in England and France, 1750–1820.* New Haven.

Rice 1894. Franklin P. Rice, comp. *Worcester Births, Marriages and Deaths.* Worcester, Mass.

Richardson 1951. Edgar Preston Richardson. "Art Aspects of 'American Processional.'" *Corcoran Gallery of Art Bulletin,* vol. 4, no. 4 (Sept.), unpag.

Richman 1974. Michael Tingley Richman. "The Early Career of Daniel Chester French, 1869–1891." Ph.D. diss., University of Delaware.

Richmond 1964. *Homer and the Sea.* Virginia Museum of Fine Arts, Richmond, and Mariners' Museum, Newport News, Va., Oct. 30–Nov. 29.

Richmond + 1976. *American Marine Painting.* Virginia Museum of Fine Arts, Richmond, Sept. 27–Oct. 31; Mariners' Museum, Newport News, Va., Nov. 8–Dec. 12.

Robertson 1995. Bruce Robertson. *Marsden Hartley.* New York.

Robinson 1989. Roxane Robinson. *Georgia O'Keeffe: A Life.* New York.

Rochester 1913. *The Inaugural Exhibition.* Memorial Art Gallery, University of Rochester, N.Y., Oct. 8–29.

Rochester + 1946. *Five Leaders of Modern Art* (also called *Five Modern Americans*). Memorial Art Gallery, University of Rochester, N.Y., Oct.; Dayton (Ohio) Art Institute, Jan. 1947; Springfield (Mass.) Museum of Fine Arts, Mar.

Rochester 1964–65. *In Focus: A Look at Realism in Art.* Memorial Art Gallery, University of Rochester, N.Y., Dec. 28–Jan. 31.

Rochester 1976. Howard S. Merritt. *The Genesee Country.* Memorial Art Gallery, University of Rochester, N.Y., Jan. 17–Feb. 22.

Rochester 1979. *Gaston Lachaise: Sculpture and Drawings.* Memorial Art Gallery, University of Rochester, N.Y., Jan. 20–Mar. 4.

Rochester 1988. Karal Ann Marling. *Looking Back: A Perspective on the 1913 Inaugural Exhibition.* Memorial Art Gallery, University of Rochester, N.Y., Oct. 8–Nov. 20.

Rogers 1935. Julia Ellen Rogers. *The Tree Book: Popular Guide to a Knowledge of the Trees of North*

America and to Their Uses and Cultivation. Garden City, N.Y.

Rogers 1985. John F. Rogers. *Origins of Sea Terms.* Mystic, Conn.

Ronnberg 1996. Erik A. R. Ronnberg, Jr. "Vincent's Cove in the 1870s: A Pictorial Record of Gloucester Shipbuilding." *Nautical Research Journal,* vol. 41, no. 4 (Dec.), pp. 209–18.

Rose 1965. Barbara Rose. "The Second Generation, Academy and Breakthrough." *Artforum,* vol. 4, no. 1 (Sept.), pp. 53–63.

———. 1970. Barbara Rose. *Claes Oldenburg.* New York.

———. 1986. Barbara Rose. *American Painting: The Twentieth Century.* Rev. ed. New York.

———. 1988. Barbara Rose. *Sultan.* New York.

Rosenblum 1971. Robert Rosenblum. *Frank Stella.* Harmondsworth, England.

Rosenthal 1977. Nan Rosenthal. *George Rickey.* New York.

Roslyn 1985. Holly Pinto Savinetti. *American Artists Abroad: The European Experience in the 19th Century.* Nassau County Museum of Fine Art, Roslyn, N.Y., June 2–Sept. 2.

Rotterdam + 1964. *De Lusthof der Naïeven.* Museum Boymans–van Beuningen, July 10–Sept. 6; Musée National d'Art Moderne, Paris, Oct.–Nov.

Rubin 1970. William S. Rubin. *Frank Stella.* New York.

Rubin 1986. Lawrence Rubin. *Frank Stella, Paintings, 1958–1965: A Catalogue Raisonné.* New York.

Rumford 1988. Beatrix T. Rumford, ed. *American Folk Paintings and Drawings Other than Portraits from the Abby Aldrich Rockefeller Folk Art Center.* Boston.

Rutland 1964. *Horace Bundy, Portrait Painter.* Chaffee Art Gallery, Rutland, Vt., Aug. 27–Sept. 20.

Rutledge 1955. Anna Wells Rutledge. *Cumulative Record of Exhibition Catalogues: The Pennsylvania Academy of the Fine Arts, 1807–1870; The Society of Artists, 1800–1814; The Artists' Fund Society, 1835–1845.* Philadelphia.

Sabin 1901. Frank T. Sabin. "Colour-Prints in Stipple and Mezzotint." *Connoisseur,* vol. 1 (Sept.–Dec.), pp. 19–26.

Samesate 1861. Lucien de Samesate. *Une Soirée à la Closerie de Lilas.* Paris.

Sandler 1957. Irving Sandler. "Mitchell Paints a Picture." *Art News,* vol. 56, no. 6 (Oct.), pp. 44–47, 69–70.

———. 1961. I. H. S. [Irving Sandler]. "Reviews and Previews: Joan Mitchell." *Art News,* vol. 60, no. 3 (May), p. 11.

———. 1988. Irving Sandler. *American Art of the 1960s.* New York.

San Francisco 1915. *Panama-Pacific International Exposition.* San Francisco, summer.

San Francisco 1937. *Exhibition of the Works of Lyonel Feininger.* San Francisco Museum of Art, Sept. 1–Oct. 29.

San Francisco + 1959. *Lyonel Feininger: Memorial Exhibition.* San Francisco Museum of Art, Nov. 5–Dec. 13; Minneapolis Institute of Arts, Jan. 5–Feb. 7, 1960; Cleveland Museum of Art, Feb. 18–Mar. 20; Albright-Knox Art Gallery, Buffalo, Apr. 8–May 8; Museum of Fine Arts, Boston, May 19–June 26.

San Francisco 1972. Wanda M. Corn. *The Color of Mood: American Tonalism, 1880–1910.* M. H. de Young Memorial Museum and California Palace of the Legion of Honor, Jan. 22–Apr. 2.

San Francisco + 1974–75. Barbara Haskell. *Arthur Dove.* San Francisco Museum of Art, Nov. 21–Jan. 5; Albright-Knox Art Gallery, Buffalo, Jan. 27–Mar. 2; St. Louis Art Museum, Apr. 3–May 25; Art Institute of Chicago, July 12–Aug. 31; Des Moines Art Center, Sept. 22–Nov. 2; Whitney Museum of American Art, New York, Nov. 24–Jan. 18, 1976.

San Francisco + 1982. *Images of America: Precisionist Painting and Modern Photography.* San Francisco Museum of Modern Art, Sept. 9–Nov. 7; St. Louis Art Museum, Dec. 6–Jan. 30, 1983; Baltimore Museum of Art, Feb. 28–Apr. 25; Des Moines Art Center, May 23–July 17; Cleveland Museum of Art, Aug. 15–Oct. 9.

San Francisco + 1992. *Expressions of Place: The Art of William Stanley Haseltine.* M. H. de Young Memorial Museum, June 20–Sept. 20; Brandywine River

Museum, Chadds Ford, Pa., Jan. 20–Apr. 18, 1993.

Santa Barbara 1941. *Painting Today and Yesterday in the United States.* Santa Barbara (Calif.) Museum of Art, June 5–Sept. 1.

Santa Barbara 1964 *Bierstadt.* *Albert Bierstadt, 1830–1902: A Retrospective Exhibition.* Santa Barbara (Calif.) Museum of Art, Aug. 4–Sept. 13.

Santa Barbara + 1964 *Chase. The First West Coast Retrospective Exhibition of Paintings by William Merritt Chase.* University of California, Santa Barbara, Oct. 6–Nov. 15; La Jolla (Calif.) Museum of Art, Nov. 19–Dec. 20; California Palace of the Legion of Honor, San Francisco, Jan. 10–Feb. 7, 1965; Seattle Art Museum, Mar. 3–Apr. 4; Gallery of Modern Art including the Huntington Hartford Collection, New York, Apr. 27–May 30.

Santa Barbara 1966. *American Portraits in California Collections.* Santa Barbara (Calif.) Museum of Art, Apr. 6–May 6.

Santa Barbara + 1969. David Gebhard. *The Enigma of Ralph A. Blakelock, 1847–1919.* University of California, Santa Barbara, Jan. 7–Feb. 2; California Palace of the Legion of Honor, San Francisco, Feb. 15–Mar. 16; Phoenix Art Museum, Mar. 24–Apr. 17; Heckscher Museum, Huntington, N.Y., May 17–June 23.

Santa Barbara + 1985. Richard V. West. *An Enkindled Eye: The Paintings of Rockwell Kent.* Santa Barbara (Calif.) Museum of Art, June 29–Sept. 1; Columbus (Ohio) Museum of Art, Oct. 12–Nov. 13; Portland (Maine) Museum of Art, Jan. 21–Mar. 2, 1986; Everson Museum of Art, Syracuse, N.Y., Apr. 11–May 18.

Santa Barbara 1991. *America in Art: Fifty Great Paintings Celebrating Fifty Years.* Santa Barbara (Calif.) Museum of Art, June 6–Aug. 11.

Sarasota 1949. *Survey of American Art of the 18th and 19th Centuries.* John and Mable Ringling Museum of Art, Sarasota, Fla., Apr. 3–28.

Saratoga Springs 1968. *American Allegorical Paintings, Drawings and Prints.* Hathorn Gallery, Skidmore College, Saratoga Springs, N.Y., Apr. 18–May 5.

Saratoga Springs 1972. *The Americans: Circa 1922.* Hathorn

Gallery, Skidmore College, Saratoga Springs, N.Y., Oct. 12–29.

Saratoga Springs 1977. *Lee Bontecou—In Retrospective.* Hathorn Gallery, Skidmore College, Saratoga Springs, N.Y., Apr. 22–May 8.

Saunders 1979. Richard Henry Saunders III. *John Smibert (1688–1751): Anglo-American Portrait Painter.* Ph.D. diss., Yale University. Reprint, Ann Arbor.

———. 1995. Richard Saunders. *John Smibert: Colonial America's First Portrait Painter.* New Haven.

Sawitzky 1951. Susan Sawitzky, ed. "Thomas McIlworth." *New-York Historical Society Quarterly,* vol. 35, no. 2 (Apr.), pp. 117–39.

Sawitzky and Sawitzky 1960. William Sawitzky and Susan Sawitzky. "Two Letters from Ralph Earl with Notes on His English Period." *Worcester Art Museum Annual,* vol. 8, pp. 28–30, 38, 40–41.

SCAQ 1939. "Recent Acquisitions of the Smith College Museum of Art." *Smith College Alumnae Quarterly,* vol. 31, no. 1 (Nov.), pp. 26–27.

SCAQ 1941. Richard Boyd Ballou. "The Liberal Arts College and Teaching." *Smith College Alumnae Quarterly,* vol. 32, no. 2 (Feb.), pp. 82–83.

SCAQ 1982. "The Much Connected Mrs. Erving." *Smith College Alumnae Quarterly,* vol. 73, no. 4 (summer), p. 23.

SCAQ 1989. *Smith College Alumnae Quarterly,* vol. 80, no. 3 (spring).

Schendler 1967. Sylvan Schendler. *Eakins.* Boston.

Schmied 1995. Wieland Schmied. *Caspar David Friedrich.* Trans. Russell Stockman. New York.

Schneider 1984. Pierre Schneider. *Matisse.* Trans. Michael Taylor and Bridget Strevens Romer. New York.

Schorsch 1977. Anita Schorsch. *Pastoral Dreams.* New York.

———. 1978. Anita Schorsch. "The Lamb in American Art." *American Antiques,* vol. 6, no. 3 (Mar.), pp. 28–32.

Schulte Nordholt 1965. J. W. Schulte Nordholt. *Amerika: Land, Volk, Kultur.* Baarn, the Netherlands.

Schweizer 1989. Paul D. Schweizer, ed. *Masterworks of American Art*

from the Munson-Williams-Proctor Institute. New York.

SCMA Bull 1951. "American Art." *Smith College Museum of Art Bulletin*, nos. 29–32 (June), pp. 30–31.

SCMA Bull 1953. "American School." *Smith College Museum of Art Bulletin*, nos. 33–34, pp. 24–25.

SCMA Bull 1954–55. "Accessions: July, 1953–June, 1955." *Smith College Museum of Art Bulletin*, nos. 35–36, pp. 39–46.

SCMA Bull 1958. "Forty-six Recent Acquisitions: A Portfolio of Reproductions." *Smith College Museum of Art Bulletin*, no. 38, pp. 8–51.

SCMA Cat 1937. *Smith College Museum of Art Catalogue.* Northampton, Mass.

SCMA Handb 1925. *Handbook of the Art Collections of Smith College: Paintings, Sculpture, Drawings, Prints, Ceramics, Textiles.* Northampton, Mass.

SCMA Suppl 1941. *Supplement to the Catalogue of 1937.* Smith College Museum of Art, Northampton, Mass.

Scott 1982. Gail R. Scott, ed. *On Art by Marsden Hartley.* New York.

Seattle 1983–84. Bill Holm. *The Box of Daylight: Northwest Coast Indian Art.* Seattle Art Museum, Sept. 15–Jan. 8.

Sellers 1957. Charles Coleman Sellers. "Mezzotint Prototypes of Colonial Portraiture: A Survey Based on the Research of Waldron Phoenix Belknap, Jr." *Art Quarterly*, vol. 20, no. 4 (winter), pp. 407–68.

Serwer 1998. Jacquelyn Days Serwer. "Heroic Relics: The Art of Robert Cottingham." *American Art*, vol. 12, no. 2 (summer), pp. 6–25.

Shannon 1923. Martha A. S. Shannon. *Boston Days of William Morris Hunt.* Boston.

Shapiro 1986. Michael Edward Shapiro. "Twentieth-Century American Sculpture." *St. Louis Art Museum Bulletin*, vol. 18, no. 2 (winter), pp. 3–40.

Sheeler 1940. Charles Sheeler. "Power: A Portfolio." *Fortune*, vol. 22, no. 6 (Dec.), pp. 78–83.

Shelburne Falls 1890. Exhibition. Post Office, Shelburne Falls, Mass., Nov.

Shelburne Falls 1946. Exhibition. Art Center, Shelburne Falls, Mass., Nov.

Shepard 1964. Hortense O. Shepard. "Pilgrim's Progress: Horace Bundy and His Paintings." *The Magazine Antiques*, vol. 86, no. 4 (Oct.), pp. 445–49.

Sherman 1920. Frederick Fairchild Sherman. *Albert Pinkham Ryder.* New York.

Sherrill 1973. Sarah B. Sherrill. "Current and Coming." *The Magazine Antiques*, vol. 104, no. 1 (July), pp. 10, 14, 18, 26, 30, 34.

——— 1976. Sarah B. Sherrill. "Current and Coming: American Portraits at Smith College." *The Magazine Antiques*, vol. 110, no. 3 (Sept.), p. 396.

Shreveport 1973. *The Hudson River School: American Landscape Paintings from 1821 to 1907.* R. W. Norton Gallery, Shreveport, La., Oct. 14–Nov. 25.

Sickert 1908. Bernhard Sickert. *Whistler.* London.

Sicre 1954. José Gómez Sicre. *Guía de las Colecciones Públicas de Arte en los Estados Unidos.* Vol. 2. Washington, D.C.

Siegel 1990. Eleanor Kathryn Siegel. "Willem de Kooning's 'Women' Paintings of 1950–1953." M.A. thesis, University of Texas at Austin.

Simon 1987. Robin Simon. *The Portrait in Britain and America.* Oxford.

Smibert 1969. *The Notebook of John Smibert, with essays by Sir David Evans, John Kerslake, and Andrew Oliver.* Boston.

Smith 1950. Wayne C. Smith. "Show of Peto's Paintings Revives Old Art Mystery." *Springfield (Mass.) Republican*, Mar. 5.

Smith 1993 "Abstract." Elizabeth A. T. Smith. "Abstract Sinister." *Art in America*, vol. 81F, no. 9 (Sept.), pp. 82–87.

Smith 1993 *Modern.* Terry Smith. *Making the Modern: Art and Design in America.* Chicago.

Smith and Kvasnicka 1972. Henry E. Fritz. "The Board of Indian Commissioners and Ethnocentric Reform, 1878–1893." In Jane F. Smith and Robert M. Kvasnicka, eds., *Indian-White Relations: A Persistent Paradox*, Papers and Proceedings of the National Archives Conference on Research in the History of Indian-White

Relations (June 15–16, 1972), National Archives Conferences, Washington, D.C., vol. 10, pp. 57–78.

Southampton 1957. *William Merritt Chase, 1849–1916: A Retrospective Exhibition.* Parrish Art Museum, Southampton, N.Y., June 29–July 20.

Southampton 1981. *The Long Island Landscape, 1865–1914: The Halcyon Years.* Parrish Art Museum, Southampton, N.Y., July 26–Sept. 20.

South Bend 1985. *George Rickey in South Bend.* South Bend (Ind.) Art Center; Snite Museum of Art, University of Notre Dame, Notre Dame, Ind.; Indiana State University, South Bend; and Saint Mary's College, Notre Dame, Ind.; Sept. 8–Oct. 20.

South Hadley 1957. *Twenty-five Years of Alfred Maurer.* Sponsored by the Mount Holyoke Friends of Art. Dwight Art Memorial Gallery, Mount Holyoke College, South Hadley, Mass., Apr. 4–23.

South Hadley + 1960. *New Sculpture Now.* Dwight Art Memorial Gallery, Mount Holyoke College, South Hadley, Mass., Feb. 22–Mar. 24; Smith College Museum of Art, Northampton, Mass., Apr. 6–May 9.

South Hadley 1962. *Women Artists in America Today.* Dwight Art Memorial Gallery, Mount Holyoke College, South Hadley, Mass., Apr. 10–30.

South Hadley 1965. *Nineteenth-Century American Landscapes from the Collections of Amherst, Smith and Mount Holyoke.* Dwight Art Memorial Gallery, Mount Holyoke College, South Hadley, Mass., Nov. 4–Dec. 10.

South Hadley 1975–76. *From Pedestal to Pavement: The Image of Woman in American Art, 1875–1975.* Mount Holyoke College Art Museum, South Hadley, Mass., Dec. 1–Jan. 30.

Springfield 1954. *Paintings and Prints from Connecticut Valley Collectors.* City Library Association, Springfield (Mass.) Museum of Fine Arts, May 9–29.

Springfield + 1955. *Paintings of the Connecticut Valley.* Connecticut Valley Historical Museum, Springfield, Mass., Apr. 29–June 10; Saint Gaudens Memorial, Cornish, N.H., July 2–31.

Springfield 1962. *First Comprehensive Exhibition of Portraits by Horace Bundy, 1814–1883, One-Time Resident of North Springfield.* Miller Art Center, Springfield, Vt., Oct. 7–Nov. 30.

Springfield + 1981–82. *Arcadian Vales: Views of the Connecticut River Valley.* George Walter Vincent Smith Art Museum, Springfield, Mass., Nov. 22–Feb. 7; Center for the Arts, Wesleyan University, Middletown, Conn., Mar. 4–Apr. 4.

Springfield + 1984. Mary Black. *Erastus Salisbury Field, 1805–1900.* Springfield (Mass.) Museum of Fine Arts, Feb. 5–Apr. 1; National Museum of American Art and National Portrait Gallery, Washington, D.C., June 10–Sept 4; Museum of American Folk Art and Metropolitan Museum of Art, New York, Nov.–Dec.; Marion Koogler McNay Art Institute, San Antonio, Jan.–Feb. 1985.

Springfield 1987–88. *Works by Augustus Saint-Gaudens.* Connecticut Valley Historical Museum, Springfield, Mass., Nov. 16–Jan. 18.

Springfield Union 1928. "Galleries of Berkshire County House Many Notable Paintings." *Springfield (Mass.) Sunday Union and Republican*, Jan. 1.

Stamford 1984–85. *Winslow Homer and the New England Coast.* Whitney Museum of American Art, Stamford, Conn., Nov. 9–Jan. 9.

Stamford 1989. *Realism and Romanticism in Nineteenth-Century New England Seascapes.* Whitney Museum of American Art, Stamford, Conn., Sept. 15–Nov. 29.

Stamford 1997. *Wind, Waves and Sail.* Bruce Museum, Stamford, Conn., Apr. 4–July 13.

Staten Island 1860. *A Catalogue of Paintings in the Gallery of John C. Henderson.* Gallery of John C. Henderson, Staten Island, N.Y.

Stavitsky 1990. Gail Stavitsky. *Gertrude Stein: The American Connection.* Sid Deutsch Gallery, New York.

Stebbins 1975. Theodore E. Stebbins. *The Life and Works of Martin Johnson Heade.* New Haven. Rev. ed., 1999.

Stein [1946] 1972. Carl Van Vechten, ed. *The Selected Writings of Gertrude Stein.* New York.

Stevens 1967. William B. Stevens, Jr. "Joseph Blackburn and His

Newport Sitters, 1754–1756." *Newport History,* vol. 40 (summer), pp. 95–107.

St James's Chronicle 1783. Review, Incorporated Society of Artists exhibition. *St. James's Chronicle* (London), May 25–27.

St. Louis 1918. *Thirteenth Annual Exhibition of Selected Paintings by American Artists.* City Art Museum, Sept. 15–Oct. 28.

Stony Brook + 1980. Martha V. Pike and Janice Gray Armstrong. *A Time to Mourn: Expressions of Grief in 19th-Century America.* Museums at Stonybrook, N.Y., May 24–Nov. 16; Brandywine River Museum, Chadds Ford, Pa., Jan. 17–May 17, 1981.

Storrs 1972. *The American Earls.* William Benton Museum of Art, University of Connecticut, Storrs, Oct. 14–Nov. 12.

Storrs 1980. Stephanie Terenzio. *Robert Motherwell and Black.* William Benton Museum of Art, University of Connecticut, Storrs, Mar. 19–June 2.

St. Paul 1972–73. Frederick D. Leach. *Paul Howard Manship, An Intimate View: Sculpture and Drawings from the Permanent Collection of the Minnesota Museum of Art.* Minnesota Museum of Art and Bush Memorial Library, Hamline University, Dec. 7–Mar. 31.

St. Paul + 1985. *Paul Manship: Changing Taste in America.* Minnesota Museum of Art, May 19–Aug. 18; Hudson River Museum, Yonkers, N.Y., Nov. 10–Jan. 5, 1986; Norton Gallery and School of Art, West Palm Beach, Fla., Feb. 1–Mar. 15; Dayton (Ohio) Art Institute, Nov. 8–Jan. 4, 1987; Lakeview Museum of Arts and Sciences, Peoria, Ill., Feb. 8–Mar. 23; Memorial Art Gallery, University of Rochester, N.Y., Aug. 15–Oct. 18; Telfair Academy of Arts and Sciences, Savannah, Ga., Nov. 17–Jan. 3, 1988.

Straeten [1914] 1971. Edmund S. J. van der Straeten. *The History of the Violincello, The Viol da Gamba, Their Precursors and Collateral Instruments.* 2 vols. London.

Strong 1991. Roy Strong et al. *The British Portrait 1660–1960.* Woodbridge, Suffolk.

Sturbridge 1976. *The Landscape of Change: Views of Rural New England 1790–1865.* Old Sturbridge Village, Mass., Feb. 9–May 16.

Sturbridge 1992–93. *Meet Your Neighbors: New England Portraits, Painters, and Society 1790–1850.* Old Sturbridge Village, Mass., May 2–Jan. 3.

Sylvester 1968. David Sylvester. "De Kooning's Women." *London Sunday Times Magazine,* Dec. 8, 1968.

——— 1995. David Sylvester. "The Birth of Woman I." *Burlington Magazine,* vol. 137, no. 1107 (June), pp. 220–32.

Syracuse 1953. *125 Years of American Art.* Syracuse (N.Y.) Museum of Fine Arts, Sept. 16–Oct. 11.

Syracuse 1965. *Five Distinguished American Artists: Dickinson, Hofmann, Hopper, Shahn, Soyer.* New York State Exposition, Aug. 31–Sept. 6.

Syracuse 1982. Ross Anderson. *Abbot Handerson Thayer.* Everson Museum of Art, Syracuse, N.Y., Sept. 16–Nov. 7.

Tampa 1989–90. *At the Water's Edge: 19th- and 20th-Century American Beach Scenes.* Tampa (Fla.) Museum of Art, Dec. 9–Feb. 25.

Tarlow 1987. Lois Tarlow. "Profile: Joan Snyder." *Art New England,* vol. 8, no. 2 (Feb.), pp. 14–15, 22.

Tarshis 1982. Jerome Tarshis. "The Precisionist Impulse." *Portfolio,* vol. 4, no. 6 (Nov.–Dec.), pp. 58–65.

Terenzio 1992. Stephanie Terenzio, ed. *The Collected Writings of Robert Motherwell.* New York.

Thaxter 1873. Celia Thaxter. *Among the Isles of Shoals.* Boston.

Thomas 1983. F. Richard Thomas. *Literary Admirers of Alfred Stieglitz.* Carbondale, Ill.

Tiger's 1947. "The Ideas of Art: The Attitudes of 10 Artists on Their Art and Contemporaneousness." *Tiger's Eye,* vol. 1, no. 2 (Dec.), pp. 42–46.

Time 1950. "Art: Cavalcade." *Time,* vol. 56, no. 3 (July 17), p. 53.

Time 1955. "Art: Charles Sheeler." *Time,* vol. 65, no. 1 (Jan. 3), pp. 64–67.

Tomkins 1982. Calvin Tomkins. "The Art World: The Truth of Appearances." *New Yorker,* vol. 58, no. 30 (Sept. 13), pp. 103–8.

Toronto + 1961. Lloyd Goodrich. *American Painting, 1865–1905.* Art Gallery of Toronto, Jan. 6–Feb. 5;

Winnipeg Art Gallery, Feb. 17–Mar. 12; Vancouver Art Gallery, Mar. 29–Apr. 23; Whitney Museum of American Art, New York, May 17–June 18.

Toronto + 1989–90. Alan G. Wilkinson. *Jacques Lipchitz: A Life in Sculpture.* Art Gallery of Ontario, Dec. 15–Mar. 11; Winnipeg Art Gallery, May 13–Aug. 12; Nelson-Atkins Museum of Art, Kansas City, Mo., Oct. 7–Nov. 25; Jewish Museum, New York, Jan. 16–Apr. 15, 1991.

Touchstone 1990. Tennessee Humanities Council. "Southern Festival of Books: A Celebration of the Written Word." *Touchstone,* vol. 16, p. 14.

Townshend 1911. J[ames] B. T[ownshend]. "Exhibitions Now On: The Ten's Annual Show." *American Art News,* vol. 9, no. 24 (Mar. 25), p. 2.

Traxel 1980. David Traxel. *An American Saga: The Life and Times of Rockwell Kent.* New York.

Trollope 1877. Thomas Adolphus Trollope, ed. *Italy from the Alps to Mount Aetna.* London.

Truettner and Wallach 1994. William H. Truettner and Alan Wallach, eds. *Thomas Cole: Landscape into History.* New Haven.

Tuckerman 1867 [1966]. Henry Tuckerman. *Book of the Artists: American Artist Life.* New York.

Tucson + 1972. *Childe Hassam, 1859–1935.* University of Arizona Museum of Art, Feb. 5–Mar. 5; Santa Barbara (Calif.) Museum of Art, Mar. 26–Apr. 30.

Tucson 1992. *Big Ideas.* Tucson Museum of Art, June 12–July 26.

Tulsa + 1981. *Painters of the Humble Truth: Masterpieces of American Still Life, 1801–1939.* Philbrook Art Center, Tulsa, Okla., Sept. 27–Nov. 8; Oakland (Calif.) Museum, Dec. 8–Jan. 24, 1982; Baltimore Museum of Art, Mar. 2–Apr. 25; National Academy of Design, New York, May 18–June 4.

Tyler 1963. Parker Tyler. *Florine Stettheimer: A Life in Art.* New York.

Tyler 1986. John W. Tyler. *Smugglers and Patriots: Boston Merchants and the Advent of the American Revolution.* Boston.

Un Bal 1908. *Un Bal d'Etudiants. Notice Historique, accompagné d'une photogravure.* Paris.

UpJohn and Sedgwick 1963. Everard M. UpJohn and John P. Sedgwick, Jr. *Highlights: An Illustrated History of Art.* New York.

Upton 1944. Melville Upton. "Art: Marsden Hartley Again; Two Galleries Present His Work—Other Exhibitions." *New York Sun,* vol. 112, no. 90 (Dec. 16), p. 9.

Utica 1946–47. *Homer-Eakins Exhibition.* Munson-Williams-Proctor Institute, Utica, N.Y., Dec. 1–Jan. 19.

Utica 1960. *Art across America.* Munson-Williams-Proctor Institute Museum of Art, Utica, N.Y., Oct. 15–Dec. 31.

Utica + 1976. *Willard Leroy Metcalf (1858–1925): A Retrospective.* Munson-Williams-Proctor Institute Museum of Art, Utica, N.Y., Sept. 5–Oct. 10; Museum of Fine Arts, Springfield, Mass., Oct. 24–Dec. 26; Currier Gallery of Art, Manchester, N.H., Jan. 14–Mar. 6, 1977; Hunter Museum of Art, Chattanooga, Tenn., Apr. 3–May 15.

Utica 1985. Ellwood C. Parry III, Paul D. Schweizer, and Dan A. Kushel. *The Voyage of Life by Thomas Cole: Paintings, Drawings, Prints.* Munson-Williams-Proctor Institute Museum of Art, Utica, N.Y., Oct. 5–Dec. 15.

Vaizey 1982. Marina Vaizey. *The Artist as Photographer.* London.

Van Bork 1966. Bert Van Bork. *Jacques Lipchitz: The Artist at Work.* New York.

Van Dyke 1896. John C. Van Dyke, ed. *Modern French Masters: A Series of Biographical and Critical Reviews.* New York.

Vanity 1918. "Sculpture at a New York Salon: The Work of a Triumvirate of Modern Sculptors." *Vanity Fair,* vol. 9, no. 5 (Jan.), p. 54.

Van Rensselaer 1893. M. G. Van Rensselaer. "Fifth Avenue: With Pictures by Childe Hassam." *Century Magazine,* vol. 47, no. 1 (Nov.), pp. 5–18.

Vogel 1976. Lise Vogel. "Erotics, the Academy and Art Publishing: A Review of *Woman as Sex Object, Studies in Erotic Art, 1730–1970,* New York, 1972." *Art Journal,* vol. 35, no. 4 (summer), pp. 378–85.

Wal 1877. Caleb A. Wal. *Reminiscences of Worcester.* Worcester, Mass.

Wallach 1977. Alan Wallach. "*The Voyage of Life* as Popular Art." *Art Bulletin*, vol. 49, no. 2 (June), pp. 234–41.

Waltham + 1964. *The Painter and the Photograph*. Art Museum, Brandeis University, Waltham, Mass., Oct. 5–Nov. 2; Museum of Art, Indiana University, Bloomington, Nov. 15–Dec. 20; Art Gallery, State University of Iowa, Iowa City, Jan. 3–Feb. 10, 1965; Isaac Delgado Museum of Art, New Orleans, Feb. 23–Mar. 22; University Art Gallery, University of New Mexico, Albuquerque (organizer), Apr. 1–May 7; Santa Barbara (Calif.) Museum of Art, May 19–June 21.

Waltham + 1994. Carl Belz. *Joan Snyder Painter, 1969 to Now*. Rose Art Museum, Brandeis University, Waltham, Mass., Apr. 15–June 5; Parrish Art Museum, Southampton, N.Y., July 10–Aug. 21.

Warren 1955. William Lamson Warren. "The Jennys Portraits." *Connecticut Historical Society Bulletin*, vol. 20, no. 4 (Oct.), pp. 97–128.

———— 1956. William Lamson Warren. "A Checklist of Jennys Portraits." *Connecticut Historical Society Bulletin*, vol. 21, no. 2 (Apr.), pp. 33–64.

Washington, Corcoran 1902. *Twelfth Annual Exhibition of the Society of Washington Artists*. Corcoran Gallery, Mar. 15–Apr. 15.

Washington, Corcoran 1925. *Paintings by Willard L. Metcalf*. Corcoran Gallery of Art, Jan. 3–Feb. 1.

Washington, Corcoran 1950. *American Processional, 1492–1900*. Corcoran Gallery of Art, July 8–Dec. 17.

Washington, Corcoran 1959. *The American Muse*. Corcoran Gallery of Art, Apr. 4–May 17.

Washington, Corcoran 1961. *Albert Pinkham Ryder*. Corcoran Gallery of Art, Apr. 8–May 12.

Washington +, Corcoran 1965. *Childe Hassam: A Retrospective Exhibition*. Corcoran Gallery of Art, Apr. 30–Aug. 1; Museum of Fine Arts, Boston, Aug. 17–Sept. 19; Currier Gallery of Art, Manchester, N.H., Sept. 28–Oct. 31; Gallery of Modern Art, New York, Nov. 16–Dec. 19.

Washington +, Corcoran 1981. Lawrence Alloway and Mary Davis MacNaughton. *Adolph Gottlieb: A Retrospective*. Corcoran Gallery of Art, Apr. 24–June 6; Tampa (Fla.) Museum, Aug. 15–Oct. 17; Toledo (Ohio) Museum of Art, Nov. 7–Dec. 19; Archer M. Huntington Art Gallery, University of Texas, Austin, Jan. 9–Feb. 20, 1982; Flint (Mich.) Institute of Art, DeWaters Art Center, Mar. 18–Apr. 24; Indianapolis Museum of Art, May 15–June 19; Los Angeles County Museum of Art, July 10–Aug. 21; Albright-Knox Art Gallery, Buffalo, Sept. 11–Oct. 31.

Washington +, Corcoran 1988. Judith E. Bernstock. *Joan Mitchell*. Corcoran Gallery of Art, Feb. 26–May 1; San Francisco Museum of Modern Art, May 26–July 17; Albright-Knox Art Gallery, Buffalo, Sept. 17–Nov. 6; La Jolla (Calif.) Museum of Contemporary Art, Dec. 2–Jan. 29, 1989; Herbert F. Johnson Museum of Art, Cornell University, Ithaca, N.Y. (organizer), Feb. 26–Apr. 23.

Washington, National Collection 1958. Thomas M. Beggs. *A Retrospective Exhibition of Sculpture by Paul Manship*. Smithsonian Publication 4336. National Collection of Fine Arts, Feb. 23–Mar. 16.

Washington, National Collection 1965–66. *Roots of Abstract Art in America, 1910–1930*. National Collection of Fine Arts, Dec. 2–Jan. 9.

Washington +, National Collection 1968. *Charles Sheeler*. National Collection of Fine Arts, Oct. 10–Nov. 24; Philadelphia Museum of Art, Jan. 8–Feb. 16, 1969; Whitney Museum of American Art, New York, Mar. 11–Apr. 27.

Washington, National Collection 1972. Janet A. Flint. *Drawings by William Glackens, 1870–1938*. National Collection of Fine Arts, Feb. 25–Apr. 30.

Washington +, National Collection 1973. Sheldon Reich. *Alfred H. Maurer, American Modernist*. National Collection of Fine Arts, Feb. 23–May 13; University Gallery, University of Minnesota, Minneapolis, June 25–Aug. 24.

Washington, National Collection 1976. Joshua Taylor. *America as Art*. National Collection of Fine Arts, Apr. 30–Nov. 7.

Washington +, National Gallery 1961. *Thomas Eakins: A Retrospective Exhibition*. National Gallery of Art, Oct. 8–Nov. 12; Art Institute of Chicago, Dec. 1– Jan. 7, 1962; Philadelphia Museum of Art, Feb. 1–Mar. 18.

Washington +, National Gallery 1967. *Gilbert Stuart: Portraitist of the Young Republic*. National Gallery of Art, July 1–Aug. 20; Rhode Island School of Design, Providence, Sept. 9–Oct. 15; Pennsylvania Academy of the Fine Arts, Philadelphia, Nov. 1–Dec. 3.

Washington +, National Gallery 1970. *Nineteenth- and Twentieth-Century Paintings from the Collection of the Smith College Museum of Art*. Organized by Smith College Museum of Art and circulated by the American Federation of Arts. National Gallery of Art, May 16–June 14; Museum of Fine Arts, Houston, Aug. 22–Sept. 13; Seattle Art Museum, Oct. 7–Nov. 22; William Rockhill Nelson Gallery of Art, Kansas City, Mo., Dec. 20–Feb. 1, 1971; Virginia Museum of Fine Arts, Richmond, Feb. 28–Apr. 11; Lakeview Center, Peoria, Ill., May 9–June 20; Columbus (Ohio) Gallery of Fine Arts, July 16–Aug. 29; Toledo (Ohio) Museum of Art, Oct. 3–Nov. 14; Dallas Museum of Fine Arts, Dec. 12–Jan. 16, 1972; Georgia Museum of Art, University of Georgia, Athens, Feb. 13–Mar. 26; Munson-Williams-Proctor Institute Museum of Art, Utica, N.Y., Apr. 23–June 4; Detroit Institute of Arts, July 5–Aug. 13; Cleveland Museum of Art, Sept. 10–Oct. 22. Not circulated by the American Federation of Arts: Colby College Museum of Art, Waterville, Maine, June–Sept. 21, 1969; Currier Gallery of Art, Manchester, N.H., Nov. 11–23, 1969.

Washington, National Gallery 1981–82 *Four*. Robert Farris Thompson and Joseph Cornet. *The Four Moments of the Sun: Kongo Art in Two Worlds*. National Gallery of Art, Aug. 30–Jan. 17.

Washington +, National Gallery 1981–82 *Ganz*. John Wilmerding, Linda Ayres, and Earl A. Powell. *An American Perspective: Nineteenth-Century Art from the Collection of Jo Ann and Julian Ganz, Jr.* National Gallery of Art, Oct. 4–Jan. 31; Amon Carter Museum, Fort Worth, Tex., Mar. 19–May 23; Los Angeles County Museum of Art, July 6–Sept. 26.

Washington +, National Gallery 1983. John Wilmerding. *Important Information Inside: The Art of John F. Peto and the Ideas of Still-Life Painting in Nineteenth-Century America*. National Gallery of Art, Jan. 16–May 29; Amon Carter Museum, Fort Worth, Tex., July 15–Sept. 18.

Washington +, National Gallery 1987–88. Jack Cowart and Juan Hamilton. *Georgia O'Keeffe: Art and Letters*. National Gallery of Art, Nov. 1–Feb. 21; Art Institute of Chicago, Mar. 5–June 19; Dallas Museum of Art, July 31–Oct. 16; Metropolitan Museum of Art, New York, Nov. 19–Feb. 5, 1989.

Washington +, National Gallery 1988–89. Nicolai Cikovsky, Jr. *Raphaelle Peale: Still Lifes*. National Gallery of Art, Oct. 16–Jan. 29; Pennsylvania Academy of the Fine Arts, Philadelphia, Feb. 16–Apr. 16.

Washington +, National Gallery 1989–90. Deborah Chotner, Lisa N. Peters, and Kathleen A. Pyne. *John Twachtman: Connecticut Landscapes*. National Gallery of Art, Oct. 15–Jan. 28; Wadsworth Atheneum, Hartford, Mar. 18–May 20.

Washington, National Gallery 1991. Jane Sweeney, ed. *Art for the Nation: Gifts in Honor of the Fiftieth Anniversary of the National Gallery*. National Gallery of Art, Mar. 17–June 16.

Washington +, National Gallery 1993. Jack Flam. *Matisse: The Dance* (exhibition catalogue). *The Dance Murals of Henri Matisse*, National Gallery of Art, May 2–Sept. 26; Musée National d'Art Moderne, Paris, Nov. 15–Jan. 30, 1994; Philadelphia Museum of Art, Mar. 27–June 12.

Washington +, National Gallery 1994. Marla Prather et al. *Willem de Kooning Paintings*. National Gallery of Art, May 8–Sept. 5; Metropolitan Museum of Art, New York, Oct. 6–Jan. 5, 1995; Tate Gallery, London, Feb. 15–May 7.

Washington +, National Gallery 1995–96. Nicolai Cikovsky, Jr., and Franklin Kelly. *Winslow Homer*. National Gallery of Art, Oct. 15–Jan. 28; Museum of Fine Arts, Boston, Feb. 21–May 26.

Washington +, National Museum 1990. Elizabeth Broun. *The Art of Albert Pinkham Ryder*. National Museum of American Art, Apr. 1–July 29; Brooklyn Museum, Sept. 21–Jan. 7, 1991.

Washington, NPG 1974. *American Self-Portraits, 1670–1973*. National Portrait Gallery, Feb. 1–Mar. 15.

Washington +, NPG 1980–81. Dorinda Evans. *Benjamin West and His American Students*. National

Portrait Gallery, Oct. 16–Jan. 4; Pennsylvania Academy of the Fine Arts, Philadelphia, Jan. 30–Apr. 19.

Washington, NPG 1987–88. Richard H. Saunders and Ellen G. Miles. *American Colonial Portraits, 1700–1776*. National Portrait Gallery, Oct. 9–Jan. 10.

Washington, NPG 1991. *Group Portrait: The First American Avant-Garde*. National Portrait Gallery, May 10–Oct. 27.

Washington +, NPG 1991–92. Elizabeth Mankin Kornhauser et al. *Ralph Earl: The Face of the Young Republic*. National Portrait Gallery, Nov. 1–Jan. 1; Wadsworth Atheneum, Hartford (organizer), Feb. 2–Apr. 5; Amon Carter Museum, Fort Worth, Tex., May 16–July 12.

Washington, Phillips 1937. Duncan Phillips. *Retrospective Exhibition of Works in Various Media by Arthur Dove*. Phillips Memorial Gallery, Mar. 23–Apr. 18.

Washington +, Phillips 1981. Sasha M. Newman. *Arthur Dove and Duncan Phillips: Artist and Patron*. Phillips Collection, June 13–Aug. 16; High Museum of Art, Atlanta, Sept. 11–Oct. 30; William Nelson Rockhill Gallery and Atkins Museum of Fine Arts, Kansas City, Mo., Nov. 13–Jan. 3, 1982; Museum of Fine Arts, Houston, Jan. 21–Mar. 21; Columbus (Ohio) Museum of Art, Apr. 18–June 9; Seattle Art Museum, July 1–Sept. 6; New Milwaukee Art Center, Sept. 29–Nov. 14.

Washington +, Phillips 1992–93. *Georgia O'Keeffe and Alfred Stieglitz: Two Lives, A Conversation in Paintings and Photographs*. Phillips Collection, Dec. 12–Apr. 4; IBM Gallery of Science and Art, New York, Apr. 27–June 26; Minneapolis Institute of Arts, July 17–Sept. 12; Museum of Fine Arts, Houston, Oct. 2–Dec. 5.

Washington +, Phillips 1994–95. *The Pictographs of Adolph Gottlieb*. Phillips Collection, Sept. 24–Jan. 2; Portland (Maine) Museum of Art, Feb. 4–Apr. 2; Brooklyn Museum of Art, Apr. 21–Aug. 27; Arkansas Art Center, Little Rock, Nov. 30–Jan. 28, 1996.

Washington +, Phillips 1997–98. Debra Bricker Balken et al. *Arthur Dove: A Retrospective*. Phillips Collection, Sept. 20–Jan. 4; Whitney Museum of American Art, New York, Jan. 15–Apr. 12; Addison Gallery of American Art,

Phillips Academy, Andover, Mass., Apr. 25–July 12; Los Angeles County Museum of Art, Aug. 2–Oct. 4.

Waterville 1985. *Landscape and Abstract Art: A Continuing Dialogue*. Colby College Museum of Art, Waterville, Maine, Mar. 3–31.

Watkins 1997. Eileen Watkins. "Images Underscore Indians' Hardships." *Newark (N.J.) Star-Ledger*, Jan. 31–Feb. 6, pp. 6–7.

Watson 1991. Steven Watson. *Strange Bedfellows: The First American Avant-Garde*. New York.

Wattenmaker 1988. Richard J. Wattenmaker. "William Glackens's Beach Scenes at Bellport." *Smithsonian Studies in American Art*, vol. 2, no. 2 (spring), pp. 74–94.

Way 1912. T. R. Way. *Memories of James McNeill Whistler, the Artist*. London.

Way and Dennis 1903. T. R. Way and G. R. Dennis. *The Art of James McNeill Whistler, An Appreciation*. London.

Webster 1991. Sally Webster. *William Morris Hunt (1824–1879)*. New York.

Wellesley 1949–50. Exhibition. Wellesley College Art Museum, Wellesley, Mass., Dec.–Feb.

Wellesley 1981. *The Railroad in the American Landscape, 1850–1950*. Wellesley College Art Museum, Wellesley, Mass., Apr. 15–June 8.

Wells and Wells 1910. Daniel White Wells and Reuben Field Wells. *History of Hatfield*. Springfield, Mass.

Weston 1986. Marybeth Weston. "Pretty Penny's Leading Lady." *House Beautiful*, vol. 128, no. 10 (Oct.), pp. 90–95, 114.

White 1930. Henry C. White. *The Life and Art of Dwight William Tryon*. Boston.

Whitley 1932. William T. Whitley. *Gilbert Stuart*. Cambridge, Mass.

Wight 1884. P. B. Wight. "The Development of New Phases of the Fine Arts in America." *Inland Architect and Builder*, vol. 4, no. 5 (Dec.), pp. 63–65.

Wilkie and Tager 1991. Richard W. Wilkie and Jack Tager, eds. *Historical Atlas of Massachusetts*. Amherst.

Willard 1964. Charlotte Willard. "In the Art Galleries." *New York Post*, Aug. 23, p. 44.

Williams 1973. Hermann Warner Williams, Jr. *Mirror to the American Past: A Survey of American Genre Painting, 1750–1900*. Greenwich, Conn.

Williamsburg 1963. Mary Black. *Erastus Salisbury Field, 1805–1900: A Special Exhibition Devoted to His Life and Work*. Abby Aldrich Rockefeller Folk Art Collection, Williamsburg, Va., Jan. 20–Mar. 17.

Williamstown 1950. *Sixteen Portraits 1600–1900*. Lawrence Art Museum, Williams College, Williamstown, Mass., Nov. 16–Dec. 20.

Williamstown 1953. *American "Fool-the-Eye" Still Life*. Lawrence Art Museum, Williams College, Williamstown, Mass., Jan. 5–22.

Williamstown 1954. *Maurer*. Lawrence Art Museum, Williams College, Williamstown, Mass., June 5–27.

Williamstown 1960. *An Exhibition of Paintings Lent by Museums and Private Collections of New England*. Lawrence Art Museum, Williams College, Williamstown, Mass., Nov.–Dec.

Williamstown 1980. Jennifer Gordon, Laurie McGavin, Sally Mills, and Ann Rosenthal. *John Storrs and John Flannagan: Sculpture and Works on Paper*. Sterling and Francine Clark Art Institute, Williamstown, Mass., Nov. 7–Dec. 28.

Williamstown 1983. S. Lane Faison, Jr. *The New England Eye: Master American Paintings from New England School, College and University Collections*. Williams College Museum of Art, Williamstown, Mass., Sept. 11–Nov. 13.

Wilmerding 1972. John Wilmerding. *Winslow Homer*. New York.

——— 1976 *American*. John Wilmerding. *American Art*. Baltimore.

——— 1976 *Growth*. John Wilmerding. "The End of Growth as an American Value? A View through the Arts." In Chester L. Cooper, ed., *Growth in America*, pp. 154–72. Westport, Conn.

——— 1979. John Wilmerding. "Thomas Eakins' Late Portraits." *Arts Magazine*, vol. 53, no. 9 (May), pp. 108–12.

——— 1987. John Wilmerding. *American Marine Painting*. New York.

——— 1991. John Wilmerding. *American Views: Essays on American Art*. Princeton.

Wilmerding and Ayres, 1990. John Wilmerding and Linda Ayres. *Winslow Homer in the 1870s: Selections from the Valentine-Pulsifer Collection*. Princeton.

Wilson 1981. Laurie Wilson. *Louise Nevelson: Iconography and Sources*. New York.

Wilson and Fiske 1894. James G. Wilson and John Fiske, eds. *Appleton's Cyclopaedia of American Biography*. New York.

Woodward 1994. Richard B. Woodward. "Where Have You Gone, Robert Frank?" *New York Times Magazine*, Sept. 4, pp. 30–37.

Wyer 1916. Raymond Wyer. "Art and the Man: Blakelock." *International Studio*, vol. 59, no. 233 (July), p. xix.

Yard 1980. Sally Yard. "Willem de Kooning: The First Twenty-six Years in New York—1927–1952." Ph.D. diss., Princeton University.

Yonkers 1979–80. Kenneth W. Maddox. *An Unprejudiced Eye: The Drawings of Jasper F. Cropsey*. Hudson River Museum, Yonkers, N.Y., Dec. 22–Feb. 24.

Yonkers 1983–84. *The Book of Nature: American Painters and the Natural Sublime*. Hudson River Museum, Yonkers, N.Y., Oct. 30–Jan. 8.

Young et al. 1980. Andrew McLaren Young, Margaret MacDonald, and Robin Spencer. *The Paintings of James McNeill Whistler*. 2 vols. New Haven.

Zoccoli 1987. Franca Zoccoli. *Dall'ago al pennello: Storia delle artiste americane*. Urbino.

Zurich 1977. *Painting in the Age of Photography*. Kunsthaus, Zurich, May 2–July 24.

Index

Page numbers in *italics* refer to
illustrations.

Abbott, Jere, 10, 140, 258 cat.52 n 1,
259 cat.55 n 1
Abstract Expressionism, 198, 201, 205,
208, 210, 213, 214, 216, 219, 224, 237,
262 cat.64 n 8
abstraction, 174, 176, 191, 198–201,
205, 210, 220, 236, 255 cat.46 n 7,
258 cat.53 n 7
Académie Julian, Paris, 116, 128, 141,
161, 188
Académie Moderne, Paris, 221
Accademia, Venice, 238
Ackerman, Frederick L., 10
Adams, Ansel, 259 cat.55 n 18
Advent faith, 58
Africa and African art, 162, 191, 228,
232, 241, 242, 244
Albany, N.Y., 56, 90
Albany Institute of History & Art, 55
Albers, Josef, 202–4
Homage to the Square series, 202,
204
Interaction of Color, 202
*Rolled Wrongly (Falsch
Gewickelt)*, 202, 204
*Study to Homage to the Square:
Layers*, 202, 203, 204,
262 cat.61 nn 1–6
Albright-Knox Art Gallery, Buffalo,
N.Y., 105
Alexander, Cosmo, 30
Alexander, John White, 128
American Academy, Rome, 147
American Antiquarian Society,
Worcester, Mass., 39, 41
American Folk Art Gallery, New
York, 46
American Museum of Natural History,
New York, 191, 232
American Watercolor Society, 116
Analytic Cubism, 209
An American Place, New York, 176,
260 cat.56 n 5
1937 Dove exhibition, 176,
258 cat.53 n 18
1950 O'Keeffe exhibition, 196
Andrews/Anderson/Baldwin,
Toronto, 13
Antiques, 46
Antonakos, Stephen, *Archangel
Gabriel*, 273
Archipenko, Alexander, 150,
258 cat.52 n 9
Architectural League, New York, 147
Arizona State Museum, Tucson, 191
Armory Show (1913, New York), 157,
174, 255 cat.46 n 8, 258 cat.53 n 7
Arnason, H. H., 198
Arnold, Benedict, 50
Arp, Jean (Hans), 171

Art Bulletin, 138
Art Deco, 149, 153, 161, 162, 172
Art Institute of Chicago, 11, 144, 161,
210, 213, 234
Artists Fund Society, 48, 74
Art News, 158
Art Nouveau, 131, 150, 153
Art of This Century Gallery, New
York, 198
Artschwager, Richard, *High Rise
Apartment*, 271
Art Students League, New York, 108,
158, 208, 231
Ashton, Dore, 205
Assyrian relief, 183
Avery, Milton, *Surf Fisherman*, 270

Bach, Johann Sebastian, 166,
257 cat.50 n 6
Ball, Thomas, 84, 249 cat.24 n 3,
250 cat.25 n 7
Daniel Webster, 274
La Petite Pensée, 84, 86
Bantel, Linda, 47
Barbizon School, 65, 87, 90, 104, 106
Barker, John Jesse, 87
Barnes, Dr. Albert C., 146,
254 cat.44 n 13
Barnes Foundation, Merion, Pa., 201
Bartlett, William H., 56
Barye, Antoine-Louis, 150
Baskin, Leonard, *Great Bronze Dead
Man*, 275
Bassett, Bethiah Smith, 50, 51,
247 cat.13 nn 1–2
Bassett, Nathaniel, 50–51,
247 cat.13 nn 1–2
Bastien-Lepage, Jules, 141
Bathurst, Henry, second earl of, 27–28
Battle of the Lapiths and Centaurs
(Parthenon, Athens), 147
Bauermeister, Mary, *Eighteen Rows*,
275
Bauhaus, 172, 202, 204, 220
Baur, John, 153
Bayerisches Nationalmuseum,
Munich, 150
Baziotes, William, *The Parachutists*,
192, 192, 194, 260 cat.58 n 14
Beard, William Holbrook:
The American Eagle, 245 n 4
The Tender Passion Universal,
245 n 4
Beardsley, Aubrey, 255 cat.46 n 11
Beaux-Arts style, 147
Bell, Larry, *Untitled*, 276
Belling, Rudolf, 258 cat.52 n 9
Bellows, Albert Fitch, *A Village School
in New England*, 245 n 4
Bellport-Brookhaven Historical
Society, N.Y., 146
Benson, Frank W., 116, 254 cat.43 n 8,
256 cat.47 n 4

Berkeley, George, 16
Berkshire Museum, Pittsfield, Mass.,
156
Bernini, Gian Lorenzo, *Ecstasy of
Saint Teresa*, 221
Bernstein, Seymour, *American Pictures
at an Exhibition*, 251 cat.33 n 10
Best, Mary, 140
Bierstadt, Albert, 67, 68, 70–73, 87,
248 cat.18 n 5
*Base of the Rocky Mountains,
Laramie Peak*, 73
*Echo Lake, Franconia Mountains,
New Hampshire*, 11, 70, 71,
72–73, 248 cat.20 nn 1–12
Emigrants Camping, 73
Platte River—Indians Encamped,
73
Recollections of Capri, 73
Bierstadt, Charles, 67, 72
Bierstadt, Edward, 67, 72, 73
Bierstadt Brothers, 67, 72, 73,
248 cat.20 nn 4, 6
*Stereoscopic Views among the Hills
of New Hampshire*, 72
Billings, Lieutenant David, 41–42,
246 cat.10 n 5
Billings, Mabel Little, 41–42,
246 cat.10 n 5
Birch, Thomas, 56
Bishop, Isabel, *Self-Portrait*, 269
Blackburn, Joseph, 18–21, 24
Andrew Faneuil Phillips, 11, 18,
20, 21, 245 cat.2 nn 1–4
Ann Phillips, 11, 18, 20, 21,
245 cat.2 nn 1–4
Gillam Phillips, 11, 18, 19, 20,
245 cat.2 nn 1–4
*Mrs. Gillam Phillips (Marie
Faneuil)*, 11, 18, 19, 20,
245 cat.2 nn 1–4
Black Mountain College, N.C., 204
Blakelock, Ralph Albert, 11, 102–3
Outlet of a Mountain Lake, 102–3,
103, 250 cat.30 nn 1–5
Blaue Reiter group, 184
Bloemink, Barbara, 159, 160
Boccioni, Umberto, 188
Bock, Arthur, 161
Boeckman (Elizabeth Mayer) sculp-
ture courtyard, Smith College
Museum of Art, Northampton,
Mass., 12, 13
Bonnard, Pierre, 252 cat.39 n 7
Bontecou, Lee, 208–9
Untitled, 11, 208–9, 209,
262 cat.63 nn 1–11
Born, Wolfgang, *Still Life Painting in
America*, 138
Boston, 9, 16, 18, 24, 30, 36, 41, 56, 67,
84, 90, 99, 125, 132, 141, 154, 168
Boston Art Club, 116
Boston Athenaeum, 65, 67

Boston School, 154, 256 cat.47 n 9
Bowdoin, James, 26
Brancusi, Constantin, 150, 196
Braque, Georges, 188
Breck, John Leslie, 256 cat.47 n 4
Breton, André, 198
Brewster, John, Jr., 39
Bricher, Alfred Thompson, 93
Bridget Duncan (Unknown artist), 39, *40*, 246 cat.9 nn 1–2
Broad (Eli) Family Foundation, Santa Monica, 236
Brooklyn Art Association, 94
Brooklyn Art School, 108
Brooklyn Museum, 191
Brown, Christopher, *China*, *272*
Brown, George Loring, 141
Brown, Henry Kirke, 90
Brown, J., 39
Brown, J. Appleton, *Spring*, 245 n 4
Brown, J. G., 8
 Blind Musician, 245 n 4
Brown, Milton, 182, 183
Brush, George de Forest, 11, 256 cat.47 n 8
Bryant, William Cullen, "Forest Hymn," 61
Bulfinch, Charles, 36, 246 cat.8 n 1
Bundy, Horace, 58–60
 Girl with a Dog, 58, *59*, 60, 248 cat.16 nn 1–4
 Portrait of a Gentleman, 58, 60
 Portrait of a Lady, 58, 60
 Self-Portrait, 58
Bunyan, John, *Pilgrim's Progress*, 54, 88
Burchfield, Charles, 177
Burleigh, C. C., 245 n 4

Calder, Alexander, 171–73, 213, 221
 Mobile, 10, 171–72, *173*, 258 cat.52 nn 1–11
 White Spray, *275*
Campbell, Thomas:
 "The Last Man," 54
 "Lord Ullin's Daughter," 55
Capri, Italy, 64–66
Carnegie Museum of Art, Pittsburgh, 200, 205
Carolus-Duran, Emile, 99, 109
Carr, Samuel S., 12, 93–94, 245 n 11
 The Beach at Coney Island, 93
 Beach Scene, 93–94, *94*, 145, 250 cat.27 nn 1–7
 Beach Scene with Punch and Judy Show, 93
 Children Playing on the Beach, 93
 Manhattan Beach, L.I., 93
 Sport on the Beach, 93
Casals, Pablo, 154
Casilear, John, 70
Cassatt, Mary, 154
Castelli, Leo, 210
Castelli (Leo) Gallery, New York, 208, 262 cat.63 n 2
Century Magazine, 117
Ceres (ship's figurehead, Unknown artist), 11, 44, *45*, 46, *46*, 246–47 cat.11 nn 1–12
Cézanne, Paul, 165, 180, 210, 214, 255 cat.47 n 2, 260 cat.56 n 7
 La Route tournante à la Roche Guyon, 9

Chambers, Thomas, 56–57
 Lake George and the Village of Caldwell, 56–57, *57*, 247–48 cat.15 nn 1–6
 other works by, 248 cat.15 n 4
Champney, Benjamin, 70
Champney, James Wells, 8
 Boon Companions, *267*
 Death and the Miser, 245 n 4
Chase, William Merritt, 9, 11, 108–9, 128, 132, 146, 180, 254 cat.43 n 8
 Lady in Black, 108
 Lady in Pink, 108
 View of Fiesole, *268*
 Woman in Black, 9, 11, 108–9, *109*, 251 cat.32 nn 1–5
Chetham, Charles, 11–12, 245 n 7
Chevreuse, Jacquesson de la, 104
Chicago, 125, 161, 162, 210, 213, 241, 255 cat.47 n 2
Chotner, Deborah, 12, 245 nn 10, 11
Christo, *Double Show Window*, *276*
Chrysler, Walter P., 11, 200
Chrysler Museum, Norfolk, Va., 11, 41
Church, Frederic Edwin, 8, 78, 87
 Morning in the Tropics, *267*
 Niagara, 92
Churchill, Alfred Vance, 9–10, 13, 148, 251 cat.34 n 1, 257 cat.50 n 3
Cikovsky, Nicolai, Jr., 88
City Art Museum of Saint Louis, 148
Civil War, 73, 81, 125
Clark (Sterling and Francine) Art Institute, Williamstown, Mass., 81, 93
Clarke, Thomas B., 113
classicism, 84, 86
Clement, Clara Erskine, 79
Cleveland Museum of Art, 195
Cleveland School of Art, 184
Cobbett, William, 47
CoBrA group, 237
Cocteau, Jean, 190
Cole, Thomas, 52–55, 61, 70
 Compositional Sketch for the Voyage of Life: Manhood, 55, *55*
 Compositional study for *The Voyage of Life: Manhood*, 11, 52, *53*, 54–55, 247 cat.14 nn 1–10
 The Course of Empire, 52
 "Essay on American Scenery," 70
 other works by, 247 cat.14 n 10
 Portage Falls on the Genesee River, 55, 247 cat.14 n 8
 Prometheus Bound, 247 cat.14 n 4
 Study for the Voyage of Life: Manhood, 55, *55*
 The Voyage of Life, 52–55, 247 cat.14 n 10
 The Voyage of Life: Manhood, 54, *54*, 55, 247 cat.14 n 10
Colman, Samuel, 8
 The Caravan of the Desert, 245 n 4
Conceptualism, 12, 224, 226, 227, 234
Congress, U.S., 22
Connecticut, 22, 27, 28, 39, 41
Connelly, Pierce, 249 cat.24 n 3
Constitutional Convention (1787), 22
Constructivism, 171, 172, 222
Continental Congress, 22
Cook, Clarence, 76
Cooper Union, New York, 74

Copley, John Singleton, 16, 18, 24–26, 27
 Boy with a Squirrel, 24
 The Death of Major Pierson, 24
 The Death of the Earl of Chatham, 24, 28
 The Honorable John Erving, 11, 16, 24, *25*, 26, 245–46 cat.4 nn 1–5
Corcoran Gallery of Art, Washington, D.C., 90, 92
 American Processional, 1492–1950, 119
Cornell, Joseph, 241
Cortissoz, Royal, 126, 157
Cottier, Daniel, 113
Courbet, Gustave, *Preparation of the Dead Girl*, 9
Couture, Thomas, 90
Cowdrey, Mary Bartlett, 11, 110
Cox, Kenyon, 158
Crayon, The, 61, 68, 72
Creative Art, 158
Crehan, Hubert, 216
Crocker, General, 65
Cropsey, Jasper F., 248 cat.18 n 5
 Sugar Loaf and Wickham Pond, *266*
Cubism, 10, 161, 162, 165, 166, 180, 184, 188, 189, 190, 209, 216, 252 cat.39 n 13, 255 cat.46 n 7
Cummings, E. E., 170
Curtis, George, 110
Curtis Galleries, Minneapolis, 131
Curtiss, Mina Kirstein, 11

Dada, 161, 256 cat.48 n 10
daguerreotypes, 49
Dallas Museum of Art, 33, 34
Daubigny, Charles-François, 87, 104
Davies, Arthur B., 144, 184
Davis, Joseph H., 251 cat.33 n 11
Davis Museum and Cultural Center, Wellesley College, 13
Dawes Commission, 240, 264 cat.73 n 12
Dawes General Allotment Act (1887), 240, 264 cat.73 n 12
De Camp, Joseph R., 254 cat.43 n 8, 256 cat.47 n 4
 Cellist, 256 cat.47 n 10
Decorative Movement, 113
De Forest, Lockwood, *Ramesseum at Thebes*, 245 n 4
Degas, Edgar, 128, 255 cat.47 n 2
 Jephthah's Daughter, 9
De Haas, R., *A Squall off the New England Coast*, 245 n 4
de Kooning, Elaine, 205, 218
de Kooning, Willem, 205, 210, 216–18, 245 n 13
 Woman in Landscape X, 216–17, *217*, 218, 262–63 cat.66 nn 1–15
 Woman I, 216, *216*
 Women, 262 cat.66 n 2
Delacroix, Eugène, 113
Delaunay, Robert, 165, 220
Delaunay, Sonia, 220, 252 cat.39 n 7
Delehanty, Suzanne, 184
De Lisio, Michael, *Shakespeare and Company*, *276*
Demuth, Charles, 158, 160, 180, 186, 256 cat.48 n 10

Derain, André, 186
 Window at Vers, 186, *186*, 260 cat.56 n 11
Deskey, Donald, 172, 258 cat.52 nn 1, 7, 8
de Stijl, 171
Detroit Institute of Arts, 95, 255 cat.46 n 17
Detroit Museum of Art, 148
Dewing, Thomas Wilmer, 154–57, 254 cat.43 n 8
 Lady with a Lute, 11, 245 n 8
 Lady with Cello, 154, *155*, 156–57, 255–56 cat.47 nn 1–17
 The Song and the Cello, 156, *156*, 256 cat.47 n 12
 Summer Evening, 156
 The White Dress, 156
de Young (M. H.) Memorial Museum, Fine Arts Museums of San Francisco, 186
Dial, 158
Dickinson, E. Porter, 119, 251 cat.36 nn 1–3
Dietrich, Mr. and Mrs. Daniel W., II, 113
Doolittle, Amos, 27
Dove, Arthur G., 128, 174–76, 195, 245 n 13, 259 cat.56 n 5
 Abstractions No.1–6, 174
 Happy Landscape, 174, *175*, 176, 258 cat.53 nn 1–18
 A Nigger Goin' Fishin', 258 cat.53 n 18
Downtown Gallery, New York, 10, 138, 180, 256 cat.49 n 3
Dreier, Katherine, 164
Dreyfuss, Henry, New York Central locomotive designed by, 182, *183*
Dublin art colony, N.H., 132
Duchamp, Marcel, 158, 160, 171, 256 cat.48 n 10
 Bicycle Wheel, 171
Duncan, Bridget, 39, 246 cat.9 nn 1–2
Durand, Asher Brown, 56, 61–63
 In the Woods, 61, *62*, 248 cat.17 n 3
 Woodland Interior, 11, 61–62, *63*, 248 cat.17 nn 1–7
Durand-Ruel Gallery, New York, 144
Düsseldorf Academy, 68, 90
Duveen, Albert, 56
Dwight, Theodore, 70

Eagle (architectural ornament, Unknown artist), 36, *37*, 38, 246 cat.8 nn 1–11
Eakins, Thomas, 135–37
 Edith Mahon, 10, 135–36, *137*, 253 cat.41 nn 1–13
 In Grandmother's Time, 8, 9, 10, 11, 135, 245 n 4, *266*
Earl, Ralph, 12, 27–29, 41
 A Master in Chancery Entering the House of Lords, 11, 27–28, *29*, 246 cat.5 nn 1–4
 Roger Sherman, 27
Earle's Galleries, Philadelphia, 138
Ecole des Beaux-Arts, Paris, 84, 99, 125, 135, 168, 188
Egan (Charles) Gallery, New York, 1950 Kline exhibition, 205
Eginton, Francis, 33, 34

302

Egypt, 38, 241
Eight, the, 144
Einstein, Albert, 171
Eldredge, Charles C., 196
Eliot, T. S., 212
Elmer, Edwin Romanzo, 11, 12,
110–12, 119–21, 245 n 11
*A Lady of Baptist Corner, Ashfield,
Massachusetts*, 11, 119–20, *121*,
251 52 cat.36 nn 1 10
The Mary Lyon Birthplace,
252 cat.36 n 3, *268*
Mourning Picture, 11, 110–11, *111*,
112, 119, 120, 251 cat.33 nn 1–11
Portrait of My Brother, 110, *266*
Elmer, Effie Lillian, 110–11, 112, *112*,
119
Elmer, Mary, 110–11, 112, 119–20
Elmer House, Buckland, Mass., 110, *112*
Elwell, William A., *Ship Building:
Fishing Schooner on the Stocks at
Vincent's Cove*, 81, *82*
Emerson, Ralph Waldo, 87
England, 16, 18, 20, 27, 30, 32, 33, 95, 99
engraving, 61
Enneking, John, 8, 11
Twilight, 245 n 4
Ernst, Max, 198
Erving, Abigail Phillips, 16, 24, 26
Erving, John, 16, 24, 26
Evans, De Scott, *Try One*, *267*
Evans-Iliesiu, Elizabeth C., 12
Expressionism, 184

Fabing, Suzannah, 12
Faneuil, Peter, 18
Farrer, Thomas Charles, 74–77, 110,
248 cat.17 n 6
*View of Northampton from the
Dome of the Hospital*, 11, 74, *75*,
76–77, 248–49 cat.21 nn 1–16
Fauvism, 145, 184, 186, 252 cat.39 n 13
Feininger, Lyonel, 165 67
Architecture III (Gables II),
257 cat.50 n 11
Gables I, Lüneburg, 12, 165–67,
167, 257 cat.50 nn 1–12
Lüneburg, 166, *166*
*Lüneburg, Wendischendorfe Street,
No. 27*, 166, *166*
*Lüneburg, Wendischendorfe Street,
Nos. 27 and 28*, 166, *166*
Lüneburg II (Gables III), 166
Fenn, Harry, 250 cat.25 n 7
Ferguson, Henry A., *Evening, Andes of
Chile*, 245 n 4
Ferrara, Jackie, *1/4 M 161 C, A/C3, C*,
277
Field, Erastus Salisbury, 49–51
Almira Dodge Bassett, 50, *51*
Bethiah Smith Bassett, 11, 49–51,
51, 247 cat.13 nn 1–7
The Embarkation of Ulysses, 49
*Historical Monument of the
American Republic*, 49
Joseph Bassett, 50, *50*
Joseph Moore and His Family, 49
Nathaniel Bassett, 11, 49–50, *50*,
51, 247 cat.13 nn 1–7
Field and Stream, 80
Field Museum of Natural History,
Chicago, 162, 241

figureheads, ships', 38, 44–46,
246 cat.8 nn 1–11, cat.11 nn 1–12
Fine Arts Museums of San Francisco,
99, 140, 186, 247 cat.14 n 4
Fink, Larry, 228
Fish, Janet, *Herb Tea*, *273*
Flam, Jack, 201
Flavin, Dan, *The Barbara Roses 3D*,
275
Flavin, Sonja, *The Barbara Roses 3D*,
275
Florence, 84, 86, 99, 249 cat.24 n 3
Fogg Art Museum, Cambridge, Mass.,
99, 149
Folsom Gallery, New York, 164
Fortune, 180, 183, 259 cat.55 n 16
Frackman, Noel, 161, 162
Frank, Robert, 218, 262 cat.62 n 3
Frankenstein, Alfred, 10, 138, 140,
251 cat.33 n 3
Franklin, Benjamin, 246 cat.8 n 2
Free Academy of the City of New
York, 102
Freeman, Samuel T., 138
Freer, Charles Lang, 107
Freer Gallery of Art, Washington,
D.C., 107
Frémiet, Emmanuel, 150
French, Daniel Chester, 84–86
The Awakening of Endymion, 86
The May Queen, 10, 84, *85*, 86,
249 cat.24 nn 1–11
The Minute Man, 84
French Revolution, 10
Freud, Sigmund, 194, 217
Frey, Viola, *World Civilization #5*, *277*
Friedrich, Caspar David, 165
The Polar Sea, 236, 264 cat.72 n 11
Frieseke, Frederick Carl, 252 cat.39 n 7
Frost, Francis Seth, 67–69
Coast Scene on the Pacific, 67
*South Pass, Wind River
Mountains, Wyoming*, 67 69,
69, 248 cat.19 nn 1–8
Frost and Adams, 69
Futurism, 161, 188

Gabo, Naum, 171
Gainsborough, Thomas, 32
Galerie Druet, Paris, 150
Gallati, Barbara, 156
Gallatin, Albert, 172
Ganz (Jo Ann and Julian) Collection,
93
Garza, Carmen Lomas, *The Blessing
on Wedding Day*, 245 n 12, *273*
Gaugengigl, Ignaz Marcel, 116
Gaugh, Harry, 205
Geist, Sidney, 216
Geldzahler, Henry, 219
George III, King of England, 33
Gerdts, William, 144
Géricault, Théodore, *Raft of the
Medusa*, 236, 264 cat.72 n 11
German Bauhaus, 202
German Expressionism, 11, 202,
263 cat.70 n 2
Gérôme, Jean-Léon, 135
Gifford, Robert Swain, 8
Old Orchard near the Sea, 8,
245 n 4
Gifford, Sanford, 248 cat.18 n 5

Gignoux, Régis François, 87
Gilliam, Sam, *Uli Montage, You Come
Flying*, and *Higher Windows*, *273*
Gimbel Brothers, New York, 10–11,
245 nn 8, 9
Glackens, Ira, 12, 146
Glackens, William, 128, 144–46,
252 cat.39 n 7
Bathers, Bellport, No. I, 12,
144–45, *145*, 146,
254 cat.44 nn 1–17
Chez Mouquin, 144
Jetties at Bellport, 146, *146*
other works by, 254 cat.44 n 17
Glasgow Museum and Art Gallery,
Scotland, 96
Gleizes, Albert, 188
"Glimpses of the Hillyer Art Gallery"
(file clipping), 9, *9*
Gloucester, Mass., 81–82, *82*, 83
Goethe, Johann Wolfgang von, 54
Goldthwait, Joel, 84
Gosse, Edmund, 100
Gothic architecture, 165–67
Gottlieb, Adolph, 191–94,
261 cat.60 n 8
Descent into Darkness, 191–92,
193, 194, 260 cat.58 nn 1–17
Expectation of Evil, 192
Mariner's Incantation, 192
Night Voyage, 192
Oedipus series, 191
other works by, 260 cat.58 n 10
Voyager's Return, 192
Gottlieb (Adolph and Esther)
Foundation, New York, 192
Gould, Thomas, 249 cat.24 n 3
Grafly, Charles, 161
Graham, John, 194
Greece and Greek art, 38, 84, 147, 150,
170
Greenberg, Clement, 189, 218,
263 cat.66 n 15
Green Gallery, New York, 1962
Oldenburg exhibition, 213
Greenough, Horatio, 84
Grey Canyon Artists, Albuquerque,
237
Gris, Juan, 188
Grünewald, Mathis, 11
Guggenheim, Peggy, 198
Gundaker, Grey, 242, 244
Guston, Philip, *Sunrise*, *272*

Hale, Philip Leslie, 256 cat.47 n 4
Halpert, Edith, 10, 46, 138, 180,
259 cat.55 n 8
Halpin, John, *The Voyage of Life:
Manhood* (after Cole), 247 cat.14 n 10
Hals, Frans, 108
Hannock, Stephen, *The Oxbow, after
Church, after Cole, Flooded:
1979–1994 (Flooded River for the
Matriarchs, E. and A. Mongan)*, *273*
Harnett, William Michael, 10, 47, 138,
140, 251 cat.33 n 3, 253 cat.42 n 2
Job Lot Cheap, 140
Harper's Weekly, 81, 83, 110, 126
Hart, James McDougal, 8
*Rising Thunderstorm/Approaching
Thunderstorm*, 245 n 4
Hart, Joel, 249 cat.24 n 3

Hartigan, Grace, *Bride and Owl*, *270*
Hartley, Jonathan Scott, 250 cat.25 n 7
Hartley, Marsden, 158, 160, 170,
184–87, 190, 195, 245 n 13
*Atlantic Window in a New England
Character*, 186
*Bermuda Window in a Semi-Tropic
Character*, 186
other works by, 260 cat.56 nn 13,
19, 20
Sea Window—Tinker Mackerel,
184, *185*, 186–87,
259–60 cat.56 nn 1–21
Tinker Mackerel, 187
Hartmann, Sadakichi, 104
Hartt, Frederick, 10–11, 187
Harvard College, 22
Haseltine, William Stanley, 64–66
Natural Arch, Capri, 11, 64–65,
65, 66, 248 cat.18 nn 1–8
Natural Arch at Capri, 65–66, *66*
Haskell, Barbara, 186
Hassam, Childe, 11, 116–18, 122–24,
254 cat.43 n 8, 255 cat.47 n 2,
256 cat.47 n 5
Boston Common at Twilight, 116
*Cab Stand at Night, Madison
Square*, 116–17, *117*, 118,
251 cat.35 nn 1–7
Horse Drawn Cabs, New York, 117
*Horse Drawn Cabs at Evening,
New York*, 117
Room Full of Flowers, 122
Street Scene, Christmas Morn, *268*
Three Cities, 117
Union Square in Spring, *268*
*White Island Light, Isles of Shoals,
at Sundown*, 122, *123*, 124,
252 cat.37 nn 1–7
Hawthorne, Nathaniel, 70,
248 cat.20 n 2
Hayes, Helen, 12, 177–78
Hays, Barton S., 108
Heade, Martin Johnson, 78–80
New Jersey Meadows, 11, 78–79,
79, 80, 249 cat.22 nn 1–8
Sunset, Newburyport Meadows,
249 cat.22 n 3
Two Sketches of Cattle,
249 cat.22 n 3
Hearn, George A., 102
Henner, Jean Jacques, 109
Henri, Robert, 128, 132, 134, 144,
252 cat.39 n 7, 253 cat.40 n 7
Henshaw, William, 39
Hermitage Museum, Leningrad, 200
Herriman, William, 65
Hess, Thomas, 166
Hicks, Edward, 78
Hill, John Henry, 248 cat.21 n 4
Hillyer Art Gallery, 9, *9*, 245 n 9
Hinshelwood, Robert, *The Voyage of
Life: Manhood* (after Cole),
247 cat.14 n 10
Hirsch, Sanford, 192, 194
Hirschl, Norman, 56
Hirshhorn Museum and Sculpture
Garden, Washington, D.C., 192
Historical Society of Rockland, New
City, N.Y., *Edward Hopper's Nyack
Years* (1982), 258 cat.54 n 3

Hitchcock, Henry-Russell, 11, 110, 182, 251 cat.33 n 1
Hobbs, Susan A., 156
Homer, Winslow, 8, 12, 81–83, 94, 160
Bridle Path, White Mountains, 81
Eagle Head, Manchester, Massachusetts, 249 cat.23 n 9
Long Branch, New Jersey, 81
Ship-Building, Gloucester Harbor, 82, 83
Shipyard at Gloucester, 11, 81–83, 83, 249 cat.23 nn 1–12
Song of the Lark, 11, 245 n 4
Hope, Henry, 34, 246 cat.7 n 9
Hopper, Edward, 177–79
House by the Railroad, 178
Pretty Penny, 12, 177–79, 179, 258–59 cat.54 nn 1–13
Study for Pretty Penny, 178, 178
Hoppner, John, 32
Hornet, U.S.S., proposal for a figurehead for, 38, 38
Hovannes, John, 208
Hudson River School, 61, 68, 87, 102
Hunt, William Morris, 8, 90–92
American Falls Niagara, 90
Niagara, 90, 92
Niagara Falls, 90, 91, 92, 250 cat.26 nn 1–5
William Sydney Thayer, 266
Hunter, Russell Vernon, 195, 196
Huntington, Daniel, 61
Hutchinson, Thomas, 18
Hutton, Laurence, 79

Impressionism, 87, 90, 92, 106, 116, 122, 124, 141, 144, 145, 250 cat.25 n 6
Independent Chronicle, 26
Indian Arts and Crafts law (1990), 240
Ingres, J.-A.-D., 104
Inness, George, 8, 11, 87–89, 103
Along the Delaware, 267
Cloudy Day, 266
Landscape, 12, 87–89, 89, 249–50 cat.25 nn 1–17
Leeds, New York, 88, 88, 89, 250 cat.25 n 11
Morning, 245
The Red Oak, 250 cat.25 n 11
Triumph of the Cross, 88
Insley, Albert Babb, 94
International Herald Tribune, photograph of damaged stern of British ferry *Herald of Free Enterprise*, 234, 234, 264 cat.72 n 3
Inter-State Industrial Exposition, Chicago, 107
Isaacson, Philip, 36
Italy, 16, 64–66, 84, 86, 87, 95, 99, 147, 208

Jackson, John, 249 cat.24 n 3
James, Henry, 249 cat.21 n 6
"A Landscape Painter," 120
James, William, 132
Janis (Sidney) Gallery, New York, 206, 216, 262 cat.65 n 6, 263 cat.66 n 15
Japanese prints, 132, 134
Jarves, James Jackson, 79
Jarvis, Ada Maud Vesey-Dawson, 95, 96, 98

Jarvis, John Wesley, 23
Jarvis, Lewis, 95, 98
Jefferson, Thomas, 30
Jennys, Richard, 41
Captain David Judson, 41
Grissel Warner Judson, 41
Mrs. David Longenecker (Effie Dock), 41
The Reverend Jonathan Mayhew, 41
Jennys, William, 41–43
Captain David Judson, 41
David Coffin, 265
Elizabeth Stone Coffin, 265
Grissel Warner Judson, 41
Isaac Stone Coffin, 265
James Clarkson, 41
Lieutenant David Billings, 41–42, 42, 246 cat.10 nn 1–5
Mabel Little Billings, 41–42, 43, 246 cat.10 nn 1–5
Mrs. David Longenecker (Effie Dock), 41
Nathaniel Coffin, 265
John, Augustus, *Madame Suggia*, 154, 156, 156
Johnson, Reverend Samuel, 22, 23
Johnson, Dr. William Samuel, 22–23
Jones, Betsy B., 9, 11, 12, 245 n 11
Judd, Donald, 208
Untitled, 276
Jugendstil movement, 150, 255 cat.46 n 11
Jung, Carl, 194
Junker, Patricia, 10, 12, 245 nn 10, 11

Kandinsky, Wassily, 184, 210, 220, 258 cat.53 n 7
Improvisations, 174
Improvisation 27 (Garten der Liebe II), 258 cat.53 n 7
Keck, Sheldon, 138
Kende Galleries, 11
Kennedy, Clarence, 259 cat.55 n 18
Kensett, John Frederick, 70, 78
Kent, Rockwell, 132–34
Dublin Pond, 9, 11, 132, 133, 134, 252–53 cat.40 nn 1–12
Monadnock, 134
Winter (Berkshire), 253 cat.40 n 7
kinetic sculpture, 171, 221–22
King, Reverend Thomas Starr, 70
Kirchner, Ernst Ludwig, *Dodo and Her Brother*, 11
Kirstein, Lincoln, 153, 168–70, 255 cat.46 n 1, 257 cat.51 n 11
Kitson, Henry Hudson, 168
Klee, Paul, 237
Kline, Franz, 205–7, 210
C & O, 206
Red Painting, 206
Requiem, 205
Rose, Purple and Black, 205–6, 207, 262 cat.62 nn 1–12
Sawyer, 262 cat.62 n 6
Scudera, 206
Siegfried, 205
Kneller, Sir Godfrey, 16
Knoedler (M.) and Company, New York, 11, 158, 187
Knowlton, Grace, Three forms from the *Brooklin* series, 277

Kootz Gallery, New York, 199, 261 cat.60 nn 3, 8
The Muralist and the Modern Architect (1950), 198, 261 cat.60 n 8
Kornhauser, Elizabeth Mankin, 12, 245 n 11
Kunsthalle, Hamburg, 236

LaBoureur, Jean-Emile, 252 cat.39 n 7
Lachaise, Gaston, 148, 158, 168–70, 245 n 13
La Force Eternelle (Woman with Beads), 274
Garden Figure, 12, 168, 169, 170, 257–58 cat.51 nn 1–13
Standing Woman (1932), 168, 170
Standing Woman (1935), 170, 170
Standing Woman (Elevation), 160, 168
Torso, 170, 274
Laemmle, Cheryl, *Two Sisters*, 272
Lahvis, Sylvia, 36
Lalique, René, 168
Lancaster Historical Society, Pa., 41
Lander, Colonel Frederick William, 67, 68, 72
Lane, James W., 113
Langham, Henrietta Elizabeth Frederica Vane, 30, 32
Langham, Sir William, 32
Lansill, Walter F., *Fishermen's Boats*, 245
Larkin, Oliver, *Art and Life in America*, 8
Lawson, Ernest, 144
Léger, Fernand, 171, 188, 221, 258 cat.52 n 8
Lehár, Franz, 128
Leonardo da Vinci, *Vitruvian Man*, 238
LeWitt, Sol, 224–27
Cube Structure Based on Nine Modules (Wall/Floor Piece #2), 12, 224, 225, 226–27, 263 cat.69 nn 1–17
Leyland, Frederick, 95
Lipchitz, Jacques, 188–90
Barbara, 188–89, 189, 190, 260 cat.57 nn 1–11
Blossoming, 190
Myrah, 190
Pierrot Escapes, 188
"transparents," 188–90
Lippard, Lucy, 218
Livingston family, 22
London, 16, 24, 27, 30, 32, 34, 56, 95
Longfellow, Henry Wadsworth, *Evangeline: A Tale of Acadie*, 251 cat.34 n 5
Los Angeles County Museum of Art, 192
Los Angeles Municipal Art Gallery, *500 Years: With the Breath of Our Ancestors* (1992), 241–42, 242, 264 cat.74 n 4
Louvre, Paris, 236
Low, Will H., *All Saints Day*, 245 n 4
Luks, George, 144

MacArthur, Charles, 177
Macbeth Gallery, New York, 1908 exhibition of the Eight, 144

McBride, Henry, 158–60, 170, 196
McCausland, Elizabeth, 176, 186
McClure's magazine, 144
McIlworth, Thomas, 22–23
Dr. William Samuel Johnson, 22–23, 23, 245 cat.3 nn 1–6
Portrait of Ann Beach Johnson, 22, 23, 23
McIntire, Samuel, 36
Maciver, Loren, *Subway Lights*, 270
MacKown, Diana, 232
McNear, Sarah Anne, 230
McNeil, George:
Darkling Disco, 272
Spring Street, 272
Mahon, Edith, 135–36, 253 cat.41 nn 1–13
advertisement for, as accompanist, 135, 136
Maier Museum of Art, Randolph-Macon Woman's College, Lynchburg, Va., 113
Manet, Edouard, 128, 144, 255 cat.47 n 2, 264 cat.72 n 10
Mangold, Sylvia Plimack, *Yardstick Margin Being Painted*, 271
Manley, Thomas R., 250 cat.25 n 7
Manship, Paul, 147–48, 148, 149, 168, 170, 257 cat.51 n 7
Centaur and Dryad, 147–48, 148, 149, 149, 254–55 cat.45 nn 1–11
Satyr Chasing Maenad, 148, 148
Marin, John, 13, 158, 160, 245 n 13, 259 cat.56 n 5
Marin, Norma, 13
Marin (Norma) Foundation, 13, 245 n 13
Marlborough International, Vaduz, 190
Massachusetts State House, 36, 246 cat.8 n 1
Matisse, Henri, 145, 150, 186, 198, 199, 200–201, 210, 220, 261 cat.60 nn 10, 12, 262 cat.60 n 14
La Danse (Merion Dance Mural), 201, 201
La Danse I, 200, 200, 201
La Danse II, 200, 201
Jazz series, 199, 200, 261 cat.60 n 12
Open Window, Collioure, 260 cat.56 n 11
Thousand and One Nights, 200
Matisse, Pierre, 258 cat.52 nn 1, 2, 7
Maupassant, Guy de, 128
Maurer, Alfred Henry, 128–31, 174
An Arrangement, 130, 252 cat.39 n 12
Le Bal Bullier, 11, 128, 129, 130–31, 252 cat.39 nn 1–16
The Fortune Teller, 252 cat.39 n 12
Le Moulin Rouge, 131
The Red Shawl, 252 cat.39 n 12
Maurer, Evan, 192
Mayan sculpture, 232
Maynard, George W., *A Soldier of the Revolution*, 245 n 4
Mead, Larkin, 249 cat.24 n 3
Mead Art Museum, Amherst College, Amherst, Mass., 142
Meech, Nanette Harrison, 11
Merrill, Linda, 12
Metcalf, Robert Reid, 254 cat.43 n 8
Metcalf, Willard Leroy, 141–43

Cornish Hills, 141–42, *142*
other works by, 254 cat.43 n 11,
256 cat.47 n 3
Willows in March, 11, 141–42, *143*,
253–54 cat.43 nn 1–12
Metropolitan Magazine, 147
Metropolitan Museum of Art, New
York, 61, 108, 148, 165, 183, 195, 198,
219, 259 cat.55 n 18, 261 cat.60 n 3
1983 Manet retrospective,
264 cat.72 n 10
Metzinger, Jean, 188
Michelangelo, 170
Milbert, Jacques Gérard, 56
*Lake George and the Village of
Caldwell*, 56, 57
*Picturesque Itinerary of the Hudson
River and the Peripheral Parts of
North America*, 56–57
Milch Galleries, New York, 156
Millay, Edna St. Vincent, 212
Miller, Dorothy C., 11
Miller, William, 58
Millet, Jean François, 90, 113
Minimalism, 12, 208, 224, 232
Minneapolis Institute of Arts, 99, 156
Miró, Joan, 171
Mitchell, Joan, 210–12
Keep the Aspidistra Flying, 270
Untitled, 12, 210, *211*, 212,
262 cat.64 nn 1–15
Model Crest Pole (Unknown artist,
Haida people, Northwest Coast),
164, *164*, 257 cat.49 nn 14–17
modernism, 103, 161, 195
Modigliani, Amedeo, 150
Moholy-Nagy, László, 171,
258 cat.52 n 9
Mondrian, Piet, 171, 220
Monet, Claude, 124, 141,
254 cat.43 n 12
*Cart on the Snowy Road at
Honfleur*, 254 cat.34 n 12
Snow at Argenteuil, 142
Montross Gallery, New York, 141
Moore, Charles Herbert, 76,
248 cat.21 n 4
Morris, George L. K., 260 cat.58 n 13
Morse, Samuel F. B., 49
Motherwell, Robert, 198–201
Le Cow-boy, 200
La Danse, 198–99, *199*, 200–201,
261–62 cat.60 nn 1–17
La Danse II, 198, 199, 200, 201,
261 cat.60 nn 3, 10
Elegy Study, 198, *271*
*Elegy to the Spanish Republic
No. 1*, 198
Formes, 200
The Painter's Wife, Pregnant, 199
"A Personal Expression" (lecture),
200
Spanish Elegies, 198, 199, 201
Wall Painting No. 1, 198, *198*
Wall Paintings, 198, 201
Moulthrop, Reuben, 39
Mount Holyoke College Art Museum,
13
mourning pictures, 111
Mowbray, H. Siddons, 158
Mumford, Lewis, 113, 176
Munich Glyptothek, 150

Munich School, 108
Munson-Williams-Proctor Institute
Museum of Art, Utica, N.Y., 55
Murphy, J. Francis, 107
Musée d'Art Moderne de la Ville de
Paris, 201
Musée de l'Homme, Paris, 162
Musée d'Orsay, Paris, 95–96
Museo Nacional Centro de Arte Reina
Sofía, Madrid, 192
Museum of Fine Arts, Boston, 24, 28,
49, 81, 90, 99, 114, 116, 142, 161, 228,
236, 254 cat.43 n 12
Museum of Fine Arts, Houston, 213
Museum of Fine Arts, Springfield,
Mass., 49
Museum of Modern Art, New York,
10, 11, 140, 153, 178, 190, 191, 192,
198, 200
1939 Sheeler retrospective, 181,
259 cat.55 n 8
1946 Stettheimer retrospective, 160
1951 Matisse exhibition, 200
1969 Oldenburg retrospective,
262 cat.65 n 1
Muybridge, Eadweard, 224

Nadelman, Elie, 150–53
Acrobat, *274*
Buck Deer, 152
Le Cerf, 152, 255 cat.46 n 13
The Dancer, 152
Horse, 152
Le Jeune Cerf, 152, 255 cat.46 n 13
Resting Stag, 11, 150, *151*, 152–53,
255 cat.46 nn 1–18
Standing Fawn, 152, *152*,
255 cat.46 n 13
Wounded Stag, 153, *153*,
255 cat.46 n 17
Nashua, N.H., 58
Nation, The, 77
National Academy of Design, New
York, 61, 65, 73, 102, 104, 108, 113,
128, 134, 147, 184, 248 cat.17 n 3,
249 cat.23 n 9
1861 annual exhibition, 73
National Gallery of Art, Washington,
D.C., 11, 30, 65, 96, 206,
247 cat.12 n 4
National Museum of American Art,
Smithsonian Institution,
Washington, D.C., 114
National Portrait Gallery,
Washington, D.C., 23
Native Americans and Native
American art, 22, 44, 68, 70, 162,
163, 191–92, 237–40, 241,
257 cat.49 nn 13–17,
264 cat.73 nn 1–12
crest (totem) poles, 164, *164*,
257 cat.49 nn 14–17
Neel, Alice, *Anthony Barton*, *271*
neoclassicism, 84, 86
Nevelson, Louise, 231–33
Canada Series III, 232, *276*
Distant Column, 231, 232, *275*
Half Moon II, 263 cat.71 n 1
Mirror-Shadow series, 232
Mirror-Shadow XIII, 13, 231–33,
233, 263 cat.71 nn 1–9

Moving-Static-Moving, 231,
263 cat.71 n 2, *275*
New Haven, Conn., 27, 41
New Jersey, 78–80, 87, 88
Newman, Barnett, 237
Newman, Henry Roderick,
248 cat.21 n 4
New Path, The, 76, 77
Newport, R.I., 18, 30, 90, 99
New York, 9, 22, 24, 28, 30, 41, 44, 56,
64, 74, 76, 87, 99, 102, 104, 107, 108,
113, 116, 117, 125–26, 141, 144, 145,
150, 154, 158, 168, 174, 184, 191, 206,
208, 210, 213, 214, 226
New York Central steam locomotive,
182, *183*
New York Daily Tribune, 76
New York Evening Post, 46
New York Gazette, 22
New York Herald, 144
New York Leader, 72, 81
New York Mercury, 22
New York Sun, 158, 187
New York Times, 73, 194, 264 cat.72 n 2
Niagara Falls, N.Y., 90–92
Nicoll, James Craig, *Closed In*, 245 n 4
Nierendorf, Karl, 257 cat.50 n 2
Ninth Street Show (1951, New York),
210
Noble, Louis Legrand, 55
Nochlin, Linda, 212
North American Review, 76, 110
Northampton Free Press, 74
Northwest Coast art, 164, *164*, 192
Norton, Charles Eliot, 76, 110
Nygren, Edward, 12

Offner, Elliot, *Helmeted Head*, *276*
O'Keeffe, Georgia, 176, 180, 195–97,
245 n 13, 259 cat.56 n 5
Chestnut Tree—Red, 196
Dead Tree with Pink Hills, 195
Grey Tree, Fall, 195–96, *197*,
260–61 cat.59 nn 1–16
Grey Tree, Lake George, 195
other works by, 261 cat.59 nn 7,
10, 14, 15
Spring, 195
Squash Flowers No. 1, 269
Oldenburg, Claes, 213–15
Giant Soft Fan, 213, *214*
Giant Soft Fan—"Ghost" Version,
213
Sketch for a Soft Fan, 12, 213–14,
215, 262 cat.65 nn 1–7
Study for a Hanging Soft Fan,
262 cat.65 n 3
O'Neill, Eugene, *Mourning Becomes
Electra*, 251 cat.33 n 1
Oregon Trail, 67
Ortgies Art Gallery, New York, 61
Ozenfant, Amédée, 221

Pace Gallery, New York, 232
Page, William, 88
Paris, 84, 87, 90, 99, 100, 116, 117, 127,
128–31, 135, 144, 150, 161, 165, 168,
171, 180, 184, 188, 191, 210, 221,
252 cat.39 nn 7–15, 260 cat.56 n 11
1889 Exposition, 116
1900 Exposition Universelle, 102,
130

Paris Salon, 65, 99, 130, 168
of 1887, 116
of 1888, 116
of 1889, 109
of 1899, 252 cat.39 n 12
of 1908, 174
of 1909, 174
Park, Richard, 249 cat.24 n 3
Parkhurst, Charles, 12
Parks, Robert Owen, 11
Parnassus magazine, 182
Parry, Ellwood C., 54
Parsons, Charles, 250 cat.25 n 7
Pasadena Art Museum, 1966–67
Cornell exhibition, 241
Pavia, Philip, 206
Paxton, William, 256 cat.47 n 4
Peabody and Stearns, 9
Peale, Anna, 48
Peale, Charles Willson, 47
Peale, James, 47
Peale, Margaretta Angelica, 47–48
Still Life: Strawberries & Cherries,
48
*Still Life with Watermelon and
Peaches*, 11, 47–48, *48*,
247 cat.12 nn 1–9
Peale, Maria, 48
Peale, Raphaelle, 47
Peale, Rembrandt, 58
Rubens Peale with a Geranium,
247 cat.12 n 4
Peale, Rubens, 47
Peale, Sarah Miriam, 48
Pearce, Charles Sprague, *A Cup of
Tea*, 267
Pei, I. M., 226
Pelham, Peter, 24
Pennsylvania Academy of the Fine
Arts, Philadelphia, 48, 64, 65, 108,
130, 135, 138, 144, 161, 180
Pepe, Sheila, 264 cat.74 n 9
Percy, Thomas, *Reliques of Ancient
English Poetry*, 251 cat.34 n 13
Peto, John Frederick, 11, 47, 138–40,
251 cat.33 n 3
Discarded Treasures, 10, 138, *139*,
140, 253 cat.42 nn 1–7
Old Friends, 267
Still Life with Books and Candle,
267
Pevsner, Antoine, 171
Philadelphia, 30, 47, 48, 64, 135, 138, 144
Centennial, 65
Philadelphia Museum of Art,
252 cat.38 n 4
Philadelphia Orchestra *Journal*, adver-
tisement for Edith Mahon, accompa-
nist, 135, *136*
Philadelphia Society of Artists, 138
Phillips, Ammi, 39, 49
Phillips, Andrew Faneuil, 18, 20
Phillips, Ann, 18, 20
Phillips, Duncan, 176, 258 cat.53 n 16
Phillips, Gillam, 18, 20
Phillips, Marie Faneuil, 18, 20
Phillips Memorial Gallery,
Washington, D.C., 176
Phoenicia, 44
Phoenix Art Museum, 149

photograph of damaged stern of British ferry *Herald of Free Enterprise*, 234, *234*, 264 cat.72 n 3

photography, 49, 67, 69, 72, 73, 94, 112, 180, 181, 182, 183, 224, 234, 235, 236, 259 cat.55 nn 8, 12, 14, 16, 18

Photo-Secession Gallery, New York, 184, 258 cat.53 n 2

Picasso, Pablo, 150, 188, 189, 255 cat.46 n 7, cat.47 n 2

The Glass of Absinthe, 260 cat.57 n 3

Guernica, 192

La Table, 10

Platt, Charles Adams, 141

Pliny the Elder, 44

Pointillism, 158

Pollock, Jackson, 205, 210, 218, 234, 237, 245 n 13, 263 cat.66 n 15

Pop art, 202, 208, 214

Post-Impressionism, 174, 184

Post-Minimalism, 234

Pound, Ezra, 212

Powers, Hiram, 84

Greek Slave, 84

Proserpine, 86

Powers, Preston, 84, 249 cat.24 n 3

Precisionism, 161, 180

Prendergast, Maurice, 144, 146, 252 cat.39 n 7

Pre-Raphaelites, 72, 74, 248 cat.17 n 6

Prior, William Matthew, 58

Mount Vernon and the Tomb of Washington, *266*

proposal for a figurehead for the U.S.S. *Hornet*, 38, *38*

Quick, Michael, 87, 88

Quick-to-See-Smith, Jaune, 237–40

Buffalo, 237

Flathead Dress, 237

Indian Horse, 237

Indian Map, 237

Quincentenary Non-Celebration series, 237, 240

The Red Mean: Self-Portrait, 12, 237–39, *239*, 240, 264 cat.73 nn 1–12

Target, 237

Trade (Gifts for Trading with White People), 237

Rambach (Harvey and François) Collection, 186

Realism, 141

Reed, Luman, 52, 61

Reeds Hill Foundation, Carlyle, Mass., 228

regionalism, 191

Renoir, Auguste, 128, 144, 254 cat.44 n 13, 255 cat.47 n 2

Revolutionary War, 18, 27, 39, 50

Reynolda House, Winston-Salem, N.C., 140

Reynolds, Sir Joshua, 22

Rhode Island School of Design, Providence, 108

Rich, Adrienne, 112

Richards, William Trost, 62, 248 cat.21 n 4

Rickey, George, 221–23

Four Lines Oblique Gyratory, 222

Four Lines Oblique Gyratory Rhombus, 221–22, *223*, 263 cat.68 nn 1–13

Four Lines Oblique Gyratory Rhombus Variation II, 222, 263 cat.68 n 13

Four Lines Oblique Gyratory Rhombus Variation III, 222, 263 cat.68 n 13

Omaggio a Bernini, 221–22

Two Lines Leaning IV (A.h.c.), 222, *276*

Two Lines Oblique—Albany Mall, 222

Rimmer, William, *The Gamblers, Plunderers of Castile*, *267*

Riopelle, Jean-Paul, 210

Rivera, Diego, 188

Rivera, José de, 258 cat.52 n 9

Robinson, Theodore, 116

Rodchenko, Alexander, 171

Rodia, Simon, *Watts Towers*, 241

Rodin, Auguste, 161

Romantic poets, 54

Rome, 64, 84, 99, 147, 148, 208

Ronnberg, Erik A. R., Jr., 81, 82

Rose, Barbara, 234, 262 cat.64 n 8

Rosenberg, Harold, 198

Rosenberg (Paul) Gallery, New York, 1942 Hartley exhibition, 187

Rosenblum, Robert, 219, 220, 227

Rosenthal, Nan, 221, 222

Rossetti, Dante Gabriel, 74

Roszak, Theodore, 258 cat.52 n 9

Rothko, Mark, 194, 245 n 13, 260 cat.58 n 17

Untitled (checklist #44), *271*

Untitled (checklist #45), *271*

Rousseau, Théodore, 87

Royal Academy, London, 24, 27, 30, 32, 33, 34, 246 cat.7 nn 1, 9

Rubin, William, 219

Rush, William, 46

Ruskin, John, 62, 74, 76, 77, 95, 110, 112, 248 cat.17 n 6, 259 cat.55 n 7

Ruskin School of Drawing and Fine Art, Oxford, 221

Ryder, Albert Pinkham, 102, 103, 113–15, 260 cat.56 n 7

Constance, 114

A Country Girl, 113, 251 cat.34 n 5

The Little Maid of Acadie, 113, 114, 251 cat.34 n 5

Lord Ullin's Daughter, 114

Perrette, 9, 113–14, *114*, *115*, 251 cat.34 nn 1–13

Perrette, King Cophetua and the Beggar Maid, 114

Saar, Alison, 264 cat.74 nn 1, 9

Saar, Betye, 241–44

Ancestral Spirit Chair, 12, 241–42, *243*, 244, 264 cat.74 nn 1–16

Black Girl's Window, 241

Diaspora, 241–42, *242*

Spirit Door, 241, 242

Sabatier, Léon, *Lake George and the Village of Caldwell* (after Jacques Gérard Milbert), 56–57, *57*

Sage, Kay, *Remote Control*, *270*

St. Andrew's Society, New York, 22

Saint-Gaudens, Augustus, 125–27, 256 cat.47 n 8

Admiral Farragut, 125

Diana, 125–27

Diana of the Tower, 10, 125–27, *127*, 252 cat.38 nn 1–8

Farragut Monument, 125

St. Paul's Church, Birmingham, England, 33, 34

Salon des Indépendants, of 1890, 130

Sanders, Rita, 146

Sandler, Irving, 212

Santa Maria della Vittoria, Rome, 221

Sargent, John Singer, 99–101, 128, 154, 255 cat.47 n 2

The Breakfast Table, 99

A Dinner Table at Night (Mr. and Mrs. Albert Vickers), 99

Fête Familiale (The Birthday Party), 99

Heaven, 268

Hell, 268

Madame X (Madame Pierre Gautreau), 108

My Dining Room, 11, 99–100, *101*, 250 cat.29 nn 1–4

Sartain, William, 8

Narcissus, 245 n 4

Satterlee, Walter, 8

The Young Dominican, 245 n 4

Saturday Evening Post, 144

Sawitzky, William, 32

Schamberg, Morton Livingston:

Landscape, 268

Victory, 269

Schenck, Edgar, 11

Schumann-Heink, Ernestine, 135

Schuyler family, 22

Science Museum of Minnesota, *First Encounters: Spanish Exploration in the Caribbean and United States, 1492–1570* (1992), 237, 238

Scott and Fowles Gallery, New York, 152

Scribner's magazine, 144

Seelye, L. Clark, 8–9, 10, 11, 107, 135, 147, 252 cat.40 n 1

Seventh Annual Utica Arts Association exhibition (1879), 93

Shahn, Ben, *Sound in the Mulberry Tree*, *270*

Shakespeare, William, 54

Shattuck, Aaron Draper, 62

Shchukin, Sergei, 200, 201

Sheeler, Charles, 180–83, 245 n 13

Conversation—Sky and Earth, 182, 259 cat.55 nn 6, 14

other works by, 259 cat.55 nn 6, 14

Powerhouse, 269

Power series, 180–83, 259 cat.55 nn 6, 14

Rolling Power, 10, 180–81, *181*, 182–83, 259 cat.55 nn 1–20

Wheels, 182, *182*, 259 cat.55 nn 12, 14

Shinn, Everett, 144

Shirley, William, 26

Shurtleff, R. M., *A Race for Life*, 245 n 4

Simmons, Edward, 254 cat.43 n 8

Siskind, Aaron, 191, 262 cat.62 n 3

Skillin, John, 36, 246–47 cat.11 n 1

Skillin, Simeon, Jr., 36, 246–47 cat.11 n 1

Skoglund, Sandy, *Tools of Expression*, *272*

Sloan, John, 144, 191

South Beach Bathers, 146

Small, Mr. and Mrs. William A., Jr., 13

Smibert, John, 16–17

The Bermuda Group, 16

Mrs. John Erving (Abigail Phillips), 11, 16, *17*, 24, 245 cat.1 nn 1–3

Smillie, James, *The Voyage of Life: Manhood* (after Cole), 247 cat.14 n 10

Smith, Thomas, *Nightfall in Winter*, 245 n 4

Smith, Walter, 116

Smith College Archives, 8

Smith College Museum of Art, Northampton, Mass., 9, 12, *13*

Boeckman (Elizabeth Mayer) sculpture courtyard, 12, *13*

collecting history and policies, 8–13, 245 nn 1–14

Peto retrospective (1950), 138

Snyder, Joan, 228–30

Love's Deep Grapes, 229

Love's Pale Grapes, 229

Mourning/Oh, Morning, 228

My Temple, My Totems, 13, 228–29, *229*, 230, 263 cat.70 nn 1–13

Resurrection, 228

Small Symphony for Women I, 228

Stroke paintings, 228, 230

Soby, James Thrall, 251 cat.33 n 1

Société Anonyme, 1923 Storrs exhibition, 164

Society for the Advancement of Truth in Art, 74, 76, 248 cat.21 n 4

Society of American Artists, New York, 104, 107, 108, 113, 116, 132, 154, 256 cat.47 n 5

1889 exhibition, 107

1904 exhibition, 9, 134

Society of American Painters in Pastel, 108, 116

Society of Artists, London, 24, 32

1783 exhibition, 32

Spencer, Lilly Martin, *Reading the Legend*, *266*

Springfield Republican, 8

Stable Gallery, New York, 210

Stankiewicz, Richard, *Untitled*, *277*

Stebbins, Theodore, 78, 79, 80

Steichen, Edward, 180

Stein, Gertrude, 128, 150, 160, 180, 184, 190, 255 cat.46 n 5, 256 cat.48 nn 10, 13, 260 cat.56 n 6

Stein, Leo, 128, 150, 180, 184, 255 cat.46 n 5

Stein, Michael, 180

Steinbach, Haim, *no wires, no power cord #2*, *277*

Stella, Frank, 219–20

Aluminum series, 219

Black paintings, 219

Copper series, 219

Damascus Gate (Variation III), 12, 219–20, *220*, 263 cat.67 nn 1–11

Dartmouth series, 219

Irregular Polygons, 219,
 263 cat.67 n 9
Notched-V series, 219
Persian paintings, 219
Protractor series, 12, 219, 220,
 263 cat.67 n 9
Purple series, 219
Running-V series, 219
Stern, Maurice, 128
Stettheimer, Florine, 11, 158–60
 Henry McBride, Art Critic, 11,
 158–59, *159*, 160,
 256 cat.48 nn 1–14
Stevenson, Robert Louis, 126
Stieglitz, Alfred, 152, 158, 160, 174,
 176, 180, 184, 195, 196, 255 cat.46 n 8,
 258 cat.53 nn 7, 9, 259 cat.56 nn 4, 5,
 260 cat.56 n 5, 261 cat.59 nn 4, 6
still-life painting, 47–48
Storrs, David W., 161
Storrs, John, 161–64, 258 cat.52 n 9
 Auto Tower (Industrial Forms), 12,
 161–62, *162*, *163*, 164,
 256–57 cat.49 nn 1–19
 Ceres, 164
 Edna Harrington, 274
 Forms in Space, 162
 *Study for Auto Tower (Industrial
 Forms)*, 161, *162*
 Winged Figure, 274
Strand, Paul, 180, 259 cat.56 n 5
Stuart, Gilbert, 23, 30–32
 *Henrietta Elizabeth Frederica
 Vane*, 11, 30, *31*, 32,
 246 cat.6 nn 1–5
 *Portrait of George Thomas John
 Nugent*, 30, 32, *32*
 The Skater, 30, 32
Sturgis, Russell, 76, 77
Stuyvesant family, 22
Suggia, Madame, 154, 156, *156*
Sultan, Donald, 234–36
 Battleship, July 12, 1983, 236
 Ferry, Sept.17, 1987, 13, 234–35,
 235, 236, 264 cat.72 nn 1–14
 Lines Down, Nov. 11, 1985, 236
 Poison Nocturne, Jan. 31, 1985, 236
Surrealism, 138, 158, 161, 162, 164, 171,
 172, 191, 194, 198
Swedenborg, Emanuel, 88,
 250 cat.25 n 14

Tarbell, Edmund, 11, 254 cat.43 n 8,
 256 cat.47 n 4
Tate Gallery, London, 24, 28, 96
Tatlin, Vladimir, 171
Ten American Painters, 116, 141, 142,
 154, 254 cat.43 n 8, 256 cat.47 n 5
Tériade, Emmanuel, 199
Thaxter, Celia, *An Island Garden*, 122
Thayer, Abbott, 9, 132, 134
 Winged Figure, 9, *9*, 11
Thompson, Robert Farris, 242, 244
Thompson, Virgil, *Four Saints in Three
 Acts*, 256 cat.48 n 13
Thyssen-Bornemisza Collection, 93
Tiffany, Louis Comfort, 8
 Old New York, 245 n 4
Tile Club, 108
Tilton, Henry Newell, 73
Time magazine, 119
Timme, Walter, 11, 245 n 8
Tonalism, 256 cat.47 n 5

Torr, Helen, *I*, *269*
Toulouse-Lautrec, Henri de, 128
 At the Moulin Rouge: The Dance,
 130, 131, *131*
Transcendentalism, 87
Trumbull, John, *The Declaration of
 Independence*, 61
Trustees of Smith College, 8, 10
Tryon, Alice Belden, 10, 104
Tryon, Dwight William, 8, 9, 10, 11,
 12, 104–7, 253 cat.40 n 12
 The First Leaves, 11, 104, *105*,
 106–7, 250–51 cat.31 nn 1–14
 November Evening, *269*
 The Rising Moon: Autumn, 106,
 107
 Sunrise: April, 106, *106*
 Twilight at Auvers, 104, *104*
Tryon Art Gallery, 10, *10*, 12
Tuckerman, Henry, 64
Turner, Joseph Mallord William, 55
 Slave Ship, 236
Turner, William, 249 cat.24 n 3
Twachtman, John, 11, 107, 142,
 254 cat.43 n 8, 256 cat.47 n 5
 Brook in Winter, 142, *142*
 Winter Silence, 142
291 Gallery, New York, 152,
 259 cat.56 nn 4, 5, 261 cat.59 n 4
 *Arthur G. Dove First Exhibition
 Anywhere* (1912), 174

Unknown artist, *Bridget Duncan*, 39,
 40, 246 cat.9 nn 1–2
Unknown artist, *Ceres* (ship's
 figurehead), 11, 44, *45*, 46, *46*,
 246–47 cat.11 nn 1–12
Unknown artist, *Eagle* (architectural
 ornament), 11, 36, *37*, 38,
 246 cat.8 nn 1–11
Unknown artist, *William Henshaw*, 39,
 39
Unknown artist (Haida people,
 Northwest Coast), *Model Crest Pole*,
 164, *164*, 257 cat.49 nn 14–17

Valentin, Curt, 257 cat.50 n 2
Van Cortland family, 22
Van Dyck, Anthony, 20
van Gogh, Vincent, 210
Vanity Fair, 180
Van Rensselaer family, 22
Van Vechten, Carl, 158
Vedder, Elihu, *Memory*, *267*
Velázquez, Diego, 108, 135
Venus of Willendorf, 170
Verdi, Giuseppe, 128
Vermeer, Johannes, 154, 157,
 256 cat.47 n 9
Vogue magazine, 180
Vorticism, 161
VVV, 198

Wadsworth Atheneum, Hartford,
 Conn., 149
Walker, Henry O., 256 cat.47 n 8
Walker Art Center, Minneapolis, 146
Walkowitz, Abraham, 259 cat.56 n 5
Ward, Samuel, 52, 55, 247 cat.14 n 8
Washington, George, 30, 58
Weber, Max, 128, 259 cat.56 n 5
Weber, Paul, 64
Weir, J. Alden, 254 cat.43 n 8

Welliver, Neil, *Winter Stream*, *272*
Wendel, Theodore, 256 cat.47 n 4
West, Benjamin, 22, 24, 27, 28, 30,
 33–35
 *Preliminary design for the painted
 window in St. Paul's Church,
 Birmingham: The Conversion
 of St. Paul; St. Paul Persecuting
 the Christians; Ananias Restoring
 St. Paul's Sight*, 11, 33 34, *35*,
 246 cat.7 nn 1–9
Weston, Edward, 180
Whistler, James McNeill, 95–98, 104,
 106, 108, 128, 154, 236, 255 cat.47 n 2
 *Arrangement in Grey and Black:
 Portrait of the Painter's Mother*,
 95
 *Arrangement in Grey and Black,
 No. 2: Portrait of Thomas
 Carlyle*, 96
 *Harmony in Grey and Green: Miss
 Cicely Alexander*, 96
 *Mrs. Lewis Jarvis (Ada Maud
 Vesey-Dawson Jarvis)*, 11,
 95–96, *97*, 98, 250 cat.28 nn 1–9
 *Nocturne: Black and Gold—The
 Falling Rocket*, 95
 The Pool, 95, 96
 Portrait of Miss Alexander, 108
 *Symphony in White No. 1: The
 White Girl*, 96
White, Henry C., 104
White, Stanford, 125, 126,
 256 cat.47 nn 8, 14
White Mountains, N.H., 70–73, 81
Whitney, Anne, *Chaldean Shepherd*,
 274
Whitney Museum of American Art,
 New York, 130, 153, 178
Whittredge, Worthington, 68
Wichita Art Museum, 228
Wight, P. B., 76
Wildenstein's, New York, 11
Wilfred, Thomas, *Clavilux*, 171
Wilkin, C., *Lady Langham*, 32
William Henshaw (Unknown artist),
 39, *39*
Williams, Frederick Ballard,
 250 cat.25 n 7
Williams, Pat Ward, *Ghosts That Smell
 Like Cornbread*, 245 n 12, *277*
Williams, William Carlos, 180
Williams College Museum of Art,
 Williamstown, Mass., 90
Willis, Nathaniel Parker, *American
 Scenes*, 56
Wilmerding, John, 138
Wilson, John, *My Brother*, *269*
Worcester, Mass., 39
World War I, 157
World War II, 164, 188, 192, 198, 216
Wright, Frank Lloyd, 162
Wyant, Alexander H., 8
 Scene in County Kerry, Ireland,
 245 n 4

Yale University, New Haven, Conn.,
 22, 202, 204, 213
 Art Gallery, 16, 27
Yamaguchi, Yuriko, *Origin #1*, *277*

Zola, Emile, 128
Zorach, William, 208

Photograph Credits

E. Irving Blomstrann: C5–C8, C14,
 C59, C60, C65, C76, C78
Geoffrey Clements: figs. 39, 49
Sheldan Collins: C54
H. Edelstein: C13, C25, C42, C66, C69
Henry Elkan: C35
G. R Farley: fig. 12
John A. Ferrari: C79
Janet Fish: C58
M. Richard Fish: fig. 4
George French: fig. 23
Grace Knowlton: C85
David Lubarsky: C81
Paul M. Macapia: fig. 31
William Nettles: fig. 61
Tim Nighswander: fig. 57
Stephen Petegorsky: cats. 2a, 2b, 2d, 3,
 7–9, 10a, 10b, 11, 12, 13a, 13b, 15, 16,
 18, 20, 24, 26, 28, 30, 34, 41, 45, 51,
 52, 54, 57–61, 63, 65–73, C1–C4,
 C11, C16, C18, C20, C34, C36, C38,
 C41, C43–C46, C48, C51–C53, C57,
 C64, C68, C72, C75, C80, C82–C84,
 figs. 2, 21, 34
John D. Schiff: figs. 42, 48
David Stansbury: cats. 1, 2c, 4–6, 14,
 17, 19, 21–23, 25, 27, 29, 31–33, 35–40,
 42–44, 46–50, 53, 55, 56, 62, 64, 74,
 C10, C12, C15, C17, C19, C21–C24,
 C26–C33, C37, C39, C40, C47, C49,
 C61, C63, C70, C71, C77, fig. 50
Herbert P. Vose: C9, C62, figs. 3, 43
Zindman/Fremont: fig. 54